Reading Images focuses on the multilayered relationships between the textual image and its reader-viewer in the Apocalypse manuscripts produced in England during the thirteenth century, a period of profound social and cultural change. The exponential expansion in the production and dissemination of illuminated manuscripts that occurred at this time provided a critical, cultural mechanism for the creation of new technologies of the self. Within the framework of this newly discernible subjectivity, Suzanne Lewis examines how contemporary theories of vision invested images with the power not only to promote memory and offer spiritual sustenance, but also to articulate and activate dominant ideological positions regarding the self, society, and the "other." As the Apocalypse narrative was visualized in pictures, it became a powerful paradigm within which problematic contemporary experiences such as anti-Judaism, the later Crusades, and expectations of the world's end could be defined. *Reading Images* explores the kinds of contemporary mythologies that constitute ideology, a realm in which visual representation becomes an agent rather than a reflector of social change.

Reading Images

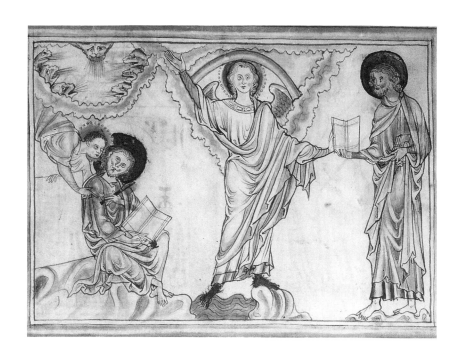

Apocalypse. Formerly Metz, Bibliothèque municipale MS Salis 38, fol. 16. John Forbidden to Write; John Takes the Book (photo: Monuments historiques, Paris).

READING IMAGES

NARRATIVE DISCOURSE AND RECEPTION IN THE THIRTEENTH-CENTURY ILLUMINATED APOCALYPSE

SUZANNE LEWIS

Stanford University

CAMBRIDGE
UNIVERSITY PRESS

Published by the Press Syndicate of the University of Cambridge
The Pitt Building, Trumpington Street, Cambridge CB2 1RP
40 West 20th Street, New York, NY 10011–4211, USA
10 Stamford Road, Oakleigh, Melbourne 3166, Australia

First published 1995

Printed in the United States of America

Library of Congress Cataloging-in-Publication Data

Lewis, Suzanne
 Reading images : narrative discourse and reception in the
thirteenth-century illuminated apocalypse / Suzanne Lewis.
 p. cm.
 Includes bibliographical references and index.
 ISBN 0–521–47920–7
 1. Bible. N.T. Revelation—Illustrations. 2. Illumination of
books and manuscripts, Gothic—England. 3. Illumination of books
and manuscripts, English. 4. Narrative art—England. 5. Image
(Theology)—History of doctrines—Middle Ages, 600–1500. I. Title.
ND3361.R5L48 1995
745.6'7'094209022—dc20 95-830
 CIP

A catalog record for this book is available from the British Library

ISBN 0–521–47920–7 Hardback

Contents

List of Illustrations

71. Apocalypse. Formerly Metz, Bibliothèque municipale
 MS Salis 38, fol. 16v. Measuring the Temple 107

72. Apocalypse. Oxford, Bodleian Library MS Douce 180,
 p. 34. Measuring the Temple 108

73. Apocalypse. Formerly Metz, Bibliothèque municipale
 MS Salis 38, fol. 17. Two Witnesses 109

74. Apocalypse. Malibu, J. Paul Getty Museum MS Ludwig
 III.1, fol. 16v. Two Witnesses 110

75. Apocalypse. Paris, Bibliothèque Nationale MS fr. 403,
 fol. 17. Witnesses before Antichrist 110

76. *Bible moralisée*. London, British Library MS Harley
 1526, fol. 24v. Witnesses before Antichrist 111

77. Apocalypse. Formerly Metz, Bibliothèque municipale
 MS Salis 38, fol. 17v. Massacre of the Witnesses 112

78. Apocalypse. New York, Pierpont Morgan Library MS
 M.524, fol. 7. Massacre of the Witnesses 113

79. Apocalypse. Malibu, J. Paul Getty Museum MS Ludwig
 III.1, fol. 17. Massacre of the Witnesses 113

80. Apocalypse. Paris, Bibliothèque Nationale MS lat.
 10474, fol. 19. Rejoicing over the Dead Witnesses 114

81. Apocalypse. Malibu, J. Paul Getty Museum MS Ludwig
 III.1, fol. 18. Resurrection of the Witnesses 116

82. Apocalypse. Paris, Bibliothèque Nationale MS fr. 403,
 fol. 18v. Seventh Trumpet 117

83. Apocalypse. Malibu, J. Paul Getty Museum MS Ludwig
 III.1, fol. 19. Ark of the Covenant 118

84. Apocalypse. New York, Pierpont Morgan Library MS
 M.524, fol. 8. Ark of the Covenant 119

85. Apocalypse. New York, Pierpont Morgan Library MS
 M.524, fol. 8v. Woman in the Sun (above); Michael
 Battling the Dragon (below) 120

86. Apocalypse. London, Lambeth Palace Library MS 209,
 fol. 15. Woman in the Sun 121

87. Apocalypse. Malibu, J. Paul Getty Museum MS Ludwig
 III.1, fol. 20. Rescue of the Child 121

88. Apocalypse. Formerly Burckhardt-Wildt Collection, fol.
 24. Ark of the Covenant and the Woman in the Sun 122

89. Apocalypse. Cambridge, Trinity College MS R.16.2, fol.
 13. Woman in the Sun 123

90. Apocalypse. London, Lambeth Palace Library MS 209,
 fol. 15v. Michael Battles the Dragon 124

91. Apocalypse. Malibu, J. Paul Getty Museum MS Ludwig
 III.1, fol. 19v. Woman in the Sun 124

92. Apocalypse. New York, Pierpont Morgan Library MS

Preface

Naming a book can be an exacting, somewhat un-nerving task, because the author is obliged to describe honestly and fully what lies ahead for the reader. That is to say, he or she must set forth in the most abbreviated terms a complicated network of expectations. Above all, the naming of the text should neither misrepresent nor mislead. Thus, *Reading Images* is a title not intended be coyly evasive, but rather to serve as a succinct but accurate description of a distinctive cognitive process of interpretive perception that formed a critical component of cultural discourse in the High Middle Ages. An exploration of how that process unfolds in the thirteenth-century English Apocalypse constitutes the subject of my book.

Although the title for a book can be found or invented at any stage of the research or writing, and indeed can and perhaps should be put off until the work has been completed, *Reading Images* presented itself almost at the outset of the project. In its conjunction of words that draw their semantic charge from disparate linguistic roots, each equally viable throughout the Middle Ages, *Reading Images* works on several levels to express both literally and metaphorically how I have conceptualized and configured my subject. The Latin-rooted *imago* (picture, likeness, semblance, figure, idea, concept) constitutes an object acted upon by the Germanic Old English verb *raedan* (Middle English = *reden*), which in its evolved modern form, "reading," now embraces "to

look at or scan, observe, peruse, study, comprehend, translate, understand meaning, penetrate thought, and record" – all of which were involved in the medieval process of reading images as I have found it, as well as forming a recognizable component of our own experience, most strikingly in the last postmodern decades of the twentieth century. This is not, however, to argue that medieval cognitive processes of interpretative perception are the same or even analogous to our own. Instead, *Reading Images* sets out to chart a territory of critical "difference" that defines the nature of intertextual meaning and the power of visual and verbal representation both then and now. Whereas such temporal and cultural distinctions remain largely implicit in my text, I have attempted throughout to sustain an awareness that medieval images and texts can only be seen through a culturally constructed lens of the late twentieth century. Thus, the reader will be offered, without apology, an ideologically grounded discourse that has as its subject another, equally charged, albeit distant, cultural discourse.

Although *Reading Images* might suggest a traditional investigation of relationships between text and image, my inquiry centers on more active but elusive relationships between the textual image and its reader-viewer. In exploring pictorial strategies of narrative representation, I shall not be concerned with questions of how an image might reflect or even represent a text but with how it constructs a new

"text," often subverting and diverting meaning into alternative channels of comprehension or cognitive interchange. Although my analysis is focused somewhat narrowly on thirteenth-century English Apocalypses, its implications can be readily expanded to engage our understanding of medieval visual discourses on a much broader front, encompassing other media and other texts, as well as wider temporal and geographical boundaries. What I would propose to offer in *Reading Images* is in the way of a paradigm, shifting the theoretical focus from more traditional philological methods and notions of image as passive "object" to an approach that recognizes a more dynamic process of interaction between viewer, text, and image. As we increasingly realize that a self-conscious problematizing of visual representation was central to the medieval process of image making and reception, we can quickly recognize how readily such thirteenth-century cultural preoccupations lend themselves to the scrutiny of contemporary poststructuralist analysis. This is not to say that the theoretical paradigm I have constructed for the thirteenth-century English Apocalypse puts forward a totalizing view of how all medieval art was conceived or perceived, but rather it suggests a more accessible way of exploring and understanding some creative and receptive processes of imagination and interpretation that may have been operative throughout the Middle Ages.

My present focus on thirteenth-century England opens the door to a medieval period of profound changes in the social and cultural fabric that both impacted and were promoted by the production and consumption of the newly imaged Apocalypse. The exponential expansion in the production and dissemination of illuminated manuscripts provided a critical cultural mechanism for the creation and cultivation of new technologies of the self. No longer conceived exclusively in corporate terms of class or social order, individuals, at least among religious and secular elites, became increasingly engaged in reading and devotional prayers that required privacy and solitary meditation. The internalizing of such cultural practices as silent reading, as opposed to an older medieval habit of oral recitation, involved active transactional experiences that, unlike our own, were both self-conscious and cultivated. In attempting to explore newly evolving technologies of the self within the context of "reading" the Gothic imaged

Apocalypse, I shall explore, for example, how reader-viewers cultivated the art of memory, as well as how thirteenth-century theories of vision invested Gothic images with the power not only to promote memory and offer spiritual sustenance, but also to articulate and activate dominant ideological positions regarding the self, society, and the "other." In an age of Church reform following Lateran Council IV and the late Crusades, thirteenth-century readers experienced the Gothic Apocalypse within the framework of a fresh wave of anti-Judaism and increased eschatological anxiety, which, as we shall see, were not unrelated. Notwithstanding their compelling connections with contemporary configurations of apocalyptic text images, however, none of these contextual issues can be regarded as firmly fixed within our historical grasp; they are just as problematical as the phenomenon of the newly imaged Gothic Apocalypse itself. Consequently, I shall be just as concerned with the problematic of cultural context as with the processes of making and reading culturally constructed illuminated texts. In undertaking the two inquiries simultaneously, I intend an explicit recognition that context, as recently set forth by Jonathan Culler, Norman Bryson, Keith Moxey, and others, is itself a text that requires interpretation.

By way of *apologia* or *explanatio* to the reader, an account of the project's origins might help to further explain or describe its scope and intention. At the same time, however, a retrospective view of the intellectual journey that brought me to this point is in a sense already both distanced and truncated, having now been fully shaped by its outcome, the end product, the book at hand. At best, the most one can hope to do is to delineate a few disparate and isolated facets of the experience. What is even more difficult is to provide a coherent rationale for how they came to be connected and merged. As I now look back on how my text was made, I am struck by the aptness of Umberto Eco's formulation of how Thomas Aquinas saw any "creative" process such as writing – as a human technology of continual tinkering, joining together what was separate and separating what was joined.

Beginning on a note of Augustinian confession, I must admit that my first experience of the Apocalypse was a grudging and uncomprehending reading of the text as a graduate student. Dutifully looking

at a work extolled by my teacher as an essential lexicon offering insight into the opaque mysteries of medieval art, I left the completed assignment totally unenlightened, but at the same time not altogether unconvinced. Either to my shame or credit, it has taken more than half a lifetime beyond that first encounter to come to terms with this text as a medieval experience of word and image. My first disappointed reading had an initially subliminal but ultimately profound impact upon my thinking about medieval art, for it was instrumental in raising my consciousness to the critical importance of texts, words, signs, symbols, and images in the complex cultural currencies of the Middle Ages. A persistent and growing fascination with the power of visual and lexical representations both in the second half of this century and those of the Middle Ages eventually brought me to a project focused upon the imagery of the Apocalypse in illuminated manuscripts. The more I learned about the medieval transformations of this text through image, gloss, and redaction, the more convinced I became that my professor was right, that the Apocalypse offered a deep mythic structure that lay at the heart of an important aspect of the medieval cultural discourse. I now realize how, as this powerfully imagined and imaged segment of Scripture was virtually visualized in pictures, it became a doubly powerful narrative paradigm within which medieval experiences of the world could define themselves.

As a social historian of art long concerned with questions of how art and ideology intersect, I could see that, perhaps more compellingly evident than in any other genre of medieval art production and consumption, the Apocalypse generated an art of visual representation that was demonstrably not passive or absorptive, acted upon and influenced by powerful patrons and shaped by larger cultural forces. Instead, it became increasingly obvious that the distinctive visual and verbal discourse constructed in the thirteenth-century illuminated manuscripts, while deeply invested both politically and socially by the elite individuals for whom they were made, functioned as powerfully active voices in shaping culture and participating in the formation of thirteenth-century ideology.

As questions of apocalyptic text, image, and ideology converge in this book, readers of my earlier work on Matthew Paris, for example, will discover what might appear to be a radical shift from an unacknowledged structuralist stance into a full-blown advocacy of semiotics and reception theory, accompanied by an inevitable dependency on theoretical works ranging from Foucault, Barthes, and Jauss to Bryson and Bal. Although the transition was by no means sudden or abrupt, to this and related charges I plead *mea culpa*. At the present stage of my thinking about Gothic Apocalypses, there seemed to be no better way to set forth the theoretical positions I wanted to stake out for the purposes of my own analytical stance than to let those far more authoritative voices speak for themselves, laying the foundations for what I have undertaken in exploring the semiosis and narratology of what is to me a thirteenth-century discourse still full of unexpected turns and ingenious surprises.

This book began as a much larger project encompassing the production and consumption of illustrated Gothic Apocalypse manuscripts on a much broader scale. As my exploratory and analytical narrative eventually took on an unwieldy shape of elephantine proportions, it became obvious when it was pointed out independently by two perceptive and judicious readers (to whom I am deeply grateful), that I was actually engaged in writing two rather different books about medieval Apocalypses. A restructuring of the project thus led to the work at hand and one that will be shortly forthcoming. The present study, *Reading Images*, is centered on narrative strategies and semiotic problems developed by the thirteenth-century English Gothic Apocalypse in its dominant discursive form structured around a Berengaudus-glossed text. The second book, *Picturing Visions*, is not a sequel but an independent narrative dealing with how archetypes and subsequent prototypes were shaped by the reception of the Gothic Apocalypse in a number of alternative versions. Here I explore ideas about contingency and reader reception in individual manuscripts on a larger geographical stage (England, France, Flanders, and Germany) across the whole diachronic span of the Gothic period from the thirteenth through the fifteenth centuries. However, the bifurcation of my overall project is not to separate theory from practice, but to engage them in different ways on a shifting scale of historical time and place.

When this research began, I gave little or no thought to the apocalyptic implications of the ap-

proaching end of this century. Now that the new millennium is almost upon us, I still have little to offer in the way of insight into what relevance the eschatological expectations involved in the conception of the Gothic illustrated Apocalypse around the middle of the thirteenth century in England might have for the global problems facing the arrival of the twenty-first century. Indeed, as I see it, the Gothic Apocalypse was less about prophecy and eschatology and more about a profoundly moving and surprisingly intimate view of the world as it was lived and perceived in the experiential present of thirteenth-century England. The pictured text offered a path to the realization and definition of self through the experience of reading images on a series of complex interconnected levels. Contrary to popular beliefs about the Middle Ages, there was nothing simple or unproblematic about reading and interpreting texts, pictures, or text images. Although a world of differ-ence inevitably exists between readers and viewers then and now, as we sift through the shards of past experience, we keep encountering pieces of a fractured mirror in which we can recognize fragments of our equally complicated present selves.

I cannot end my *apologia* without commenting on what is all too obvious but left too often unremarked in my text – and that is the sheer captivating brilliance of the images themselves. It is so easy to become enmeshed in their lexical, representational, and narratological complexity that the artists' elegant calligraphy of drawing and sophisticated syntax of design tend to be taken for granted. But it was surely just as much the medieval reader's pleasure in gazing at visual images of such stunning and consummate beauty as the other affective experiences they movingly evoked that made the thirteenth-century English Apocalypse into a Gothic best seller.

Acknowledgments

No one can approach the study of Gothic Apocalypses without first acknowledging an immense debt to George Henderson's magisterial studies on English manuscript illumination. Over the years, I have valued his encouragement, generous criticism, and collegial friendship. I am also indebted in many diverse ways to Janet Backhouse, Adelaide Bennett, Michelle Brown, Mildred Budny, Brigitte Cazelles, Claire Donovan, Richard Emmerson, Thomas Kren, Ruth Mellinkoff, Nigel Morgan, Lucy Sandler, Claire Sherman, Harvey Stahl, and Patricia Stirnemann, for patiently listening and providing much needed expert advice.

I also wish to thank all the individual librarians and keepers of manuscripts who generously made accessible the treasures in their care. At the same time, I am grateful to Stanford University librarians Alex Ross, Amanda Bowen (who is now at Smith College), and Sonia Moss for all the occasions on which they cheerfully provided their skillful assistance.

Special thanks are extended to the graduate students in my Art History seminars on medieval manuscripts and visual theory, as well as those in the Graduate Program in the Humanities at Stanford University, who over the years heard some of the ideas in this book in their earliest and most inchoate form. They provided inspiring and informative audiences from whom I learned some invaluable lessons.

I am grateful to the National Endowment for the Humanities and the Pew Foundation for research and travel grants, as well as to the American Council of Learned Societies for a grant-in-aid and to the School of Humanities and Sciences and the Art Department at Stanford University for subsidizing photographic and reproduction costs.

I owe a particular debt of gratitude to Chris Pearson and Erin Blake for their painstaking care over two summers in preparing the bibliographies and undertaking the final proofreading.

Lastly, I wish to gratefully acknowledge the critical role of Beatrice Rehl, the Fine Arts editor at Cambridge University Press, who had the uncanny good sense to patiently negotiate just the right encouraging moves at strategic times along the way toward transforming an unwieldy elephantine project into what I can now hope is a reasonably readable book.

Reading Images

Introduction

Apocalypsis depictus: A Book of Visions

The Apocalypse, or Book of Revelation, constituted a powerful, pervasive presence in the dominant discourses of medieval culture. As a book of images, the illuminated text *(Apocalypsis depictus)* gained particular momentum in the last three centuries known as Gothic, a period marked by an exponential surge in manuscript production. More than half the illustrated manuscripts of the Apocalypse surviving from the Middle Ages belong to the distinctive Gothic tradition that began in England in the mid-thirteenth century. Of the eighty-three manuscripts surviving from the last and most extraordinary expansion of medieval Apocalypse cycles, fifteen English examples dating from the period of its inception form a paradigmatic corpus of ideas that constitutes the subject of my present inquiry.[1] Although illustrated Gothic Apocalypses have been analyzed and discussed since they were introduced in the groundbreaking study by Delisle and Meyer almost a century ago,[2] the time now seems ripe to bracket the prevailing philological search for origins, filiations, and stylistic definitions in order to consider how thirteenth-century manuscript cycles engaged in the creation of a dominant cultural discourse. In short, rather than revisiting traditional debates, the discussion of Gothic Apocalypse manuscripts might be more productively pursued along new paths mapped out by semiotics and poststructuralist theory. By turning to questions of representation, narrative, and reception, we might better position ourselves to examine the visual and cultural concerns that led book designers, artists, and readers to convert a difficult, opaque text into a Gothic best seller.

As Keith Moxey recently observed, theory and practice do not constitute a binary opposition, an antithetical polarity.[3] To the contrary, they are symbiotically related. The art historian cannot construct a narrative of the past without some kind of theoretical speculation. Nor is it possible to write art history without engaging the present, for our interpretations are "valued or devalued according to the way in which their articulation . . . either coincides or differs with our own perspective on the political and cultural issues of our time."[4] This is not to say, for example, that we shall find Foucault's epistemic structures duplicated in thirteenth-century England. To paraphrase John Hay, when one reads *The Order of Things* from a medieval perspective,

it is as though one is constantly seeing its images reflected brilliantly in a pile of mirror shards. So many of the same issues are to be seen, but in fragments that need to be rearranged, often but perhaps not always differently, in the reconstruction of another history. . . . I suspect that . . . it is partly the disordered resonances of its conflicts with our own histories that both mesmerize and confuse us.[5]

Indeed, it is the very opacity of the work, the ways in which its historical and cultural conventions resist our gaze that provide openings to meaning: "It is only through a recognition of the unqualified alterity

of the work that we can hope to understand the cultural forces that once flowed through it."[6] As Norman Bryson reminds us, writing about art has a double mandate. Whereas the archive traces it back to its original context of production, the hermeneutic mission responds to the work as sign projecting itself forward in space and time, so that interpretation is now governed by two historical "horizons" – then and now.[7] Semiotics as a theoretical position locates art history within a broader transdisciplinary landscape as we see cultures themselves as neither static nor stable but engaged in an "eternal process of redefinition."

We do not inherit a set of petrified conventions and unchanging codes but active and dynamic values, which change according to the new significance invested in them by succeeding generations. Semiotic theory thus enables us to account for the variety and relativity of the cultural values we inherit from the past, as well as for our ability to interpret and manipulate those values in the creation of new cultural meaning.[8]

Before mapping the contents of each chapter in my exploration of the Gothic Apocalypse, I would like to sketch out an itinerary through the cultural territory of the later medieval illuminated book in more global terms by fixing the coordinates of our inquiry within thirteenth-century patterns of reading, optical perception and cognition, hermeneutics and spirituality.

READING THE TEXT

Because our inquiry centers on the cultural politics of image-text relationships, we might remind ourselves that "word and image" is a deceptively simple label not only for different kinds of representation, but for deeply contested cultural values. As W. J. T. Mitchell acutely observed,

The "differences" between images and language are not .nerely formal matters: they are, in practice, linked to things like the difference between the (speaking) self and the (seen) other; between telling and showing; between "heresay" and "eyewitness" testimony; between words (heard, quoted, inscribed) and objects or actions (seen, depicted, described); between sensory channels, traditions of representation, and modes of experience.[9]

Without suggesting the possibility of some kind of

totalizing master narrative that cuts across all strata of culture, however, visuality and textuality cannot be productively sustained in a relation of binary opposition. Images are read, and texts are imaged:

Images are readings, and the rewritings to which they give rise, through their ideological choices, function in the same way as sermons: not a re-telling of the text but a use of it; not an illustration but, ultimately, a new text. The image does not replace a text; it is one. Working through the visual, iconographic, and literary traditions that produced it, these images propose for the viewer's consideration a propositional content, an argument, an idea, inscribed in line and color, by means of representation. By means, also, of an appeal to the already established knowledge that enables recognition of the scene depicted. Paradoxically, this recognition is an indispensable step in the communication of a new, alternative propositional content.[10]

What emerges as a paramount concern is the realization that, in the complex interplay between visuality, institutions, discourse, and figurality, seeing (the look, gaze, interior imagery) can be as deeply problematical as various forms of reading (decipherment, decoding, interpretation).[11] Although visual literacy might not be fully explicable on the model of textual comprehension, the two cognitive channels rarely operate independently within the historical contexts of Western European cultures as we know them, and most particurly in the Middle Ages. Thus, our inquiry will center upon intersection rather than divergence as we attempt to find our way into the visual culture of a medieval illustrated text by picking up the broken threads of philosophy, optics, theology, and psychology that might help reconnect us to an almost lost and distant experience of reading images.

The new cycles of Apocalypse illustration that were created in England around the middle of the thirteenth century reveal some revolutionary changes in the medieval conception of the book. As evoked in an early fourteenth-century English vernacular prologue to a manuscript belonging to John London, monk of Crowland Abbey, the Gothic idea of the illustrated Apocalypse radically transforms reading into a visual experience. Reading becomes the discovery of arcane meaning and ultimate salvation in a book of images:

Who reads this book of imagery
Will be comforted and made ready
To understand, his wits to clear,

The beasts that are portrayed here.
And full knowing much of truth
That is now hidden, it is ruth.
To find their meaning in their kind
Look at the gloss and you will find
It is the key that will unlock
The door which is now fully stuck.
This key is for good men to find
To make them see who now are blind.
God give us grace to have that sight
Which, to be saved, will rule us aright.
Amen.[12]

By the second half of the thirteenth century, books appear to have been less commonly read aloud and increasingly scanned or studied privately in silence, particularly by lay readers.[13] As early as the twelfth century, Hugh of St. Victor and John of Salisbury recognized among the various categories of reading "the occupation of studying written things by oneself."[14] From the thirteenth century on, lexical shapes on the page no longer functioned as triggers for sound patterns but as visual symbols of concepts. Reading became an individualized, solitary discourse between the self and the page.[15] The shift in emphasis from one kind of reading to another, from an oral tradition to a visual orientation more characteristic of the later Middle Ages, offered a new conceptual framework for the design and perception of books that had a profound effect on the creation of the Gothic illustrated Apocalypse. The solitary reader of a written text could now confront that text critically. As opposed to the ephemeral character of a spoken text, the written word was enduring, and interpreted meaning could be held visually in the memory with the aid of illustrations.

Just as written words were seen rather than heard, rich sequences of pictures sharing some of the same lexical and narrative functions as the text could also be placed before the eyes of the silent reader. Determined by the scriptural master text that appears on the same page, the image takes on, as a sign, the same kind of syntagmatic construction as the verbal sign. As Bryson has argued, the discursive image plays down the independent life of its signifying material and becomes transparent, "a place of transit through which the eye must pass to reach its goal, the Word."[16] Illustrations could nonetheless be relieved of their function as substitutes for the text, enabling them to constitute an extratextual semantic code for the reader.[17] Pictures create a privileged metadiscursive imagery that finds its special distinction in its inherent silence, seeming to enter the mind directly and thus transcending the mundane.[18]

Because privacy engendered mind wandering and speculation was no longer controlled by instant correction, as had been the case in the earlier practice of public *lectio*,[19] Revelation's opaque allegories and prophecies clearly demanded that they be insulated by layers of protective apparatus in both textual and pictorial glosses to contain and stabilize the silent reading of the text within the parameters of orthodox Church doctrine.[20] Gothic cycles of illustration thus respond to the new cultivation of private silent reading by providing a visual matrix capable of guiding and controlling the reader's perception of the written text. Vision's synchronic gaze produces an instantaneous totality, which forecloses open-ended explorations for truth through language.[21] Conversely, the biblical image must not be allowed to extend into an independent life as the spectator, left to his or her own devices, might expand imaginative contemplation beyond permissible limits. Thus, the text and gloss inscribed beneath the framed picture guarantee a further hermeneutic closure to the performative discourse active in the present.[22]

In conjunction with the new and more powerful interpretive role of its illustrations, the thirteenth-century English Apocalypse expands the text into a book in which the pictures assume a dominant role. In some cases, the number of miniatures has been extended to more than a hundred. Although the Book of Revelation had already been transformed into a few isolated picture books in the twelfth century, such as that in the *Liber Floridus*, the Gothic images stand in a new relationship to the text. Large, semitransparent tinted drawings appear above a half-page of text (figs. 1–3); the illustrations now occupy a position of precedence in the hierarchy of the reader's perception. In the new thirteenth-century *ordinatio*, the picture commands the reader's attention before the text is read, thus conditioning and even predetermining how its message is to be perceived and understood.

The dominance of pictures within the experiential regime of the Gothic Apocalypse seems to stem in part from current medieval notions such as that of Anselm of Havelberg who expected readers to contemplate events in the text "as though on a stage."[23]

Figure 1. Apocalypse. Oxford, Bodleian Library MS Douce 180, p. 17. Fifth Seal (photo: The Bodleian Library, Oxford).

Figure 2. Apocalypse. Formerly Metz, Bibliothèque municipale MS Salis 38, fol. iv. First
Vision and the Seven Churches (photo: Monuments historiques).

As John of Salisbury observed, it was the imagination, not the text, that opened a reader's understanding of invisible things.[24] "Illustration" (illustratio) or "picturing" (picturatio) was a device by which many medieval authors elucidated their material. Stimulated by imagery, the power of the reader's soul resorted to the images stored in the memory, and from its sifting through the images of things it wanted, imagination was born. Thus meaning, or visualization, preceded words.[25] The critical act of reading was visualization, and readers were spectators. As he read the apocalyptic account of the war in heaven in Rev. 12, the twelfth-century commentator Rupert of Deutz realized the power of imagination to transform words into "an amazing spectacle of images [that] appeared before the gaze of John's soul." Reading the words of the Apocalypse, he continued, we can recover the summit of John's awe mixed with horror only by dreaming or by imagining drawn from inward meditation.[26] As Bryson remarked in his discussion of the medieval discursive-figural symbiosis active in the stained glass windows of Canterbury Cathedral,

Image is less important in praesentia than it is as anticipated memory: the moment of its impact may be intense, but only so that the visual impression can go on resonating within the mind after it has ceased to contemplate the actual image. Present qualities – as in advertising – are subordinated to future ones, and the qualities likeliest to endure are those that cluster around the verbal components.[27]

THEORIES OF VISION AND COGNITION

What makes the visual intelligible is itself unseen, for it is an anonymous body of practice spread out in different places. In Foucault's archaeology, knowledge requires a way of spatializing itself, a sort of "technology of the visible."[28] We might now ask how later medieval concepts of visibility came to be embedded in certain cultural and institutional practices as matters of contingent historical configuration.

By the middle of the thirteenth century, images claimed a position of primacy within Apocalypse manuscripts as well as in Psalters and other sorts of scriptural texts used for devotional purposes. Before we can explore the history of such images further, however, we must first concern ourselves with the history of vision itself, that is, with ideas circulating about how images were thought to be seen. As Michael Camille framed the question, "What was it about the scopic regimes of pre-modernity that allowed the gaze to gain power from its object?"[29] Notwithstanding the privileging of vision in the reading of the Gothic Apocalypse, the primacy of sight is much too frequently metaphorical and circumscribed by texts to consider the phenomenon as evidence of ocularcentrism as it was known in postmedieval regimes. Indeed, the inherent ambiguity in attitude and practice between logocentrism and what might be perceived as the specular model of "ocular desire" seems to reflect an analogous constraint of epistemic and discursive determination in thirteenth-century theories of vision just as it does in our own time.[30]

The dialectic of word and image seems to be a constant in the fabric of signs that a culture weaves around itself. What varies is the precise nature of the weave, the relation of warp to woof. The history of culture is in part the story of a protracted struggle for dominance between pictorial and linguistic signs.[31]

Although sight had enjoyed a privileged role in the phenomenology of the senses since the time of Plato and Aristotle,[32] ancient valorizing metaphors such as the "eye of the soul" gained new and more compelling currency in the Western Middle Ages in the wake of Latin translations of Greek and Arabic sources on optics and perception theory dating from the eleventh to the thirteenth century.[33] At the same time that the optical theories of Avicenna, Alhazen, Averroës, and Al-Kindi impacted older Platonic conceptions of how substantial images are propagated by objects and forcibly impress themselves on the senses, newly accessible Aristotelian texts, as well as Arabic commentaries, further legitimated Aristotelian "intromission" theory, which held perception and cognition to be affective processes in which the object transmits a likeness or image of itself to the eye and hence to the intellect and soul.

Leaving aside for the moment our working assumption that the literal sense of the word "image" is a graphic, pictorial representation (a concrete material object), we must now also understand "image" in the thirteenth-century sense of the Latin similitudo, not as a "picture" but as "likeness" or species. The concept of species, as applied to optics and cognition, had its origin in the Neoplatonic doctrine of

Figure 3. Apocalypse. Malibu, J. Paul Getty Museum MS Ludwig III.1, fol. 3. First Vision (photo: Collection of the J. Paul Getty Museum, Malibu, California).

emanation. Plotinus maintained that all things tend to emanate their power outside themselves:

All existences, as long as they retain their character, produce – about themselves, from their essence, in virtue of the power which must be in them – some necessary, outward-facing hypostasis continuously attached to them and representing in image the engendering archetypes.[34]

As it was used throughout the Middle Ages, the word *species* remained narrowly connected to its root *SPEC* and thus inevitably and unproblematically implied the idea of vision.[35] In a formula offered by Hugh of St. Victor, "Species is visible form, which in turn contains two, figure and color."[36] Whereas the early Middle Ages had focused on the ontological relation of *species* to "reality," the thirteenth century saw a radical shift to its epistemological ramifications pertaining to cognition.[37] These ideas were developed by Robert Grosseteste (d. 1253) into the doctrine of the multiplication of species, which was to underlie most late thirteenth- and early fourteenth-century "perspectivist" theories of cognition as they were understood to involve a process of abstraction from vision:

A natural agent propagates its power from itself to the recipient, whether it acts on the senses or on matter. This power is sometimes called species, sometimes a similitude, and is the same whatever it may be called; and it will send the same power into the senses and into matter. . . . For it does not act by deliberation and choice, and therefore it acts in one way, whatever it may meet, whether something with sense perception or something without it, whether something animate or inanimate. But the effects are diversified according to the diversity of the recipient.[38]

Among the "perspectivists," as they were known to their late medieval readers, it was Roger Bacon who succeeded in providing the most compelling account of the "multiplication of species." By synthesizing Grosseteste's doctrine with theories of vision drawn from Alhazen, he formulated what was to become the standard thirteenth-century explanation of cognition based on perception.[39] For Bacon as well as Grosseteste, visible species are only one instance of a general multiplication of species by all objects and powers in the universe:

For every efficient cause acts through its own power, which it exercises on the adjacent matter, as the light *[lux]* of the

sun exercises its power on the air (which power is light *[lumen]* diffused through the whole world from the solar light *[lux]*). And this power is called "likeness," "image," and "species" and is designated by many other names, and it is produced by substance as well as accident. . . . This species produces every action in this world, for it acts on sense, on the intellect, and on all the matter of the world for the generation of things.[40]

First formulated in his annotated translation of the pseudo-Aristotelian *Secret of Secrets*, Bacon's doctrine on the multiplication of species was not regarded in the thirteenth century as new knowledge but as wisdom that was revealed long ago by God to his "pagan" prophet.[41] Thus, within the cognitive system formulated by Grosseteste and Bacon, it is the idea of species as power or force (*vis, potentia*) that served as the raison d'être for the medieval scopic regime that enabled the gaze, intellect, and soul to gain spiritual power and insight from its object of vision.[42] According to the formulation most prevalent in the thirteenth century, a visible object generates or "multiplies" species, which Bacon called "powers," "forms," "images," or "likenesses," which are conveyed to the eye, mind, and soul of the viewer through a process of successive actualization of the potentials of the various media involved. In short, as the eye gathers multiple images, likenesses, or species within the imagination, perception, and cognition involve the activity of visible objects upon passive recipients. Bacon's appropriation of Aristotelian theory along with Avicenna's reformulation locates the essentially cognitive functions in the intellectual and sensitive realms of the soul, through which the process of multiplication continued.[43] Transparent to sight, species is already *magis spiritualiter et immaterialiter* and thus becomes the object of internal senses, especially of imagination and memory.[44] Just as in the doctrine of the Eucharist *species* of bread and wine designated the sensible aspect of the body and blood of Christ, the icon of St. Christopher constituted a visible *species* believed to have the power to protect the beholder on the day it was seen.[45]

Thirteenth-century theories of vision that configured the image as a transparent picture or "privileged representation" capable of dominating notions of mind and language, and hence of investing images with such extraordinary power, are founded upon the prevalent distinction between visible *lux* and invisible *lumen*. As we encounter the dichotomy in

Grosseteste, *lux* is understood as the profane, natural illumination in the eyes of mortals, whereas *lumen* is the primal light produced by divine radiation.[46] As Martin Jay observes, "echoes of the old Platonic distinction between eternal forms or ideas and their imperfect resemblances in the world of human perception can be heard in the privileging of divine radiation in the mind of the viewer over mere perception."[47] Within the framework of Dante's *Divine Comedy,* the dual nature of light was expressed as a distinction between a higher mirror of the soul reflecting *lumen* and a lower mirror of the mind/eye perceiving only *lux.*[48] In the inherent hierarchy of the specular model, *lumen* is always understood as superior to *lux,* and thus constitutes one of the most powerful sources of ocularcentrism in the Western Middle Ages.[49] In the world of medieval images, light is immanent in the world of things that reach the eye of the beholder as sources of their own luminosity. Thus, as Ivan Illich points out, the medieval artist "neither paints nor suggests any light that strikes the object and is then reflected by it. The world is represented as if its beings all contained their own source of light." More to the point as we encounter luminous figures silhouetted against a transparent ground in thirteenth-century Apocalypse illustrations, "the light of medieval manuscripts 'seeks' the eye, as God 'reaches out' to the soul."[50]

Returning to the thirteenth-century notion of "image," not as "picture" but as "likeness" (*species*), we are dealing with a matter of spiritual similarity. Within the essentialist notion of the image as the bearer of the inner presence of that which it represents, the true, literal image is the mental or spiritual one; the figurative image is only the material shape perceived by the eye. If "spiritual image" can be understood semantically as a series of predicates listing similarities and differences, we might then ask how and why *imago* became confused with pictorial representation. Along with Mitchell, we can only surmise that "the terminology of the image was the result of a sort of metaphorical 'drift,' a search for a concrete analogy that became literalized."[51] Within the medieval tradition of "spiritual optics," the possibility of a transparent, fully visible, and meaningful reality inheres only in God. Art thus provides repetitive "similitudes," which circulate a series of visual and linguistic signs without a humanly visible external referent.

In light of the endemic confusion between likeness and picture, the "true image" is not in any material object but is encoded in the spiritual, that is, in verbal and textual understanding. When images are to be understood as something inward and invisible, the imaging of the invisible reveals itself as necessarily verbal in character.[52] Inscribed language continues to be the locus of revelations, the space in which truth is both manifested and expressed. As Foucault saw it, "The relation of languages to the world is one of analogy rather than of signification; or rather, their value as signs and their duplicating function are superimposed; they speak the heaven and the earth of which they are the image."[53]

The medieval view of the visually constituted epistemological field is in a sense similar to the twentieth-century phenomenological position developed by Merleau-Ponty in providing an ontology of embodied vision in which a different kind or level of perception might provide the link between the visible and invisible. While maintaining the visual tradition of observation and speculation, a third alternative of revelatory illumination is offered, albeit a human perception that still falls short of perfect transparency or fusion with divine light.[54] That "spiritual" as well as pictorial images are inevitably conventional and contaminated by language was recognized and accounted for within thirteenth-century vision theory. Because the correspondence between objects and veridical mental images were construed from Augustine to Bacon as causally determined, then species are "natural signs" (*signa naturalia*) of their objects. This relation of natural sign to the object that it "signifies" is the nexus of knowing and meaning (*significatio*).[55] As Tachau points out, however,

Signification also involves the relation of words to concepts, and just as Bacon takes one sense (vision) to be prototypical, so, like his contemporaries, he takes nouns (*nomina*, literally names) as the words for which an explanation of meaning primarily accounts, largely construing other words derivatively.

In a culture based on semantic resemblances, images were understood to be decipherable hieroglyphs of meaning, erasing the distinction between what is seen and what is read.[56] Thus "there is no difference between the visible marks that God has stamped upon the surface of the earth and the legible words of Scripture."[57] As Foucault first formulated his notion

of the assumed unity of word and image within dis-
cursive formations up to the end of the sixteenth cen-
tury,

Resemblances play a constructive role in the knowledge of
Western culture. It was resemblance that largely guided
exegesis and the interpretation of texts; it was resemblance
that organized the play of symbols, made possible knowl-
edge of things visible and invisible, and controlled the art
of representing them.[58]

Foucault then continues to explicate the premodern
episteme in semiotic terms:

There are no resemblances without signatures. The world
of similarity can only be a world of signs. . . . The system
of signatures reverses the relation of the visible to the in-
visible; but in order that this form may be brought out
into the light in its turn there must be a visible figure that
will draw it out from its profound invisibility.[59]

The distinction between the spiritual and material,
the inner and outer image, as well as the relation
between word and image itself, was not simply a
matter of theological doctrine or optical theory but
a question of ideology. In the words of W. J. T.
Mitchell, "The relationship between words and im-
ages reflects, within the realm of representation, sig-
nification, and communication, the relations we posit
between symbols and the world, signs, and their
meaning."[60] In contrast with the gulf we now per-
ceive between words and images, words and things,
culture and nature, medieval interests and powers
were better served by notions of specular identity,
albeit operating on disparate hierarchical levels.
From Augustine to Grosseteste and Dante, the figu-
rative mirror posited the ultimate dialectical unity of
subject and object. Within the regime of the image
as "likeness" or species, "consciousness itself is
understood as an activity of pictorial production, re-
production, and representation governed by mecha-
nisms such as lenses, receptive surfaces, and agencies
for printing, impressing, or leaving traces on these
surfaces."[61] It is within the realm of the resemblance
theory of vision that the medieval revival of the an-
cient notion of macrocosm comes into play – the
world view that everything will find its mirror and
macrocosmic justification on another, larger scale. In
the words of Foucault, "In an *episteme* in which
signs and similitudes were wrapped around one an-
other in an endless spiral, it was essential that the

relation of microcosm to macrocosm should be con-
ceived as both the guarantee of that knowledge and
the limit of its expansion."[62] The mind and the soul
are thus conceived as a kind of mirror on whose re-
flecting surface object and subject are joined. The
specular model

absorbs all perception and consciousness into the visual
and pictorial paradigm; it posits a relation of absolute sym-
metry and similitude between mind and the world; and it
affirms the possibility of a point by point identity between
object and image, worldly phenomena and representation
in the mind or in graphic symbols.[63]

Baldwin of Canterbury (d. 1190) thus enjoined his
readers, "The discerning eye without the light of de-
votion, or the devotional eye without discerning
light, sees not at all."[64]

HERMENEUTICS AND SPIRITUALITY

Pictures transform words into another realm of re-
ality by moving the reader from the abstraction of
written signs (words) to another level of comprehen-
sion where optical perception not only authenticates
the experience but determines the direction of the
reader's understanding. For Robert Grosseteste, the
transformative process engaged the faculty of imag-
ination, which in its medieval context was primarily
and properly concerned with the power of fixing the
fluctuating impression of the senses in a definitive
and lasting form.[65] The text image mediates the read-
er's transition from the physical-optical perception of
the written and illustrated page to the intellectual
realm of thought and idea, memory and association.
What I have just described is the Augustinian se-
quence of modes for understanding Scripture (*cor-
porale*, *spirituale*, and *intellectuale*) that provide
access to the higher levels of understanding sought
by the medieval reader of sacred texts.[66] In this sense,
the English illustrated Apocalypse can be seen as an
effort to "spiritualize" and "intellectualize" the text.
The Book of Revelation was not read in the Middle
Ages as clairvoyant prognostication, but as a "spir-
itual" or allegorical understanding of Scripture.[67]
By placing the illustration above the text, the new
thirteenth-century cycles elevate the "spiritual" or al-
legorical aspects to the front rank of the reader's
cognitive process. Just as textual explications in a

glossed book are rendered "upon" or "above" the text, the painted image in the illustration can be perceived as standing *super illam litteram.*[68]

John's initial declaration (1:10) that he was "in the spirit" (*fui in spiritu*) lays the cornerstone for the allegorical and symbolic interpretations given in the glosses that form an integral part of the thirteenth-century English illustrated Apocalypse.[69] In preparing the ground for the leitmotif of spiritual understanding that runs through the rest of the exegesis, the Berengaudus commentary asserts that "He said he was in the spirit because mysteries such as those which follow cannot be seen with the eyes of the flesh but only in the spirit."[70] Similarly, the author of the prologue to the French prose gloss[71] indulges in a long excursus on allegorical vision, saying that

Because this book, among the other books of the New Testament, is called prophecy, St. John saw in the spirit and announced the secrets of Jesus Christ and Holy Church, those which have in large part been fulfilled, and those now in the present, and those which are still to come. . . . However, because John saw them in the spirit, and holy Scripture distinguishes three kinds of vision, it would be well to understand how he saw them in the spirit: for one vision is corporeal, when we see something with our bodily eyes; another is spiritual or imaginary, when we see in dreams [sleep] or in waking imagination something which signifies something else; the third kind of vision is called intellectual, when the Holy Spirit illuminates the understanding of man's soul and makes him see with spiritual eyes the truth of God's secrets. And in this way St. John not only saw the figures but understood their meaning.[72]

Notwithstanding the tendency to cultivate the dominance of the spiritual, visionary images were also to be read on a cognitive level. As Augustine suggests, "when a good spirit seizes or ravishes the spirit of a man to direct it to an extraordinary vision, there can be no doubt that the images are signs of things useful to know, for this is a gift from God."[73] Left alone, however, spiritual vision cannot interpret the images it forms, or even decide which images are worthy of interpretation:

Those to whom signs were manifested in the spirit by means of certain likenesses of corporeal objects had not yet the gift of prophecy, unless the mind had performed its function, in order that the signs might be understood; and

the man who interpreted what another had seen was more a prophet than the man who had seen [them].[74]

Hence the necessity, keenly felt throughout the Middle Ages, for a confluence of apocalyptic text, image and gloss.

In the English Gothic Apocalypse, images serve a special function. The illustrations interpret the text and serve as a pictorial commentary in relation to the primal discourse as defined by Foucault:

There can be no commentary unless, below the language one is reading and deciphering, there runs the sovereignty of an original Text. And it is this text which, by providing a foundation for the commentary, offers its ultimate revelation as the promised reward of commentary. The necessary proliferating of the exegesis is therefore measured, ideally limited, and yet ceaselessly animated, by this silent dominion.[75]

As God's ultimate revealed word in the last book of Scripture, the Apocalypse is full of allusive and metaphorical language, convoluted narrative and symbolism that virtually cry out for explanation and interpretation. A brief passage from one of the letters of Jerome is frequently given as a prologue to set the stage for the hermeneutic reading of the Apocalypse as a glossed text: "I cannot say enough about the value of the book. All praise is inadequate: many meanings are hidden in a single word."[76] Medieval exegetes read Scripture to explore the diversity of significations with which they believed it had been invested in such overwhelming abundance by God.[77] As Robert Hanning suggests, the invasion of text by commentary to the point that a gloss manipulates rather than explains its text is by no means a peculiarly modern idea.[78] Indeed, it was not only a question of finding what is hidden in a text, but of adding to it that which is not yet there.[79] Throughout the Middle Ages, manuscript illuminations were freighted with exegetic and heuristic cues to prompt the pious reader to the meaning of the written word. A *titulus* in the twelfth-century English Albani Psalter instructs the reader-viewer: "What this picture allows you to grasp with the bodily senses [*corporaliter*] is that which you should bring forth spiritually [*spiritualiter*]."[80] In the multilayered structure of the thirteenth-century English Apocalypse, the cycles of illustration respond to pressures of the glosses and commentaries by their careful weighting of narrative

elements, literary allusions, and dislocations or abbreviations of narrative sequences, thus blurring the boundaries between pictorial narrative and exposition.[81]

Redundancy or duplication of the text is no longer an essential aspect of meaning,[82] for the discursive text and figural representation are no longer in competition but mutually reflexive. Nevertheless, as Michael Camille points out, frequent inscriptions, captions, and legends, particularly those that evoke the protagonists' speeches, as in the Trinity Apocalypse and elsewhere (for example, see fig. 36), evoke an earlier pattern of text-image equivalency in which both picture and script serve as conventional *signata* for the spoken word in a lingering oral tradition.[83] In the words of Ivan Illich, "The textual lines are a sound track recorded on speech scrolls, voiced by the protagonists for the reader's ear. By reading and looking, the page becomes literally embodied, incorporated."[84] In *De Trinitate*, Augustine argues that the act of human speech becomes an analogue of the Incarnation, when he considers how "the word in its outward sounding is a sign of the word that is inwardly luminous."[85] Where the spoken word becomes visible in speech scrolls as well as in the pictorial rendering of the text, the redundant presence of language serves to authenticate the image in the medieval tradition of "speaking pictures."

An insistent emphasis upon the close contiguity of word (text) and image runs throughout the long medieval history of illustrated Apocalypses, not only in the format but also in the inclusion of legends, *tituli*, and captions within the illustrations, inviting the reader to enter a world of pictures where, with the help of inscriptions, its allusive messages can be "read" without shifting back to the text. In thirteenth-century England, the tendency to liberate cycles of Apocalypse illustrations from the text achieves its most radical expression in the so-called "aristocratic" picture book represented by Morgan 524 (for example, see figs. 92 and 97), which is composed entirely of pictorial representations, accompanied by inscriptions, captions, and speech scrolls. The inherent tensions between the literal and spiritual levels of the written text and textual image have been resolved by merging them, and the text has been totally "spiritualized" for the reader's undivided attention and comprehension. Most thirteenth-century English Apocalypses, however, structure the experience of reading and understanding by dividing the book into very short illustrated segments so that images are juxtaposed on facing pages, generating a semantic charge that neither image taken alone could possess. The fragmentation of the text constitutes a powerful interpretive device that undergoes a number of significant transformations as the medieval tradition develops. The tempo is gradually transformed over the centuries from an expansive *andante* in the ninth-century Carolingian versions, where very long passages comprising a whole page of text face a full-page image, to an accelerated *allegro* of increasingly short illustrated text passages, culminating in the Gothic cycles with their cinematic surge of brilliantly imaged verses sometimes numbering a hundred or more.

In the English Gothic Apocalypse, the reader's cognitive experience becomes increasingly interiorized as he or she is invited to conceptualize the allegorical images in the text as a carefully orchestrated sequence of pictures. Sprung from the prophetic allegory and its exegesis, the illustrations promote an interior appropriation of the text in the reader's imagination. Where words are preceded and dominated by graphic imagery, the inner textuality of the Gothic Apocalypse becomes fixed within the vertical hierarchy of the page design (see figs. 1–3). Indeed, as E. A. Lowe observed, even

the Gothic script is difficult to read. It has the serious faults of ambiguity, artificiality, and overloading. . . . It is as if the written page were meant to be looked at and not read. Instead of legibility its objective seems to be a certain effect of art and beauty.[86]

The reader is thus situated visually within a literal lexical experience defined by the vellum page and the difficult-to-decipher discourse of the text. A Gothic reader would first have to master a kind of semiotics of scripts, not only in identifying the various forms a letter might take but also in knowing what these forms meant within the text structure.[87] The illustrations are then perceived to exist within their frames, not only as representations of the text, but also as pictorial signifiers of an inner world that lies beyond the mundane and material, enabling the reader to experience the text as John perceived his visions, that is, "in the spirit." For John on Patmos, as well as for medieval readers and exegetes, spiritual understanding was an act of seeing.[88]

Like any allegory, the Apocalypse is perceived as a vertically organized spatial hierarchy. To understand such a text, according to Barthes,

is not only to follow the unwinding of the story, it is also to identify various levels, to project the horizontal links of the narrative sequence onto an implicitly vertical axis; to read a narrative is not only to pass from one word to another, it is also to pass from one level to another.[89]

However, because the upper level of meaning is located not in the text but in the self-consciousness of the reader, allegory must work horizontally before the perception of vertical hierarchy comes into play. Thus "meaning accretes serially, interconnecting and criss-crossing the verbal surface long before one can accurately speak of moving to another level 'beyond' the literal."[90] What is then achieved by the intervention of illustrations onto the cognitive grid of allegorical text reading is a visual mapping of relationships generated in the reader's consciousness, picturing the ways in which he or she creates the meaning of the text along a continuous horizontal axis of surface narrative from one page to the next, while at the same time allocating levels of meaning on a hierarchical vertical axis on each page marked by image above text. The process of explication is one of gradual unfolding, sequential in form,[91] as the reader responds to allegory's horizontal pressure to keep attending to the action occurring on its surface.

There are disjunctions in this surface, or illogical juxtapositions of sequence, which tempt translation as a means of bridging the gaps. But the exegesis of meaning at any one point can be made only in reference to the next event in sequence, to the next bit of information on the surface of the text, and the reader must constantly revise his commentary as he takes into account the next turn of the narrative. These revisions are, in fact, the most significant part of the process, providing the necessary self-consciousness on the part of the reader, which becomes the goal of the narrative.[92]

Paralleling the allegorical language of biblical exegesis in such terms as *figura*, *schema*, and paradigm, one of the most important means by which interpretation is generated in allegory is the inherently visual nature of its figural language. In Fletcher's astute observation, the most striking sensuous quality of allegorical images is their isolation from each other, offering bits and pieces of allegorical "machinery"

such as scales of justice, mirrors, etc.[93] As devices placed on the picture plane without any clear location in depth, their relative sizes violate perspective, but at the same time their extremely sharp-etched outlines infuse each object with a kind of demonic efficacy or magical power.[94] The visual clarity of the allegorical image is not normal but represented in discontinuous, lavish fragmentary detail of a hallucinatory vision. Because the image is so detailed in its materially curious aspect, it seems to be present, giving us a sense of strange dislocation in space and time.[95] The ritual microscopic effects of allegory's syntactical isolation of imagery has been eloquently summarized by Carlo Levi:

Its syntax, therefore, is paratactic: every word, every image is closed in itself, complete, without ties, and equal in its value to every other one. The images, all equally symbolic, stand side by side, without correlation or opposition: discourse is a mosaic. The stress falls upon every word; all . . . are on the same plane: there cannot be perspective. Furthermore, as there is no syntactic relationship, every single word must contain in itself the entire concept.[96]

As it presupposes a potential sacralizing power in language, allegory appeals to readers as readers of a system of signs within a cultural context that grants to language a significance beyond an arbitrary system of signs. Based upon overarching assumptions about the interpenetration of language with cosmic truth, the pervasive authority of Isidore of Seville's *Etymologies* epitomizes medieval sensitivity to the polysemy of words.[97] In the medieval economy of words, "Allegory becomes the basis of all textual interpretation," and "All commentary is allegorical interpretation."[98] Medieval theory termed the cosmos of Scripture "difficult ornament" *(difficulta ornata),* whose calculated obscurity elicits an interpretive response in the reader to the extent that the actual process of deciphering the exegetical content of a passage is traditionally regarded as painfully arduous and uncertain.[99] Readers and listeners were conditioned from their allegorical reading of sacred texts to expect that "the most featureless surface could be made to yield profound significance."[100] A large proportion of medieval works were themselves allegorical, addressed to an audience prepared to undertake an energetic form of reading that demanded perceiving connections both vertically and horizontally within the work and beyond it. In what Paul de Man

has termed the "allegory of unreadability," in which a dreamer-visionary like John admits the impossibility of reading his own text and thus relinquishes his power over it, the text demands from the reader

a mental attitude that is highly self-reflective, persistently aware of the discrepancies between the formal and the semantic properties of language, fully responsive to the seductive plays of the signifier yet wary of their powers of semantic aberration. It supposes an austere analytical rigor that pursues its labors regardless of the consequences, the most rigorous gesture of all being that by which the writer severs himself from the intelligibility of his own text.[101]

The reader's participation in allegory is centrally active and self-conscious. The final focus of the narrative is its reader, and the real "action" is learning to read the text properly. In a process that ultimately takes the form of self-discovery, the reader gains his or her own subjective involvement: "After reading allegory, we only realize what kind of readers we are and what we must become in order to interpret our significance in the cosmos."[102] Because, like myth, the allegorical mode requires the acceptance of an overwhelming paradox, it imposes control over the way any given reader must approach the text.[103] In its search for pure power in a higher reality, allegory does not accept doubt. Despite the focus upon multiple interpretations, allegory moves through the intricacies of system toward an order that assumes "moral coherence between individuals and groups, between past, present, and future."[104] Dominated by an ideological structure, the allegorical narrative points toward a system and metaphysic beyond the action and the reader; its didacticism rests on collective values and consensus of beliefs.[105]

The thirteenth-century experience of the Apocalypse inheres in a tension between two worlds, between reading texts and reading images. Nonetheless, the illuminated images recognize the reality of the reader's world and make direct connections with it. The cycles address the spiritual and moral responsibilities invested in those who wield power, speaking to their aristocratic and clerical viewers in terms that are increasingly more direct and compelling. By 1240, the illuminated book had become an object of private ownership and its miniatures a declaration of wealth and social status.[106] Even after the Book of Hours supplanted the Psalter and became the most popular repository of private devotional reading in the fourteenth and fifteenth centuries, illustrated Apocalypses continued to provide intimate spiritual instruction and devotion for elite individuals whose interests and demands were met in increasingly more striking and sometimes eccentric ways. A notable example of how this interiorized perceptual aspect of the Apocalypse experience affected English Gothic Psalter illustration ca. 1260 can be seen in the historiated initial to Psalm 101 in the Rutland Psalter (fig. 4) where we see a king and queen kneeling before an altar, presumably beseeching God, "Hide not thy face from me." As the king gazes at the apocalyptic Lord within a half-mandorla above, his Psalter falls to the ground.[107]

■ ■ ■

In the ensuing chapters, I shall explore the thirteenth-century idea of the illustrated Apocalypse as a multivalent metaphorical structure. The Gothic book represents the end point of the medieval "reading" of the Book of Revelation, a long process of configuring and reconfiguring cycles of images in an apparent effort to bridge the inherent gaps in understanding the allegorical text and to resolve the tensions between allegory and narrative discourse in what might be called "pictorial exegesis."

In the first part, I shall attempt to unravel or decode the thirteenth-century Apocalypse by first considering the narrative as direct, first-person discourse where John is visibly present as both author and protagonist in the dramatic disclosure of his visions. Here we shall explore how the new and complex roles of the narrator tend to problematize and at the same time valorize the seer-author who operates both inside and outside the book. I shall then turn to problems of archetype, genre, and narrative. Although the close juxtaposition of the Latin-glossed Revelation text with a series of textual illustrations might seem to constitute a simple, straightforward configuration of text-image relationships, the moment we move beyond the level of mimetic representation, we find ourselves no longer in a secure, stable world of reading and perception that can be defined easily within the parameters of traditional notions of genre or archetypal definition. As we begin to explore the problematics of identity, definition, and categorization, we become immediately aware of the richly complex medieval experience of image-text reading as a dynamic transactional process involving

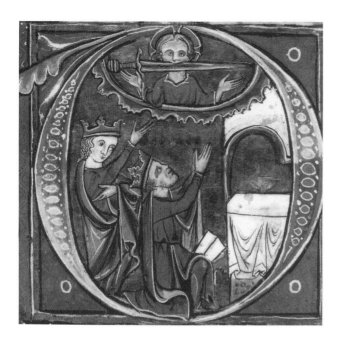

Figure 4. Rutland Psalter. London, British Library MS Add. 62925, fol. 99v. Historiated Initial to Psalm 101 (photo: The British Library).

author, text, compiler, scribe, designer, and reader-viewer.

The English Gothic illuminated Apocalypse will then hold center stage in Chapter 3 for an extended semiotic analysis of the thirteenth-century narrative paradigm, as seen through its several versions and variants. By engaging a series of immediate and contemporaneous retellings, we shall attempt to map and decode the text-image discourse as both structure and responsive act. Rather than localizing the analysis within a web of complicating historical contingencies, we shall adopt a synchronic view of the manuscript variants dating from the second half of the thirteenth century as constituting a defining phenomenon, a singular discourse inflected by several visible "voices." As this discourse tends toward what Hayden White calls a "metadiscursive reflexiveness" endemic to all discourses,[108] we shall discover that it is "about" visionary perception and private devotion, that is to say, it is about the inner world of the reader.

Unlike other illuminated biblical texts, the Apocalypse offers what appears to constitute a literal transformation of the text into an extended cycle of pictures representing every episode, moment, and

gesture. Instead of retelling stories in pictures, however, the images create another narrative discourse in the complex of semiotic systems confronting the reader. By construing for the eye a configurative meaning in the sense of "putting things together," gaps between written and unwritten texts that would conventionally be worked out in the reader's mind[109] are "pictured" for the imagination. The text thus assumes a new shape by shifting the reading of words to another level of experience, while at the same time creating an experiential framework within which the text can be understood. Because "reading must be understood as the constantly transformed product of historical change, not a timeless process focused on a timeless text,"[110] the medieval experience of the illustrated Apocalypse becomes remarkably accessible to the terms and strategies of contemporary poststructuralist criticism. As Stanley Fish observed, meaning is not something one extracts from a text, like a nut from a shell, but an experience one has in the course of reading.[111] The text is not to be regarded as a fixed object of attention, but as a sequence of events that unfold within the reader's mind.

In Part II, we shall turn to the strategies and problematics of locating the reader in the book. Although the reader's transactional experiences encoded in the imaged text are theoretically without limit, we shall confine ourselves to what is most obvious and central to our purpose by exploring how the illuminated Apocalypse served and promoted the art of memory within the context of private devotion and meditation, how the book served to evoke a private liturgy in which the reader could spiritually experience the sacrament of the Eucharist, and how the book negotiated the dangerous straits of prophetic vision within the confining medieval framework of orthodox Christian belief. Although access to the "real world" is mediated through the cultural codes inherited from the society to which the reader belongs, the book's messages are aimed at individuals, and the subjectivity of the reader-viewer is constituted in relation to that expectation. As the book increasingly addresses the rich inwardness of private life, we shall see the medieval system beginning to subordinate corporate sociality to a solitary individual enterprise. Indeed, we shall encounter a remarkable cultivation of subjectivity that seems to resonate closely with a "modern" ideology of elitism and individualism that

assumes "at the center of the world [there] is the contemplative individual self, bowed over its book, striving to gain touch with experience, truth [or] reality."[112]

"Reality," however, is a fiction produced and sustained only by its cultural representation. Representation, as Craig Owens reminded us, is an integral part of the social process of differentiation, exclusion, incorporation, and rule.[113] In a Lacanian sense, it is the double movement between identification and alienation that enables the subject to realize itself as a social being.[114] Thus, we shall first consider thirteenth-century apocalyptic discourse as a coming to terms with the problematical domains of experience in the wider cultural praxis, moving across the historical and contextual trajectories constituted by thirteenth-century events, attitudes and fears – Church reform, anti-Judaism, the later Crusades, and visions of the end. We shall find ourselves exploring the kinds of contemporary mythologies that constitute ideology, a realm in which visual representation becomes an agent rather than a reflector of social change.[115] The referential status of the apocalyptic image claims no less than to represent reality as it really is, an ideologically and culturally constructed ideal order behind and beyond appearance. Defined as appropriation, representation thus becomes constituted as an apparatus of power, a semiotic system at once fully historicized and politically inflected. When we examine the work as a "nexus of cultural activity through which social transactions circulate and flow," we will not interpret the Gothic Apocalypse as a representational system appropriated for political or propagandistic purposes nor will we attempt to decipher ideological messages encoded therein. Instead of endeavoring to assign its images a meaning, we shall be more interested in what they *do*.[116]

As a discourse of longing and desire, the Apocalypse became increasingly more accessible to the medieval reader's capacity to appropriate and to absorb its message on many levels – optical-perceptual, intellectual, and spiritual, as the pictured text is engaged and eventually ingested through the art of memory as it was understood and practiced in the later Middle Ages. Within the framework of the growing privatization of spiritual life, reading and gazing at textual images became a central nurturing and soul-sustaining experience, at times supplanting the sacrament of the Eucharist in an age when lay reception of the host was being discouraged. Present throughout is the book's author, John – seer, preceptor, and pilgrim, guiding the reader to the ultimate goal of seeing God face to face, beyond time. As a book of prophecy, the thirteenth-century Apocalypse was a book about longing and fulfillment on a more encompassing or global level of human experience, thus offering a potent vehicle for shaping contemporary responses to crisis. The Gothic Apocalypse provided an image-structure capable of configuring an ideological framework within which such issues as Church reform and the Crusades were perceived, problematized, and resolved in spatializations of past, present, and future time.

In the last chapter, we shall conclude our exploration of the reader's experience within the framework of private devotion by considering three special cases in which the discourse of the thirteenth-century Apocalypse is expanded in prefatory or epilogue cycles of images. Conceived as integral components of the visionary book, these new images create paratactic semiotic structures that locate the pictured Apocalypse within a metadiscourse of longing and desire to "see" God within a new "technology of the self." As they evoke new surface realizations of Revelation's "deep-plot" structure, the pictorial adjuncts open onto the problematic of visionary perception and private devotion as a spiritual and meditative preparation to the reading of the Apocalypse. At the same time that they expand and enrich the central discourse of the revelatory book by enveloping the imaged text within a matrix of correlate metaphorical structures, the ancillary cycles create new thresholds of understanding. As they invite the reader to cut back, peel away, and lay bare the nucleus of the book's experience, they set into motion the operation of certain feelings and assumptions. The new Gothic images open up an encompassing metadiscourse of longing and desire, a threshold experience that in time creates clear hierarchies of relevance and centrality in the reader's understanding of the book's meaning.

PART I

DECODING THE THIRTEENTH-CENTURY
APOCALYPTIC DISCOURSE

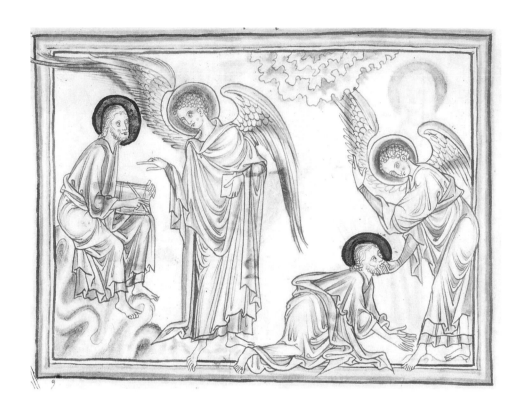

Apocalypse. Formerly Metz, Bibliothèque municipale MS Salis 38, fol. 12v. John Commanded to Write (photo: Monuments historiques, Paris).

Auctor et Auctoritas:

St. John as Seer, Author, Preceptor, and Pilgrim

In the graphic unfolding of the Apocalypse narrative as direct discourse, John is visibly present as both author and protagonist in the dramatic disclosure of his visions. He functions as a human intermediary between the reader and divine revelation. His stance and gestures register reactions ranging from awe-struck terror to joy, as he is commanded, comforted, warned, admonished, and reassured by angels and finally by the Lord himself. In a sense, John's intimate footing with God and his angels echoes that of the psalmist in the Old Testament. The Book of Revelation is still closely attached to the Judaic tradition of the first-century Apocalypses of Baruch and Ezra. Written in a post-Advent, post-Ascension framework and focusing upon the return of the Messiah in a Second Coming, John's metaphorical discourse resonates with longing for God who is again remote and distant from his people.[1]

In its multiple conceptualizations of St. John, the thirteenth-century Apocalypse stands on the threshold of the individualization of the author in Western culture, raising questions of authenticity and attribution, as well as attendant systems of valorization in which the author becomes the hero of his own biography.[2] The Gothic idea of apocalyptic authorship, however, tends to vacillate between the author who is outside and precedes the text, as it is authenticated by the presence of John in his own book and exclusively given in the first person in the present tense, and the attendant assertion of God as the book's sole author and its past. As Barthes tells us,

the Author, when believed in, is always conceived of as the past of his own book: book and author stand automatically on a single line divided into a *before* and *after* . . . which is to say that he exists before it, thinks, suffers, lives for it in a relation of antecedence.[3]

Hence, the saint's *vita* becomes an integral part of the thirteenth-century Apocalypse in a pictorial cycle that precedes and follows the illustrated text, beginning with John's preaching in Ephesus, his trials under Domitian, his exile to Patmos, and resuming at the end of the text with his return to Ephesus (see figs. 9, 10, and 12). Yet the principle of *écriture* still prevails, granting primordial status to the writing, reinscribing in transcendental terms the theological affirmation of its sacred origin. Although the survival of the work is seen as a "kind of enigmatic supplement of the author beyond his own death," the work is perceived to operate on the religious principle of hidden meanings (which require interpretation) and the critical assumption of implicit significations, silent purposes, and obscure contents (which gives rise to the commentary).[4]

In the thirteenth-century English manuscripts, the visions of the Apocalypse become for the first time phenomenonologically accessible to the reader's optical perception as the illustrations respond with unprecedented sensitivity to John's authorial presence. The new annalistic interpolation of John's figured

presence as an authenticating witness to the truth of his visions literally marks the textual referencing of his aural and visual perceptions. The illustrated passages almost invariably respond to the same textual cues, such as "I heard a voice" (1:9), "I turned around to see . . . and I saw" (1:12), and "In my vision I heard" (5:11). The reader thus becomes a sensory participant in the apocalyptic experience, seeing in pictorial images what John saw and heard. Although his ubiquitous appearances throughout the early thirteenth-century Vienna version of the Parisian *Bible moralisée*⁵ clearly presage his role in the English Apocalypses, neither their scale nor range of dramatic expression anticipates what happens across the Channel at midcentury. Each time John sees or hears ("I saw" or "in my vision I heard"), his perceptual experience is graphically plotted out in full detail. We see John shielding his eyes from the brilliance of his visions (fig. 83) or listening with his ear pressed against a small opening in the frame (fig. 115). In concession to the human limitations of his comprehension, he must pull his mantle back to enable him to hear or see (figs. 144 and 190) or shield his eyes by making a protective tent of his mantle propped over his staff (fig. 129). In a sequence of unfolding perceptions, the reader sees John's voice speaking, just as John sees the voice speaking to him.

The author-seer is represented not only when his presence is required as a protagonist in the drama, but also as a preceptor whose visible reactions guide the reader's perception and understanding of the illustrated vision. In his role as archetypal allegorical hero, John's experience has a clearly segmented character. As each episode occurs, a new and discrete aspect is revealed, almost as if it had no connection with prior events. As Fletcher has remarked, "the allegorical hero is not so much a real person as he is the generator of other secondary personalities, which are partial aspects of himself."⁶ Thus, John covers his ears to insulate himself from the blasphemies of the beast (fig. 103) and runs away from the violence of battle, in one case making a quick escape by slipping behind the frame into the margin (fig. 152). He is distressed and saddened by the eagle's cries of woe (fig. 60), and frightened by the dragon's heads snapping at his heels as he protectively pulls his skirts around him (fig. 155); at his first encounter with the whore of Babylon he must be carried and comforted like a frightened child (fig. 136). As he gestures and

reacts to what he sees and hears, John is miming a pictorial gloss on his own text.

The figure of the seer-poet often serves as a bracketing device to close off the narrative action as it unfolds across the open pages. Indeed, the bracketing marginal figures sometimes literally mimic the actions and gestures of the protagonists within the frame, as in the representation of the Witnesses (fig. 74), where John echoes the stance of the preaching figure on the left by enveloping his arms within his mantle. On the facing page (fig. 79), he bends over as a counterfoil to the bestial Antichrist who massacres the Witnesses, not only riveting the reader's attention on the gruesome act, but also alerting the viewer to a whole series of binary oppositions at work within the frame. As the Antichrist first raises and then lowers his scimitar, he brings the upright figures of the Witnesses to their recumbent positions as martyrs on the right, signaling that with the rise of evil, the good shall fall.

Aside from the few passages where the text explicitly requires a representation of John writing, the seer is rarely characterized as *auctor*. In a single instance toward the end of Morgan 524 (fig. 163), he is shown writing his text on the vellum surface within the frame next to his vision of the heavenly Jerusalem. However, in contrast with the twelfth-century figure of Grimbald, who makes conventional declamatory gestures next to the illustrations of stories he is recounting in John of Worcester's Chronicle,⁷ John's thirteenth-century role transcends that of an oral witness to serve a more direct authenticating function in graphic presences that validate his visions in the written record by reenacting his seeing and hearing for the reader.⁸ John serves as a human intermediary between the reader and divine revelation, a preceptor whose optical and auditory experiences provide an authenticating conduit through which the reader finds access to his visions.

In many thirteenth-century English manuscripts, John frequently witnesses the apocalyptic events as a spectator physically isolated from the vision. Standing outside the frame (for example, see fig. 63), he shares a place in the corporeal world of the reader, clearly distinguishable from the spiritual, timeless realm represented within. The frame is no longer perceived as an impermeable boundary, a perimeter conceptually disavowed or repressed, but now plays an active role in the visual semiosis of the text-image.

Drawing the reader's attention not only to the arcane nature of John's visions, but also to the barrier separating the two worlds, he is frequently obliged to peer through a small opening or window in the frame (see figs. 31 and 32). By stepping out of the frame, John enters the reader's realm of "unwritten images," a spiritual limbo that lies outside the spiritual world of "written images" belonging to the scriptural text and its formal illustration. More importantly, John's spatial position outside the frame confirms his authorial role standing outside the text, both preceding and following it in time. Indeed, in one striking instance (fig. 57), John is positioned as a dorsal figure gazing through an aperture appended to the frame in the right margin, thus representing him standing outside the text as he sees its events in retrospect.

By virtue of his extraordinary ability to move from one realm to the other by shifting his position back and forth, within and outside the frame, between the world of the reader (text) and the world of vision (image), John becomes a complex transgressive figure. Through this powerful intermediary, the reader can "see" and experience his visions "in the spirit," as he or she is admonished to do in the text. Sometimes the transition is spelled out in more direct graphic terms as, for example, when the Elder is shown literally pulling John into the framed space (fig. 55), or where John flees a visionary battle behind the frame (fig. 152). In the earlier thirteenth-century precedent introduced in the Vienna version of the *Bible moralisée*, John similarly makes frequent appearances outside the frame in the interstices between the pairs of roundels where he also functions as an intermediary, but in this case linking the illustrations of the text with those for the gloss.

Although the text conveys a powerful unity of ego in its first-person, present-tense discourse, the new thirteenth-century psychological delineations of that voice imply a fundamental decentering of the subject-hero. Not only is the subject-author represented as outside the framed narrative, but throughout his discourse John reminds us that he, as the narrative subject, is the one "subjected," both to a discourse of which he is not the master/author, and to the will and intentions of other subjects, including God.[9] In the underlying split identity of the hero-narrator who is both subject and object of his own story, the "I" who speaks is speaking of himself as another, a past

self who no longer exists.[10] Thus, John does not just tell his story; he interprets himself. Indeed, the concept of the author becomes a heuristic device created by the process of interpretation, a mythical subjectivity created by the text and those who interpret it.[11] As the seer stands adjacent to his text-vision, the spatial axis of interpretation becomes horizontal rather than vertical. Refusing to attempt to see behind or through the text, interpretation depends upon surfaces, upon what has been projected onto the representational screen, elaborating on what is already there and constructing new meaning from it.[12]

Further complicated by the structure of the dream-vision, the author-seer subject becomes fragmented into several distinct, discontinuous selves, all of which exist contingent to the dream: (1) the dreamer who, apart from the dream experience, has only an iterative existence as an uninvolved spectator of the dream-spectacle; (2) the hero of the dream who is both seen and perceived by the dreamer from the "outside" and at the same time becomes fused with him "inside" the dream-experience; (3) the real-life hero, John, who is always implicitly present and whose existence is fully developed in the enframing pictorial *vita* rather than merely postulated; and (4) the narrating, authorial "I" whose identity is complex as he negotiates an ill-defined line between memory and imagination as sources for his narrative material.[13] Although the different selves tend to be discontinuous, discrete, and cut off from one another, reflecting a medieval view of human personality and experience, all four "voices" are congruent in their point of view, infusing the narrative with a powerful internal intensity. Within the interpretive matrix established by John's visibly ubiquitous presence in the Gothic picture cycles, it is clear that the narrator experiences a stronger, more intense emotion in recalling the event than that of the hero of the dream in living it.

As he negotiates the discursive terrain among his split identities, John signals to the reader that he is not telling a story but retelling it. Thus, the narrative itself becomes subordinated to purposes that are not essentially narrative but belong to the world of discourse. Presupposing a reader open and receptive to the narrator's words, John assumes the reader's complicity in his project. Indeed, within the mode of medieval apocalyptic allegory, the distinctions between author and reader are erased by the necessity of in-

terpretive reading. As Paul de Man observed in another context, "the deconstruction is not something we have added to the text but it constituted the text in the first place."[14] The Evangelist is not primarily narrating in this work; he is speaking to others who agree with his values and attitudes, delivering a sermon with his own experience serving as an *exemplum*. Clearly, it is to "us" that the narrator is speaking. The tension between unity of ego and splintering of identity in the new thirteenth-century text-image configuration creates the powerful subjectivity of what Barthes has called "the author 'confiding' in us."[15] He wants us to "see" his vision, to see what he saw, to become involved in what we read and see. Contemplating his own experience, John associates himself with his reader as the *destinaire* of his own sermons. As Barthes observed, "the reader is the space on which all the quotations that make up a writing are inscribed without any of them being lost; a text's unity lies not in its origin but in its destination."[16] Within the context of the author's ambitions, the reader becomes caught between the paradoxical forces of unshakable stasis and relentless progression, between the perception of immobility and the belief in the possibility of transformation.[17] The appearance of the dreamer-narrator at the conclusion of the dream vision reveals him unchanged by his experience. Because he has written his text after the fact, he could not be changed; he is the "reawakened dreamer."[18] With the realization of the impossible contradiction inherent in the poet's dream vision, it is the reader, not the dreamer, who is to be transformed by the experience.

To the degree that John is embodied as an individual subject or self, he constitutes a concrete and single exemplification of a universal. Within the medieval definition of self, it is the soul rather than a unique configuration of human psychological traits that becomes individuated on a grid of relationships – on the vertical axis with the transcendent (God) and on the horizontal axis with respect to humankind.[19] At the outset, John flattens himself on a horizontal earthly axis as a being like all other men: "I am your brother and share your sufferings, your kingdom and all you endure" (1:9). He is defined as unique only by his state of exile, his isolation from all other men, a spatial position metaphorically visualized in his liminal placement outside the frame. Following the basic orientation that pervades almost all medieval thinking about human character and change in terms of exaltation or abasement, John is humiliated on the horizontal axis of worldly exile but elevated through spiritual enlightenment on the vertical axis toward God. Thus, he uniquely defines himself as being "in the spirit," first represented by his unconscious state in the first illustration (fig. 25) and then being physically lifted as if he were a child by an angel (fig. 136). In both images, the dichotomy between his "lowered" or "reduced" physical status and his "elevated" spiritual stature dramatize the perceived tension operating within the human condition. In the ensuing apocalyptic discourse, the seer's progress is measured by similar patterns of rise and fall.

Throughout the dream-vision narrative, John is confronted by experiences too complex and elusive for him to comprehend. The inherent strangeness of the surface narrative is generated not so much from its exoticism as its enigmatic lack of congruity where things are only half-familiar but at the same time infused with compelling intensity. Admitting the impossibility of reading his own text, the author-hero relinquishes his power over it to the interpretive agency of an angel. The ensuing dialogues between John and his authoritative celestial mentor then explicate and control the enigmatic images of the visionary experience, and the author-hero's problems are resolved when viewed in the perspective of the total pattern of God's plan.[20] Within the thirteenth-century framework of Grosseteste's defense of Augustinian theory, theophanic visions occur only through the mediation of angels, because their instrumentality is more truly God's than their own.[21] By simulating detachment and lack of control, John ultimately invokes an archetypal allegorical strategy of acting out irresponsibility for the substance of the work and placing responsibility for the meaning to be derived from it on the reader, albeit through angelic mediation.[22] From another perspective, John's abdication of authority over his own text can be seen as a splitting of the dreamer and the foregrounding of the iconography of the text.[23] The split between the dreamer-character and the dreamer-narrator is most dramatically revealed toward the end of the text when the omniscient author records a mistake made by his fallible alter ego in the dream. In Rev. 22:8–9, John knelt before the angel to worship him (see figs. 169 and 170), only to be admonished:

"Don't do that. I am a servant just like you. . . . It is God that you must worship." John has made a mistake – he has misinterpreted the power of the angel, but the misinterpretation is immediately manifest to the reader. As the dreamer-hero shows himself to be incapable of interpreting his own dream, he himself becomes an object of interpretation.

Just as voyages, wanderings, quests, and pilgrimages provide the outer frame of many medieval narratives, the spatial and psychological displacements of John's exile and dream-state create a series of inside-outside dichotomies that express structures of the self as being defined by longing and desire.[24] Indeed, desire is the sole defining trait of John's character. In the Gothic cycles, he is moved in and out of a world made visible within the boundaries of the frame, allowed to see and hear but not to have what he wants, not to be where he wants to be. The story itself is a disclosure, an opening of secrets, a revelation, but at the same time the story we are reading is "closed," a "mystery," a hidden truth to be explained and "opened" for us through pictures and gloss.

Unlike the hero of romance, however, John's desire is never satisfied. In this sense, there is no narrative closure. His sole fulfillment is the heroic act of writing about what he has seen in a vision but has never attained. The heavenly Jerusalem is brought within his visionary perception but remains closed and unattainable to his pilgrim's quest. As subject-author-seer, John is not a master but a servant, not inside but outside. In the last image (fig. 173), John kneels before the Lord enthroned within a barrier of celestial clouds, still filled with longing and desire as he reaches out for what remains beyond his grasp. John embodies a paradigm that had been eloquently created by Bernard of Clairvaux, the twelfth-century "theologian of desire," whose mystical teaching stressed that union with God is realized in desire and becomes inseparable from it: "He who wishes to merit reaching the threshold of eternal life, God asks of him only a holy desire."[25]

If, as Foucault suggested, the function of an author is to "characterize the existence, circulation and operation of certain discourses within society," in the Middle Ages, the author function was primarily that of authentication, providing an "index of truthfulness" that marked a proven discourse.[26] By providing an author portrait to serve as frontispiece to the text,

Figure 5. Apocalypse. Valenciennes, Bibliothèque municipale MS 99, fol. 4. John with the Book (Phot. Bibl. Nat. Paris).

the earliest illustrated Apocalypses observe an ancient convention and at the same time offer a pictorial acknowledgment of the chain of authorial command laid out in the prologue (1:1–2): "This is the revelation given by God to Jesus Christ . . . he sent his angel to make it known to his servant John, and John has written down everything he saw." In the early ninth-century Juvenianus Codex, the line of authorship from God through an angelic intermediary is fully pictorialized in the incipit initial, which is awkwardly formed by the standing figure of Christ commanding a strangely levitated angel to hand the sealed book to John.[27] In the contemporary Valenciennes manuscript, John first accepts the book in the form of a roll with seven seals from the hand of God and then, in a second author portrait (fig. 5) he stands alone in a frontal pose, holding the book and declaring to the reader, "I am John, brother and companion in your tribulation."[28] Whereas the Valenciennes illustrations omit the text's reference to angelic mediation, the contemporary but indepen-

dently conceived author portrait in the Trier Apocalypse reveals the angel alone commanding John to write.[29] In the later Beatus tradition, the conflicting Carolingian inflections of *auctoritas* are resolved by a simple juxtaposition of transmission scenes in double registers (see fig. 6) in which the book is first relayed by Christ to his angel and then by the angel to John.[30] In the St. Sever version, the urgency of the command is conveyed from one figure to the next in a rush of gestures agitating the drapery to echo the propulsion of angels' wings, moving from the Lord and angels in the upper register to the winged messenger below; the movement is ultimately directed toward the waiting figure of John who, in a second representation, stands quietly at the right, wrapping his arms around the book in a metaphorical gesture of internalizing absorption. In all the early medieval author portraits, John extends his open hands as receptor, signaling that he serves merely as a passive

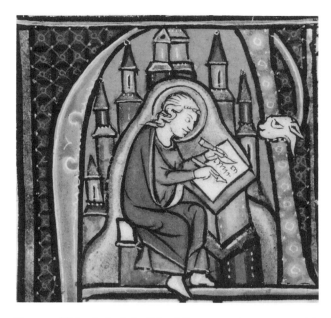

Figure 7. Bible. Oxford, Bodleian Library MS Auct. D.1.17, fol. 381. Initial to the Apocalypse: John Writing to the Seven Churches (photo: The Bodleian Library, Oxford).

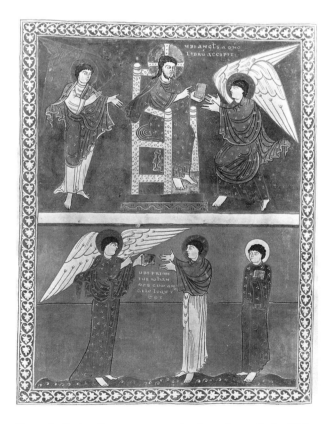

Figure 6. Beatus Commentary on the Apocalypse. Paris, Bibliothèque Nationale MS lat. 8878, fol. 26v. Angel Receiving the Book from the Lord (above); John Receiving the Book from the Angel (below) (Phot. Bibl. Nat. Paris).

human conduit through whom the divine message is conveyed.

Although God remained the sole *auctor* of things and the source of *auctoritas* in Scripture, the thirteenth-century rediscovery of Aristotle's theory of causality contributed to a new awareness of the individual human authors of the Bible.[31] As Beryl Smalley put it, "the book ceased to be a mosaic of mysteries and was seen as a product of a human, albeit divinely inspired, intelligence."[32] The idea of *duplex causa efficiens* became a popular and useful formula to describe the inspired authorship of biblical texts, particularly the Apocalypse, as in a prologue formerly ascribed to Albertus Magnus: "The efficient cause which is moving and not moved was the entire Trinity . . . the cause moving and moved was the man Christ, and the angel, and John."[33] John Russel, a contemporary Franciscan theologian, further argued that a quadruple efficient cause was operative in the Apocalypse: God, Christ, the angel who visited John on Patmos, and St. John himself.[34]

A significant shift in emphasis from the first and second causes to more immediate angelic and human agents can be seen in the authorial presences chosen to inhabit the historiated initials heading Apocalypse texts in English Bibles from the twelfth to the thir-

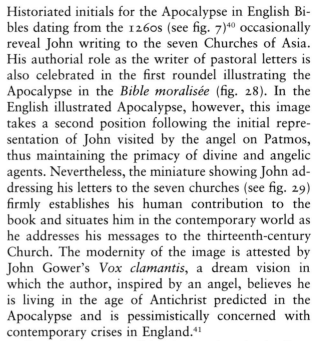

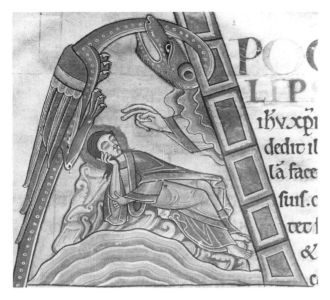

Figure 8. Dover Bible. Cambridge, Corpus Christi MS 4, fol. 276. Initial to the Apocalypse: John on Patmos (photo: The Master and Fellows of Corpus Christi College, Cambridge, and the Conway Library, Courtauld Institute of Art, London).

teenth century. Supplanting the Christological figure of the Lord with the sword in his mouth from the First Vision,[35] we now see John writing (fig. 7).[36] Similarly, instead of the hand of God emerging from the clouds to inspire the sleeping John on Patmos, as in the Romanesque Dover Bible (fig. 8),[37] it is the angel who becomes the messenger in the Gothic Apocalypse cycles (see figs. 25 and 27). In his commentary on the authorial role in the psalms, Nicholas of Lyra argues that God uses human beings as his instruments but must make use of their mental capacities as he finds them, for better or worse.[38] The man who sees visions or dreams is now much more than a mere scribe.

John not only acquires a more powerful role as the human *auctor* of the Apocalypse, he also becomes rooted in the contemporary world as God's preacher and propagandist. In the standard early thirteenth-century prologue formerly attributed to Gilbert of Poitiers, the author claims that, beyond the truths revealed to John by Christ through the agency of the angel who visited him on Patmos, John's own contribution can be seen in the pastoral messages addressed to the seven churches of Asia:

Therefore, the material of John in this work is in particular

the state of the Church of Asia, and moreover the state of the whole Church, namely those things that it suffers in the present life and what it will receive in future life.[39]

Historiated initials for the Apocalypse in English Bibles dating from the 1260s (see fig. 7)[40] occasionally reveal John writing to the seven Churches of Asia. His authorial role as the writer of pastoral letters is also celebrated in the first roundel illustrating the Apocalypse in the *Bible moralisée* (fig. 28). In the English illustrated Apocalypse, however, this image takes a second position following the initial representation of John visited by the angel on Patmos, thus maintaining the primacy of divine and angelic agents. Nevertheless, the miniature showing John addressing his letters to the seven churches (see fig. 29) firmly establishes his human contribution to the book and situates him in the contemporary world as he addresses his messages to the thirteenth-century Church. The modernity of the image is attested by John Gower's *Vox clamantis*, a dream vision in which the author, inspired by an angel, believes he is living in the age of Antichrist predicted in the Apocalypse and is pessimistically concerned with contemporary crises in England.[41]

One of the most striking innovations in the English Gothic Apocalypses is the introduction of the Life of John in a pictorial cycle that precedes and follows the illustrated text, beginning with the Evangelist's preaching in Ephesus, his trials under Domitian, and his exile to Patmos, and resuming at the end of the text with his return to Ephesus in a series of episodes leading up to his death (see figs. 9, 10, and 12).[42] As in the eleventh-century *vita* recounted in Ælfric's sermon on the Feast of St. John's Assumption, the revelation on Patmos is perceived as the central episode in an extended hagiographical narrative:

When the cruel one [Domitian] could not suppress the preaching of the blessed apostle, he sent him into exile to an island called Patmos, that he there, through the sharpness of hunger, might perish. But the Almighty Saviour did not leave his beloved apostle to neglect, but revealed to him, in that exile, the revelation of all things to come, concerning which he wrote the book which is called Apocalypse.[43]

In the Apocalypse itself, the figure of John dominates almost every scene in the Berengaudus cycles. As John's revelations are embedded within the matrix of

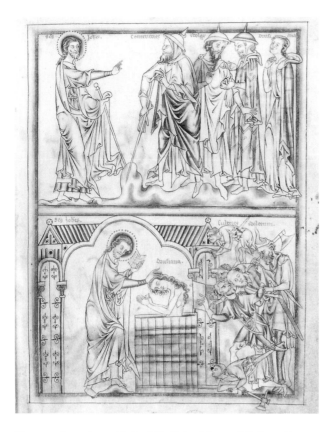

Figure 9. Apocalypse. Oxford, Bodleian Library MS Auct. D.4.17, fol. 1. John Preaching (above); Baptism of Drusiana (below) (photo: The Bodleian Library, Oxford).

his *vita,* the timeless visions become rooted in a single, concrete event within the chronological unfolding of his life, his exile on Patmos. The illustrated Life of John provides a characteristically medieval "outer frame" to contain the narrator's memory that comprises its interior structure.[44] The thirteenth-century English Apocalypse has been described as a "Life of St. John" in which the Apocalypse becomes a part of the *vita,* a seamless text in which it is difficult to tell where one narrative ends and the other begins.[45] In the Morgan Apocalypse, the first illustration of John on Patmos (fig. 11) reveals an unmistakable residue from the last episode of his voyage in the *vita* (fig. 10) in the ferryman at the left pushing his boat off shore after depositing the exiled preacher on the island.[46] Once the author has been discovered in the work, the text is "explained." The enveloping pictorial matrix of John's *vita* gives the text an author who can, in Barthes' terms, "impose a limit on that text, furnish it with a final signified, [and] close

the writing."[47] The thirteenth-century cycles close the work with John's death (see fig. 12), providing a biological/biographical end point to a "life" in which the Apocalypse constitutes the central episode as lived experience. In the earlier medieval tradition of Spanish Beatus manuscripts, such as the tenth-century Morgan 644, the Apocalypse ends with John's return from exile to Ephesus. The last illustration is inscribed UBI JOHANNES AD EFESUM REDIT,[48] thus offering a strategy of authorial closure that roots the work in the self-reflexive circularity of writing rather than in the writer's life, as he stands next to the seven churches to which he was commanded to write letters at the beginning of the book.

In the thirteenth century, the authorial name "John" occasioned graphic references to episodes from the legendary *vita* in another context. In an East Anglian Bible dating from ca. 1240–50 in Bodleian MS Auct. D.4.8, the three Epistles of John are marked by initials historiated with scenes of John be-

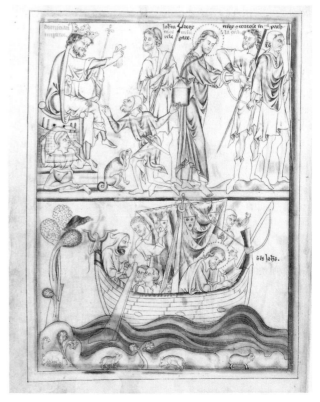

Figure 10. Apocalypse. Oxford, Bodleian Library MS Auct. D.4.17, fol. 2v. John Exiled (above); Voyage to Patmos (below) (photo: The Bodleian Library, Oxford).

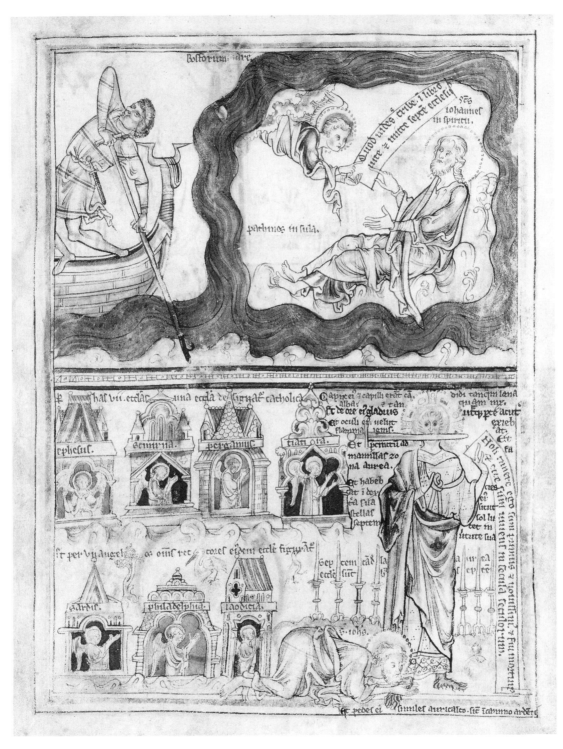

Figure 11. Apocalypse. New York, Pierpont Morgan Library MS M.524, fol. 1. John on Patmos (above); the Seven Churches and the First Vision (below) (photo: The Pierpont Morgan Library).

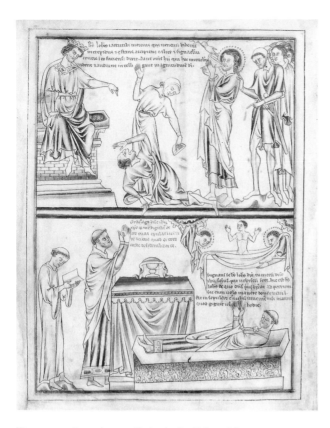

Figure 12. Apocalypse. Oxford, Bodleian Library MS Auct. D.4.17, fol. 23v. The Poisoned Cup (above); Death of John (below) (photo: The Bodleian Library, Oxford).

ing boiled in oil, poisoned, and finally sealed in his tomb.[49] As Foucault observed, the name of an author constitutes a means of classification, pointing to the existence of certain genres of discourse and refers to the status of this discourse within society and culture.[50] In this case, the implied relationship raises the author of the Apocalypse to apostolic rank.

Half the English manuscripts surviving from the thirteenth century are framed within an illustrated Life of John, suggesting that the pictorial addendum held some special significance. The *vita* appears only in manuscripts that either contain a Berengaudus gloss or descend from a related prototype. This distinctively English innovation occurs in eight manuscripts descending from four different groups of Berengaudus cycles: (a) Morgan 524, Bodl. Auct. D.4.17, and Paris fr. 403; (b) Getty and Add. 35166; (c) Eton 177 and Lambeth 434; and (d) Trinity R.16.2.[51] A compelling rationale for the merger of an illustrated Life of St. John with the thirteenth-century

English Apocalypse can be found at the beginning of the Berengaudus commentary. In his explication of Rev. 1:2, the exegete addresses the conventional medieval question of authorial authenticity.[52] Berengaudus argues that the writer of the Apocalypse must be none other than John the Apostle and Evangelist:[53]

This book was written not by another John but by the one who wrote the Gospel, he who at the banquet table reclined on the breast of the Lord in which all treasures of wisdom and knowledge are concealed, from which he deserved to obtain an immense font of wisdom. Therefore he guaranteed the testimony of the word of God when he said, "In the beginning was the Word, and the Word was God."[54]

In the early fourteenth-century Apocalypse in Corpus Christi MS 20 (fig. 13), the episode of John sleeping on the Lord's breast and his arrival and dream on Patmos are juxtaposed in contiguous representations at the beginning of the French metrical version of the text. A similar authorial authentication is visualized in a full-page picture appended to Lambeth 209 (fig. 14) where John is seated on the island of Patmos, enframed by the sea and surrounding islands, commanded by the angel to write his Book of Revelation (Rev. 1:11) in an open ruled codex, while a long scroll is unfurled in front of his lectern bearing the incipit of his Gospel ("In principio erat verbum . . ."). The authorship of the Apocalypse appears to have remained an open question during the Middle Ages, for in a thirteenth-century commentary formerly ascribed to Albertus Magnus, another exposi-

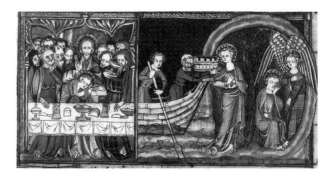

Figure 13. Apocalypse. Cambridge, Corpus Christi College MS 20, fol. 1. John Sleeping on Christ's Breast (left); John on Patmos (right) (photo: The Master and Fellows of Corpus Christi College, Cambridge, and the Conway Library, Courtauld Institute of Art, London).

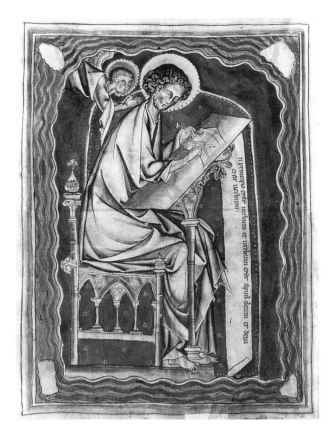

Figure 14. Apocalypse. London, Lambeth Palace Library MS 209, fol. 47v. John on Patmos (photo: The Conway Library, Courtauld Institute of Art, London).

tor asks if John the Evangelist wrote this text, noting that the style of the Apocalypse is very different from that in John's Gospel:

This book is full of obscurities and many figures, in which there is not revelation but rather obscurity and convolution. . . . They say that John the Apostle wrote useful things, whereas in truth this book has nothing worthy of apostolic gravity. . . . Indeed others say that this was the book of a certain St. John who was not the Apostle; and they prove this by the fact that the mode of writing [*modus scribendi*] in this book does not resemble the style of St. John the Apostle.[55]

Medieval forms for proof of authorship going back to Jerome invoke not only quality, conceptual coherence, and stylistic uniformity, but a series of events converging in a historically defined figure.[56] And it is the latter contextual requirement that the thirteenth-century pictorial *vita* seeks to provide in

an effort to guarantee the *auctoritas* of St. John the Evangelist as author of the Apocalypse. "Authorship" thus becomes an elaborate work of framing, an aggregated, multilayered, exclusionary concept designed not only to circumscribe the work within a body of texts but also to serve as a term of explanation. In the case of the Gothic Apocalypse, John is both literally and metaphorically transparent, like a window through which we look to see the causal factors that helped produce the work as well as a hermeneutic screen through which the reader-viewer can interpret its meaning.

Pictorial echoes of the Berengaudus argument can also be seen in the historiated initials to the Apocalypse in mid-thirteenth-century English Bibles (see fig. 15) that show John sleeping on Christ's bosom.[57] The image-idea seems to have enjoyed a fairly wide currency in both England and France during this period. In the Toledo version of the *Bible moralisée*, Jacob sleeping on his pillow of stone serves as a prefiguration of the Evangelist who "fell asleep on the Lord's breast and saw celestial mysteries which he afterwards revealed in the Apocalypse."[58] The symbiotic image of the dreaming Evangelist drawing spiritual wisdom from the Master's breast is extended in the Vienna version of the *Bible moralisée* to embrace the spiritual understanding of Scripture

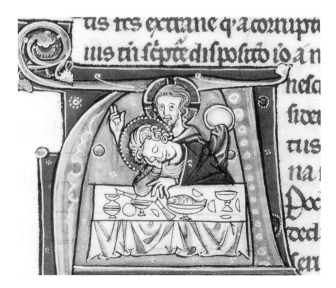

Figure 15. Bible. New York, Pierpont Morgan Library MS Glazier 42, fol. 371. Initial to the Apocalypse: John Sleeping on the Lord's Breast (photo: The Pierpont Morgan Library).

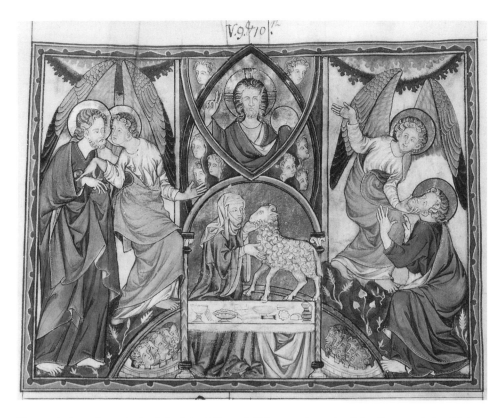

Figure 16. Apocalypse. Oxford, Bodleian Library MS Douce 180, p. 80. John Commanded to Write; Marriage of the Lamb (photo: The Bodleian Library, Oxford).

by contemporary clerics and laymen, as the sleeping John is joined by a bishop, monk, and king.[59] In a further effort to authenticate the Apocalypse as the word of God because it is transmitted through the Evangelist, Berengaudus asserts that John's claim that what he saw is "the testimony of Jesus Christ" (1:2) is also guaranteed by his Gospel (John 20:30): "There were many other signs that Jesus wrought and which the disciples saw, but they are not recorded in this book."[60]

Berengaudus evokes the image of John resting on the bosom of the Lord from Bede's homily on the Feast of St. John, where he is identified as the bridegroom at Cana, who is called away from his new wife to become Christ's beloved disciple and, after the marriage feast, sleeps on the Lord's breast and sees heavenly secrets that he will later write down.[61] Writing in the thirteenth century, the pseudo-Bonaventure refers to Jerome as his authority for the view that John was called away from the wedding at Cana: "When the feast was over the Lord Jesus

called John aside and said, 'Leave this wife of yours and follow me, for I shall lead you to a higher wedding.'"[62] One of the earliest iconographical traditions for John's abandonment of his new bride and spiritual espousal of Christ at Cana is given in the illustration accompanying the prayer to St. John the Evangelist in Anselm's *Meditationes et Orationes*.[63] In the Admont version dating ca. 1160, the story is evoked in two cyclical episodes in which John first leaves his disappointed wife and then rests his head on Christ's bosom.[64] In the historiated initial to John's Gospel in the Bible of Robert de Bello made ca. 1230–40 for the abbot of the Benedictine Abbey of St. Augustine, Canterbury, the full sequence can be read from bottom to top in four compartments, beginning with the wedding banquet at Cana, followed by Christ calling John away from his new bride, John sleeping on the Lord's bosom, and an eagle-headed figure of John pointing to the text ("In principio").[65]

The thirteenth-century English Apocalypse evokes

John's role as bridegroom in a pictorial allusion to the Song of Songs 2:9: "Lo he stands behind our wall, looking through the windows." Drawing on traditional exegesis for this passage in Canticles in which the windows become metaphors for the senses and the enlightenment of Scripture,[66] the figure of John peering at his vision through a window in the frame occurs throughout several Berengaudus cycles (see, for example, figs. 31, 32, and 37). John's role as bridegroom is made pictorially even more explicit in Douce's illustration of the Marriage of the Lamb (fig. 16), as the angel first leads the seer to the nuptial banquet in the center where we see the veiled personification of Ecclesia cupping the chin of the Lamb-Bridegroom. In a subsequent episode in the right compartment, the angel mimics the bride's affectionate gesture as he lifts John's head toward the celestial image of Christ in the upper center. Thus, John is designated as the prospective bridegroom of the Church, which, according to the Berengaudus commentary, is signified by heaven.[67]

Among the newly popular saints of the thirteenth century, John the Evangelist inspired more legends than any other apostle. As well as providing an enframing cycle for the illustrated Apocalypse, the apocryphal events of his life appear in the stained-glass windows of the great cathedrals at Chartres, Bourges, Tours, Reims, Lyons, and Lincoln.[68] For an age of Church reform and the rise of the Franciscan and Dominican orders, John was the perfect saint – celibate priest, preacher of mendicant virtues of penance and almsgiving, reforming his churches, stripping them of worldly involvement and materialism, theologian expounding the faith, set against paganism and heresy, and special apostle to the Jews, preaching their conversion at the end of time. Already in the late twelfth century, John is characterized as an abbot, wearing a mitre and pectoral cross in the author portrait given at the beginning of a copy of Bede's commentary on the Apocalypse.[69] A similar portrait occurs in the large historiated initial in a twelfth-century copy of the Berengaudus commentary in Lambeth 359,[70] in which John stands bearded and tonsured, dressed in rich priestly vestments, holding a crosier.

As it appears in the thirteenth-century Apocalypses, the illustrated Life of St. John seems ultimately to have been based on the second-century apocryphal Acts of St. John.[71] The very early Pseudo-

Mellitus was the source of the life reported by the Norman chronicler Ordericus Vitalis.[72] However, as Nigel Morgan has argued, it seems certain that the *vita* in all its details was known in England since the time of Ælfric's eleventh-century homily for the Feast of St. John the Evangelist, which contains most of the episodes represented in the Gothic picture cycles.[73] The Life of St. John that appears in the illustrated Apocalypses is also related to those in the later *Golden Legend* and the South English Legendary.[74] Within the double-registered spiritual and temporal structure of the *Golden Legend*, the feast of St. John's "martyrdom" of being boiled in oil at the Porta Latina in Rome (May 6) is assigned a privileged position directly before the Greater and Lesser Litanies.[75]

The pictorial *vita* begins with John preaching, followed by his baptism of Drusiana (fig. 9); John is then brought before the proconsul of Ephesus, who sends him to Rome. He is brought before Domitian, who orders that he be boiled in oil; John miraculously survives but is banished by the emperor (fig. 10). The last of the prefatory scenes shows John's voyage to Patmos as an episode antecedent to the beginning of the Apocalypse.[76] Following the end of the Apocalypse, John's cycle resumes with his return to Ephesus where he raises Drusiana from the dead, condemns hypocrites, performs the miracles of sticks and stones, destroys the temple of Diana, drinks the cup of poison in response to the philosopher's challenge, and then dies in a tomb that he had prepared for himself (fig. 12).[77] In the Morgan group, as in Lambeth 209, the pictures are arranged in double registers, but they are provided with captions, similar to those that appear on the Berlin–Moscow leaves, based on the same model. Only the cycles in Add. 35166 and Getty carry full texts beneath their half-page miniatures. Trinity's cycle is accompanied by single-line rubrics and speech scrolls, followed by a brief text at the end of the prefatory series recapitulating the narrative leading to John's exile on Patmos.

Although obviously based on the same model as Morgan 524 and Lambeth 209, Trinity's compositions have been significantly and consistently revised. To match the subsequent Apocalypse miniatures, the protagonists are given speech scrolls, providing a more vivid vocal as well as visual authenticity to the events. In the first episode registering John's preach-

ing (fig. 17), he is isolated as the frontal centerpiece of a symmetrical composition, so that he no longer faces a group of challenging pagans and Jews, but addresses his message directly to the reader. Similarly, Drusiana is turned in a frontal pose and gazes outward, inviting a more direct identification with the recipient of John's ministrations. Provocative genre details are added to lend color and veracity to the legendary episodes. Thus, the familiar discomforts of a rough Channel crossing characterize John's voyage to Rome, where a man's head is being held as he bends overboard to relieve his seasickness.[78] Figures and sequences are shifted to provide a more vigorous and continuous passage as the episodes are read from left to right, in marked contrast with the closed and bracketed compositions in Morgan and Lambeth 209. For example, John is no longer shown being boiled in oil, but quickly stepping in and out of the vat in an accelerated cyclical sequence of actions more appropriate to an obstacle race than to his miraculous deliverance from death. Following the end of the Apocalypse, the cycle of John's illustrated Life resumes in Trinity with the interpolation of a unique representation of the assassination of Domitian, thus providing the *deus ex machina*, apparently based on the Ælfric version, which enables John to return to Ephesus and continue his mission.[79] Trinity's hagiographical epilogue to the Apocalypse is similarly expanded to sixteen registers, comparable but not identical to the expanded *vita* in Add. 35166.

As the Apocalypse is perceived by the medieval reader as embedded within the matrix of John's life experience, the text becomes a pilgrim's account, an interior journey into the future and beyond time. Indeed, *homo viator*, the wanderer between the two worlds of earth and heaven, can be said to have been the *personage régnant* of the Middle Ages, and the idea of life as a salvific journey toward a higher spiritual realization its dominant metaphor.[80] For Hugh of St. Victor, the act of reading itself was seen as a form of self-exile in which the reader starts on a pilgrimage that leads through the pages of a book, a *peregrinatio in stabilitate*.[81] In most thirteenth-century Apocalypse manuscripts, John carries the most distinctive emblem of the pilgrim's quest, the staff purportedly used for driving off wolves and dogs that symbolized the snares of the devil.[82] John was particularly venerated in England as the pilgrim to whom Edward the Confessor gave his ring.[83] As

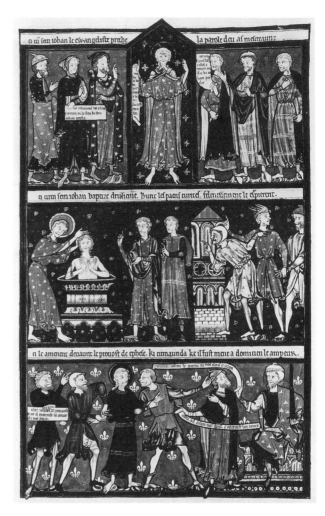

Figure 17. Apocalypse. Cambridge, Trinity College MS R.16.2, fol. 1. John Preaching, Baptizing Drusiana, and Being Brought before the Proconsul (photo: The Master and Fellows of Trinity College, Cambridge).

David Freedberg has remarked, pilgrimage phenomena are paradigmatic: They deal with aspirations and expectations that cannot be wholly fulfilled on earth; they illuminate the mediating role of images in attaining that fulfillment.[84]

The seer's experience can be analyzed into three parts: his existence as an evangelistic preacher in Ephesus before the vision, the vision on Patmos itself (Apocalypse), and the resumption of his life after his return to Ephesus. Within the anthropological perspective of Victor and Edith Turner, the vision can be seen as a rite of passage: Detached from his former world, John is placed on its margin in exile where he passes through a uniquely privileged realm

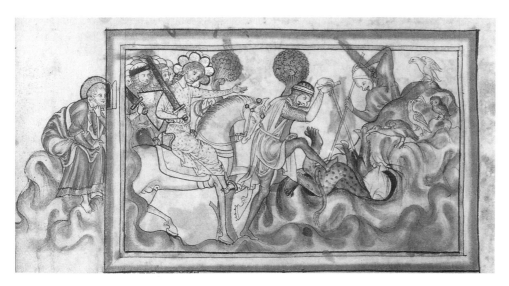

Figure 18. Apocalypse. Malibu, J. Paul Getty Museum MS Ludwig III.1, fol. 41v. Defeat of the Beast (photo: Collection of the J. Paul Getty Museum, Malibu, California).

or dimension and then returns to his old life in a newly defined role.[85] The middle, unstable, and transitional state is the realm of the vision, a state of liminality that calls into question the social structures and paradigms from which the pilgrim-seer has come. His vision coincides with an access to power, because what the allegorical hero sees constitutes an initiation.[86] John's liminality is thus doubly defined in terms of physical exile and spiritual vision – hence, his frequent marginal positioning outside the framed visions, which redefines in Boethian terms the poet-seer's interior life as central and relegating his earthly, physical existence to the marginal or liminal by identifying it as exile or pilgrimage.[87] By the same token, the physical transition from one place to another serves as a spatial metaphor for John's journey from the visible world into a realm in which he becomes a spectator of the invisible. On the last surviving page of the Getty manuscript (fig. 18), the seer is still sitting on a rock, his island of exile or refuge outside the frame, watching the battle that leads to the defeat of the Beast.

Like the pilgrimages of the eleventh and twelfth centuries, John's apocalyptic goal is still Jerusalem, but no longer the earthly city. The hero's starting point was indeed another city, Ephesus, a place of foreclosed origin outside the text, to which he will return. Within the text, however, the places of the world are transfigured by his spiritual vision.[88] Just

as Babylon shifts from a place (city) to a metaphorical figure (harlot), Jerusalem is also transformed. The apocalyptic journey ends with a vision of the celestial new Jerusalem. The illustrations serve the reader as a pictorial itinerary or map, with John ever present as guide, describing the brilliant montage of marvels, miracles, and dangers along the route. At the outset of his journey, he is literally embedded within a map (see fig. 25), surrounded by cartographic conventions representing islands in the sea, thus locating John (and the reader) in a site-specific place of exile from which the pilgrimage will be launched.[89] As it is taken in short stages, the pilgrimage of the Apocalypse creates a semblance of the medieval journey, the diurnal travel represented metaphorically by the brief illustrated segments of glossed text. The English Gothic manuscripts were created at a time when the holy city had become an inaccessible goal, Jerusalem having fallen for the last time in 1244. Thus, during a dark period when the physical journey was no longer practical or even possible, the illustrated Gothic Apocalypse offered its readers an experience of spiritual pilgrimage or even of Crusade.[90]

In its recreation of an interior peregrination, the English Gothic Apocalypse becomes an expression of contemporary devotional piety. Ultimately stemming from the *peregrinatio in stabilitate* urged upon monastic readers by Hugh of St. Victor, the reader only

temporarily exiles him- or herself to start on a pilgrimage that leads through the pages of the book.[91] Unofficial, unstructured, and cultivated in solitude, silent reading is typically an aid to meditation in which the individual stands alone before God by fixing his or her attention on an inspiring image.[92] Although the crucifix alone most frequently served to awaken the deeper self to God, the heavenly Jerusalem remained the spiritual goal of such exercises. In the prologue to his *Journey of the Mind into God*, Bonaventure fixes the image of Christ crucified as the doorway, for "no one can enter the heavenly Jerusalem by contemplation unless he enters through the blood of the Lamb as through a door."[93] Perhaps in response to this Franciscan idea, we see in the historiated initial at the beginning of the Douce Apocalypse (fig. 19), Prince Edward and Eleanor of Castile kneeling before the crucified Christ held by God the Father in a familiar *Gnadenstuhl* formulation of the Trinity on the eve of their Crusade undertaken in 1270. In the seventh chapter of the *Journey* dealing with the passage of the soul into God, Bonaventure bids the reader to gaze upon the humanity of Christ, symbolized by the Throne of Mercy:

whoever turns his face fully to the Mercy Seat and with faith, hope and love, devotion, admiration, exultation, appreciation, praise and joy beholds him hanging upon the cross, such a one makes . . . the Passover with Christ.[94]

In a similar way, the imaged Apocalypse itself could function in private devotion as a guide for the soul's interior expedition to the heavenly Jerusalem, enabling the devotee to enter the events as an eyewitness, vicariously present to John's visions.[95]

As the Life of John unfolds on another level, its images offer an exemplary model of the priestly ministry; the Evangelist preaches, converts, and baptizes under divine protection and guidance, enabling him to perform miracles and overcome the persecutions of powerful pagan adversaries. The Apocalypse is thus perceived within the framework of a clerical life – a timeless journey undertaken in exile from which the good priest returns to do God's work in the place from which he had begun. The resumption of John's life following his revelation responds to the Berengaudus commentary on 22:7: "Blessed is he who keeps the words of prophecy in this book" as he "fulfills them by his deeds and is unremitting in their meditation."[96] In a sense, John's dramatic bodily

demonstrations of emotional response to the visions throughout the illustrated Apocalypse also contribute to his role as perfect priest. Voicing a new awareness of the body as an expressive agent, Peter the Chanter urged clerics to make pictures when praying publicly in tableaux vivants: "Let there be an image that represents the gesture of the supplicant."[97] In the illustrated Apocalypse, the reader has before him the paradigm of John making pictures by acting out his interior states and moral attitudes in bodily gestures. The visual experience of the book is brought back to an earthly time and place, albeit on the level of a saintly ideal, to apply the lessons of spiritual enlightenment and moral purpose to a clerical career.

The model of John's life, however, would appear to be directed not toward the cloistered ideal of the old Benedictine order, but to the public ministry of the new mendicants. John's evangelism and preaching respond to the ideals of the *vita apostolica* and the new goals of clerical reform emanating from Lateran Council IV. As John proceeds through each episode of the illustrated Apocalypse, he carries a staff, an attribute not only of the pilgrim but also of the reformer. In Getty and Add. 35166, John's walking

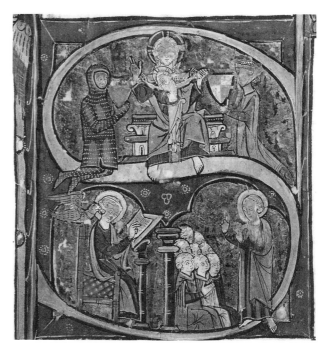

Figure 19. Apocalypse. Oxford, Bodleian MS Douce 180, fol. 1. Historiated Initial: Lord Edward and Eleanor of Castile Adoring the Trinity (photo: The Bodleian Library, Oxford).

stick takes on the distinctive form of a majuscule Greek *tau* (see figs. 68, 79, 132, and 133), marking him as a *tau*-writer who, like the man clothed in linen in the terrifying vision of the destruction of Jerusalem described in Ezekiel 9:4–6, was commanded by the Lord to mark the last letter of the Hebrew alphabet on the foreheads of all who repent of their sins.[98] Within the context of the Apocalypse narrative, John becomes an active adversary of the Beast from Rev. 13:16–18 who brands his followers with the mark of Antichrist, countering the pernicious insigne with a cleansing emblem of repentance. In the famous sermon preached by Innocent III at the invocation of Lateran IV in 1215,[99] the *tau*-writer served to epitomize the spiritual reformer, walking the streets of Jerusalem seeking the penitent and the righteous and carrying out his apostolic duty to cleanse the Temple. John thus becomes the embodiment of an ideal to be espoused by all ranks of the clergy in thirteenth-century England, bridging the differences between cloistered monks, mendicant preachers, as well as secular priests, canons, and bishops, all rallying to the same cause of reform and renewal of the Church.

As messenger of the sixth age, John is also the apostle to the Jews and functions as an active instrument in their conversion at the end of time. In the first episode of what must represent the prototype for the illustrated *vita*, because it appears in the same form in Morgan, Fr. 403, the Moscow leaves, and in the epilogue sequence in Lambeth 209, John preaches to a group of Jews (fig. 9). The ancient pagan idolaters of Ephesus have been transformed into ugly caricatures, extravagantly dressed, wearing pointed hats, and gesticulating violently as they reject John's message. In Morgan, Fr. 403, Lambeth, and Trinity, even the proconsul is characterized as a Jew wearing a pointed cap. In the Apocalypse illustrations, John himself is frequently portrayed as a veiled priest of the Old Dispensation, resembling Aaron and Moses as, for example, in Metz and Lambeth 209 (figs. 124, 135, 144, and 149), Getty (fig. 150), and Add. 35166 (fig. 153). Although John is frequently represented as a bearded old man in very early medieval author portraits, the Evangelist is only very rarely veiled.[100] However, like Moses who appears in the endpiece to the Carolingian Moutier-Grandval Bible, his veil has been drawn back in a metaphorical gesture of revelation.[101] In the

thirteenth-century Apocalypses, following the Berengaudus commentary on the Third Seal, John's unveiled face signifies his spiritual understanding of the Law.[102] Reflecting an ancient symbolism of the sky separating heaven from earth, John's veil reiterates his role as mediator between the human and divine,[103] but most importantly the lifting of Moses' veil signals the eschatological expectation of the conversion of the Jews at the end of time.[104]

In his commentary on Rev. 11:1–2, Berengaudus stresses John's unwavering affection for the Jews who remain outside through their unbelief, quoting Paul from Romans 9:3–4: "I would willingly be condemned and cut off from Christ if it could help my brothers of Israel, my own flesh and blood."[105] In the *Glossa ordinaria*, John is identified with the Synagogue, based on a reading of John 20:4.[106] Following Gregory the Great, Hugh of St. Victor also associates John with the Synagogue, contrasting him with Peter, who is read as a type for Ecclesia, because John, although he arrived first at the Lord's tomb on Easter morning, waited for Peter to enter first.[107] This relationship between Peter and John is illustrated in the Gulbenkian commentary illustration on fol. 19 (fig. 20), where the bearded and veiled Evangelist stands behind Peter as the apostles follow Christ into a church at the right, having preached the Gospel first to the Jews and then to the gentiles.[108] Although the Evangelist stands below the personification of Synagogue at the Crucifixion in the Psalter of Robert de Lindesey, ca. 1220, John himself appears as an enshrouded figure of the Old Law withdrawing from the dead Christ in a fragmentary Hours of the Virgin dating from the end of the century (fig. 21).[109]

Drawing on the scriptural impetus for the rich allegory of Moses' veil in II Corinthians 3, John is otherwise characterized throughout the various recensions of the illustrated *vita* as well as the Apocalypse itself as an idealized Christlike figure, distinguishable only by the absence of the cross in his nimbus. With his "unveiled face reflecting like a mirror the brightness of the Lord," John is "turned into the image that he reflects." In his emulation of the ministry and miracles of Christ, John is not so much an embodiment of the ideal apostle as he is an earthly surrogate or agent for Christ. Departing from the old monastic ideals of sainthood, he more closely approaches the hagiographical paradigm promulgated by St. Francis and his thirteenth-century fol-

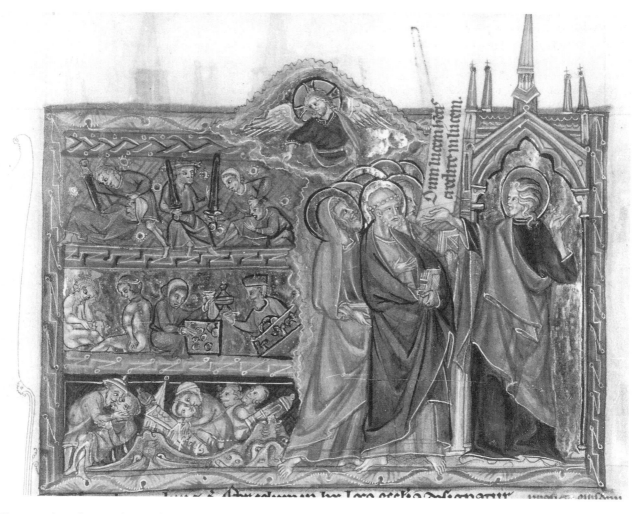

Figure 20. Apocalypse. Lisbon, Calouste Gulbenkian Museum MS L.A.139, fol. 19. Commentary Illustration for Rev. 8:13 (photo: The Conway Library, Courtauld Institute of Art, London).

lowers. However, in the last two episodes of his last mass and death, John suddenly becomes a tonsured priest, short-haired, beardless, and wearing liturgical vestments (fig. 12).[110] In the penultimate scene, the priestly John is invested with the cross-staff, the emblem of highest ecclesiastical authority reserved for archbishops. His jurisdictional power is further stressed in the sequence of six episodes dealing with the runaway penitent who is rescued by John and returned to his ecclesiastical guardian, a story explicated in the text as illustrating how John instructed the priests of his new churches.[111] In the spirit of Lateran IV, John in all his guises embodies a paradigm focused on clerical discipline and Church reform.

For the thirteenth-century reader, the enframing pictorial *vita* of St. John transforms the Apocalypse into another genre of illuminated book, that is, an illustrated saint's life in which his vision becomes the central episode marking his exile on Patmos. Since the early twelfth century, English hagiographical texts appeared as *libelli*, or small books, devoted to the lives and miracles of the saints and sometimes accompanied by extended cycles of illustrations. Saints' lives provided edifying reading primarily for religious houses either for oral recitation or private meditation, and their increasing popularity in the twelfth century can probably be associated with the reformation and expansion of Benedictine abbeys.[112]

Bede's Life of St. Cuthbert was produced in at least two lavishly illustrated redactions for Durham Cathedral Priory, the Life and Miracles of St. Edmund for the influential house at Bury, and the Guthlac Roll ca. 1200 for Crowland Abbey.[113] The hagiographical *libellus* was intimately associated with the patron saints and relics of the great Benedictine monastic houses. A special kind of book, a sacred text, the illustrated *vita* was not kept under the jurisdiction of the abbey librarian but by the sacristan and formed part of the "title-deeds" of the monastery, a sacred relic to be housed with the Gospel books and chalices in the treasury of the monastery.[114] However, there appears to have been no fixed tradition for the illustration of saints' lives. Unframed, multicolored outline drawings illustrate each chapter of Bede's Life of St. Cuthbert in Oxford, University College MS 165, dating from ca. 1100, and ink drawings tinted with green comprise the Guthlac roll, whereas the Life of St. Cuthbert in Add. 39943 as well as the Morgan Life and Miracles of St. Edmund contain extended sequences of full-page painted miniatures either integrated within or preceding the text.

With the appearance of the illustrated saints' lives associated with Matthew Paris in the 1240s and 50s, the old monastic Latin *libellus* was transformed into

Figure 22. Matthew Paris, *Vie de Seint Auban*. Dublin, Trinity College MS 177, fol. 56v. King Offa's Vision (photo: The Board of Trinity College, Dublin).

a vernacular book with half-page, tinted outline drawings strikingly similar in format and technique to the thirteenth-century Berengaudus-glossed Apocalypses. Although Matthew's illustrated *Vie de Seint Auban* (see figs. 22 and 23) still celebrated the sacred heritage of his monastery and served as a paradigm for the spiritual life of the Benedictine community, his other hagiographical works apparently appealed to an audience beyond the cloistered walls of St. Albans, as suggested by the flyleaf that records that a book containing his lives of Sts. Thomas and Edward was lent to the countesses of Arundel and Cornwall.[115] The only surviving manuscript of Matthew's Life of St. Edward the Confessor in Cambridge probably represents a later copy made in a London workshop for Eleanor of Castile between 1265 and 1270, based on the autograph exemplar destined for Queen Eleanor of Provence.[116] Thus, although the new thirteenth-century productions of illustrated saints' lives still had one foot in the old Benedictine world of *libelli* created for local monastic consumption, their exciting picture cycles and vernacular verse form made them accessible to a wider audience of aristocratic lay readers.

Notwithstanding the possibility that the *Thomas* leaves might be as early as the 1240s,[117] the dating of Matthew Paris's *Alban* after 1245[118] suggests that the archetypal cycle for the Berengaudus-glossed

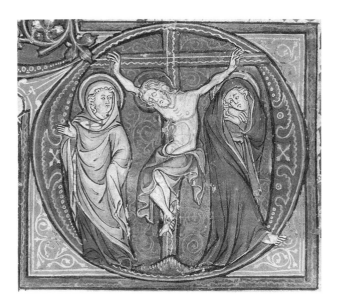

Figure 21. Fragmentary Hours of the Virgin. Cambridge University Library MS Dd.8.2, fol. 36. Historiated Initial: Crucifixion (photo: The Syndics of Cambridge University Library).

Figure 23. Matthew Paris, *Vie de Seint Auban.* Dublin, Trinity College MS 177, fol. 31. St. Alban Watching Amphibalus Kneeling before the Cross (photo: The Board of Trinity College, Dublin).

Apocalypse was created about the same time. Although it has been generally assumed that the Apocalypse cycles were influenced by illustrated saints' lives,[119] it equally well could be argued that the earliest illustrated Apocalypses provided the inspiration for the cycle of tinted drawings created by Matthew Paris in his *Life of St. Alban.* At the beginning of the Dublin manuscript, half the illustrations are only a single column wide, suggesting that the half-page format was adapted rather hesitantly and inconsistently until Matthew became accustomed to its expanded spatial possibilities. Although the Alban story is one of conversion, martyrdom, and miracles rather than revelation, the artist nevertheless twice stresses the visionary aspects of the legend in representations of Alban's dream and Offa's vision (fig. 22) in which an angel descends upon the dreaming king in a scene heavily reminiscent of John sleeping on Patmos in the Gothic Apocalypses (see figs. 25 and 27). Moreover, like John, Alban looks through a window that serves as a pictorial metaphor for his visionary dream, as he sees Amphibalus kneeling before the cross (fig. 23). Alban thus becomes another bridegroom of Christ, who dreamed divine secrets.[120] In contrast with the Apocalypse cycles, the *Alban* illustrations do not respond precisely to the content of the text but rather to Matthew's rubrics above. As in the case of the angelic messenger who appears in Offa's vision, the idea of the window mentioned in the rubric ("Ci veit auban par le fenestre") was developed by the artist independently of the text and conceivably

under the influence of a contemporary illustrated Apocalypse.[121] As in his illustrations for the *Chronica majora,*[122] Matthew was again very likely reacting to artistic currents outside the monastery.

With the problematical exception of the *Thomas* leaves, surviving examples of the newly formatted vernacular saints' lives are linked directly or indirectly with Matthew Paris and St. Albans, whereas all the evidence for the new Apocalypse cycles indicates that they were produced in commercial workshops in large urban centers, such as London or Oxford. Nevertheless, the texts are Latin, and the Berengaudus gloss still promotes the values of Benedictine spirituality. Like Matthew Paris's illustrated saints' lives, pictured Apocalypses appear to have been created initially for a clerical readership but quickly found their way into the hands of aristocratic lay people. A tenuous but suggestive link is provided by a note written by Matthew Paris on fol. 2v in the *Vie de Seint Auban* in which he gives instructions for a set of miniatures intended for Lady de Quincy, perhaps the owner of Lambeth 209: "In the countess of Winchester's book [perhaps a psalter] let there be pairs of images on each page thus," followed by a list of saints.[123] Although most of the names reflect Eleanor's special devotions, the inclusion of St. Alban and St. Amphibalus reveals the countess's interest in Matthew Paris's abbey and his influence over her spiritual life. Conceivably, her commission for an illustrated Apocalypse less than a decade later was similarly inspired by another Benedictine mentor. The compilation and design for the book most plausibly still emanated from a clerical source, but the actual execution by scribes and artists belonged to the entrepreneurial world of commercial book production. Unlike earlier monastic *libelli,* the illustrated Apocalypse, once formulated in its many redactions, became directly accessible to a wide audience of clerical and lay readers alike.

The appearance of the illustrated Apocalypse in England ca. 1245–50 coincides with the end of the tradition for illustrated saints' lives and the waning influence of the great Benedictine houses whose prestige was beginning to be supplanted by secular bishops and mendicant friars. The singular example of Giles de Bridport's episcopal gift of an illustrated Apocalypse to Abingdon Abbey aptly signifies the secular bishop's new jurisdiction over the old and powerful Benedictine houses of England.[124] As we

shall see, the goals of the reforming bishops and friars, represented by such figures as Robert Grosseteste and Adam Marsh, were admirably served by the new illustrated Apocalypses as they brought cleric and layman alike into a renewed spiritual experience of reading Scripture.

The initial framing of the Gothic Apocalypse within the illustrated Life of St. John documents the merging and brief overlap of two important traditions. Whereas the illustrated Apocalypse soon shed its hagiographical mantle by dropping its Life of St. John, the illustrated *vita* nevertheless reveals its most probable genesis in a clerical compilation and book design at or shortly before midcentury. Unlike the heroes of the illustrated lives of Sts. Cuthbert, Edmund, Guthlac, and Alban, however, St. John was not a local saint bound by tradition or relics to one of the great and powerful shrines of an earlier England. No longer an actor confined to a monastic stage, the peripatetic John was celebrated in his illustrated *vita* as a paradigm of clerical virtue and a universal patron saint of the ecclesiastical ideals promoted by the Fourth Lateran Council. By the same token, the author of the Apocalypse became the hero of an interior spiritual experience that could be viewed as exemplary by layperson and cleric alike.

Problems of Archetype, Genre, and Narrative

Throughout its historical permutations, the generic medieval structure of the illustrated Apocalypse is dominated by the idea of vision, as both internally generated by the imagination and externally perceived by the senses. By stressing the accessibility of the supernatural world to human perception and understanding, the genre embraces the notion of hierarchy involving heaven and earth, outside and inside, margin and center, levels of being that are not only differentiated but traversed.

Among the books of Scripture, the Apocalypse is uniquely comprised of visions personally experienced and described by its author, St. John, each signaled by "I saw" or "in my vision, I heard." Its cataclysmic horrors and ecstatic glimpses of celestial majesty do not "happen" or "unfold," as in the scriptural narratives of Genesis or the Gospels. Described in vivid, often metaphorical language by a seer-author-poet, they are seen and heard in visions and dreams. Throughout the Middle Ages, the Book of Revelation was conceived as a text that called for special strategies of pictorial illustration. By the mid-thirteenth century in England, the medieval idea of the Apocalypse as a book of visions achieved its fullest realization as pictured discourse. Although the text becomes a semiotic framework upon which the Gothic designer and artist build a metadiscursive imagery, the double-layered vertical structure was at the same time conceived as a triple-tiered semiotic system comprised of image, text, and gloss.

Before turning to the project of decoding the complex, multilayered text-image discourse that constitutes the Gothic illustrated Apocalypse, we must first inquire into the paradoxical nature of the tensions inherent in a picture book so symbiotically dependent upon its inscribed text. Of paramount importance are the selection and function of the Berengaudus commentary, which becomes an integral and pivotal component of the tripartite semiotic structure of the book. From the recognition of the critical role played by this exegetical apparatus then flow questions concerning the responsibility for the book's design *(ordinatio* and *compilatio)*. We shall then attempt to define the problems of genre raised by the distinctively English Gothic pictorial inflection of this glossed text, as well as those of "archetype" presupposed by such a large body of variant surface realizations of the same recognizable conception of the book. We can then ask how the thirteenth-century idea of apocalyptic discourse is narratively invested as the visionary, revelatory text is transmuted into a new sequence of pictures.

TEXTUS GLOSSATUS: THE BERENGAUDUS COMMENTARY

Commentaries signify a gap that must be bridged between reader and text. Juxtaposed in any order or position on the page, the gloss necessarily creates a

fracture in the perception of the text, but at the same time, the rupture itself is a signifying or semiotic structure that becomes an element of the text. As Noakes points out, the gloss constitutes "an intermediate passage between past illumination (text) and present interpretation, and its placement on the page with the text engenders a visibility for the split between the moment of past understanding and the moment of "present" (later) comprehension.[1] In the Gothic Apocalypses, short segments of text comprising only a few verses are headed by an illustration and followed by a brief commentary. For the most part, the glosses consist of contemporary compilations of Latin excerpts from a larger exegetical work; the only vernacular translation is represented by the Trinity Apocalypse.

Since the first systematic study by Delisle and Meyer appeared in 1901,[2] textual scholars and art historians have been investigating illuminated Apocalypses of the Gothic period mainly in search of archetypes and sources. Thus far, however, the impact of the accompanying commentaries on the formation of new iconographical traditions has not played a significant role in the philological equation. By introducing just such relationships between text and image into the "old" philological equation, I propose to expand our horizons of inquiry.[3] At the same time, a needlessly complex network of iconographical and stylistic filiations among the manuscripts will yield itself to transparent simplification. Briefly stated, two distinctive cycles of Apocalypse illustrations were created in England in the mid-thirteenth century. One was designed for a text accompanied by excerpts compiled from the Latin commentary of Berengaudus; the other, the so-called Corpus-Lambeth stem,[4] was made for an anonymous French prose gloss. The eighty-two illustrated manuscripts that constitute the Anglo-French tradition of illustrated Apocalypses[5] all descend from these two seminal configurations of image, text, and exegesis. Although the English Gothic Apocalypse cycles were configured to respond to two very different textual glosses, it was the twelfth-century Latin commentary of Berengaudus[6] that formed the exegetical framework for the dominant apocalyptic discourse of the thirteenth century, and it is the dozen or so illustrated manuscripts with excerpted Berengaudus glosses from that period that constitute the focus of the present study.[7]

Although the half-page format of large tinted drawings above the glossed text in the Berengaudus manuscripts (see figs. 1–3) differs radically from the irregular dispersion of small but heavily painted miniatures in books equipped with the French prose gloss, both cycles disrupt the integrity and flow of the text. Larger dramatic and narrative structures tend to become lost as each moment is isolated, causing the reader to linger over each picture, text, and gloss. The reader's perspective shifts from one of expectancy geared to what happens next in a normal narrative mode to one of leisurely contemplation. Differing from twelfth- and thirteenth-century Bibles in which a continuous text is enveloped by marginal or interlinear glosses,[8] the Gothic illuminated Apocalypse offers a semiotic structure that effectively moves the reader's experience from a temporal, sequential context to a timeless framework conducive to a different mode of understanding the text.

Laid out in double columns on the page, the commentary is sometimes distinguished from the text only by differently colored or flourished versals, as in Trinity, or by the rubrics "Textus" and "Expositio," as in Metz (fig. 2) and Lambeth 209. In Paris lat. 10474 and Douce 180 (fig. 1), however, the visual architecture of the page takes on the appearance of a more traditionally glossed text where the commentary is written in a script only half the size of that for the Apocalypse and is thus subordinated to it. In Getty (fig. 3) and Add. 35166, the disjunctive effect becomes even more pronounced in the chromatic contrast between the scriptural text and the glosses written in rubric. The most radical disruption occurs in the Gulbenkian and Abingdon Apocalypses, which contain fully illustrated commentaries on separate pages alternating with the illustrated Apocalypse text. Although internal glosses cause discontinuity in reading the narrative, they at the same time urge a more reflective relation to the unfolding of the text in which the narrative is but one element.[9] As Ivan Illich put it, "The visible page is no longer the record of speech but the visual representation of a thought-through argument."[10]

Of the twenty-two manuscripts dating from the second half of the thirteenth century, all but seven contain Berengaudus commentaries, suggesting that the exegetical text served as an essential component in the initial conception of the English illustrated Apocalypse. At least six different compilations of excerpts from the Berengaudus commentary appear

in the extant manuscripts. Although selections often overlap, no two redactions are exactly alike. Compilations of glossing texts in turn coincide with groups of manuscripts recognizably related by the number, sequence, and iconography of their illustrations, such as those headed by Metz or Getty, confirming a critical link between the commentary and the formation of the pictorial cycles.[11]

The name of the author of the *Expositio super septem visiones* is revealed as Berengaudus in a cryptogram at the beginning of the epilogue to the commentary[12] and is confirmed in a twelfth-century manuscript (Paris lat. 2467) that carries an original scribal annotation, "Auctor huius libri Berengaudus appellatur."[13] Based on his frequent citations of the Rule, Berengaudus has long been identified as a Benedictine.[14] Because the earliest extant manuscript copies of his text date from the early twelfth century,[15] the exegete can be recognized as a contemporary of Rupert of Deutz and Bruno of Segni,[16] whose conservative commentaries defended the Benedictine Rule against the new orders (Cistercians and Canons Regular) but were nonetheless cognizant of new theological currents emanating from the early schools represented by Anselm of Laon. The eschatological ideology of Berengaudus can be linked most plausibly with the institutional reorganization and moral reform inspired by the Gregorian initiative at the end of the eleventh century.

In his association of the apocalyptic visions of John with the biblical history of the Old and New Testaments, Berengaudus adopts a typological approach popular in twelfth-century exegesis. At the same time, his text is close to the kind of scholastic expansion of glosses represented by Richard of St. Victor (d. 1173) who interprets the Apocalypse as a recapitulation of superimposed epochs "ab exordio nascentis Ecclesiae usque in finem mundi." Frequently prefaced by a short prologue excerpted from the letters of Jerome in which the Apocalypse is characterized as a book whose text is filled with multiple hidden meanings,[17] Berengaudus's text offers a conservative commentary in which the Apocalypse is not yet read literally or historically, but allegorically. The struggles and triumphs of the Church are seen within a timeless framework extending from Creation (or the Incarnation) to the Second Coming, and the vision of the celestial Church is superposed upon the

sufferings and accomplishments of the Church in its earthly mission.

Faithful to the principle of *recapitulatio* inaugurated in the fourth century by Tyconius,[18] Berengaudus interprets the septenaries of the Churches, Seals, Trumpets, and Vials as overlapping the same indefinite period between the first and second advents of Christ. Although, as Christe points out, the articulative and recapitulative system of successive visions may vary from one twelfth-century commentator to the next,[19] Berengaudus typically perceives the Apocalypse as a vision of the celestial Church and of the present and future struggle of the terrestrial Church for its eschatological realization. Not yet influenced by the millenarian prophecies of Joachim of Fiore, which appeared in 1196, claiming that the world then in the sixth age would end in 1260,[20] Berengaudus remains a transitional figure still rooted in familiar older traditions. Indeed, Berengaudus allies himself with Bede in structuring his commentary in seven visions, as allegorical manifestations of the Church universal through the ages from Genesis to the end of time. The overall sevenfold scheme of the commentary is symmetrical: The three septenaries constitute a center framed by two visions of the earthly and celestial Church at the beginning and a pairing of visions of resurrection and the future at the end.

Because a canonical interpretation of the Apocalypse already existed at the beginning of the thirteenth century in the last version of the *Glossa ordinaria*,[21] the Gothic compiler's selection of a marginal and outmoded commentary such as that of Berengaudus gives rise to some interesting questions that might enable us to speculate about the genesis of the English illustrated Apocalypse. Judging from the number of extant medieval copies, the Berengaudus commentary appears to have enjoyed widespread popularity among monastic readers in England in the twelfth century. John of Lanthony made extensive use of the earlier exegete's text in his own commentary on the Apocalypse, written in the third quarter of the twelfth century.[22] A dozen surviving manuscripts are recorded as having belonged to English monastic libraries.[23] A particularly handsome copy is contained in an early twelfth-century manuscript now in Berlin that was made for the Rochester Cathedral Priory of St. Andrew.[24] The single painted

frontispiece belonging to the Longleat manuscript of the Berengaudus commentary, dating from ca. 1100 and perhaps made for the Benedictine abbey of St. Benet Holme in Norfolk, seems to represent an isolated pictorial embellishment of an otherwise unillustrated book.[25] Set out in double registers, Christ and the Lamb in Majesty appear above John being approached by the angel on Patmos in a vertical hierarchy representing the celestial vision of Rev. 4–5 and forming a traditional but visionary author portrait at the beginning of the book. It would thus seem likely that the first illustrated versions were also designed and produced in the second half of the thirteenth century for clerical, although no longer necessarily monastic, readers.[26] The exegetical text addresses itself to matters of doctrine, the authority of the Church, its priesthood, sacraments, and preachers, as well as the conversion of heretics and Jews. Within an antiworldly ecclesiastical framework, the faithful are consistently perceived as the corporate body of the Church universal and are never appealed to as individual believers. For the thirteenth century, as we shall see, the concept of universality becomes a critical issue as the great councils pressed the view that the "universal Church" contains all the others and that the Church's sovereignty in matters of faith resides in the community taken as a whole.[27]

Although the Berengaudus commentary had its origins in the Benedictine world of the twelfth century, its reformist message appears to have been recognized by later compilers as an opportune legacy in the wake of Lateran Council IV (1215) to promote the newly declared "magisterial" authority of the Church.[28] Adaptation to the needs of the secular bishops who assumed jurisdiction over the monastic houses within their dioceses is particularly evident in the illustrations provided for the glosses in the Gulbenkian and Abingdon Apocalypses.[29] The Berengaudus commentary represents an older, more conservative Benedictine view that was first popular in unabridged, unillustrated copies in English monastic houses in the twelfth century.[30] Although the Latin text remained largely inaccessible to lay readers when it was recast in its abridged thirteenth-century illustrated form, the Berengaudus commentary became a book whose pictures, like those in contemporary Psalters, rendered it useful for private devotion among laymen and laywomen, as attested by the Lambeth and Douce Apocalypses.

The somewhat surprising persistence of the Latin glossed text demonstrates a pervasive medieval attitude toward the Sacred Page and its allegorizing interpretations. Where we would separate *translatio* (finding an equivalent word or phrase in a different language) from exegesis (explaining the sense in the same language), the medieval reader saw these explicating strategies as part of a single process.[31] Premised on the belief that the Bible had been written initially in Latin, there is widespread insistence on the power of its primacy within the bilingual cultures of the Middle Ages. As Ruth Morse points out, this insistence upon reference to the Latin text is argued with striking emotional force well into the fourteenth century:

Insofar as you can, read the books [of the Bible] in Latin, and be certain that you will enjoy reading in Latin, that stories or instruction will please your heart more than half a dozen stories in French. For Holy Scripture, written and dictated by the saints in Latin, and afterwards translated into French, does not give the same substance to readers as streams from the source itself. . . . For there are in Holy Scripture certain, even many, Latin words which pierce the heart with great devotion in the reading, which, translated into French, are without spice and taste in the vernacular.[32]

GLOSSA DEPICTUS AND THE DESIGNER OF THE BOOK

The illustration of glossed texts and the consequent exponential expansion of their interpretive capacities constitute a thirteenth-century phenomenon exemplified not only by the English cycles for the Berengaudus and French prose glosses, but also by the earlier Parisian *Bible moralisée*.[33] As full cycles of miniatures uniquely designed to visualize a glossed text first appear in the early thirteenth-century French moralized Bibles, Apocalypse illustration becomes a full-fledged vehicle of allegorical interpretation. With over three hundred miniatures for the Book of Revelation, the *Bible moralisée* contains one of the most prolific cycles of expository pictures ever devised for this text. In its most definitive form,[34] each page is laid out in two vertical rows of four roundels enframing the illustrations, accompanied by

texts aligned in columns at the left. Each short illustrated paraphrase from Scripture is followed by a brief illustrated exposition of its theological and moral significance. Unlike the *Bible moralisée*, however, the new English cycles pictorialize the text and gloss in the same image.[35] The commentaries not only constitute an essential component of the thirteenth-century English illustrated Apocalypse, they provide the critical textual framework and impetus for the creation of distinctive new cycles of illustration. The glosses thus exerted a profound, distinctive, and direct impact on the choice, conception, and design of the illustrations.

As with the *Bible moralisée*, the English cycles reveal nuanced and complex responses to the commentaries of an order that would suggest that a large measure of responsibility for the overall layout, selection of subjects, and their interpretive relationship to the glossed text should be ascribed to someone more appropriately characterized as the "designer of the book," an individual who was most likely a theologically trained cleric rather than a draftsman, painter, or scribe.[36] The directorial relationship I am proposing between the designer and the actual producer of the book is graphically demonstrated by the lower pair of figures in the dedication page of the Morgan *Bible moralisée* (fig. 24), where a cleric, with the text opened before him, is dictating the layout of the page to a craftsman who could be construed either as scribe or artist. The kind of literate, educated person who designed the model layout *(ordinatio)* or textual pictorial program at the level of complexity and intellectual sophistication observed in the thirteenth-century English Apocalypse cycles could plausibly be identified with the compiler of the gloss. Once the *mis-en-page* had been established for the whole book, the designer's configuration of text and images could be disseminated through exemplars. The operation of such a procedure is evident in the Berengaudus cycles where the various compilations of extracts have the same or very closely related pictorial programs as, for example, in the groups of manuscripts related to Metz, the Paris-Douce pair, or Getty and Add. 35166.[37]

In the thirteenth century, the art of compilation achieved an elevated status, in purported value as well as in the thought and energy invested in the process.[38] With the rediscovery of Aristotelian logic came a desire to make texts available in a rearranged,

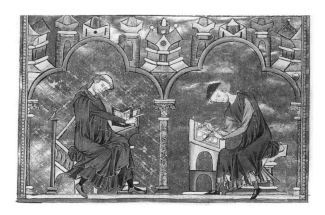

Figure 24. Bible moralisée. New York, Pierpont Morgan Library MS M.240, fol. 8. Compiler/Designer and Artist/Scribe (detail) (photo: The Pierpont Morgan Library).

condensed form, newly divided into *lemmata*, marked paragraphs, headings, rubrics, and, in some cases, pictures. Compiling became an important industry or literary genre that derived its usefulness from the layout and organization of the text and its exegetical apparatus.[39] In the case of the thirteenth-century English illustrated Apocalypse, *ordinatio* and *compilatio* merge into a single creative undertaking.[40] As Sandra Hindman points out, by the time an illuminator began work on a manuscript, it had already passed through a number of decisive stages in which the layout of the page, ruling, writing, rubricating, and the selection as well as placement, size, and format of the miniatures had already been determined.[41] Because it established the armature for the manuscript page in all its subsequent stages, ruling of the gatherings was a particularly critical process. Ruling set out the text in a fixed relationship to the margins of the page, determined the number and placement of the columns, the number of lines of writing and the size of the script, as well as the width and to a certain extent the compositional structure of the miniatures, because the illustrations are aligned with the columns of text.[42]

Illumination normally represented the last phase of the book to be completed by drawing and painting a predetermined program of pictures in preexisting blank spaces.[43] Evidence for this practice can be seen in Fr. 375, where the draftsman in the illuminator's shop inadvertently omitted one of the pictures in Rev. 11 as he was copying the model, with the result

that half the illustrations are aligned above the wrong texts, and the missing scene appears at the end.[44] Although this kind of error might suggest pictorial execution by *illiterati*, it also suggests that thirteenth-century cycles of illustration were sometimes codified into pattern books of sequenced pictures without texts.[45] Further evidence for the circulation of Apocalypse illustrations in "model books" or portfolios of loose sheets of drawings without texts is suggested by Cambrai B.422, where the same cycle of seventy-eight illustrations that appears in Metz was copied into an unbound manuscript without its text.[46] At the same time, the close relationship between the text redaction and its picture cycle in groups of manuscripts, such as the French metrical version, Metz, Morgan, Westminster, and Paris-Douce, increases the probability that written or pictorial programs of Apocalypse illustration normally accompanied the text in a maquette or in a fully illustrated exemplar.[47] The relationship between Lambeth 209 and the Gulbenkian Apocalypse offers a case in point where, with a few notable exceptions, the cycles of seventy-eight illustrations are the same and are even executed in closely related styles; the glossed texts are identical down to the smallest textual aberrations.

The appearance ca. 1200 of the professional *librarius*, the stationer and entrepreneur under whose control books could be copied in one place and then sent to another for illumination,[48] further complicates our ideas of how Gothic Apocalypses were produced. Exemplars could be borrowed from commercial establishments or owners, and, where lending was not possible, scribes and draftsmen could be sent out to copy texts or sketch in sets of pictures *in situ*.[49] Evidence of the probable transfer of an illustrated Apocalypse from a stationer and scribe to an illuminator in a different shop occurs in Trinity B.10.6, where minuscule rubric inscriptions survive in the margins next to each picture.[50] Although other types of books occasionally document another kind of guide for the illuminator in very small marginal sketches that were later erased or made on disposable materials, such as discarded remnants of vellum or wax tablets,[51] there is no evidence of this practice in the Apocalypse manuscripts surviving from the Gothic period. Given the complexity of detail involved in these long programs, neither the kind of abbreviated written instructions surviving in

Trinity B.10.6 nor marginal sketches could provide an adequate vehicle for the transmission of iconography from designer to artist. Such simplified, shorthand notations could merely identify which subject is to be represented in which space but little more. The thirteenth-century English Apocalypse cycles most probably circulated in the form of exemplars that supplied the redacted glossed text laid out in columns, with blank spaces provided for the miniatures to be filled in with the aid of detailed written or verbal instructions or a pictorial model book, or, more probably, in the form of exemplars already fully illustrated.

THE PROBLEM OF ARCHETYPE

However they may have been generated and circulated, the existence of a large number of demonstrably interconnected manuscripts inevitably presupposes their ultimate dependence or descent from an ancestral model. Inaugurated by Delisle and Meyer at the turn of the century,[52] the search for an archetype, as well as for stemmae defining interfilial relationships between manuscript versions, set the dominant course for art historical scholarship on the Gothic Apocalypse. As Pächt observes,

the historian of medieval art can never lose sight of the fact that more often than not it is from copies that his knowledge of important artistic creations is derived. In his anxiety to form an idea of the original form he feels compelled to reconstruct mentally something which either has not survived or has perhaps yet to be discovered. To the student of medieval illumination in particular this search for the lost archetype presents itself as a task similar to that of the philologist engaged in textual criticism.[53]

In the medieval transmission of texts, the original or archetype is characteristically transformed in unintentional and negative ways, through negligence, misreading, or misunderstanding; the occasional occurrence of this kind of lapse in miniature cycles can similarly be read as a symptom of dependency or filiation. As Pächt points out, however, changes occurring in cycles of illustration more often tend to be deliberate, because they constitute pictorial reinterpretations of the text passage or text illustrated, creating far greater divergences between the various descendants of the lost original than among aberrant texts.[54] Images in this context are themselves read-

ings; they are not a retelling of the text, but a new use of it, not an illustration, but ultimately a new text.[55]

Although the analogy between reconstituting a lost text from more or less adulterated transcriptions and reconstructing a cycle of book illustrations from later recensions or "copies" is far less close than is generally assumed, efforts to identify or determine the archetypes or ancestral models from which related Gothic Apocalypse picture cycles descend still tend to be made within a fairly rigid philological conception of what an "archetype" might be. Before attempting to define such a postulated configuration, we might well ask how the idea of "archetype" can be grounded within its medieval as well as its present context. For the High Middle Ages, "archetype" evoked the "exemplary idea" upon which the artist's work is based. If the thinking of Thomas Aquinas on this problem can be regarded as typical of the cultural tradition to which he belonged, then "archetype" in the medieval sense must be defined as ultimately conceived by God. The archetypal idea exists inchoately in the divine exemplar and becomes determinate in the intellect of the artist who conceives it. In adopting a Platonist position on this issue, Aquinas asserts that all things imitate the divine idea "in different ways, each one according to its own proper manner."[56] Within the problematic matrix of medieval ontology, artistic creation becomes a human technology of continual tinkering, joining together what was separate and separating what was joined, as the artist or designer attempts to give visible form and tangible substance to an exemplary idea given by God.[57] Art thus imitates and reworks, but it does not invent or create. As Bonaventure put it, "the soul can make new compositions, but it cannot make new things."[58]

For the modern art historian, the term "archetype" possesses an ineluctable philological denotation premised on the assumption of an initial human creation and the assumption that the original ancestral model actually existed in a tangible, visible form capable of generating several related recensions or "copies." In its present philological sense, "archetype" implies relationships analogous to those a familial ancestor produces among biological progeny through several generations that enable us to speak of "family" ties between groups of manuscripts. A

modern reconstruction of an archetypal Apocalypse cycle would then attempt to determine the layout, number, and sequence of illustrations, as well as identify their attendant texts and describe their iconographical formations, as accurately as surviving evidence would allow. Such a construct, however, would not qualify as "archetype" in Aquinas's sense, because for him "there is no idea corresponding merely to matter or merely to form . . . there will be only one idea, that of the subject with all its accidents." That is, in the medieval sense, the archetype only exists for human intellection in *all* its copies.

Grosseteste may have suggested a solution to our present dilemma when he distinguished two meanings for the word *exemplar*. The first can be defined by the matrix of a seal that imprints a figure in wax, but, he argues, art is an active process of making and not an instrument of this type. Consequently, the model must be a spiritual ideal that is degraded by its incarnation in matter. Grosseteste concludes, however, that when an object plunged in shadow is reflected in a luminous mirror, one knows it better in its image than in its reality.[59] Thus, we are not seeking to define the form of a mold that made stereotypical impressions, but to locate the responsive energies that generated entropy, so that we can discern a process in which designers' "emendations" and "corrections" reflect a system of discourse that we can call "archetype."

Grosseteste's "luminous mirror" constitutes what Hans Robert Jauss conceptualized as the "horizon of expectations, in the face of which a work was created and received in the past," enabling us to discover the questions that the archetype and its recensions (revisions) gave answer to, and thereby to discover how thirteenth-century readers could have viewed and understood the work.[60] In attempting to reconstruct this "horizon," Jauss suggests an analysis that combines the synchronic and diachronic.[61] The first analyzes the systems of discourse that characterize a genre of works in cross-section; the second examines the way a sequence of works or texts is received and exerts influence on other works and readers. The modern reader must mediate between a formalistic approach and a hermeneutic one by studying a whole system of discourse, including how works fit into a "series," answering each other, solving formal and substantive problems left by the previous work, and suggesting

new ones of their own.[62] In searching for an archetype, however, it soon becomes apparent that pure synchronic description is impossible, because any characterization of a system implies a before and an after.[63] A synchronic method is useful in locating constant (archetypal) formations within a system and in thus defining paradigmatic values, but they nevertheless emerge only in constrast with "innovative" values implied by changes observable in works seen in diachronic series. Within Jauss's intersubjective system, archetypes are to be sought in the familiar norms and implicit relationships through which the reader's comprehension occurs. The strategy thus attempts to establish a "transsubjective horizon of understanding" that determines the influence of the text-image configuration. As long as we insist on the possibility of reconstructing an archetype as a horizon of expectations with evidence or signals from the works that have survived, however, we are measuring the effect or impact of a lost paradigmatic system against a horizon that is abstracted from those works.[64] How can we escape the tautologous bind created by the dialectical process of production and reception in Jauss's *Rezeptionsäsethetik?*

An argument first can be made that, for the thirteenth century, the production and reception of illuminated manuscripts were much more closely interdependent than for other genres of artworks in the period. The dialogue between maker and consumer transpired in more direct terms because it was a dialectical transaction negotiated between two different categories of "readers," that is, between an artist-designer and a reader-viewer. The critical relationship between Gothic art and society unfolded within a microcosm of shared experiences as well as expectations, so that the cultural distances between production and reception were much closer than we could imagine in a postmedieval context.[65] The problem, as Holub points out, lies in Jauss's objectivist model, in presupposing a neutral position from which observations are made by both the medieval and modern reader. "Familiar standards" for the thirteenth century are verifiable only by assuming that, from a present perspective, we can make objective judgments about what those standards actually were. Because we cannot, as Jauss would suggest, ignore or bracket our own historical situatedness, we must find a way of mediating between then and now.

Although I would tend to reject Gadamer's idea of the "fusion of horizons" (*Horizontverschmelzung*), historical and modern,[66] I would argue that the historicality of the interpreter can usefully intervene in the process of interpretation, not as a barrier to understanding but as a "ground of difference" against which an historical "horizon of expectations" could be comprehended in a relative rather than absolute sense. In this way, the modern bias that seems to intrude when Jauss declares that "the more stereotypically a text repeats the generic, the more inferior its artistic character and degree of historicity"[67] can be maneuvered to reveal not only the modern bias toward novelty, innovation, and change, but an opposing medieval rejection of "value as difference" for order, hierarchy, repetition, and "likeness that permits recognition."

No work constitutes an exact replica of its predecessor, but modern perception tends to isolate and valorize differences that promise change, whereas the medieval eye looks for similarities that ensure continuity. Adherence to convention in the recreation of past models is an ideologically invested activity that emerges only when recognized within a broader historical grid of modern bias, for that kind of cultural prejudice forms an integral part of a present paradigm that enables us to comprehend an "other" through the perception of differences. Rather than attempt to escape or ignore our own historical situatedness, we could more actively enter its terms of discourse into a dialogue of interpretation between past and present. Within such an historically grounded context, the profound compliance with accepted patterns by medieval artist-designers who generate meaning for the reader-viewer through reformulation can be seen as defining their position in a thirteenth-century system of discourse. The overwhelming Gothic tendency was to interpret reality in terms of universals or essences and forms as the created expressions of universal archetypes or the divine ideas of God, notions that held, whether the particular inspiration was Neoplatonist or Aristotelian.[68]

Beyond the vexing problems of "then and now," the hermeneutic project of defining an archetype supplants questions of "what" by an interrogation of "how." What the cycles of Gothic Apocalypse illustrations signify can be readily determined from their glossed texts, but the complex mechanisms that en-

gendered meaning for the medieval reader-viewer remain to be explored. Images are not merely a form of conveyance for a particular content either absent or present in the text in the same manner that words carry meaning or reference. On a primary or superficial level, what is visible has already been made legible by the presence of a text. What now must be addressed is how words and images intersect to produce new meaning through the apparent redundancy created by their close juxtaposition.

I propose to consider the dominant "archetypal" discourse developed in the thirteenth-century English Gothic Apocalypse cycles by exploring a synchronic cross-section of textually based representations from existing manuscripts. Although such an archetype might not have existed in quite the same way in historical actuality as lost ancestral models, the proposed number, sequence, and layout of the paradigm represent "horizons of expectation" adduced from the interchanges that constitute a comprehending reception observable in the surviving manuscript cycles. Within the synchronic framework, the chronology of the manuscripts has little or no bearing on our consideration of the archetype, for I shall not be describing a diachronic process of formulation, but a pervasive system of discourse that dominated the second half of the thirteenth century. My description nevertheless implies the anterior existence of other works. Although not concerned with origins or sources for the images per se, thirteenth-century English formulations will be measured against the prior currency of pictorial ideas or visual modes of interpreting the text. The existence of "precedents" implies not a model relationship, but a pattern of tradition, a grounding mode of conceptualizing the text that can operate independently of models as well as under their direct influence.

Archetypal claims have been made for three major English Gothic manuscripts – Morgan, Trinity, and Metz – but thus far there is no incontrovertible or even persuasive evidence that a single extant thirteenth-century illustrated Apocalypse manuscript represents a plausible ancestral model for all the Berengaudus cycles.[69] Because Morgan's full-page picture-book format can so readily be envisaged as two half-page illustrations assembled one above the other, with fragments of the text moved into the pictorial space within the frames, it seems most likely that the seminal idea for the Berengaudus cycles envisioned a configuration of half-page illustrations replete with text and commentary. The most compelling argument for a half-page format of course lies in the overriding importance of the text and commentary in the conception of the pictures for the Berengaudus cycle. Each illustration was created to be perceived in conjunction with a glossed text. Indeed, the pictures in Morgan 524 often fail to be comprehensible without their textual components, suggesting that the so-called "aristocratic picture book" was very probably developed within a manuscript genre configured to accommodate an accompanying glossed text.

In the half-page format of the Berengaudus cycles, the framed picture becomes a shallow, narrow stage in which the height of the figures equals that of the frame, and the figures dominate the space in dramatic confrontations. As in the mid-thirteenth-century illustrated saints' lives associated with Matthew Paris (see figs. 22 and 23), the stage-space of the half-page format provided an ideal vehicle for the Life of John and the Apocalypse. Freyhan aptly styled the English Apocalypse as a "life of St. John" in which his visions are represented as a part of the *vita*.[70] No doubt the dominant paradigm resembled Bodleian Auct. D.4.17 insofar as the cycle began with scenes of John's preaching in Ephesus, his trials under Domitian, and his exile to Patmos. As Freyhan points out, it is difficult to tell where the Life of John ends and the Apocalypse begins. At the end of Revelation, the Life of John resumes with his return to Ephesus in a series of episodes leading to his death. Of the twenty English manuscripts surviving from the thirteenth century, half include an illustrated Life of John.[71] In the Apocalypse itself, the figure of John dominates almost every scene of the Berengaudus cycles, whether the Life is included or not. John usually stands at the full height of the frame and, as the author-hero of the book, he dominates and commands the sequence of visions through the force of his presence and the recollection of his visual perceptions. The intersection of thirteenth-century illustrated Apocalypses and saints' lives suggests that the Berengaudus cycle was conceived at midcentury as a dramatic narrative of exile, visionary experience, and return, a tripartite structure fusing the discursive traditions of the hagiographical *vita* and apocalyptic *visio*.

PROBLEMS OF GENRE AND NARRATIVE

The first illustration in the cycle (figs. 25 and 27) opens the text by opening a problem of genre, and with it, the reader's expectations of the text. On the initial level of narrative sequence, John's dream-vision on Patmos is perceived as an episode in a continuing hagiographical *vita* that has already begun and at the same time functions as the catalytic event that inaugurates the Apocalypse. By this pictorial move, the structure of the narrative is fugued. The sequence of one genre is imbricated in another, as the first term of a new sequence is cut in before the prior sequence is completed, and the two generic narratives move in counterpoint.[72] At the beginning of the Gothic cycle, the overlapping temporalities of the two structured categories of narrative continuum produce a new chronological illusion, one in which the order of a chronological succession is absorbed into an atemporal matrix where the time representing the syntax of human behavior has been suspended as a requisite to prophecy or revelation.[73]

Although the discourse of the thirteenth-century Apocalypse is shaped throughout by the pervasive idea of an experience lived through by its saintly narrator, the narrative is driven by the dynamic of a powerful genre defined as "apocalypse." In John Collins's useful formulation, Apocalypse constitutes a

genre of revelatory literature within a narrative framework in which a revelation is mediated by an otherworldly being to a human recipient, disclosing a transcendent reality which is both temporal, [only] insofar as it envisages eschatological salvation, and spatial [only] insofar as it involves another, supernatural world.[74]

Whereas the transcendence of the apocalyptic genre suggests a loss of meaning and sense of alienation, the power of John's Apocalypse lies in its dramatically symbolic mode of communication. As Bernard McGinn argues, symbols have a magnetic effect on the human imagination through the very nature of their polyvalence and ambiguity.[75] Seeming to work at odds with the kind of spiritual paradigm offered by the saint's life within which the Gothic Apocalypse is embedded, the type of knowledge contained in the Book of Revelation is of a totally different order. Its wisdom is both "vertical" – a revelation of

the secrets of heaven and of the universe – and "horizontal" – an uncovering of the meaning of history and its end.[76]

Although from the inception of postapostolic efforts to explicate its mysteries, the hermeneutic challenges posed by the Book of Revelation have been perceived to lie within the problematic narrative structure of the text, particularly with regard to its numbered sequences of Seals, Trumpets, and so forth, the English Gothic picture cycles tend to mask and even to erase those salient discursive structures in their fragmentation and dispersion of the visionary events, distending and expanding its signs along a protracted narrative chain. The inherent fragmentation of the text tends to be further intensified by the inevitable intrusion of commentaries. As John Whitman points out, the efficacy of God's Word assured each passage of "an explosive multiplicity of meanings, diverging in all directions from each other."[77] The sacred text tended to split Scripture into piecemeal interpretations, loosely strung as intervals of episodic exegesis: "The meanings signified by a text kept tumbling over themselves in a breathless effort to disclose the depth of God's word."[78] The fragmentation of the text further serves the purposes of prayer and meditation, for in St. Anselm's view,

The purpose of prayers and meditations . . . is to stir up the mind of the reader to the love or fear of God, or to self-examination. . . . The reader should not trouble about reading the whole of any of them, but only as much as, by God's help, he finds useful in stirring up his spirit to pray. . . . Nor is it necessary for him always to begin at the beginning, but wherever he pleases. With this in mind the sections are divided into paragraphs, so that the reader can begin and leave off wherever he chooses.[79]

As we shall see, however, what has been disjoined in the apparent Gothic disintegration of narrative structure is joined again on another level, on a performative plane, where the consciousness of John and the reader come together as complicit witnesses, immanent to the discourse, and where the meaning of the utterance becomes the very act by which it is uttered. Writing and picturing visions are, in Barthes' words, "no longer descriptive, but transitive, striving to accomplish so pure a present in its language that the whole discourse is identified with the act of delivery."[80]

Within the new narrative framework of the Gothic Apocalypse, the structure of the book *qua* book plays an integrational role, no longer as an indexical sign but as agent acting as the self-reflexive hero of all the sequences. Initiated by the creation of the "bookish text," the thirteenth century was the era of the book.[81] The text could now be seen as something distinct from the book, an object that could be visualized even with closed eyes. As an entity created by the pen in the hand of the scribe, the book was no longer a transparent optical device, a window onto nature or God, but an object in which thought is gathered and mirrored.[82] On the other hand, the figure of the world as mirror or book recurs throughout the Middle Ages. For Alain de Lille, "all creation, like a book or picture, is a mirror to us."[83]

As the repository of writing and speech, the coded signs of narrative, the book is now transformed into image, thus no longer "transmuting" narrative but *displaying* it. In the analysis of A. Y. Collins, John's visionary experience is structured in two main parts: Following an introduction, the Apocalypse consists of the revelation of the content of the closed book of seals (Rev. 6 to 11) and of the open book in the hand of the angel (Rev. 12 to 22). Each section is introduced by a commissioning vision, the vision in which he is taken up into heaven to view the celestial liturgy and the Lamb opening the book (Rev. 4 to 5), and the vision of the angel descending from heaven with the open book (Rev. 10).[84] In the English Gothic picture cycles, it is the shifting and uncertain identity and status of the book – as divine archetype, humanly inscribed text, and the illuminated book beheld by the thirteenth-century reader – that take center stage as a dominating presence within the narrative discourse. To be sure, the sevenfold sequencing of "events" has by no means been lost, but its expansive, parametrical structure disperses the semantic tension of the discourse, and it is only with the dramatic display, displacements, and transitions of the "book" that tension is restored, inaugurating further uncertainty.

Beyond its peculiar merger of hagiographical *vita* and apocalyptic *visio*, one of the questions that has fascinated modern commentators on the newly pictured Gothic Apocalypse is its quick acceptance and increasingly attentive audience among lay readers of the thirteenth century. What attracted aristocratic men and particularly women to the newly pictured Apocalypse, notwithstanding its wholesale condemnation of the world and its institutions? It has by now become a widely accepted assumption that Gothic designers transformed the illustrated Apocalypse into an appealing picture book of popular romance designed for rich lay readers, based on the premise that the Book of Revelation would have been recognized by artists and patrons alike as the one biblical text that corresponded to aristocratic literary taste for entertaining romances, with "ladies in distress, noble knights riding into battle, magic, and mysterious and monstrous beasts."[85] Further arguments have cited parallels in format and narrative style with illustrated saints' lives, as well as the innovative presentation of the Apocalypse as part of the Life of St. John in which the Evangelist is perceived as the hero of the book, "who sees fabulous monsters and unheard-of happenings, to survive it all and return to tell the tale."[86] In short, the distinctive pictorial inflections of the English Gothic cycles further problematize the contemporary reader's genre expectations by indexing the narrative as romance *(roman arthurien)*.

The long sequences of illustrations are molded to a horizon of expectations determined by a pervasive textual genre similarly structured to convey profound didactic and moral lessons to the reader through a system of discourse veiled in symbol and allegory. John of Garland's *Parisiana Poetria*, which sets forth the parameters and functions for a variety of literary forms,[87] reveals a heightened thirteenth-century awareness of genre expectations. The appropriation of a romance model for the Gothic illustrated Apocalypse provided the contemporary reader with a preliminary presupposition of information and a trajectory of expectations that enabled the comprehension of a difficult text within a familiar framework. It must be understood, however, that, in contrast with frequent modern misperceptions of medieval romance as entertainment, the *roman arthurien* was intended to serve the more serious purpose of moral as well as social instruction for its twelfth- and thirteenth-century readers, and thus could be appropriated to the familiar structures of reading the Apocalypse without trivializing or compromising its devotional and contemplative ends.

As outlined by Jauss, the medieval genre of romance generates a fundamental model that can be described in terms of four modalities: narration,

forms of representation, representational unities, and social function,[88] which are in turn embodied in the structure of the Gothic Apocalypse cycles. In the relation between narrator and text developed in the Berengaudus archetype, the emphatic and often empathetic responses to John's authorial apostrophes ("Then I saw, I heard") cast the text into an unmistakable romance mode in which the poet writes to an unseen audience, stepping forward as a mediating presence behind the material, either as a ubiquitous witness or as a protagonist in the narrative action. John's interpolations *(signes de narrateur)* further promote the importance of interpreting the narrative by signaling to the reader a rupture between the "fable" and its meaning *(matière et sens),*[89] and hence the necessity of the accompanying glosses. As indeterminate modes of thought become increasingly dominant in the thirteenth century, the "undirected vision" of romance, with its characteristic multiplicity and indeterminacy of meaning, often thematizes it own indeterminacy.[90] Just as the romance is narrated from an epic distance in the *passé du savoir,* apocalyptic images are perceived as visions of an immense panoramic grandeur. At the same time, however, they are interleaved with glimpsed moments of a more intimate actuality in a juxtaposition familiar to readers of the *roman.*

The microcosmic reportage of the narrator's experiences from moment to moment in as many as ninety framed scenes draws the reader into the suspenseful unfolding of "fable," counterbalanced by the secure expectation of the happy salvific ending. As Bakhtin observed, within the chronotopical mode of the romance, time breaks down into a sequence of "adventure-fragments." However, there is a contradiction, even an antagonism, between the form-generating principle of the whole and the temporal form of its separate parts. Each image strains toward fulfilling its potential within a megastructure shaped by the kinetic drive of the allegorical action.[91] Dominated by the otherworldly vertical axis of the dream-vision, narrated events violate elementary temporal relationships and perspectives; in the mode of romance, they are characterized by a subjective playing with time.[92]

In romance and allegory, as well as in saints' lives and the dream vision, the central structural unit of medieval narrative is not "plot" but episode.[93] Modular in form and serial in content, episode can be defined as a syntactical unit of narrative structure or semiotic model within the semantic system as a whole, but it has no meaning or validity outside that system.[94] Thus, the principal development in medieval narrative is neither linear nor dynamic, but one of the repetition of episodes within the global structure of the text.[95] In such modular apocalyptic sequences as the seven Seals, seven Trumpets, and seven Vials, the reader-viewer is presented with a series of systematic permutations in which repetition is ultimately ontological and paradigmatic in its impact. Repetition gives the reader a cumulative understanding of the abstractions that control the meaning. As Peter Haidu argues,

since amplifications of the basic pattern have no narrative function, they stress the fact of repetition and inscribe it in the consciousness of the reader . . . these additional amplificatory details provide a rhetorical convergence and establish that consciousness as an element of signification.[96]

Like romances, the Gothic Apocalypse exhibits multiple climaxes in the repeated resolution of episodic tension. In a serial procession of catastrophes and triumphs, a sequence of "pictures rises in the mind, succeeding, displacing, and correcting one another."[97] The possibilities for extending this process of moral testing in the anaphoric repetition of trials, encounters, and battles is potentially endless. In the absence of an inherent limit of modular extension, the narrative remains essentially unfinished, projected from the past and present into an unpredictable future. Nevertheless, each isotropic grouping of repetitive episodes creates a syntagmatic disfunction, creating gaps that give rise to a sense of provisional closure and isolation.[98] Just as the meaning of events and episodes is found in an overhanging layer of significance, the silences perceived within such narrative interstices become as significant as spaces filled in with episode, because, as Fletcher eloquently argued, "by bridging the silent gaps between oddly unrelated images we reach the sunken understructure of thought."[99]

As a story that resolves itself into a string of juxtaposed, mutually independent event-clusters, each with its own beginning, middle, and end, the Gothic Apocalypse most closely resembles what has been called a *roman à tiroirs,* a chest of drawers that are explored one after the other.[100] Generated by an initial impulse (the dream) that calls into play the series

of episodes of which the *roman* is composed, a single hero seems to provide the elementary principle of unity in this sort of narrative. Minimally constituted by two fixed elements, a beginning and end, with the middle then filled with various "adventures," the resulting structure is aptly described by Ryding as resembling an accordion, "flexible in the middle and steady at both ends."[101]

In its *modus dicendi*, the illustrated Gothic Apocalypse most consciously appropriates the mode of romance by its insistence on representing itself at every conceivable opportunity as a *written* book opposing an oral tradition. Notwithstanding the plethora of messages aurally received by John throughout his visions, they are inevitably transcribed into a lexical record. The reader is constantly confronted with images of books either being held or written. Just as the *romanz* is quite literally a book rewritten in the vernacular, the Apocalypse is a text transcribed by John that arises from another tradition written in the celestial archetype held by the Lord and his angelic messengers. In terms of closure and sequel, the paradigmatic enframement of the Apocalypse picture cycle within the unfolding Life of St. John tends to catapult the thirteenth-century English Apocalypse into the more "modern" genre of the novella, as the temporal tension of the exile on Patmos, running from an arbitrary beginning to a dissolving end, implies both antecedent and continued episodes. However, Gothic recensions such as Metz and Paris-Douce, by eschewing the illustrated *vita*, restore the Apocalypse to a representational mode more typical of romance in which a singular series of adventures lends a sense of closure that no longer refers to a before and after.

In terms of its construction and levels of significance, the action *(argumentum)* of the illustrated Apocalypse unfolds as romance happening, for John's adventures are perceived as a structure for the fulfillment of meaning arising from seemingly inexplicable phenomena that seem to have their center above and beyond the text. The unity of action emerges in the singular character of the exemplary hero as he witnesses and comprehends the otherwise fractured narrative of his vision. As Morton Bloomfield pointed out, the hero lays himself open to instructions from a higher power.[102] He is tested by the unknown, and he is measured by his reaction to this test. As far as the "characters" of the story are concerned, as in romance, they tend to be exclusively aristocratic, with a heavy intrusion of crowns and heraldic insignia, but their differentiation operates on the level of ethnic rather than social prejudice more characteristic of earlier epic. The represented exemplary reality of the Apocalypse, like that of the romance, can be most readily conveyed in images that form weightless colored silhouettes against a flat ground. Elevated through the fairy-talelike fortune of the "other world," the Gothic Apocalypse forms an elegant pictorial equivalent of the stylized courtly realm that forms the framework within which an excluded unideal reality is transformed into elements of an opposing magical sphere.

At the same time, the Gothic Apocalypse hovers precariously between the degrees of reality in medieval genres distinguished by John of Garland as *res gesta* and *res ficta*. Romance follows a fictional principle in which no occurrence may be like reality, while the courtly narrator claims to discover a *sensus moralis* in the *res ficta*. Whereas on one level in the Gothic Apocalypse, the extension of the narrative voice into an accompanying gloss enables the text to be read allegorically, the scriptural claim to revealed (historical) truths and their preservation for enduring memory belongs to the realm of epic. Nonetheless, the Apocalypse transmuted into pictorial romance elicits a mode of reception that fuses pleasure with instruction, as it communicates a doctrine of spiritual education through a fairy-talelike ideality of adventure, thus confirming its serious socioreligious function as an initiation into a more spiritual life. Because the ownership and reading of luxurious illustrated books were just as much an affirmation of social and economic privilege as an exercise in pious devotion, the courtly framework of the Gothic romance–Apocalypse expanded the reader's experience into a legitimate quest for terrestrial happiness regulated by religious and moral discipline.

Finally, the perception of the Gothic Apocalypse as romance opens into the heart of the book's problematic as genre and narrative discourse. As Hayden White reminds us, "Narrative becomes a problem only when we wish to give real events in the form of a story. It is because real events do not offer themselves as stories that their narrativization is so difficult."[103] To be sure, setting aside for the moment questions of belief or theological doctrine, the "real" in the case of the Book of Revelation does not make

the same order of "truth claim" as that in historical writing. As in the case of historical annals or chronicles, however, the Apocalypse text nevertheless operates in the domain of memory, albeit the remembering of events experienced in an altered state of being "in the spirit," and events unfold under the sign of the "real" rather than that of the "imaginary." Again, to quote Hayden White,

Narration and narrativity thus become instruments by which the conflicting claims of the imaginary and the real are mediated, arbitrated, or resolved in a discourse. . . . Events must be not only registered within a chronological framework of their original occurrence but narrated as well, that is to say, revealed as possessing a structure, an order of meaning, which they do not possess as mere sequence.[104]

The fictive structure of the textually and pictorially constructed Gothic Apocalypse narrative is tropical, figurative, and metaphorical. As a deviation from the literal, conventional use of language, its metaphorical expansion into allegory can be seen as a defense against literal meaning in discourse, as well as a deviation toward another meaning.[105] Unlike the last entry in an annalistic chronicle, the end of the apocalyptic narrative, as the finite goal of a discursive chain of metaphors, can "cast its light back over the events originally recorded in order to redistribute the force of a meaning that was immanent in all the events from the beginning."[106] Equally important to Revelation's project is that the distinction between evidence in the sense of the "eyewitness" to actual events and the "eye" that reads forthcoming events is collapsed in the figure of the author, thus making visible the unseen spaces of his seeing.[107]

In a sense, the Gothic picture cycles deepen and expand the tension already present in the text between the story structure, which is hierarchical, and the chronicle structure, which is sequential and juxtapositional. The merger between chronicle and story is particularly common in medieval romance with its marked affinity for chronological or sequential strings of episodes. However, as Evelyn Vitz points out, this tendency to "flatten out" narrative, to lose its circularity, is not simply a question of genre, but of a more profound medieval discourse engaging an understanding of the relationship between truth and narrative, between reality and art.[108] Operating within a belief system that regards time as the sequential revelation of God acting purposefully in history is the medieval conviction that every sequence of events that occurs is a "story," that all events have causality, meaning, and finality, although they are often known only to God.[109] Thus, what we are witnessing in the Gothic illustrated Apocalypse is not the explicit intervention of human artistic invention in order to have a story, but a visual and textual document of human effort to comprehend meaning in the mere sequence of shapeless, temporal raw data that constitutes a story, that is, God's story.

In its genre intersections with *vita*, romance, and historical chronicle, the thirteenth-century illustrated Apocalypse transforms scriptural speech and prophecy into visually witnessed narrative action. Operating within the protocol of a medieval fictive genre, John's revelations move from the apprehension of a "strange" and threatening reality to a metonymic dispersion of elements across a temporal series and spatial field beyond human experience. The appeal of its historical discourse lies in the degree to which the real is made into an object of longing and desire by imposing upon events that are represented as real, the formal coherency of story *(fabula)*.[110] At the same time, the "truth" claim of spiritual passage offered to the reader is guaranteed because it is one already sanctified by the passage of the prophet, thus preparing the reader-viewer to perceive the revealed scriptural narrative in text and image so that he or she, like John, may arrive at truth in a vision of God.[111]

The Narrative Paradigm:
A Synchronic View

Although the scriptural text of John's Apocalypse already exemplifies many of the most distinctive structures of medieval narrative, thus perhaps explaining its pervasive popularity throughout the Middle Ages, the Gothic picture cycles transform the book into a salient medieval narrative paradigm. Its long and complex form is characterized by multiplicity and surprise rather than by Aristotelian norms of economy, unity, and inevitability.[1] As we have already observed with respect to the enframing Life of St. John and will further explore in other pictorial cycles appended to the thirteenth-century Apocalypses,[2] the medieval practice of attaching sequels and preludes to preexisting texts had the effect of blurring the classical concept of beginning, middle, and end. To the frequent exasperation of modern readers, the exaggerated episodic structure of medieval narrative creates a distracting sense of discontinuity not simply on the grounds of its loose dispersion, but, what is more important, the absence of a sequence grounded by probability or necessity, thus creating disturbing ruptures with normal patterns of human discourse. As in John's Apocalypse, the characteristic medieval "story" resolves itself into a string of juxtaposed episodes whose narrative coherence depends upon some kind of encompassing frame, such as the dream-vision and the continuous presence of a single hero. In its pictured Gothic versions, the medieval Apocalypse becomes an unmistakable part of the vast body of medieval literature classed as "cyclic."

The peculiar structures that inflect the further coherence of medieval narrative operate affectively and dramatically throughout the thirteenth-century cycles of Apocalypse illustration. The narrative technique of interlacing first observed by Ferdinand Lot in the prose *Lancelot*[3] is not only embedded in the text itself, but is expanded and elaborated when the text episodes are imaged. Thus, one narrative sequence such as the Seven Seals, which breaks off abruptly at the end of Rev. 6, is interrupted to launch into another sequence dealing with the Four Winds (Rev. 7), before the seventh and last seal is broken in 8:1. In an analogous interlacing strategy, the beginning of Rev. 11 is merged with the end of Rev. 10 in the Berengaudus cycles, fusing two seemingly discontinuous narrative episodes of John taking the book with his measuring of the temple (see fig. 70). Similarly, the vision of the Ark of the Covenant at the end of Rev. 11 intrudes upon the beginning of a new series of episodes whose narrative center shifts to the Woman in the Sun (Rev. 12). Thus, as we shall see, various threads tangle and untangle, cross and recross, in accordance with a carefully prearranged plan of narrative coincidence and interdependencies that is not immediately apparent to the reader-viewer, but, upon further reflection on the text and gloss, illuminates their meaning. As explained by William Ryding, the medieval structure of the interlaced narrative does not form a convergent pattern in which the various threads move toward a major

knot, "the threads instead diverge to form a broad and spacious tapestry."[4]

Although what has been called the diptych structure applies to the tendency observed in medieval narrative to divide a story into two more or less symmetrical halves,[5] Kellermann's further observation of this phenomenon as two contrasting and deliberately juxtaposed tableaux in the *Conte du Graal*[6] closely approaches what we will see again and again in the juxtaposition of imaged episodes on facing pages of the open Apocalypse manuscript. Indeed, the half-page illustrations rarely stand alone for the reader as isolated visual perceptions but are clearly intended to operate in mutually reflexive relationships as, for example, in the representation of the Seventh Trumpet facing the Ark of Covenant (figs. 82 and 83), thus juxtaposing two celestial visions of the kingdom of the Lord and the Temple of God in Heaven. The calculated pauses created for the reader, as he or she is invited to contemplate the pictorial diptych displayed on the bipartite opening, are frequently prolonged by the inherently static character of many of the images themselves. As in the representation of the Third Horseman in Lambeth 209 (fig. 46), they tend to arrest the eye and invite the mind to ponder the secret design underlying their allegorical form.[7]

Above all, the designers of the Gothic cycles joined medieval rhetoricians in their primary concern with amplifying and extending the narrative line. Like the medieval author, the designer of text images did not create stories, he found them. As a *trouvère*, his real task was to amplify what he found, to give it fullness and magnitude.[8] According to the practice of amplification recommended in *Ad Herennium*, a "Ciceronian" handbook widely used throughout the Middle Ages,[9] a text is best expanded by employing precepts originally designed for use in persuasive oratory – *expolitio* and *interpretatio*. Hence the pictures and glosses. As in the pair of illustrations formed by the representation of the Worship of the Dragon followed by an almost identical scene in which the Beast from the Sea is adored (figs. 101 and 102), certain symmetrical effects are acknowledged by repetition and duplication where the figures are reversed or inverted so that the same action is enacted by different characters. The narrative structure then depends upon a pervasive system of correspondences between sets of episodes. The most important mode of rhetorical and material amplification found in the Gothic cycles lies in the visual accumulation of details around the action. As recommended by the early thirteenth-century English poet and rhetorician Geoffroi de Vinsauf, the story can be made longer and hence more effective by providing more in the way of circumstantial detail.[10]

Notwithstanding the immediate priority of structuralist narratology in establishing our terms of analysis, we cannot ignore the ideological core around which medieval narrative is organized. As every story is structured from within a *Weltbild*, we shall see events linked through an external center of discursive reference. In this as well as in later chapters, we shall ask why a story is being retold in a particular way in a particular place and time – to what purpose, to what audience? Our analysis of the thirteenth-century apocalyptic discourse will focus not only on narrative structures, but also on the ideological content and implications of those structures. Indeed, without considering the relation of narrative elements to the broader rhetorical *discours* of medieval culture, we cannot adequately decipher the glossed and imaged text. To demonstrate the point before passing on to our analysis of individual illustrations in the Apocalypse, we can consider just one aspect of the profound implications of the medieval belief in the existence and omnipotence of God and of the related conviction that life largely defies human comprehension. Again and again, John's visions and the unfolding of his *récit* are visually projected onto the text-page "screen" from a divine – that is, distant and somewhat elevated perspective, history as it appears to God. Events are displayed synchronically, devoid of the human experience of change or "chronicity" because time is believed to be merely an illusion. Thus, the simultaneous visual perception of heaven and earth, of what happens inside and outside the frame, and of sequential events occurring as if simultaneously, an ontological blurring of past, present and future. If, as Vitz points out, the ideologically constituted medieval view of true causality is understood to be a divine prerogative in which human as well as angelic agencies are used for God's own ends, the narrative working out of God's purpose then remains consciously and pointedly unclear, unexplained, and inexplicable.[11]

Having postulated a format and narrative framework for the Berengaudus archetype as a cycle of half-page pictures accompanied by a glossed text,

preceded and followed by an illustrated Life of St. John, we can now turn to the problem of describing its system of discourse in further detail. The most important evidence for defining the paradigm is of course offered by the major clusters of surviving manuscripts – the Metz, Morgan, and Westminster groups as well as the Trinity Apocalypse.[12] A close comparative analysis of these types and their recensions yields a grid of intersecting pictorial configurations upon which an idea of the archetype can be roughly approximated page by page. Rather than attempting to define or describe an *ur*-image from which all could have descended, however, we shall explore and analyze the often wide disparities among images from one manuscript group to the next for a given illustrated passage in an effort to discover underlying narrative structures. The various manuscript recensions can be seen to constitute radical revisions of a generic paradigm to meet a variety of purposes and demands. Even text divisions and glossing texts as well as iconography vary from one manuscript group to the next. Working backward from the observable results of a number of revisionary processes – reduction and expansion, rejection and adoption, clarification and obfuscation – we can recognize the motivating impetus that engendered the critical emendations. That is, we can reconstruct the questions to which so many different answers have been given. Our task will thus be interpretive rather than reconstitutive. We shall ask not only what was meant by a particular image, but also how that pictorial configuration intersected with text and commentary to produce meaning for the reader. We shall be examining the shifting relationships of signifier *(signifans)* to signified *(significatum)* as revealed by a process of critical reception and revision within a synchronic framework of contemporary readers. Although discourse is still conceived within a two-leveled structuralist scaffolding consisting of sets of discrete signs that encode sets of discrete and specific ideas, objects or events, it is also seen as a series of responsive narrative acts and transactions.[13]

Within the dynamic process of signification we call semiosis, viewers rarely will stop at the first association but will continue to consider the image-sign as open and porous within a common concept of code. The potential mix of Peircian iconicity, indexicality, and symbolism present in every image reveals its fractured nature, the "difference within" that allows for image-seeing that is active and at the same time positioned in time.[14] We shall thus become involved with the notion of intertextuality, which refers to the ready-made quality of linguistic and visual signs that an image-sign finds available in the earlier texts and images that a culture has produced.[15] Although this Bakhtinian idea seems to overlap that of iconographical precedent, the relationship between tradition and work is no longer seen as passive but rather as an active intervention into the material handed down. To borrow a motif is not *a priori* to borrow a meaning. But, as Bryson and Bal point out, a sign is appropriated precisely because of its signifying power. It comes with a meaning that will not be necessarily endorsed, but either rejected, modified, or simply inserted into a new text. As we shall see, by reusing images, the artist inevitably takes along at least a residue of the text from which the borrowed element has been broken away. The art historian then brings his/her own legacy of discursive precedents, and reading images then entails the inevitable mixture of these signs with those perceived in the work.[16] As readers and viewers bring to images their own cultural baggage, there can be no fixed predetermined meaning for the polysemous sign, but rather the recognition of the specific circumstances in which sign-events occur and the finite number of culturally valid, conventional rules or codes leading to a specific interpretative behavior, which is itself socially formed.[17]

Thus, because no discursive system capable of being understood can emerge from a semiotic vacuum, it will prove both useful and necessary to establish traditional patterns of past discourse as a ground against which and within which the Gothic idea of the illustrated Apocalypse was generated. It will be difficult, however, to speak of origins or sources, for the connective threads between thirteenth-century England and prior traditions of Apocalypse illustration have been lost to us. When we observe an apparent congruence in pictorial conception between Gothic and Carolingian representations for a given text passage, for example, all we can safely conclude is that the idea for the text image was not new to medieval patterns of discourse on the text; but we cannot know whether the thirteenth-century designer was aware of an exemplary tradition or not. Con-

versely, in the absence of demonstrable precedents, a Gothic formation may appear to be innovative to us, but we cannot confidently argue for innovation *ab silentio* because so much material has been lost. Adherence to tradition, reformulation, and change will then emerge most plausibly as strategies of discourse and patterns of expectation.

Unfortunately, we cannot document the presence in England of a tradition of Apocalypse illustration earlier than the Berengaudus cycles dating from the mid-thirteenth century on, but they were clearly not created *ab initio*. Abundant anecdotal evidence of dependency on known models would suggest that a very rich legacy of earlier traditions was available to the thirteenth-century designers. Some pictorial conceptions can be traced back to the ninth-century Carolingian cycles surviving in Valenciennes MS 99 and Trier MS 31, whereas others appear to be later. Whether an older repository of Apocalypse illustration was transmitted by way of compilations existing in twelfth-century picture books similar to those in the *Liber Floridus* and Bodl. 352 or whether the images were drawn from disparate sources is impossible to determine. Moreover, the frequent but by no means consistent intersections with both major redactions of the *Bible moralisée* suggest the availability of some version of these earlier thirteenth-century Parisian cycles to the designers of the English Gothic Apocalypse,[18] although their idea of illustrating the commentary as well as the text was taken up only by the Gulbenkian-Abingdon pair related to the abbreviated cycle in Metz.

Just as we see the thirteenth-century apocalyptic discourse emerge from a matrix of preexisting semiotic text-image structures, involving the adoption, rejection, and modification of earlier patterns, the Gothic narrative itself comprises a series of immediate or contemporaneous retellings. As Barbara Herrnstein Smith has argued, "for any particular narrative, there is no single basic story subsisting beneath it but rather an unlimited number of other narratives that can be constructed in response to it or perceived as related to it."[19] The form and features of any "version" will be contingent upon, among other things, the particular motives that generated such a transformed or translated "copy" and upon the particular interest and functions it was designed to serve. Some versions or close replicas, as Smith

further points out, may be constructed to preserve and transmit a culturally valued narrative structure; others, which are patently adaptations or variants, may be constructed in order to instruct a specific audience. While recognizing the social, cultural, and other contextual conditions that can be examined for their relevance to differences between diverging realizations of the thirteenth-century discourse, such as the Metz, Morgan, Westminster, and Trinity Apocalypses, I shall not directly address those problems of historical contingency here, but defer their consideration to another, closely forthcoming project.[20]

The description of the thirteenth-century apocalyptic discourse that follows is structured on a sequential series of ninety text images that constitute the Gothic idea for the Berengaudus cycle. The process of the formulation and reception of the Berengaudus paradigm is described in terms of both the abstractions of an exemplary idea and the vicissitudes of contemporary praxis. In either case, however, the construct is an imaginary one. We shall probably never know whether anything like the "archetype" we are describing actually existed in the form of illustrated manuscript exemplars or model books that could be copied in response to the scribe's instructions, such as those written in the margins of Trinity B.10.6. Lost prototypes could have existed in the form of model books, consisting of loose sheets, perhaps with drawings only on one side as in the Mons fragment, which could be readily transmitted but also easily lost. Thus, the designers of the various recensions responding to the archetype might have simply selected and modified illustrations from a standard compilation of scenes to meet the special requirements of a new edition. Mutations and transformations would have occurred for a variety of reasons, ranging from simple errors in reading by the artist or scribe, loss of models and the use of defective or wrong models, to more complex changes caused by the scribe altering the text, the artist's new reading of the text, use of a better model, or updating his model to conform to new ideas and conditions, sometimes under the patron's instructions.[21] As we proceed, we shall ask how some of the variant recensions developed as well as how the initial idea for the cycle was formulated. However, it must be borne in mind that we are probably not describing anything closely resembling historical "fact" and must content

ourselves with the discovery of a system of discourse in the form of an idea known only imperfectly and distantly by the modern reader.

Notwithstanding the inherent opacity of the text, the Gothic Apocalypse narrative is clearly structured by the thematic domination of the Berengaudus commentary. Punctuated by intervals of episodic exegesis, the visionary landscape of John's fragmented experiences is mapped as a traditional metastructure of seven great encompassing "visions." Salient guideposts are struck into the smoothly undifferentiated and seemingly timeless surface of the narrative as Berengaudus organizes its allegorical dimensions into a referencing set of spatial and temporal axes. The exegete begins by arguing that his sevenfold structure is not arbitrary, but required by reason *(ratio)*. Soon, however, the scheme takes on the character of a God-given journey through the text. Toward the end, Berengaudus heaves a sigh of relief as, "Thanks to the boundless mercy of our Lord Jesus Christ, we arrive at the sixth vision, which is shorter than the others."[22] Within the sevenfold structure, each new vision is formally announced and explicated as a traditional incipit to each new division of the text at 1:1, 4:1, 5:5, 8:6, 15:6, 20:11, and 21:9.[23] In addition, as we shall see, a long excursus on the significance of the number seven for the structuring of the whole text in seven visions is given at 1:4, where the allegorical scaffolding is laid out both in the commentary and illustration in a metaphorical image of the Seven Churches.[24]

Indeed, like Bede, Berengaudus sees embedded in the Apocalypse a revelation of the Church in all its earthly and heavenly manifestations both inside and outside time.[25] The first of the seven visions (Rev. 1 to 3) focuses on the earthly Church addressed in the letters to the seven churches of Asia; the second forms a unique segment constituted by Rev. 4, not found among other medieval commentators, in which the celestial Church manifests itself to the faithful; with the opening of the seven Seals in the third vision (Rev. 5 to 8:5), the Church is founded on earth with the opening of Scripture in both the Old and New Testaments; the fourth vision extends from Rev. 8:6 to 15:5 in which the events evoked by the seven Trumpets are seen as the trials and persecutions of the Church; the fifth comprises Rev. 15:5

to 20:10 in which the seven Vials are construed as the wrath of God brought down upon the wicked and in which the world and its institutions are destroyed[26]; the sixth vision (Rev. 20:11 to 21:8) then sees what has been promised by the Church and its teaching fulfilled in the general resurrection and renewal of God's mercy; and the seventh finally focuses on the vision of the future in the figure of the new Jerusalem. As an allegorical structure of continual yearning, the journey back to a foreclosed heavenly origin, the pilgrimage to the sacred founding shrine in a new Jerusalem holds out promises of meaning for the text in a prophesied future that will be indefinitely deferred.

Against the undifferentiated order of the cosmos and God's position as unmoved mover within it, Berengaudus introduces a synchronic system of differences that declines the structure vertically through an order of discourses spatially projected on earth or in heaven, so that, for example, the first and second visions construct representations of the "Church" as a metaphorical figure first on earth and then in heaven. As the narrative develops laterally through the time of John's experience as well as of its telling, a diachronic principle is realized through the shifting status of the figures of representation, such as the "book," which, as we shall see, undergoes a critical transformation from its first appearance in the third vision to the fourth (Rev. 10), or the "city" of Babylon, which is transfigured from woman to urban center and back again as we move from Rev. 17 to Rev. 19, or the relentless serial incarnations of Antichrist encountered in the fourth and fifth visions in a temporal extension of the trope through the septenary sequences of Trumpets and Vials. Within the exegetical spatial and temporal structure of the seven visions, allegory becomes a "vivifying archaeology of occulted origins and a promissory eschatology of postponed ends."[27]

FIRST AND SECOND VISIONS (REV. 1 TO 3 AND REV. 4)

The overarching allegorical system is structured symmetrically: The three extended septiform sequences of Seals, Trumpets, and Vials in the third, fourth, and fifth visions are preceded by two brief visions of the earthly and celestial Church and bracketed by

two equally short concluding visions of resurrection and the future. A pervasive pattern of symmetry can be seen to operate in the structuring of the first two visions as a pair of binary oppositions between earth and heaven, as well as in striking metaphors linking them together, such as the presence of Christ given in the figure of the One seated on the throne in the First Vision and Majesty (figs. 30 and 31). The upward spatial projection of the second vision in which the figure of Ecclesia is shifted *in coelo positam* is stressed in the incipit: "Just as [the faithful] must strive toward lofty virtue, the position [*status*] and indeed the obvious loftiness of the Church [must] be described."[28] Both allegorical visions are initiated by experiences of opening, as John's inner spiritual voyage is seen to begin in a dream (fig. 25) and the door is opened in heaven (fig. 31). In the illustration for the end of Rev. 4, the second vision ends not with a gesture of closure, but with another aperture as the book from 5:1 already stands open. In the first of an encompassing series of such anticipatory mergers designed to maintain the formal momentum of the narrative, the concluding text signals the next vision as the new spans the old.

Although the first vision is focused upon the earthly Church universal allegorically configured as the seven churches of Asia, the incipit (*De prima visione*) centers on the book and its author: "Let it be known that this book, the Apocalypse was produced by St. John apostle and evangelist; however, there are others who say that it was composed not by him but by another: but what follows would obviously have been his."[29] As we shall see, the subsequent demonstration of John's ordination (fig. 30) confirms the author's apostolic priestly role within the Church to which he ministered as evangelist and preacher (fig. 9), thus establishing him within the matrix of the controlling figure of the text (Ecclesia). More important for locating the first vision on earth, however, is the literal "mapping" of John's place of exile on Patmos (fig. 25), where cartographic conventions for representing the islands situate him in a flat, legible, and determinate space familiar to the reader's world.

1. John on Patmos: *1:1–3 [and 1:9–11]*

This is the Revelation of Jesus Christ given to him by God to make known to his servants what must soon take place,

and he gave a sign by sending his angel to his servant John who bore witness to the word of God and witness to Jesus Christ of what things he has seen. Blessed is he who reads and hears the words of this prophecy and he who keeps what is written in it, for the time is near. . . .

[I John . . . was on the island which is called Patmos, for the word of God, and the testimony of Jesus. I was in the spirit on the Lord's day and I heard behind me a great voice like a trumpet, saying: "What you see, write in a book, and send it to the seven churches which are in Asia."][30]

As the first illustration in the English Gothic Berengaudus cycle, the image of John recumbent on Patmos (fig. 25) constitutes an unusual "author portrait" or headpiece for the text, not only stressing its visionary character, but at the same time forging an unequivocal link between the sequence of visions reported in the Apocalypse and the events leading to his exile in the preceding illustrated *vita*. In the Morgan Apocalypse, the image of John on Patmos (fig. 11) forms an obvious continuation of the preceding scenes from the *vita*, so that the end of the first installment of the Life merges with the beginning of Revelation. Here we see the ferryman at the left pushing the boat off after depositing his passenger on the island, thus providing a narrative transition from the representations of John being ordered into exile and his voyage to Patmos in the two registers on the facing verso (fig. 10),[31] by marking the initial image with a lingering trace of the "enframing" narrative. In Add. 35166 (fig. 26), John lands on Patmos and steps onto the shore in two cyclical episodes moving quickly from left to right on fol. 2v, while he reclines on the island facing the left on fol. 3 (fig. 27), forming a closed episodic sequence. In a manuscript like Paris. lat. 10474, however, which omits the enframing pictorial *vita*, the Patmos scene is developed quite differently. In the representation of John sleeping fully reclined across the space of the island, a series of strong directional movements flow naturally across the page above the left-to-right sequential structure of the text, conveying a sense of restful equilibrium and repose consonant with the spiritual nature of John's vision, as set forth in Rev. 1:11.

In the Gothic Apocalypse, the episodes of John's *vita* immediately leading up to his exile on Patmos, followed by the visionary experiences on the island, and ending with the resumption of his life after his return to Ephesus, correspond to the essential features of a stable medieval literary genre in England going back to Bede's eighth-century recounting of the

Figure 25. Apocalypse. Paris, Bibliothèque Nationale MS lat. 10474, fol. 2. John on Patmos (Phot. Bibl. Nat. Paris).

Figure 26. Apocalypse. London, British Library MS Add. 35166, fol. 2v. Voyage to Patmos (photo: The British Library).

Figure 27. Apocalypse. London, British Library MS Add. 35166, fol. 3. John on Patmos (photo: The British Library).

dream-vision of Drycthelm.[32] Cast within a framework more familiar to the medieval reader, the spiritual passage through journey, purification, and divine revelation might be alternatively described in Augustinian terms: "The mind should be cleansed so that it is able to see that light [immutable truth] and cling to it once it is seen. Let us consider this cleansing as a journey or voyage home."[33] The paradigmatic discourse revealed in the first Berengaudus illustration thus centers on three metaphorical images: the departure of the ship signifying the temporary suspension of mundane or material concerns as well as John's transcendence of the world into the realm of the spirit, the seer dreaming in a transitory state between body and soul, and the arrival of the angel as spiritual emissary. In this context, the ocean serves not merely as a symbol of the vast powers of the unconscious, but as the very place of their operation.[34]

One of the most striking and distinctive aspects of the dominant initial Gothic image of John lying asleep on Patmos is his inert, somnolent state as he is being commanded by an angel to "Write down all that you see in a book." Unlike the scribal figure who conventionally heralds the Apocalypse text in thirteenth-century French and English Bibles (fig. 7) as well as in the *Bible moralisée* (fig. 28), the seer's eyes are closed, denoting the interior nature of his visionary experience as a dream. Before he becomes an active *auctor* who assiduously writes at his desk, John must first be a passive receptor acted upon by the angel. Removed from the world by his physical exile on the island of Patmos, John is thus prepared to "see" and "hear" the celestial messenger "in the spirit" with his inner eye and ears. In the Paris lat. 10474 version, his experience of *revelatio* is rendered even more explicit by the veil framing his face as he dreams. Positioned at the head of a long sequence of

pictures, the representation of John sleeping on Patmos places the entire cycle within an oneiric frame.

The English Gothic cycles offer an image of the seer with his eyes closed in an obvious and apparently calculated contradiction of the angel's instruction to write down what he sees. In accordance with the commentary, where the reader is advised that "it is said that he was in the spirit because the eyes see such mysteries not in the flesh but in spirit,"[35] the closure of visual perception serves as a pictorial metaphor for the opening of spiritual vision. The image of the dreaming Evangelist casts the author in a conventionally perceived state of physical and psychological receptivity appropriate to his vision; it constitutes a graphic demonstration of the dictum from the widely circulated Neoplatonic tract of Macrobius that dreams allow the eyes of the soul to glimpse some rays of truth, for we see the dream through a veil that can be made thin and transparent.[36] In Morgan, where John is fully awake, alertly acknowledging the angel's message, the allusion to the seer's spiritual vision in a somnambulant state has been lost, taking the image in another interpretative direction by generating a transitional moment of conscious reception as an activating antecedent to his writing to the seven churches in the next frame.

The revelation of privileged truths in the dream experience entered the medieval consciousness of vision directly through Macrobius's *Commentary on the Dream of Scipio*.[37] Through its centering on the marginal relationship of body and soul, the visionary dream offered the perfect vehicle to explore the threshold between spirit and matter. As Alcher of Clairvaux describes the oneiric experience, "While your body lies down, the soul walks. The tongue of your body is silent, the soul speaks. Your eyes are closed, but the soul sees."[38] Because of its liminal character, combining the realms of spirit and matter in a single experiential phenomenon,[39] the dream became a powerful poetic vehicle in the High Middle Ages, as attested by its multiple literary incarnations from Bede to Guillaume de Lorris. In the definition of medieval theorists, both dreams and visions are varieties of Augustine's *visio spiritualis*.[40] Although, like any other epistemological phenomenon, they begin with the appearance of images to the imagination, dreams speak more personally and authoritatively than daily experience because they lead to

Figure 28. Bible moralisée. Vienna, Nationalbibliothek MS 1179, fol. 223v. John on Patmos (photo: Nationalbibliothek, Vienna).

knowledge that transcends bodily limitation. Because the senses are quiescent in the dream state between body and soul, John of Salisbury argued, the spirit returns to its own sphere where it contemplates truth in Pauline terms, now enigmatically, now face to face.[41]

Without claiming an originary relationship to earlier medieval traditions of apocalyptic imagery, it is important to note that the thirteenth-century Gothic image of the dream-vision is not without precedent. Although something of a rarity until the mid-thirteenth century, the representation of the recumbent dreamer-seer appears very early in an isolated framed illustration heading the Apocalypse with Bede's commentary in the ninth-century Juvenianus Codex, where John sleeps comfortably in bed as the hand of God commands his angel to make known the revelation.[42] The somnolent figure occurs again in Berlin 561 where the idea of the two successive stages of John's revelatory experience (dreaming and writing), as well as his isolation on the island, are rendered in a cyclical illustration.[43] An equally rare

and eccentric English precursor of the mid-thirteenth-century Berengaudus image can be seen in the figure blissfully sleeping on the rocky island in the historiated initial of the Apocalypse in the mid-twelfth-century Dover Bible (fig. 8).[44] John is now being commanded directly by the hand of God without the mediation of an angel, thus breaking with the text's chain of authority so assiduously observed in the Juvenianus version as well as in the Trier Apocalypse. Although the early representations visualize several critical aspects of the dream-vision, the Gothic image uniquely merges John's passive reception of a celestial message and his liminal isolation on the island in a single event that centers on a threshold experience of transcending body and spirit, heaven and earth.

Because the action of the episode is limited to verbal discourse, the narrative thrust of the image turns on the angel's speech scroll. Far from representing an archaic vestige of earlier traditions, the unfurled phylactery represents a new element introduced by the designer of the English Gothic cycle. In contrast with the trumpet blast that transforms the seer's state into a surprised awakening in the *Bible moralisée*, the words gently wafted on the Gothic scroll remain silent yet possess the urgency of a news bulletin flashed across a television screen. At the same time, the intrusion of words into the framed image itself invites the reader to begin "reading" its message on a lexical level as if it were an extension of the text. Indeed, the dream on Patmos stands both within and at the beginning of the allegory as a threshold text. The inscribed text of the angelic message constitutes the central "event" on which the thirteenth-century visual narrative revolves, focusing on the moment in which the "voice" becomes visible as an angel flying down with a scroll toward the reclining figure of John on the island. Among the various Gothic manuscripts, however, the illustrations do not follow the text closely. Almost all place the angel in front of John rather than behind him, as called for in the next verse. Paris lat. 10474 offers the only version that responds directly to the explanation of the retroposition of the voice in the commentary:

The voice of the Lord is behind us because we are like fugitive slaves: the Lord calls after us to bring us back. Therefore John heard the voice behind him because the

mysteries which were revealed to him at that time had not yet been completely known.[45]

Although the first miniature unmistakably illustrates the Lord's command to John (1:1 and 11), there is a disconcerting disparity among the texts that accompany the Patmos scene in the various thirteenth-century recensions.[46] The inconsistency and slippage observable among the various cycles seem to signal a problem encountered by the thirteenth-century designers in aligning text and image to initiate a coherent narrative discourse in the first illustration. The Book of Revelation introduces John's account of his dream-vision by enframing it within a twofold metanarrative. In the first verses, the originating chain of authorship from God to Christ to the angel to John is presented to the reader, constituting the first pre-text addressed in such early images as the Juvenianus codex, the Trier Apocalypse, and the Dover Bible. The second metanarrative in 1:4–8 then casts the text into an epistolary frame, as John addresses the seven churches; both Berlin 561 and the *Bible moralisée* (fig. 44) manage fairly successfully to merge these two pre-texts into a single image. However, John's authorial voice recounting his visionary experience during his exile does not begin until 1:9–11 ("I John . . . was on the island called Patmos"). As they stand at the head of the whole book or at the end of a long passage encompassing Rev. 1, the images in the earlier manuscripts present no visible misalignment of text and image to the reader. In most versions of the Gothic cycle, however, the expectation of transparency in an equivalent relationship of text to image created by the half-page layout of illustrations is frustrated by the absence of text for verses 9–11 below. Although the earlier thirteenth-century *Bible moralisée* potentially posed the same problem in its close juxtaposition of roundel image and text, the designer neatly avoided it by beginning the illustrated text cycle with 1:9–11. Rather than opt for textual equivalency or elision, the designers of the Gothic cycles visualize two framing narratives in the overlapping, proleptic references of 1:1–8. Forming a pair of pictorial pre-texts to John's reportorial account beginning with 1:9, the initiating image of the dream-vision on Patmos (1:1–3) is thus followed by John addressing a second prefatory metatext to the seven churches of Asia (1:4–8). In this way, the thirteenth-century reader's ex-

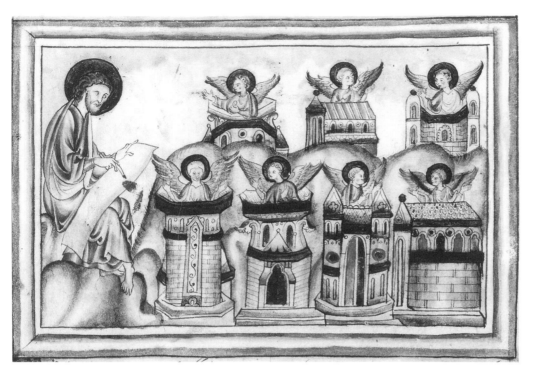

Figure 29. Apocalypse. London, British Library MS Add. 35166, fol. 3v. John and the Seven Churches
(photo: The British Library).

perience can still be clearly conceived as being shaped
by the illustrations prior to scanning the text.

2. Seven Churches: *1:4–12 (to "quae loquatur mecum")*

> From John to the seven churches which are in Asia . . . I
> John your brother, who shares your tribulation and king-
> dom and patience in Jesus Christ, was on the island which
> is called Patmos, because of God's word and witness to
> Jesus. I was in the spirit of the Lord's day and I heard
> behind me a loud voice like a trumpet saying, "Write down
> what you see in a book and send it to the seven churches
> of Ephesus, Smyrna, Pergamum, Thyatira, Sardis, Philadel-
> phia and Laodicia." And I turned around to see who had
> spoken to me.

A composite configuration (fig. 29) of seven ecclesi-
astical structures grouped together, with John seated
at the left writing, constitutes a second author por-
trait within the enframing metanarrative. Although a
similar illustration of the seven Churches appears
twice in the Trier Apocalypse in response to the same
text,[47] the image does not form a traditional part of
the early medieval cycles.

The introduction of the composite illustration of
the seven Churches coincides with the text passage
beginning with 1:4 ("From John to the seven
churches of Asia"), which is glossed with a long ex-
cursus on the paramount significance of the number
seven for the structure of the Apocalypse as a whole,
citing its reiteration in the seven Churches, the can-
delabra, stars and lamps, the horns and eyes of the
Lamb, the Seals, Trumpets, thunders, and angels
with vials, as well as the Dragon and Beast with
seven heads.[48] The exegete further explains that he
divided his commentary into seven parts or visions,
corresponding to the seven Letters to the Churches.
Following the representation of John on Patmos that
included the angel's command ("Write down all that
you see in a book and send it to the seven churches
of Asia"), the second illustration centers on John's
subsequent compliance. The seated Evangelist writes
on a scroll, as he surveys the distant churches clus-
tered in a hilly landscape. As the seven discrete struc-
tures are gathered together into a single corporate
entity within John's towering gaze, the illustration
offers the reader a simple graphic evocation of the
"one universal Church" signified by the seven
churches of Asia in the commentary.[49] The Getty
Apocalypse and Paris lat. 10474 visualize the idea of

the septiform catholic Church even more emphatically in a literal fusion of the seven buildings to form a frieze of contiguous facades facing a single street.

Although the Metz group as well as Getty align the composite representation of the Seven Churches with a radically abridged text of Rev. 2 to 3, most recensions regard the image as belonging to Rev. 1 and place the illustration before the First Vision. Based on the link made in 1:20 ("The seven stars are the angels of the seven churches, and the seven lampstands are the seven churches themselves"), the buildings with their angelic personifications are pictured together in Rev. 1 as part of the First Vision. Indeed, the commentary on 1:20 ("The seven candelabra are the seven churches") stresses the point, as reflected in the Getty version where John stands outside the frame, gazing at the vision. In all the Berengaudus recensions, except Metz and Morgan (figs. 2 and 11) where the Seven Churches and the First Vision appear together within the same frame, the two scenes appear on facing verso and recto pages. In all likelihood, this is how they were initially conceived, with the text and commentary for 1:4–12 given beneath the image of the Seven Churches, from the beginning of John's letter to the churches of Asia to the angel's command to write to them; the break at "who had spoken to me" in the middle of verse 12[50] then would require a new page for the important illustration of the First Vision on the facing verso above the text and commentary for 1:12–20.

Although the representation of the Seven Churches clearly functions as a second author portrait, the early medieval conception of John as a Gospel writer transmitting divinely revealed truths by means of the written word tends to be overshadowed in the thirteenth-century English Apocalypse by a new perception of his role as seer of visions. This critical shift is clearly reflected in the omission of illustrations for the second and third chapters in the Gothic cycles. Breaking with a long-standing medieval convention requiring a series of separate illustrations for each of the letters to the seven churches of Asia given in Rev. 2 to 3, most Berengaudus manuscripts simply delete the text for the second and third chapters altogether.[51] As Freyhan pointed out,[52] the seven letters clearly stand outside the visionary content of the Apocalypse and interrupt its narrative sequence. But perhaps more critical for the new thirteenth-century English design is the fact that, in

Rev. 2 to 3, John does not see anything. The two chapters consist entirely of textual messages.[53]

The omission of the text and illustrations for Rev. 2 to 3, however, clearly created a problem for the designers of the various Berengaudus recensions, because the illustration of the Seven Churches could be construed to belong to two different texts – either Rev. 1:4 to 12 or Rev. 2 to 3. The Getty designer tried to resolve the difficulty by attaching an abbreviated text for Rev. 2 to 3 beneath the illustration of the Seven Churches, but this only creates more confusion because the text appears out of order, preceding Rev. 1:12–19 on the following page.[54] In Morgan, the composite illustration (fig. 11) combines the Seven Churches with the First Vision, but locates the Seven Churches on the left, preceding the First Vision; excerpts from the text are quoted from 1:13–20, making it clear that the sequence is correct and that the image does not pertain to Rev. 2 to 3. In a similar merger of the same scenes, however, Metz-Lambeth (fig. 2) gives the First Vision at the left, aligning the illustration above the column containing the text for 1:12–20, while the representation of the Seven Churches appears above the truncated text for Rev. 2 to 3 followed by a gloss on the seven Churches and the kingdom of God as the Church and its priests. The angel who flies down to deliver a second command functions as an effective connector between the texts for 1:19–20, in which we can see the secret of the seven stars and the seven golden lamp stands revealed as the angels of the seven churches and the seven churches themselves, and 2:1 ("Write to the angel of the church in Ephesus") signaled by the angel's gesture, pointing to the first church. The two episodes are further connected in Metz by the angel pointing to John's raised hand, which mimics the gesture of the Lord at the left, as the seer is instructed to say, "Here is the message of the one who holds the seven stars in his right hand."

Although a composite image had been conceptualized as early as the ninth century in the Trier Apocalypse, the image of John writing simultaneously to all seven churches of Asia belongs to the thirteenth century, when it becomes a standard historiation for Apocalypse initials in French and English Bibles (see fig. 7). The first miniature in the Vienna version of the *Bible moralisée* (fig. 28) thus reveals the Evangelist addressing his book-scroll to seven pinnacled Gothic structures surrounding the island of Patmos

to evoke the idea given in the accompanying gloss of John serving as an example to all priests. A similar composite image of the Seven Churches was created in the Berengaudus cycle to illustrate 1:4–12, and at the same time to offer a graphic demonstration of the ideas of the sevenfold structure of the Apocalypse and the septiform figure of the Church universal set forth in the commentary.

3. First Vision: 1:12–20 (beginning "Et conversus vidi septem candelabra")

> And, having turned, I saw seven golden lamp stands, and in the midst of the seven lamp stands a figure like a Son of man, clothed in a long robe and girded with a golden belt at his breast; his head and hair were white as wool, white as snow, and his eyes like burning flames; and his feet like burnished bronze as if tempered in a furnace, and his voice like the sound of many waters, and in his right hand he held seven stars, and from his mouth came a sharp, double-edged sword, and his face was like the sun shining in its full strength.
>
> And when I saw him, I fell at his feet, as if dead, and he placed his right hand over me and said, "Do not be afraid. I am the first and the last: and I lived and was dead, and behold I am living for ever and ever and I have the keys of death and of hell. Therefore write what you have seen and what is and what is to come after this. The mystery of the seven stars you have seen in my right hand and the seven golden lamp stands: the seven stars are the angels of the seven churches, and the seven lamp stands are the seven churches.

The First Vision is pictured in a central and salient position in all medieval Apocalypse cycles. Holding the seven stars in his raised right hand and the "keys of death and the underworld" in the other, the frontal figure of the Lord appears between the seven tall candelabra as John lies prostrate at his feet. However, the English Gothic image (see figs. 3 and 30) breaks with a long-standing iconographical formula by revealing the Lord enthroned on a long, low arcaded base on which the tall candlesticks are aligned to adjust the tall figure to a horizontal format. Responding to the accompanying commentaries that identify the Son of man as the glorified Christ,[55] the figure is distinguished by a crucifer nimbus. In the Berengaudus cycle, the text for the illustration of the First Vision begins eccentrically in the middle of 1:12 ("Et conversus vidi septem candelabra aurea") to coincide with a brief commentary that identifies the seven lamp stands as the seven Churches and re-

iterates the idea of the one septiform universal Church.[56] The clearest and most dramatic pictorial evocation of this exegetical idea is given in Douce 180 where the Lord is enframed within an elaborately gabled and pinnacled Gothic structure, whose elegant columns echo the vertical shapes of the tall candelabra, visually transforming the metaphor of the church into its earthly architectural form.[57]

The new merger of the throne with the long arcaded platform supporting a row of tall candelabra provides a striking configuration in which the Lord can be perceived as literally amidst the seven golden lamp stands, which the commentary interprets as a metaphor for Christ's declaration in Matt. 28:20: "I am with you until the end of time."[58] At the same time, however, the fusion of these two supporting structures apparently created a confusing ambiguity in the archetypal figuration of the enthroned figure for, in the absence of a clearly defined throne, the Lord could be read as either seated or standing. Consequently, there is no consistency in the stance of this figure among the various thirteenth-century manuscripts. Metz-Lambeth and Getty (figs. 2 and 3), along with Douce (fig. 30), offer a magisterial enthronement, visually linking the Lord of the First Vision with the One seated on the throne in Rev. 4 and 5. In contrast, Trinity and Morgan (fig. 11) opt for an upright image Lord looming above the prostrate figure of John, thus providing a more effective evocation of the gloss, which explains that when John "fell at his feet as if dead," he realized that "he was nothing by comparison" and "could not in any way comprehend the incarnate mystery before him."[59] Abandoning the stiff, horizontal configuration of the seer in earlier traditions, John's body is drawn into a graceful pose where the knees are pulled up and the back is arched in an elegant Gothic curve, resembling the Byzantine gesture of *proskynesis*. By the mid-thirteenth century, this prostrate kneeling position had become well known in the West through such illustrated prayer manuals as the *De oratione et speciebus illus* of Peter the Chanter, who dubbed this mode of praying "the custom of camels" (*more camelorum*).[60]

Despite an earlier medieval emphasis on the Lord touching John's head with his right hand,[61] the comforting gesture is eschewed in all the English Gothic cycles but Douce, where the Lord's fingers lightly graze the edge of John's nimbus. Whereas Christ's

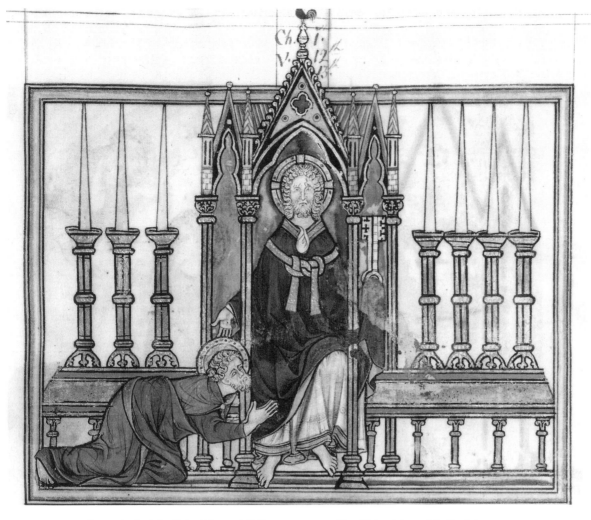

Figure 30. Apocalypse. Oxford, Bodleian Library MS Douce 180, p. 3. First Vision (photo: The Bodleian Library, Oxford).

open hand is extended above John's head in Metz, it develops into a descending gesture of imposition in the Douce version. Reserved for persons of authority, and denoting a relationship of superior to inferior in a hierarchical scale of power, the imposition of hands on another's head in a narrow sense signifies a guarantee of protection, but the medieval gesture is also charged with symbolic and ritual meaning.[62] As it holds an important place in the liturgy marking confirmation, ordination, and consecration of priests and deacons by bishops,[63] the gesture could have been read as a signifier of John's spiritual ordination by Christ. In an effort to stress the sacerdotal aspect of the Son of man, most Berengaudus manuscripts

render the "zona aurea" as an elaborately knotted priestly stolelike vestment draped loosely across the shoulders; in Metz and Douce, the stole is worn over a chasuble.[64]

As we have already seen, both the Metz and Morgan manuscripts crowd the illustrations of the Seven Churches and the First Vision into a single frame, but they compress and merge them in different ways. The relative dominance of the two scenes is reversed, so that in Metz the scale of the Vision of the Son of man, given first at the left, overpowers the minuscule churches, whereas in Morgan, the churches encroach upon the First Vision and tend to rob it of its drama and grandeur as the large figures are pushed and

crowded into the remaining space at the right. With its majestic enthroned figure dwarfing the seven Churches at the right, the Metz revision provides an effective pictorial evocation of the gloss on 1:6 in which the kingdom *(regnum)* and the priesthood are said to signify the Church universal.[65] The Metz manuscripts also add a second figure of John standing at the right, facing an angel who flies down to touch his hand and point to the seven Churches below.

Some of the stock elements encountered in the text, such as the seven stars in the right hand and sword held in the mouth, are presented as word-illustrations in all the Gothic cycles.[66] Within the ritual context of John's initiation represented by the First Vision's ordination, the cornucopia of arcane images and secrets presents the seer with a litany of objects veiled in enigmatic shapes that no longer signify in ordinary ways and cannot be interpreted unaided. Lamps, stars, keys, and swords become metaphorical images whose meaning will be clarified and explicated only as the doctrine offered in the commentary gradually gives the initiated seer the required knowledge to decode them. In the medieval literary genre of dream visions, subsequent dialogue with a figure who explicates the allegory's imagistic elements gives access to this level of meaning for the dreamer and reader alike.[67] Because the scriptural text of the Apocalypse alone is not sufficient for this purpose, the voice of the commentary serves as a sapient and percipient interpreter initiating both seer and reader in the ever critical hermeneutic distinctions conveyed by words, images, and their spiritual significance.

The dramatic illustration of the First Vision is conceived as the harbinger of a blinding vision of the "future after the resurrection, when the righteous shall see God face to face."[68] The image of John prostrate before the Lord enthroned amidst the seven golden candelabra anticipates the last episode in the cycle (see figs. 172 and 173) where John again kneels before the Lord but now lifts his head to behold the divine visage and when the Lord will again proclaim, "I am the Alpha and Omega, the first and the last." In the commentary on the spiritual order of the seer's perceptual experiences, the exegete explains the apparent contradiction of John's "seeing the voice" in 1:12 as follows:

How could he have perceived the voice not with his ears but with his eyes? [Because] John was in the spirit, he deserved to see what transpired through the eyes of the spirit. . . . In other words, he who hears the word of God will gaze unceasingly at what he hears with his mind's eye.[69]

The reader is thus invited to contemplate spiritually what John saw in the visual image above the text.

4. Majesty: 4:1–8

> After this I saw, and behold a door open in heaven and I heard the first voice that I had heard, speaking to me, like a trumpet, saying, "Come up here, and I will show you what is to come after this." And immediately I was in the spirit, and I saw a throne was placed in heaven. And the one sitting on the throne was like jasper and precious stone; and surrounding the throne there was a rainbow that looked like an emerald. And encircling the throne were twenty-four thrones and upon the thrones sat twenty-four Elders, dressed in white robes, with gold crowns on their heads; and from the throne went forth flashes of lightning and voices and thunders; and seven lamps were burning before the throne, which are the seven Spirits of God. And in the presence of the throne was a sea of glass, like crystal, . . . and encircling the throne were four Beasts full of eyes in front and behind. And the first like a lion, the second like an ox, and the third Beast with a face like a man, and the fourth Beast like a flying eagle. And each of the four Beasts had six wings full of eyes all around and within and day and night they never ceased declaiming, "Holy, holy, holy is the Lord God Almighty, he who was and who is and who is to come."

In the Berengaudus text, this passage opens the second part of the commentary ("De visione secunda"), which describes the sublime state of the Church in heaven following John's letter to the seven Churches signifying the one universal Church on earth.[70] The new vision reveals the Church as heaven itself; the throne in heaven signifies the hearts of the saints dwelling in the Church ("You are God's temple and the Spirit of God dwells in you"); and the seven lamps represent the seven gifts of the Holy Spirit.[71] Thus, the Majesty of the One enthroned in heaven is pictorially rendered in a bilaterally symmetrical, heavily compartmentalized composition (see figs. 31 and 204) in which this new aspect of Ecclesia can be displayed in the full detail of its heavenly splendor.

Because the representation of the Majesty itself requires almost the full width of the page, the illustration of the *ostium apertum* is accommodated outside the frame. By moving John beyond the frame and

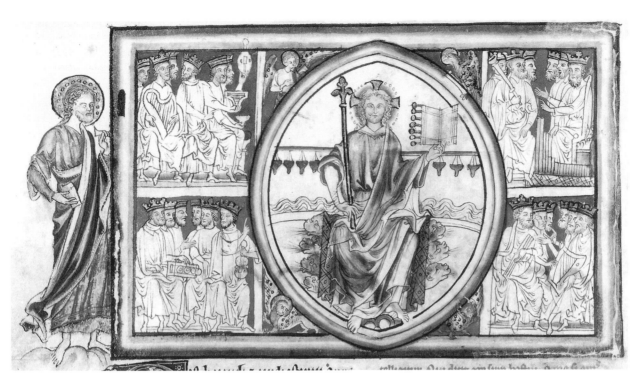

Figure 31. Apocalypse. Malibu, J. Paul Getty Museum MS Ludwig III.1, fol. 3v. Majesty (photo: Collection of the J. Paul Getty Museum, Malibu, California).

providing a "door" through which he can see the vision, the image provides an ingenious pictorial evocation of the seer's liminal position in the commentary on 4:1. The open door is interpreted as Christ, and the Evangelist represents those who believed in Christ through John the Baptist whose voice called out in the wilderness awaiting the Messiah.[72] Following its initial visualization for Rev. 4, the "open door" functions as an important leitmotif throughout the rest of the Gothic cycle as John continues to stand outside the picture looking through a window in the frame.

The Majesty represents a recurring type of solemn, sacred image based on very old traditions of apse and tympanum compositions as well as manuscript models. The Lord enthroned within an elongated mandorla frame dominates the center, with the four Beasts filling the corner interstices and the twenty-four Elders arranged in two rows at the right and left; the seven lamps ("the seven spirits of God") are suspended in a row above. Frontal and static, the nonnarrative, iconic image is intended for extended contemplation by the reader-viewer. Whereas John's perception is limited to what he can glimpse through a narrow aperture, the reader is given a full *en face* perspective on the celestial spectacle. Contemplating the imaged juxtaposition of the speaker and the content of his discourse, the viewer thus joins the seer and the Elders who gaze directly at the Lord.

The elegant foliated scepter that appears in several Berengaudus manuscripts is mentioned neither in the text nor in the commentary. In Morgan 524, it is labeled "virga equitates" and in Trinity "virga iustitiae."[73] The prominence of the scepter in the Morgan and Metz manuscripts, as well as in Trinity and Getty, suggests that it played a role in the first paradigm. The foliated staff is not an element taken from the traditional iconography of Christ in Majesty, but occurs instead as an attribute of royal authority in thirteenth-century English representations of kings.[74] The well-known tenth-century representation of Christ holding a foliated rod in St. Dunstan's Classbook[75] provides a scriptural source in Hebrews 1:8 ("His royal scepter is the scepter of vir-

tue [*virga aequitatis*]''), which in turn refers to Psalm 44(45):6. In the context of the Apocalypse, this reference to the proof of the divinity of Christ in the Old Testament is consonant with the insistent Christological reading of the Old Testament throughout the commentary. The fleur-de-lis that surmounts the scepter in the thirteenth-century representations can be read as a common attribute of royalty, but its presence in the hand of Christ in Majesty suggests a more profound significance, defining his role in the history of salvation as the unique mediator of the alliance between the human and divine in the mystery of the Incarnation.[76] The tripartite petal structure of the flower symbolizes a dual nature, implying the coexistence of a natural and supernatural aspect, reconciling two incompatible and contradictory realities.[77] In a similar vein, one of Trinity's most eccentric references to the gloss appears in the green coloring of the Lord's hair, mantle, and scepter, alluding to the greenness of the jasper, which is said to signify Christ's divinity.[78]

Whereas the globe at the feet of the Lord in Trinity and Morgan proleptically refers to the One on the throne as the Creator of the universe given in 4:11, Metz-Lambeth (fig. 204) makes a pictorial

move that keeps the image within the parameters of the text and at the same time signals the subject of the second vision as the state of the church in heaven, by placing a small building at Christ's feet, alluding to the gloss that interprets heaven as the Church. The literal depiction of this metaphorical figure recalls the building at Christ's feet in the Anglo–Saxon Æthelstan Psalter where reference is probably made to Isaiah 66:1, "Heaven is my throne, the earth my footstool."[79] In this way, the elements of the narrative are singled out by the simple device of word-illustration to demonstrate the textual exposition in allegorical fashion, but at the same time, the image maintains the integrity of John's visionary experience.

5. Adoration by the Twenty-Four Elders: 4:9 to 5:1

> And, when the Beasts give glory and honor and praise to the One sitting on the throne, who lives for ever and ever, the twenty-four Elders fell down before him who is seated on the throne and adored the One who lives for ever and ever. And they threw down their crowns before the throne, saying, "You are worthy, our Lord and our God, to receive glory and honor and power, because you created all things, and they exist and are created by your will."
>
> And I saw in the right hand of the One sitting on

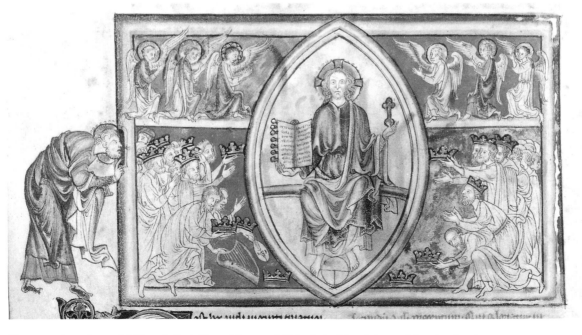

Figure 32. Apocalypse. Malibu, J. Paul Getty Museum MS Ludwig III.1, fol. 4v. Adoration by the Twenty-Four Elders (photo: Collection of the J. Paul Getty Museum, Malibu, California).

the throne a book written within and without, sealed with the seven seals.

Although the second phase of the vision in Rev. 4 in which the twenty-four Elders prostrate themselves and throw down their crowns in front of the throne is illustrated separately in all the thirteenth-century English Apocalypses except those based on Morgan, the Gothic image (fig. 32) was probably generated from a long-standing tradition in which representations for 4:9–11 and Rev. 5 were merged into a single, complex, full-page illustration laid out in several registers, as in the Roda Bible.[80] Dominated by a large vesica-shaped frame enclosing the enthroned Lord in the center, the Elders holding their crowns form descending lines as they fall to their knees at the right and left, in a close reprise of the preceding illustration of the Majesty; two groups of angels appear as half-figures in rows flanking the Lord at the top. Although the angels have no scriptural reference, they provide a celestial counterpart to the laying down of crowns in response to the commentary in which the crowns signify good works on earth corresponding to the saints glorifying God in heaven.[81]

The image signals another ritual stage of John's initiation in which his singular gesture of prostration before the First Vision is now joined by a multitude of saintly men who humble themselves before the power of God.[82] Because the Lord in the vesica signifies the Church, the ritual gesture of removing crowns might be perceived as a metaphor of tonsure in a further allusion to clerical ordination initiated by the priestly garb and gesture of the Lord in the First Vision. Thus, John's vision gives him knowledge of the order and ritual of a celestial Church that will transform him in preparation for his return from exile. For the reader, the gesture serves as a powerful demonstration of the rejection of worldly power in the spiritual realm of John's visionary experience.

In the Berengaudus archetype, the Lord is seated on a rainbow arc repeated from Rev. 4:3, holding a large book now open, with the loosened seals still visibly attached in reference to 5:1, his left hand raised in a gesture of speech as in Metz or holding a seal as in Getty, where the pages are inscribed on both the recto and verso in a clumsy effort to pictorialize the "book written inside and outside." The inclusion of the book not only responds to the ad-

dition of the text for 5:1 at the end of Rev. 4,[83] but signals the beginning of a new section of the commentary ("De visione tertia") that describes the Church in terms of the metaphorical figure of the open book, thus accounting for the prominent display of the codex prematurely unsealed. The archetypal illustration reveals that it is written both inside and outside, according to "allegory" and "history."[84] The two sides of the book further allude to the reiterated theme of spiritual understanding in the commentary: "This book contains the Old and the New Testaments, for the spiritual understanding of the Old Testament is nothing other than the New Testament."[85]

In most thirteenth-century manuscripts, the illustration of the Adoration of the Twenty-Four Elders is pulled out of textual sequence so that the scene follows rather than precedes the miniature representing John being consoled by the Elder (5:2–5), presumably to avoid placing two almost identical illustrations on facing verso and recto pages, but also to locate the image of the open book more squarely and unequivocally within the enframing allegory of the third vision. As a consequence of this shift, the angel who asks, "Who is worthy to open the book and break its seals?" is now positioned on the third recto page and thus initiates a significant page turn by the reader, which then reveals the image of the Lord holding the open book with its seals broken on the following verso, similar to that in Getty (fig. 32).

THIRD VISION (REV. 5 TO 8:5)

Under the metaphorical guise of the book, the earthly Church is revealed in its temporal past as the opening of the seals discloses a diachronic sequence of historical eras.[86] Beginning with the Old Testament periods before and after the Flood, then under the Law, the book subsequently opens onto the New Testament with the advent of Christ, the martyrs, the rejection of the Jews, and the calling of the pagans. Organized to fill the gap between the present and the disappearing past, this is the most typological section of the text in which the Old Testament is troped by the New, as the closure of Old Testament "blindness" is played off against the opening gesture of the Lamb taking the book (fig. 39); he stands as the pivotal figure of the Incarnation and the inauguration of the earthly time of the Church. The diachronic

procession of images then addresses the dominating role of the Church in the world – the conversion of the Roman Empire through the powerful dissemination of the Gospels to the four corners of the earth in subsequent images of the Four Winds and of the Censer and the Altar. As was the case in making the transition between the last two visions, the next vision is anticipated in the seven angels with trumpets who appear on stage (fig. 57) before the close of the fourth vision to announce their imminent arrival.

6. John Consoled by the Elder: 5:2–5

> And I saw a powerful angel crying in a loud voice, "Who is worthy to open the book and break its seals?" And no one in heaven or on the earth or under the earth was able to open the book and look upon it. And I wept many tears because no one worthy was found to open the book and see it. And one of the Elders said to me, "Do not weep: Behold, the Lion of the tribe of Judah, the root of David, has triumphed in order to open the book and to loosen its seven seals."

Beginning with verse 2, this discourse is isolated and developed as an independent image (figs. 33 to 36) for the first time in thirteenth-century England. As it breaks with earlier traditions, the English Gothic archetype uniquely conflates the two stages of the interrogation, giving equal weight to each interlocutor. Explicating the ways in which the vision remained beyond John's comprehension, the image signals a glossed passage in which the angel and Elder represent two contrasting aspects of the Old Testament patriarchs. The angel represents those who prophesied that Christ would come to redeem mankind; the Elder stands for those who "saw the book of the Old Testament and did not see, [for] they saw according to the letter and did not understand according to the spirit."[87] In the same context, the weeping John also represents the Old Testament patriarchs who held the Old Testament but did not see it.[88] The plaintive demonstration of their inability to see the Lord is rendered all the more visually effective because the image was initially conceived to appear on a recto page, as in the Westminster manuscripts, thus precluding a glimpse of the next illustration of the Lord holding the open book from 5:1 on the succeeding verso without an intervening page turn by the reader.

In Metz-Lambeth's loose frieze of figures (fig. 33), the powerful angel at the left unfurls a scroll with the text of 5:2 ("Who is worthy to open the book

and loosen its seals?"); John stands disconsolate in the center, as the Elder attempts to comfort him. The figures convey an eloquent sense of longing and desolation as they make their slow, unsteady progress, traversing the width of the page. The angel's scroll stretches yearningly toward the center but is thwarted by the reluctant figure of John who draws back from the Elder's urgent grasping at the edge of his mantle. In Lambeth 209, the Elder reaches beyond the frame, as if to turn the page himself, but instead points to the vision of the Lord holding the book on the facing page.

In its graphic evocation of the dramatic withdrawal of the vision, the Gothic image fails to distinguish between the contrasting roles of the angel's desire to see God and the blindness ascribed to John and the Elder. Getty (fig. 34) addresses this aspect of the commentary by shifting the figures out of textual order, so that John stands at the left with his back turned to the image of the Lord on the facing verso in a literal reference to his "blindness," as he is consoled by an Elder in the guise of an Old Testament patriarch in a pointed cap. It is the angel's scroll, representing the "desire of the saints to see Christ," and now separated from the pair at the left by a tree referring to the "root of David who will open the scroll," which activates the turning of the page to reveal the celestial vision on the next verso.

In Douce (fig. 35), the textual alliance between John and the Elder is abandoned as the weeping visionary turns to the angel for consolation. Now closed off by the bracketing figures at the right and left, the composition has lost the strong directional momentum of the archetype, as it focuses on the book itself, placed between the tree representing the "root of David" and the Lion of Judah who signifies Christ.[89] As John stands in the center and steps out of the frame toward the reader, he is comforted by a small book held with covered hands close to his heart, an ingestive, absorptive gesture that anticipates his eating the little book (*libellus*) in Rev. 10. It is the same book, the Apocalypse, that is sealed, as well as the book that will eventually be unsealed and opened before the eyes of the reader. To stress the Christological interpretation given in the gloss, the angel who represents those who desire the coming of Christ asks the Elder when the time will come.[90] Tonsured and holding a long cross-staff, the angel signifies the patriarchs of the Old Testament

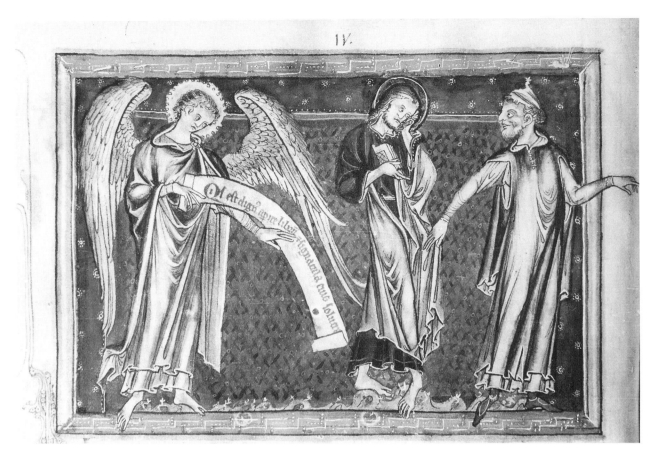

Figure 33. Apocalypse. London, Lambeth Palace Library MS 209, fol. 2v. John Consoled by the Elder
(photo: The Conway Library, Courtauld Institute of Art, London).

who prophesied that Christ will come to redeem humankind. John is thus informed by two metaphorical "voices" whose gestures toward the two books generate a centripetal turn that visually opens the text's discourse to the reader.

In an even more acutely sensitive response to exegetical nuance, Trinity's designer expands the conflated archetypal frieze into a cyclical narrative (fig. 36). In his colloquy with the angel, John does not weep until he confronts the Elder, who tries to comfort him, thus stressing the gloss. The angel's question ("Who is worthy?") is now addressed to the reader, thus differentiating a present and ongoing experience of optical perception from the metaphorical blindness of John and the Elder, as the frontal figure of the angel is aligned directly above a representation of the Lamb taking the book from the Lord in the celestial vision below.[91]

Given their internal relationship to the narrative,

text-scrolls have already played an important role in signifying speech-acts in the earlier episodes of John on Patmos and the First Vision (see fig. 11). In this event, however, speech-scrolls become critical, because the narrative tends to be altogether lost without their presence. As active agents in the process of signification, the scrolls not only denote spoken utterances conveying a message, they also function as reflexive indexical signs, directing the reader-viewer's attention to their subjects.[92] Because they are read directionally, they activate and indeed dramatize the dialogue between characters. Whereas in Trinity the speech-acts are addressed to the reader, in Getty the Elder holds the text downward, perpendicular to the reader's text; the two figures both grasp the scroll, but the Elder places an insistent hand over John's as he urgently points to the inscribed message. Thus, the visual "weight" of the scrolls as represented objects acquires a critical narrative function.

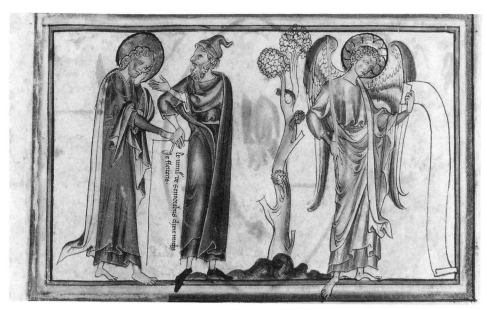

Figure 34. Apocalypse. Malibu, J. Paul Getty Museum MS Ludwig III.1, fol. 4. John Consoled by the Elder (photo: Collection of the J. Paul Getty Museum, Malibu, California).

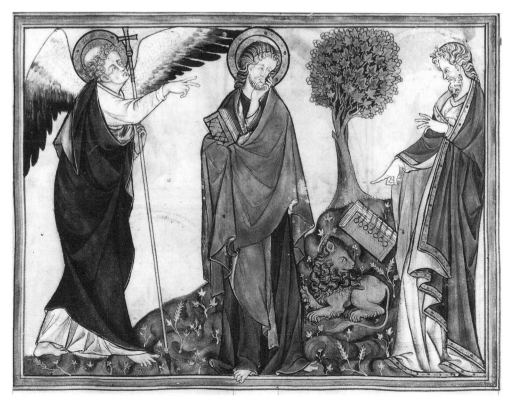

Figure 35. Apocalypse. Oxford, Bodleian Library MS Douce 180, p. 11. John Consoled by the Elder (photo: The Bodleian Library, Oxford).

Figure 36. Apocalypse. Cambridge, Trinity College MS R.16.2, fol. 5. John Consoled by the Elder (photo: The Master and Fellows of Trinity College, Cambridge).

Text-scrolls lend another, additional "weight" to the pictorial narrative in the sense that, for the medieval reader-viewer, words were still perceived as semantic signs, more fully invested than images. They had a different weight, a more lasting power, because writing fixed the words immutably.[93] As we shall see throughout the Gothic cycles, the verbal persistently penetrates the visual in processes that fuse word and image. By their incorporation into the very fabric of the scrolls, words become images and the verbal becomes visual.[94] As Alison Flett has recently argued, "the significance of text-scrolls as visual signs and carriers of meaning lies as much in their impact as formal compositional elements as in the content and arrangement of the Latin words on their surfaces."[95]

7–8. Vision of the Lamb: 5:6; the Lamb Takes the Book: 5:7–14

> And I saw, and behold in the midst of the throne and the four Beasts and in the midst of the Elders a Lamb standing as if slain, with seven horns and seven eyes, which are the seven spirits sent by God all over the world.
> And then he came forward and received the book from the right hand of the One seated on the throne. And, when he opened the book, the four Beasts and twenty-four Elders fell down before the Lamb, each one holding a harp and a

golden vial filled with perfumes, which are the prayers of the saints; and they sang a new song, saying "You are worthy Lord to receive the book and open its seals, because you were slain and by your blood you redeem us to God, from every tribe and tongue and people and nation, and you have made for us a kingdom and priests and they will reign over the earth." And I saw and heard the voice of many angels encircling the throne, and Beasts and Elders; and there were thousands upon thousands of them, saying in a loud voice: "Worthy is the Lamb who was slain to receive power and divinity and wisdom and strength and honor and glory and praise." And I heard all the creatures in heaven and earth and under the earth and who are in the sea and all who are in it, saying, "To him who sits on the throne and to the Lamb praise and honor and glory and power for ever and ever." And the four Beasts said, "Amen," and the Elders fell down and worshipped.

The Berengaudus cycle contains a sequence that first celebrates the solitary image of the Lamb for 5:6 (fig. 37), followed by the book taking for 5:7–14 (fig. 39), thus reversing the priority of images given in the earlier pictorial traditions.[96] The text of 5:6 is isolated in the Berengaudus cycles to provide space for an important gloss essential to understanding the historical structure of the commentary as a whole, in which the seven horns are said to signify the seven eras of the Church. Similarly, the sequence of hieratic compartmentalizations visualizes the interpretation of the throne, the four Beasts, and the twenty-four Elders as the Church with all its orders.[97]

Figure 37. Apocalypse. Formerly Metz, Bibliothèque municipale MS Salis 38, fol. 3v. Vision of the Lamb (photo: Monuments historiques, Paris).

Although the solitary image of the Lamb offers a strikingly effective image in which the seven horns and eyes are enlarged to a scale matching their importance in the commentary, the reversal of the vertically structured order creates a problem because the Lamb should no longer stand behind or upon the book, as in the Vienna *Bible moralisée* (fig. 38), because this does not occur in the text until 5:7. Nevertheless, the designer of the Berengaudus cycle retains a strong vestige of an early model such as the Harley version of the *Bible moralisée*, where the Lamb holds a flat rectangular "book" resembling a placard.[98] From Metz, it took but a short step to transform the trapezoidal vestige of the book into the top surface of a rectangular vested altar (see fig. 205).

Throughout the Berengaudus manuscripts, the Lamb holds a cross-staff from which a fringed pennon was suspended as a symbol of his "dominion over death" from the gloss on 5:6. In Metz (fig. 37), however, the substitution of a lance with a tall narrow banner bearing a double-armed cross, perhaps

alludes to the contemporary Crusades or to the relic of the Holy Lance recently acquired by Louis IX.[99] The juxtaposition of the lance with the emblem of the True Cross may indeed refer to the so-called Triumphal Cross, miraculously made for St. Helena in Jerusalem and carried by the Byzantine emperors into battle to ensure victory, a relic that purportedly came to Paris from Constantinople in 1241 along with the Holy Lance.[100]

In the next miniature (fig. 39), the Lamb actually takes the book (5:7–14), visualizing a symbolic transferal that is interpreted in the commentary as the incarnation of the Son of God.[101] The book thus functions as a "document" created in heaven, linking the divine Christ with his earthly nature that will undergo sacrifice to redeem humankind. Within the central mandorla, the Lamb stands on his hind legs not only to accommodate the narrow space of the elongated frame, but more importantly to raise himself to a stature worthy of receiving the book. A unique pictorial precedent occurs in the Vienna *Bible moralisée* (fig. 40), where the image is reversed and

Figure 38. Bible moralisée. Vienna, Nationalbibliothek Cod. 1179, fol. 228. Adoration of the Lamb (photo: Nationalbibliothek, Vienna).

the book is still sealed, but the passage is similarly glossed to refer to Christ's Passion in his human nature. At this point, the Berengaudus commentary again stresses the idea of John's spiritual vision, for he sees Christ in both his natures, human and divine. At the same time that the Lamb signifies his assumed humanity, the One seated on the throne is both Christ and God the Father, in response to the gloss's quotation of John 14:9–10: "He who sees me sees the Father."[102] As in the Majesty (fig. 31), the fleur-de-lis is invoked as a symbol of Christ's dual nature. Again the Lord holds a long foliated scepter in Morgan and Metz as well as in Trinity[103]; in Morgan, the scepter is labeled "virga iustitiae inflexibile." As in Metz and Morgan, the book is displayed in an open position, for it signals an important gloss in which the exegete asks, "How can the book be opened before the seals are broken?" and then responds that it is to be understood spiritually, just as the prophecies of Christ are given in the Old Testament.[104]

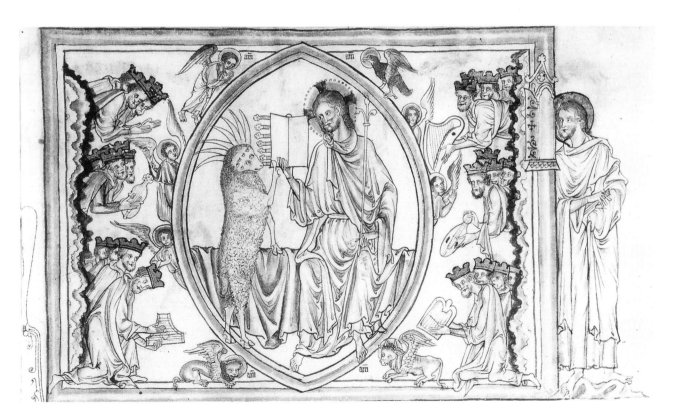

Figure 39. Apocalypse. Formerly Metz, Bibliothèque municipale MS Salis 38, fol. 4. Adoration of the Lamb (photo: Monuments historiques, Paris).

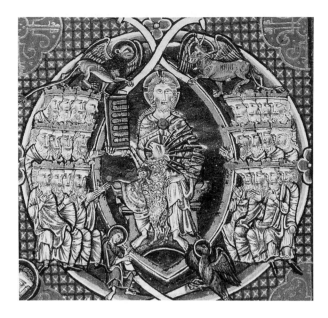

Figure 40. Bible moralisée. Vienna, Nationalbibliothek Cod. 1179, fol. 228. Lamb Taking the Book (photo: Nationalbibliothek, Vienna).

9–12. The Four Horsemen: 6:1–8

> And I saw that the Lamb opened one of the seven seals, and I heard one of the four Beasts say in a voice like thunder, "Come and see!" And I saw, and behold a white horse, and he who sat upon him had a bow, and a crown was given to him, and he went away conquering that he might conquer again.
>
> And, when he opened the second seal, I heard the second Beast say, "Come and see!" And out came another horse, bright red; and he who sat upon him was allowed to take peace from the earth, that people should slay each other, and he was given a large sword.
>
> And, when he opened the third seal, I heard the third Beast say, "Come and see!" And behold a black horse, and he who sat upon him had in his hand a balance. And I heard what seemed to be a voice in the midst of the four Beasts saying, "A ration of wheat for a denarius, and three rations of barley for a denarius, but do not harm the oil or the wine."
>
> And, when he opened the fourth seal, I heard the voice of the fourth Beast say, "Come and see!" And behold a pale horse, and his name was Death, and hell followed him; and he was given power over a quarter of the earth to kill with sword and famine and with pestilence and wild beasts of the earth.

In a radical departure from earlier picture cycles, the thirteenth-century designers of both the *Bible moralisée* and the English cycles disperse the Horsemen in separately framed representations. As each rider appears. John is repeatedly commanded to "Come

and see." A phantasmagoric succession of mounted horses passes before the reader's eyes in a dynamic sequence of events, almost cinematic in character, responding more closely to the perceptual experiences described in the text. Although earlier medieval traditions still visualize, albeit ineptly, the Lamb unsealing the book *in seriatim*, the English cycles abandon the idea. In the Berengaudus archetype, however, the series of miniatures illustrating the opening of the seals begins on a recto page facing the image of the Lamb taking the open book, thus rendering redundant the repetition of the Lamb loosening each seal.[105] Only the Douce designer boldly revives the image (see fig. 49) to stress that the little book John had earlier acquired as a consoling token (fig. 35) is indeed the same book being opened by the Lamb, as poignantly conveyed by the mirrored gestures of John and the Lamb holding the two books in the sequence of opening the first four seals.[106]

Because the text fails to designate which of the four Beasts shouted, "Come and see," as each of the seals was broken, the Berengaudus archetype introduces a canonical sequence of Evangelist symbols (angel, lion, ox, and eagle), corresponding to the Vulgate sequence of Gospels, thus ignoring the order of Beasts given in 4:7. Newly stressed in the English Gothic sequence is the inscribed scroll unfurled by each of the winged Beasts, thus focusing the reader-viewer's attention on the commentary's command to understand each vision spiritually, which is fully quoted in Morgan: "Veni et vidi id est spiritaliter intelligere" (fig. 42).

As the Gothic designers attempt to pictorialize various and conflicting aspects of the commentary, the allegorical riders remain somewhat opaque to the reader's attempts to "read" the image in purely visual terms. In Trinity (fig. 41), for example, the rider aims his arrow at an unseen target in response to the gloss that interprets the bow and arrow as God's vengeance.[107] The slow, stately gait of the horse, however, contradicts the aggressive gesture, as well as the mantle flying behind the archer, to make the representation conform to the commentary's identification of the rider as "the Lord who presides eternally over his saints."[108] In Metz, however, the gesture is immobilized. The horseman holds the bow and arrow in each hand as if displaying attributes, literally representing the text, which states that the

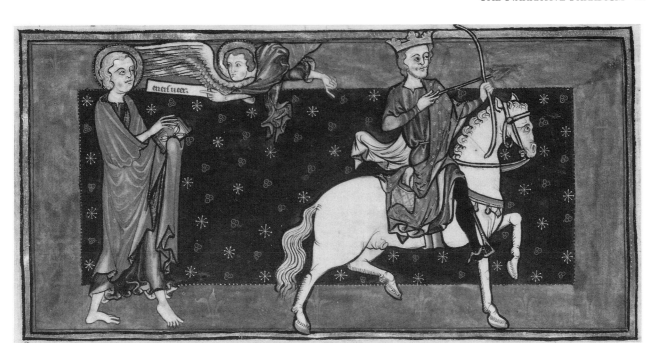

Figure 41. Apocalypse. Cambridge, Trinity College MS R.16.2, fol. 5v. First Seal (photo: The Master and Fellows of Trinity College, Cambridge).

rider is "holding the bow." In their exclusive concentration on the lordly dignity of the rider, Metz and Paris-Douce reinforce the static character of the image by turning the crowned figure in a solemn frontal pose. In Morgan 524 (fig. 42), the horseman still raises his bow but holds the arrow as if he has just pulled it from the quiver attached to his saddle, thus transforming the aiming gesture into an antecedent preparatory action, again more consonant with the horse's slow gait.

The first rider's crown is worn in all the Berengaudus manuscripts but Morgan. Pursuing a different interpretive direction, all Morgan's riders wear pointed caps to respond to the gloss that identifies each of the horsemen with successive eras of the Old Dispensation. The first horseman thus signifies "the things that occurred before the Flood" designated on the angel's scroll at the left ("intelligitur que ante diluvium facta legisti"), although the rider himself is identified as the Lord in the legend from Berengaudus that appears below. Indeed, the gloss on 6:1 is given over entirely to material drawn from Genesis.

In all the Berengaudus manuscripts but Trinity, the second horseman wears a pointed hat to characterize him as an Old Testament figure who rides the red horse representing the era "after the Flood,"

based on the commentary (see fig. 43).[109] As he looks out toward the viewer, holding his sword behind him, the figure pantomimes his retrospective allegorical role. In the Metz manuscripts (fig. 44), however, where the second rider is decked out in full mail armor and an emblazoned sleeveless surcoat, the equestrian warrior gazes ahead and extends an open hand in a gesture of command as if signaling the start of a battle. Visualizing the text, which says that the second rider was commanded to instigate war, Metz transforms the Old Testament figure into a contemporary knight or crusader.

As he raises his scales, the third horseman (fig. 45) makes an awkward but visually arresting left-handed gesture, presumably intended to convey the "sinister" significance given in the commentary, as the harshness of justice under the Old Law. The rider is characterized as an Old Testament figure wearing a soft or pointed hat. According to the commentary, the opening of the third seal refers to the Law and those who live under the Law, the scales signifying Old Testament justice, which cries out, "Life for life, eye for eye, tooth for tooth," and the black horse symbolizes the darkness and harshness of Mosaic Law.[110] In Metz-Lambeth (fig. 46), the face of the figure representing Old Testament justice is partly

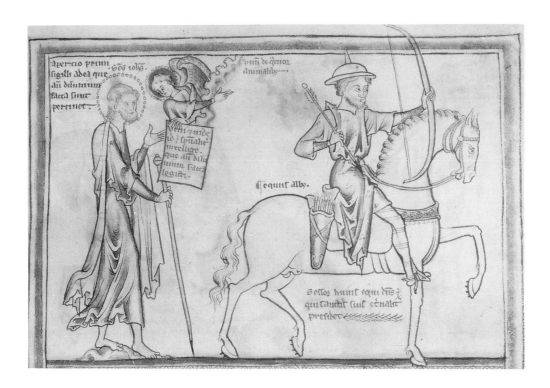

Figure 42. Apocalypse. New York, Pierpont Morgan Library MS M.524, fol. 2. First Seal (photo: The Pierpont Morgan Library).

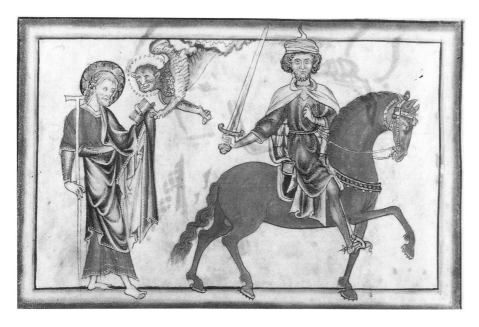

Figure 43. Apocalypse. Malibu, J. Paul Getty Museum MS Ludwig III.1, fol. 6v. Second Seal (photo: Collection of the J. Paul Getty Museum, Malibu, California).

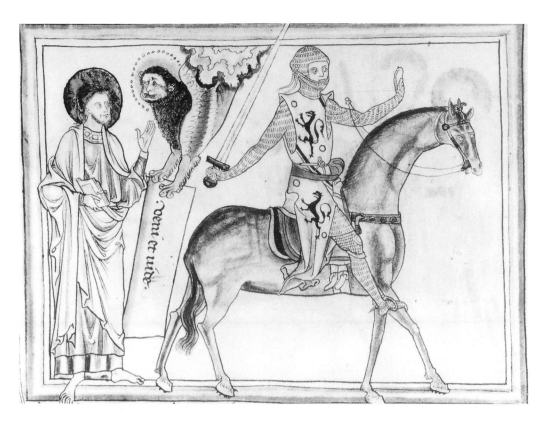

Figure 44. Apocalypse. Formerly Metz, Bibliothèque municipale MS Salis 38, fol. 5. Second Seal (photo: Monuments historiques, Paris).

obscured by a cowl in response to the exegetical reference to "Moses having a veil over his face."[111]

In the absence of attributes dictated by the text, the English Gothic configuration of the fourth horseman strikes out on an adventuresome but enigmatic course. As he gallops from the mouth of the inferno (fig. 45), the rider holds a large flaming bowl unaccounted for in the text. However, a short gloss in Morgan explains the flaming cup as a pictorial reference to the Berengaudus explication of 6:8, which asserts that the fourth rider is called death because the people of Israel fell into mortal sin, quoting from Deuteronomy 32:22: "A fire is kindled by the Lord's anger, and it burns to the depths of the inferno."[112] In the Metz manuscripts (fig. 47), the horseman wears a shroudlike veil to denote his Old Testament character as well as death. In the Abingdon Apocalypse (fig. 48), the horse has been harnessed to draw the flaming hell mouth behind him in a remarkable pictorial metaphor responding to the

accompanying anti-Jewish commentary in which the Old Testament prophets signified by the pale horse are burdened by the yoke of punishment for the whole of Israel.[113] However, none of the Berengaudus manuscripts outside the Morgan recension includes this part of the commentary. The Morgan gloss is obviously intended to explain the illustration rather than the text, for it refers to "the fire which the rider carries in his hand" ("Per ignem quem sessor manum gestat"), suggesting that the inscription referring to the commentary was copied from a set of written instructions compiled by the designer of the pictorial cycle.[114]

Perhaps because the meaning of the new attribute was less apparent in the available models or instructions than in Morgan 524, the illustration of the Fourth Horseman became less stable and subject to change among the various recensions. Instead of mindlessly copying the exemplar, for example, Trinity's designer deleted the model's meaningless flames

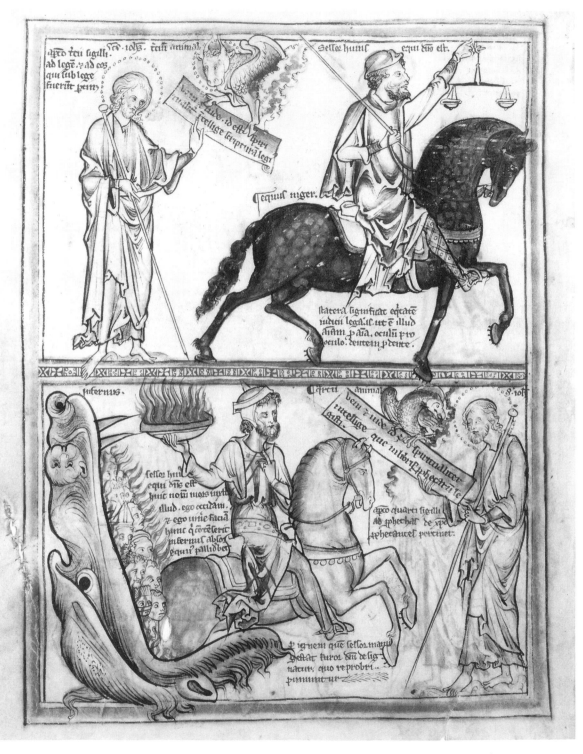

Figure 45. Apocalypse. New York, Pierpont Morgan Library MS M.524, fol. 2v. Third Seal (above); Fourth Seal (below) (photo: The Pierpont Morgan Library).

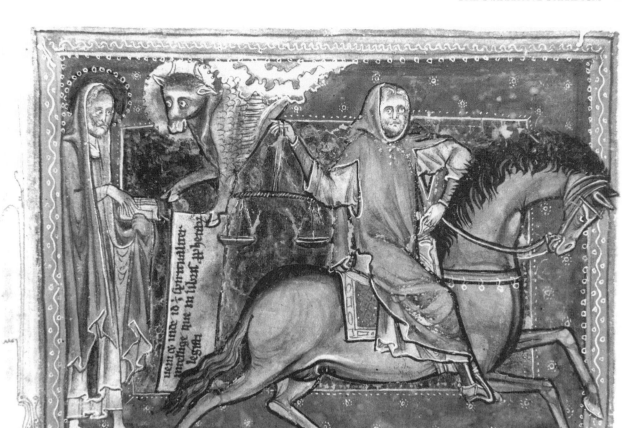

Figure 46. Apocalypse. London, Lambeth Palace Library MS 209, fol. 5v. Third Seal (photo: The Conway Library, Courtauld Institute of Art, London).

but retained the empty vessel, thereby creating an even more eccentric and ambiguous image, whereas others revert to a more traditional and literal visualization of the text. Thus, Douce 180 (fig. 49) substitutes the enigmatic flaming bowl with a textually generated sword attribute. Striking out in a different hermeneutic direction, Douce develops an aspect of the commentary not given in Metz or Getty, which sees the fourth horseman as Christ the Savior, prefigured by David killing the lion and bear who are interpreted as persecutors of the Church.[115] In its emphasis on the Fourth Seal pertaining to Christ's advent, passion, and resurrection, Douce's rider is nimbed and his horse is marked with a cross; he brandishes his sword at a demon riding a hell mouth in the form of an enormous lion's head mounted on

lion's paws striding behind him in a literal pictorialization of 6:8 ("and the inferno followed at his heels").

In most thirteenth-century cycles, the witnessing figure of the seer has been shifted to the right, signaling the end of the equestrian series. John's presence brakes the vigorous left-to-right action of the galloping horse, as well as the swooping movement of the eagle, as it announces the flaming cup of God's wrath. In Douce, however, John remains at the left, pointing to the book, his book, which is still in the process of being revealed. The self-reflexive circularity of meaning in his experience of revelation is embedded in the structure of an image that turns back upon itself. The horse, rider, and lamb pull the reader around and down into the glossing text in the

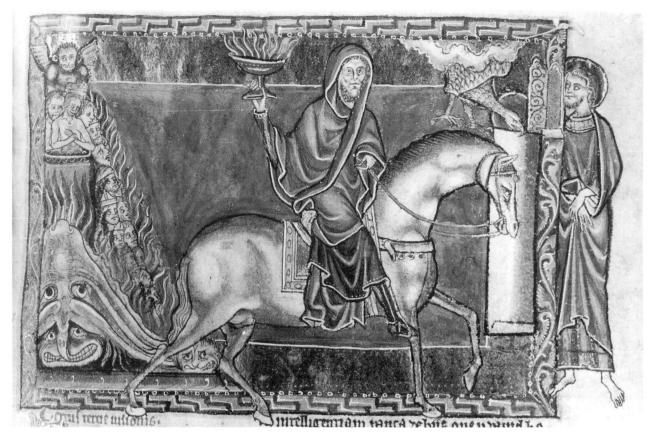

Figure 47. Apocalypse. London, Lambeth Palace Library MS 209, fol. 6. Fourth Seal (photo: The Conway Library, Courtauld Institute of Art, London).

right column and then back into the picture again, bringing with it a battery of textual signifiers to decode the image.

Instead of accelerating the narrative action, the series of horsemen envisioned in the opening of the first four seals move in a slowly measured, stately procession, enabling the reader to pause over the meaning of each rider's attributes. In Metz-Lambeth, the rider turns toward the viewer, gazing directly outward and demanding to be read on an allegorical rather than narrative level. Clearly, the riders have no real destination or relation to each other, but hold symbolic attributes declaring their meaning. The third horseman thus holds his scales behind him or over his mount's head, restraining the action of his horse as it pulls forward to the right. But the Fourth Horseman suddenly accelerates the pace as he leaps from the hell mouth at the left. In Morgan (fig. 45),

Figure 48. Apocalypse. London, British Library MS Add. 42555, fol. 14v. Fourth Seal (photo: The British Library).

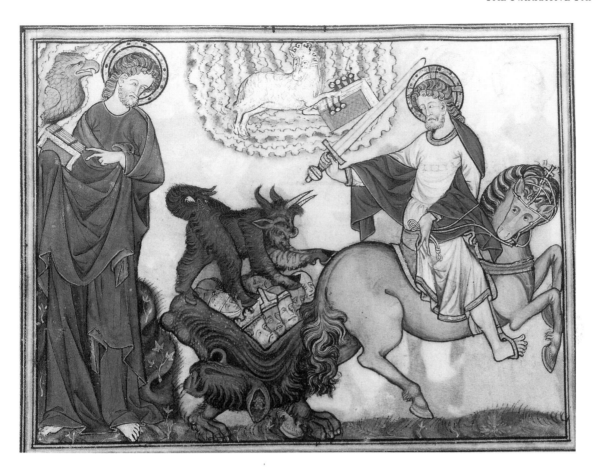

Figure 49. Apocalypse. Oxford, Bodleian Library MS Douce 180, p. 16. Fourth Seal (photo: The Bodleian Library, Oxford).

the rearing horse makes a veritable assault upon John; in Lambeth 209 (fig. 47), the seer wisely seeks refuge outside the frame, but in doing so underscores the horror of death and the inferno brought by the rider.

In the Berengaudus cycle, where the Fourth Horseman normally appears on a verso facing the Opening of the Fifth Seal (see fig. 50), the reader is confronted with a juxtaposition anticipating the Last Judgment at the end of the book. The unmistakable staking out of the realms of death and resurrection, heaven and hell, and the ultimate fate of the elect and the damned, visually unfolds as doomed souls burn in the hell mouth inferno behind the last horseman on the left page of the opening opposite the blessed souls who emerge from beneath the sheltering altar on the facing recto.

13–14. Fifth and Sixth Seals: 6:9–17

And, when he opened the fifth seal, I saw under the altar the souls of those who had been slain for the word of God and for the witness they had borne. and they cried out with a loud voice, saying "How long, Lord, holy and true, before you will judge and avenge our blood on those who dwell upon the earth?" And they were each given a white robe; and it was said to them that they should rest for a short time, until their fellow servants and brethren who were to be killed as they themselves had been slain should be complete.

And I saw, when he opened the sixth seal, and behold there was a great earthquake, and the sun became black as sackcloth, and the full moon became like blood, and the stars of the sky fell to the earth as the fig tree sheds its green fruit when shaken by a great wind: And the sky disappeared like a scroll that is rolled up, and every mountain and island was moved from its place. And the kings and princes of the earth and commanders and the rich and the strong, and every slave and free man, hid in the caves and among the rocks of the mountains: And they said to the

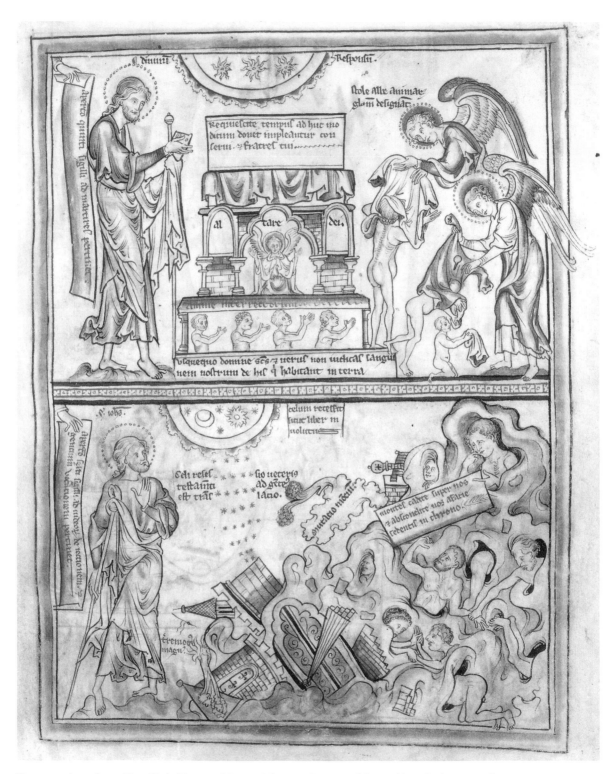

Figure 50. Apocalypse. New York, Pierpont Morgan Library MS M.524, fol. 3. Fifth Seal (above); Sixth Seal (below) (photo: The Pierpont Morgan Library).

mountains and rocks: "Fall upon us and hide us from the face of him who is sits upon the throne, and from the wrath of the Lamb: For the great day of their wrath has come, and who can survive it?"

Departing from earlier medieval cycles in which the illustration of the Fifth Seal centered exclusively on the naked figures of the souls beneath the altar, the English Gothic image (fig. 50) shifts its focus to angels conferring robes on the martyrs. The interpretive emphasis moves from a static display of the martyrs as victims associated with the symbolic sacrifice at the altar to a more joyful action undertaken by the angels to reward and comfort them. On an allegorical level, the opening of the last three seals signals the beginning of a new era, as they pertain to the New Testament, so that what was obscure in the opening of the first four seals associated with the Old Testament now becomes clear.[116] The gloss interprets the opening of the fifth seal as a vision of solace and comfort for the martyrs awaiting the next resurrection when they will receive a second white stole.[117] The angels' vigorous clothing of the resurrected martyrs dominates the action. The new image closely resembles the angels covering the naked souls of the resurrected dead in late Byzantine renditions of the Last Judgment, as reflected in the Tuscan drawing in the late thirteenth-century *Supplicationes variae* in Florence,[118] where the gesture probably alludes to Matt. 25:36–40. The dramatic activation of the episode in the English Gothic cycle can be readily explained as an attempt to visualize the commentary's assertion that, before the resurrection, the saints will receive a single stole for the soul alone but that, after the resurrection, the reception will be twofold, one for the soul and another for the incorruptible body,[119] in anticipation of the general resurrection that will dominate the sixth and penultimate vision.

The altar is firmly fixed to a high architectural base enclosing a frieze of small naked martyrs moving in procession from left to right, as if the relics beneath the altar table were transformed into newly embodied souls emerging from a crypt or arcaded frontal to receive the vestments from the angelic messengers. For many thirteenth-century English readers, the image would have provoked the particular immediacy of the pilgrimage experience at the shrine of St. Edward the Confessor at Westminster Abbey, where the faithful crawled into openings in the shrine itself, seeking to touch the holy body within, as rep-

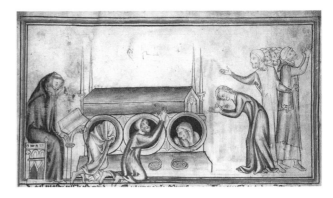

Figure 51. La Estoire de Seint Ædward le Rei. Cambridge University Library MS Ee.3.59, fol. 33. Pilgrims at the Shrine of St. Edward the Confessor (photo: The Syndics of Cambridge University Library).

resented in a contemporary miniature from *La Estoire de Saint Ædward le Rei* (fig. 51).[120] Although the multitude of martyrs beneath a single altar clearly refers to their collective reward in the abstract, the procession of souls emerging from the sacred space *sub altare* reaffirms the reader's belief in the salvific power of pilgrimage.

The opening of the Sixth Seal elicits an image (fig. 50) that responds quite literally to the text's description of the earthquake's devastation; figures in caves and fallen buildings are enfolded within the irregular outline of a tall mountain at the right, while stars fall onto the earth from a cloud bank enclosing the sun and moon at the left. Berengaudus interprets this text as a reference to the rejection of the Jews and the calling of the pagans.[121] Thus, the earthquake signifies the destruction of Jerusalem by the Romans, providing the impetus for the pictorial rendering of the fallen walls, gates, and towers, as the people flee the destroyed city to hide in caves.

In the Gothic image, however, it is not the graphic evocation of the victims, but John's horrified and fearful response to the first of his cataclysmic visions that affectively moves the reader. In Morgan, we see him walking quickly away toward the left, as he looks back apprehensively and raises his left hand in a gesture of dismay. As John gathers up his mantle, the wadded drapery is caught around the handle of his staff, making it look as if it is being used as a crutch, suggesting that he too has become a wounded casualty and is limping away from the disaster. Up to this point in the narrative, John has remained an

impassive witness to the visions revealed by the opening of the seals, but he now registers his terrified reaction in a variety of gestures. In Paris lat. 10474, he brings his hand to his face, and in Add. 35166, he raises both hands as he turns to face the catastrophe.

15. The Four Winds: 7:1–8

> After this I saw four angels standing at the four corners of the earth, holding back the four winds of the earth, that no wind might blow on the earth or sea or against any tree. And I saw another angel ascend from the rising sun, with the seal of the living God; and he called in a loud voice to the four angels who had been given power to harm the earth and sea, saying: "Do not harm the earth or the sea or the trees, until we have inscribed a seal upon the foreheads of the servants of our God." And I heard the number of those sealed, 144,000 sealed from all the tribes of the sons of Israel. . . .

Before its appearance in the thirteenth-century cycles, the representation of the "world" as the central focus of the illustration for 7:1–8 was rare. The idea of the world, however, stands at the center of the Berengaudus commentary, which interprets the four angels as the four pagan empires, conquered and unified by the Romans, from which the Church was formed, and the four angels staying the winds signify the *pax romana*.[122] As in the Gulbenkian manuscript (fig. 52), the schematic conception of the world as a rhomboid within a circle corresponds to Cassiodorus's description of the earth as an orb with four corners visualized in the ninth-century Carolingian figure of the *mundus tetragonus*.[123] In contrast, the elongated vesica-shaped *orbis terrae* in Morgan (fig. 53) resembles the late fourteenth-century mandorla-shaped map in Higden's *Polychronicon*, believed to have derived from the practice described by Hugh of St. Victor of drawing *mappae mundi* in the presumed shape of Noah's ark:

The perfect ark is circumscribed with an oblong circle, which touches each of its corners, and the space the circumference includes represents the earth. In this space, a

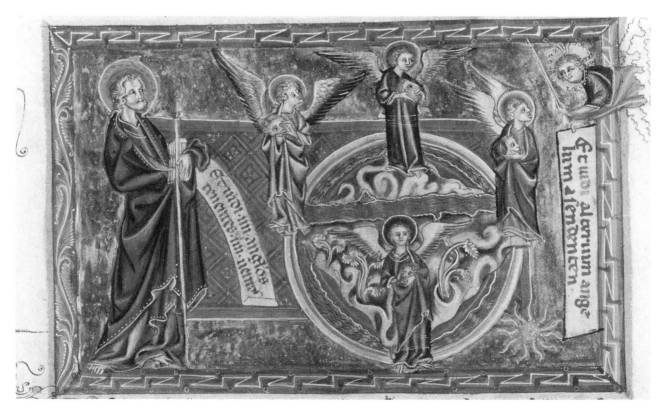

Figure 52. Apocalypse. Lisbon, Calouste Gulbenkian Museum MS L.A.139, fol. 13v. Four Winds (photo: The Conway Library, Courtauld Institute of Art).

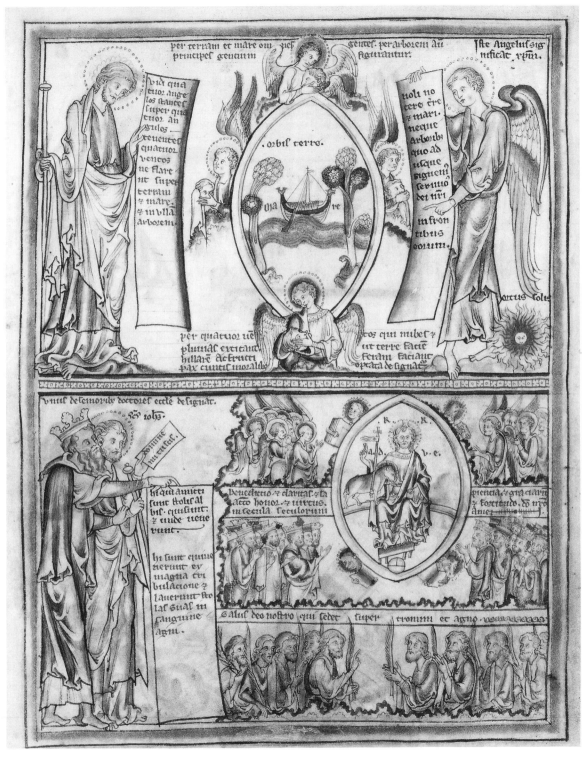

Figure 53. Apocalypse. New York, Pierpont Morgan Library MS M.524, fol. 3v. Four Winds (above); Adoration of the Lamb (below) (photo: The Pierpont Morgan Library).

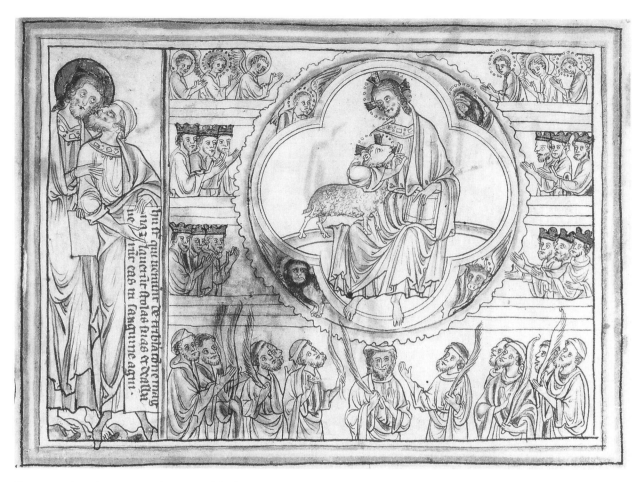

Figure 54. Apocalypse. Formerly Metz, Bibliothèque municipale MS Salis 38, fol. 2. Adoration of the Lamb (photo: Monuments historiques, Paris).

world map is depicted in this fashion. . . . In the apex to the east formed between the circle and the head of the ark is paradise. . . . In the other apex, which juts out to the west, is the Last Judgment, with the chosen to the right and the reprobates to the left. In the northern corner of this apex is hell, where the damned are thrown with the apostate spirits.[124]

Within the metastructure of the third vision, the macrocosmic *mappa mundi* could thus represent the cosmic history of the world, from creation to final judgment. On a more mundane level within the ideological framework of the thirteenth century, the microcosmic image signifying the "pacification" of the four corners of the earth under the aegis of the Church probably served as a transparent metaphor for the Crusades.

Unlike earlier Apocalypse cycles, which represent the other angel of 7:2 as a commanding full-length figure, the Gothic cycles usually marginalize him as a fractional figure, flying down from a cloud bank outside the frame, holding a scroll inscribed, "Do not harm the earth." Although his position conforms to the gloss in which Christ "descends where the sun rises," the angel descending from the clouds created difficulties in conforming to the text that asserts that the angel "rises where the sun rises." Moreover, the sun serves as an important metaphorical image in the commentary where it is first associated with the Old Testament *sol iustitiae* (Malachi 4:2) and then designated as a symbol of Christ's virgin birth.[125] Morgan's designer addresses this problem by representing the angel emerging from a flaming disc in the lower right corner labeled "ortu soli," creating an elegant symmetrical composition in which the tall

figures of the angel and John hold long scrolls that bend on each side to protectively bracket the elongated ovoid *mundus* in the center.[126]

In the Berengaudus archetype, the Sixth Seal and Four Winds appear on facing pages, evoking a contrast similar to that in the preceding opening. Counteracting the violent devastation wrought by the earthquake at the opening of the Sixth Seal, the angelic intervention to halt the destructive forces of the winds thus results in a stabilized image, anticipating the eirenic calm of the Adoration of the Lamb within its celestial frame on the next verso (see fig. 54).

16. Adoration of the Lamb: 7:9–17

> After this I saw a great multitude which no one could count, from all nations and tribes and peoples and tongues, standing before the throne and in the presence of the Lamb, clothed in white robes, with palms in their hands, and crying out with a loud voice, saying: "Salutation to our God who sits upon the throne and to the Lamb!" And all the angels and Elders and the four Beasts surrounding the throne prostrated themselves before the throne and adored God, saying, "Amen. Blessing and glory and wisdom and thanksgiving and honor and power and strength to our God for ever and ever! Amen."
>
> And one of the Elders said to me: "Do you know who are those clothed in white robes and whence they have come?" I said to him, "My lord, you know." And he said to me, "They have come from great tribulation, and they have washed their robes and made them white in the blood of the Lamb. Now they stand before the throne of God and serve him day and night in his temple, and he who sits upon the throne will dwell above them. . . ."

Like the *Bible moralisée*, the Berengaudus cycle (figs. 53 to 55) breaks with early medieval traditions in which the Lamb appears alone to include the One seated on the throne within the central mandorla frame. The binary figuration more accurately corresponds to the text ("Victory to our God who sits on the throne, and to the Lamb"), as well as visually registers the Christological dogma of the two natures given in the exegesis. To further respond to the commentary's traditional interpretation of the great assembly before the throne as the triumph of Holy Church,[127] the illustration incorporates all the pictorial material for 7:9–17 in a complex compartmentalized composition crowded within a single frame.[128] Two-thirds to three-quarters of the space are given over to the adoration of the enthroned Lord and Lamb by tiers of angels, Elders, and saints, and John

and the Elder are relegated to a lateral compartment. The two scenes, however, are aligned out of textual sequence; the Elder at the left carries a scroll inscribed with the text of 7:13–14, and the vision at the right pictorializes 7:9–12.[129] Within the range of thirteenth-century perceptions, the exchange between John and the Elder functions as an explanatory interpolation in a text that begins and ends with the adoration of the Lord and Lamb; the images could thus be reversed without altering the sense of the text, so that the verbal colloquy could serve as a narrative preface to the vision.

As in Metz and Getty, John and the Elder are isolated as a confronted pair within a narrow framed compartment; the Elder is still characterized, as in Rev. 5, as an Old Testament prophet wearing a soft cap. In Morgan, however, the Elder is crowned to signify his identification as the "doctors of the Church."[130] Locked together with the seer within a liminal space at the left, the Elder forms a barrier between John and the vision that is the subject of their discourse; in Metz, John is clearly the aural recipient of the Elder's speech as he bends his ear close to the voice. Morgan revises the archetype so that the encounter between John and the Elder opens onto the vision at the right, as the Elder guides the seer's gaze along a sight line toward the rows of saints holding palms, corresponding simultaneously to 7:9 ("After that I saw") and 7:13–14; nonetheless, the Elder still speaks into John's ear.

Although the Gothic image clearly evokes another vision of a heavenly liturgy, the reader is no longer invited to participate in the celestial worship, but rather to share John's witnessing of the glorious vision that awaits the faithful. Whereas Morgan displays a traditional theophany in its frontally enthroned Lord, Metz introduces a singularly affective gesture of the Lord cradling the Lamb's head in the crook of his arm. As the figures within the quatrefoil mandorla turn inward, breaking the axes of the frame, they create an encircling feeling of tender intimacy, which in turn creates a moving consonance between the Lord's blessing and the comforting promise of salvation offered at the end of the text passage. In Getty, however, the figures of the One on the throne and the Lamb have been uniquely separated and placed one above the other, with the Lord's foot resting on the Lamb's forehead, so that each could be represented ritually displaying the

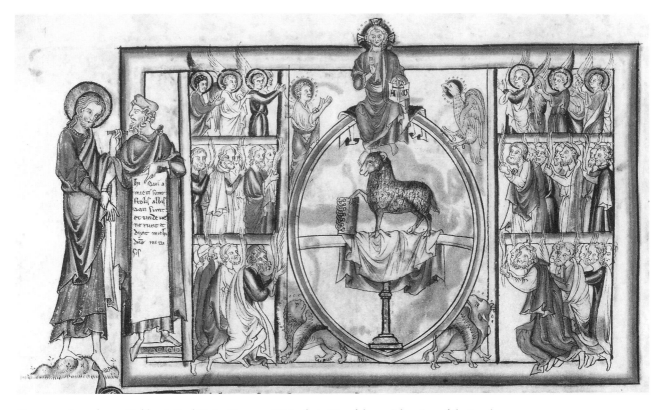

Figure 55. Apocalypse. Malibu, J. Paul Getty Museum MS Ludwig III.1, fol. 9v. Adoration of the Lamb
(photo: Collection of the J. Paul Getty Museum, Malibu, California).

sealed book in anticipation of the opening of the Seventh Seal, which follows on the facing recto.

17–18. Seventh Seal: 8:1–2; Censing the Altar and Pouring the Censer on the Earth: 8:3–5

> And, when the Lamb broke the seventh seal, there was silence in heaven for about half an hour. And I saw seven angels standing in the presence of God, and they were given seven trumpets.
>
> And another angel, who had a golden censer, came and stood before the altar, and he was given a large quantity of incense, so that he could offer the prayers of all the saints at the golden altar, which stands before the throne of God. And from the angel's hand the smoke of the incense rose with the prayers of the saints in the presence of God. And the angel took the censer and filled it with the fire from the altar, which he then threw down on the earth; and there were peals of thunder and voices and flashes of lightning and a great earthquake.

As a prelude to the sequence of seven Trumpets, the Berengaudus cycle provides two miniatures to illustrate glossed texts for 8:1–2 and 8:3–5. Marking a departure from earlier traditions in which the seven angels already hold or blow their trumpets, the literal rendition of the text ("I saw seven trumpets being given to the seven angels") as an angel distributing trumpets constitutes a pictorial innovation that first appears in the thirteenth-century English cycles. Visually responding to the commentary, the image provides a dramatic antecedent to the sounding of each of the seven Trumpets: "Just as the herald is sent before the king or prince to announce his arrival, so by the angel is meant St. John, so that he can announce the great things [they portend] before he comes to recount each one."[131] In Morgan (fig. 56), John stands at the left opposite the angel, raising his hand in a gesture of speech to fulfill the heraldic task enunciated in the gloss. In contrast, Getty (fig. 57) interrupts the distribution of trumpets with a central mandorla-framed image of the Lord that refers not only to the "presence of God," but also to the "si-

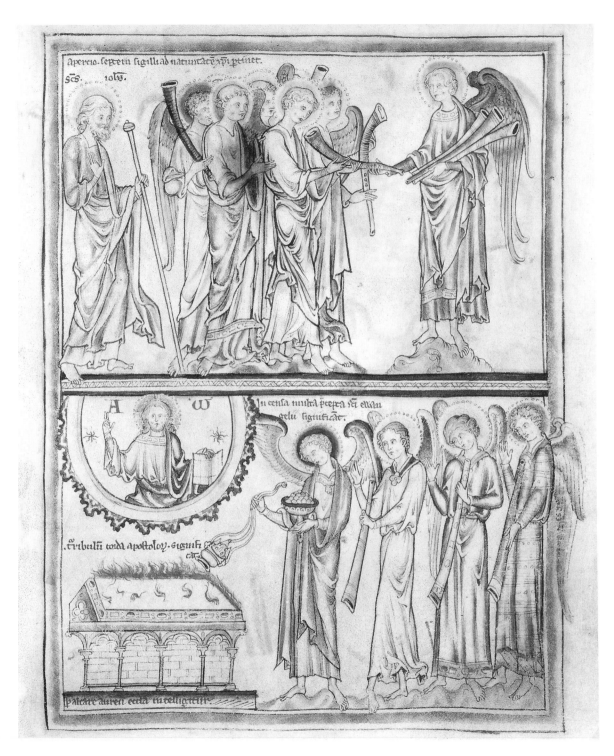

Figure 56. Apocalypse. New York, Pierpont Morgan Library MS M.524, fol. 4. Seventh Seal (above); Censing the Altar (below) (photo: The Pierpont Morgan Library).

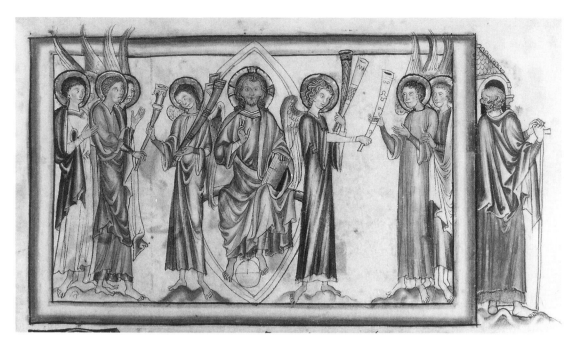

Figure 57. Apocalypse. Malibu, J. Paul Getty Museum MS Ludwig III.1, fol. 10. Seventh Seal (photo: Collection of the J. Paul Getty Museum, Malibu, California).

lence in heaven." To further signal the important transition in the narrative, John turns his back to us, forming another gesture of silence. Now shifted to the right, the seer's brief stop to peer through an opening in the extended frame creates a pause that sustains the silencing frontal gesture of the Lord's blessing.

The next illustration (see fig. 58) unfolds as a cyclical narrative in which the angel, who is identified as Christ in the commentary, is repeated twice as he censes the altar, which represents the Church, with incense signifying the Gospels, and pours a censer representing the hearts of his disciples filled with the fire of the Holy Spirit over the earth.[132] In a radical departure from Getty's cyclical image, Morgan (fig. 56) develops another aspect of the gloss, in which the large quantity of incense signifies the teachings of the Gospels ("incensa multa precepti sancti evangelii significat"): Four angels, one with the censer, followed by three others with trumpets, represent the four books as they approach the altar at the left, and the first angel holds a bowl of incense to reinforce the quotation from Berengaudus inscribed above the altar ("thuribulum corda apostolorum significat").

As witnessed by the merging and slippage of epi-

sodic material among the thirteenth-century manuscripts, the archetypal text illustration for 8:1–5 generated a critical series of tropic responses among the designers of the Berengaudus cycles, signaling their desire to alert the reader to the meaning of the narrative hiatus announced by the "silence in heaven." The text passage forms a transition from the seven Seals to the seven Trumpets. Up to this point, the writing of the Letters and opening of the Seals involved the transmission of messages and commands, either directly or, by implication, by the written word. With the introduction of the Trumpets in Rev. 8, the primary signifiers become "voices," which are in turn more direct and powerful. To this juncture in the narrative, John has only heard voices "like trumpets." Now the metaphors of sound take on a life of their own as they "speak," each one capable of inducing a destructive force more devastating than the last. The distribution of instruments to the angelic choir of seven constitutes a conferral of voices by divine sanction to which a ritual dimension is given by the censing of a golden altar that stands before the divine presence. The ritual reversion from writing to the more primitive power of speaking is then heralded by the angel's ceremonial gesture of

emptying the sacred fire from the altar onto the earth, so that the ensuing thunder, lightning, and earthquake can provide a foretaste of the awesome destructive power with which the trumpets have been endowed.

FOURTH VISION (REV. 8:6 TO 15:4)

According to the exegete's inexorable logic, the seven angels sounding trumpets follow the seven seals, be-cause, once the book has been opened, it must then be explained: the newest angelic contingent then sig-nify the teachers *(doctores)* sent by God to instruct his people. Thus, the longest and most complex of the structuring visions is initiated by a pattern of symmetrical repetition, forming an allegorical pal-impsest in which the present set of figures overwrites the last. Despite the seeming displacement of vision by John's aural perception of trumpet blasts, Beren-gaudus assures us that "in the fourth vision the seven angels sounding trumpets were [indeed] seen."[133] As the Church on earth undergoes a relentless series of trials and persecutions at the hands of heretics and pagans, Antichrist makes his first appearance in the guise of Abaddon, the beast from the abyss (figs. 61

and 63), to be followed by successive incarnations as the seven-headed dragon in Rev. 12 (figs. 85 to 89) and the beasts from the sea and earth in Rev. 13 (figs. 98 to 108). The sequence of seven Trumpets in which the Church defends its orthodoxy is interrupted by two major subtexts in Rev. 10 and 11, which extend the discourse to address the power of written inter-pretation and the power of spoken prophecy. The new book introduced in Rev. 10 is a commentary that stakes out the parameters of doctrine and the divine sense of Scripture, whereas the persecution and triumph of the martyred witnesses in Rev. 11 provide an adroit segue into the last of the seven Trumpets heralding the Church's holy preachers at the end of the world.

Although the serial trumpet blasts logically con-clude a significant segment of the text spanning more than three chapters, Berengaudus sees the fourth vi-sion as encompassing three more chapters in which the persecution of the Church is resumed, first in heaven (Rev. 12), then again on earth (Rev. 13), as the drama of trial and triumph is replayed on shifting stage sets by new casts of characters. The second re-prise ends in Rev. 14 with an expansive celebration of triumph as the New Song is performed in heaven, but this is then followed by a lengthy transition fore-

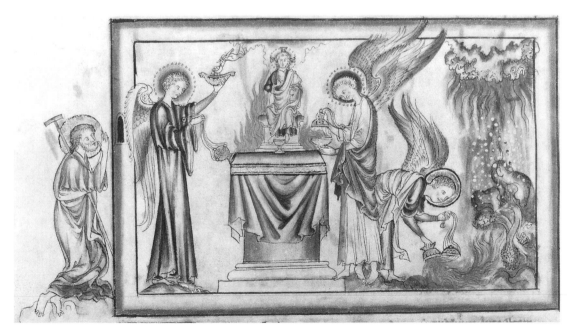

Figure 58. Apocalypse. Malibu, J. Paul Getty Museum MS Ludwig III.1, fol. 10v. Censing the Altar and Pouring the Censer (photo: Collection of the J. Paul Getty Museum, Malibu, California).

shadowing the punishments of the wicked that will dominate the next long vision. In making the transition from the Trumpets to Vials, the oncoming punitive actions are first announced by angels and then enacted on the metaphorical level of the Harvest and Vintage at the end of Rev. 14. Following a precedent established in the last transition, the Vials are visibly displayed by an assembly of seven angels at the end of the fourth vision in the first verses of Rev. 15 (fig. 122), before they are serially activated at the beginning of the next vision.

19–23. The First Four Trumpets and the Voice of the Eagle: 8:6–13

> And the seven angels who had the seven trumpets made ready to sound them.
> And the first angel blew his trumpet, and there followed hail and fire, mixed with blood, dropping on the earth; and a third of the earth was burned, and a third of all trees were consumed, and all the green grass was burned.
> And the second angel blew his trumpet, and something like a great mountain, all on fire, was thrown into the sea, a third of the sea turned into blood, and a third of the creatures that lived in the sea died, and a third of the ships were destroyed.
> And the third angel blew his trumpet, and a great star

fell from the sky, burning like a torch and it fell on a third of the rivers and springs. And the star is called Wormwood; and a third of all water turned to bitter wormwood, and many people died from the water that had been made bitter.
> And the fourth angel blew his trumpet, and a third of the sun and a third of the moon and a third of the stars were struck, so that a third of their light was darkened; and there was no light for a third of the day, the same with the night.
> And I saw and heard the voice of an eagle flying though the midst of the heavens, calling in a great voice, "Woe, woe, woe to those who dwell on the earth, when the voices of the other three angels will sound trumpets."

Most English Gothic cycles reserve an independent illustration for each of the first four Trumpets, but the Morgan and Metz versions combine two or three trumpeting angels within one frame.[134] Whereas the brass ensemble in Metz accelerates the pace of the serial trumpet blasts, stressing the relentless monotony of the ensuing catastrophes with scarcely a moment's pause, Getty's solo trumpeter (see fig. 59) opens a spatial and temporal gap at the right. The narrative opening draws the viewer into the large spatial lacuna within the frame to become the vicarious earthly target for each celestial wrath.

The archetypal juxtaposition of the Pouring of the Censer and the First Trumpet on facing verso and

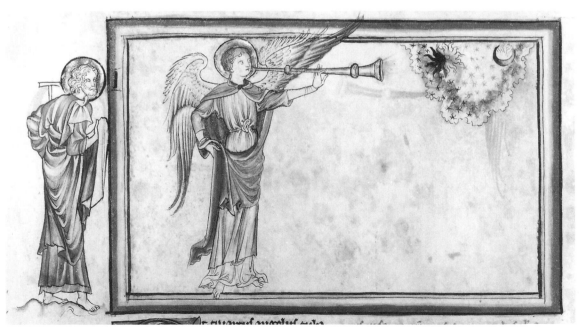

Figure 59. Apocalypse. Malibu, J. Paul Getty Museum MS Ludwig III.1, fol. 12v. Fourth Trumpet (photo: Collection of the J. Paul Getty Museum, Malibu, California).

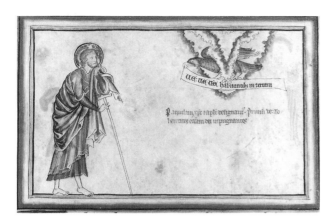

Figure 60. Apocalypse. Malibu, J. Paul Getty Museum MS Ludwig III.1, fol. 13. Voice of the Eagle (photo: Collection of the J. Paul Getty Museum, Malibu, California).

recto pages maintains a compelling focus on the destructive power of the "voices" as each illustration reveals the sky pouring forth its devastation on the earth.[135] In a more pronounced way than we encountered in the seven Seals, the first four Trumpets reveal an obvious strategy of accumulation; the paratactic work is composed by simply placing one thing after another, where each predication stands alone in a model of ritual syntax. Although the serial projection engages the reader in an allegorical structure as temporal and spatial sequence, the result is not dynamic but static, ritualistic, and repetitive. As Craig Owens remarked in another context, "it is thus the epitome of counter-narrative, for it arrests narrative in place, substituting a principle of syntagmatic disjunction for one of deigetic combination."[136]

In the Berengaudus archetype, the Fourth Trumpet and the Voice of the Eagle are juxtaposed on facing pages (see figs. 59 and 60), where the eagle flies in from the right on the recto page to close the composition and end the narrative. In Getty, John reappears as both preceptor and auditor in response to the text ("And I saw and I heard"), as the great eagle flying toward him holds a scroll inscribed "Woe, woe, woe, to all who inhabit the earth." John raises his covered hand to his face in a gesture of dread, but in Add. 35166, he turns around and lifts his hand to his eyes to draw attention to his visual as well as aural perception of the baleful messenger. The archetypal image was probably detached from its traditional association with the Fourth Trumpet

to stress the dramatic juxtaposition of John and the eagle as symbol of his Gospel as well as to evoke the interpretation of this passage in the commentary where the eagle signifies Christ and his apostles. According to Berengaudus, the eagle flies through the heavens as Christ first preached the Gospels in Judea and then the apostles preached to the nations throughout the world; three woes signify the persecutions to be suffered by the Church from heretics, pagans, and Antichrist.[137]

24. Fifth Trumpet and Locusts: *9:1–12*

> And the fifth angel blew his trumpet; and I saw a star fall from heaven to the earth, and he was given the key to the pit of the abyss. And he opened the pit of the abyss, and from the pit rose smoke like smoke from a great furnace; and the sun and air were darkened by the smoke from the pit; and from the smoke of the pit locusts came upon the earth, and they were given power like the power of scorpions on the earth; and they were commanded not to harm the grass of the earth or any green thing or any tree, but only the men who do not have God's seal on their foreheads; and they were allowed to torture them for five months but not to kill them, and their torture was like the torture of a scorpion's sting. And in those days men will seek death and not find it, and long to die, and death will flee from them. And these locusts resembled horses armored for battle; on their heads were what looked like gold crowns, and their faces like human faces. And they had hair like women's hair, and teeth like lions' teeth; and they had body-armor like iron breastplates, and the noise of their wings was like the noise of many horse chariots charging into battle, and they have tails like scorpions, and stings were in their tails and power in them to harm people for five months. And they have over them as king the angel of the abyss, whose name in Hebrew is Abaddon, or Apollyon in Greek, and in Latin Exterminans. . . .

As in the Getty Apocalypse (fig. 61), the archetypal design for the Berengaudus cycle probably envisioned only one illustration for the blowing of the fifth trumpet and the unlocking of the abyss that releases the army of locusts led by Abaddon (9:1–12). John stands outside looking through a window in the frame at the great star ("I saw a great star") and key falling into a smoking pit; the locust army emerges, led by a crowned and sceptered prince at the right.[138] The trumpeting angel is identified in the commentary as defender of the faith of the Church against heretics (symbolized by the star fallen from heaven) and heretical books (represented by the key).[139] Consequently, the key is never given to the angel, but is visually "attached" to the falling star. Whereas the archetype probably rendered the abyss as an irregu-

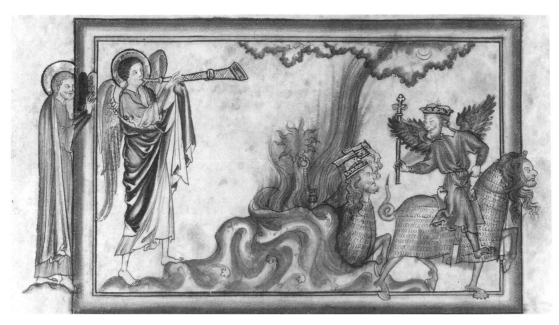

Figure 61. Apocalypse. Malibu, J. Paul Getty Museum MS Ludwig III.1, fol. 13v. Fifth Trumpet and Locusts (photo: Collection of the J. Paul Getty Museum, Malibu, California).

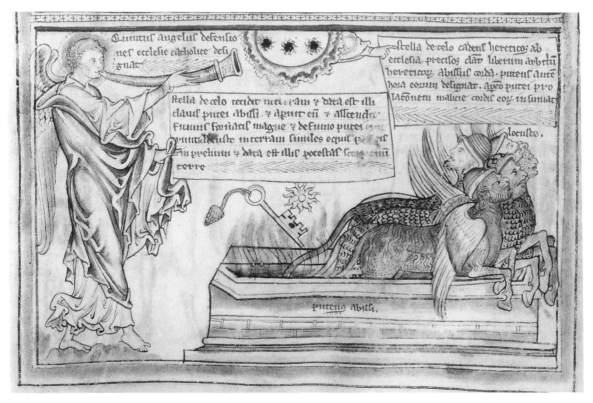

Figure 62. Apocalypse. New York, Pierpont Morgan Library MS M.524, fol. 5. Fifth Trumpet (photo: The Pierpont Morgan Library).

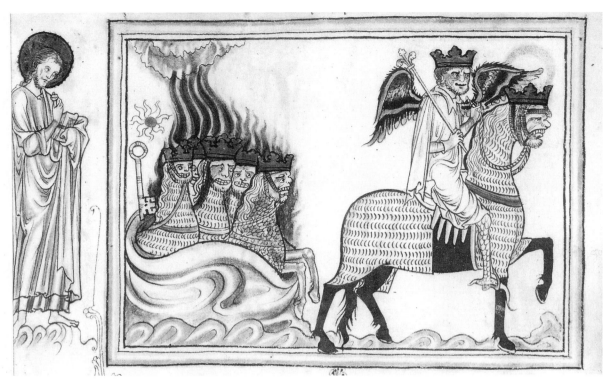

Figure 63. Apocalypse. Formerly Metz, Bibliothèque municipale MS Salis 38, fol. 14v. Locusts (photo: Monuments historiques, Paris).

lar opening in the earth, the distinctive rectangular box-lidded structure, labeled "puteus abyssi," that appears in the Morgan manuscripts (fig. 62) constitutes a striking pictorial metaphor linking the abyss with a "box of death" in the shape of an open sarcophagus. In most Berengaudus cycles, the locusts are provided with wings in accordance with the text and the commentary that asserts that they represent the words of the heretics.[140] Abingdon (fig. 109) introduces a unique detail in the wheels attached to the harness of the first locust emerging from the abyss in a literal visualization of the simile in which the sound of the locusts' wings is compared to "a great charge of chariots into battle."

Although the *Bible moralisée* makes an emphatic distinction between the paratactic episodes comprising the trumpeting of the fifth angel (9:1–3) and the appearance of the army of Locusts led by Abaddon (9:7–11), the decision to divide the text in so many Berengaudus manuscripts appears to have been independently dictated by the practical need to extend the lengthy glossed text over two pages. The revisions in Morgan and Metz still blur the demarcation of the two narrative moments but nevertheless fracture the composite image to focus more forcefully on the figure of Abaddon who is given a fully realized human form in response to his identification as Antichrist. Although in Douce and Trinity he retains a more traditional bestial form, in Metz (fig. 63), he betrays only vestiges of his origins in the scaly leg gripping the stirrup. In response to the gloss quoted next to this figure in Morgan, which asserts that "the king of the locusts signifies the devil," Abaddon appears in another thirteenth-century diabolical guise, caricatured as a Jew wearing a pointed cap.[141] Where the locust leader holds a long-handled foliated scepter, as in Getty and Metz (figs. 61 and 63), or a trefoil emblem as in Morgan, his identity as Antichrist is proclaimed by the blasphemous appropriation of a Christological symbol signifying the Incarnation.[142] Although the commentary characterizes Abaddon only as the "devil," his identification as Antichrist

nevertheless operates proleptically, looking ahead to the later gloss on 11:7, where the "beast from the abyss" signifies Antichrist.[143]

25. Sixth Trumpet: 9:13–16

> And the sixth angel blew his trumpet; and I heard a voice come out of the four horns of the golden altar before the eyes of God, saying to the sixth angel who had the trumpet, "Release the four angels who are bound in the great river Euphrates." And the four angels, who had been held ready for the hour and the day and the month and the year, were released so that they could kill a third of humankind. And the number of equestrian troops was twice ten thousand times ten thousand, and I heard their number.

For this passage, the English designers developed an image (see fig. 64) very similar to that in the *Bible moralisée*, where the four angels stand unfettered with raised swords as the sixth angel blows his horn.[144] In the Berengaudus illustration, the angels standing on the waters hold various weapons to sig-nal the destructive purpose of their release, an idea that is further developed in Morgan where they wear helmets and armor. The deepened malignant char-acterization of the angels with dark faces in Trinity or as bestial demons in Paris lat. 10474 appears to be an unrelated modification of the archetype in re-sponse to the commentary that identifies the four an-gels as the four pagan empires, persecutors of the martyrs.[145] In Metz, the figure emerging from the clouds is the angel representing the single voice from the four corners of the altar, which the gloss inter-prets as the one faith enumerated in the four Gos-pels.[146] Veering away from earlier traditions of visualizing this passage as the actual release of the angels, the English Gothic cycle focuses on a moment of transition in which the armed and sometimes ar-mored angels pause in preparation for battle. As the image appears between the vigorous onslaughts of two terrible bestial armies, the angelic company of-fers a moment of eirenic calm before the violence of John's current series of visions resumes.

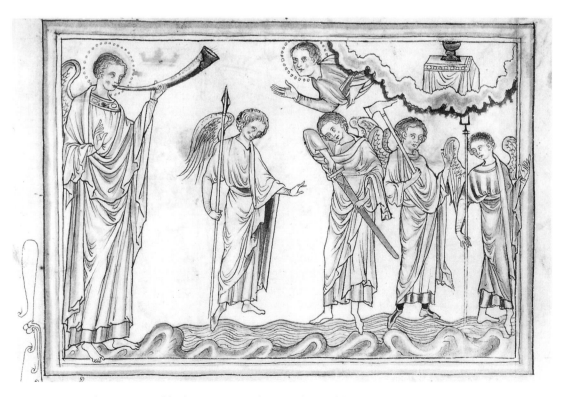

Figure 64. Apocalypse. Metz, Bibliothèque Municipale MS Salis 38, fol. 15. Sixth Trumpet and Angels of the Euphrates (photo: Monuments historiques, Paris).

Figure 65. Apocalypse. Cambridge, Trinity College MS R.16.2, fol. 10. Army of Beasts (photo: The Master and Fellows of Trinity College, Cambridge).

26. Army of Beasts: *9:17–21*

> And thus I saw the horses in my vision; and those who sat upon them had breastplates the color of fire and of sapphire and of sulphur, and the heads of the horses were like lions' heads, and from their mouths issued fire and smoke and sulphur. And by these three plagues a third of humankind was killed, by fire and by smoke and sulphur which issued from their mouths. For the power of the horses is in their mouths and in their tails; for their tails have heads like those of serpents, and by means of them they wound.

Following the tradition established by earlier cycles going back to Trier, the thirteenth-century English designers provide a separate illustration for the Army of Beasts (fig. 65). In response to the commentary's envisioning of the horses' fire-breathing leonine heads as the Roman emperors who persecuted the early Church with their idolatry, blasphemy, and martyrdom of the faithful,[147] a group of helmeted warriors in mail, armed with lances, ride their hybrid fire-breathing beasts as they trample fallen victims. In Trinity, however, the army is transformed into an armored force of diabolical beasts. Although the text begins "In my vision I saw," the seer is accompanied by a young man who speaks in his ear. As he listens, John gazes at the reader to signal a reference to the

last line of the previous text passage above the illustration ("And I heard the number of them") in an image that ingeniously serves to elide an ambiguous break in the text.[148]

The destructive violence of the scene concludes the series of disasters generated by the sequence of trumpets and anticipated by the pouring of the censer in Rev. 8. However, the text provides no preparatory transition to the enigmatic realm of the book in Rev. 10. With a turn of the page or glance across to the facing recto, the reader is suddenly confronted with an abrupt shift from the world of trumpets and voices back to the power of the written word in which the seer undergoes a further stage in his initiation, demanding new strategies of inscribed utterance and perception.

27–28. John Forbidden to Write: *10:1–7*; The Angel Gives John the Book: *10:8–11*

> And I saw another powerful angel descending from heaven, wrapped in a cloud, and a rainbow over his head, and his face was like the sun, and his legs like columns of fire; and in his hand he had a small open book, and he set his right

foot on the sea and his left foot on the land, and called out in a loud voice, like a lion roaring; and, when he called out, the voices of the seven thunders spoke; and when the voices of the seven thunders had spoken, I was about to write, and I heard a voice from heaven saying to me, "Seal what the seven thunders have said, and do not write it down." And the angel whom I saw standing on the sea and on the land raised his right hand to heaven and swore by him who lives for ever and ever . . . for time shall be no longer; but in the days of the voice of the seventh angel, when he shall begin to sound the trumpet, the mystery of God shall be consummated, as he has preached through his servants the prophets.

And I heard a voice from heaven speaking to me and saying, "Go and take the open book from the hand of the angel who is standing on the sea and on the land." And I went to the angel asking him to give me the book, and he said to me, "Take the book and eat it, and it will make your stomach sour, but in your mouth it will be sweet as honey." And I took the book from the hand of the angel and ate it; and it was sweet as honey in my mouth; and, when I had eaten it, my stomach was sour. And he said to me, "You shall prophesy again to many peoples and nations and tongues and kings."

In the Berengaudus cycle, the text for Rev. 10 is divided into two separately glossed and illustrated seg-

ments for 10:1–7 and 10:8–11, corresponding to an archaic capitulation given in the ninth-century Carolingian versions. The first illustration (see fig. 66) shows John at the left witnessing the descent of the powerful angel "wrapped in a cloud, with a rainbow over his head," holding the book and standing in the center to illustrate 10:1–2 as well as verses 5–7, as he raises his right hand to heaven. The commentary interprets the *angelus fortis* as the Lord incarnate, and the open book signifies that Christ is seen as he appears to the doctors of the Church in the divine sense of Scripture.[149] Thus, the central image of the mighty angel functions not only as the major antecedent to John's taking the book but more importantly to verify the commentary's dictum that "through visible figures are demonstrated the invisible" ("Verum per figuras visibiles saepe invisibilia demonstrantur"). In a visually and psychologically compelling reference to the multivalent illumination of this figure, the great angel in Douce breaks into a broad smile, graphically rendering explicit an asso-

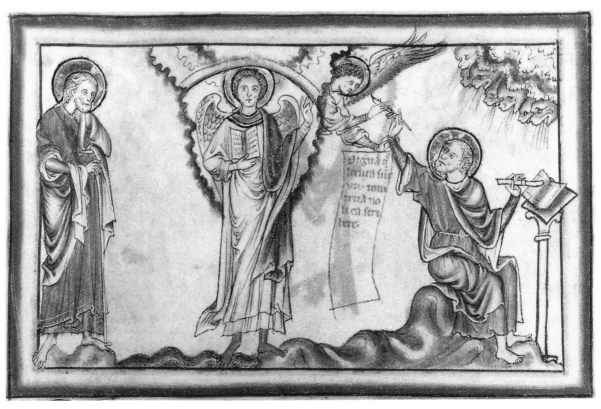

Figure 66. Apocalypse. Malibu, J. Paul Getty Museum MS Ludwig III.1, fol. 15. John Forbidden to Write (photo: Collection of the J. Paul Getty Museum, Malibu, California).

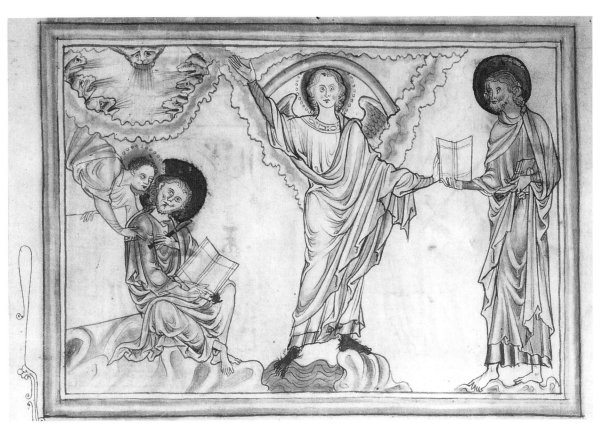

Figure 67. Apocalypse. Formerly Metz, Bibliothèque municipale MS Salis 38, fol. 16. John Forbidden to Write; John Takes the Book (photo: Monuments historiques, Paris).

ciation of smiling and light suggested by the text, "his face was like the sun."[150]

As the cyclical illustration unfolds, the voice from heaven forbids John to write down the words of the seven thunders at the right. The pictorial emphasis on this aspect of the narrative was very likely inspired by the long commentary in which the voice from heaven is the "voice of the Church" and the delay in receiving the book indicates that the apostles and their clerical successors needed to purify themselves in order to receive the spiritual message of Scripture.[151] The Evangelist is seated beneath a bank of clouds enclosing the seven thunders, holding a pen and scraper poised above an open codex on his lap, as an angel representing "a voice from heaven" flies down behind him with a scroll, commanding him to "keep the words of the seven thunderclaps secret." The sequential action of the text is thus rendered as a cyclical narrative in which John first appears as a

spectator gazing at the angel, then as a protagonist at his desk attempting to transcribe the "words of the seven thunders," which are literally spewed from the sky above him. The forbidding voice from heaven issues a verbal command that is reinforced by a physical gesture as the angel grasps John's wrist and confiscates his pen.

In Metz (fig. 67), this episode is conflated with the appearance of the powerful angel in a miniature that compresses Rev. 10's narrative into a single image. The first figure of John witnessing the angel's arrival has been omitted and replaced at the left with the episode of the Evangelist being forbidden to write. The mighty angel still stands in the center of the composition but now hands the book to John at the right to illustrate 10:8–10. In contrast to Getty's disjunct, paratactic juxtaposition of events, Metz accomplishes a smooth process of transferal, as the pivotal gesture of the mighty angel substitutes one book for

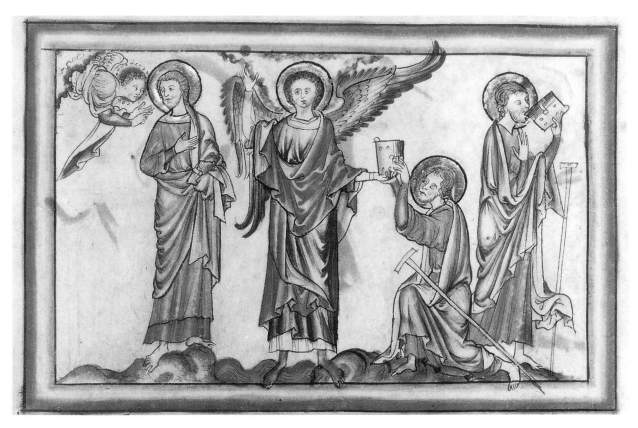

Figure 68. Apocalypse. Malibu, J. Paul Getty Museum MS Ludwig III.1, fol. 15v. John Eats the Book
(photo: Collection of the J. Paul Getty Museum, Malibu, California).

another, that is, a heavenly scripture for an earthly, human one, signified by the relative positions of the two codices. John's right ear becomes curiously bent and enlarged as he strains to hear the angel's whispered instructions against the din of the seven thunders. The angel representing the "voice" becomes more fully visible at the left behind John, interrupting his labors by discretely tapping him on the shoulder.

In the cyclical illustration for 10:8–11 (fig. 68), John receives the book from the mighty angel, after a small angel first emerges from the clouds, commanding him to take the book. Although Metz and Morgan omit the episode of John eating the book, the text is illustrated in Getty where John first takes the open codex from the angel and then turns to eat it in a second episode at the right. His troping gesture literally visualizes the gloss in which the ingestion of the book signifies "divine Scripture turned in the mind." Trinity (fig. 69) further extends the cyclical narrative sequence. Following the densely compacted

episodes leading to John's taking the book in the upper frieze, the lower register opens up to focus first on the seer devouring the book. Then, seated on a writhing mound that provides a sympathetic metaphorical response to his acute gastric distress, a second figure of John continues the sequence of graphic reactions to the commentary: "By the mouth, in which all flavors are judged, we can understand the hearts of the apostles. By the abdomen, in which dwells all the filth of the body, we must understand the remembrance of our sins."[152]

The Morgan designer tropes the two archetypal illustrations for Rev. 10 to a different end. After isolating the episode of John being forbidden to write within a separate frame, he conflates the illustration for the rest of Rev. 10 with the first verse of Rev. 11 in a second illustration (fig. 70) in which John stands next to the temple at the right as he is handed a measuring rod from heaven at the same time as he takes the book from the mighty angel of 10:5 who

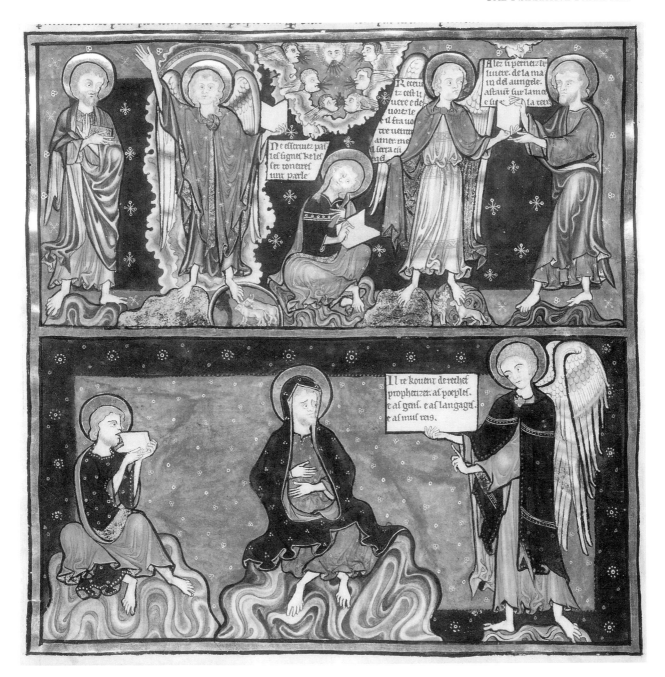

Figure 69. Apocalypse. Cambridge, Trinity College MS R.16.2, fol. 10v. John Forbidden to Write; John Eats the Book (photo: The Master and Fellows of Trinity College, Cambridge).

appears at the left. The angel no longer stands but is seated within an enveloping arc of twisted dark blue bands, presumably intended to visualize the messenger "wrapped in a cloud." The rainbow, interpreted in the gloss as representing not only Christ's mercy but also his divinity before the Incarnation, is distinctively rendered as an inverted arc.[153] A short quotation from the commentary ("The open book signifies the meaning of divine Scripture") confirms that the Morgan image was composed of elements

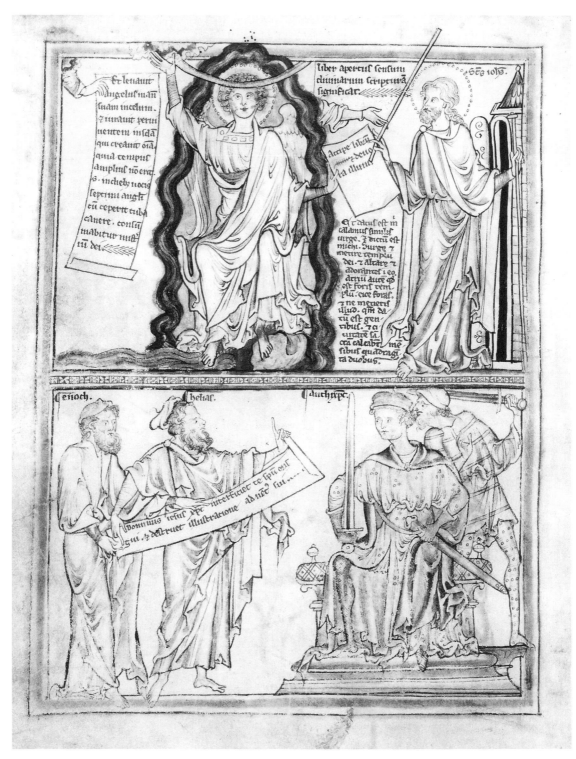

Figure 70. Apocalypse. New York, Pierpont Morgan Library MS M.524, fol. 6v. John Takes the Book and the Measuring Rod (above); Witnesses before Antichrist (below) (photo: The Pierpont Morgan Library).

arbitrarily reassembled from two illustrations in an earlier model.[154] Morgan's abrupt displacement and truncation of episodes appear to have been caused by the need to provide more space at this point for the interpolation of an Antichrist cycle in Rev. 11.

The designer of the paradigm was obviously eager to incorporate all four phases of the microdrama into two cyclically structured illustrations, but the merger and slippage of figural gestures among the Berengaudus manuscripts alert us to a problem posed by what was apparently perceived to be an inadequate archetypal representation of the text in Rev. 10. Up to this point, the seer has assumed that he is capable of transcribing his visionary experiences directly into his own book, following the divine protocol issued in Rev. 1:11 ("Write down all that you see in a book"). But now he learns that he must undergo a further step in his initiation before he is deemed worthy to record anything further. By juxtaposing the episode of John being forbidden to write with the appearance of the angel, a transaction as well as a condition is implied whereby one book will be substituted for another. The Evangelist cannot create his own Book of Revelation until he has accepted and absorbed a scripture given by the angelic messenger who, we are told in the commentary, is Christ himself. As John moves from the first densely filled moments to the single encounter with the angel, their relationship shifts from remoteness to intimacy, from the seer's peripheral spatial position to shared dominance in which John now "understands" the book in his heart and mind. In the second illustration, where the transaction is expanded into three stages of instruction and acquiescence, reception and consumption, a contract is offered and accepted in the juxtaposition of John taking and eating the book. At the same time, his digestion of the divinely delivered words serves as a multivalent metaphor for John's preparatory experiences, as he must acquire knowledge and wisdom by reading, comprehending, memorizing, and thus imprinting his soul with the contents of the book. John has not only been given the reportorial contents of his book in the form of divinely inspired visions, but is also now conditioned to perceive them within the framework of a new system of discourse represented by the book he has just eaten and digested. In Trinity, the conditioning process has been demonstrated to prove painful, and in Morgan, a further condition has been imposed upon John's taking the

book, as it is now coupled through its merger with 11:1–2 with his acceptance of moral and spiritual discipline signified by the measuring rod.

29. Measuring the Temple: *11:1–2*

> And I was given a measuring rod like a staff, and I was told, "Arise and measure the temple of God and the altar and those who worship there, but do not measure the courtyard outside the temple; leave that out, for it is given over to the pagans, and they will trample over the holy city for forty-two months."

Judging from the uniformity among thirteenth-century representations, the illustration for 11:1–2 showed John seated at the left receiving a long measuring rod from an angel standing in the center and gesturing toward an elaborate temple structure on the right (see fig. 71). In Getty, Douce, and Trinity, "the people who worship there" (11:1) are also represented. The commentary interprets the temple as the Church, the altar as its saints; the worshipers are those instructed in doctrine, and the rod signifies their acceptance of moral and spiritual discipline.[155]

Douce (fig. 72) makes a singular departure from the archetype and illustrates both parts of the text by dividing the space into three compartments, with John receiving the rod at the left, the temple with its altar and worshipers in the center, and at the right John again with the rod, pointing to the faithful

Figure 71. Apocalypse. Formerly Metz, Bibliothèque municipale MS Salis 38, fol. 16v. Measuring the Temple (photo: Monuments historiques, Paris).

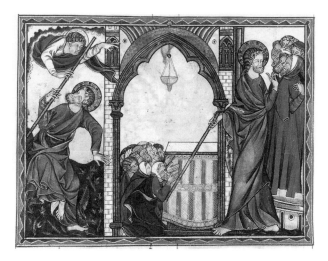

Figure 72. Apocalypse. Oxford, Bodleian Library MS Douce 180, p. 34. Measuring the Temple (photo: The Bodleian Library, Oxford).

In Metz (fig. 71), the book has fallen to John's lap, but the multivalent meaning of the rod is signaled by the angel's gesture, for he no longer extends the rod and points to the temple to signal a connection between the instrument and object of his command, but crosses his arms in a conflicted gesture, suggesting the anteriority and posteriority of the textual referents. Because the Metz illustration appears on a verso page facing the depiction of the preaching of the two witnesses, the tall candlesticks on the altar were probably intended to anticipate "the two lamps that stand before the Lord and in the world" on the facing recto. The distinctive gesture of the angel who crosses his arms as he gives the rod to John at the left and points to the altar at the right thus creates a pair of sagittal signs marking the textual references back and forth between the end of Rev. 10 and the beginning of Rev. 11.

30. Two Witnesses: *11:3–6*

> And I shall send my two witnesses to prophesy for 1260 days, wearing sackcloth. These are the two olive trees and the two candlesticks that stand in the presence of the Lord of the earth. And, if anyone tries to harm them, fire will come from their mouths and consume their enemies; if anyone tries to injure them, they will indeed be killed. They have the power to lock up the sky so that it does not rain on the days of their prophesying; and they have the power to turn water into blood and strike the earth with any other plague, whenever they will.

Notwithstanding the proleptic alliance between the first two verses and the rest of Rev. 11 in Metz's image of the angel's command to measure the temple, the next four episodes clearly constitute a hiatus in John's visionary narrative. Bracketed off from the prior sequence by the architectural barrier of the Temple in Heaven (see fig. 71), the "story" of God's two witnesses unfolds as an interlaced subtext in which John's role as witness has been temporarily suspended and supplanted as the terms of the prophetic discourse shift into a more direct and powerful exemplary mode.

Breaking with the conventional treatment of the two witnesses in early representations, the thirteenth-century English cycles activate these figures into miracle-working preachers to illustrate 11:3–6. As in Metz (fig. 73), the archetypal witnesses appear together in two back-to-back pairs. At the left, the two witnesses breathe fire upon a group of figures fallen on the ground, while those at the right face a group

kneeling at the altar and forbidding entry to the group of pagans who stand on the other side of a low parapet representing the atrium. The commentary interprets the "pagans" as Jews who remain outside through their unbelief.[156] In this singular instance where John appears to speak, he is accorded his special role as apostle to the people of the Old Law.[157] As Rosemary Wright observes, his backward glance leads across to the illustration of the witnesses preaching on the facing page, thus pairing him with the prophetic speakers who follow.[158]

The Metz manuscripts uniquely give the last verse of Rev. 10 at the beginning of this text along with the entire commentary, which refers to John's preaching on his return from Ephesus. Although there was sufficient room in Metz to have included the text at the end of the previous page with the rest of Rev. 10, the text and commentary were shifted to the beginning of Rev. 11 to connect them with the idea of John's mission to preach, signified by the bestowing of the rod to measure the temple as a prelude to the preaching of the two witnesses. Precedents for the merger of texts from the end of Rev. 10 with the beginning verses of Rev. 11 can be found in several early capitulations dating from the ninth century, such as Trier and Valenciennes, but it rarely had pictorial consequences outside Morgan (fig. 70), where John simultaneously takes the book and holds the measuring rod within a single miniature.

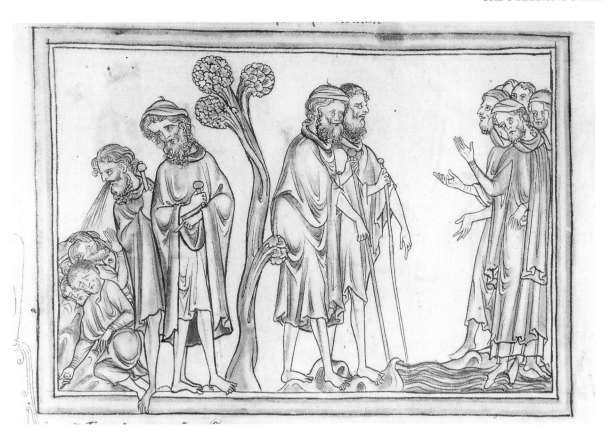

Figure 73. Apocalypse. Formerly Metz, Bibliothèque municipale MS Salis 38, fol. 17. Two Witnesses
(photo: Monuments historiques, Paris).

of spectators who point to the sky in reference to the miracles of locking up the sky and of turning water into blood. Stress on the miracles represents a new element of thirteenth-century discourse, as seen in the Harley version of the *Bible moralisée* where an abbreviated image succinctly evokes the commentary's interpretation of the witnesses' power to represent the power of the preachers against all sin. In the Berengaudus cycle, the commentary identifies the witnesses as Elias and Enoch, as they are labeled in Getty (fig. 74), who will precede the second coming of the Lord and represent spiritual wisdom *(sapientia spirituale).*[159] The two metaphorical trees and candelabra, however, appear only occasionally among the Berengaudus manuscripts and apparently did not enter into the formulation of the paradigm. The witnesses themselves are variously characterized among the thirteenth-century manuscripts, ranging from bearded Old Testament prophets in Jewish caps and

voluminous robes in Morgan and patriarchal bearded friars in Douce to the ascetic half-naked hermits wearing short mantles in Getty. The witnesses were probably intended to resemble ascetic desert fathers in Metz and Getty to evoke the parallel drawn by the exegete between their roles as preachers of the Second Coming and that of John the Baptist as the precursor of Christ's first Advent.[160]

Morgan and Fr. 403 (fig. 75) make a radical departure from the archetype by abandoning the miracle episodes altogether. Instead, the two witnesses stand together at the left, holding a scroll on which is inscribed the text from II Thessalonians 2:8: "The Lord will kill him with the breath of his mouth and will annihilate him with his glorious appearance at his coming." Although not quoted in the commentary, the Pauline text must refer to 11:5: "Fire can come from their mouths and consume their enemies."[161] The witnesses stand before a seated figure

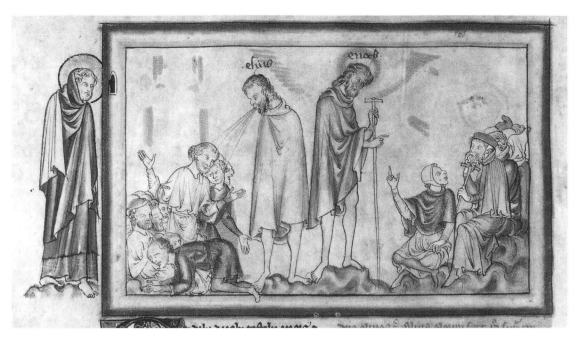

Figure 74. Apocalypse. Malibu, J. Paul Getty Museum MS Ludwig III.1, fol. 16v. Two Witnesses (photo: Collection of the J. Paul Getty Museum, Malibu, California).

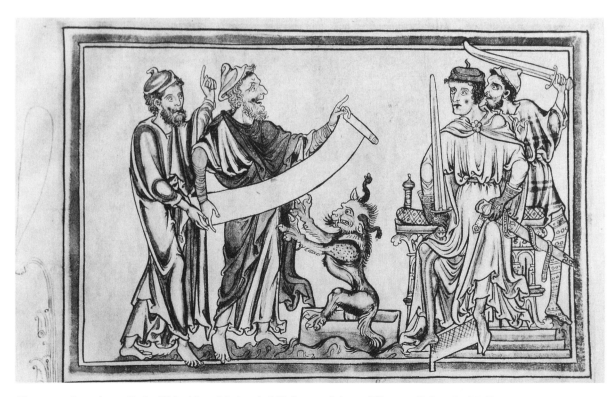

Figure 75. Apocalypse. Paris, Bibliothèque Nationale MS fr. 403, fol. 17. Witnesses Before Antichrist (Phot. Bibl. Nat. Paris).

in a soft pointed cap who draws his sword from its sheath; he is labeled Antichrist. Although the gloss asserts that the fire from the mouths of the saintly preachers will destroy the errors of Antichrist and his ministers,[162] the quotation from II Thessalonians appears in this context to anticipate the destruction of Antichrist by the breath of the Lord, which constitutes the last scene in the Antichrist cycle that follows.[163] A close precedent for the Morgan illustration appears in the commentary illustration for II Maccabees 6:18–19 in the Harley *Bible moralisée* (fig. 76). To accompany the short excursus ("At the end of the world the Lord will send Enoch and Elias against Antichrist to preach to the faithful"), the two witnesses stand before the upright figure of Antichrist, crowned and armed with an upright sword, as two kings block their path to the evil ruler.[164] Inspired by commentaries based on the *Glossa ordinaria*, thirteenth-century Bibles sometimes illustrate the death of Antichrist or Paul preaching against Antichrist within the historiated initial for II Thessalonians.[165]

The interpolation of episodes from the legend of

Figure 76. Bible moralisée. London, British Library MS Harley 1526, fol. 24v. Witnesses Before Antichrist (photo: after Laborde 1911–27).

Antichrist in Morgan was clearly motivated by the commentary on 11:2 in which the forty-two months of prophetic preaching are seen to signal the coming of Antichrist.[166] As Yves Christe points out, there is no reason to be surprised by the presence of Antichrist in the illustration of Rev. 11; the Berengaudus text justifies it.[167] What is surprising, however, is the extension of these scenes into a full-scale pictorial legend and its recourse to the tenth-century tract of Adso, *De ortu et tempore Antichristi*[168] or one of several later versions of the epistolary tract that were composed under different names.

The transformation of the bestial Antichrist into a diabolical human ruler figure, while relatively recent and not central to the Berengaudus cycle, was not without precedent.[169] In Vat. lat. 39, a richly garbed figure wearing a flaming crown and holding a foliated scepter commands the execution of the two witnesses from a lofty throne.[170] The Morgan illustration was probably based on a twelfth-century Antichrist cycle similar to that used for the *Hortus Deliciarum*.[171] Because the figure remains isolated in Morgan and the Gulbenkian subgroup of the Metz recension, the interpolation of the human Antichrist in the cycles for Rev. 11 can be regarded as an independent modification not present in the Berengaudus archetype.[172] Even in Fr. 403 (fig. 75), where the image depends directly on the Morgan model, the textually grounded notion of Antichrist as the beast from Rev. 9 has not been shaken off entirely. To clarify that the Morgan miniature is intended to illustrate 11:3–6, Fr. 403's designer adds a small beast emerging from a box between the witnesses and Antichrist's throne as a reference to "the beast that comes out of the abyss."

31. Death of the Witnesses: 11:7–8

> And, when they have completed their witnessing, the beast that comes out the abyss shall make war against them and shall overcome them and kill them. Their bodies will lie in the street of the great city which is spiritually called Sodom and Egypt, and where their Lord was crucified.

The Berengaudus cycle continues to illustrate the subtext with a fully developed representation of 11:7–8 (see fig. 77) based on a model similar to that in the *Bible moralisée* in which the text is interpreted literally and the witnesses are attacked by a beast. In

Figure 77. Apocalypse. Formerly Metz, Bibliothèque municipale MS Salis 38, fol. 17v. Massacre of the Witnesses (photo: Monuments historiques, Paris).

the English archetype, "the beast that came out of the abyss" is endowed with the unmistakable features of the hybrid locust creatures that had emerged from the bottomless pit (see fig. 63). The innovative alliance between the beast from the abyss in 11:7–8 and the locust-beasts from 9:7–10 was probably provided by their common association with Antichrist in the commentaries most widely circulated in England in the thirteenth century. The Berengaudus gloss for Rev. 11 asserts that the beast signifies Antichrist.[173] To the literal bestial characterization of the creature from the abyss in Rev. 11, Metz adds a winged, crowned figure holding a scepter of authority to command the massacre as he rides one of the locust beasts, copied from the figure of Abaddon illustrated in Rev. 9 (see figs. 63 and 77). In Metz and Trinity, the prospective time lapse in the narrative given in 11:8 ("the corpses will lie in the main street of the Great City") is pictorialized in the juxtaposition of one witness being massacred while the other already lies dead outside a low crenellated wall.

Morgan (fig. 78) departs altogether from the ar-

chetype to concentrate on the action of a human Antichrist whose miracles and downfall appear in a cycle of three illustrations interpolated into the Apocalypse at this point. The witnesses are beheaded by human executioners at the command of an enthroned ruler. The depiction of the martyrdom as a decapitation by swordsmen appears in very old cycles, such as the Beatus manuscripts and Berlin 561, and represents an iconographical tradition that developed fairly early as an alternative to the more literal pictorialization of the beast in response to exegetical texts that identified the beast from the abyss as Antichrist. Adopting a strategy similar to that seen in the representation of Antichrist commanding the execution of the witnesses in the *Bible moralisée,*[174] Morgan provides the commanding ruler figure with an upright sword instead of the scepter that serves as his attribute of power in Metz, thus registering a more immediate causal link between Antichrist and the massacre.

Apparently dissatisfied with both the locust and human images of the beast for Antichrist, the de-

Figure 78. Apocalypse. New York, Pierpont Morgan Library MS M.524, fol. 7. Massacre of the Witnesses (photo: The Pierpont Morgan Library).

Figure 79. Apocalypse. Malibu, J. Paul Getty Museum MS Ludwig III.1, fol. 17. Massacre of the Witnesses (photo: Collection of the J. Paul Getty Museum, Malibu, California).

signer of Getty (fig. 79) renders him literally as a bestial figure in an antecedent episode where he emerges from the pit of the abyss, before he himself massacres the witnesses with a sword. Getty's cyclical illustration reveals the witnesses first standing before a menacing emergent Antichrist, preaching the admonitory sermon of II Thessalonians 2:8, as in Morgan, before the bestial figure labeled Antichrist. In contrast with the conventional representations of violent destruction in Morgan and Metz, Getty's image stresses the idea of rupture and cleavage, as the witnesses, who were initially joined in the first episode, are ripped apart by the beast's scimitar. The centripetal movements of the two episodes fractures the narrative unity of the framed illustration, causing the groups of figures to break apart in opposing directions, just as the witnesses themselves are pulled apart in an anticipatory move on the facing verso (fig. 74).

32. Rejoicing over the Dead Witnesses: *11:9–10*

And their corpses will be seen by every tribe and people and tongue and nation, for three-and-a-half days, without allowing them to be buried. And those who dwell upon the earth will rejoice over them and they will celebrate and exchange gifts; because these two prophets had tormented all who dwelled upon the earth.

In the thirteenth century, both the *Bible moralisée* and the Berengaudus cycle (see fig. 80) add an illustration of the rejoicing over the dead witnesses for 11:9–10. Although the text specifies that the bodies of the witnesses lay in the main street of the great city, their placement outside the crenellated wall extending between two towers or city gates, as in Getty and Trinity, draws the viewer's attention to the commentary that interprets the failure to bury the corpses to signify that just men are outside the walls, whereas those inside are full of iniquity.[175] In Paris lat. 10474,

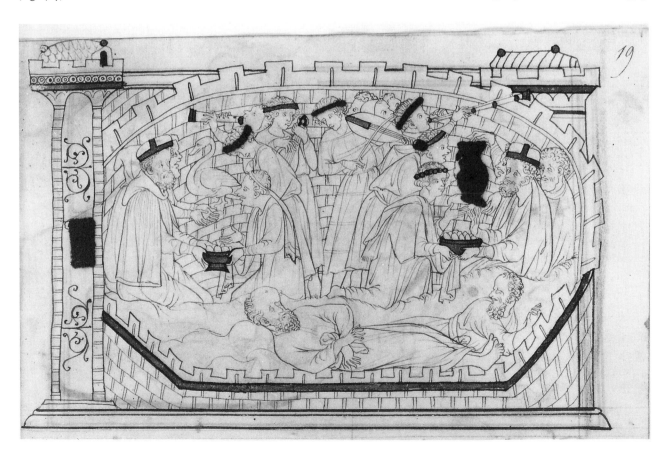

Figure 80. Apocalypse. Paris, Bibliothèque Nationale MS lat. 10474, fol. 19. Rejoicing over the Dead Witnesses (Phot. Bibl. Nat. Paris).

however, the whole scene is given within the elliptical circumference of the city walls, transforming the event into a spectacle performed in an amphitheater. By focusing on the spectators within the city, the image draws the reader's attention to the commentary in which a metaphorical distinction between inside and outside is drawn between historical and spiritual understanding,[176] thus stressing the theme of the spiritual understanding of the text that runs as a leitmotif throughout the Berengaudus commentary.

33. Resurrection and Ascension of the Witnesses: 11:11–14

And after three-and-a-half days, the spirit of life entered into them from God. And they stood up, and a great fear came upon those who saw them. And they heard a loud voice from heaven say to them, "Come up here." And at that hour there was a great earthquake, and a tenth of the city collapsed; seven thousand persons were proclaimed dead in the earthquake; and those who remained were seized with fear and gave glory to God in heaven.

The prophetic interlude concludes with a representation of the resurrection and ascension of the witnesses, thus providing a satisfying image of vindication and reward, following the frustration of their heroic sacred mission by persecution, death, and humiliation at the hands of the archenemy. Both phases of the witnesses' resurrection and ascension are represented in a conflated narrative image (see fig. 81) showing the corpses lying on the ground with doves flying into their mouths in a literal pictorialization of "God breathing life into them." Because the commentary stresses that when "they stood up," it was the time of resurrection,[177] the two figures offer a literal demonstration of their resurrection as well as their subsequent ascension. The upper bodies of the witnesses are cut off by the frame, conforming to the pervasive image of the "disappearing Christ" in English Ascension scenes.[178]

Whereas Morgan stresses the vindication of the witnesses' martyrdom in the literal destruction of Antichrist at the end of his illustrated legend, the archetype structures the last image as a binary contrast between the rising witnesses and the downfall of their enemies. At the right, the earthquake is represented in terms of its consequences, falling buildings and tumbling figures. As in Getty, the victims of the earthquake are differentiated into two groups: those who die, representing "a tenth of the city," and "the survivors who, overcome with fear, could only praise the God of heaven," to respond to the commentary that identifies those who die as the Jews who observed the Law and the survivors as the remnant of Jews to be converted at the end of time.[179] As the two illustrations for the Rejoicing and the Resurrection are juxtaposed on facing verso and recto pages in the archetype, virtue is vindicated and wickedness finds its retribution.

The complex sequences of pictures created for the text of 11:3–14 have attracted a great deal of scholarly attention focusing on the interpretation of the Antichrist interpolations. We should not forget, however, that they were not generated *in vacuuo*, but constituted answers to a question that was initially formulated in the discourse of the English Gothic Apocalypse. Briefly stated, the problem hinges on developing a pictorial strategy that would best focus the discourse on the meaning of the illustrative sequence as it is explicated in the Berengaudus commentary.

Following John's acknowledgment of the command to measure the temple at the beginning of Rev. 11, the narrative suddenly reveals an important entropy, for it is the voice of God, not John, that constitutes the "I" who announces in 11:3, "But I shall send my two witnesses to prophesy for these 1260 days." The seer is no longer present to the reader as a mediating witness or authorial voice. Just as the space outside the temple is not to be measured, the time span, albeit carefully measured, lies outside the realm of his vision. Where can it be securely placed within the reader's framework of comprehension? The interlude of the witnesses belongs to a liminal and hence dangerous realm of direct prophecy, inhabiting a limbo between scriptural "history" and the future end of time.

In the narrative amplitude of an English Gothic cycle such as Metz, Westminster, or Trinity, the sequence of events constitutes a metaphorical microdrama of the Christ legend – ministry, preaching, death, resurrection, and ascension. For the thirteenth-century reader, the witnesses cannot be seen simply in terms of contemporary hagiography but in the context of their unfolding *imitatio Christi*. As they embody spiritual wisdom preceding the Second Coming, they are opposed by the archdeceiver who

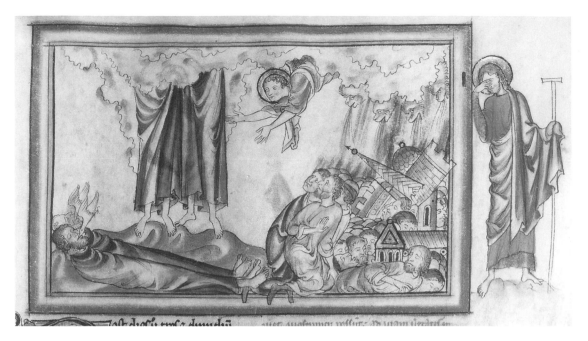

Figure 81. Apocalypse. Malibu, J. Paul Getty Museum MS Ludwig III.1, fol. 18. Resurrection of the Witnesses (photo: Collection of the J. Paul Getty Museum, Malibu, California).

claims that he is Christ, but his deceptions are belied by the true *imitatio Christi* enacted by the witnesses. Whereas Berengaudus makes a coherent hermeneutic connection between the text of Rev. 11 and the Antichrist legend, the interpolation in Morgan goes far beyond the parameters laid out in the twelfth-century exegetical text, as it appropriates the scriptural account of the witnesses into the realm of apocrypha to make the point. The sacred myth no longer ends with the ascension of the witnesses, but with the death of Antichrist in a vindictive circumscription of the prophetic trope.

34. Seventh Trumpet: *11:15–18*

> And the seventh angel sounded his trumpet; and there were great voices in heaven saying: "The kingdom of this world belongs to our Lord and his Christ, and he shall reign for ever and ever. Amen." And the twenty-four Elders, who are enthroned in the presence of God, fell on their faces and adored God, saying: "We give thanks to you, Lord God almighty, he who is and he who was, because you have assumed your great power and you have reigned. And the nations were angry, and the time has come for your own wrath, and the dead to be judged, and for your servants the prophets, for the saints and for all who worship you, small or great, to be rewarded. The time has come to destroy those who are destroying the earth."

The Berengaudus archetype breaks with older reductive traditions that simply show the angel sounding the seventh trumpet. As in the *Bible moralisée*, a major new focus is given to the twenty-four Elders adoring the Lord in Majesty (fig. 82). To visualize the identification of the twenty-four Elders with the souls of the saints who dwell with the Lord in celestial beatitude in the gloss, the angels mirror the Elders' adoring gestures in two symmetrical groups flanking the Lord. At the same time a traditional focus on the angel blowing the seventh trumpet is maintained to respond to the commentary in which the celestial messenger is interpreted as the "holy preachers who are born at the end of the world."[180]

Although the voices in heaven are interpreted in the commentary as the saints who exalt the coming of the Lord to judgment,[181] the archetypal illustration stresses the vertically structured realization of the kingdom of the Lord on earth. The crowned Elders adoring the celestial Lord can thus be read as a legion of earthly vassal-kings recognizing their supreme Lord, as suggested by the inscription, "Confessio regnum," given in Morgan and by the angel in Metz who holds a small scroll inscribed "Factum est regnum."

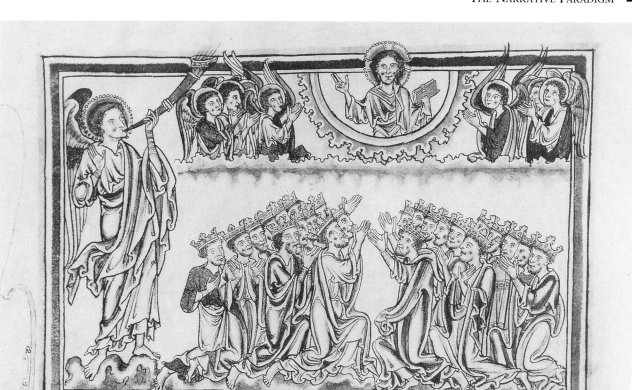

Figure 82. Apocalypse. Paris, Bibliothèque Nationale MS fr. 403, fol. 18v. Seventh Trumpet (Phot. Bibl. Nat. Paris).

Following the prophetic interlude of the witnesses' narrative, the episode of the Seventh Trumpet ends the sequence of "voices" that began in Rev. 8 on a note of hiatus, focusing on the Kingdom of God as a manifestation of hierarchical power in heaven and on earth. Unlike its predecessors, the destruction promised by the seventh angel ("the time has come to destroy those who are destroying the earth") is delayed until the next frame illustrating the last verse of Rev. 11, in which God's sanctuary in heaven opens in paratactic juxtaposition with the ensuing lightning, thunder, and earthquake.

35–36. Ark of the Covenant: *11:19;* Woman in the Sun: *12:1–6*

> And the temple of God was opened in heaven, and his Ark of the Covenant could be seen in his temple, and there were flashes of lightning, voices, and an earthquake, and great hail.

> And a great sign appeared in heaven: a woman clothed in the sun, standing with the moon at her feet, and upon her head a crown of twelve stars. And having pains in the womb, she cried out and was in torment to be delivered. And another sign was seen in heaven, and behold a great red dragon having seven heads and ten crowns, and on his head were seven crowns; and his tail dragged down a third of the stars in heaven and cast them on the earth; and the dragon stood before the woman who was in labor, so that, as she gave birth, he could devour her son. And she gave birth to a male child, who was to rule all peoples with an iron rod; and her son was carried away to God and to his throne; and the woman fled into the wilderness, where God had prepared a suitable place, so that she would be cared for for 1260 days.

In the earlier cycles, the last verse of Rev. 11, with its dramatic revelation of the Ark of the Covenant as the sanctuary of God opened in heaven, is either included with the Seventh Trumpet or isolated, so that the illustrated text can function to conclude the sequence of seven trumpets. Among the Berengaudus manuscripts, only Trinity and the Metz group follow

the early capitulation that merges the last verse of Rev. 11 with its illustration for the Woman in the Sun (see fig. 86), whereas the Morgan and West-minster groups isolate 11:19 as an independently il-lustrated text. The migration of 11:19 to the beginning of Rev. 12 suggests that its probable iso-lation in the archetype caused a problem for later designers.

Although the first-person narrative voice of the seer is still silent in this passage, John reappears to witness the vision of the temple of God in heaven, in response to the text's conditional locution that "it could be seen." In Getty (fig. 83), the celestial sanc-tuary is rendered as a Gothic church structure, raised on a bank of clouds. Within the open sanctuary, which signifies the Old Testament in the gloss, the

Ark of the Covenant is revealed in the form of an ornate Gothic shrine similar to the magnificent struc-ture created for Edward the Confessor's tomb in Westminster Abbey that was visually described in the chronicles of Matthew Paris.[182] Standing on a vested altar, the Ark of the Covenant is interpreted by Ber-engaudus as the New Testament and its sacraments revealed in the Old Testament opened by Christ.[183] The archetypal Ark of the Covenant appears on a recto page adjoining the Seventh Trumpet on the op-posite verso, so that the two celestial visions of the kingdom of the Lord and the Temple of God in heaven (figs. 82 and 83) are juxtaposed to conclude Rev. 11.

Morgan (fig. 84) deviates from the archetype by deleting the "lightning, peals of thunder, earthquake,

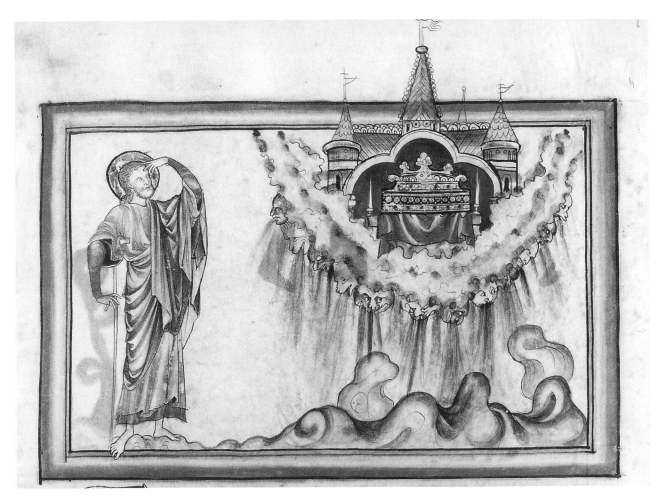

Figure 83. Apocalypse. Malibu, J. Paul Getty Museum MS Ludwig III.1, fol. 19. Ark of the Covenant (photo: Collection of the J. Paul Getty Museum, Malibu, California).

Figure 84. Apocalypse. New York, Pierpont Morgan Library MS M.524, fol. 8. Ark of the Covenant (photo: The Pierpont Morgan Library).

and hail," as well as the figure of John, to concentrate exclusively on an expanded spectacle of the temple and the Ark of the Covenant now dominating the center of a symmetrical composition. There is no text incorporated within the frame aside from the two legends identifying the *templum dei* and *archa testamenta*. In Morgan, the illustration for 11:19 appears in the lower register of a recto page, anticipating the image of the Woman in the Sun for 12:1–6 (see fig. 85) at the head of the next verso. In accordance with the commentary, the reader-viewer is to understand the *Templum dei* as the subsequent figure of Mary.[184] The temple of God containing the Ark of the Covenant then becomes a potential vessel for Christ incarnate, and the opening of the temple serves as a metaphor for the birth of Christ from Mary's womb. The altar being censed by angels is thus empty, awaiting the reception of a new Covenant. In Morgan, the sequential images of the temple and the woman in the sun stand as mutually reflexive pictorial metaphors for the Nativity.

Following the old Carolingian capitulation, which incorporates 11:19 into the beginning of Rev. 12, the Metz manuscripts (fig. 86) merge the Ark of the Covenant with the first illustration of the Woman in the Sun. Metz's more intimate juxtaposition of the Temple of God and the Woman in the Sun serves to clarify their interchangeable relationship, as the dragon turns to threaten the sanctuary in heaven, as well as the maternal figure who serves as a symbol of Holy Church at the right. The commentary given in Metz

refers only to 12:4 ("And the dragon stopped in front of the woman as she was having the child so that he could eat it as soon as it was born"), explicating the woman as Mary, the mother as the Church, and the dragon as Herod who tried to kill Christ at his birth.[185] In the Metz miniature, the seven-headed dragon forms a pivotal link fusing the two disparate halves of the composition. His seven heads rotate in both directions to threaten both the open tabernacle and the woman with her child. The Metz designer replaces the violent images of thunders, hail, and earthquakes that appear beneath the Temple with small animals peacefully grazing in a landscape, conveying the idea of a tranquil earth under the aegis of the celestial Church. The ornate shrine within the sanctuary has been replaced by a single tall candle on the altar, flanked by two small hanging lamps, creating a pictorial reference to the Ark of the Covenant that appropriates the temple of God from the Old Dispensation as a figure for the Church.

In illustrating 12:6, the Berengaudus image (see figs. 85 and 86) follows a more traditional path by emphasizing the rescue of the child. The woman is surrounded by a huge flaming aureole as she reclines in bed, her legs extended to the left, the crescent at her feet, making a contrapposto turn as she hands the child to an angel within a half-mandorla frame in the upper right corner. In the commentary, both the seventh head and the tail of the dragon are identified as Antichrist, who drags down a third of the stars in an action that prefigures Antichrist's deceptive seduction of some of the wisest and most excellent men (stars) of his age.[186] Morgan and Getty (figs. 85 and 87) make a point of expressing this idea pictorially. As Freyhan points out, the Morgan designer solves the problem of drawing visual attention to the commentary's reference to Antichrist by representing the dragon with six heads and affixing the seventh to its tail, with the inscription, "Cauda draconi antichristum significat," whereas Getty and its related manuscripts add an eighth head to the tail in contradiction of the text.[187]

As in Morgan, the archetypal composition is constructed on an ascending diagonal rising from the dragon at the lower left to the angel in heaven at the upper right in an eloquent visual metaphor expressing the gloss on the rescue of the child as the Ascension of Christ.[188] The idea of ascension is made even more salient in Getty (fig. 87), where the rising di-

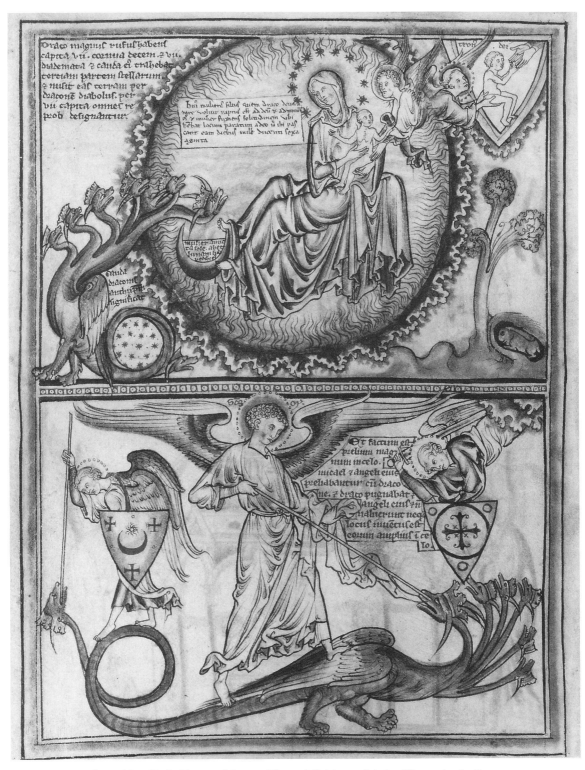

Figure 85. Apocalypse. New York, Pierpont Morgan Library MS M.524, fol. 8v. Woman in the Sun (above); Michael Battling the Dragon (below) (photo: The Pierpont Morgan Library).

■ 120

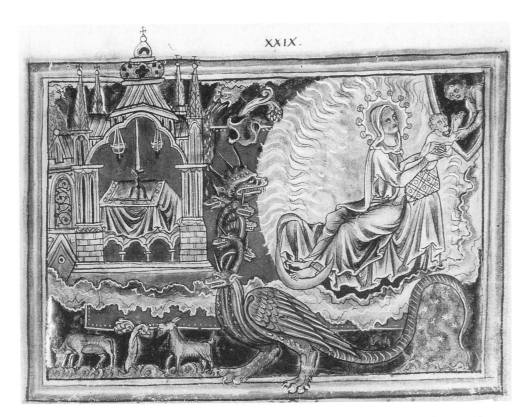

Figure 86. Apocalypse. London, Lambeth Palace Library MS 209, fol. 15. Woman in the Sun (photo: The Conway Library, Courtauld Institute of Art, London).

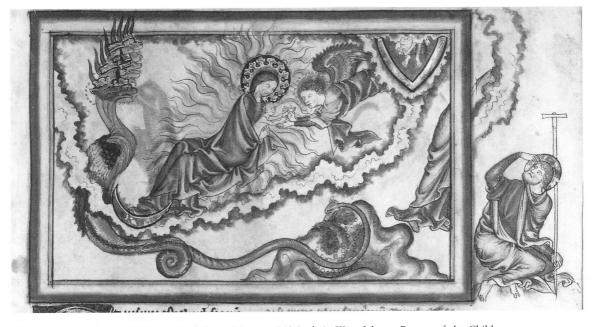

Figure 87. Apocalypse. Malibu, J. Paul Getty Museum MS Ludwig III.1, fol. 20. Rescue of the Child (photo: Collection of the J. Paul Getty Museum, Malibu, California).

agonal stream of clouds culminates in a mandorla-framed image of the Lord's feet, quoted from the distinctive English iconography of the "disappearing Christ." The rescue is thus rendered in two successive actions, where the woman hands the child to the angel who is then shown a second time carrying him to heaven. Ideally, however, the space beneath the rescued child at the right should be occupied by the figure of the woman finding refuge in the desert to illustrate 12:6, as in the later French Burckhardt-Wildt version of Metz (fig. 88), where she is seated holding a book. Trinity (fig. 89) expands the illustration to fill a whole register below the rescue of the child so that they form a complementary pair of parallel scenes, with the dragon repeated at the left, menacing the woman in her safe refuge in anticipation of the pursuit that follows in 12:13. To fill the empty space left by the rescued woman in the upper register at the right, the Trinity designer has added a full-length figure of the rescuing angel in a composition that now places the mother solidly in a four-poster bed on the ground, so that the narrative action moves horizontally rather than on an ascending diagonal. Because the Metz designer shifted the figure of the rescued child to the right to accommodate the Ark of the Covenant at the left, there was no longer enough space to include the woman in the desert within the same frame, thus causing the Metz designer to shift this figure, still seated with her book in a landscape, to the next verso page (see fig. 90), where the illustration for 12:6 now appears at the left of the scene depicting Michael battling the dragon, out of alignment with the accompanying text for 12:7–12.[189]

The archetypal figure of the woman escaping into the desert represents a new image that may have been introduced for the first time in the *Bible moralisée*, where a similar representation of the woman seated in landscape and holding a book appears next to the angel holding the rescued child to stress the gloss that interprets the woman's escape into the desert as the Church's separation from worldly pleasures, a meaning closely paralleled in the Berengaudus commentary.[190] The motivation for the image in Trinity is clearly given in the gloss, for directly beneath the figure of the rescued woman elegantly enthroned on a mound of earth fed by streams and flanked by twisted trees we read: "This woman signifies Holy Church, [and] in this place we can understand

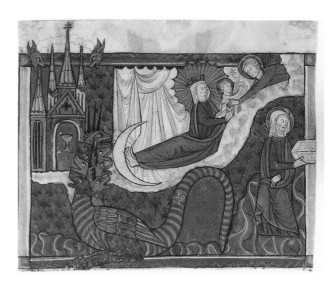

Figure 88. Apocalypse. Formerly Burckhardt-Wildt Collection, fol. 24. Ark of the Covenant and the Woman in the Sun (photo: Sotheby's, London).

'heaven' to mean the world."[191] In Getty (fig. 87), the escape is rendered more actively and literally as a fractional figure disappearing through the frame into the clouds in the right margin, thus locating the duration of her rescue in a liminal interval outside narrative time.

The Westminster manuscripts (see fig. 91) deviate from the archetype by interpolating a new illustration for 12:1–2 between the miniatures for the Ark of the Covenant and the Rescue of the Child. In all the manuscripts of the Westminster group except Paris lat. 10474, the added illustration appears on a page facing the rescue, forming a juxtaposition of images that finds an early thirteenth-century precedent in Vat. lat. 39.[192] Although John has not yet reentered the narrative, the interpolated illustration shows him standing at the left to witness the appearance of "the great sign in heaven" in the form of the woman in the sun, holding her swollen abdomen in a gesture denoting the "pangs of childbirth." The addition of an extra scene at this point created a pair of facing pages devoted to the opening six verses of Rev. 12, enabling the insertion of a commentary on the first two verses.[193] The new image visualizes the added commentary's evocation of Christ as the true sun and its interpretation of the woman in the sun as the faithful baptized in the Church by amplifying the solar frame around the cen-

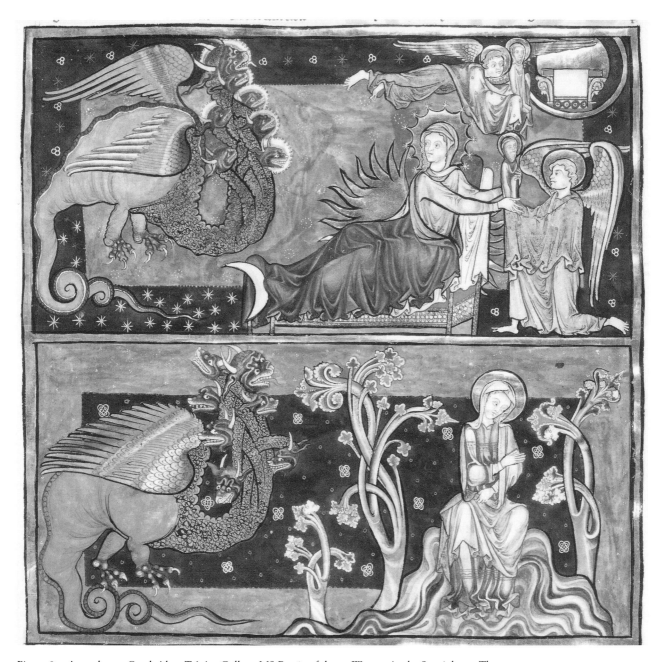

Figure 89. Apocalypse. Cambridge, Trinity College MS R.16.2, fol. 13. Woman in the Sun (photo: The Master and Fellows of Trinity College, Cambridge).

tral figure into a magnificent radiance that forms the dominant image.[194]

Unlike the preceding interlude of the witnesses, which was intended to be read as prophecy pertaining to the future and the end of time, the narrative

of Rev. 12, heralded as "a great sign," is to be perceived as an openly declared metaphor or allegory of past or present events. In contrast with earlier traditions of illustrating and explicating this apocalyptic text, the designers of the Berengaudus cycles,

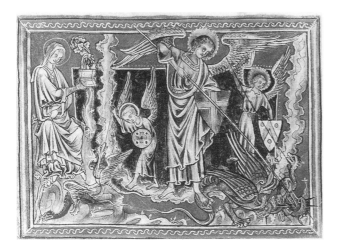

Figure 90. Apocalypse. London, Lambeth Palace Library MS 209, fol. 15v. Michael Battles the Dragon (photo: The Conway Library, Courtauld Institute of Art, London).

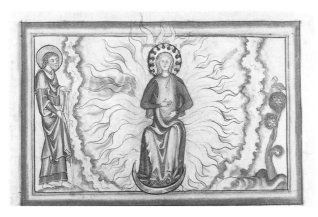

Figure 91. Apocalypse. Malibu, J. Paul Getty Museum MS Ludwig III.1, fol. 19v. Woman in the Sun (photo: Collection of the J. Paul Getty Museum, Malibu, California).

like the architect of the *Bible moralisée*, juxtaposed the rescue of the child, interpreted in the commentaries as the ascension of Christ, with the woman's escape from the dragon, which was read allegorically as the Church's separation from the world. The observable tropes among the English Gothic cycles seem to be attempting to reconcile the parallel but at the same time diverging Christological and ecclesiological thrusts of the metaphorical narrative into a coherent sequence of images without reaching a consensus about how this ought to be done. Equally cen-

tral to the pictorial structuring of the text passage is its implied relationship to the metanarrative of the whole chapter, for the victory and respite are only temporary. Trinity's designer expanded the image into superposed registers (fig. 89) to express the simultaneity as well as the separation of the rescue and escape as they transpire in the differentiated hierarchical spaces of heaven and earth. Thus, in Trinity, the dragon still threatens the woman in the desert; in the later French Burckhardt-Wildt version (fig. 88), the narrative suspense is sustained by the woman's gesture of thrusting her open book beyond the frame, again alerting the reader that there is more to follow.

37–38. Michael Battles the Dragon: *12:7–9*; The Fall of Satan: *12:10–12*

> And there was a great battle in heaven: Michael and his angels fought with the dragon, and the dragon and his angels fought back; and they did not prevail, nor was a wide enough place found for them in heaven. And the great dragon was cast out, that ancient serpent, who is called the Devil and Satan, who seduced the whole world, and he was cast down upon the earth, and his angels were sent with him.
>
> And then I heard a great voice in heaven saying: "Now salvation and strength and reign are won by our God. . . . Let the heavens rejoice and all who dwell therein. Woe to the earth, and to the sea, because the devil had come down to you in great anger, knowing that he had but a short time."

In a significant departure from the early cycles in which the monumental image of Michael Battling the Dragon stands alone, the Berengaudus designers pay more lavish pictorial attention to the subtext describing the war in heaven by developing a narrative sequence comprising the battle itself followed by the fall of Satan and his angels. In the first scene, a Herculean archangel dominates the dragon (fig. 85), echoing the tradition of the twelfth-century pictorial Apocalypses where Michael tramples the body of the beast.[195] The Berengaudus gloss interprets the archangel as Christ subjugating the devil through his Passion, so that Michael's victory represents salvation for all the elect,[196] thus accounting for the singular dramatic focus on the first verses of the text as well as the gesture of *calcatio* from the familiar iconography of Christ Trampling the Beasts from Psalm 90. While the archangel thrusts the lance into the mouth of the dragon's first head, smaller angels pierce the gullets of lesser dragons. The dissemination of the

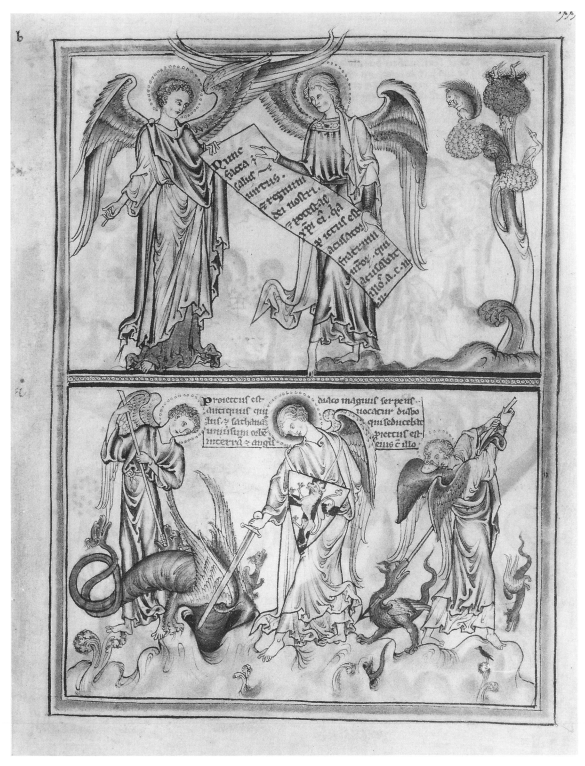

Figure 92. Apocalypse. New York, Pierpont Morgan Library MS M.524, fol. 9. Announcement of Victory (above); Fall of Satan (below) (photo: The Pierpont Morgan Library).

battle action to the ancillary engagements draws the reader's attention to 12:7 ("And the dragon fought back with his angels"), which Berengaudus explains as an allegory for the devil and his demons who stirred up the Jews and pagans against Christ's apostles so that they would be persecuted and killed.[197]

Following the war in heaven, Morgan interpolates an elegant composition (fig. 92) in which two tall, graceful angels hold a scroll inscribed with the victory message from heaven (12:10).[198] The angelic pair do not quite fill the composition, leaving an empty space at the right marked with idyllic landscape "fillers." The interpolated image is given out of textual sequence, as it precedes rather than follows the illustration for 12:9, which appears below. Although Morgan inserts the angels personifying the "voice from heaven" out of order, the image occurs in a logical narrative position between two representations of the battle, an innovation that could be made only in a version without a full accompanying text, and at the same time positions the celestial proclamation of victory in an appropriately "superior" place above the vanquished enemy. The juxtaposition of eirenic calm prevailing over the violence of battle further fixes the idea of an eternal dimension lying outside the dynamic flux of narrative time and thus reinforces the idea of the coexistence of timeless eternity and temporal narrative within the framework of John's visions.

The representation of the "great voice shouting from heaven" appears to have formed an important

Figure 94. Apocalypse. Paris, Bibliothèque Nationale MS lat. 10474, fol. 22v. Fall of Satan (Phot. Bibl. Nat. Paris).

component of the archetypal illustration of the Fall of Satan.[199] In the commentary, the celestial pronouncement signals salvation for humankind, quoting from Luke 15:7: "There will be more rejoicing over one repentant sinner than over ninety-nine virtuous men."[200] Having already been announced by angels proclaiming the victory message in the upper register, Morgan's illustration of the Fall of Satan in the lower register (fig. 92), simply reverses the composition for Michael's battle in heaven. The largest angel in the center faces left as he plunges a sword into the dragon, pushing the dragon's heads into a hole in the rough terrain in a literal representation of his fall to the earth, anticipating the episode in Rev. 19 of the Beast cast into hell. The large triangular shield suspended around the neck of the archangel is emblazoned with a crowned lion rampant against a blue cross on a white ground, suggesting a possible reference to Richard of Cornwall's Crusade of 1240–1.[201]

Contrasting with the disjunct sequences developed for 12:7–12 in Metz and Morgan, the Westminster cycles follow their representations of the Battle in Heaven with an image that focuses exclusively on 7:12, as in Getty (fig. 93), where an angel flies down from a cloud bank, but instead of holding a scroll to proclaim the victory message of 12:10, he raises his hands to refer to the first words of 12:12 – "Let the heavens rejoice." Next to the angel appears another heavenly messenger bearing a scroll inscribed with the warning of trouble for the earth and the sea, as he points to the "devil gone down in a rage." The hooves of this horned, hairy demon extend beyond

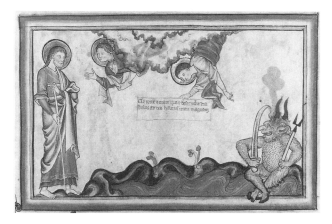

Figure 93. Apocalypse. Malibu, J. Paul Getty Museum MS Ludwig III.1, fol. 21. Fall of Satan (photo: Collection of the J. Paul Getty Museum, Malibu, California).

the frame into the reader's space of the text, in which the word "dyabolus" occurs twice in the four lines of commentary below. Direct images of the devil, such as that given in Getty, are almost unprecedented in the English Gothic Apocalypses, where Satan is always represented under one of his many guises as the dragon, beast, or the human Antichrist. As Michael Camille has observed, representations of evil caused a disconcerting unease in the medieval viewer, as attested by countless private acts of exorcism in erasures of manuscript representations.[202] Although in other medieval contexts artists and viewers sought to make the devil visible in order that the represented force of evil, once depicted, could be controlled as a visual sign capable of being overturned and erased, the prophetic context of the Apocalypse coupled with the mnemonic power of its images probably caused the designer of Paris lat. 10474 (fig. 94) to render the satanic presence invisible. In an otherwise carefully finished graphic representation of the angel announcing the victory as well as his prophetic warning, the omission can be read as an attempt to render the demonic presence powerless by denying him visibility. Nevertheless, in contrast with the Getty's brash representation, the large spatial gap left in Paris lat. 10474 now appears all the more ominous, for there is nothing more terrifying than the enemy we cannot see.

The first lines of the subtext constitute a straightforward narrative explaining the origins of the dragon in the guise of Satan cast out of heaven as the fallen Lucifer, clearly focusing on two centers of action, the battle with Michael and his archangels and Satan's fall to earth. The endemic confusion and entropy among the thirteenth-century manuscripts was probably generated by an archetypal text division that ignored the logical separation of the conflict from its outcome, by fusing the battle and fall into a single complex and dynamic pictorial narrative, followed by a static moment of victory, as in Getty. The meaning of the resultant illustrations was no longer self-evident, causing Morgan to divide the text further into three separately framed but sequentially garbled actions (figs. 85 and 92). Only Trinity, because it maintained the integrity of the subtext for 12:7–12, managed to provide a coherent visual account of the consecutive actions in a cyclical sequence, but the contrasting reactions of heavenly celebration and lingering satanic rage, which were so eloquently developed in the Morgan and Westminster manuscripts and which are essential to understanding the subsequent episodes of Rev. 12, are relegated in Trinity to the periphery and consequently lost.

39–40. The Woman Given Wings: 12:13–14; The Woman Pursued by Dragon: 12:15–16

> And when the dragon saw that he was cast down upon the earth, the woman who gave birth to the male child was persecuted; and the woman was given two large eagle's wings, so that she could fly into the desert, to the place where she was nourished for a year and twice a year and half a year. And the serpent vomited from his mouth water like a river after the woman, so that she would be carried away by the river. And the earth helped the woman and the earth opened its mouth and swallowed up the river which the dragon sent out from his mouth.

Perhaps in an effort to create a pictorial narrative symmetry with the first two episodes of rescue and escape for 12:1–6, in tandem allegories of Christ and the Church, the designer of the English Gothic cycle broke with tradition by isolating 12:13–14 for a special illustration (fig. 95). Because the ancillary action of 12:14 follows the introduction of the dragon's pursuit, it is easy to see why earlier illustrators had been reluctant to disrupt the pictorial narrative to insert an illustration of the angel providing the woman with wings. This aspect of Rev. 12 is customarily ignored in the older cycles or conflated with the woman's flight. In the *Bible moralisée*, however, the texts for 12:13–16 are combined in a single illustration (fig. 96) that closely resembles the Berengaudus archetype. The singular isolation of 12:13–14 serves the purposes of the commentary by drawing visual attention to the eagle's wings, which are interpreted as the two Testaments, as demonstrated in the commentary illustration where Ecclesia holds the two tablets of the Law and an open codex.[203] A similar hermeneutic purpose probably motivated the designer of the Berengaudus archetype to isolate the text in order to provide an illustration for the commentary in which the eagle is identified as Christ and the two wings are given to the woman in the same way that the Church receives and accepts two Testaments.[204] In the archetypal image, the angel has already positioned the first wing on the woman's shoulder as she makes a gesture to accept the second, thus visualizing the temporal sequence of the Old and New Testaments, as she stands facing right but

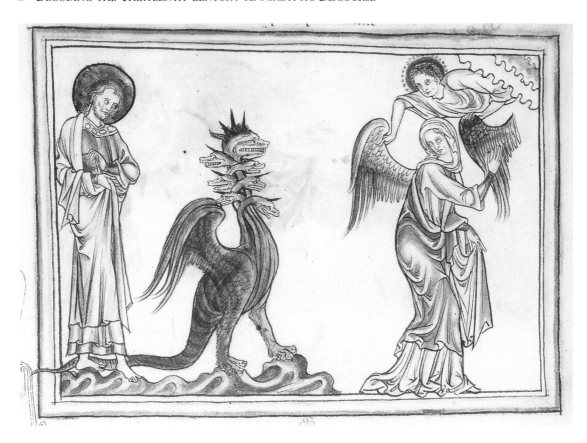

Figure 95. Apocalypse. Formerly Metz, Bibliothèque municipale MS Salis 38, fol. 18. Woman Given Wings (photo: Monuments historiques, Paris).

looks back. Because this illustration occurs on a recto page in the archetypal cycle, the designer probably added a second figure of the woman flying away at the right, as in Morgan (fig. 97), to represent the escape implicit in the text ("but she was given a huge pair of eagle's wings to fly away from the serpent into the desert"). As the woman flies away, she carries a book representing the two Testaments from the commentary.

The subsequent archetypal illustration for 12:15–16 (fig. 97) represents the dragon vomiting a river of water at the left, and the flying female figure holding the book is repeated above a landscape filled with small animals.[205] Notwithstanding its visual redundancy, the second unstable hovering or disappearing figure of the flying woman maintains the suspense of the unfinished allegory and carries the reader to the next page where the frustrated rage of the dragon is finally vented upon the woman's "other children."

41. War Against the Woman's Children: *12:17–18*

> And the dragon was enraged with the woman and went away to make war on the rest of her offspring, who obey God's commandments and keep the testimony of Jesus Christ.

Like the ancillary episode of the Woman Given Wings, the last verses of Rev. 12 dealing with the dragon's war against the woman's offspring were not pictured in the early cycles. The *Bible moralisée* visualized the text for the first time as a transition to the next chapter in which the dragon joins forces with the sea beast.[206] The introduction of a new illustration for this text in the Berengaudus cycle serves similar transitional and glossing purposes. At the same time as it visualizes an important commentary in which the woman's children represent the elect of the Church who will be born at the end of

the world and will battle against the devil, the sea-shore of 12:18 signifies the multitude of reprobates who will come in the future.[207]

In the thirteenth-century image (fig. 98), the seven-

Figure 96. Bible moralisée. London, British Library MS Harley 1527, fol. 135. Woman Given Wings and Pursued by the Dragon (above); Commentary Illustration for 12:13–14 (below) (photo: after Laborde 1911–27).

headed dragon is being attacked by a group of small figures wielding a variety of weapons. As the visual conception of the text develops, the dragon stands on a rocky island platform jutting up from the water, thus linking the seven-headed dragon with the beast who will emerge from the sea at the beginning of Rev. 13. In Morgan, the text for 12:17 is inscribed on a scroll unfurled above the warriors at the right, but the smaller scroll below, which was presumably intended for 12:18, has been left blank. In Douce (fig. 99), John makes a unique appearance in response to 12:18, visualizing a pause that runs counter to the text but signaling a long addendum to the short gloss.[208] He inserts his fingers between the pages of his book as if to mark the place, as he gestures toward four warriors vigorously attacking the seven heads of the dragon, which had been identified in the earlier gloss on 12:3 as the wicked in the six ages down to the present persecutors of the Church and the Antichrist to come, thus alluding to the added commentary's interpretation of the sea-shore as the future multitudes of the wicked.[209] The extended commentary includes an exhortation to battle against the seven cardinal vices in anticipation of the beast with the seven heads, which will reappear in Rev. 13 and which Berengaudus identifies as the seven vices enumerated by Prudentius.[210]

Among the thirteenth-century permutations of the Berengaudus archetype, we can perceive the problematic driving its underlying discourse. The expanded sequence of six new miniatures for Rev. 12 demonstrates that the convoluted allegorical narrative was being read as a dramatic recapitulative pattern of threat, rescue, and escape, ending in the dragon's repeated frustration and rage, in preparation for the full-scale resumption of John's visions when he will encounter the dragon and beasts in Rev. 13. Whereas earlier medieval designers were content to depend upon the image of the Fall of Satan to account for the appearance of the sea beast in Rev. 13, the strategists of the Berengaudus cycles carefully outline the mounting stages of demonic rage generated by Satan's fall from heaven and the dragon's repeated failures to capture the child or the woman, propelling him to carry on his vendetta against the woman's progeny to the end of time. The sequences of Rev. 12 thus prepare the reader to perceive the episodes of the next chapter on a hermeneutic level as the persecution and temptation of the contempo-

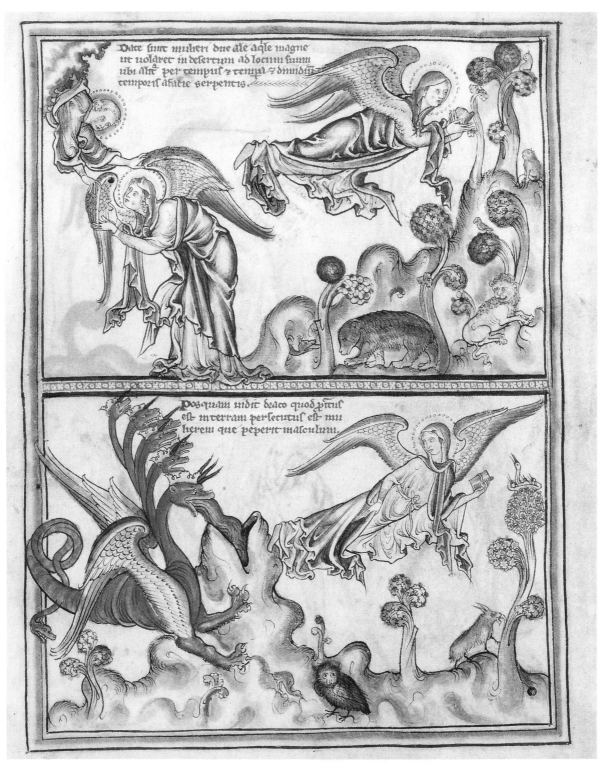

Figure 97. Apocalypse. New York, Pierpont Morgan Library MS M.524, fol. 9v. Woman Given Wings (above); Woman Pursued by the Dragon (below) (photo: The Pierpont Morgan Library).

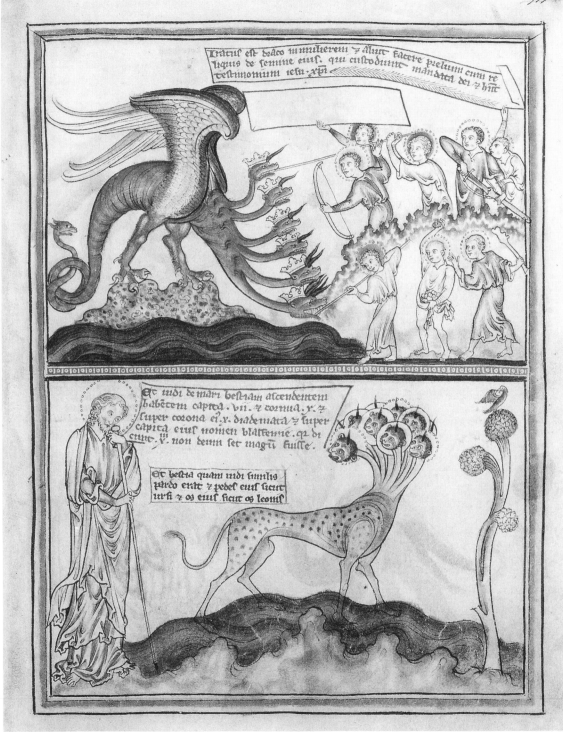

Figure 98. Apocalypse. New York, Pierpont Morgan Library MS M.524, fol. 10. War Against the Woman's Children (above); Beast from the Sea (below) (photo: The Pierpont Morgan Library).

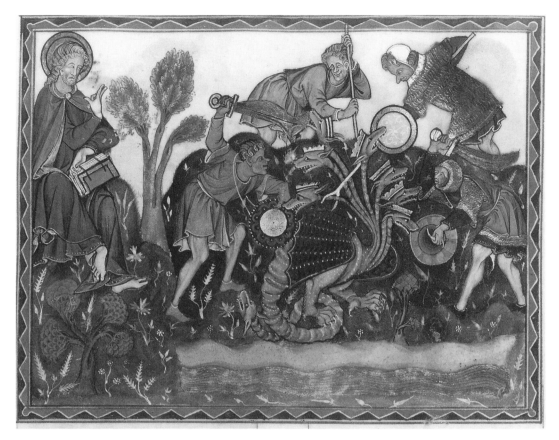

Figure 99. Apocalypse. Oxford, Bodleian Library MS Douce 180, p. 47. War Against the Woman's Children (photo: The Bodleian Library, Oxford).

rary Church and its faithful by Satan and Antichrist in a new series of incarnations.

42. Beast from the Sea: *13:1–2 to "os leonis"*

> And I saw emerge from the sea a beast having seven heads and ten horns, and above his horns were ten crowns, and upon his heads the names of blasphemy. And the beast that I saw was like a leopard; and his feet were like the feet of a bear, and his mouth was like the mouth of lion.

The early cycles provide only two illustrations for Rev. 13, dividing the chapter into two parts dealing with the Beast from the Sea (13:1–10) and the Beast from the Earth (13:11–18). As in the *Bible moralisée*, however, the Berengaudus archetype expands the pictorial cycle for Rev. 13 to meet the needs of the commentary. The English cycle provides two illustra-

tions for the first three verses to image the quick succession of visions at the beginning of the chapter where John first sees the beast emerge from the sea (13:1), witnesses the transfer of power from the dragon to the beast (13:2), and then sees the fatal wound that healed (13:3–6). To accommodate the new sequence of pictures, the compiler of the archetype found it necessary to make a number of eccentric breaks in the text, splitting several verses into fragmentary phrases, which then resulted in confusion and irregularities among the subsequent recensions.

The cycle for Rev. 13 begins with a traditional illustration of the beast emerging from the sea. However, the text breaks off after the description of the beast at "mouth like a lion." As in Morgan (fig. 98), John stands on the seashore, leaning on a long staff contemplating the latest menace in the form of a

seven-headed leopard, identified in the commentary as Antichrist, who emerges from a society of reprobates and whose seven heads represent the principal vices enumerated by Prudentius.[211] In the Westminster manuscripts, the beast actually climbs onto the shore in a more literal rendering of the text but in a countertextual direction to heighten the confrontational nature of the encounter, as John steps over the frame into the reader's space, thus increasing the sense of the beast's imminent threat.

43. Dragon Gives Power to the Beast: 13:2–3 (beginning "Et dedit illi draco")

> And the dragon gave him his strength and great power. And I saw one of his heads seemed to have had a fatal wound, but the mortal wound had healed. The whole world was in adoration of the beast.

As in the *Bible moralisée*, the Berengaudus cycle develops a new pictorial idea that shifts the traditional focus of the narrative from the simple emergence of the beast to the transfer of power and authority from the dragon to the sea beast. The *Bible moralisée* begins its cycle for Rev. 13 with an image of the two hybrid creatures grasping an unfurled scroll representing the pact *(consortium)* made by the devil with the princes of the world in which he elicits their aid in his battle against the Church.[212] Essentially, the same confronted bestial pair dominates the Berengaudus illustration for 13:2–3 (see figs. 100 and 101) in which the seven-headed dragon at the left surrenders a long-handled foliated scepter to the seven-headed spotted leopard. According to the gloss, it is Antichrist who becomes the recipient of power, but, as the commentator explains, because all power emanates from God, it is Antichrist who subverts that power into an evil force.[213] The archetypal text for this illustration begins where the preceding text segment breaks off in the middle of the second verse ("And he handed it over to the dragon") and ends with 13:3.[214]

In Morgan and Metz, one of the beast's heads has been severed from its long tubular neck, correspond-

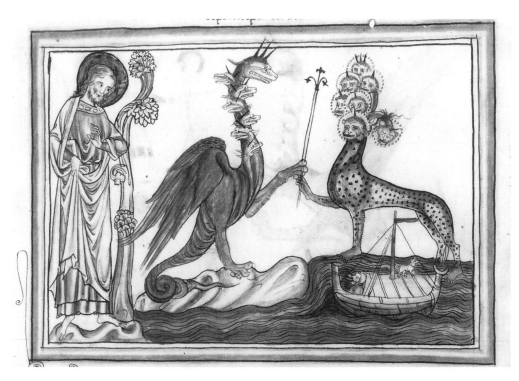

Figure 100. Apocalypse. Formerly Metz, Bibliothèque municipale MS Salis 38, fol. 19v. Dragon Gives Power to the Beast (photo: Monuments historiques, Paris).

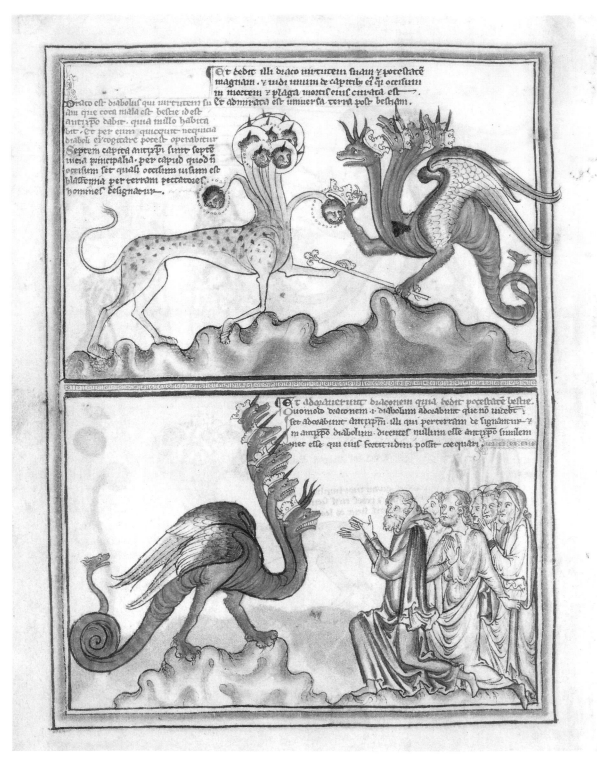

Figure 101. Apocalypse. New York, Pierpont Morgan Library MS M.524, fol. 10v. Dragon Gives Power to the Beast (above); Worship of the Dragon (below) (photo: The Pierpont Morgan Library).

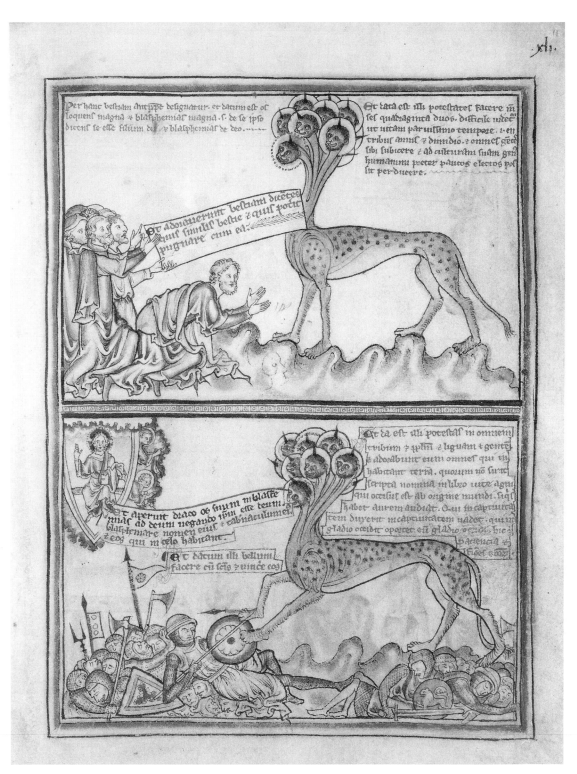

Figure 102. New York, Pierpont Morgan Library MS M.524, fol. 11. Worship of the Beast (above); War against the Saints (below) (photo: The Pierpont Morgan Library).

ing to the fatal wound observed by John. In a literal response to the text requiring John's presence to witness the miraculous cure of the beast's severed head by the text (13:3), the Evangelist takes up his usual position at the left directly behind the sea beast to stare at the mortally wounded head in undisguised astonishment. In Metz, the glossed text ends with "curata est," thus concentrating on the confronted beasts holding the scepter, jointly sharing power, as they stand on the land and sea in splendid isolation, but, in accordance with the truncated text, with no pictorial reference to their worshipers. The Morgan version (fig. 101) elides the idea of audience altogether, but transforms the simple transaction into a coronation ceremony in which the dragon places a crown on the first head of the sea beast who kneels as he accepts the scepter. The commentary inscribed at the left stresses the evil power that the dragon (devil) invests in the beast (Antichrist), and the blasphemy signified by the wound "that looked fatal but did not kill him."[215]

44–45. Worship of the Dragon: 13:4 (to "potestatem bestiae"); Worship of the Beast: 13: 4–6 (beginning "Et adoraverunt bestiam")

> And they adored the dragon, who gave power to the beast. And they adored the beast, saying: "Who can compare with the beast? And who can fight with him?" And he was allowed to mouth boasts and blasphemies, and he was given power for 42 months. And he opened his mouth in blasphemies against God, to blaspheme his name and his tabernacle and those who dwell in heaven.

The Berengaudus paradigm divides verse 4 into two illustrated segments: 13:4 (to "potestatem bestiae") and 13:4–6 (beginning "Et adoraverunt bestiam"). This eccentric disruption of the narrative created separately glossed texts for a symmetrical pair of images representing the Worship of the Dragon and the Worship of the Beast, where the reversal of their positions conveys the idea of equivalence between the dragon and beast as interchangeable personae of the devil and Antichrist.[216]

The initial conception of the Berengaudus cycle clearly envisaged a separate illustration of the Worship of the Beast (fig. 102), but the various recensions reveal considerable confusion concerning the choice of an accompanying text. Although the beast's blas-

phemies against God provide the focus for the commentaries accompanying the scene of the Worship of the Beast, both Morgan and Metz defer their pictorial references to the text to the subsequent illustration dealing with the beast's war against the saints. To adjust its illustration (see fig. 103), the Eton designer adds a half-figure of the Lord adored by angels in a small cloud-framed mandorla in the upper right corner, as John covers his ears to avoid hearing the beast's blasphemies. In Getty's composite illustration (fig. 104), the beast is enthroned in the center holding a huge sword in reference to Getty's extended text, which now includes 13:10 ("the sword for those who are to die by the sword"). Seated on a draped throne instead of an earth mound, the sea beast's legs are crossed in the conventional pose of the wicked tyrant, visually confirming the commentary's identification of the beast with Antichrist. In his expanded role as a blasphemous usurper, denying that Christ is God, the beast raises his hand in a gesture of rejection, as if to push the disappearing image of Christ out of the frame; below, a group of figures representing the saints, flee from the beast's blasphemies and persecutions. As John similarly rushes away through the frame, pulling his skirts protectively

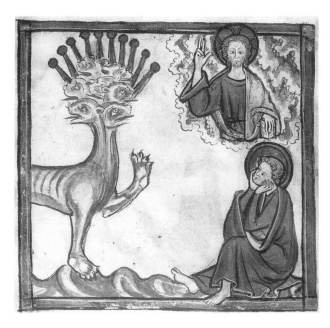

Figure 103. Apocalypse. Windsor, Eton College MS 177, p. 50. Blasphemies of the Beast (photo: The Provost and Fellows of Eton College and the Conway Library, Courtauld Institute of Art, London).

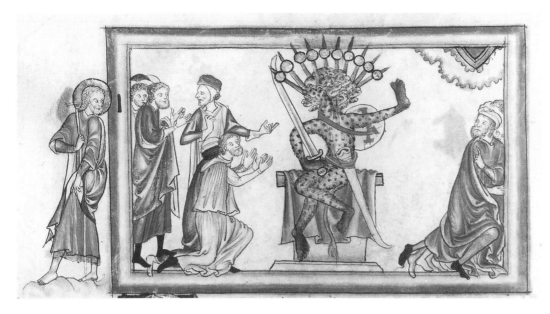

Figure 104. Apocalypse. Malibu, J. Paul Getty Museum MS Ludwig III.1, fol. 24v. Worship of the Beast
(photo: Collection of the J. Paul Getty Museum, Malibu, California).

around him, he still cannot resist turning a last, fleeting but consternated glance at the fascinating and powerful creature commanding the center stage of his and of the reader's vision.

46. War of the Beast against the Saints: *13:7–10*

> And [the beast] was allowed to make war against the saints and to conquer them, and he was given power over every tribe and people, tongue and nation, and all who inhabit the earth adored him. . . .

The Berengaudus cycle also introduces a new illustration depicting the war of the beast against the saints in which the spotted beast is shown trampling the saints already fallen victim to the onslaught (fig. 105). A single figure raises himself in an attempt to thrust his lance, but it is broken by a powerful feline paw. In an effort to create a more accurate alignment of illustrations and glossed texts, the Morgan and Metz designers shift the text for 13:6 ("And it mouthed blasphemies") from the representation of the beast being worshiped to this illustration in which it is given next to a small image of the Lord surrounded by angels within a cloud-framed mandorla at the upper left. In Paris-Douce, the scene has been elaborated to include the worshipers of the

beast still kneeling or acclaiming him in opposition to the saints struggling against him. In addition to locating the two opposing groups before and behind the beast, the hands and hats of his followers are labeled with names like "Antealoc" and "Arpeneno," whereas the saints are marked with small crosses, visualizing in the simplest terms the commentary where Berengaudus observes that, just as Christ has the cross as his emblem, Antichrist has his own mark.[217] By manipulating numerical values of the Latin alphabet, early exegetes devised several names that could be symbolically identified with Antichrist by the number of the beast (666) given in 13:18.[218] Although Berengaudus declines to define the mark of the beast in this way, his acknowledgment that "concerning this number many have said many things and have discovered many names in whose letters this number can be found"[219] seems to have encouraged the designer of Paris lat. 10474 to join their ranks.

The Berengaudus illustration of the beast's war against the saints represents a thirteenth-century innovation anticipated in the *Bible moralisée* (fig. 106). In a double-tiered image, the Lord and Lamb are adored by angels in heaven above a group of idolaters worshiping the beast as he tramples the saints.

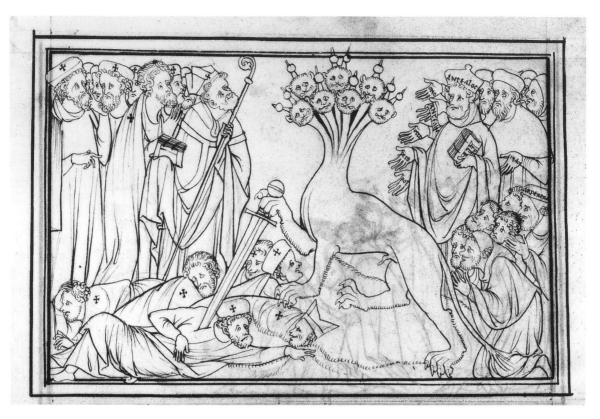

Figure 105. Apocalypse. Paris, Bibliothèque Nationale MS lat. 10474, fol. 25v. War against the Saints
(Phot. Bibl. Nat. Paris).

According to the gloss, the Lord allowed the bodies of the saints to be tormented to liberate their souls, and the Lamb who was killed is Christ who was first "crucified" at the beginning of the world through Abel.[220] The same text is isolated for illustration in the Berengaudus cycle to stress an important commentary in which the faithful are reassured that the saints shall never succumb to Antichrist and his false doctrine, for the beast wages war against the elect by flattering some, frightening others, and finally tormenting them to convert to his error, but he will fail, for "he will conquer them not by overcoming them but by killing them," that is, he will serve as an instrument for their martyrdom, just as the Lamb served as the eternal sacrifice of Christ.[221] In Douce (fig. 107), a unique pictorial reference to the "sacrificial Lamb" bleeding into a chalice brings the image closer to the formulation in the *Bible moralisée*. Instead of the hierarchical layering of heaven and earth and the lateral juxtaposition of good and evil plotted on a pictorial grid in the *Bible moralisée*, however,

Douce positions the Lamb in juxtaposition with the beast to display the proper and divine object of the saints' "worship" through their martyrdom. Moreover, as the Lamb confronts the image of the false prophet on the facing recto in Douce, he again offers a "true" signifier of the divine in opposition to the beast from the earth that "had two horns like a lamb."

The sequence of five illustrations devoted to the predatory exploits of the sea beast centers on the appropriation and perversion of divinely given prerogatives. As the satanic force of Antichrist now fixes its sights on the corruption of the faithful, the reader becomes an immanent point on his shifted target, and the apocalyptic images begin to function as cautionary admonitions with immediate and personal consequences. The first warning is conveyed by the new image of the beast being invested with power by the dragon, for the transfer constitutes a diabolical investiture and coronation that corrupts secular authority, a pact made by the devil with the princes of

the world that renders all princely power suspect and vulnerable to corruption. The sequential emergence, investiture, demand for obedient adoration, and persecution of dissenters were and still form a familiar pattern of terrestrial tyranny, alerting the pious reader to distrust the world. The dual spectacle of the corrupted faithful as well as the infidel worshiping first the dragon and then the beast underscores not only their raw power of intimidation, but their power to seduce through deception. Douce's introduction of the sacrificial Lamb into the illustration of the fallen saints (fig. 107) then demonstrates the corruption of faith in the Augustinian sense that "faith is the virtue by which we believe in that which we cannot see," reminding the thirteenth-century reader of the declaration that begins the canons of the Fourth Lateran Council in 1215: "We firmly believe and simply confess that there is only one true God, eternal, without measure, omnipotent, unchangeable, incomprehensible, and ineffable."[222]

Figure 106. Bible moralisée. London, British Library MS Harley 1527, fol. 136v. War against the Saints (photo: after Laborde 1911–27).

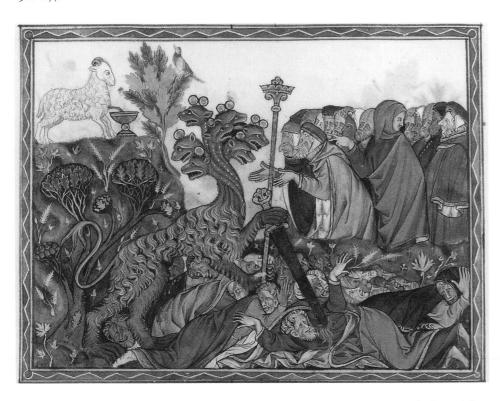

Figure 107. Apocalypse. Oxford, Bodleian Library MS Douce 180, p. 50. War against the Saints (photo: The Bodleian Library, Oxford).

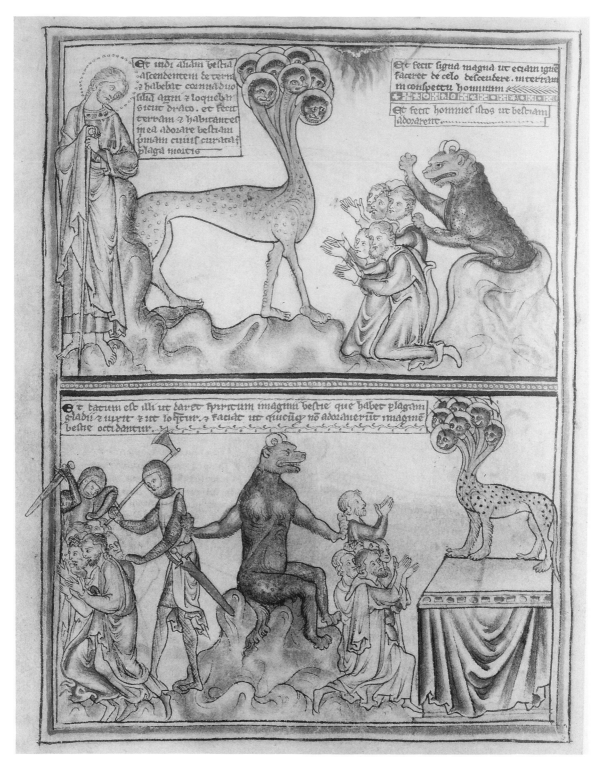

Figure 108. Apocalypse. New York, Pierpont Morgan Library MS M.524, fol. 11v. False Prophet (above); Massacre of the Faithful (below) (photo: The Pierpont Morgan Library).

47. False Prophet: *13:11–14 (to "habitatantes in terra")*

> And I saw another beast ascend from the earth, and he had two horns like those of a lamb and he spoke like a dragon. And he exercised all of the power of the first beast in his presence; and he made the earth and its inhabitants adore the first beast whose mortal wound was healed. And he worked great miracles, so that he made fire descend from heaven to earth in the sight of men. And he seduced the earth's inhabitants.

Following the three illustrations dealing with the antimessianic figure for 13:1–10 in which Antichrist in his bestial guise emerges from the sea, is worshiped, blasphemes against God, and wages war against the saints, the Berengaudus cycle provides three miniatures pertaining to the terrorist exploits of Antichrist's disciple, the false prophet who emerges as the beast from the earth. As in the *Bible moralisée,* the appearance of the two-horned beast is heralded by the miracle of fire called down from heaven onto the earth (fig. 108).[223] Although the magical prowess of this powerful disciple of Antichrist provides the dramatic focus in Metz, where he commands the flames to descend with a conjuring stick, it is his role as "servant of the first beast," carrying out a mission "to make the world and all its people worship [the sea beast]," that dominates most thirteenth-century images. As in Morgan, the second beast betrays his chthonic origins as he emerges from a high earth mound, literally pushing worshipers toward Antichrist in the guise of the first creature from the sea. In Getty, a sword supplants the earth beast's wand to stress the gesture of coercive threat.

48. Worshiping the Image of the Beast and the Massacre of the Faithful: *(13:14–15 (beginning "Propter signa")*

> Because of the miracles which [the second beast] was allowed to work in the presence of the beast, he said to the inhabitants of the earth that they should make an image of the beast which had been wounded by the sword and had lived. And he was allowed to give life to the image of the beast and to make the image of the beast speak, and to have anyone who would not adore the image of the beast be killed.

As in the *Bible moralisée* (fig. 109), the Berengaudus cycle devotes a new miniature to the illustration of 13:15. Linking the new narrative development with the previous episode, the two-horned beast is seated

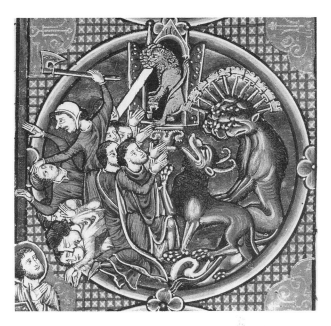

Figure 109. Bible moralisée. Vienna Nationalbibliothek MS 1179, fol. 232. Massacre of the Faithful (photo: Nationalbibliothek, Vienna).

on the high earth mound in the center, again prodding and threatening the beast-worshipers (fig. 108). Turning in a contrapposto pose, the lower half of his body faces the image of the spotted beast standing on the large vested altar, being worshiped by a group of kneeling figures at the right, while his head and upper body swivel to the left; with a pushing gesture, he commands two henchmen to massacre those who refuse to worship the image of the beast.

The commentaries focus on the image of the beast as an image of Antichrist and its characterization of the two-horned beast as a diabolical magician who caused the statue to move and talk, comparing him to Simon Magus.[224] The *Bible moralisée* illustration centers the reader's attention on the idolatrous worship of the beast's image by juxtaposing the actual beast at the right with a small carved effigy within a niche raised in the center; the massacre of the faithful is given as a subtext at the left margin. In contrast, the Berengaudus representation gives the two actions equal dramatic weight, with the swiveling false prophet functioning as an impressario directing the performance from the center. Whereas the statue in the aedicule conjured up for the thirteenth-century reader a familiar pictorial reference to pagan and

purported Jewish idolatry, the nearly life-size figure of the beast standing on a vested altar denotes a more directly blasphemous usurpation of the position customarily reserved for the Crucifix or Madonna. Such a distinction is demonstrated in the *Bible moralisée*, where St. Paul forbids all *simulacra* of the "unknown god," but presumably allows the placement of a crucifix on a vested altar.[225] Indeed, in the Apocalypse illustration, the beast and his image are one and the same; his "icon" is rendered transparent to his "reality" through the simple but powerful maneuvre of elevating the familiar figure (*simulacrum*) to a consecrated place where it can be displayed as a sacred image.

49. Mark of the Beast: 13:16–18

> And [the beast] compelled everyone – small and great, rich and poor, slave and citizen – to have a mark on the right hand or on the forehead; and no one could buy or sell anything unless he had the mark or name of the beast or the number of its name. . . .

Again, following a precedent established by the *Bible moralisée*, the designer of the Berengaudus cycle

added a new illustration for 13:16–18. In Metz (see fig. 110), the two-horned beast, still seated cross-legged atop a high earth mound, faces a large number of people who raise their palms to display the mark of the beast. Unlike the *Bible moralisée*, which depicts the people being inscribed on the hand and forehead, the Berengaudus image focuses on the *fait accompli*, responding to the gloss that asserts that they already had the mark of Antichrist on their right hands because "their evil deeds were consonant with his malignant doctrines."[226] That the beast's brand was imposed on everyone "small and great, rich and poor, slave and citizen" is pictorially acknowledged by the disparity in scale among the figures, as well as noblemen on horseback standing next to beggars, but these distinctions of status and condition tend to become lost in the other recensions. Trinity retains major elements of the archetypal illustration, but a new component has been added in the center where two of the beast's henchmen inscribe a sign on the forehead and hand of two kneeling figures to alert the reader to Trinity's gloss in which the body sites of the marks are differentiated to signify bad thoughts and deeds.[227] Among the thirteenth-century

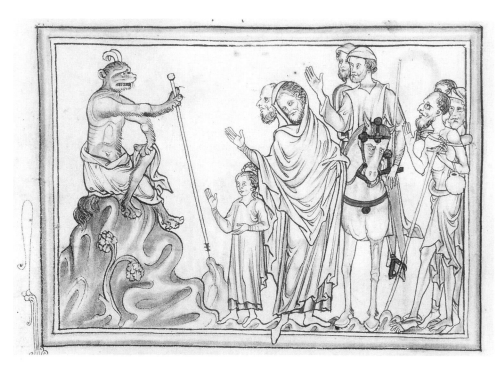

Figure 110. Apocalypse. Formerly Metz, Bibliothèque municipale MS Salis 38, fol. 22v. Mark of the Beast (photo: Monuments historiques, Paris).

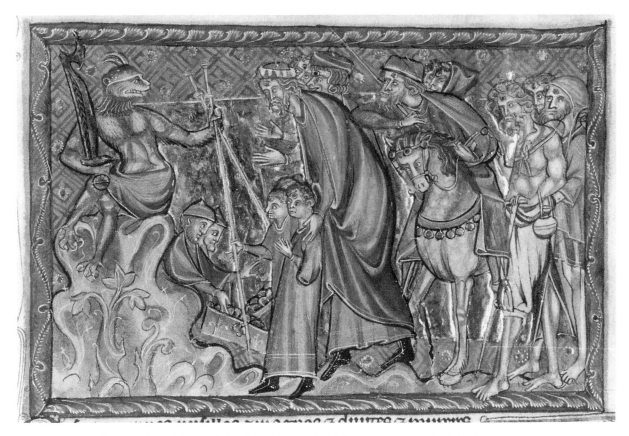

Figure 111. Apocalypse. Lisbon, Calouste Gulbenkian Museum MS L.A.139, fol. 40. Mark of the Beast (photo: The Conway Library, Courtauld Institute of Art, London).

cycles, there is a noticeable tendency to shift the emphasis from the mark on the right hand to that on the forehead. In Paris lat. 10474, the people have round insignia visible on their foreheads; in Douce, they are inscribed with names like "Anpenor," similar to those given in Paris lat. 10474 for 13:7–10. Gulbenkian's revision of Metz (fig. 111) seems to have been influenced by this shift in its addition of prominent gold circles resembling coins on the foreheads of those who have been marked by the beast. The designer of the Gulbenkian Apocalypse thus merges idolatry of the beast with the worship of money, reflecting a contemporary urban society caught up in a nascent profit economy, where avarice overtakes pride as the "root of all evil."[228] In the twelfth century, Alain de Lille had defined the vice of *nummulatria* (worship of money) as an offspring of *idolatria*, for it is the "evil through which money is deified in the souls of men, and the authority for

divine veneration is given to cash."[229] The Gulbenkian designer further shifts the focus of the image to an anti-Jewish accusation of *nummulatria* under the aegis of beast worship. Seated at the left below the two-horned beast, two figures in pointed Jewish caps preside over open coffers of coins, in an allusion to 13:17, which states that the beast "made it illegal for anyone to buy or sell anything unless he had been branded with the name of the beast."[230]

Although the second part of Rev. 13 dealing with the beast from the earth constitutes a close reprise of the narrative pattern in 13:1–10, repeating the sequence of emergence, adoration, and persecution, the pictorial focus on power and investiture shifts to deception, idolatry, and encoding. On one level, the inscription of Satan's mark can be seen as a pernicious trope of the insignia and distinctive dress that Jews and Muslims, as well as lepers and prostitutes, were forced to wear in thirteenth-century Europe, so

that "at all times they shall easily be distinguishable from the rest of the population."[231] More importantly, the mark of the beast appears to have been perceived as the tyrannically imposed insigne of a diabolical egalitarianism that erases what was believed in the Middle Ages to constitute a God-given hierarchical order of rank and class. New inflections in iconography reveal a contemporary anxiety about threats to the stability of thirteenth-century social and political structures. Within the new discourse of the English Gothic Apocalypse, the bestial Antichrist of Rev. 13 subverts the political order through his satanic investiture and usurpation of power, enabling him to overthrow the social hierarchy by reducing all people to the same status as "marked" men and women. In Gulbenkian, the diversion of focus to the mercantile restrictions imposed by the beast creates the implication that the new order will be based no longer on aristocratic birth rank and landholding, but on monetary wealth and entrepreneurship, thus revealing a thirteenth-century perception of threat to the existing socioeconomic structure.

50–51. The Lamb on Mount Sion: *14:1;* New Song: *14:2–5*

> And I saw, and behold the Lamb stood on Mount Sion, and with him 144,000 who had his name and the name of his Father inscribed on their foreheads.
> And I heard a voice from heaven like the voices of many trumpets and like the voice of great thunders; and the voice that I heard was like harpers harping on their harps. And they sang a new song before the throne, and before the Beasts and Elders. . . .

Like the Harley version of the *Bible moralisée*, the Berengaudus cycle illustrates an isolated glossed text for 14:1. John witnesses the vision of the Lamb from the left (fig. 112); according to the commentary, he sees a figure of "Christ standing firmly in celestial bliss with his saints,"[232] adored by the multitude of 144,000. The two groups of worshipers are divided by a striking dorsal figure who stands directly beneath the Lamb and serves as a surrogate within the frame with whom the reader can identify, thus providing more direct access to John's vision. Beyond

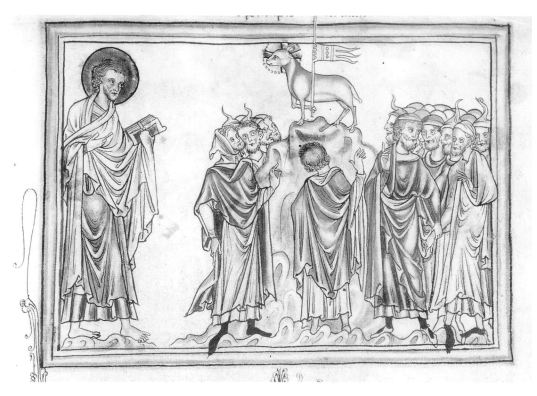

Figure 112. Apocalypse. Formerly Metz, Bibliothèque municipale MS Salis 38, fol. 23. Lamb on Mt. Sion (photo: Monuments historiques, Paris).

serving as a dramatic metaphor of receptivity, the dorsal figure in Metz epitomizes the frequent Vulgate and later medieval usage of the verb *convertere* in a sense that joins the physical with the spiritual, to retire from the world, literally turning back to God *(convertere ad dominum)*.[233]

In Paris-Douce (fig. 113) and Getty, the 144,000 people have been transformed into herds of sheep clambering up the hillside, perhaps in reference to 14:4 ("they follow the Lamb wherever he goes"), for the commentary interprets the multitude of worshipers simply as "the elect whose souls exult with God in celestial beatitude."[234] A precedent for the inclusion of lambs among the human worshipers occurs in the illustration for 14:2–5 in the Harley version of the *Bible moralisée*. The thirteenth-century revival of this Early Christian iconographical configuration could conceivably have been inspired by the extensive renovation under Pope Innocent III (1198–1216) of the apse mosaic in Old St. Peter's in Rome, in which the lower frieze carried a highly visible, ideologically charged image of the lamb procession.[235]

Figure 113. Apocalypse. Paris, Bibliothèque Nationale MS lat. 10474, fol. 27. Lamb on Mt. Sion (Phot. Bibl. Nat. Paris).

In the metanarrative structure of the Apocalypse, the first five verses of Rev. 14 represent an antipodal inversion of the preceding sequence dealing with the bestial Antichrist by opening with a vision of the Lamb adored by the faithful. The celestial interlude is divided into two parts by the sequence of John's

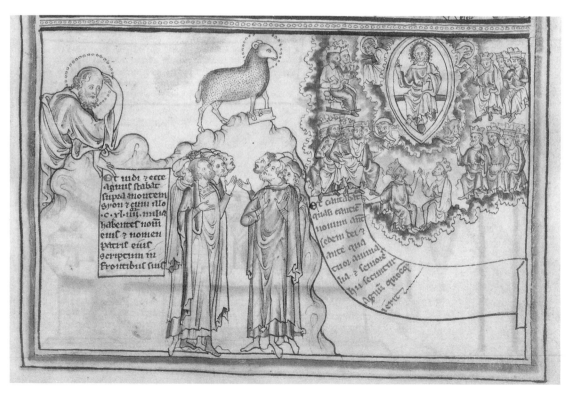

Figure 114. Apocalypse. New York, Pierpont Morgan Library MS M.524, fol. 12. Lamb on Mt. Sion and the New Song (photo: The Pierpont Morgan Library).

perceptions, as he first *saw* the Lamb being adored by the faithful and he then *heard* the New Hymn.[236]

In the Berengaudus archetype, the isolated illustration of the Lamb appeared on a verso page facing a representation of the New Song for 14:2–5. As in the Harley *Bible moralisée*, another new episode has been added to the English Gothic cycle in which the elect sing a new hymn signifying the New Testament before the throne of heaven, responding to the long and important gloss on saintly virtue. As a representative of the faithful in this life, John hears a celestial doctrine from the voices of the saints in heaven.[237] His "heart of gold" is filled with eagerness to imitate their acts of goodness as he hears the "sound of the ocean."[238] By reminding his readers that holy men on earth keep the glory of the saints in heaven constantly in their mind's eye as they labor to attain perfect virtue,[239] Berengaudus transforms John's aural experiences into an inner vision. In Morgan (fig. 114), the internalization of his perceptions is signaled by gesturing to his forehead as he gazes at the Lamb,

while at the same time he externalizes his experience into the verbal account inscribed on his speech scroll. In Getty (fig. 115), John listens with his ear pressed against the edge of the frame to illustrate "Et audivi vocem" as he gazes at the reader. Because John signifies "the faithful of this world" in the commentary, he is visibly connected with the figures representing the 144,000 who follow the Lamb leading his flock to the celestial throne at the right. To retain a pictorial reference to 14:4–5, Getty inserts the Lamb on the central axis beneath the throne. Following the initial image of worship in the vision of the Lamb on Mt. Sion in which the reader is invited to join the adoring multitude, the visualization of the New Song more emphatically shifts the venue of adoration to heaven. Enframed by clouds, the new hymn is intoned in a celestial liturgy that extends the moment of celebration clearly away from the earthly predations of the beasts in Rev. 13 to the realm of angels who will dominate the ensuing episodes of this chapter.

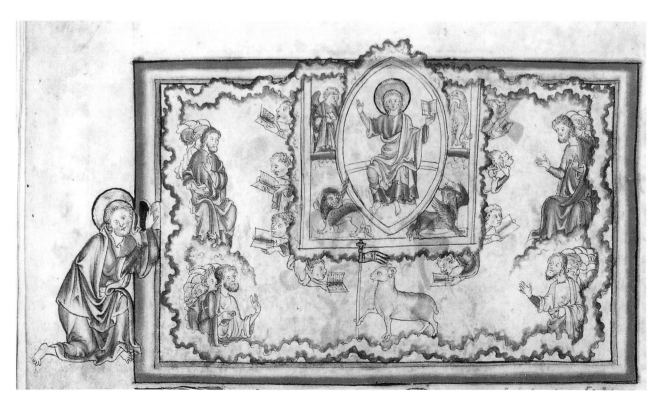

Figure 115. Apocalypse. Malibu, J. Paul Getty Museum MS Ludwig III.1, fol. 26v. New Song (photo: Collection of the J. Paul Getty Museum, Malibu, California).

52–54. Three Angels Announcing the Eternal
Gospel, the Fall of Babylon, and the Doom of
the Beast Worshipers: *14:6–12*

> And I saw another angel flying through the heavens, with the
> eternal gospel, to evangelize those who sit upon the earth
> and every nation and tribe, tongue and people; he was call-
> ing in a loud voice: "Fear God and give him honor, because
> the hour of his judgment is coming; and adore him who cre-
> ated heaven and earth, the sea and the water-springs."
> And another angel followed, saying, "Babylon has
> fallen, Babylon the great, which made all the nations drink
> the wine of the wrath of her fornications, has fallen."
> And a third angel followed him, saying in a great voice:
> "All those who worship the beast and his statue, or have
> had themselves branded on the hand or forehead, will be
> made to drink the wine of God's fury which is ready, un-
> diluted, in his cup of anger; in fire and brimstone they will
> be tortured in the presence of the holy angels and the Lamb;
> and the smoke of their torments will go up for ever and
> ever, for there will be no respite, night or day, for those
> who worshiped the beast or its statue or accepted the mark
> of his name." Here is the patience of the saints who keep
> the commandments of God and faith in Jesus.

The Berengaudus cycle divides the text for 14:6–12
into three illustrated episodes, commanded by a suc-
cession of message-bearing angels. Except for Trin-
ity, which adheres to the old composite text, all the
thirteenth-century manuscripts maintain this pattern
of serial differentiation. The first deals with the angel
who brings the Eternal Gospel in 14:6–7 in an illus-
tration (see fig. 116) that is remarkably uniform
throughout the thirteenth-century recensions. John
leans on his staff, gazing at the angel who flies across
the upper two-thirds of the picture, holding a scroll
on which is inscribed the text of 14:7: "Fear God
and praise him."[240]

The first angel carries a scroll to represent the
Eternal Gospel, following an early iconographical
tradition represented by Vat. lat. 39.[241] Nevertheless,
the distinctive treatment of the Eternal Gospel in the
Berengaudus cycle raises the question of a possible
reference to the contemporary Joachist controversy.
Freyhan argued that the representation of the Eternal
Gospel in the form of a scroll rather than a codex
indicates that the English Gothic cycle was conceived
in reaction to the Joachist scandal.[242] However, the
inscribed scroll not only conforms to the old pictorial
formula represented by Valenciennes and Vat. lat. 39
in which the "book" itself is inscribed "Timete Dom-
inum," but also responds to the Berengaudus com-
mentary, which, although it includes the customary
interpretation *ex bono* in which the angel signifies

Christ's preachers and disciples, centers on his efforts
to combat the evils and persecutions of Antichrist by
preaching the fear of God.[243] The pointed hats and
veiled bearded men who figure prominently among
the inhabitants of the earth in manuscripts like Metz
ally those who turn away from the Gospels to Ju-
daism, continuing the dark anti-Jewish thread that
runs throughout the Berengaudus commentary and
the illustrations of the English Gothic Apocalypse,
whereas versions such as Getty simply reference the
targeted audience as worldly, wayward laymen.
Thus, the adoption of the scroll inscribed with 14:7
probably had little or nothing to do with the Joachist
controversy, but more simply was motivated by a
desire on the part of the compiler and designer to
homogenize the pronouncements of the three angelic
messengers, making the first as dire as the others.

All the Berengaudus manuscripts except Trinity
give a separate illustration in which a flying angel an-
nounces "Babylon has fallen." Below, the towers and
walls of the city fall, visibly verifying the angel's pro-
nouncement. Some cycles lend colorful touches of gore
to the scene by adding corpses and decapitated heads.
Getty uniquely alludes to "Babylon, which gave the
whole world the wine of God's anger to drink" (14:8),
as a literalized metaphor in the fractional figure at the
lower right imbibing from a large goblet.

The responses among the Berengaudus manu-
scripts to the text for 14:9–12 are considerably more
disparate than those for the illustration of the first
two. In Metz (fig. 117), the angel's earlier role as
messenger now becomes complicated as he domi-
nates and even generates the central action, pointing
with one hand to the foreheads of the beast wor-
shipers and with the other to the flaming cup con-
taining the wine of God's fury, placed on the earth,
in the presence of the Lamb and angels. The first two
images easily convey the import of the angelic pro-
nouncements in unequivocal pictorial terms, but the
last illustration becomes problematic. Although Metz
recognizes the importance of linking the Doom of the
Beast Worshipers with their idolatry and marking in
Rev. 13, the connective references tend to disappear
in other versions such as Morgan and Getty. In Metz,
the narrative unfolds as a scene of judgment and im-
pending punishment. Morgan, in contrast, registers
the meaning of the Beast Worshiper's idolatry by
raising the Lamb on a mountain above the altar as
a pictorial reminder of his juxtaposition with the

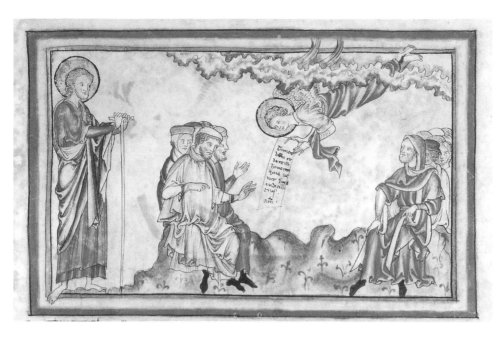

Figure 116. Apocalypse. Malibu, J. Paul Getty Museum MS Ludwig III.1, fol. 27. Angel Announcing the Eternal Gospel (photo: Collection of the J. Paul Getty Museum, Malibu, California).

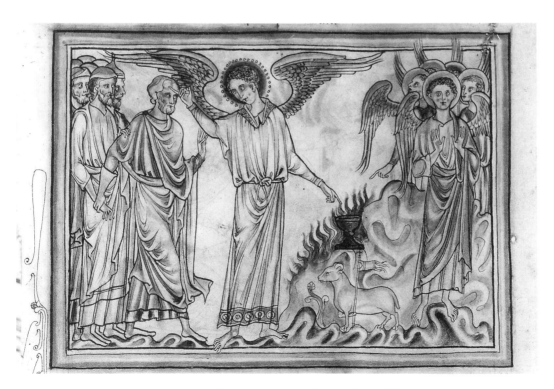

Figure 117. Apocalypse. Formerly Metz, Bibliothèque municipale MS Salis 38, fol. 25. Angel Announcing the Doom of the Beast Worshipers (photo: Monuments historiques, Paris).

beast at the beginning of Rev. 14. In Getty, both centers of discourse are lost in a weakened variant of the archetype.

55. Blessed Dead: 14:13

> And I heard a voice from heaven saying to me: "Write: Blessed are the dead who die in the Lord. From now on, says the Spirit, they may rest from their labors; for their works follow them."

The text that concludes the section dealing with the three angelic messages is illustrated in the thirteenth century for the first time. Responding to the glosses in both the *Bible moralisée* and the Berengaudus cycle, the Gothic cycles graphically display the rewards of those who heed the warnings of the three angels. In the Berengaudus cycles (see fig. 118), John is seated at the left with a scroll across his lap, holding a pen and scraper poised to write, in reference to the beginning of the verse: "Then I heard a voice from heaven say to me, 'Write.'" Whereas in Metz the commanding angel points to the blessed dead as he touches John's shoulder, the gesture is embellished in Getty and Paris lat. 10474 by showing the angel hand John a pen and an inkpot suspended on a short chain. Although Berengaudus failed to comment on the command to write, the later pictorial emphasis on inscribed documentation probably refers less to the witnessing of a celestial contract than the idea of preserving for posterity the deeds of the Blessed Dead. Following the line of interpretation taken by other twelfth-century exegetes like Bruno of Segni, the images in Getty and Paris lat. 10474 stress the phrase "their good deeds go with them," for "what is worthy of being remembered will give great testimony in the presence of God."[244] John's act of inscription thus reminds the reader to commit the text to memory or, in the words of Haimo of Auxerre's gloss on this passage, "Write it in your heart."[245]

The thirteenth-century image gives the reader easy access to personal identification with the blessed dead for they are no longer characterized as martyrs but simply as the righteous who have abandoned sin and worldly temptation. Their happiness resides in the repose after their labors – evoked by the peaceful, somnolent appearance of the dead in Metz, and their acceptance by God, expressed in the shroud full of souls carried upward by angels.[246] As the illustration of the Blessed Dead faces the representation of the

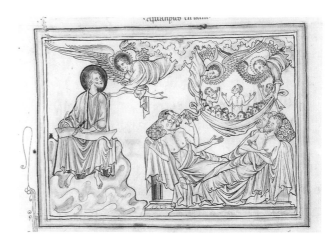

Figure 118. Apocalypse. Formerly Metz, Bibliothèque municipale MS Salis 38, fol. 25v. Blessed Dead (photo: Monuments historiques, Paris).

Doom of the Beast Worshipers, the two images offer a dramatic contrast between the punishment of the wicked and the reward awaiting the elect, anticipating the Last Judgment to come in Rev. 20.

56. Harvest: 14:14–16

> And I saw, and behold a white cloud and seated upon the cloud one like the Son of man, having on his head a gold crown and in his hand a sharp sickle. And another angel emerged from the temple crying in a loud voice to the one seated on the cloud: "Take your sickle and reap, because the hour has come to reap, for the harvest of the earth is ripe." And he who sat on the cloud set his sickle on the earth and the earth was reaped.

Among the early Apocalypse cycles, the texts for the Harvest and Vintage tend to be combined and accompanied by one illustration, sometimes showing the angel emerging from the sanctuary commanding the Lord in the clouds with the sickle to reap, or in a composite representation with successive cyclical actions encompassing more elements within a single frame. In contrast, the *Bible moralisée* gives two illustrations for the Harvest alone, dividing the text to represent the consecutive actions of the angel's command and the actual reaping of the grain. The Berengaudus illustration (fig. 119), similarly envisions the text as registering two episodes into a cyclical narrative encompassing the Harvest. The compromise between the compression of the early cycles and

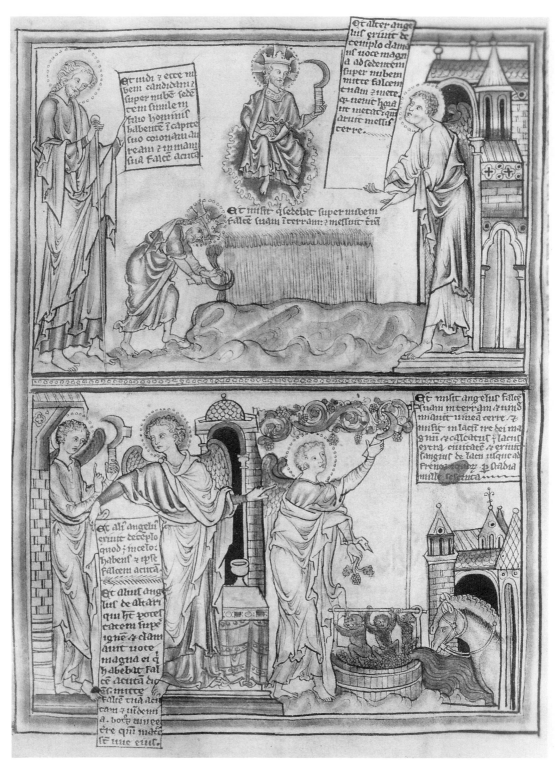

Figure 119. Apocalypse. New York, Pierpont Morgan Library MS M.524, fol. 13v. Harvest (above); Vintage (below) (photo: The Pierpont Morgan Library).

Figure 120. Bible moralisée. London, British Library MS Harley 1527, fol. 139. Harvest II (photo: after Laborde 1911–27).

the expansion in the *Bible moralisée* seems to respond to a difficulty posed by the commentary, which interprets the Vintage and Harvest together in a single gloss for 14:14–19: Both angels represent Christ, and the two sickles signify the fire that shall consume the whole world at the end of time.[247] The crowned figure of the Lord appears in the center, enthroned on a cloud and holding the sickle. Although the gloss identifies the angel rather than the crowned figure seated on the cloud as Christ, Morgan (fig. 119) incorrectly shows this figure with a cross-nimbus, probably in response to the simile given in 14:14 comparing him to the "Son of man" or perhaps under the influence of a model resembling the *Bible moralisée* (fig. 120), where this figure is identified as the Lord in both the gloss and illustration. A second crowned figure, now standing on the ground below, cuts a stand of grain with his sickle.

Repeating a distinctive gesture that appears in both versions of the *Bible moralisée*, the reaper has already begun to level the wheat field to stubble and grasps a handful of stalks as he cuts. The graphic gesture of grasping the grain-laden sheaves while leaving the barren stalks was clearly designed to stress the interpretation of 14:16 given in the *Bible*

moralisée gloss, which asserts that on the day of judgment Christ will separate the good from the bad, and those who are "grain" will be stored in his granary and those he rejects will be cast into the fire.[248] However, the harvesting gesture has no particular significance for the Berengaudus archetype because no allusion to the Last Judgment is made in the commentary, thus offering further evidence that it was inspired by the *Bible moralisée*. Having lost its original significance, the harvesting gesture is treated with varying degrees of understanding in the Berengaudus manuscripts.

57. Vintage: 14:17–20

> And another angel came out of the temple, which is in heaven, and he also had a sharp sickle. And another angel came out of the altar, who had power over fire; and he cried in a loud voice to him who had the sharp sickle, saying: "Take your sharp sickle and vintage the clusters from the vine of the earth, for their grapes are ripe." And the angel set his sharp sickle on the earth and vintaged the earth's vines and threw it into the great winepress of God's wrath; and it was trodden outside the city, and blood came out of the winepress up to the horses' bridles for sixteen hundred furlongs.

The English Gothic designers develop a cyclical image in which the command and execution of the Vintage provide narrative symmetry to the preceding illustration of the Harvest. As in the *Bible moralisée*, which divides the text into two illustrated segments, the angel emerges from the temple carrying a sharp sickle, as he speaks to another angel standing next to an altar at the left; the second angel pulls at his mantle and gestures to the right as he commands the ripened grapes to be cut from the vines (see fig. 120). The right half of the miniature is then given over to the vintaging angel who cuts the grapes from a high trellis, dropping ripe clusters into a "winepress" where the grapes are trampled by devils. At the right, two horses emerge from the city gates in a literal rendering of "the blood that came out of the winepress [was] up to the horses' bridles"; in all the recensions, two horses stand at the right, with only their forequarters visible as they emerge from the city gates. The commentary interprets the winepress of God's wrath as hell, thus accounting for the presence of demons.[249]

The representations of the Harvest and Vintage form a complementary pair of illustrations in most thirteenth-century cycles, but the Metz designer fur-

Figure 121. Apocalypse. Formerly Metz, Bibliothèque municipale MS Salis 38, fol. 26v. Vintage (photo: Monuments historiques, Paris).

ther divides the text for the Vintage into two illustrated segments, which then appear on a facing verso and recto.[250] In the Metz illustration for 14:17–18 (fig. 121), the first angel flies out of the sanctuary at the upper left to make room for a grape arbor below. In response to the gloss, which identifies the grapes as the wicked, the angel pulls up the trailing end of his mantle to avoid contamination by the evil fruit, as the second angel standing next to the altar at the right issues the command for the Vintage. The isolated juxtaposition of the two angels in this passage allows the reader to perceive a clear relationship between the image and the commentary, which interprets the two angels to signify that Christ appears mild to the just but terrible to the wicked, in an implied reference to the Last Judgment.[251] The angel at the right thus makes a judgmental gesture by pointing down at the grape vines to signal their connotation of evil and upward toward the vested altar, which the gloss treats as a metaphor for the

Church, a meaning reinforced by the prominent display of a covered ciborium. Within the polysemous discourse of the Gothic Apocalypse, the Harvest and Vintage can also be perceived as self-reflexive metaphors of reading, drawn etymologically from the Latin *legere*, which connotes "picking," "harvesting," and "collecting."[252] Particularly striking are the rows of vines imaged directly above the text in Metz, evoking Pliny's observation that the word *pagina* (page) can refer to rows of vines joined together.[253] As developed by Hugh of St. Victor, the lines on the page were a trellis supporting the vines.[254]

After a long absence of several chapters, the angels return in 14:6 as the major protagonists of John's visions. The idea of their reappearance is stressed pictorially in the representation of their winged advents to deliver the Eternal Gospel and announce the Fall of Babylon. Thereafter, they dominate both heaven and earth as they issue dire warnings of punishment and reward. By commanding John to write, they re-

instate the authorial dimension of his visionary role following a long silence. In the last verses of Rev. 14, the angels then command and execute a judgment upon the earth and its cultivated abundance, now transformed into metaphors of evil, as the harvest of grain and vintaging of grapes signify the punishment and destruction of the wicked.

58–59. Seven Angels: *15:1;* Sea of Glass and Fire: *15:2–4*

> And I saw another sign in heaven, great and marvelous: seven angels with the seven last plagues, because in them is consummated the wrath of God.
>
> And I saw what seemed to be a sea of glass suffused with fire; and standing upon the sea of glass those who conquered the beast and his image and the number of his name, having the harps of God and singing the song of God's servant Moses and the song of the Lamb. . . .

The first four verses of Rev. 15 are traditionally illustrated by a single miniature in the early Apocalypse cycles: The seven angels with their vials representing the plagues are aligned in a frieze at the top, and the harpists stand by the lake of glass and fire below. As in the Harley version of the *Bible moralisée,* however, the Berengaudus cycle divides this passage into two illustrated glossed segments for verses 1 and 2–4. Within the pervasive perceptual structure of the archetype, the texts are interpreted pictorially as two distinct visual experiences – "I next saw," followed by "I seemed to see." John thus stands at the left witnessing each vision, one in heaven of angels enclosed within a cloud frill, the other on a lake of glass suffused by fire. Although the angels are empty-handed in Trinity and Lambeth 209, the angels in the illustration for 15:1 (fig. 122) usually hold vials representing the seven new plagues to conform to the gloss, which refers to the "septem angelorum phialas habentium" and the great mysteries they contain, to draw a parallel with the seven trumpets of Rev. 8–9.[255] Signaled as a "great and wonderful sign," the isolation of the seven angels with their vials serves the same important rhetorical function in the picture cycle as in the text, for it creates a dramatic opening onto a new series of cataclysmic events.

The illustration for 15:2–4 (fig. 123) represents the harpers clustered in irregular groups, plucking their instruments as they stand on the sea of glass

Figure 122. Apocalypse. Malibu, J. Paul Getty Museum MS Ludwig III.1, fol. 30. Seven Angels with Vials (photo: Collection of the J. Paul Getty Museum, Malibu, California).

Figure 123. Apocalypse. Malibu, J. Paul Getty Museum MS Ludwig III.1, fol. 30v. Harpers (photo: Collection of the J. Paul Getty Museum, Malibu, California).

mixed with fire, under the watchful eye of John. This illustrated text was probably isolated from the first verse of Rev. 15 in response to the commentary in which the harpers signify the spiritual understanding of Scripture, an idea consistently stressed by Berengaudus and the thirteenth-century compiler; the lake suffused with fire signifies the mixture of the spiritual and intellectual in divine Scripture.[256] The tendency to transfer the characteristics of the angels with the vials to the harpers might be explained by the superposition of two rows of angels and harpers in an early medieval model, but the interchange of attributes was more likely motivated by the accompanying hermeneutic.

FIFTH VISION (REV. 15:5 TO 20:10)

Just as there is a savoring of God's retribution against the wicked in its long anticipation at the end of the fourth vision, vindictive satisfaction is prolonged well beyond the end of Rev. 16 when the vial-bearing angels, dispatched from an ecclesiastical sanctuary in heaven, have completed their work of pouring God's wrath upon his earthly enemies. The sequence of Vials carefully maintains the symmetry

of reiterated patterns of seven with the preceding Trumpets according to the concerns expressed by Berengaudus in his incipit to the fifth vision, "just as these agree with those above, we say, in sequence . . . then they signify preachers who were from the beginning and they will be at the end."[257] Then the corrupted world embodied in the two great metaphors of Rev. 17 and 18, the whore of Babylon and the city itself, are destroyed. The condemnation of the body and its sensual desires thus serves as a preface to the condemnation of the world and its secular institutions of power. Forming a celebratory interlude symmetrical with that in the fourth vision, the first verses of Rev. 19 shift the venue to heaven with scenes of rejoicing and the nuptial banquet attending the Marriage of the Lamb (fig. 144). The final battle with Antichrist then ensues on a cosmic scale in heaven at the end of time. However, the bestial adversaries of God must be overcome and contained again in all the old guises of the beast, dragon, and Satan before the struggle is finally over (Rev. 20: 10). The renewal first hinted at in Rev. 6 and 11 is partially given toward the end of the fifth vision in the First Resurrection, thus anticipating and forming a bridge to the penultimate, sixth vision.

60. Distribution of the Vials: *15:5–8 to 16:1*

> And after this I saw, and behold the temple of the tabernacle of testimony was opened in heaven, and seven angels with the seven plagues came out from the temple, dressed in pure white linen and with golden girdles circled around their breasts. And one of the four Beasts gave the seven golden vials filled with the wrath of God, who lives for ever and ever. And the temple was filled with smoke from the majesty of God and from his power; and no one was able to enter the temple, until the seven plagues of the seven angels were consummated.
>
> And I heard a great voice from the temple saying to the seven angels: "Go and pour the seven vials of God's anger upon the earth."

Allying itself with the *Bible moralisée*. the illustration for 15:5–8 centers on the distribution of the vials.

However, the wide disparity among the English Gothic manuscripts suggests that the thirteenth-century designers encountered a significant problem in attempting to visualize the glossed text. As they shift the venue for the event from heaven to earth, the Berengaudus illustrations fall into two distinct groups: those that enclose all the elements of the scene within a wreath of clouds, as in Metz (fig. 124), and those that place all the figures on the ground, as in Morgan and Getty (figs. 125 and 126).

Metz departs significantly from earlier iconographical traditions by elevating and thus visually isolating the sanctuary, angels, and Beast within a

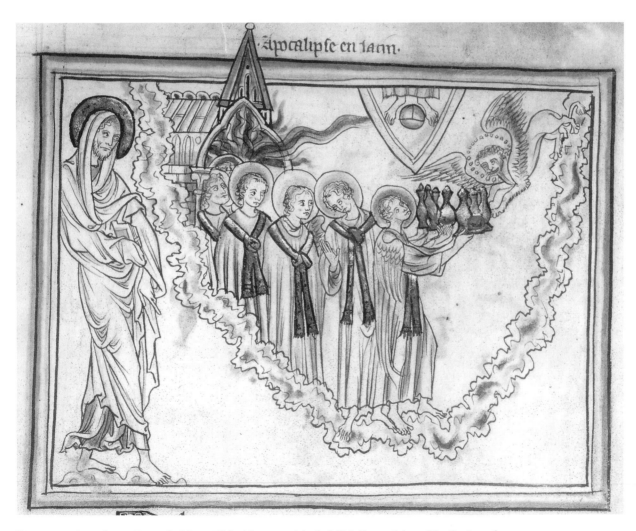

Figure 124. Apocalypse. Formerly Metz, Bibliothèque municipale MS Salis 38, fol. 7. Distribution of Vials (photo: Monuments historiques, Paris).

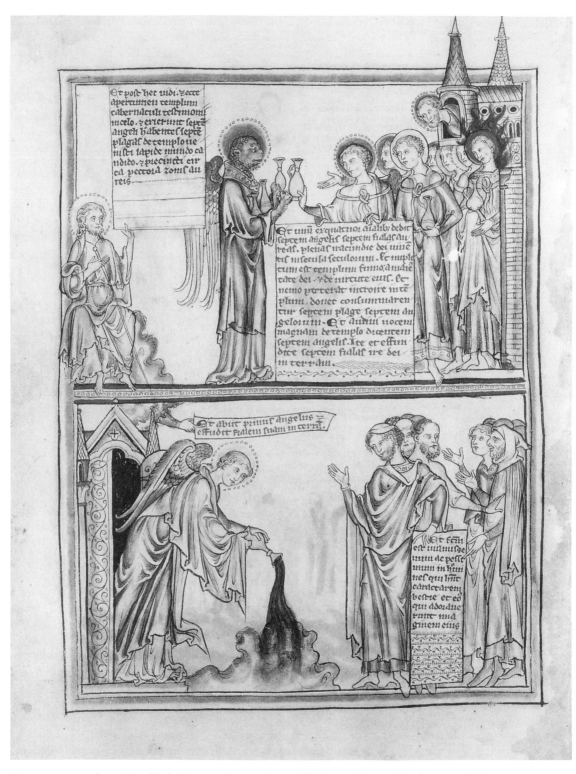

Figure 125. Apocalypse. New York, Pierpont Morgan Library MS M.524, fol. 14v. Distribution of Vials (above); First Vial (below) (photo: The Pierpont Morgan Library).

cloud frill, thus transforming the whole transaction into a timeless celestial event. The new focus on the otherworldly aspects of the vision probably stems from the commentary, which interprets the sanctuary as the heavenly Jerusalem, while the seven angels are preachers bringing doctrine from a celestial homeland, protected from errors by the golden girdles representing divinely inspired wisdom.[258] Unlike those in Metz, the angels in Morgan emerge from a temple solidly established on *terra firma* to denote its significance in the commentary as the Church, thus stressing their earthly mission as preachers. The angels in Metz receive their vials filled with God's anger from a celestial source in a literal rendering of the text for 15:7, but the Morgan representation, by shifting the Beast to the ground, implies an earthly source for the seven vials, which in the gloss represent the seven principal vices.

Metz further pursues the visionary interpretation of this passage in its pictorial development of 15:8, where waves of dark smoke pour out from the temple toward the image of the disappearing Lord. The fractional glimpse of the Lord's feet poised on a globe within a partial mandorla frame refers not only to the "glory and power of God," but to the commentary that interprets this passage to mean that even the elect in this life are unable to contemplate heaven in their mind's eye, for it is hidden in darkness, quoting from I Corinthians 13:12: "Now we see through a glass darkly, but we shall be seeing face to face."[259] John's obscured vision, enabling him to see only the feet of the Lord, is further emphasized by his veil, a feature that also survives in Trinity. Getty (fig. 126) negates Metz's more nuanced reading by adding a full-length frontal figure of the Lord enthroned within the sanctuary at the right, in a straightforward reference to the "glory and power of God" rising above the smoke.

In addition to 15:5–8, the Berengaudus paradigm very probably also included 16:1. On the grounds this eccentric text division corresponds to no other known capitulation, we may assume that the modification was made expressly for the English Gothic cycle. Indeed, Morgan and Getty, as well as Trinity,

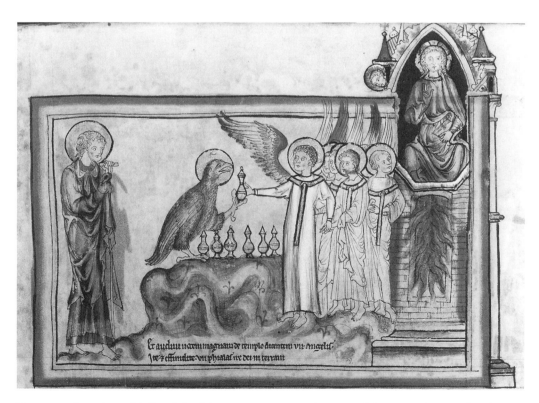

Figure 126. Apocalypse. Malibu, J. Paul Getty Museum MS Ludwig III.1, fol. 31. Distribution of Vials (photo: Collection of the J. Paul Getty Museum, Malibu, California).

make explicit pictorial references to the "voice from the sanctuary" commanding the seven angels to empty their vials on the earth as a necessary antecedent to the succeeding series of illustrations for the pouring of each vial. In Getty, where the "voice" is rendered as an angel partially visible as he emerges from behind the sanctuary, the text for 16:1 is uniquely inscribed at the lower edge of the illustration.

In their differing interpretations of the Beast who distributes the vials, the Berengaudus manuscripts reveal another problem posed by this passage. Because neither the text nor the commentaries specify which of the four animals undertook the task, the older cycles omit the Beast, include all four, or choose either the lion or eagle. As in the *Bible moralisée*, the Beast in Metz assumes the form of a winged lion, whereas in Morgan, the lion becomes a tall, upright humanoid figure, dressed in a chasublelike mantle held at the breast by a large brooch, reminiscent of episcopal garb. The selection of the lion in both cases apparently refers to the Berengaudus commentary that identified the beast as Christ by harking back to Rev. 5:5, where the Lion of Judah is read as Christ in the gloss,[260] as well as to the older Christological identifications of the *leo fortis* in the *Physiologus* and Bestiaries.[261] In Trinity and the Westminster manuscripts, the vials are distributed by the eagle, which represents Christ in the gloss on 12:13.[262] Although the eagle might suggest a possible influence from the Beatus tradition, the choice could more plausibly have been made independently to stress different aspects of Christ. In contrast with the leonine guise, which evokes Christ's rulership, the eagle denotes Christ's victory over Satan and by extension over the sins embodied by the seven vials. Moreover, according to the *Physiologus*, the eagle's extraordinary powers of sight allow him to look up at the sun without blinking; thus, Christ gazes upon God the Father and raises men up to the contemplation of the Godhead.[263] The eagle who sharpens its vision by looking at the sun is then linked with the writer of the Apocalypse in a mid-twelfth-century sequence of verses on St. John the Evangelist, ascribed to Adam of St. Victor.[264] Perceived as a multivalent figure that not only serves as a guise for Christ but also for John through the symbol of his Gospel, the Eagle-Evangelist thus

becomes a protagonist in the drama, acting as God's agent to disburse the vials filled with divine anger.

61–62. First Vial: 16:2; Second Vial: 16:3

> And the first angel departed and poured his vial upon the earth, and cruel and malignant wounds were inflicted upon men who had the mark of the beast, and upon those who had adored his image.
> And the second angel poured his vial over the sea, and it turned to blood, as if dead, and every living creature in the sea was dead.

Although the simple device of representing the angels flying down from heaven to distribute the contents of their vials over the earth would appear to be the most straightforward way of pictorializing the text, the Berengaudus cycles maintain the terrestrial location of what transpires in the fifth vision by situating the angels on the ground as they disburse God's wrath over the earth. The large standing figures in the Berengaudus cycle also convey the earthly mission assigned to the angels in the commentary, where they are identified as preachers, theologians, and prophets.

While pouring the First Vial on a mound of earth, the angel faces a group of well-dressed men at the right who extend their hands to reveal the mark of the beast, which is interpreted in the gloss as *superbia*, or pride, "the worst vice of our time." The beast worshipers make gestures of rejection and withdrawal to further visualize the commentary, which interprets the first angel as the preachers before the Law who were rejected by the wicked. Although the thirteenth-century manuscripts tend to pair the subsequent vials within a single framed miniature, the absolute lack of consistency with which this is done tends to suggest that the archetypal conception envisaged an isolated illustration for each vial. In Morgan, the second and third vials are combined within a single frame (fig. 127), but the pouring of each vial is treated as a separate episode, each with its own text and gloss by virtue of the insertion of a tall towered sanctuary that serves as a vertical barrier, dividing the two scenes into separately framed compartments. As Henderson has already pointed out,[265] the awkward and complex composition in Metz (fig. 128), with its illogical overlapping of episodes, looks as if it has been constructed by shifting and merging

motifs from a series of separate miniatures. A compression of three illustrations from the archetype is further confirmed by Metz's division of the text into three segments, each introduced by a new rubric.[266]

63. Third Vial: 16:4–7

> And the third angel poured his vial upon the rivers and upon the springs of water, and they turned to blood. And I heard the angel of the waters say, "You are just, Lord, you who are and who were; holy because you have judged these things: For the blood of the saints and of the prophets was poured out, and you have given them blood to drink; they are worthy of it." And I heard another from the altar saying: "Yes, Lord God almighty, your judgment is true and just."

Although the text for 16:5–7 ("Then I heard . . . I heard") would normally signal a new half-page miniature in the Berengaudus cycle, the pronouncements of the angel of the waters and the voice of the altar are incorporated into the illustration of the Third Vial (see fig. 127). The failure to provide a separate image for John's auditory experiences was most likely generated by an irregularity in the text for 16:5 that substituted "angelum quartum" for "angelum aquarum."[267] Because this variant is present in the commentary that interprets the "fourth" angel as those who praise God's justice in punishing the wicked,[268] the pictorial interpretation of the "angel of the waters" as the "fourth angel" holding a vial is dictated by the aberrant locution in most thirteenth-century recensions.[269]

In Metz (fig. 128), the third angel pours his vial on the waters flowing from the rocky terrain to respond to the commentary, which interprets the pouring of the third vial as the prophets announcing the word of God to the impious people who will reject their message, killing God's ministers and thus truly transforming the rivers into blood.[270] At the right, the "fourth" angel is engaged in a colloquy with the angelically embodied voice of the altar that echoes his approbation of the Lord's just punishments. Personified in the guise of an angel who stands behind a vested altar bearing a chalice, the "voice" raises his hand in an oratorical gesture denoting speech as if answering a similar gesture made by the "fourth" angel, whereas in Morgan (fig. 127), a hand descends

from heaven to denote the presence of the deity to whom the "fourth" angel speaks.

In Metz, where the "fourth" angel holding the vial on the right turns back toward the angel of the altar, the textual sequence was probably reversed to maintain the declamatory exchange. In Morgan, which adds a half-page miniature for 16:5–7, the two angels appear in textual order, so that the "fourth" angel appears to be addressing John, now seated at the left in place of the angel pouring the third vial, and the angel of the altar correctly raises his voice (hand) to the hand of God extended from heaven. Indeed, the text that accompanies this figure reads: "And I heard another angel speaking from the altar," modifying the Vulgate "altare dicens" to correspond to the pictorial representation of the "voice" of the altar as an angel standing behind it.[271] The repeated oratorical gestures and speech scrolls of the angel's declamatory utterances emphatically convey that John's experience is auditory rather than visual ("Then I heard . . . And I heard"). Because there was probably not sufficient space to include the figure of the witness within the archetypal illustration, John stands outside in Metz, pressing his ear against a small opening in the frame.

Although the serial separation of the Vials appears to have been almost obligatory for the sake of narrative symmetry with the seven Seals and Trumpets, the merging and shifting of episodes among the thirteenth-century manuscripts reveal a pervasive unwillingness to succumb to a predictable and hence monotonous repetition of very similar images. Thus, although each pouring was conceptualized as a discrete, individuated act followed by its own distinctive consequences, the rhythmic structures created by the variant sequences, such as that in Metz, offer dramatic inflections that expand their meaning for the reader. In Morgan, for example, the first event unfolds in response to a written rubric, slowly and deliberately across the whole expanse of the half-page picture space, whereas in Metz, the angel empties his vial more hurriedly, as if pushed by the moving crowd of angels behind him. The urgency of Metz's action spills into the next frame where the succeeding two vials are simultaneously poured, one above the other at the left, in contrast with the more measured sequence in Morgan created by its compartmentalizing frames.

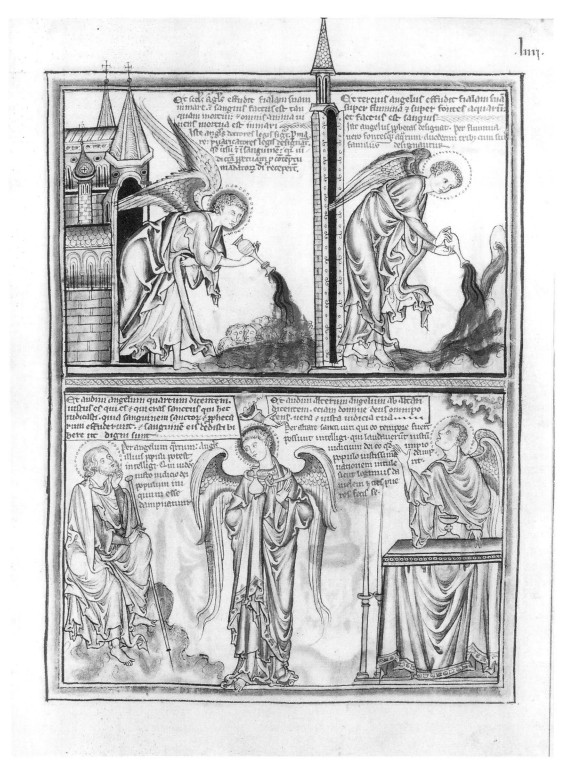

Figure 127. Apocalypse. New York, Pierpont Morgan Library MS M524, fol. 15. Second and Third Vials (above); Fourth Angel and Angel of the Waters (below) (photo: The Pierpont Morgan Library).

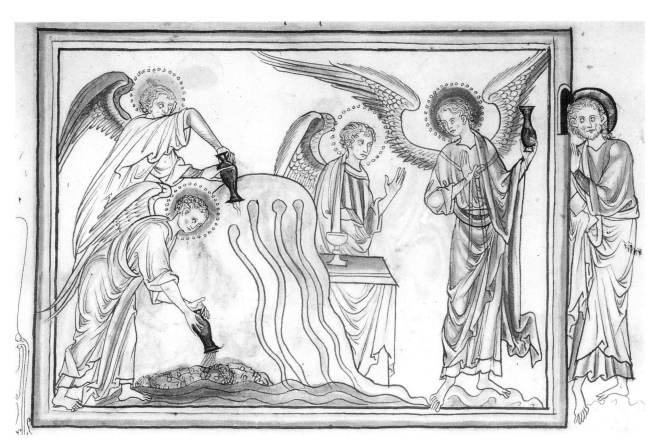

Figure 128. Apocalypse. Formerly Metz, Bibliothèque municipale MS Salis 38, fol. 8. Second and Third Vials (photo: Monuments historiques, Paris).

Whether they interpret the angel of 16:5 as the "fourth angel" or the "angel of the waters," all the thirteenth-century cycles treat the colloquy with the angel of the altar as a welcome and necessary hiatus that momentarily halts the relentless surge of destruction leveled upon the wicked. Indeed, the "fourth" angel in Metz, Getty, and Morgan signals a pause by holding the vial upright, gesturing his hesitation to continue until the justification for the punishments has been resolved. Thus, a narrative interstice has been created between the pouring of the third and fourth vials to permit the reader to absorb the impact of the sequence through the intermediary of John, who reappears as an auditory witness. While he eavesdrops on the angelic exchange in Metz, the seer himself becomes directly involved in Getty and Morgan as he is addressed by the two angels within the frame.

64. Fourth Vial: *16:8–9*

And the fourth angel poured his vial upon the sun, and he was given power to strike men down with heat and fire; and men were burned with the great heat and they blasphemed against the name of God, who had the power over these plagues, instead of repenting to give him glory.

The sevenfold sequence resumes with the pouring of the fourth vial (fig. 129). The scorching solar flames descend upon a dense pyramid of fallen figures who have expired from the fierce heat. In Getty, the stricken men attempt to shield themselves as they fall, and John, who stands as a spectator at the left, props up his veil with his staff to form a protective tentlike shield. The intensity of the solar heat is further signaled by the dorsal figure at the right who covers his eyes as he blindly points to the flames; an adjacent foot, similarly pointed upward, belongs to another dorsal figure whose bare buttocks are ex-

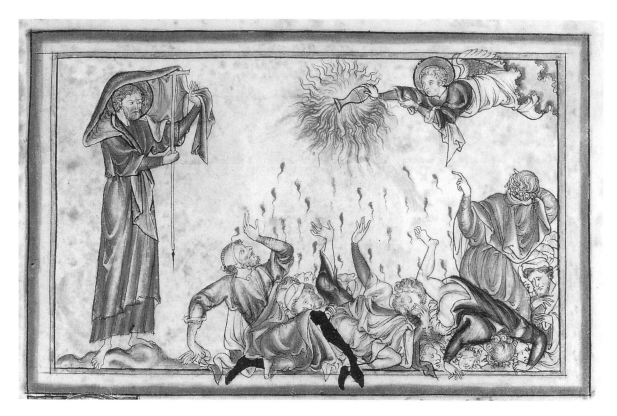

Figure 129. Apocalypse. Malibu, J. Paul Getty Museum MS Ludwig III.1, fol. 33. Fourth Vial; Historiated Initial: Men Shielding Themselves against the Sun (photo: Collection of the J. Paul Getty Museum, Malibu, California).

posed to the painful torture as he plunges into the crowd of fallen victims. The commentary interprets the pouring of the fourth vial on the sun as the destruction of the Jews by the Romans, thus accounting for the veiled and caricatured figures among the scorched victims.

65. Fifth Vial: 16:10–11

> And the fifth angel poured his vial upon the throne of the beast, and his kingdom was made dark, and they bit their tongues for pain and blasphemed against the God of heaven, because of their pains and wounds and they did not do penance for their deeds.

In all the Berengaudus cycles, the paratactic text is visualized in a binary opposition of up-and-down gestures in which the angel at the left pours his vial on the empty throne of the beast, while at the right a group of men gesticulate toward heaven. The com-

mentary interprets the fifth angel as the orthodox Fathers struggling against heresy, hence the downward pressure of suppression so vigorously activated by the angel. As the heretics bite their tongues in pain because each blamed the others for his errors, their curses against God are signaled by their aggressive gestures as they point their fingers accusingly upward toward heaven; in Douce (fig. 130), the image of the Lord appears in an aureole above to clarify the meaning of the glossed text. Whereas Metz and Morgan concentrate exclusively on the unrepentant blasphemous curses of the beast's followers, Douce expands its pictorial response to the text's declaration that "the whole empire [of the beast] was plunged into darkness" by depicting the two-horned false prophet from Rev. 13 in the center foreground, toppled from his throne and crawling helplessly back into the earth. In contrast, Getty eschews the figure of the beast for another literal figuration of the text

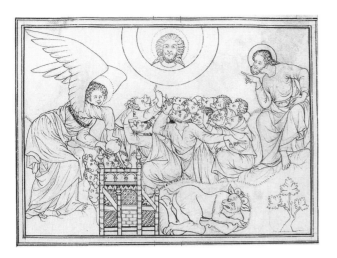

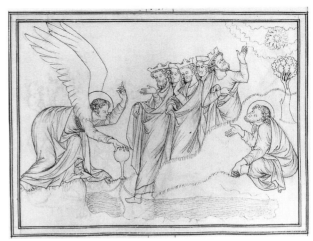

Figure 130. Apocalypse. Oxford, Bodleian Library MS Douce 180, p. 66. Fifth Vial (photo: The Bodleian Library, Oxford).

Figure 131. Apocalypse. Oxford, Bodleian Library MS Douce 180, p. 67. Sixth Vial (photo: The Bodleian Library, Oxford).

by showing the "empire's plunge into darkness" as an inky black veil descending from the clouds over the cursing blasphemers.

66. Sixth Vial: *16:12*

> And the sixth angel poured his vial upon the great river Euphrates and its waters dried up in order to prepare the way for the kings from the rising sun.

The archetypal conception of the English Gothic cycle clearly called for a separate illustration for the text describing the pouring of the sixth vial, particularly because space was needed for an important commentary that identifies the sixth angel as holy martyrs and the Euphrates as the persecutors of the Church,[272] but the absence of narrative thrust in the bland representation of the angel pouring his vial on the river posed a challenge to the designers of the thirteenth-century recensions. The vigorous up-and-down gesturing of the angel in Douce (fig. 131) activates the whole image as his thematic hand movements are echoed in a number of variations by John and the three "kings from the east," who are interpreted by Berengaudus as the "multitude of people who have faith in Christ," and by the king at the right who turns and gestures upward toward the sun which the gloss explains as a harbinger of Christ's Advent.[273] Another sign of the Incarnation, the dry-

ing up of the Euphrates, is signaled in Douce by a blank space that breaks the flow of the river's undulating lines, thus "preparing the way."[274] As in the *Bible moralisée*, where the kings signal a textual reading *in bono*, the royal figures in Douce form a virtuous antithesis to the evil followers of the beast in the previous illustration.

67. Unclean Spirits: *16:13–16*

> And I saw from the mouth of the dragon and from the mouth of the beast and from the mouth of the false prophet three unclean spirits like frogs. Truly they are the spirits of demons making signs, and they went forth to the kings of the whole earth to gather them together in battle on the great day against almighty God. . . . And he shall gather them in a place which is called Armageddon.

Although John's vision of the unclean spirits could be conceived as a consequence of the pouring of the sixth vial, most English Gothic cycles give a separate illustration for these verses (see fig. 132). The isolation of the image was established early and continued into the *Bible moralisée*. The vision of the Unclean Spirits is clearly envisaged as a brief hiatus lying outside the sequence of Vials. As in the overheard conversation between the angels of the altar and the waters, John returns to the narrative discourse not only as witness, but also as an active participant to confront the poisonous emission of demonic spirits.

163 ■

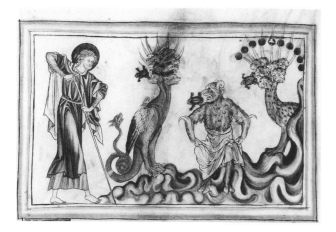

Figure 132. Apocalypse. London, British Library MS Add. 35166, fol. 18v. Unclean Spirits (photo: The British Library).

In Add. 35166, the Evangelist literally "stands his ground" against his adversaries as he steadies himself against his staff.

The commentary interprets all three beasts as preachers of Antichrist whose hoarse voices resembling those of frogs signify the wickedness of those who are filled with blasphemous preaching.[275] As a consonant extension of his association with the dragon and sea beast, the false prophet is cast in the guise of the two-horned beast from Rev. 13. In Add. 35166, the traditional hierarchical tiers of beasts confronting the Evangelist have been abandoned in favor of an arrangement where the false prophet occupies a position of greater dominance and authority. Realigned between the dragon and the sea beast who attend his preaching, the enthroned false prophet can be more readily identified with Antichrist.

68. Seventh Vial: *16:17–21*

> And the seventh angel poured his vial upon the air, and a great voice came out of the temple, from the throne, saying: "It is done." And there were lightnings and voices and thunders and there was a great earthquake, so great as never had been since men were upon the earth, indeed so great the earthquake. And the great city was divided into three parts; and the cities of the gentiles fell, and Babylon the great came into memory before God, to give her the cup of the indignation of his wrath. And every island vanished, and mountains disappeared. And great hailstones like talents descended from heaven upon men; and they blasphemed against God because of the plague of hailstones, because it was so violent.

The angel pours his vial on a curving bank of clouds

representing the "air" (see figs. 133 and 134). Below is spread the destruction of Babylon, with tumbling walls, buildings and towers, flames mixed with hail, amidst falling boulders and trees. Because the commentary specifies that the temple signifies the Church,[276] the sanctuary is represented as a towered ecclesiastical structure hovering on the clouds. In Getty, the Lord appears within the sanctuary to announce that the end has come, whereas in Add. 35166, a head emerging from the door of the temple represents the great "voice," which Berengaudus interprets as the voice of holy preachers at the time of Antichrist.[277]

The pouring of the last vessel not only brings the serial destruction wrought by the vial-bearing angels to an end (conclusion), it also heralds the God-ordered end (destruction) of Babylon. Thus, the long serial sequence of aerial attacks as the vials are emptied upon the earth constitutes an extended preparation for the final assault. In Add. 35166 (fig. 133), the seer holds his staff upside down in an echoing acknowledgment of the fallen city before him, but the reversal also signals an end to his journey that proves only temporary, for he is witnessing the destruction of one city (Babylon) in order that he might continue his pilgrimage to another (Heavenly Jerusalem). In Getty (fig. 134), John looks back as he walks away, not only signaling the end of his serial experience of seeing the vials poured, but also a change of direction so that the angel can show him

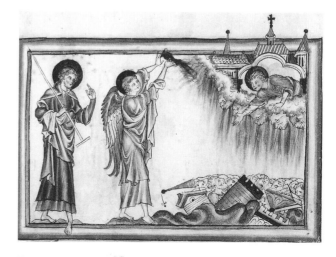

Figure 133. Apocalypse. London, British Library MS Add. 35166, fol. 19. Seventh Vial (photo: The British Library).

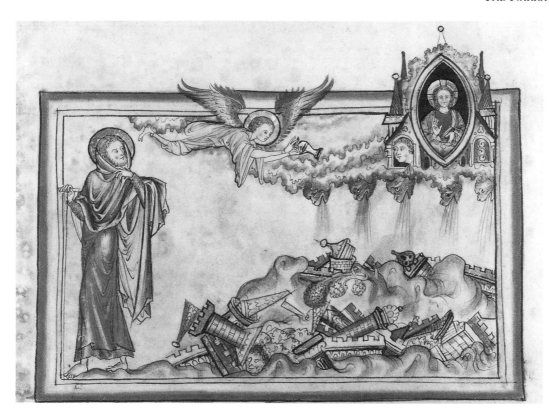

Figure 134. Apocalypse. Malibu, J. Paul Getty Museum MS Ludwig III.1, fol. 35. Seventh Vial (photo: Collection of the J. Paul Getty Museum, Malibu, California).

the past and future of what he has just witnessed. Thus, the last frame of Rev. 16 concludes with the destruction of Babylon, only to be followed by one of the vial-bearing angels showing John the city not yet destroyed but transfigured in the guise of the Great Harlot.

69. Harlot of Babylon: 17:1–2

> And one of the angels who had the seven vials came and spoke to me, saying: "Come, I will show you the damnation of the great harlot, who is seated upon many waters, with whom the kings of the earth have fornicated, and those who inhabit the earth have been made drunk with the wine of her prostitution."

Differing profoundly from the older traditions that portray the harlot seated on the beast, the Berengaudus paradigm (see figs. 135 and 136) isolates the first two verses for an illustration that shows her first seated on a mound over or through which flow streams representing the "abundant waters," because, according to the commentary, they signify that Babylon, the city of the devil, was constructed by a multitude of peoples.[278] The dominant thrust of the text focuses on the harlot's rulership over earthly kings through sexual domination, making "the world drunk with the wine of her adultery." Whereas the sexual reference is made pictorially more explicit in the *Bible moralisée*, where the woman is seated between two kings who embrace her and cup her chin, the Berengaudus image abandons this kind of anecdotal characterization and transforms the prostitute into a personification of *luxuria* or lechery by endowing her with the identifying attribute of a small circular mirror into which she gazes as she adjusts her veil.[279] Beyond serving a simple emblematic purpose, the mirror also embraces the wider meaning of Babylon as the "world." In the sense developed by Plotinus, the mirror represents the elusiveness of ex-

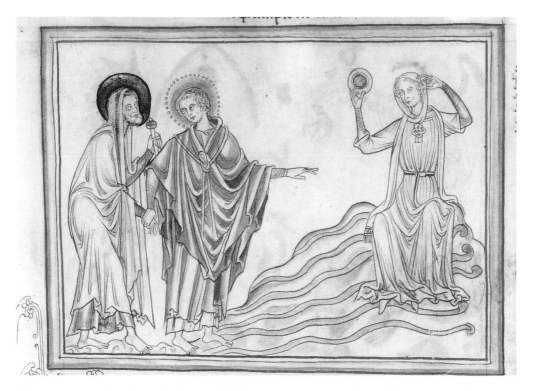

Figure 135. Apocalypse. Formerly Metz, Bibliothèque municipale MS Salis 38, fol. 10v. Harlot of Babylon (photo: Monuments historiques, Paris).

perience in the sensible world, a world of shifting images, a world of illusion.[280]

In the absence of the kings, a fateful juxtaposition of the streams and mirror gazing further transforms the harlot into a female reincarnation of Narcissus, as her fornications become acts of self-love. Gazing at her reflection in the mirror, the harlot offers the reader a perversion of John's inner vision, for what the harlot sees is a reflection not of love but death. As Plotinus warned, "Whoever would let himself be misled by the pursuit of those vain shadows, mistaking them for realities, would grasp only an image as fugitive as the fluctuating form reflected by the waters. . . . Likewise he would plunge not his body but his soul into the gloomy abyss."[281]

In the Berengaudus gloss, the angel represents holy preachers, and John serves as a type for all the faithful.[282] To convey the idea of the angel's persuasive, if not coercive sermonizing, the angelic preacher in Metz (fig. 135) grasps John's hand, guiding the reluctant seer into the harlot's line of vision. In Morgan (fig. 136), the angel pulls John through an

elaborate city gate that stresses the isolation of the desert to which the Evangelist is being transported "in spirit" (17:3) at the same time as it makes a graphic reference to the "city" of the faithful from which John emerges, that is, the Church, opposite the city of the devil (Babylon) personified by the harlot in the gloss.[283] The subtlety or ambiguity of the Morgan image, however, apparently caused it to remain unique.

70. Harlot on the Beast: *17:3–7 [8–18]*

And [the angel] took me in spirit into the desert. And I saw a woman sitting upon a scarlet beast having seven heads and ten horns, full of blasphemous names. And the woman was dressed in purple and scarlet and gilt with gold and precious stones and pearls, holding in her hand a gold cup full of the abomination and filth of her fornication; and on her forehead was written her name, a secret name, Babylon the great, earthly mother of fornication and abomination. And I saw the woman drunk with the blood of the saints and with the blood of the martyrs of Jesus: and I was struck, upon seeing her, with great wonder. And the angel said to me: "Why do you wonder? I will tell you what binds

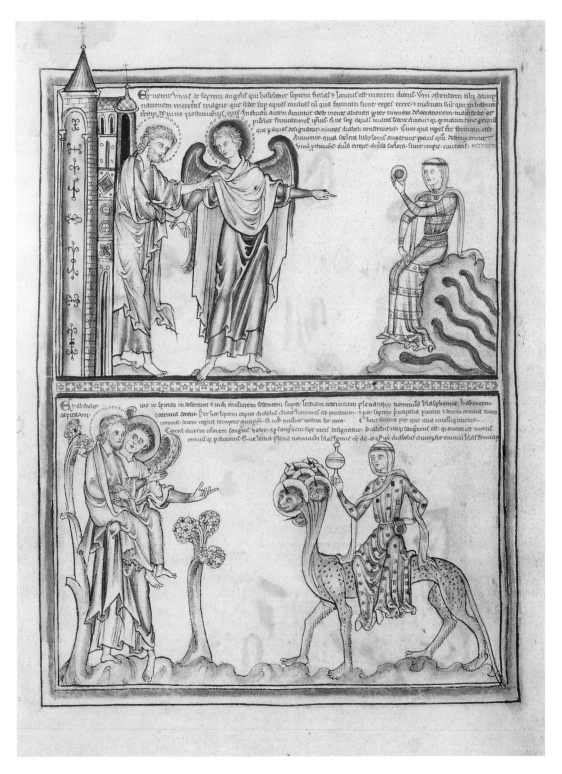

Figure 136. Apocalypse. New York, Pierpont Morgan Library MS M.524, fol. 16v. Harlot of Babylon (above); Harlot Riding the Beast (below) (photo: The Pierpont Morgan Library).

the woman to the beast who carries her, who has seven heads and ten crowns."

As in the *Bible moralisée*, the illustrated text for 17:1–2 in the Berengaudus cycle serves as a narrative prologue to the vision of the woman riding the scarlet beast. As it appears in Morgan (fig. 136), the archetypal illustration shows John being carried and cradled like a frightened child by the angel at the left. The clumsy effort to render the text ("he took me in spirit to a desert") provides compelling evidence for an intertextual relationship between the English Gothic archetype and the *Bible moralisée* cycle (see fig. 137) in which the angel carries off a small childlike figure representing John's spirit, while the seer's corporeal incarnation sleeps below. Although partly generated by the text and commentary, John's extreme reluctance to look at the harlot also alerts the reader to join him in his refusal to engage her in a reprehensible phallic gaze that would cause him to enter into a dialogue of desire. In a collection of thirteenth-century axioms entitled "On Not Looking at Women," Gerald of Wales urges his readers to avoid staring at women: "Even if your gaze should

Figure 137. Bible moralisée. Toledo Cathedral Treasury, III, fol. 187. Harlot Riding the Beast (photo: MAS).

fall upon a woman, you must never fix your gaze."[284] Conversely, John's trepidation is also caused by his terror of the harlot's gaze. As long as the harlot fixes her gaze in the mirror, the danger of scopic domination is held in abeyance, but when in the next moment she lays aside her narcissistic *speculum* for the cup of abominations, John seeks protection in a multivalent maneuvre by leaping into the angel's arms.[285] In such thirteenth-century Apocalypses as Morgan and Metz, where the harlot retains her mirror in the second illustration, John's avid pursuit of "spiritual refuge" can further be perceived as a flight from the apotropaic power of the harlot's powerful "eye" (the female gaze) signified by the *speculum*.

Although another aspect of John's vision newly referenced in 17:6 ("I saw that she was drunk") would normally signal another illustration, the addition of an illustration for the episode of the drunken harlot appears only in the Westminster manuscripts (see fig. 138). The graphic unfolding of the harlot's wild abandon clarifies the ambiguous image of the woman on the beast holding the covered wine cup to respond to the commentary in which her drunkenness signifies that she is damned beyond God's mercy, and John's complete mystification represents the reaction of the faithful when they see how the wicked have no fear of God in their flagrant indulgence in sin.[286] In Paris lat. 10474 (fig. 138), John patiently listens to the angel's disquisition inscribed on a speech scroll. His didactic explanatory discourse unfolds in disapproving lines held stiffly over the undignified collapse of the inebriated figure below. The drunken harlot in Paris lat. 10474 falls backward, holding a wine cup in one hand as a second falls to the ground, visually marking the measure of her excessive thirst. In Add. 35166, the inebriated woman careens wildly as she falls backward, dropping both cups, whereas in Getty, she holds an empty cup and jug as she dances tipsily toward a wine vat for a refill. With her skirts pulled up in various degrees of disarray, the drunken harlot boldly displays a bare leg above her high buskins following the medieval custom of prostitutes. In his commentary on the biblical phrase "making bare the thigh" (*revela crura*), Albertus Magnus pointed to the example of Venus painted with her skirt raised to reveal her leg "that she might provoke lust."[287]

Within the larger structure of the Berengaudus cycle, the two illustrations of the Harlot of Babylon are

Figure 138. Apocalypse. Paris, Bibliothèque Nationale MS lat. 10474, fol. 36v. Drunken Harlot (Phot. Bibl. Nat. Paris).

isolated and framed by images first presaging and then accomplishing the destruction of the great city she personifies. The first image of the woman follows the pouring of the seventh vial with its announcement that "the end has come," prophesying that Babylon the great will be destroyed, for "God made her drink the wine cup of his anger." Accompanied by the text identifying her as "Babylon the Great," the second representation of the harlot holding the cup as she rides the beast prefaces the destruction of the city, where the prophecies of 16:17–21 and 17:8–18 are fulfilled.

71–72. Fall of Babylon: *18:1–3*; Exodus and Lament: *18:4–20*

And after this I saw another angel come down from heaven, having great power; and the earth was illuminated by his glory. And he exclaimed loudly: "It has fallen, Babylon the great has fallen and it has become the habitat of demons and the custody of every unclean spirit and of every unclean and odious bird; for all the nations have drunk the wine of the wrath of her fornications; and the kings of the earth have fornicated with her, and the merchants of the earth have been made rich from the power of her pleasures."

And I heard another voice from heaven saying: "Come out from her, my people, so that you will not be participants in her sins and that you not receive her plagues. . . . There will be mourning and weeping for her by the kings of the earth who have fornicated with her and lived with her in luxury. They see the smoke as she burns, while they keep at a safe distance from fear of her agony. They will say:

'Mourn, mourn for this great city,
Babylon, so powerful a city,
doomed as you are within a single hour.' . . . "

The disparity of texts and illustrations among the Berengaudus illustrations suggests that visualizing the narrative for 18:1–20 posed some problems for thirteenth-century designers, but the cycle was probably conceived initially to contain at least two illustrated pages to accommodate this long text as well as to visualize John's perceptions ("I saw another angel . . . I heard a new voice speak from heaven").[288] Responding in the first illustration (fig. 139) to the text of 18:1, which signals a new vision ("After this I saw another angel"), John acknowledges the arrival of the angel who flies down from the clouds to announce the fall of Babylon. The angel points to the tumbled mass of fallen walls and towers of the city below, now inhabited by demons and birds of prey. The gloss interprets the angel who descends from heaven to earth as Christ with the great power of the Father and the angel's voice that shouted with great authority as Christ's doctrine in the Gospels,[289] thus accounting for the pictorial isolation of the first three verses.

Although the text for the next illustration varies, the Fall of Babylon is logically followed by the Exodus and Lament over the lost city. In Getty, these two scenes are given as separately illustrated segments of text, each provided with an extensive commentary, but this recension, like most of the others, omits a considerable block of text. The second Getty illustration (fig. 140) represents an angel descending from the clouds to call God's people from Babylon, as John stands outside with his ear pressed against a small aperture in the frame to hear the voice. A

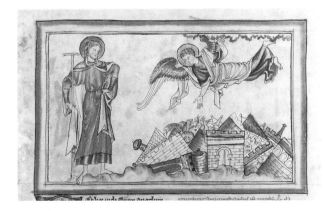

Figure 139. Apocalypse. Malibu, J. Paul Getty Museum MS Ludwig III.1, fol. 37. Fall of Babylon (photo: Collection of the J. Paul Getty Museum, Malibu, California).

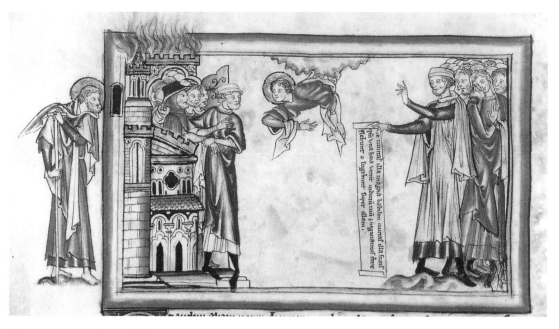

Figure 140. Apocalypse. Malibu, J. Paul Getty Museum MS Ludwig III.1, fol. 37v. Exodus and Lament (photo: Collection of the J. Paul Getty Museum, Malibu, California).

crowd of well-dressed people emerges from the burning city at the left; at the right, kings lament the fall of the city, led by a man holding a scroll inscribed with the text from 18:11.

As witnessed by the *Bible moralisée*,[290] textual lacunae appear to have been endemic to the thirteenth-century conception of Rev. 18. Apparently, the laments of the kings, merchants, and sailors were regarded as repetitious and redundant. As the litany of the harlot's punishments is overshadowed by the rescue of God's people, this part of the text was simply deleted in many redactions. The Berengaudus cycle, even when it was complete, probably lacked at least 18:11–14 and perhaps more. The destruction of Babylon in Rev. 18 represents the climax of the condemnation of the world and its institutions. The actual fall of the city is reported at the beginning of the chapter, followed by a denouement consisting of the three dirges in which the kings, merchants, and sailors remember and enumerate the vast treasures and luxuries of the megalopolis and lament their loss. The sequence that began with the crashing fall of the city then descends to an awed realization of the end – the silence after the collapse. In the Berengaudus cycles, this silence becomes a wide pictorial gap in the narrative.

73. Millstone: 18:21–24

> And a powerful angel lifted up a stone like a great millstone and cast it into the sea, saying: "This is how Babylon the great city will be violently cast down and shall be found no more. And the voices of the harpers and musicians and pipers and trumpeters shall be heard no more, and the voice of the millstone shall be heard no more, and the light of the lamps will shine no more. . . ."

All the early cycles contain a representation of the angel casting the millstone into the sea, the coup-de-grace capping the destruction of Babylon. The text describes the action in two sequential gestures: "Then a powerful angel picked up a boulder like a great millstone, and he hurled it into the sea." The conflated English Gothic image offers a curious compromise between cyclical illustration and a frozen single action, for the angel is most frequently represented only once raising the millstone, but the millstone is then revealed a second time in its subsequent submerged state. The commentary explains that "the angel throws the stone into the sea because Christ will plunge *(demerget)* the whole multitude of the wicked into the inferno," thus requiring a distinctive graphic characterization of the action because the angel is Christ "whose strength is beyond human com-

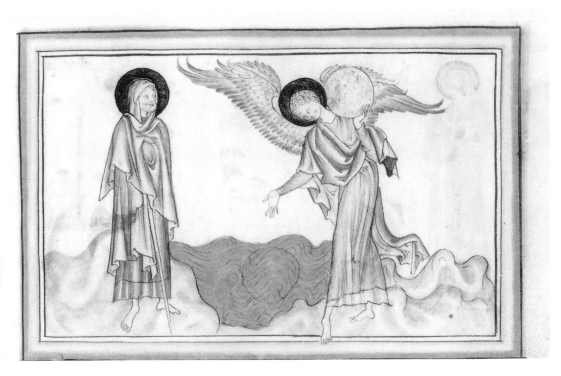

Figure 141. Apocalypse. London, British Library MS Add. 35166, fol. 22. Angel Casts the Millstone
(photo: The British Library).

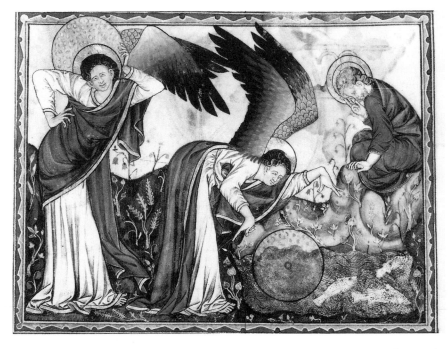

Figure 142. Apocalypse. Oxford, Bodleian Library MS Douce 180, p. 77. Angel Casts the
Millstone (photo: The Bodleian Library, Oxford).

prehension," and the millstone represents the weight of the whole great multitude of sins.[291] Thus, the angel becomes a Herculean figure who lifts an enormous weighty stone disc upon his shoulder to illustrate the first phase of the action, as in Add. 35166 (fig. 141). At the same time, a second phase of action is implied as the angel gestures toward a stone already submerged in the water at the right. In this version, the countertextual direction of sequential narrative serves as an effective gesture of metaphorical closure.

In Douce (fig. 142), the two phases of action are developed in full cyclical style, where the angel is represented twice, first lifting the huge stone at the left and then bending over as he releases it into the sea. The successive movements of contraction and release are graphically plotted in the upward sweeping drapery of the first angel followed by the downward arc of the second figure. As the angelic Christ bends under the metaphorical weight of human wickedness represented by the millstone, he confronts the viewer with an accusatory gaze. Acting as the reader's surrogate, John responds by averting his eyes, as he makes a penitent gesture acknowledging human wickedness in a feeble reprise of the angel's splaying fingers as he releases the stone. John's turning inward provides a gesture not only of closure to the entire sequence of events in Rev. 18, but also of internalized meditation responding to the last part of the gloss advising the reader that "all these things are to be understood in a spiritual sense."[292] The image of the two millstones might further evoke the metaphor so powerfully developed in the *Ancrene Riwle* of the carefully balanced tension in the religious life between hope and fear, between saintliness and sin:

Hope and fear must always be mingled. It was to signify this that it was decreed in the Old Law that two millstones should not be separated. The lower one, which lies still and bears a heavy load, signifies the fear which holds man back from sin. . . . The upper stone signifies hope, which runs and busies itself with good works always trusting to be greatly rewarded.[293]

74. Rejoicing in Heaven: *19:1–5*

> After this I seemed to hear the great sound of many trumpets in heaven, saying: "Alleluia: salvation and glory and power to our God: for his judgments are true and just, who has judged the great harlot, who corrupted the earth with her prostitution, and he has vindicated the blood of his servants at her hands." And they again said: "Alleluia." And her smoke goes up for ever and ever. And the twenty-four Elders and four Beasts fell down and adored God seated upon his throne, saying: "Amen, alleluia." And a voice came out of the throne, saying: "Praise our God, all his servants, and those who fear him great and small."

A conventional symmetrical image of the Lord in Majesty adored by crowned Elders (fig. 143) signals the great Alleluia that opens Rev. 19. Because all the Berengaudus manuscripts contain a variant text for 19:1 in which John hears a voice like trumpets ("quasi vocem tubarum") instead of a crowd ("turbarum"), a number of angels emerge from the clouds blowing trumpets; they signify the elect from the Old Testament before the giving of the Law.[294] Responding to the text ("I seemed to hear the great sound"), John appears as an attentive listener. In Paris lat. 10474, the Evangelist points to his ear as he stands outside listening to their voices, whereas in Trinity (fig. 190), he pulls back his mantle to hear angels rather than trumpets.

Within the pictorial context of the great Alleluia, the designer of the Berengaudus archetype introduces for the first time the flaming corpse of the dead harlot stretched horizontally at the bottom of the composition, thus visualizing the cause for the rejoicing in heaven. Because the commentary deals with this aspect of the text only in an oblique way, the introduction of the prostitute being consumed by flames as her body lies beneath the heavenly rejoicing throng presents something of an enigma. In most manuscripts, such as Morgan, she still holds the mirror that first appeared as an emblem of her lechery in the illustration for 17:1–2. Now enveloped in flames, her retribution is complete. The lifeless, recumbent harlot serves as a complex signifier responding to the commentary's assertion that the smoke and flames of Babylon rise forever because her infamy will never disappear from the mouths of the faithful.[295] As in Getty, the dead harlot personifies the destroyed city, and the faithful fan the flames with their prayerful gestures.

The Elders are clustered on the ground in symmetrically opposing groups, removed from the recumbent corpse only as the living from the dead. In Getty, they no longer wear crowns and hence more effectively represent the faithful calling forth the infamy of Babylon from the commentary. In these versions, the traditional hierarchy expounded in the

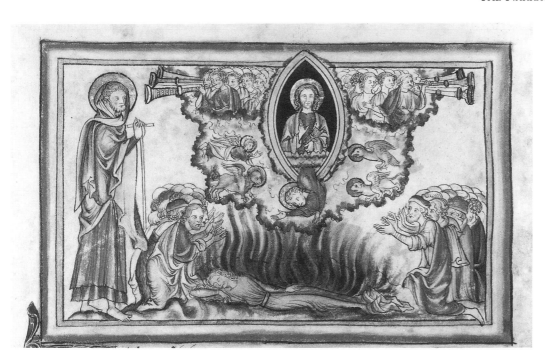

Figure 143. Apocalypse. Malibu, J. Paul Getty Museum MS Ludwig III.1, fol. 38v. Rejoicing in Heaven (photo: Collection of the J. Paul Getty Museum, Malibu, California).

commentary in which the four Beasts take their place in heaven as symbols of the New Testament is maintained; the twenty-four Elders remain below as representatives of the patriarchs under the Law.[296]

75. Marriage of the Lamb: 19:6–8

> And I seemed to hear the voice of a great trumpet and like the voice of many waters and like the voice of great thunders, saying: "Alleluia, for our Lord God almighty reigns. Let us rejoice and exult and give glory to him, for the nuptials of the Lamb have come, and his bride has prepared herself. And it was given that she clothed herself in fine linen, splendid and white; for the fine linens are the justifications of the saints."

The representation of the Marriage of the Lamb is a creation of the thirteenth century. In all the manuscripts except Douce, the narrative leaps forward to 19:9, where the nuptial rite announced by the angelic trumpet is dominated by a wedding banquet, with guests feasting and toasting the bride and groom.[297] Following the Rejoicing in Heaven, the nuptial scene continues and expands the joyous celebration of the death of the harlot and the destruction of Babylon.

The Lamb is positioned at the end of the table, embraced by his bride, but in order to raise the small "groom" to a prominently elevated position, he stands on a mound, presumably Mount Sion borrowed from 14:1, from which the Lamb approaches his bride.[298]

In Metz (fig. 144), the marriage rite centers on the kiss, which in the thirteenth century occurred during the nuptial mass shortly after the *Agnus Dei*, when the groom receives from the priest the kiss of peace, which he immediately passes on to his bride, and in doing so he gives her a true kiss *(osculando eam)*.[299] As explained by the contemporary Dominican theologian Guillelmus Peraldus, great importance is attached to the nuptial kiss, for the husband makes a promise to love his wife when he gives her this sign of love and peace during the mass.[300] In Add. 35166 (fig. 145), the Lamb and his bride hold a huge ring, signaling another ceremonial gesture from the medieval liturgical rite.[301] The marriage is further sanctified by angels who hold a *velatio nuptialis* over their heads, implying a benediction by an unseen celestial priest. Probably traceable to the Judaic tradition of the *huppa* symbolizing heaven and the

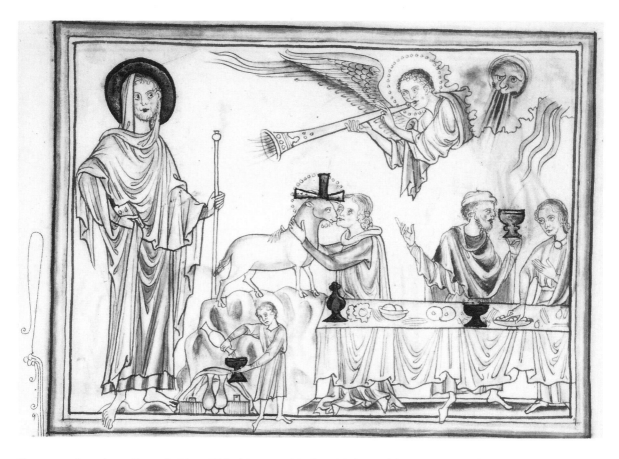

Figure 144. Apocalypse. Formerly Metz, Bibliothèque municipale MS Salis 38, fol. 12. Marriage of the Lamb (photo: Monuments historiques, Paris).

canopy of God, the nuptial veil is documented in the Christian rite as early as the fourth century by Ambrose and in the thirteenth century by Thomas Aquinas and the Sarum Missal.[302] In Add. 35166, the Lamb stands on an altar set apart from the feasting table, extending the wedding band to his bride, perhaps in a misunderstanding of the hand-clasping gesture.[303] At the same time that the fusion of elements from the nuptial liturgy with a banquet creates a celebratory moment in which the Rejoicing in Heaven finds a blissful conclusion, the shared meal forms an essential component of the thirteenth-century marriage, in which a symbolic repast of bread and wine is blessed with a prayer alluding to the Marriage at Cana.[304] The *convivium* further provides a necessary public dimension to the marriage, for, according to Gratian's Decretals, "without a public celebration there is no marriage."[305]

The most extreme variation occurs in Douce (fig. 146), which leaves the archetype far behind to develop a solemn nuptial ceremony in which the banquet has been omitted entirely. Instead, we see the center of the composition filled with compartments containing the bust of Christ at the top, officiating as the celestial priest, while the dove of the Holy Spirit hovers below. The inclusion of the dove to indicate the presence of the Trinity alludes to the commentary in which the "three voices" (of the trumpet, the ocean, and the thunders) refer to "faith in the doctrine of the holy Trinity, which proceeds from the Gospels, that is, from the great trumpet, which is Christ."[306] As the bride kneels at the left and the Lamb approaches from the right holding the ring, the solemn interpretation given in Douce clearly develops another aspect of the commentary interpreting the bride as Ecclesia, indicated by the church build-

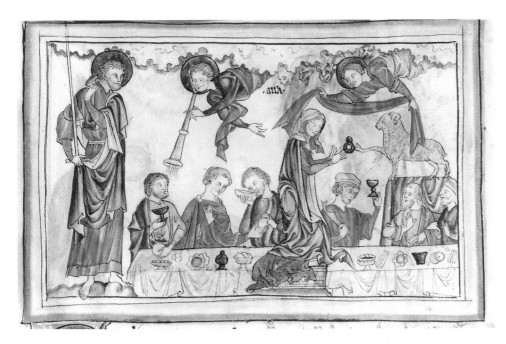

Figure 145. Apocalypse. London, British Library MS Add. 35166, fol. 23. Marriage of the Lamb (photo: The British Library).

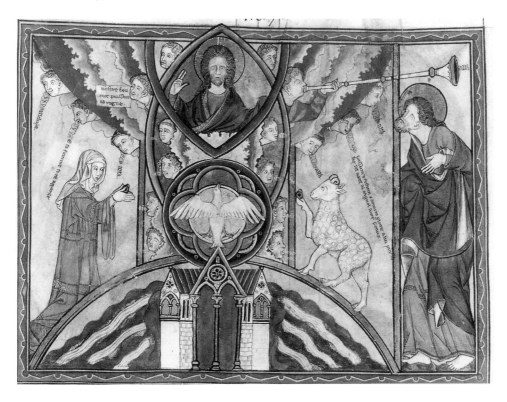

Figure 146. Apocalypse. Oxford, Bodleian Library MS Douce 180, p. 79. Marriage of the Lamb (photo: The Bodleian Library, Oxford).

ing below, from which flow six streams representing the multitude of people who believe in Christ.[307]

Although the introduction of the Marriage of the Lamb in the English Gothic archetype may have been inspired by the strong ecclesiological interests of its first patrons, with clear implications for church reform and clerical celibacy,[308] the image also conveys the idea of the Lamb's more intimate and immediate espousal of the reader's soul. For the thirteenth century, the apocalyptic Marriage of the Lamb becomes a more universal image of eternal life, as witnessed by its appearance at the end of Joinville's *Credo* (see fig. 147), composed in 1250–1 as an illustrated spiritual guide for the aristocratic laity.[309] In explanation of the image, Joinville writes:

We must believe firmly that saintly men and women who

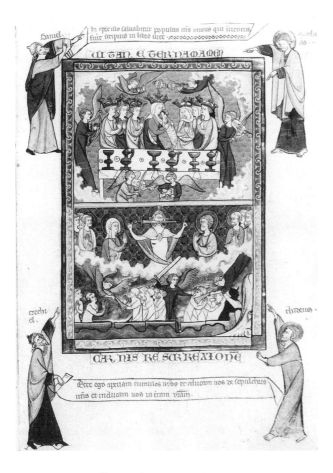

Figure 147. Joinville, *Credo.* St. Petersburg Public Library MS Lat. Q.v.1,78, fol. 190. Marriage of the Lamb (above); Last Judgment (below) (photo: after Friedman 1958).

have passed away, and the prudent men and women who are now living, will have eternal life and bliss in heaven, and they will be at the table of our Lord. This joy you see painted below, according to the explication of it in the Apocalypse.

He then compares the saints to the Wise Virgins of the New Testament parable as they enter the nuptials of the Son of God, who is signified by the Lamb.[310] In the Parisian version dating from 1285–97, in St. Petersburg, the *Sponsa* and Lamb embrace and kiss at an elaborate nuptial banquet.[311] As it appears under the rubric "Vitam eternam amen," above the Last Judgment illustrating "Carnis resurrexionem," the Bride and all the wedding guests wear "crowns of eternal life."[312]

76. John Commanded to Write: *19:9–10*

> And [the angel] said, "Write: Blessed are those who are called to the wedding feast of the Lamb." And he said to me: "These are the true words of God." And I fell at his feet to adore him. And he said to me: "Do not do this; I am your fellow servant and your brother in having the testimony of Jesus. Adore God; for the testimony of Jesus is the spirit of prophecy."

The angel's command to John to write about the wedding feast of the Lamb unfolds in two episodes in a cyclical sequence. As in Metz (fig. 148), John is seated at the left, with his pen poised above an open codex on his lap; the angel stands before him, gesturing his command to write.[313] In the right half of the composition, John falls to his knees before the angel who affectionately cups his chin, pointing upward at a bank of clouds to indicate that "It is God that you must worship." The temporally disjunct reiteration of the Evangelist's authorial persona from the beginning of the book and the presaging of the penultimate illustration in the Berengaudus cycle for 22:8–9 where John again attempts to worship the angel at the end of the book evince the fragile limitations of human understanding and John's continuing need for guidance and instruction. The brief dialogic sequence involving John and the angel constitutes an important preludic hiatus between the preceding moments of celebration and the ensuing final battle against Antichrist. As the angelic command directs the seer's attention to what he has just witnessed in his privileged vision of the Marriage of

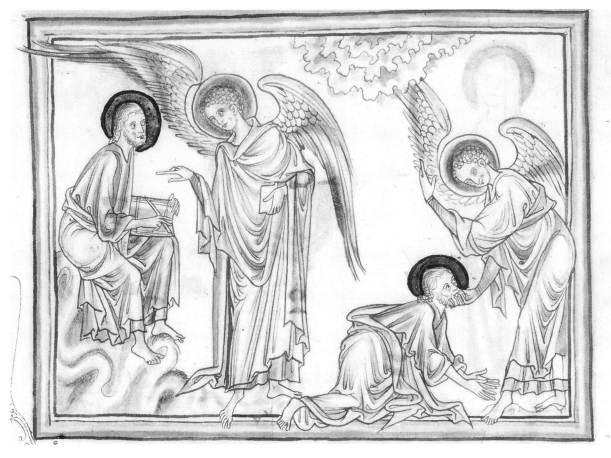

Figure 148. Apocalypse. Formerly Metz, Bibliothèque municipale MS Salis 38, fol. 12v. John Commanded to Write (photo: Monuments historiques, Paris).

the Lamb, John's mentor is nevertheless engaged in preparing the novice in his charge for what he is about to witness. Still subject to lapses of comprehension, as evidenced by the misplaced adoration of the angel, John, as well as the reader, must be reminded of the spiritual "reality" that lies beyond the experience and its text and thus redirected toward the prophetic significance of the vision that is to come.

77. The Army of Heaven *19:11–16*

> And I saw heaven open; and behold a white horse, and he who sat upon it was called faithful and true, and with justice he judged and fought. Moreover, his eyes were like flames of fire, and upon his head were many crowns, having the name written which no one knew but himself. And he was clothed in a garment sprinkled with blood and his

name is called Word of God. And the armies which are in heaven, clothed in pure and white linen, followed him on white horses. And from his mouth came a sharp double-edged sword, so that with it he could strike down the nations; and he shall rule them with an iron rod, and he shall tread the winepress of the furious wrath of almighty God. And he had written on his garment and on his thigh: "King of kings and Lord of lords."

Eschewing earlier traditions for illustrating this passage in which the army is composed of equestrian angels, the thirteenth-century *Bible moralisée* and English Apocalypse cycles conceive the military power led by the Lord of lords in more mundane terms,[314] as they respond to the interpretation of the army as the saints who, at the end of the world, battle against Antichrist.[315] In the new Gothic images, John first sees the army of heaven on the march and then witnesses the King of kings trampling the grapes

of wrath. In Getty, the true and faithful rider appears in profile moving across the page, but in Metz (fig. 149) he confronts the reader-viewer directly and thus more powerfully alludes to his glossed meaning as the Lord of the Second Coming.[316] Dressed in a red robe or a white tunic covered with blood stains, the rider carries a large sword in his mouth, and an iron scepter in his hand, in close adherence to the text description and glosses that interpret the sword as divine Scripture with which he converts the Jews and defends the elect from the errors of Antichrist.[317]

By enclosing the true and faithful rider and his army within a cloud bank, the English Gothic image retains the narrative idea of the heavens opening, but at the same time establishes a clear line of demarcation between two separate spheres as he moves to a terrestrial venue in the subsequent episode of the trampling of the wine of God's wrath.[318] The visualization and literal foregrounding of the Lord trampling the grapes of his wrath in a huge wine vat constitutes a new Gothic addition in the Berengau-

dus and *Bible moralisée* cycles. The Parisian Bible gives an illustrated gloss in which the trampling of the grapes is seen as Christ's death on the cross to liberate humankind from sin. In contrast, the Berengaudus commentary, while acknowledging the traditional identification of the winepress with the cross based on Isaiah 63:3, asserts that in this context, the winepress signifies an ultimate place of punishment, harking back to the Doom of the Beast Worshipers (14:10) and the Vintage (14:19–20), where the wicked are plunged into the inferno.[319] Its counter-textual position creates an effective pause in the relentless narrative flow as the text visually turns back upon itself, in Metz centering on the two figures of the sword-bearing Judge.

As we have already noted, the abrupt apparition of the Lord of lords leading the army of heaven comes on the heels of the cyclical representation of John commanded to write and his attempt to worship the angel above a text that reminds the reader that John was given the spirit of prophecy (19:10),

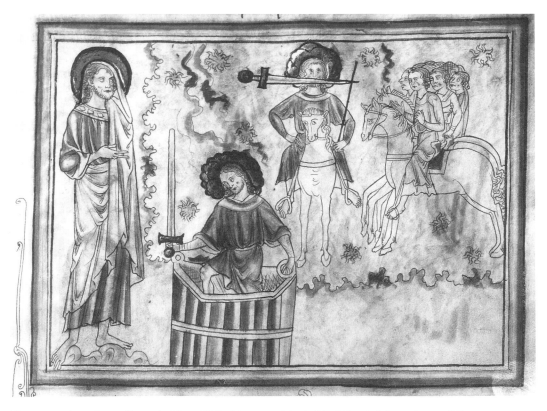

Figure 149. Apocalypse. Formerly Metz, Bibliothèque municipale MS Salis 38, fol. 27. Army of Heaven (photo: Monuments historiques, Paris).

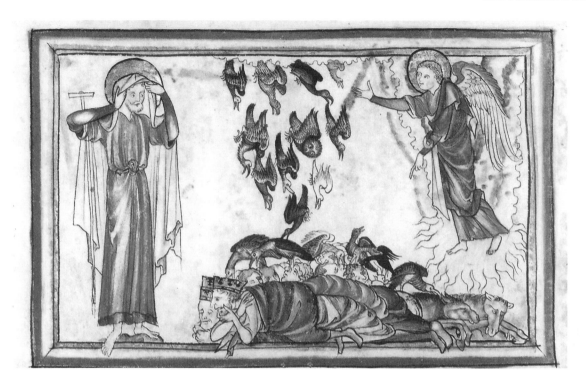

Figure 150. Apocalypse. Malibu, J. Paul Getty Museum MS Ludwig III.1, fol. 40v. Birds Summoned (photo: Collection of the J. Paul Getty Museum, Malibu, California).

thus juxtaposing a phase of his present initiation by the angel with a vision of the future. The Second Coming of the Lord and the ensuing judgment of the wicked now form an indissoluble paratactic pair of events, as the celestial army arrives on a cloud, and the vindictive judgment embedded in the metaphor of the winepress is carried out on earth. The equestrian Lord's frontal surge forward into the next moment, when he appears to emerge from a winepress brought uncomfortably close to the lower frame, creates a powerful effect of relentless inevitability, as both figures threaten to invade the reader's own terrestrial space in the text below.

78. Birds Summoned: *19:17–18*

> And I saw an angel standing in the sun, and he cried out in a great voice saying to all the birds that were flying through the midst of the heavens: "Come and gather together for God's great feast, so that you may eat the flesh of kings and the flesh of commanders and the flesh of the powerful and the flesh of horses and those who sit upon them and the flesh of all free men and slaves and of the small of the great."

Concentrating on birds feasting on the corpses of kings and heroes, the illustration of this passage (see fig. 150) follows the line taken by the *Bible moralisée* (fig. 151). As the carrion birds descend upon the corpses heaped at the bottom of the composition, the angel standing on the flaming sun commands them from a thick bank of clouds that envelops his full-length figure within a celestial frame. The commentary interprets the sun as the true Christ; the angel represents the preachers who come at the end of the world and are united with the saints and Christ. The "flesh of kings, generals, heroes, horses, and all kinds of men, great and small," is represented as a dense mass of fallen naked bodies; two or three wear crowns. The birds, which, according to the Berengaudus gloss, represent all the faithful, are shown in two successive phases of action – first flying down from the sky and then feasting, which is read as a collective metaphor for the extermination of the wicked.[320]

In breaking with earlier traditions of illustrating this passage, the designers of the Berengaudus and *Bible moralisée* cycles envision the angel in the sun

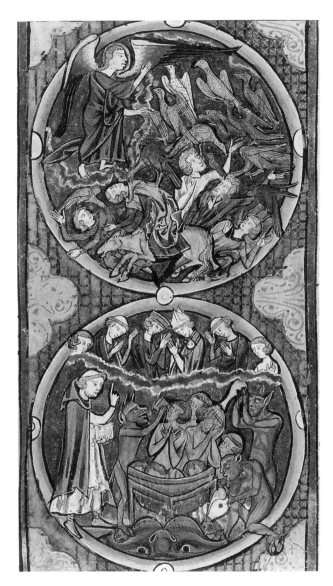

Figure 151. Bible moralisée. New York, Pierpont Morgan Library MS M.240, fol. 1v. Birds Summoned (above); Commentary Illustration (below) (photo: The Pierpont Morgan Library).

commanding the birds in heaven as a reiteration of the Christological figure leading the celestial army in the previous episode. Within this new narrative frame, the interpolation of the birds feasting on the flesh of kings can then be perceived by the reader on the same metaphorical level as the Lord trampling the winepress. By virtue of its parallel structure, the image thus signifies another vindictive punishment at the end of time, as is particularly evident in the commentary illustration in the *Bible moralisée* (fig. 151).

79. The Battle Against the Beast: *19:19*

> And I saw the beast and the kings of the earth and their armies gathered together to make war against him who sat on the horse, and with his army.

Interpreted in the *expositio* as the battle of the saints and the Church against Antichrist and his followers,[321] the new miniature develops a full-scale representation of armed conflict. Although John again witnesses the scene in accordance with the text ("Then I saw"), he is sometimes overwhelmed by its violence. In Metz, John takes refuge behind an outcropping of rocks, whereas in Paris lat. 10474 (fig. 152), he escapes the mêlée by ducking behind the frame into the margin; in Douce, he disappears altogether.

Although the text does not specify an equestrian combat, the army of heaven is represented on horseback in an obvious effort to provide continuity with the preceding army of heaven. In contradiction of the text, Metz shows the rider combatting the beast alone and unaided by the army of the faithful, presumably to emphasize the commentary that interprets the battle as the Second Coming of Christ. In other recensions, such as Paris lat. 10474, the rider is accompanied by armed horsemen. As one of the major recurring paradigms of allegorical action, the battle between demonic and cosmic agents again acquires the character of ritual necessity, as opposed to narrative probability, through its balanced, almost symmetrical structure. Although the violent conflict is cast in technological military terms, the battle action itself produces a curiously static effect by stressing an oscillating motion between two equally matched opposing forces. As Fletcher so aptly observed, allegory's ritual "debate" of antithetical polarities slows and regulates the pace of narrative representation by preventing a threatening ambivalence from taking up any focal point other than those defined by the strictest polar frame of reference.[322]

80. The Beast Cast into Hell: *19:20–21*

> And the beast was captured and with him the false prophet, who made signs on his behalf, with those he had seduced, who had accepted the mark of the beast and those who had adored his image. These two were cast alive into a fiery lake of burning sulphur, and the rest were killed by the sword which came out of the mouth of him who sat upon the horse, and all the birds were gorged with their flesh.

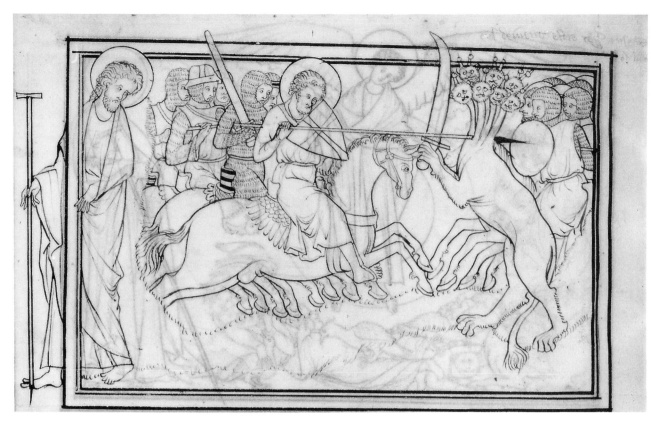

Figure 152. Apocalypse. Paris, Bibliothèque Nationale MS lat. 10474, fol. 41v. Battle against the Beast
(Phot. Bibl. Nat. Paris).

The episode of the capture and punishment of the
beast and false prophet is illustrated in all the oldest
cycles, but, as the representation developed, it shifted
from an emphasis on the capture where the beast and
the false prophet are taken prisoner by angels who
impale them with their lances or bind them to-
gether,[323] to verse 21, where the birds gorge on the
flesh of the slain army of the beast. By the thirteenth
century, the illustration for this passage had moved
toward a concentration on the last part of 20:20 in
which the beast and the false prophet are "thrown
alive into the fiery lake of burning sulphur."[324]

The Gothic image (fig. 153) concentrates its nar-
rative attention on God's agents with lances thrust-
ing the beast and false prophet into the flames of the
burning lake. In an image resembling that in the
Vienna *Bible moralisée*, the Berengaudus miniature
requires that the presence of the rider be made graph-
ically explicit not only to conform to the text

("All the rest were killed by the sword of the rider,
which came out of his mouth"), but also to the com-
mentary, which cites II Thessalonians 2:8: "The Lord
will kill [Antichrist] with the breath of his mouth and
will annihilate him with his glorious appearance at
his coming."[325] To signal the continuation and out-
come of a prior action, the rider emerges at the left,
his horse partly obscured by a hill, as in Metz, or
arbitrarily bisected by the frame, as in Add. 35166.
Shouldering his sword, the rider extends his arm for-
ward in a gesture of command, reaching from an
antecedent action to extend his domination into a
new space.

Breaking with the long-standing medieval tradi-
tion that envisaged the Lord's executioners as angels
signaling the celestial source of the retributive act,
the new pictorial conception of the text clearly cen-
ters on a punishment carried out by human agents.
In Add. 35166, they have acquired armor and hel-

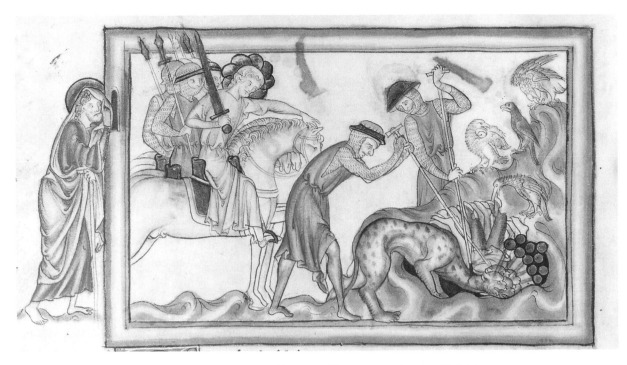

Figure 153. Apocalypse. London, British Library MS Add. 35166, fol. 25v. Beast Cast into Hell (photo: The British Library).

mets. Although responding to an increasing tendency to transfer the temporal venue of such actions to the contemporary earthly arena where Crusaders routinely carried out what they perceived to be a divinely ordered punishment upon "God's enemies," the secularization of the image subverts the meaning of the text. The traditional consistency with which angels assume this function, reiterating their primordial role generated by the Fall of Satan, is uniquely restored in Gulbenkian (fig. 154). Gulbenkian's designer responds more sensitively to the commentary, which refers back to the fate of the beast and false prophet in connection with that of the dragon, binding together the evil triumvirate from Rev. 13 and 16 as the three damnations of the devil, executed by an angel who is identified as Christ.[326] In the Gulbenkian cycle, where the illustration of the Dragon Enchained follows on the next verso, the great angel who now dominates the right foreground turns away in an elegantly sweeping contrapposto move to point the end of his long trident toward the margin, signaling his identity with the angel who concludes the retribution against the three satanic incarnations on the next page.

81. The Dragon Enchained: 20:1–3

> And I saw an angel coming down from heaven, holding the key of the abyss and a great chain in his hand. And he seized the dragon, the old serpent who is the Devil and Satan, and bound him for a thousand years; and he cast him into the abyss and closed it and set a seal upon him so that he could not seduce any more people until the thousand years had passed; and after that he will be released for a short time.

Although the text calls for the representation of successive actions, the Berengaudus designers rarely illustrate all three without conflation. Only Trinity fully manages to disperse the repeated protagonists across its singularly wide space in the correct textual sequence. Most recensions collapse the sequential action into two salient phases, as in Add. 35166 (fig. 155). The angel's descent from heaven, interpreted in the gloss as the Incarnation, is conflated with the next action in which the angel leads the chained dragon to the abyss with one hand and unlocks it with the other, forming a transitional movement from verses 2 to 3 that has a long history in the tradition of Apocalypse illustration going back to the Carolingian period. In the English Gothic cycles,

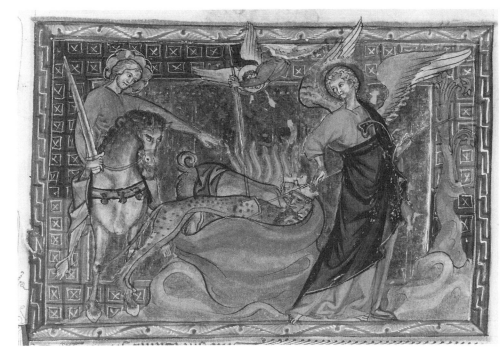

Figure 154. Apocalypse. Lisbon, Calouste Gulbenkian Museum MS L.A. 139, fol. 67. Beast and False Prophet Cast into Hell (photo: The Conway Library, Courtauld Institute of Art, London).

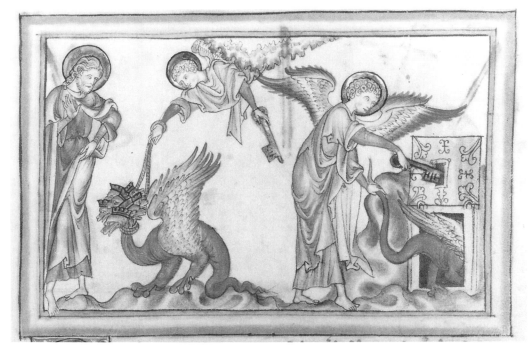

Figure 155. Apocalypse. London, British Library MS Add. 35166, fol. 26. Dragon Enchained (photo: The British Library).

the prominence given to the figure of the angel holding the chain focuses the reader's attention on the gloss that identifies this figure as Christ and the chain as his great power over Satan.[327] As the chain and key are held out for display as metaphorical signifiers, the chain's power is already being put to the test to restrain the ferocious dragon threatening John who protectively pulls his skirts around him as he hurries away. In a second cyclical episode, another angelic figure inserts the key in the lock as the dragon disappears within the abyss at the right.

The threefold action, described in the text as (1) flying down from heaven with the chain and key, (2) overpowering and enchaining the dragon, and (3) throwing him into the abyss and locking it, constitutes an elaborate gesture of temporary closure necessary to the narrative, as the forces of Satan must be held in check for an interregnum of a thousand years, during which interval John witnesses the First Resurrection. Thus, the dragon is literally being removed from the reader's field of vision as he disappears into the abyss.

82. First Resurrection: 20:4–6

> And I saw thrones, and they who sat upon them, and judgment was given to them; and the souls who were beheaded for the testimony of Jesus and for the word of God, and those who had not adored the beast or his image, nor accepted his mark on their foreheads or on their hands and they lived and reigned with Christ for a thousand years. The rest of the dead will not live [again] until the thousand years have passed. This is the first resurrection. Blessed and holy are those who are part of the first resurrection: the second death has no power over them, but they shall be priests of God and of Christ and will reign with him for a thousand years.

Throughout the Middle Ages, this passage provoked theological controversies over its meaning that were never satisfactorily resolved. Before the thirteenth century, most cycles do not illustrate the First Resurrection, but Trier (fig. 156) establishes an early precedent in representing "those who are given the power to be judges" as six nimbed figures or "saints" seated on an enormously long bench extending across the entire width of the picture at the top of the page, and below another group of figures stand at the left representing the martyrs who had been beheaded for their faith. At the lower right, the angel holds the tail of the dragon in the abyss to demonstrate his impotence during the thousand-year reign of Christ. Eschewing potentially controversial inter-

Figure 156. Apocalypse. Trier, Stadtbibliothek MS 31, fol. 65. First Resurrection (photo: Stadtbibliothek, Trier).

pretations of the text, the ninth-century image maintains an emphatic vertical separation between the judicial court of heaven above and the resurrected martyrs who still inhabit an earthly space below. Still governed by the temporality of passing time as measured by the duration of the dragon's incarceration at the lower right, the angel's gesture of grasping the disappearing tail signals the ephemeral conditions under which the thousand-year reign transpires.

Although the thirteenth-century arrangement of judges and resurrected souls varies from one recension to the next, the two figural groups remain clearly distinct and separated, as in Trier. Rejecting the idea of the thousand-year reign with Christ in heaven so strongly espoused in the *Bible moralisée*,[328] English Gothic cycles such as Metz (fig. 157) situate the First Resurrection within an emphatically terrestrial context, whereas Add. 35166 (fig. 158), albeit in less specific terms, still grounds the judges' solid thrones firmly on a weighted gravitational base line. From behind a rocklike screen in Metz, John's gaze is focused on the resurrected souls represented as small naked figures rising from their recumbent bodies; the judges are seated in two gesticulating groups

Figure 157. Apocalypse. Formerly Metz, Bibliothèque municipale MS Salis 38, fol. 28v. First Resurrection (photo: Monuments historiques, Paris).

at the right, aligned above the commentary passage that nonetheless interprets the thrones as the celestial homeland and those seated on the thrones as the souls of the saints.[329] As if responding to a question posed by the text, Add. 35166 abandons the vestiges of the old hierarchy in Metz, but, at the same time, John's gaze shifts from the event of the resurrection to the judges who now dominate the vision. The spectator's gaze is riveted on three monumentally scaled judges, seated on separate pedestallike thrones, holding upright swords as if they were the attributes of personified figures of Justice on a cathedral portal.[330] In this context, however, the sword becomes a multivalent sign, as the saints display attributes of martyrs who were beheaded as well as those of preachers in reference to Paul's "sword of the Spirit, which is the word of God" (Ephes. 6:17), responding to the text of Rev. 20:4 that refers to the "souls of all who had been beheaded for having wit-

nessed and for having preached God's word."

Notwithstanding their differences, the Berengaudus illustrations convey an impression of discord and contention that tends to undermine the idea of the happiness and blessed joy of those who share in the thousand-year reign of Christ. In Metz, the judges are divided into two groups, gesticulating back and forth as if representing sides of a debate. The foremost judge at the right enumerates the points of his argument on his fingers, whereas his opponent gestures toward the resurrected souls of the martyrs below.[331] In a feeble effort to reconcile the two sides, a solitary small figure at the bottom of the picture in Metz pulls at the foot of one of the judges, attempting to engage the attention of his argumentative neighbor on the other side of the throne. In Add. 35166, there is no resurrection, as three enthroned judges with raised swords grimly watch over the still-sleeping dead.

Figure 158. Apocalypse. London, British Library MS Add. 35166, fol. 26v. First Resurrection (photo: The British Library).

The Berengaudus illustration conceivably alludes to the contemporary controversy of 1254–6 during which the Joachite theory of the First Resurrection as a final happy age on earth was brought into notorious disrepute.[332] Rejecting the idea of a future earthly kingdom of Christ, William of St. Amour led the attack on pseudo-Joachite position of Gerardo of Borgo San Donnino by reaffirming the traditional Augustinian conception of the ages of the world in which humankind was believed to be living in the sixth and last earthly age before the Last Judgment.[333] Augustine saw the thousand-year kingdom of Christ in Rev. 20:1–6 as a figure for the life of the Church in the present.[334] Differing from other twelfth-century interpretations of the First Resurrection as a wondrous age of the saints reigning on earth during the time of the binding of Satan when the pagans and Jews would be converted and the Church would be reformed to a state of apostolic perfection,[335] the Berengaudus commentary clings to the old Augustinian view, defining it simply as the time from Christ's Passion to the end of the world.[336] Because the pic-

torial archetype was probably formulated in the 1250s at about the same time as the Joachite controversy, the disputation among the judges over the status of those involved in the First Resurrection in the miniature designed to illustrate 20:4–6 could conceivably have been intended to alert the reader to the conservative Augustinian, anti-Joachite view espoused in the Berengaudus gloss.

83–84. Release of Satan: *20:7–9 (to "devoravit eos"); Satan Cast into Hell: 20:9–10 (beginning "Et diabolus")*

> And, when the thousand years have passed, Satan will be released from his prison and go forth and seduce the nations, Gog and Magog, which are at the four corners of the earth, and he shall gather them together for battle. . . . And they will come up over the breadth of the earth, and they will surround the fortress of the saints and the beloved city. And God's fire will come down from heaven and consume them.
>
> And the devil, who seduced them, was cast into a lake

of fire and sulphur, where the beast and false prophet will be tormented day and night for ever and ever.

Because the text segment breaks off in the middle of the last verse,[337] the narrative dealing with the release of Satan is divided into two separately illustrated phases: the release of Satan and his armies to besiege the city of the saints is thwarted by divine intervention in the form of fire coming down to consume them ("devoravit eos"); and the devil is thrown into the lake of fire (beginning "Et diabolus"). In the first episode (fig. 159), the actual release of Satan, now characterized as the seven-headed dragon from Rev. 12 to 13, is conflated with the siege of the city, whose outcome elides the actual attack, so that we see only the approach and defeat of Satan's army as they are consumed by fire coming down from heaven. Like Metz, most Berengaudus images visualize the assault in concrete military terms. A new plethora of armor, weapons, and heraldic insignia propels the armed struggle into the contemporary Crusader ideology of the reader's imagination. Satan's attack is now targeted upon the great crenellated walled city of Jerusalem, identified by a circular shape that recalls the great rotunda of the Holy Sepulchre within the old earthly city that had been irrevocably lost to the Muslims in 1244.[338] The successful conclusion of the centuries-long siege could then be perceived as a pivotal moment in the prophetic narrative that began in 19:11, preparing for the ultimate transmogrification of Jerusalem into the heavenly city of Rev. 21.

The next illustration (fig. 160) forms a continuation of the narrative begun in the Release of Satan and resumes where the previous segment left off to complete the sequential action on the next verso page. The archetypal Leviathan swells into an enormous multiple-headed monster that fills the entire space within the frame. The transformation of the "lake of fire" into a hell mouth allows the artist to reveal the beast and the false prophet already within its gaping jaws as a hairy demon thrusts the seven-headed dragon into the flames to join his cohorts.[339] The horrendous image of the double-headed hell mouth stands above a short gloss that reads: "This will be accomplished when our Lord says, 'Go ye cursed into the everlasting fire, which was prepared for you by the devil and his angels' " (Matt. 25:41). For the last verse, the gloss offers a prayer: "From which torment may the mercy of our Redeemer, who lives and reigns with the Father and the Holy Spirit for ever and ever, deliver us."

The long aftermath of the rider's defeat of the beast follows a tortuous course in which Satan's punishment, release, and incarcerated exile unfold in preparation for the Last Judgment. Whereas the beast and false prophet are permanently disabled by their consignment to the fiery lake, the dragon is only temporarily disarmed by his forced retirement to the former abode of the beasts from Rev. 13. During his short "millennial" sojourn locked in the pit of the abyss, a harbinger of the coming resurrection is glimpsed, but the prefiguration of promised bliss is so brief and elusive that its temporal and sequential ambiguity arouses false expectations and creates a problem that demands both narrative and theological resolution. The partial and temporary restoration of life is thus momentarily abandoned as an unfinished project within the grand divine scheme of human salvation. In this larger context, the great figures who loom over the dead at the First Resurrection (fig. 158) can be perceived as guardians of the tomb, thus explaining the sarcophaguslike appearance of their thrones as well as swords in Add. 35166, assuring the reader that all has been secured and the dead will not be further disturbed by the ensuing release, defeat, and eternal banishment of Satan. This having been finally accomplished, the long prophetic narrative that began with the Lord's "Crusade" against Satan in 19:11 will now find its conclusion

Figure 159. Apocalypse. Formerly Metz, Bibliothèque municipale MS Salis 38, fol. 29. Release of Satan (photo: Monuments historiques, Paris).

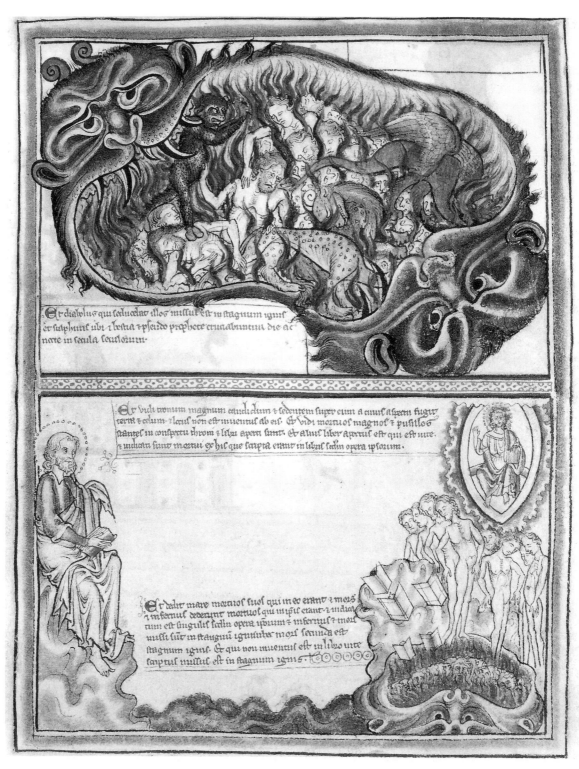

Figure 160. Apocalypse. New York, Pierpont Morgan Library MS M.524, fol. 20. Satan Cast into Hell (above); Last Judgment (below) (photo: The Pierpont Morgan Library).

in the Last Judgment, followed by the transfiguration of the holy city of Jerusalem.

SIXTH AND SEVENTH VISIONS (REV. 20:11 TO 21:8 AND REV. 21:9 TO 22:21)

As symmetrically opposed to the old heaven and earth in the first and second visions, the last two transpire in spheres divinely renewed at the end of time. The sixth vision presumably centers on the new earth where, according to the exegete, the wicked are condemned and the just are glorified in the general resurrection. By shifting the Last Judgment to the beginning of the sixth vision, a discernible barrier is placed between the first and last resurrections. Berengaudus tells his readers that "the last resurrection is correctly positioned in the sixth place because the trimeter number is perfect, and what is a sacred promise is completed in the resurrection."[340] Following the rhetorical protocol observed throughout the seven visions, the penultimate section makes a transition to the last vision in the descent of the new Jerusalem from heaven to the new earth.

The themes of resurrection and the renewal of God's mercy that dominated the sixth vision then shift to the ultimate future vision of the New Jerusalem and the Lord:

We arrive, God willing, at the seventh vision to which pertains everything in that time which is the future after the resurrection. And order demands that, the general resurrection having been described, the glory of the saints, which after the resurrection they possess without end, be described, which in this vision is described under the figure of the city of Jerusalem.[341]

Thus, the idea of the "city," essential to an ordered, conscious life, a repository for traditional wisdom, a frame of reference for thought and speculation, is restored. The hostile cities of Ephesus and Rome, John's points of departure, were first abandoned for an isolated island. Then he encountered the totally corrupted city of Babylon only to see it destroyed. Now at the end of his pilgrimage, John has "found" the city he sought in Jerusalem, transfigured from its lost earthly incarnation into a celestial ideal of indescribable splendor whose realization now lies beyond the temporal and spatial projections of his vision.

85. Last Judgment: *20:11 to 21:1*

> And I saw a great white throne and the One sitting upon it, from whose presence the earth and heaven fled, leaving no trace. And I saw the dead great and small standing in the presence of the throne; and the books were opened, and another book was opened, which is the book of life; and the dead were judged from what was written in the book, according to their deeds. And the sea gave up the dead who were in it, and death and hell gave up the dead who were in them, and each one was judged according to his deeds. And hell and death were cast into the lake of fire. This is the second death. And anyone who was not found written in the book of life was cast into the lake of fire.
>
> Then I saw a new heaven and a new earth; the first heaven and the first earth had disappeared. . . .

Almost all the medieval cycles offer a graphic representation of the last five verses of Rev. 20 in which the One seated on the great white throne presides over the judgment of the dead given up by the sea, Death, and Hades.[342] As is always the case when the text reports that John saw the vision ("And I saw"), he appears as a witness at the edge of the frame. In Eton 177 (fig. 161), however, John assumes his more traditional Gothic role of intercessor as he pleads for the salvation of the newly resurrected dead. Because John's vision is interpreted in the gloss as a demonstration of the Lord's abundant mercy (*misericordia largiente*),[343] the reader is invited to perceive the image optimistically. No differentiation between the elect and damned has yet been made; two groups rise from the earth and sea, equally expectant that their names will be found in the book(s) of life held by the Judge. In response to the last verse, however, Metz (fig. 162) implies a traditional separation between those on the Lord's right and left, so that the hell mouth, in contradiction of the text, does not represent Hades giving up its dead but rather the inferno swallowing the wicked who have been damned.

Although the "book of life" is traditionally held open by the enthroned Lord to signal the ensuing judgment, as in Eton where he holds an open book in each hand, the books are further multiplied in the other recensions to encompass the meaning given in the gloss. Morgan (fig. 160) thus offers a pessimistic reading in its depiction of the resurrected dead as pagans and reprobates at the right holding and then discarding the books in which the deeds of their lives have been recorded, clearly responding to the commentary declaring that the wicked having many books signifies their multiple sins and offenses against God, whereas the elect have only one book,

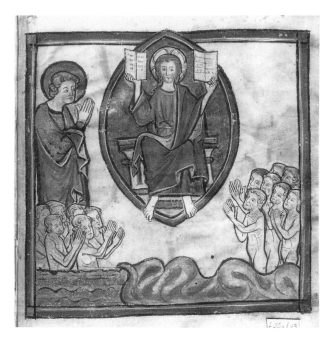

Figure 161. Apocalypse. Windsor, Eton College MS 177, p. 93. Last Judgment (photo: The Provost and Fellows of Eton College and the Conway Library, Courtauld Institute of Art, London).

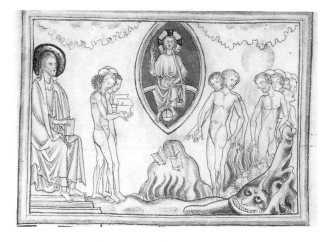

Figure 162. Apocalypse. Formerly Metz, Bibliothèque municipale MS Salis 38, fol. 30. Last Judgment (photo: Monuments historiques, Paris).

which is the Book of Life held by the enthroned Lord, because they confess one faith to one God.[344] Although traditional doctrine remained unchanged, the collective eschatology and expectation of the final resurrection are fading; the attention of the faithful is fixed less on the destiny of the Church than on the destiny of each believer.[345] Whereas earlier eschatology had cultivated a tension between individual and corporate expectations, spiritual concern is now concentrated upon the individual's personal destiny and hope for heaven.[346]

86. New Jerusalem: 21:2–8

> And I John saw the holy city, the new Jerusalem, coming down out of heaven from God, prepared like a bride adorned for her husband. And I heard a great voice from the throne saying: "Behold the tabernacle of God among men, and he will dwell with them; and they shall be his people, and God himself with them shall be their God. . . . And the One who sat upon the throne spoke: "Behold, I make everything new." And he said to me: "Write, for these words are most faithful and true."

Although the Berengaudus designers compress the narrative into a single half-page illustration, they all tend to envision the episode as a transitional moment antecedent to revealing the apparition of the heavenly Jerusalem in its full splendor. As in the *Bible moralisée* (fig. 252), John witnesses the actual descent of the celestial city hovering above the earth to stress the commentary's interpretation of the city descending from heaven as the Lord coming to judgment.[347] In Morgan (fig. 163), Christ dives from a cloud above the floating metropolis, whereas in Paris lat. 10474 (fig. 164), a full-scale figure of the Lord enthroned within a mandorla monopolizes John's gaze as he descends next to the heavenly city. The *Bible moralisée* continues the traditional isolation of this subtext in a separate illustration (fig. 252), for it not only signals a new prophecy but guarantees its fulfillment. In contrast to the earlier evocation of authorial action in Rev. 19 (fig. 148), John no longer requires the mediating guidance of his angelic mentor but is commanded to write by the Lord himself. The Morgan designer ingeniously visualizes the scribal command by showing John penning his signature in the text inscribed in the space that separates him from his vision. Paris lat. 10474 appears to express the archetypal idea more closely in depicting only one episode for 21:2–8 in an image close to the *Bible moralisée*, but shows John kneeling below the commanding figure of the Lord with a scroll across his knee, and adjusts the text by omitting the first words ("Et ego Ioannes vidi") to focus on the subsequent episode in which he hears the command from the

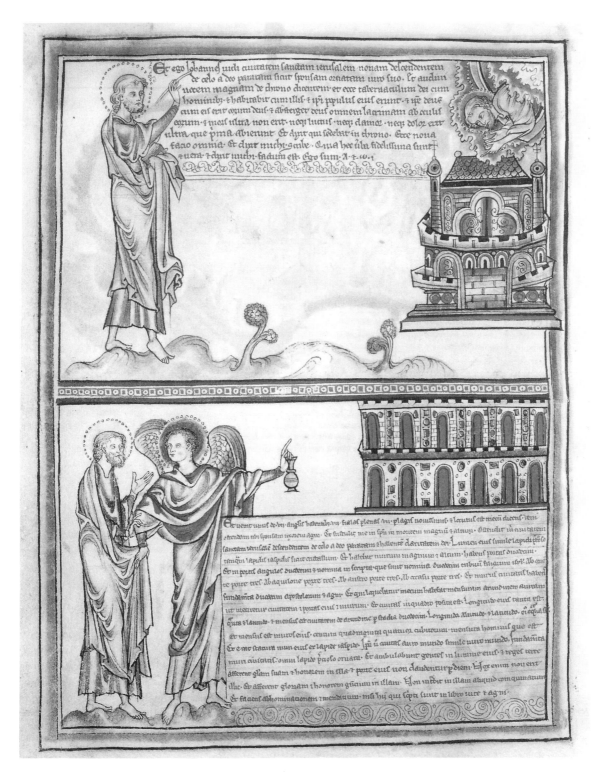

Figure 163. Apocalypse. New York, Pierpont Morgan Library MS M.524, fol. 20v. Heavenly Jerusalem Descending (above); Description of the City (below) (photo: The Pierpont Morgan Library).

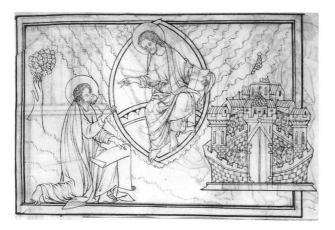

Figure 164. Apocalypse. Paris, Bibliothèque Nationale MS lat. 10474, fol. 45. Heavenly Jerusalem Descending (Phot. Bibl. Nat. Paris).

87. Description of the City: 21:9–27

> And one of the angels that had the seven vials full of the seven last plagues came to me, saying: "Come and I will show you the bride of the Lamb." He took me in spirit to the top of a great and high mountain and showed me Jerusalem, the holy city, coming down from God out of heaven, having the radiant glory of God and its light was like a precious jewel of crystal-clear diamond. And it had walls of great height and had twelve gates; at each of the twelve gates there was an angel, and over the gates were written the names of the twelve tribes of Israel; on the east there were three gates, on the north three gates, on the south three gates, and on the west three gates. The city walls stood on twelve foundation stones, each one of which bore the name of one of the twelve apostles of the Lamb.
>
> The angel that was speaking to me was carrying a gold measuring rod to measure the city and its gates and walls. The plan of the city is perfectly square, its length the same as its breadth. He measured the city with his rod and it was twelve thousand furlongs in length and in breadth, and equal in height. . . .

One seated on the throne. In this eloquent version, the juxtaposition of books held respectively by the Lord and John implies that the Evangelist will transcribe into his own book what has been written in the divine archetype.

Whereas the *Bible moralisée* gives seven illustrated segments for 21:9–27, the Berengaudus cycle continues to consolidate large blocks of *Revelation* into only a few illustrations.[348] The culminating vision (figs. 163, 165, and 166) is opened to the reader's gaze by the angel holding the vial and pointing to

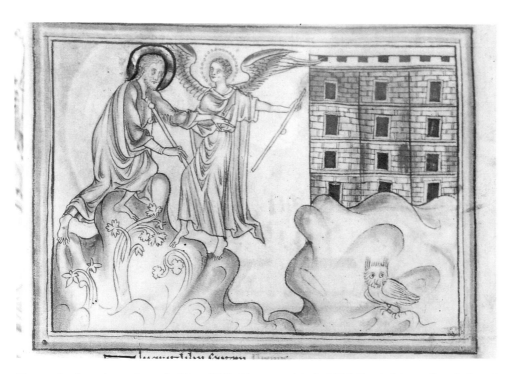

Figure 165. Apocalypse. Formerly Metz, Bibliothèque municipale MS Salis 38, fol. 31. Description of the City (photo: Monuments historiques, Paris).

Figure 166. Apocalypse. Cambridge, Trinity College MS R.16.2, fol. 25v. Description of the City
(photo: The Master and Fellows of Trinity College, Cambridge).

Jerusalem with one hand while clasping the edge of John's mantle with the other. The angel with the vial not only heralds the beginning of the text, but also signals the last division of the commentary corresponding to the seventh vision. The commentary relates "one of the angels who had the seven vials" showing John the city of God in the figure of Jerusalem to the fifth vision in Rev. 17 where one of the vial-bearing angels showed John the city of the devil in the figure of the Harlot of Babylon. The last angel signifies the preachers who have been and will be to the end of time, and John represents the faithful.[349] Further stressing the relationship between the two visions, Paris-Douce repeats the motif of John being carried by the angel, in this case not only to allude metaphorically to John's transcendent state of being "in the spirit," but also to convey in vivid graphic terms the great height to which he is being transported, both physically and spiritually. In Metz (fig. 165), however, the angel is carrying a gold measuring rod. The substitution of the rod for the vial signals not only the illustration of a different verse (15), but a contrasting interpretation in the commentary of the angel who "in this place signifies Christ who rules all peoples with an iron rod," which in turn represents the discipline of the Gospels.[350]

Among the Berengaudus recensions, only Metz accurately reflects the textual siting of the episode ("He took me to the top of an enormous high mountain and showed me Jerusalem")[351]; the other cycles locate John and the angel on the ground line at the left. The pictorial configuration of John and the angel standing on a hill pointing to the holy city raised on a high square base harks back to a very early medieval tradition exemplified in Trier where Jerusalem rests on rectangular masonry foundations. In Metz, the masonry base becomes a squared-off hill, whereas in Morgan, the elevated position of the heavenly Jerusalem provided a convenient space for the designer to insert a long block of text.[352] In Trinity (fig. 166), however, we see vestiges of another iconographical tradition where the Lamb is celebrated as the centerpiece of a city laid out in a flat maplike diagram, surrounded on four sides by concentric circuits of walls and twelve gates.[353] In earlier medieval representations, however, the plan of Jerusalem is given a circular configuration, a convention also reflected in medieval maps of the Crusader city.[354] The English Gothic manuscripts changed this traditional configuration to a square most plausibly to conform to the text of 21:16: "The plan of the city is perfectly square," as well as to reference contemporary maps, such as those of Matthew Paris.[355]

In contrast with the radical expansion of Rev. 21–2 in the *Bible moralisée*, the thirteenth-century designers of the Berengaudus archetype can be seen as having developed the sequence of two illustrated texts in a fairly traditional way. In Add. 35166 and Metz, two visions of the city, first descending from heaven and then raised atop a high mountain, are juxtaposed on facing verso and recto pages. Both images stress its remoteness and distance from the seer who first sees the city approaching earth and then realizes that he must cross a chasm and scale a mountain in order to reach it. Just as the earthly Jerusalem had been lost, the heavenly city seems equally distant and unattainable. Within the context of contemporary Crusader ideology, the vision of the heavenly Jerusalem seems hardly reassuring in its failure to offer an image of victorious realization. However, the distancing devices that place the city beyond the reach of both John and the reader function effectively as metaphors of time, spatializing the temporal gap that separates the present from the future.

88. River of Life: 22:1–7

> And he showed me the river of life, clear as crystal, proceeding from the throne of God and of the Lamb. In the middle of its street and on either side of the river were trees of life, bearing twelve fruits for each month of the year. . . .
>
> And he said to me: "These words are faithful and true, and the Lord God of the spirits of the prophets sent his angel to show his servants what should soon be done And behold I am coming soon. Blessed is he who keeps the words of prophecy in this book."

Although their text divisions vary, all the thirteenth-century Berengaudus recensions shift the focus of this text from the River of Life to John's vision of the Lord. John contemplates the Lord and Lamb enthroned within an elongated vesica from which the River of Life flows into the city in the central foreground. In most versions, the heavenly Jerusalem has diminished into a small shrinelike vessel, and in Paris lat. 10474 (fig. 167), the architectural traces of the city disappear altogether.

To signal a shift of the discursive center to a dramatic anticipation of the seer's ultimate perception of God "face to face," John points to his eye in Mor-

Figure 167. Apocalypse. Paris, Bibliothèque Nationale MS lat. 10474, fol. 46. River of Life (Phot. Bibl. Nat. Paris).

gan, whereas in Metz, he climbs to a high vantage point above the heavenly city from which he can reverently glimpse the Lord and Lamb enthroned. In Add. 35166 (fig. 168), a second figure of the Lord leans out from the central mandorla to face the seer in a literal pictorial evocation of the commentary that refers to the ultimate splendor of John's vision by quoting I Corinthians 13:12: "Now we see a dim reflection in a mirror, but we shall see [him] face to face."[356] The servants of God also gaze upward at the mandorla-framed vision, thus providing a pictorial reference to the gloss that again stresses the supernatural perceptual experience of the saints, for when they see God face to face, "what they see transcends all sweetness and pleasure." The exegete again quotes St. Paul (I Corinthians 2:9): "God has prepared for those who love him what no eye has seen, no ear has heard, things beyond human comprehension."[357] In Paris lat. 10474 (fig. 167), however, John, now guided by the angel who embraces him protectively as he gestures toward the River of Life,

looks down, leans on his staff, and seems to grope blindly as he approaches the great vision. Here, as in

Figure 168. Apocalypse. London, British Library MS Add. 35166, fol. 29v. River of Life (photo: The British Library).

Metz, where John clambers up the mountain, a divergent graphic interpretation of the gloss stresses the insurmountable distance between the divine vision and its human comprehension.

89. John Adores the Angel: 22:8–9

> And I John heard and saw these things. And, after I had heard and seen them, I fell down in adoration at the feet of the angel who had shown them to me. And he said to me: "Do not do that; for I am your fellow servant and brother of your prophets and of those who preserve the words of prophecy in this book: Adore God."

As underlined in the text, this passage has critical importance in the unfolding of John's story, for the gesture of his kneeling before the angel constitutes his ultimate response to the entire sequence of visions he has witnessed up to this juncture. The accompanying commentary explicates why John wanted to

adore the angel at this point but not earlier: "For when the angel showed to St. John Christ sitting on his throne surrounded by the four Beasts and the twenty-four Elders, he did not say that he wanted to adore the angel. . . . [Only] when he came to this place where the angel demonstrates how the bride of Christ, that is, the Church, is joined to Christ did John wish to adore the angel." John wanted to adore this angel because he demonstrated the conjunction of the Church with Christ."358 The angel consequently occupies a pivotal position in the archetypal image for he serves as an intermediary not only between John and Christ, but also between Christ and his Church on earth, represented by John who signifies the faithful throughout the commentary.

John thus kneels before an angel who stands in the center, gesturing upward to the Lord who appears in a mandorla at the upper right. In Metz (fig. 169), the angel grasps John's wrist in a gesture of

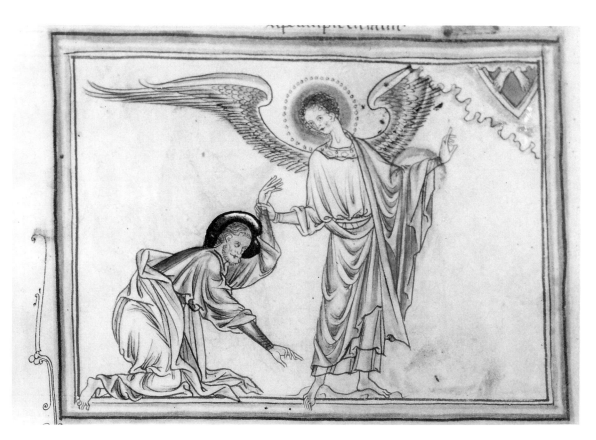

Figure 169. Apocalypse. Formerly Metz, Bibliothèque municipale MS Salis 38, fol. 32. John Adores the Angel (photo: Monuments historiques, Paris).

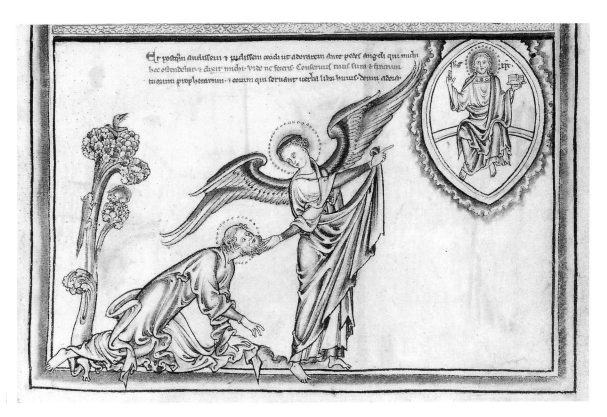

Figure 170. Apocalypse. New York, Pierpont Morgan Library MS M.524, fol. 21. John Adores the Angel (photo: The Pierpont Morgan Library).

constraint, pulling him off balance as he simultaneously exerts his power over the Evangelist with one hand and acknowledges the higher authority of God with the other. In Morgan (fig. 170), the angel cups his chin in an intimate gesture most commonly seen in representations of courtly love.[359] Here the ambiguity of the angel's response to John's adoration is intensified by the twisting pose of the crossed arms gesturing in opposite directions, up and down, right and left, as well as conflicting expressions of dominating power and tender affection. Among the thirteenth-century manuscripts, the variant representations of the Lord reveal a reluctance to undermine the dramatic impact of John's ultimate vision, as well as to stress the vast chasm of transcendent power and being that separates God from his angels. Thus, in Morgan, Christ is isolated in the upper right corner as a distant frontal Majesty enthroned within a cloud-encrusted mandorla, whereas in Metz, only a fleeting glimpse of the divine feet or bust is given. In

Douce, whether by accident or design, the angel effectively gestures toward a still invisible Godhead within an empty mandorla frame.

In the Berengaudus cycle, the pictorial evocation of John's *faux pas* serves as an admonition to the reader of the consequences of misreading or not reading allegorically, as conveyed in the accompanying commentary: "However, as we have so diligently maintained in the text of this book, it is not made to be gazed at in vain."[360] The image not only signals an awareness of the increasing number of lay and clerical readers who lacked the moral discipline and hermeneutic training of their monastic predecessors, but also alerts the reader that the art of interpretation depends upon a proper understanding of time. As the pilgrim draws nearer to God, he betrays his flawed human understanding by failing to realize that no interpretation of Scripture or human events can be accepted as final until the journey has ended. Thus, until John and the reader are privileged to see

the ultimate vision, their comprehension is vulnerable to error.[361]

90. John and the Lord: 22:10–21

> And he said to me: "Do not seal the words of prophecy in this book; for the time is near. . . . Behold I am coming soon, and my reward is coming with me, to restore to each one according to his deeds. I am the Alpha and Omega, the beginning and the end, the first and the last. Blessed are they who wash their robes clean in the blood of the Lamb, so that they may have the right to the tree of life and to enter through the gates into the city. Outside are dogs and sorcerers and the shameless and murderers and idolaters and all who tell lies.
> "I Jesus have sent my angel to reveal to you these things in the churches. I am the root and descendant of David, the radiant morning star." And the spirit and the bride said: "Come." And he who hears says: "Come." And he who is thirsty, let him come. And he who wishes, let him take the water of life for nothing. For I call to witness all who hear the words of prophecy in this book: If anyone adds to it, God will add over him the plagues written in this book; and, if anyone takes away the words from this book of prophecy, God shall delete his part from the book of life and from the holy city and from what has been written in this book. He who gives these revelations says: "For I am coming soon. Amen." Come, Lord Jesus. The grace of our Lord Jesus Christ be with you all. Amen.

Introduced without precedent in earlier traditions, the representation of John kneeling before the Lord was uniquely created to serve as the last illustration in the Berengaudus cycle. In a visually as well as dramatically satisfying image, the pilgrimage ends with the seer's ultimate reward as he now confronts his Lord alone, gazing up at Christ in a vision no longer mediated by angels. What he could glimpse only fractionally in the previous vision is now fully revealed before him.

The unannounced shift in the identity of the speaker from the angel to Christ in 22:10 ("And he said to me") is not immediately apparent to the reader of the text until verses 12–13 ("Very soon now, I shall be with you"). However, the abrupt transition of voices and personae is made dramatically clear and present in the image of John now adoring the Lord instead of the angel. Indeed, in Morgan (fig. 171), the Lord touches the edge of the inscribed text for 20:10–21 in a gesture that appropriates the entire utterance. The representation of John kneeling before the Lord was probably created as an end piece for the Berengaudus cycle to complete the chain of events initiated in the previous miniature. Thus, John's closing gesture visually as

sures the reader-spectator that he did in fact obey the angel's command to worship God.

In Add. 35166 (fig. 172), the eccentric beginning of the text at 22:16 ("I, Jesus, have sent my angel") instead of verse 10 causes a dramatic break with the dominant paradigm. Two angels appear at the right and left, holding lighted tapers, as the seer kneels before the Lord enthroned on a faldstool, transforming the mystical vision into a courtly scene in which John drops to his knees in a gesture of vassalage to the great Lord. The angelic taper-bearers direct the reader's attention to the commentary in which Christ, "the bright morning star," is called *lucifer*, for he alone can illuminate the shadowed obscurities of the book that John is unable to explicate for fear of falling into error and heresy.[362] In Gulbenkian (fig. 173), the sun and moon appear in the upper center of the composition in reference to Christ as a bringer of lights, offering another, perhaps more plausible way in which this pictorial allusion could have been made in the archetype, because they are small in scale and could have been easily overlooked by copyists and adapters.

Finally, the last illustration in Douce (fig. 174) reverses the archetypal composition so that the Lord, holding the open codex inscribed with the Anglo–Norman text of 22:16, appears within a mandorla frame at the left, thus creating a sense of closure in the sense of halt or standstill by its countertextual subversion of the originating dialogic relationship. As he holds his pen poised above the inkpot, John kneels between two books, the celestial archetype and his earthly transcription of it. The Lord's book proclaims to John that he has sent his angel to make these revelations, as the angel behind him issues a solemn warning that nothing is to be added or deleted from the book. The author's empty-handed gesture signals that his scribal work is complete, the vision is ended, and the pilgrim has reached his goal. At the same time, the gesture conveys a feeling of helplessness and lack of resolution that confirms the divine source and direction of John's project, for he is left in a powerless state of indeterminate suspension between heaven and earth, revelation and return.

John kneels before the Lord as the receptor of the epilogue's ultimate promise: "I shall indeed be with you soon." Responding to the commentary on 22:7 ("Blessed is he who keeps the words of prophecy in

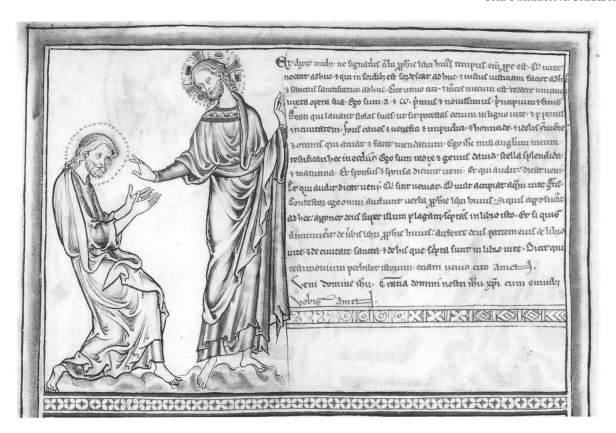

Figure 171. Apocalypse. New York, Pierpont Morgan Library MS M.524, fol. 21v. John Adores the Lord (photo: The Pierpont Morgan Library).

this book") as "the one who fulfills them by his deeds and is unremitting in their meditation,"[363] the visionary pilgrim returns to Ephesus to preach and perform miracles. As the last command signals the resumption of John's life, Morgan, Add. 35166, and Trinity resume the interrupted pictorial *vita* in the next framed illustration, whereas the Metz and Paris-Douce end at this point.

In the Berengaudus cycle, the last illustration represents the ultimate rite of passage before John emerges from the liminal experience of his visions, transformed and ready to resume his exterior life. Indeed, in the ceremonial ambiance of Add. 35166, the seer undergoes a visible rite of initiation in which he becomes a spiritually armed *miles Christi*. In Gulbenkian, the pilgrim reaches yearningly for a heavenly realm that lies beyond the boundaries of his vision. The insurmountable distance is expressed in the spatial gap between the two figures. The disparity

between their heavenly and earthly spheres is further stressed by the metaphorical scenic props of cloud and tree, as John is still anchored to the earth while the Lord will be momentarily lifted heavenward. In Douce (fig. 174), the scene takes on the sadness and nostalgia of farewell, as the Lord recedes from John's vision behind the multiple barriers of distancing frames. More reassuring is the Lord's gesture of blessing in Morgan, given in a shared liminal space at the margin of the text, a transitional space to which the reader also has access and thus finds hope for salvation through his vicarious spiritual journey.

■ ■ ■

As we have seen thirteenth-century Apocalypse illustrations function as a full-fledged vehicle of allegorical interpretation in both the English Berengaudus paradigm and the *Bible moralisée*, we have been witnessing a radical subversion of pictorial narrative by

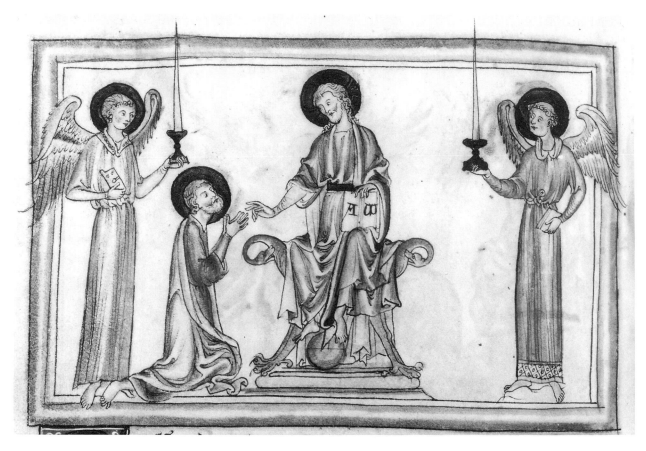

Figure 172. Apocalypse. London, British Library MS Add. 35166, fol. 30v. John Adores the Lord (photo: The British Library).

the glosses. Story-telling action and dialogue tend to be replaced by static emblematic gestures that exemplify meaning. Gestures are often contrived to signify the interpreted meaning of the text rather than advance the narrative, as when the woman from Rev. 12 reaches up to grasp the wings, signaling the Church's acceptance of both Testaments (see figs. 95 and 96). Instead of developing the image textually from left to right, the illustrations frequently freeze moments of confrontation between two protagonists of good and evil, facing each other in a closed, fixed sequence, which in the *Bible moralisée* is then mirrored in the corresponding commentary image. Thus, the dragon menacing the Woman in the Sun (fig. 96) is matched below by a horned demon threatening to undermine the moral discipline of the Church personified at the right by a cleric tempted with false

doctrine emblematized by an alternative church (building) and scripture (book).

Although the roundels in the *Bible moralisée* engage the commentary more directly, both the Parisian and English cycles constitute sets of optical mirrors through which the telescoped textual image is newly perceived through the lens of the gloss. Thus, in the *Bible moralisée*, for example, we see beneath the illustration of the Birds Summoned (fig. 151) a Dominican preacher presiding over the fiery "baptism" of the damned, officiated by demons in a hell mouth; the good souls look down from their heavenly, cloud-framed perch to pictorialize the gloss, which identifies the angel as preachers and the birds as good Christians who always strive for the heights by contemplating celestial good.[364] The angel stands at the left directly above the preacher in

the lower roundel, mimicking his oratorical gestures as he exhorts the birds, further breaking with pictorial precedent by proleptically showing them the promised feast and again providing a pictorial image to be mirrored in the commentary illustration below. Whereas the narrative elements of the text are similarly disposed in a vertical hierarchy in the English Gothic paradigm (fig. 150), each component is more emphatically isolated and crisply defined, thus exaggerating their syntactic isolation. In the absence of an accompanying glossing image, the allegorical illustration alone maps the surface narrative within a dislocated space and time. Contrasting with the significant grammatical shift in the textual paraphrase from the impersonal third-person narrative in the *Bible moralisée* to the first-person Latin Vulgate John is now present, performing a mediating role between the eternal and temporal, celestial and mundane, as well as between glossed text and pictured vision.

Unlike earlier medieval attempts to engage the gloss by inventing pictorial word equivalencies, the thirteenth-century cycles develop visual strategies that interpret the text on a metaphorical level. For example, the respective readings of the New Jerusalem (figs. 164 and 252) offer a pointed departure from earlier medieval diagrammatic images. No longer accompanied by the angel, John stands alone, registering his awed reaction to the spectacle, as the heavenly city literally descends on a cloud. In the *Bible moralisée*, the designer's revisions are all clearly calculated to redirect the reader's attention to the descent ("New Jerusalem coming down from God out of heaven, as beautiful as a bride all dressed for her bridegroom"), textually interpreted as the Church and pictorialized in the lower roundel as the Coronation of the Virgin where Ecclesia, crowned and holding a chalice, becomes the bride of Christ. In contrast, the introduction of a dominating Christo-

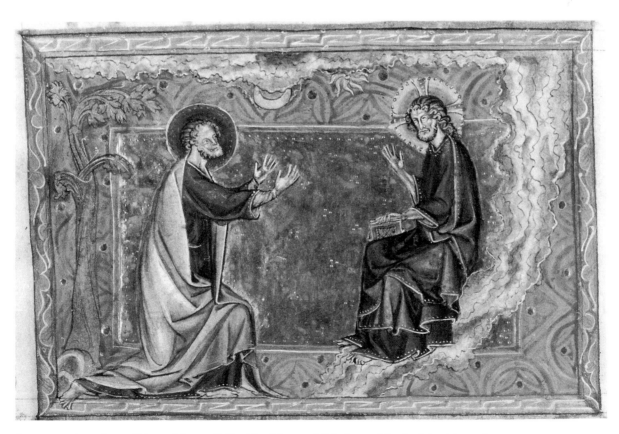

Figure 173. Apocalypse. Lisbon, Calouste Gulbenkian Museum MS L.A.139, fol. 76v. John Adores the Lord (photo: The Conway Library, Courtauld Institute of Art, London).

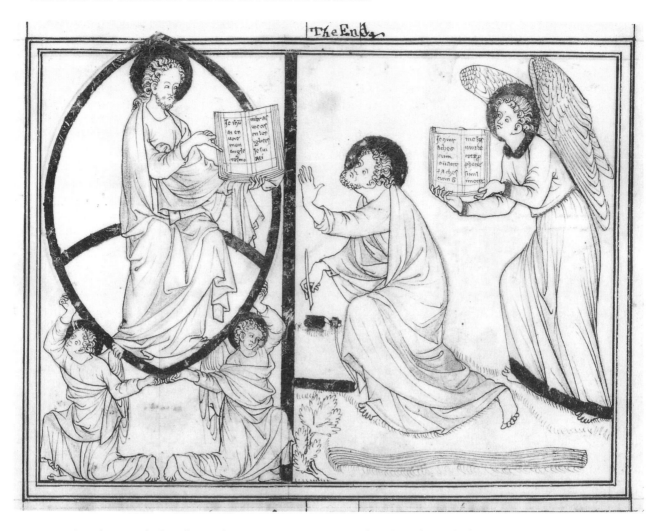

Figure 174. Apocalypse. Oxford, Bodleian Library MS Douce 180, p. 97. John Adores the Lord (photo: The Bodleian Library, Oxford).

logical figure in the Berengaudus illustration stresses a divergent aspect of the commentary's interpretation as the Lord coming to judgment.[365]

As we have seen abundantly demonstrated in our analysis of the Berengaudus paradigm, many new scenes and iconographical revisions introduced in the *Bible moralisée* to respond to its copious glosses and abbreviated segments of text also appear in the later English Gothic cycles.[366] Given the closely related character of the glosses themselves, as well as the inevitable intertextualities generated by the larger structure and ideology of thirteenth-century apocalyptic discourse, such overlapping of pictorial analogues is not surprising. Although many examples

can be plausibly explained as independent pictorial representations developed for the new text divisions and exegeses, however, a number of striking iconographic intersections between the *Bible moralisée* and the English cycles cannot be accounted for by the glossing texts, suggesting the possibility of a more direct relationship between the French and Insular Apocalypse traditions. For example, the Lamb standing on a placard in Metz (fig. 37) looks as if it had been derived from a similar image in Harley 1527,[367] where the book has been drastically simplified from what was clearly an open codex in Vienna 1179 (fig. 38). The *Bible moralisée* offers the only known precedent that shows the Lamb standing on the book

rather than awkwardly holding it, as in earlier representations. Although the echoing of the angel's adjustment of the woman's wings in the Harley illustration for 12:13–14 (fig. 96) in Metz (fig. 95) responds to a similar gloss that interprets the eagle's wings as the Old and New Testaments, the gesture seems too distinctive to have been developed independently in both cycles. Similarly, the representations of the confronted figures of the dragon and beast, each holding an emblem of authority, a scroll in the *Bible moralisée*[368] and a scepter in the English Gothic cycles (fig. 100), are equally unprecedented, again suggesting a direct connection. In the English illustration of the Harvest (fig. 119), the reaper has already begun to cut the wheatfield down to stubble and grasps a handful of stalks as he cuts, representing a distinctive gesture that appears in both versions of the *Bible moralisée* (fig. 120). Although the pictorial gathering of grain-laden sheaves, leaving the barren stalks, responds to the Parisian gloss on 14:16, which announces that on the day of judgment Christ will separate the good from the bad, and those who are "grain" will be stored in his granary and those he rejects will be cast into the fire,[369] the harvesting gesture has no particular significance for the English Berengaudus commentary, because no allusion to the Last Judgment is drawn, thus offering further evidence that it was probably influenced by a French model. In the English cycles, the new thirteenth-century illustration of the Marriage of the Lamb is rendered as a banquet scene replete with wedding guests (figs. 144 and 145). Like the image of the Lamb standing on the placard in Rev. 5, this distinctive English illustration could plausibly have evolved from a misreading of the Toledo version of the *Bible moralisée*, where the scene is related to the upper register and the altar on which the Lamb stood was extended into a long table to provide a simple horizontal barrier between the upper and lower scenes within the roundel frame.[370] The designer of the English Gothic illustration then took the next short but logical step in transforming the upper register of the Paris roundel into a full-fledged wedding banquet.

Judging from the number and range of examples cited, it seems possible that the designer of the Berengaudus cycle had access to the illustrated Apocalypse that appeared at the end of the *Bible moralisée*,[371] perhaps in a form similar to that in

Add. 18719. Dating from the end of the thirteenth or early fourteenth century, this incomplete copy of the Oxford–Paris–Harley version contains ink drawings over lead-point sketches in square frames rather than roundels.[372] Perhaps intended as a less costly version of the royal moralized Bible rather than as a maquette or pattern book, Add. 18719 or a similar copy could nevertheless have served as a convenient exemplar, providing a reservoir of images to the designer of the English illustrated Apocalypse. Indeed, the various misunderstandings of the *Bible moralisée* model that appear in the English cycle could have typically occurred if he had been working from roughly inked sketches like those in Add. 18719.

The Parisian abbey of St. Victor, where the *Bible moralisée* manuscripts were very probably produced,[373] served as an important intellectual center to which English clerics were regularly drawn, and a number of Victorine houses had been established in England. English followers of Peter the Chanter, such as the Victorine Robert of Flamborough, Thomas de Chobham, or Stephen Langton, could have provided the conduit through which a version of the Parisian moralized Bible reached England. Writing at St. Victor, Robert of Flamborough dedicated his *Liber Poenitentialis* to Master Richard Poore, one of Langton's students at Paris, who became bishop of Chichester (1215), Salisbury (1217), and Durham (1228) and played a leading role in Church reform.[374] A copy of the *Bible moralisée* provided with rough sketches similar to those in Add. 18719 could have been made in the Victorine center at Paris and then brought to England, as suggested by the documented case of Master Robert of Adington, who brought a set of glossed books of the Bible, along with recent works by Peter Lombard, Peter Comestor, Peter of Poitiers, and other Parisian masters from the abbey of St. Victor to Durham Cathedral in the 1190s.[375] An early manuscript of Richard of St. Victor's commentary on Ezekiel (MS Bodley 494) was copied by an English scribe from the exemplar at St. Victor (Paris lat. 14516) and given to Exeter Cathedral by Hugh, archdeacon of Taunton (ca. 1219–44).[376] Although the three-volume moralized Bible was probably not accessible in a sumptuous royal edition on this side of the Channel, a roughly illustrated and glossed text similar to that in Add. 18719 could have played an important role in inspiring the designers of the English Gothic cycles. In more than a few in-

stances, we have evidence that the distinctive iconography of its pictures very probably had a direct impact on the formation of the new English narrative paradigm so similarly subverted by its allegorical glosses.

PART II

LOCATING THE THIRTEENTH-CENTURY
READER IN THE BOOK

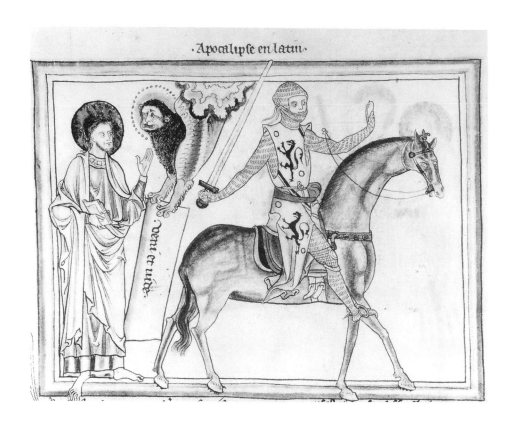

Apocalypse. Formerly Metz, Bibliothèque municipale MS Salis 38, fol. 5. Second Seal (photo: Monuments historiques, Paris).

The Ideology of the Book

Referencing Contemporary Crisis within Specular Structures of Power

In the following two chapters, we shall see how the Gothic transformation of the illustrated Apocalypse is located in a pivotal moment in the cultural construction of the self, problematized both as a subjectively inward-directed consciousness and as actively complicit in publicly manifested expansions of power over the alien "other." The visual strategies that activate the spiritual self are inseparably bound up with contemporary ideological constellations of hierarchical values. The very issues that come into play in picturing John's vision – prophecy, allegorical reading, the valorization of images, eucharistic devotion – are precisely those around which Christian society in the thirteenth century defined itself against Jews and Muslims, targets of a militant apocalyptic rhetoric preaching their "conversion" (extinction). The "other" is not merely referenced in the gloss or in the iconographic surface of the text illustrations, but is constructed out of the same discourse that also produces the medieval reader's conception of self. Ideology is not limited to the representation of the content of John's visions, but pervades how the images work to construct spiritual experience. Thus, the ideological and spiritual, although treated in separate chapters almost as if operating on parallel tracks, must be seen as interpenetrating components of a single *mentalité* in which the dualities between active propagandizing and devotional meditation, external social realities and the internal world of the reader, tend to dissolve.

Throughout the long medieval tradition of biblical interpretation was the implicit and even explicit possibility of turning the exegesis of Scripture into an allegory of the world. The belief that God authored not one book but two – the Bible and the world – implied that the elucidation of one involved the understanding of the other.[1] As the allegorical interpretation of Scripture expands beyond the text into the world, uncertainty about the text's multiplicity of meanings elicited a deep sense of contingency about the status of the world and the self, situating the thirteenth-century reader-viewer of the Apocalypse within the realm of a self-determining and self-defining activity we can call ideology. Far more subtle, pervasive, and unconscious than a set of explicit doctrines, ideology as defined by Althusser is the "realm of signs and social practices" that binds the individual to the social structure and lends a sense of coherent purpose and identity.[2] Rather than merely reflecting or expressing value systems, beliefs, and ideologies, the totality of practices and artifacts in material culture construct and constitute them; in Althusser's words, "Ideology has a material existence." Works of art thus generate ideology, as they reproduce ideology through the forms of their representation.[3] Within the chiasmatic Lacanian process by which the subject becomes part of the picture, the work of art privileges its own ideal spectator and in turn confers a sense of social dominance upon the comprehending beholder.[4] As the viewer produces

rather than perceives meaning, "the person who does the looking is the person with the power."[5]

The individual comes to feel that the world is significantly "centered" on the self in a reciprocal relationship. As Althusser argues, the structure of all ideology is specular, a mirror structure, just as all ideology is centered.[6] Governing the paradigm drawn for Christian religious ideology, the Absolute Subject occupies the unique place of center; around it an infinity of individuals become subjects, as God's mirrors, reflections, made in his image, in a double mirror-connection that subjects the subjects to the Subject (God). The human subject is thus supplied with a satisfying unified image of selfhood by identifying with an object that reflects this image in a closed, narcissistic circle as mirror (speculum). But the image involves a misrecognition, because it idealizes the subject's reality.[7] As Althusser put it,

Ideology represents the imaginary relationship of individuals to their real conditions of existence. . . . While admitting that ideologies do not correspond to reality, i.e., that they constitute an illusion, we admit that they do make allusion to reality, and that they need only be "interpreted" to discover the reality of the world behind their imaginary representation.[8]

If, as Lévi-Strauss has argued, "the purpose of myth is to provide a logical model capable of overcoming a contradiction,"[9] the mythic narrative of the Apocalypse sets out to overcome the tension perceived by the author between what was and what ought to have been.[10] As a narrative paradigm for the High Middle Ages, the apocalyptic allegory still addresses the reader's cognitive dissonance between expectations and reality. Within its dualistic structure, power is divided between God and Satan; both claim dominion over the whole earth and eternal rule. The book's textual and pictorial rhetoric calls for the reader's commitment to actions, beliefs, attitudes, and feelings. chartered by cultural dominance. Fear and resentment of the alien "other" are assuaged by repeated representations of the destruction of God's enemies. The author invites the reader to see himself or herself persecuted and caught within a "strange" and "threatening" conflict-ridden reality, which is then resolved when the persecutors are destroyed by divine wrath and the persecuted are exalted to a new, glorious mode of existence.[11] Once the layers of allegorical veneer are peeled away, the

ideological core around which the apocalyptic discourse is organized for the thirteenth-century reader emerges as a *Weltbild* of tensions centering around the heavenly and earthly Jerusalem as they existed on many different levels – for the Church caught up in the midst of reform, for the seemingly irreconcilable differences between Christianity and Judaism, and for the irreparable loss of the Holy City on earth. As it addresses the thirteenth-century reader's sense of loss and longing, "the content of Revelation involves a hidden heavenly reality that shows the visible world to be radically different from what it seems."[12] The strange and terrifying events of John's visions then become linked through an external center of thirteenth-century ideology focused upon the triumph of the Church, the destruction of the Jews, the recovery of Jerusalem, and coming to terms with eschatological expectations of the end.

CHURCH REFORM

Since the fourth century, the Apocalypse had been perceived as a book of the Church, whose "spiritual" reading revealed ecclesiological messages dealing with the time between the first and second advents of Christ.[13] Within the framework of the English Gothic illustrated Apocalypse, the accompanying Berengaudus gloss responds to a quickening of religious life in the thirteenth century. In its unequivocal emphasis on the moral state of the Church and clerical discipline, the commentary interprets the Apocalypse as a rallying force for Church reform. When in 1237 the papal legate Otho preached a sermon on that subject in St. Paul's, his text was Rev. 4:6. According to Matthew Paris's apocalypticizing account, the cardinal took his lofty seat before the altar, "lifting his voice like a trumpet," and interpreted the "living creatures" as the bishops whose eyes were to be everywhere and on all sides, at which moment a terrific storm burst over the cathedral to the terror of the whole congregation.[14]

Although the reform movement had already gone through a series of early stages in the immediate wake of Lateran Council IV (1215), the immense tasks of ecclesiastical renewal envisioned by Innocent III were by no means accomplished by midcentury. Church life in England was still deeply involved in efforts to raise the moral and professional standards

of the clergy and to meet the needs for clerical education and pastoral care. Whereas the effects of Lateran IV were felt throughout the English Church by priest and monk alike, the major burden of reform fell upon the jurisdictional authority of the bishops in disciplining the clergy, instructing them in doctrine and the proper administration of the sacraments, regulating the activities of the friars, and overseeing the monasteries within their dioceses.[15] A steady flow of diocesan statutes beginning in the 1220s and extending to the end of the century addressed a wide range of clerical abuses.

One of the major figures demanding reform was Robert Grosseteste, bishop of Lincoln (d. 1253).[16] His letters are filled with indignant complaints of clerical neglect and lax moral standards. Grosseteste's friend, the Franciscan Adam Marsh, was equally disturbed by lapses among the clergy.[17] The councils convened by Archbishop Boniface of Savoy at London in 1257, in 1258 at Merton, and in 1261 at Lambeth all focused on the reformation of the Church.[18] The 1268 constitutions of the papal legate Ottobuono were largely addressed to correcting clerical abuses. Later in the century, Roger Bacon in his *Compendium studii* still perceived the Church to be in a lamentable state and attributed its depressed condition to the materialism and corruption of the papal court.[19] Another Franciscan, Archbishop John Peckham of Canterbury (1279–92) saw the seven major evils of the English Church as the plagues brought by the seven vials of the Apocalypse.[20]

The apocalyptic framing of diatribes against clerical corruption and ignorance had occurred much earlier, ca. 1200, in a brutal but powerful parodic Latin poem widely circulated in England under the name *Apocalypse of Golias the Bishop*.[21] The literary phantom known as Golias and mockingly dignified with the rank of *episcopus* can be regarded as the personification of contempt for official hypocrisy.[22] Following in the footsteps of the seer on Patmos, the new dreamer-poet is told by an angel (vv. 16–17):

> Look up – and see what only John has seen.
> To seven Asian churches the Apostle
> Sent description of his mystic visions;
> To seven English churches you will do
> The same – with one or two minute revisions.

The irreverent satire tropes the opening of the seven seals (Rev. 5 to 8) with mordant savagery to reveal increasing degrees of clerical decadence, descending through the hierarchy until the seventh seal reveals the Abbot, "the monks' own guide to Hell, who knows the shabbier the cloak, the better to conceal a lecher's tail." The apocalyptic Beasts are transformed into an "odd quartet" comprising "our holy Pope Voracious" (lion), "Bishop Avarus the worst" (ox), "Archdeacon Pilferpurse" (eagle), and "the human face belongs to the good Dean, a master of refined depravity" (vv. 26–9). Not only the eschatological content, but also its rhetorical mode is held up to ridicule by the angel who "held up that mighty Book" (v. 22):

> This Book is allegorical in style;
> No other style could suit the subject more:
> A Prelate is an allegory inside-out,
> A handsome shell, but rotten at the core.

In playing out the notion of trapping the reader within a delusional ploy, medieval traditions of apocalyptic exegesis going back to Augustine come under attack, as the spiritual significance of the text is wittily undermined by Golias's gross physical needs.[23] At the climactic moment of transcending visionary experience, he cannot ignore the insistent claims of the flesh as his empty stomach growls (v. 107):

> While all this passed before my dazzled eyes,
> A pang of hunger made my stomach quiver.
> I calmed it with a loaf of poppy-bread,
> Washed down with water from the Lethe River.

The poem ends with a hollow sigh of regret (v. 110):

> The wonders and the mysteries I've seen!
> Things you'll never know until you're dead.
> I've seen God! the angels! Paradise!
> And then forgot them when I ate some bread.

As F. X. Newman notes, the poem implies that Bishop Golias is not merely a witness to contemporary ecclesiastical rot, but a cynical visionary who has seen all.[24] Writers ranging from a reforming bishop such as Grosseteste to the satirical Goliard poets had found their ideals betrayed by the obscene spectacle of the Church as a great and propertied corporation and political machine blinded to corruption by its own power.

In response to such bitter attacks, the bishops held regular synods and issued statutes devoted to eccle-

siastical reform throughout the thirteenth century. The diocesan statutes of Giles de Bridport convey the episcopal pride taken in that tradition:

Like the sun in the heavens, the church of Salisbury is conspicuous in its divine office and administration, above all the other churches of the world, diffusing its light everywhere in order to make good their defects.[25]

In the thirteenth century, the English Church was a church of bishops. Its new saints – Edmund of Abingdon, Hugh of Wells, and Richard Wych – all wore miters. As we shall see, the new ecclesiastical statesmen charged with governance and reform are evoked in the solemn hagiographical presences attached to the Lambeth Apocalypse (fig. 227).[26] As a result of the reorganization of the Church following Lateran IV, centers of religious power shifted from the monasteries to the cathedrals. Bishops replaced Benedictines as the ecclesiastical heroes of the Gothic age.[27] In their splendid new cathedrals, the bishops created a New Jerusalem on earth, celebrated by poets like Henry d'Avranches, who likened the joyfulness of the new Salisbury cathedral to that of Jerusalem delivered from bondage.[28]

As Brieger observed, the English formulation of Gothic art was adapted to the peculiar needs and conceptions of the newly powerful reforming episcopate.[29] Nowhere is this more evident than in the commanding figures of bishops who dominate the commentary illustrations in the Apocalypse given to Abingdon Abbey by Giles de Bridport, bishop of Salisbury. The illustration for the Berengaudus commentary on Rev. 1:4 (fig. 175) is typical of its focus upon the Church and its priesthood. The text reads:

By the seven churches is meant one Church universal, because of the seven gifts of the Holy Spirit whose illumination shines brightly in the world. . . . The kingdom signifies the Church of God. For Christ the Lord created the kingdom of God from men when he established those . . . he deemed worthy to live and reign with the Father and the Holy Spirit. By those . . . are meant priests. Therefore priests signify the elect of God.[30]

The illustration represents the Church in both its celestial and earthly manifestations as a Gothic cathedral surmounted by a multitude of towers and pinnacles. The central nave of its tripartite structure contains the figure of Christ from whom the seven gifts of the Holy Spirit fly in the form of doves toward the priests in the side aisles. As the blood flows from the wound in Christ's side onto the heads of two small kneeling figures, demons escape in visible demonstration of his "washing away of our sins with his blood" (Rev. 1:5). Christ's mantle is slit open to display his wound, a striking motif that occurs with some frequency in the second half of the thirteenth century in England.[31] In this context, the wound in Christ's side serves as another symbol of the Church.[32] However, instead of pulling open the cut in his tunic to point the way to salvation through his sacrifice on the cross, as he does in the Last Judgment tympanum of Lincoln Cathedral,[33] Christ places his hand on the heads of the repentant sinners in a priestly gesture of absolution. Christ's blood suffuses his earthly Church in scarlet streams flowing into the gabled structures occupied by his priests represented by two mitered bishops kneeling before an altar with a gold chalice at the left and a single tonsured figure at the right in a striking image evoking the cleansing renewal of the Church.

In reality, however, the English Church was plagued by endless litigation and quarreling among the clergy over rights and privileges.[34] Whereas the laity generally suffered neglect, the ranks of the clergy swelled with ignorant and venal men. As described by the acid pen of the Goliard poet (v. 77),

The Parson has so many parishes,
His function has become just ornamental;
He moves around so much, that if he's found
In his own church, it's merely accidental.

In his constitutions of 1268, the papal legate Ottobuono Fieschi defined the three great evils of the Church as pluralism, absenteeism, and the refusal of the lower clergy to proceed to holy orders.[35] In the Abingdon Apocalypse, the bishop's power to exact discipline is graphically demonstrated in an illustration (fig. 176) accompanying the Berengaudus gloss on the pouring of the second vial as the eternal punishment of those who transgress the Law.[36] Heading a group of Benedictines, a bishop commands the torments of the wicked by issuing his judgment on a speech scroll, as he brandishes a large document affixed with seals. On a less momentous but more practical level, the gesture can also be interpreted to address the mistreatment of books, as it visualizes the anathema given in an erased *ex dono* inscription at the top of the facing page:

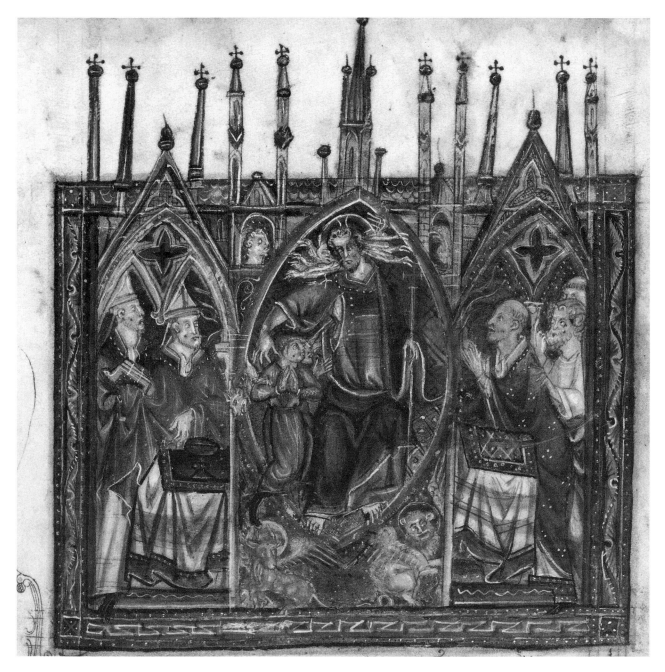

Figure 175. Apocalypse. London, British Library MS Add. 42555, fol. 6. Commentary Illustration for Rev. 1:4 (photo: The British Library).

Figure 176. Apocalypse. London, British Library MS Add. 42555, fol. 58. Commentary Illustration for Rev. 16:3 (photo: The British Library).

This book was given to the monastery church at Abingdon by Giles, lord bishop of Salisbury. . . . A sentence of anathema has been pronounced by the aforesaid bishop against anyone who removes . . . this book from the . . . church.[37]

Even the sacrament of the Eucharist was not immune from clerical abuse. In the parodic description offered by the contemporary *Apocalypse of Golias* (v. 60):

> The Priest is called by God to Holy Orders,
> And is charged with care of sacred things,
> But since he's almost always charged with wine,
> He fouls the service, belching as he sings.

To remedy such lapses in discipline among the or-dained clergy, many injunctions among the new statutes concern the correct celebration of mass. For example, the altar was to have two lights burning upon it in order to make the service as dignified as possible,[38] and care was to be taken that no drops of consecrated wine were spilled.[39] Papal legates and bishops demanded that every parish should have complete sets of vestments, silver chalices, frontals, bells, books, and candles.[40] Designers of the illustrated Apocalypses lost no opportunities to place before their readers pictorial demonstrations of appropriately vested altars, replete with candles, altar lamps, chalices, and covered ciboria to protect the elements of the Eucharist (see figs. 71, 72, 83, 121, and 127).

Many diocesan statutes refer to the neglect of clerical dress[41] and the tonsure, the most visible badge of the clerical profession, which many priests had allowed to disappear under fashionable coiffures.[42] In the penultimate episodes of his illustrated *vita*, John is shown as an exemplary tonsured priest, dressed in liturgical vestments, performing mass at a vested altar (see fig. 12). Clerical celibacy was also a major concern expressed in the statutes; Giles de Bridport, for example, ordered all the clergy within his diocese of Salisbury to get rid of their concubines within a month.[43] The illustrated Apocalypse that the bishop of Salisbury gave to Abingdon Abbey contains a vivid reference to clerical celibacy in a pictorial vignette borrowed from the Bestiary (fig. 202) representing a beaver biting off his testicles. According to the medieval legend, when the animal was hunted for its testicles, purportedly valued for their medicinal

properties, the beaver bit them off and threw them at the hunters who would then abandon the chase. The Bestiary allegory then admonishes those who wish to live chaste lives to sever themselves from sin and throw it in the face of the devil.[44]

Beyond the internal concerns for clerical discipline, the canons of Lateran IV and the subsequent synodal constitutions of the English dioceses issued to the end of the thirteenth century were taken up with pastoral care. The new focus of the *cura animarum* was upon the laity. Parochial priests were urged not only to explain the Gospels read during the mass and discuss the virtues of the saints, but to deliver regular sermons on the profession of faith as well as the sacraments and confession.[45] Books of sermons, collections of exempla, manuals of confession such as William of Waddington's *Manuel des péchés* (ca. 1260), expositions of the Ten Command-

Figure 177. Apocalypse. Lisbon, Calouste Gulbenkian Museum MS L.A.139, fol. 52v. Commentary Illustration on Rev. 16:1–2 (photo: The Conway Library, Courtauld Institute of Art, London).

ments, compendia of vices and virtues, and other manuals of popular theology such as the *Lumière as lais* (1267) of Peter Peckham, comprised a vast literature of pastoral care circulating in thirteenth-century England.[46] The presence and activity of the friars further intensified the revival and expansion of preaching.[47] Although they were welcomed by the towns, the secular bishops, and the king, and were particularly valued for their reformist efforts, the friars were perceived as formidable rivals by the older monastic orders; quarrels developed between the friars and seculars over the right to preach, hear confessions, and bury the dead, questions that were not settled until 1300 by a papal bull.[48]

The major contributions of the friars toward Church reform lay in preaching and clerical education. Because heresy seems to have posed no visible threat in England, the Dominicans, whose primary reform mission was inquisitorial, were overshadowed by the popular preaching of the early Franciscans as well as by their academic distinction in the Oxford schools.[49] Paralleling the role undertaken by the Dominicans in the Paris schools, the friars became involved in the teaching of theology and canon law with direct reference to the practical problems of the Church. Thus, it is not surprising to find Franciscans appearing among the saints and the righteous in the illustrations of the Trinity Apocalypse, because Franciscans like Adam Marsh held positions of confidence at the royal court, and a special chapel for the friars minor was built near the queen's lodgings at Clarendon. In tacit recognition of their distinctive role as popular preachers, the two witnesses of Rev. 11 are portrayed in friars' garb in Douce 180,[50] whereas the false prophet appears in Dominican robes in the fourteenth-century Lincoln Apocalypse. Along with the bishops, the friars minor appear as the heroic protagonists of the illustrated commentary in the Gulbenkian Apocalypse, preaching to the wicked (see fig. 177) and leading the battle against Antichrist at the end of time.[51]

Scripture reading played a central role in the Church's effort to reform itself and revitalize the clergy. In his constitutions of 1240, Bishop Walter Cantilupe of Worcester devoted a paragraph to Bible reading and drew up a lectionary to correspond with the Church calendar. For three weeks from Easter to the Feast of the Ascension, the Apocalypse was chosen because of its references to the "Lamb that had

been slain."[52] Although Bibles were so expensive that few individuals could afford to own them before 1300,[53] familiarity with Scripture is widely documented among the bishops. Grosseteste was renowned for his profound biblical knowledge; Godfrey Giffard, bishop of Worcester, preached on texts from both testaments. The learned and saintly Richard of Chichester was well supplied with books for scriptural study, including a commentary on the Apocalypse.[54] Like many of his contemporaries, Bishop Giles de Bridport of Salisbury, who played an exemplary role as *pastor pastorum* and gave an illustrated glossed Apocalypse to Abingdon Abbey, bore the title of *magister*, and was probably trained in theology and canon law at Oxford.[55]

One of the most profound shifts involved in thirteenth-century Church reform was the emergence of new conceptions of authority and of determining what was authoritative. In 1215, the second canon of Lateran Council IV established a new, formal definition of the magisterial power of the Church over matters of faith.[56] At issue was not only the source of authority, but the concept of universality. Although Alexander III had already spoken of the *magisterium* of the Church in terms that gave the pope doctrinal prerogative,[57] universal sovereignty in the Church in matters of faith tended to be defined by the conciliarists who pressed the view that "universal" authority resides in the community taken as a whole.[58] As G. R. Evans argues, "it is ecclesiological, and at the same time it reappraises the whole ancient complex of ideas about revelation, witness, and the authority of authors."[59] As Durandus declared, "Perish the thought that we should say anything less than what the catholic Church preaches throughout the world."[60] Culminating in the *Catena aurea* of Thomas Aquinas writing at the request of Urban IV in 1261, concerns for the Church's magisterial teaching increasingly turned to enlarging glosses on Scripture. Like the thirteenth-century compilers of excerpts from the Berengaudus commentary on the Apocalypse, Aquinas selected a "chain" of exegetical texts "not only to pursue the literal, but also the mystical sense . . . to put down errors and confirm catholic truth."[61]

To gain an idea of how the reformists approached biblical study, we can turn to the work of Robert Grosseteste. As Beryl Smalley pointed out, Grosseteste's exegetical writings were based upon an insis-

tence that doctrine and theological speculation ought to be kept within the framework of Scripture.[62] As part of his campaign to reform the clergy, Grosseteste promoted an older, spiritual exposition of Scripture that enabled preachers to call for reformation with the authority of God's own word: "Light comes when the literal sense of Scripture bursts forth into the spiritual sense."[63] In his letters, Grosseteste used proof texts to support a variety of applications of the reforming ideal. In his view, the role of the Church in society formed part of God's plan as mirrored in Scripture, and he entrusted its interpretation to the Church and its "masters of the sacred page." The Bible, as Grosseteste read it, mandated his program of ecclesiastical reform.[64] Although the schoolmen in the universities were laying greater emphasis on the literal and intellectual senses in which Scripture was subjected to the scrutiny of syllogistic logic and argument, reformers like Grosseteste exploited traditional scriptural exposition as more suitable to their goals. Grosseteste even eschewed the new system of capitulation introduced early in the thirteenth century by Stephen Langton, and kept to the old method of expounding continuously by *lemmata* or the short passages into which the Fathers and earlier medieval commentators had divided their texts for exegetical exposition. Roger Bacon, writing in 1266–7, laments the passing of the custom observed by Grosseteste.[65] Insofar as they attached their theological teaching exclusively to Scripture, Franciscans like Adam Marsh kept Grosseteste's focus on Bible reading alive,[66] but, with the Dominicans, he took a more literal and moral approach to understanding Scripture. In Franciscan meditations, for example, the Gospel was read in its literal sense, as evoked by the crucifix or later by the rosary.[67]

Within the context of the reformist mentality of Grosseteste and his thirteenth-century followers, it is now possible to understand why a traditional early twelfth-century commentary like that of Berengaudus was chosen for the English illustrated Apocalypse. Although in every respect, the new mid-thirteenth-century compilation of excerpts from this spiritual exposition of Revelation met the needs and strategies of Church reform, it was neither originary nor unique. The commentaries of the *Bible moralisée* can be associated with a transitional group of reformist theologians active in Paris in the 1220s,

whose concerns for preaching, pastoral care, moral reform, and the struggle against heresy inaugurate the new era of functional theology proclaimed by Lateran IV.[68] The first redaction was very probably compiled about 1220 by theologians closely allied with the Paris schools, for it numbers among the earliest examples of the newly revised university Bible.[69] The Apocalypse commentary in the moralized *Bible moralisée* has been excerpted from a lost work that also provided the Latin model for the French prose gloss in the Corpus-Lambeth cycles of the thirteenth-century English Apocalypse.[70] Like the Berengaudus commentary, the glosses in the moralized Bible belong to a mode of spiritual exegesis rooted in the twelfth century.[71] Unlike the Berengaudus text, however, the Parisian commentary breaks with its older sources in a number of ways that more directly express contemporary concerns with Church reform, Anti-Judaism, and the Crusades, and at the same time stress preaching, penitence, and penance in ways that far surpass the appeals to new mendicant projects that we have seen implied in the English Apocalypse. The *Bible moralisée* stands as a vast typological compendium proclaiming the new policies of spiritual reform that resonated on both sides of Channel to the end of the century. Like the *Bible moralisée*, the English Gothic idea of the illustrated Apocalypse, in which the words of Scripture are transmuted into images, offered an ideal instrument to serve Grosseteste's goals of spiritual exposition. In his commentary on Aristotle's *Posterior Analytics*, he argues that, just as the light of the sun irradiates the organ of vision and things visible, enabling the former to see and the latter to be seen, so too the irradiation of a spiritual light brings the mind into relation with that which is intelligible.[72]

ANTI-JUDAISM

Notwithstanding reformist aspirations toward spiritual enlightenment, nowhere does Walter Benjamin's oft-quoted aphorism, "There is no cultural document that is not at some time a record of barbarism,"[73] more aptly apply to the Gothic Apocalypse than in its exegetical and visual imagery of Jews. Judging from the number of diocesan statutes devoted to the Jews, they were perceived as a "problem" in thirteenth-century England, posing a crisis equal in im-

portance to Church reform and in some ways related to it. Although Jewish lives and property were still protected by canon law, unconverted Jews increasingly came to be regarded as a threat to the well-being of the Church. Although the Jews still occupied a special place in Christian theology as the chosen people of the Old Testament who had given birth to Christ, they were also perceived as the descendants of those held responsible for his death and who obstinately refused to recognize him as the Son of God. In the view of Innocent III,

Christian piety accepts the Jews who, by their own guilt, are consigned to perpetual servitude because they crucified the Lord, although their own prophets had predicted that he would come in the flesh to redeem Israel . . . and, like Cain, they are [condemned] to be wanderers and fugitives.[74]

The conception of medieval Judaism as an intolerable anomaly gained increasing urgency in the thirteenth century's zealous efforts to reform the Church as well as in the apocalyptic expectation that the Jews would be converted or destroyed at the end of time.[75]

The reform movement among the secular bishops in England, with its strong emphasis on authority, hierarchical order, discipline, group loyalty, and religious conformity, provided a classic framework for the nurturing of anti-Jewish prejudice.[76] The synods of Worcester in 1240, Chichester in 1246, Salisbury in 1256, Merton in 1258, and Lambeth in 1261 all adopted increasingly stronger measures against the Jews.[77] After promoting the restrictive canons adopted by the synod of Oxford in 1222, Langton, together with the bishops of Lincoln and Norwich, attempted to initiate a boycott to starve out their Jewish communities, but was thwarted by the king's justiciar, Hubert de Burgh.[78] That Robert Grosseteste shared the harsh sentiments of Langton is made clear by the following passage from his letter to Lady Margaret de Quincy:

Being guilty of murder, in cruelly killing by crucifixion the Savior of the world . . . [the Jews] lost their status unhappily at the hands of Titus and Vespasian, and having entered into captivity, were scattered as slaves throughout the world, and they shall not be restored to freedom until the end of the world, when in the last days the Jews shall attain salvation through belief in Christ. In the meantime, how-

ever, while the same people of the Jews persist in their unbelief . . . they will be held captive under the rulers of the world as a just punishment for their sin.[79]

The decade of the 1260s was a period of devastation and terror for the Jews of England. With the turning point reached in 1253 when Simon de Montfort expelled the Jews from Leicester and Henry III issued restrictive legislation based largely on earlier ecclesiastical canons,[80] the situation steadily worsened until the Jews were expelled from England in 1290. The first to suffer severely in the 1260s were the Jews of Canterbury in 1261; they were attacked again in 1264. In 1262, seven hundred Jews were killed by the baronial armies in London, and the new synagogue was burned in 1263–4 during a second siege. Similar attacks occurred at Worcester, Winchester, Bristol, Bedford, Ely, and Lincoln, where the synagogue was sacked in 1266.[81] During the disturbances of the barons' war, the failure of civil, royal, or ecclesiastical authority to protect Jews against physical attack and destruction of property left the Jewish communities of England in a deplorable condition by the time peace was declared in 1268.[82]

By virtue of its Berengaudus commentary, the new illustrated Apocalypse becomes infused with expressions of anti-Judaism that provide a framework of justification for abuses against the Jews. In the twelfth century, writers such as Bruno of Segni, Richard of St. Victor, and Anselm of Laon include the Jews with pagans, heretics, and false Christians in their interpretations of the forces of evil to be overcome in the visions of the seven Trumpets and seven Vials. Only rarely, however, are the Jews singled out for special attack. In both the number and virulence of its anti-Jewish assaults, the Berengaudus commentary stands apart from other twelfth-century exegetical texts on the Apocalypse. Jews are condemned for the harshness of their Law, as disciples of Antichrist, and as persecutors of the Church.[83] Berengaudus repeatedly dwells upon the rejection of the Jews and the calling of the gentiles, followed by the destruction, displacement, and enslavement of the Jews by the Romans, with no hope for a conversion at the end of time, when the remnant of Jews will be destroyed to vindicate the blood of Christ. The only other twelfth-century commentator who mentions the destruction and dispersion of the Jews is Richard of St. Victor, who does so only in his interpretation

of the pouring of the first vial, where he identifies the earth as Judaea and characterizes the Jews as followers of Antichrist.[84]

From the perspective of the Berengaudus commentary, all medieval Jews are blind and unregenerate, with little or no possibility offered for redemption or conversion. Similar expressions of untempered hostility toward the Jews can be found in the English moralized *Bestiaire* of Guillaume le Clerc, written in Anglo-Norman verse in 1210–11.[85] A number of thirteenth-century English sources link the rejection of the Jews with the destruction of Jerusalem, ranging from Peter of Blois' *Contra perfidiam Judaeorum*, ca. 1200,[86] to the *Pictor in carmine*, which offers five Old Testament typologies for the Roman devastation of ancient Israel.[87] Even the allegorical exposition of Scripture itself plays a role in arguing the anti-Jewish position, for Berengaudus repeatedly condemns the Jews' literal understanding of the Bible. In this respect, Berengaudus resembles the later writings of Guillaume le Clerc and Peter of Blois,[88] as well as Bartholomew of Exeter (d. 1184), who writes in his *Dialogues against the Jews*:

The chief cause of disagreement between ourselves and the Jews seems to me to be this: They take all the Old Testament literally . . . they will never accept allegory. We interpret not only the words of Scripture but the things done and the deeds themselves in a mystical sense.[89]

The frequency and virulence of the anti-Jewish attacks in the Berengaudus commentary, however, are rarely reflected in the Apocalypse illustrations. Aside from the characterization of the followers of the beast as Jews in Rev. 13, only two illustrations among the thirteenth-century manuscripts translate the Berengaudus text into images directed against the Jews. For the gloss on the opening of the third seal, the thirteenth-century compilers omit the long Berengaudus commentary on Moses as a prefiguration of Christ[90] and give instead the passage that explicates the meaning of the black horse and its rider as the harshness of Judaic Law. Having rejected an alternate reading given by Berengaudus in which the horse signifies those who are saved by the Law,[91] the gloss reads:

By the black horse we may understand the teachers of the Law. Indeed, the blackness of the horse signifies either the obscurity or the harshness of the Law they had taught. For Moses had a veil over his face, insofar as [he] could not see the splendor which is understood spiritually in the Law . . . the scales indicate the true impartiality of legal justice, of such a kind as "a life for a life, an eye for an eye, tooth for tooth, foot for foot."[92]

In the Lambeth illustration (fig. 46), the third rider wears a cowl or hood that obscures his vision so that he cannot see the winged beast delivering the scroll to John at the left in a literal representation of the Jews' inability to "see" or understand Scripture in the spiritual sense in which it was revealed to John.

The most ominous aspects of Berengaudus's anti-Jewish attitudes occur in his arguments for divinely sanctioned violence against Jews. In three different passages, the commentary stresses the destruction of the Jewish people, first by the Romans and then at the end of time.[93] In the commentary on the opening of the fourth seal, for example, the Roman destruction of Israel is set forth as a punishment mandated by God at the advent of Christ, when the pagans accept him as their Messiah but the Jews reject him. According to Berengaudus,

Hell follows this horse, because the inferno will swallow up all those who hold in contempt the warnings of the prophets. "Death and Hades were given authority over a quarter of the earth to kill by sword, famine, death, and wild beasts." By the fourth part of the earth is meant all the land of Israel.[94]

The commentary continues by asserting that the fourth rider is called Death because the people of Israel fell into mortal sin, quoting from Deuteronomy: "A fire is kindled by the Lord's anger . . . and it devours the earth."[95] In Morgan and Lambeth 209 (figs. 45 and 47), the Fourth Horseman is either veiled or wears a Jew's cap and holds up a flaming bowl, as he is followed by a gaping hell mouth filled with flames consuming the souls of the damned. In this illustration, the images of hell, death, and the consuming fire of God's anger dominate the fulfillment of the Old Testament prophecy for those who are presumed to have refused to answer the summoning of the people at Christ's advent.

Although the majority of thirteenth-century cycles of Apocalypse illustrations remain relatively untouched by the anti-Jewish sentiments of the Berengaudus gloss, two manuscripts stand apart in this

respect. Dating from the 1260s, the Gulbenkian and Abingdon Apocalypses contain full cycles of illustrations for the commentary in addition to those for their biblical texts, and it is in these two cycles that the anti-Jewish thrust of the glossing texts are fully translated into pictorial images.[96]

The commentary on the sixth seal links the destruction of Jerusalem and the rejection of the Jews, anticipating a thirteenth-century idea found in English sources ranging from Peter of Blois' *Contra perfidiam Judaeorum* to the *Pictor in carmine*:

The opening of the sixth seal refers to the rejection of the Jews and the calling of the gentiles. And . . . Christ gave birth to the destruction of the Jews and the election of the gentiles. . . . "There was a great earthquake." In this place the earth signifies the Jews, [for] there was a great earthquake when these people were devastated by the Romans.[97]

In the Gulbenkian and Abingdon illustrations for this commentary (see fig. 178), a massacre of Jews at the left is commanded by an enthroned Roman emperor; the weeping women refer to Berengaudus's quotation of the Lord's admonition to the women of Jerusalem: "Weep not for me, but for yourselves and your children."[98] The emperor then turns to sell thirty Jews for a penny to a man reaching into his purse to pay for the men in pointed hats who are bound and shackled behind him.[99] At the right, another emperor

Figure 178. Apocalypse. Lisbon, Calouste Gulbenkian Museum MS L.A.139, fol. 13. Commentary Illustration for Rev. 6:12 (photo: The Conway Library, Courtauld Institute of Art, London).

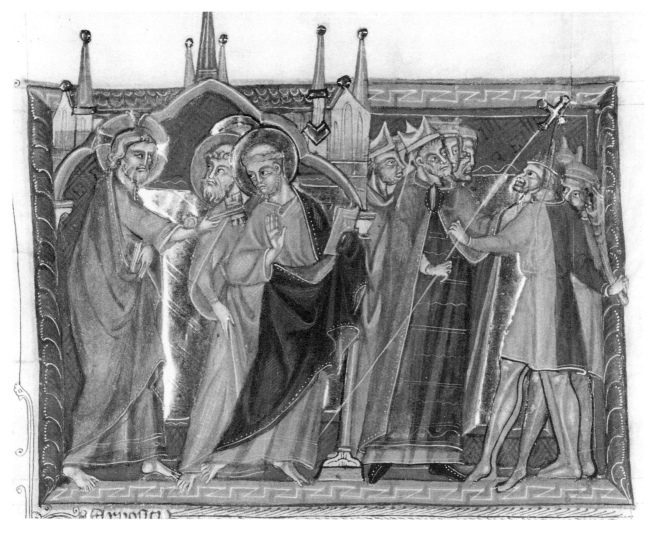

Figure 179. Apocalypse. Lisbon, Calouste Gulbenkian Museum MS L.A.139, fol. 54v. Commentary
Illustration for Rev. 16:8–9 (photo: The Conway Library, Courtauld Institute of Art, London).

is cured of leprosy by the miraculous image of Christ known as the Veronica, demonstrating the conversion of the pagans, juxtaposed against the rejection and degradation of the Jews. Enframed within a mandorla at the upper left, the Lord enthroned in heaven presides over the scene, holding what appears to be a huge episcopal seal, as if to bestow divine approval upon the vindictive destruction below. As we have already observed, this harsh image reflects an anti-Jewish feeling shared by significant numbers of secular bishops in thirteenth-century England.

One of the strongest and most direct expressions of ecclesiastical hostility toward the Jews appears in the commentary illustration on fol. 54v in the Gulbenkian Apocalypse (fig. 179), where we see mitered bishops engaged in physical combat with Jews in pointed hats. An archbishop wields his long cross-staff as if it were a lance and grasps the first man by the throat. This distinctive figure, wearing a bicolored tunic and holding a club, is probably intended to represent the God-denying fool from Psalms 13 and 52, who appears with a club in thirteenth-century English and French Psalter illustrations and is sometimes shown arguing with a cleric.[100] From

Augustine to Peter Lombard, medieval commentators have interpreted "the fool who says in his heart there is no God" to signify the Jews who killed Christ, claiming "non est Deus."[101] In a contemporary English Psalter from York (Add. 54179), the association is set forth unequivocally in the illustrated initial for Psalm 52 in which the fool is seated below a scene of Jews stoning Christ.[102] In the Abingdon version (fig. 180), a bishop and Jew struggle over a crozier, while a king raises a great sword against the adversaries of the Church.[103] The explanatory text for the pouring of the fourth vial informs the reader that

Christ and his apostles clearly predicted that the wicked Jews would be destroyed. And thus the Romans . . . poured [the fourth vial] on the Jews to take vengeance for the blood of Christ. . . . By fire, hunger and the sword . . . almost all the Jews were destroyed . . . because it was mandated by God . . . to inflict diverse calamities on the Jews and to kill some of them.[104]

Differing from the illustrations in the Lisbon Apocalypse, the Abingdon interpretation of the Berengaudus commentary transfers God's mandate to destroy the Jews from the Roman emperors to the Church of Rome, represented by the apostles at the left. As Christ thrusts the keys of authority at Peter, the first bishop appears reluctant to accept the command to kill the Jews as a condition of his stewardship, but his thirteenth-century successor eagerly rises to the task, aided in the Abingdon version by a zealous king. Although this violent image offers a highly exaggerated view, it nevertheless appears to express a sentiment shared by at least some thirteenth-century English bishops to justify the violence and persecution of Jewish communities within their dioceses in the 1260s.

Although the Franciscans and Dominicans were not formally charged with preaching and missionizing among the Jews until 1278, Innocent IV had already asserted a papal right to compel Jews to listen to conversionist sermons.[105] The Gulbenkian illustration for the commentary on 16:1–2 (fig. 177) can be read as a direct declaration of the contemporary mendicant mission,[106] in keeping with Augustine's advice to "preach to the Jews whenever we can . . . whether they welcome our words or spurn them."[107] Two preachers, a Franciscan friar and an Old Testament prophet, stand back to back, dividing the

Figure 180. Apocalypse. London, British Library MS Add. 42555, fol. 59. Commentary Illustration for Rev. 16:8–9 (photo: The British Library).

composition into contrasting halves, as they pictorialize the gloss on the voice from the temple and the pouring of the first vial. At the right, "the holy man who was before the Law" holds a scroll inscribed "Vox domini est precientis," and preaches to "the wicked who scorn the preaching of the saints sent by God"; at the left, an angel representing the voice from the temple, which is the voice of God, holds a scroll labeled "praedicatoribus" and points to a friar with a cross-staff, preaching to a group of Jews who reject his message.[108] In England, homes for Jewish converts were built early in the thirteenth century, the first probably at Leicester; the *domus conversorum* built in London in 1233 by Henry III is illustrated in the chronicles of Matthew Paris.[109]

Although the more optimistic missionary zeal of the mendicants to convert the Jews through preaching had occasional success, it was the harsher anti-Jewish sentiment of the Berengaudus tract that prevailed, not only among the older Benedictines and secular bishops, but among many friars as well. Henry of Wodestone, a contemporary of Bishop Giles de Bridport, who was sent to Oxford by the minorite house at Salisbury, authored in 1256 a short treatise entitled *Contra Judaeos* in the course of pleading a case on behalf of St. Albans against the

Jews before the royal council.[110] He was eulogized in the annals of the Greyfriars' convent in London, where he was buried with the extravagant claim that "by his efforts all the Jews were finally expelled from England in the time of Edward I."[111]

THE "LAST" CRUSADES

Just as antagonism toward contemporary Judaism of the diaspora found a complicit voice in the Gothic Apocalypse, the conflict between Christendom and Islam provided a nurturing ground for apocalyptic speculation during the thirteenth century. As Christian power in the Middle East grew increasingly more tenuous and crusading efforts became less successful and more desperate, prophecies of the imminent end offered solace and hope.[112] Initially dominated by eschatological concerns, the deliverance of Jerusalem had served the Western Middle Ages as a symbol of both the presence of God among men and his eventual coming at the end of time. Dreams of universal peace and reconciliation centering on the holy city fueled a dynamic myth whose power was proved by its longevity, as the calls for Crusade continued at least until the end of the century.[113] Although royal appropriation of control over the Crusades and their diversion to encompass the temporal interests of the papacy ended in failures and disillusionment, the myth surrounding the armed pilgrimage to the Tomb of Christ transcended its political and social cleavages and acquired new meaning for the thirteenth century.

After the fall of Jerusalem in 1187, the recovery of the holy city ceased to be a major goal of the Crusades. Although Jerusalem was briefly restored to the Christians in 1229 as part of a ten-year truce negotiated by Frederick II, the city fell again in 1244, lost to hopes of Christian domination forever. Earlier religious longing for the holy places was transmuted into a hope for preserving the political dream of a Mediterranean empire.[114] The Third and Fourth Crusades strengthened the Latin states and succeeded in capturing the Byzantine capital at Constantinople in 1204, but the Fifth Crusade (1217–21) ended in defeat at Damietta, and the Crusade of Louis IX in 1248–54 concluded in another disaster in Egypt. The new Crusade of 1270–2 of Louis IX, now joined by Prince Edward of England, temporarily succeeded in

buttressing the defense of Acre and the crusader outposts in the Latin Kingdom, but the capture of Acre in 1291 signaled the end of the last Christian stronghold in the Middle East.

By the 1260s, belief in the spiritual value of the Crusades was rapidly losing ground.[115] Redemption of crusader vows caused skepticism and disillusionment among the faithful.[116] The practice had already grown flagrant in England by 1240, when Matthew Paris complained that the friars had absolved from their vows those who were willing to pay the amount they would spend for personal expenses on Crusade.[117] The extent to which potential crusaders resorted to this evasive strategy in the latter part of the century is made evident by a list of three hundred redemptions for 1274 in the register of Archbishop Walter Giffard of York.[118]

The first naive objectives of the crusaders to convert the "pagans" beyond the pale quickly vanished in the face of superior military power as well as the awesome religious force of Islam. Among the followers of Joachim of Fiore, with support from the later Franciscans, the idea of apocalyptic conversion took root as an alternative to the military Crusades, as a preparation for the reunification of the Greek and Latin Churches and the conversion of the pagans and Jews at the end of time.[119] This missionary ideology is demonstrated in the commentary illustration for 19:17 in the Gulbenkian Apocalypse (fig. 181), where a great phalanx of bishops, abbots, and tonsured clerics, accompanied by a pious king and other laymen, confront the infidel. The miniature offers a graphic representation of the Berengaudus exegesis in which the angel signifies the preachers who are to come at the end of the world and stand in the sun, by which we are to understand Christ, because the holy preachers will be so solidly rooted in Christ that they cannot be torn from the faith by any persecution.[120]

Hostility to the Crusades developed in many quarters. Citing St. Paul's distinction between the two Jerusalems, monastic critics claimed aspiration to the heavenly rather than the earthly city.[121] In the twelfth century, Peter the Venerable reminded Hugh of Chalons that "if it is good to visit Jerusalem where the feet of the Lord had stood, it is far better to long for heaven where he can be seen face to face."[122] Although the friars had become the papacy's principal agents for preaching the cross, the fullest criticisms

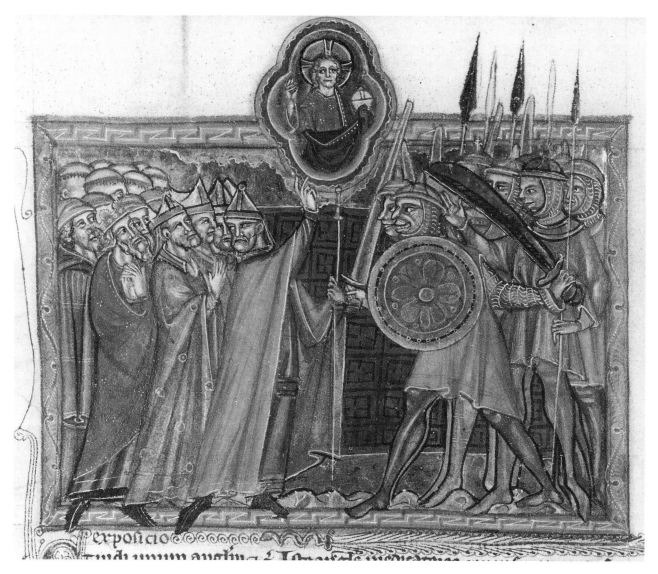

Figure 181. Apocalypse. Lisbon, Calouste Gulbenkian Museum MS L.A.139, fol. 65v. Commentary Illustration for Rev. 19:17 (photo: The Conway Library, Courtauld Institute of Art, London).

flowed from a memoir composed by Humbert of Romans, who had been minister general of the Dominican Order from 1254 to 1263.[123] Thirteenth-century critics blamed the failure of the Crusades on human iniquity.[124] Among the episcopal spokesmen, Roger Niger attributed the collapse of the Second Crusade to divine judgment on men's transgressions and advised those who planned the Third Crusade to make a spiritual pilgrimage to the heavenly Jerusalem as well as an armed pilgrimage to the earthly city.[125] From the 1240s through the 60s, the English Church

and its clergy openly resisted papal taxation for the Crusades.[126]

Among the most widely read anticrusading works of the period was a commentary on Jeremiah written in the 1240s by a follower of Joachim of Fiore.[127] Harshly critical of the papal promotion of further Crusades, the pseudo-Joachite author of the *Super Hieremiam* argued that Christ himself was opposed to the restoration of Jerusalem and that the Crusades ran contrary to divine plan. The popes should concentrate on the welfare of their own Jerusalem, the

Church, and cease exhausting Christendom with hopeless wars against the Saracens.[128] The pseudo-Joachist polemic attacks the crusading idea for reasons that are apocalyptic, arguing that the peace and unity of the Church will be achieved eventually, not by warfare, but by conversion of the Muslims, pagans, and Jews and the healing of the schism between the Greek and Latin Churches that will occur after the last terrible persecution by Antichrist prophesied for the year 1260.[129]

Other, less strident voices, such as that of William of Tripoli, a Dominican friar living in Acre, whose tract, *De statu Saracenorum*, written ca. 1270, also registered disapproval of the Crusades in the belief that the conversion of Islam could be better accomplished without military weapons.[130] Jerusalem, he argued, had been recovered by the excommunicated Emperor Frederick II without holy warfare, but the saintly Louis IX, whose zeal for the conversion of the Saracens relied wholly on the sword, suffered disastrous defeat.[131] In the second half of the century, there was a growing conviction among the mendicants that preaching and conversion by peaceful missions should entirely supplant efforts toward military conquest.[132] In England, two distinguished Franciscans, Adam Marsh and Roger Bacon, became eloquent partisans of the missionary alternative of conversion through preaching. Although Adam Marsh commended the Crusade to Henry III in 1250, he stressed the value of missionary work that should attend the military expedition, because it was by preaching that Christianity was first spread.[133] The priority of missionary preaching over military expeditions emerges clearly in the *Bible moralisée*, where the capture of Jerusalem is accomplished by *predicatores* as well as by armed knights, pitted against the biblical enemies of Israel now designated as *sarraceni* or *mohammeri*.[134] In 1268, Roger Bacon asserted that the Crusades were hurtful to Christianity because they hindered conversion, at the same time reinforcing his contention by arguing the pressing need for intensive preaching efforts, because the advent of Antichrist was imminent.[135]

Despite such expressions of doubt and despair, the Crusades still retained more than a vestige of popular appeal in England. Notwithstanding all the crusading opportunities throughout Europe and the Mediterranean, the English consistently expressed a marked preference for the Holy Land.[136] Resonances

of Edward I's resumption of the struggle in 1270 can be seen in the Douce Apocalypse (see fig. 19) as well as in the Trinity Apocalypse, probably commissioned by his young wife, Eleanor of Castile, before she accompanied her husband on Crusade.[137] In the latter manuscript, the unprecedented inclusion of a richly garbed woman wielding a sword as she joins several tonsured clerics in an attack against the seven-headed beast can probably be read as a pictorial expression of Eleanor's crusading resolve.[138] In contrast with other cycles that present heaped corpses of unarmed victims as a *fait accompli*, Trinity stands alone with Morgan in characterizing the saints as warriors battling the beast with sword and lance. Another allusion to royal participation in the same expedition might be seen in Douce's illustration of the Sixth Vial (fig. 131), where the three "kings from the east" appear in response to the Berengaudus commentary that interprets them as the "multitude of people who have faith in Christ," a meaning made graphically explicit by the figure at the right who gestures upward toward the sun, explicated in the gloss as a harbinger of Christ's advent.[139] During his long reign, Henry III took three, albeit unfulfilled, crusading vows, including one in 1250 and another in 1271.[140]

Direct pictorial references to the Crusades among thirteenth-century Apocalypse manuscripts were, however, relatively infrequent. One of the most striking examples can be seen in Metz's distinctive revision of the archetypal representation of the Second Horseman (fig. 44), where the rider has cast off his customary Old Testament garb and is decked out in full mail armor and an emblazoned surcoat. The new equestrian knight swings the sword back and extends his open hand forward in a gesture of command, as if signaling the start of battle, reflecting the text of 6:4 to the effect that the second rider was empowered to instigate war, thus transforming the figure into a contemporary crusader. However, the rarity of such direct references to a lingering crusading spirit in the Gothic Apocalypse cycles constitutes the reality of thirteenth-century attitudes. In 1246, Henry III issued a royal charter changing his intended burial site from the New Temple to Westminster Abbey, thus shifting his allegiance from the Crusaders' cause represented by the Templars' church to an exclusive spiritual investment in an English shrine to emblematize his aspiration to personal salvation.[141] A wide-

spread disillusionment in the elusive and remote spiritual goals of the Crusades is voiced by the "objector" in the crusading song, *La Desputizons dou Croisie et Descroisie*, written by the French poet Rutebeuf in 1268–9:

Am I to leave my wife and children, all my goods and inheritance, to go and conquer a foreign land which will give me nothing in return? I can worship God just as well in Paris as in Jerusalem. One doesn't have to cross the sea to get to Paradise. . . . God is everywhere: to you he may only be in Jerusalem, but to me he is here in France.[142]

In a similar but more optimistic spirit, the new feast and procession of Corpus Christi, formally inaugurated by Urban IV in 1264 *(Transiturus de hoc mundo)* proclaimed that Jerusalem was to be found in every town in the West.[143] So, too, the heavenly Jerusalem was present in every church. As churches began to acquire icons and relics imported from Byzantium in the wake of the thirteenth-century Crusades, an even more concrete realization was being achieved through the cultivation of authentic images and visual documents of that lost world.[144] The symbolism of the physical church as an image of the celestial city described in the Book of Revelation· is given in the dedication rite compiled by Bishop Richard Poore (d. 1237) for Salisbury and widely adopted in English cathedrals throughout the thirteenth century, where one of the versicles for the consecration procession is based on 21:2–5: "Urbs nova Ierusalem descendens spiritualem attulit ornatum lucis ab arce datum."[145] The allegorical and ideological meaning of the new Jerusalem in relationship to the Church in both its physical and corporate manifestations is made clear by William Durandus (ca. 1230–96), one of the principal medieval canonists and a legal official of the Roman Curia, in the first book of his *Rationale divinorum officiorum*. The heavenly Jerusalem signifies the Church Triumphant, "our future home."[146]

Already in the twelfth century, Jerusalem had become an image-object for individual meditation rather than collective ambition, following the dictum of Augustine: "If you wish to be armed against temptations in the world, let the desire for the eternal Jerusalem grow and flourish in your hearts."[147] Even in the age of Crusades, there is a shift away from cosmic expectations to personal piety, longing, and individual eschatology. Jerusalem is each soul striving for the "vision of eternal peace in the presence of God."[148] The apocalyptic image of the heavenly Jerusalem coming down from heaven has been supplanted by the upward struggle of the soul to the new Jerusalem. Saluted from afar in the most famous of all Jerusalem hymns, attributed to Abelard, the exile longs for home:

Now in the meanwhile, with hearts raised on high,
We for that country must yearn and must sigh,
Seeking Jerusalem, dear native land,
Through our long exile on Babylon's strand.[149]

In a sense, the thirteenth-century illustrated Apocalypse can be experienced as a spiritual Crusade or pilgrimage whose goal is no longer the lost earthly Jerusalem, but the new celestial city beyond time and the reach of human endeavor. Although the magnificent Gothic cathedrals of the thirteenth century had acquired important apocalyptic connotations, the heavenly Jerusalem is not represented as a church structure in contemporary illustrated Apocalypses. Instead, the celestial vision of Rev. 21:2–27 retains its corporate integrity as a walled city (see fig. 159) in accordance with the spiritual significance of its meaning as the Church given by Durandus:

The word church has two meanings: the one, a material building, in which the divine offices are celebrated: the other a spiritual fabric, which is the collection of the faithful. . . . Sometimes [the Church] is called a city, because of the communion of its holy citizens, being defended by the weapons of the Scriptures.[150]

It is also a vision of the apocalyptic Jerusalem that has supplanted the lost ancient city as the spiritual goal of the Gothic age. Although Metz's illustration (fig. 165) is more faithful to the text, a chasm separates John and the angel from their celestial goal, stressing its remoteness and inaccessibility. In Trinity (fig. 166), however, Jerusalem is laid out as a flat square diagram, surrounded on four sides by concentric circuits of walls and twelve gates, to conform to the traditional configuration given in contemporary maps and itineraries, like those of Matthew Paris,[151] perhaps still clinging to the fading idea of the actual journey, but nevertheless reinforcing the idea of the illustrated Apocalypse as a spiritual crusade beyond time.

VISIONS OF THE END

The thirteenth century was one of apocalyptic expectation. A new sense of urgency created an important turning point in medieval eschatology. Based on a fundamental conviction that time is related to eternity, that human history has a discernible structure and meaning in relation to its end, and that the end of time is determined by divine plan, visions of the end left their mark on major figures and events throughout the century. As Bernard McGinn points out, such beliefs are incapable of rational demonstration and can only be revealed or manifested in symbolic or dramatic form.[152] Signals of the impending finale were perceived in the momentous struggle between Frederick II and the popes, the drastic need for Church reform, the failure of the Crusades and the eventual loss of Jerusalem, and the devastating Mongol invasions of Eastern Europe. In the mid-twelfth century, the end of the world was a remote expectation in most people's minds; a century later, most felt that the end was close at hand.[153]

Although the English Gothic Apocalypses seem surprisingly restrained in light of such pervasive intense feeling, the new illustrations introduced to conclude their cycles rivet attention on eschatological expectations. The last illustrated text segment begins, "And he said to me, 'Do not seal the prophecies in this book, for the time is at hand,' " accompanied by a representation of John kneeling before the Lord.[154] Whereas the twelfth-century Berengaudus commentary passes over 22:10 ("the time is at hand"), in silence, the French prose gloss twice refers to "this century" *(ceste siecle)* in its explication of Rev. 22:10–15.[155] However, both glosses are equivocal or noncommittal in their interpretation of other key passages. In his exegesis on 1:3 ("The time is close at hand"), Berengaudus advises that time is relative[156] and vaguely explains 22:20 as referring to a "time in the future after the resurrection when all the saints will reign with Christ without end."[157] Similarly, the French prose gloss explicates the latter passage by quoting Mark 13:32–3: "But as for that day or hour, nobody knows it, neither the angels in heaven, nor the Son; no one but the Father. Be on your guard, stay awake, because you never know when the time will come."[158]

Matthew Paris gives compelling testimony to the general wave of apprehension that overtook Europe in the thirteenth century. In the margins of his *Chronica majora*, he added a sketch of the Nativity to mark the inauguration of the sixth age, accompanied by the quotation of verses signaling its end in 1250:[159]

> When twice six hundred years and fifty more
> Are gone since blessed Mary's son was born,
> Then Antichrist shall come full of the devil.[160]

Their prophetic import had a profound impact on Matthew's overall plan for the *Chronica majora*. At one point, he decided to end the work with the annal for that year and concluded his chronicle with a summary of the prodigious events of the last half-century, all portending the end of the sixth and last age of the world, which had begun with the Incarnation of Christ. Although he was to take up writing the great chronicle a few years later, presumably after his eschatological expectations had failed to materialize, and continued making entries to the end of his life in 1259, the resounding finality with which he invested his concluding assessment in 1250 leaves little doubt that Matthew felt compelled by some overriding portentous belief that his life's work was then at an end. He concludes by saying

> Matthew's chronicle here ends,
> And the Jubilee Year sends
> Repose down from the skies;
> May repose to him be given,
> Here on earth and in heaven,
> When he there shall rise.
> . . .
> Matthew, here your toils are over,
> Stop your pen and labor no more:
> Seek not what the future brings;
> Another age has other things.[161]

Like Matthew Paris, many leading figures of his century subscribed in one way or another to the general expectation of the world's imminent end, whether it would be in 1250, 1260, 1290, or 1305. In 1227 and again in 1249, Frederick II wrote, "Perhaps we have reached the end of time," a belief shared by his arch adversary, Pope Gregory IX.[162] An aura of apocalyptic speculation surrounded the meteoric career of the Hohenstaufen emperor, who was believed in some circles to be the Antichrist whose

prophesied death in 1260 would usher in a new apocalyptic era of glory for the Church.[163] While Gregory IX characterized the emperor as the beast that rose up from the sea (Rev. 13:1–2) to persecute the Church, Frederick in turn characterized the pope as the great dragon of Rev. 12, "who leads the world astray," and a later contemporary Dominican supporter of the emperor saw Antichrist in the person of his successor, Innocent IV.[164] Eschatological speculations continued to be expressed to the end of the century by such diverse figures as Roger Bacon, Thomas Aquinas, and Dante.[165]

The pictorial and ideological ramifications of such pervasive eschatological conjectures sometimes occur in unexpected and obscure places within the English Gothic Apocalypse, as in a singular historiated initial in the Getty manuscript. The body of a fallen eagle with the initial "E" (fig. 182) perhaps offers a link not only to the representation of the Defeat of the Beast within the frame, but also to the aura of apocalyptic speculation that surrounded the momentous contemporary events outside the book. The imperial eagle with splayed claws can be recognized as the unmistakable emblem of the charismatic but fallen Frederick II (d. 1250).[166] Because visual logic would dictate that eagle's spread wings should normally form the horizontal bar of the letter "E," in which case it could perhaps be recognized as St. John's symbol, there can be no doubt that the eagle image has been "troped" in the Getty initial to signify one of the text's "kings of the earth" toward which its turned body points. The titanic Church–State struggle between papacy and emperor was waged on one level by a barrage of abusive epithets.[167] Among the most explicit invocations of apocalyptic rhetoric was Gregory IX's characterization of the Hohenstaufen emperor as the beast who rose from the sea to persecute the Church. Following the pope's second excommunication of Frederick II in 1239, he issued a letter entitled *Ascendit de mari bestia* to the Archbishop of Canterbury in which he declared "the beast filled with the names of blasphemy has risen up from the sea . . . this beast is Frederick called emperor."[168] When the Getty Apocalypse was produced in the 1260s, the savage vendetta against the last of the Hohenstaufen rulers continued with prophecies concerning Manfred and hopes for the emergence of a third Frederick, among which was a tract entitled *Veniet aquila*: "An eagle with one head . . . will

come."[169] Within the framed miniature in the Getty manuscript, John stands over the toppled imperial emblem as guarantor of the ultimate triumphant outcome of the struggle. Hence, the fallen Hohenstaufen eagle embedded within Getty's initial for the text "Et vidi bestiam" can be seen to invoke a contemporary eschatological interpretation of the Battle against the Beast, represented in the framed miniature above, as the ongoing struggle of the Church against the imperial ambitions of the thirteenth-century German emperors.

The chief agent in bringing about this new wave of apocalypticism was the Calabrian abbot Joachim of Fiore (d. 1202), who saw menacing dangers closing in on the Church from within and without, as the world moved into its last age and the stage was set for the coming of Antichrist.[170] In their obsessive interest in the structure of history, sense of present crisis, and hopes of vindication for the just, Joachim's prophecies proved to be a potent force in thirteenth-century apocalypticism. His interpretations of Scripture turned apocalyptic speculation to focus upon the imminent advent of Antichrist whose defeat would usher in a new and last age of the world in which a renewed Church would reign victorious over the forces of evil to the end of time. As reported by Roger of Howden, Joachim discussed his ideas with Richard I in a celebrated interview held in 1090–1 at Messina, in which the Calabrian abbot expounded John's vision of the dragon with seven heads as seven kings, beginning with Herod and ending with Antichrist, who had already been born but had not yet come to power.[171] Ralph Coggeshall's account in the *Chronicon Anglicanum* provides evidence of the extent to which Joachim's interpretation of the Apocalypse was already known in England ca. 1198.[172] It appears likely that his ideas were circulating in England by 1213, because a Joachist discourse on the theme of pagan and heretical hordes believed to be massing in the far regions against the Church appears at the end of a manuscript containing the works and letters of Peter of Blois; although similar to the account given by Coggeshall, this tract sets the date for the defeat of Antichrist at 1260.[173] Joachim's own exegetical works were probably fairly well known in England. Shortly before Robert Grosseteste died in 1253, Adam Marsh sent him what may have been a small anthology ("libellus de variis expositionibus") of Joachim's works.[174] By the 1240s, Joachim's influ-

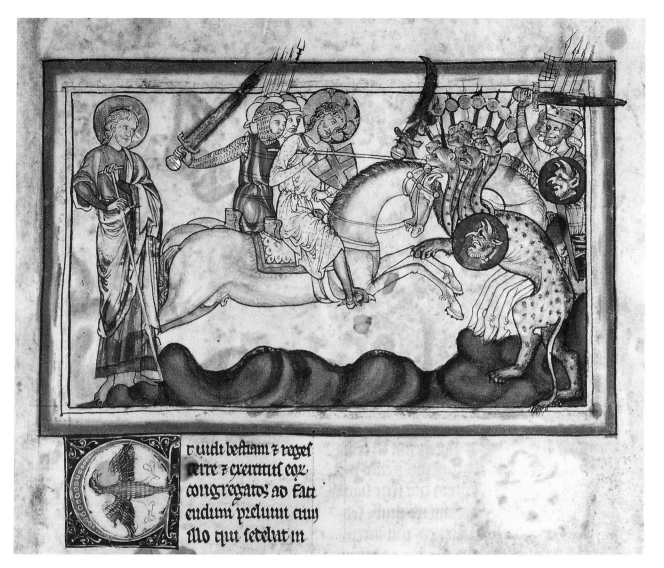

Figure 182. Apocalypse. Malibu, J. Paul Getty Museum MS Ludwig III.1, fol. 41. Battle against the Beast; Historiated Initial: Fallen Eagle (photo: Collection of the J. Paul Getty Museum, Malibu, California).

ence had become widely pervasive. Despite repeated attacks and condemnations of Joachim and his followers, a growing body of prophetic writings focusing on a date for the transition to the new age in the year 1260 had spread throughout Europe.[175]

We must now ask what effect Joachism had upon the formation of the thirteenth-century illustrated Apocalypse. It has been argued that the representation of the Eternal Gospel as a scroll rather than as a codex (see fig. 116) reveals that the Berengaudus cycles were conceived as a conservative rejection of the Joachist interpretation in the work of Gerard of Borgo San Donnino, the *Liber introductorius in Evangelium Aeternum*, discredited in the scandal of 1254 and condemned by the Commission of Anagni in 1256.[176] However, the scroll inscribed with the text of 14:7 ("Timete Dominum et date illi honorem") not only conforms to an early pictorial formula going back to the ninth century, it also responds directly to the Berengaudus commentary that focuses on the efforts of Christ's disciples to combat the evils and persecutions of Antichrist by

preaching the fear of God.[177] The pointed hats and veiled bearded men who figure prominently among those "sedentibus super terram" in manuscripts like Metz and Eton 177 identify those who reject the Gospels with the Jews, thus continuing the anti-Judaic thread that runs throughout the Berengaudus commentary and its illustrations. The adoption of the traditional scroll inscribed "Timete Dominum" was probably not inspired by a reaction to the Joachist controversy of 1254–6, but instead directs a new focus on the imminent advent of Antichrist, as well as a decision by the compiler and designer to bring the image of the Eternal Gospel into line with the dire pronouncements of the Fall of Babylon and the Doom of the Beast Worshipers.[178]

Although the illustration for the First Resurrection is also based on an older iconographic tradition,[179] a more plausible case might be made for seeing the image as a rejection of Joachist ideas about the nature of a future kingdom of Christ on earth. In a representation that offers a disturbingly comfortless prospect for the blessed who share in the thousand-year reign of Christ, the composition is dominated by enthroned judges divided into opposing groups as if representing sides in a debate. In Metz (fig. 157), a judge at the right enumerates the points of his argument on the fingers of his raised hand, and his opponent gestures toward the resurrected souls of the martyrs below. In Add. 35166 (fig. 158), the first resurrection fails to materialize at all, as three enthroned judges with raised swords watch grimly over the still-sleeping dead. As has been suggested earlier, the illustrations can be seen to allude to the contemporary condemnation in 1254–6 of the views of Gerard of Borgo San Donnino and the revival of the old Augustinian conception of the ages of the world in which men were then already living in the sixth and last earthly age before the final judgment.[180] Augustine saw the thousand-year kingdom of Christ in Rev. 20:1–6 as a metaphorical figure for the life of the Church in the present.[181] In contrast with twelfth-century exegesis on the first resurrection as a joyous age of saints when the Jews would be converted and the Church reformed to a state of apostolic perfection,[182] Berengaudus adheres to the more conservative Augustinian view, defining it simply as the time from Christ's Passion to the end of the world.[183] In this context, the disputation among the judges over the status of those raised at the first resurrection in

the thirteenth-century English illustrations for 20:4–6 could plausibly have been intended to alert the reader to the Augustinian, anti-Joachist view espoused in the Berengaudus commentary.

It is already clear that the eschatological concerns of the thirteenth century were largely focused on the imminent advent of Antichrist. More than a dozen copies of a French translation of Adso's letter, *De ortu et tempore Antichristi*, on which most of the Antichrist legends are based, date from the thirteenth century.[184] Anglo–Norman poems on Antichrist are also documented from the same period, of which one was composed by an English Templar named Henry d'Arci.[185] In his commentary on the two witnesses of the Apocalypse (Rev. 11), Martin of León (d. 1221) introduced a long excursus on Antichrist taken from Adso, which concludes with a warning to all the faithful that they will see the appearance of Antichrist.[186] In his address to the papal curia in 1250, Robert Grosseteste declared that the corrupt state of the Church, if left uncorrected, would foreshadow the appearance of Antichrist and the end of the world.[187] However, as Southern astutely points out, although Grosseteste was clearly influenced by the apocalyptic expectations aroused by the prophecies of Joachim of Fiore, his warnings of catastrophe were not driven by convictions of the inevitability of a divine plan, but were based instead on reflections about contemporary conditions and evidence of the contamination of spiritual affairs by secular ambition throughout Christendom.[188] In Grosseteste's eyes, the advent of Antichrist was linked in a direct causal relationship with the corruption of the Church and could be averted by ecclesiastical reform. His letter of 1252 to Innocent IV protesting the appointment of the pope's nephew to a canonry at Lincoln raises the specter of Antichrist as the adversary of Church reform and enemy of pastoral care.[189] More than a decade later, Roger Bacon echoed his sentiments in a letter to the pope in 1266–7, when he advised

If only the Church would examine the prophecies of the Bible, the sayings of the saints, the sentences of the Sibyl and other pagan prophets... it would without doubt be able to provide usefully against the coming of Antichrist. For it is a great question whence he will arise and who he will be.... For not all prophecies are irrevocable and many things are said by the prophets about the coming of Antichrist which will come to pass only through the negligence of Christians. They could be changed if Christians

would strenuously inquire when he will come, and seek all knowledge which he will use when he comes.[190]

While responding to the eschatological expectations that were circulating widely in Europe in the middle years of the century, the English illustrated Apocalypses of the 1250s and 60s were addressed just as much to preventing the advent of Antichrist through Church reform as to sounding the alarm of its dire possibilities.

Under the spell of the expectation of Antichrist, the designer of Morgan 524 interpolated a series of miniatures representing the antimessianic legend into the cycle of pictures for Rev. 11 (see figs. 70 and 78)[191]; in the Gulbenkian and Abingdon Apocalypses, similar Antichrist scenes were incorporated into the illustrations of the preaching, death, and resurrection of the two witnesses. Based on a model similar to the late twelfth-century cycle in the *Hortus Deliciarum*, the dramatic appearances of the tyrannical ruler and blasphemous magician in human guise transform vague apprehensions of his future advent into a more pressing and immediate threat. However, the new cycles of illustration designed for Morgan and Gulbenkian as well as those for Metz and Getty provide pictorial vehicles for a traditional and doctrinal exegesis untouched by historical prophecies linked to specific dates or events. The images for 11:3–7 in Metz and Getty respond directly to the Berengaudus commentary.[192] Breaking with earlier medieval Apocalypse cycles, the miracles of the witnesses are graphically represented for the first time (see figs. 73 and 74) to assert that the Holy Spirit speaks through the fire from their mouths to destroy the errors of Antichrist,[193] and the witnesses are characterized as ascetic desert preachers to evoke the exegetical parallel drawn between their roles as harbingers of the Second Coming and that of John the Baptist as the precursor of Christ's first Advent.[194]

In a similar vein, the unprecedented expansion of illustrations for 13:1–10 continues to develop the idea of Antichrist's reign of terror and deception, breaking verses to accommodate portentous glosses from the Berengaudus commentary. The emergence of the beast from the sea is isolated (fig. 98) in an illustration for 13:1–2 (to "os leonis") to reveal a bestial Antichrist whose seven heads symbolize the principal vices enumerated by Prudentius[195]; the next two verses (beginning "Et dedit illi draco") portray Antichrist's corruption of power (figs. 100 and 101)

as the dragon bestows his authority upon the beast.[196] In the almost identical but reversed compositions illustrating the Worship of the Dragon and the Worship of the Beast in Morgan (figs. 101 and 102), the devil and Antichrist appear as interchangeable personae from the commentary, and in Getty (fig. 104), the latter scene stresses Antichrist's blasphemy in denying that Christ is God.[197] In the last illustration of the War of the Beast against the Saints (figs. 105 and 107), the faithful are reassured that the saints will never succumb to Antichrist and his false doctrine, for he can overcome them only by killing them.[198] In Metz and Morgan, the battle is over and all the saints but one have been massacred in an image that offers a graphic recapitulation of the death of the witnesses in Rev. 11 (see fig. 77).

Because the Jews had been traditionally labeled as followers of Antichrist, the presumed imminence of the final battle between his satanic forces and the Christian faithful added further fuel to the fire of anti-Judaism.[199] In the Gulbenkian Apocalypse, Antichrist and his Jewish followers dominate the text and commentary illustrations for Rev. 13. Following a text illustration showing Jews worshiping the dragon and the beast, for example, Antichrist's conversion of the Jews (fig. 183) is represented to accompany the Berengaudus gloss on 13:4 ("And they adored the dragon"):

They do not see that the dragon whom they worship is the devil. But those who are designated by the earth [the Jews] adore Antichrist, and in Antichrist the devil, declaring none comparable to Antichrist, nor equal to him in his power.[200]

Dressed in a fashionably elegant *surcote* and wearing a pointed crown, Antichrist sits cross-legged on a faldstool, holding an oversized upright sword in one hand and in the other a scroll inscribed "I am the Son of God and none other except me." A grotesquely bloated dwarf sits at his feet, and a demon flies in from the left to complete the identification of Antichrist with the Devil in the Berengaudus gloss. The coercive power of the evil ruler is represented by helmeted soldiers in short tunics and mail who stand before the worshipers at the right. Most thirteenth-century Apocalypse illustrations show a variety of converts being led to worship Antichrist, including kings, bishops, and priests, in addition to Jews wearing pointed hats, but throughout the Gulbenkian se-

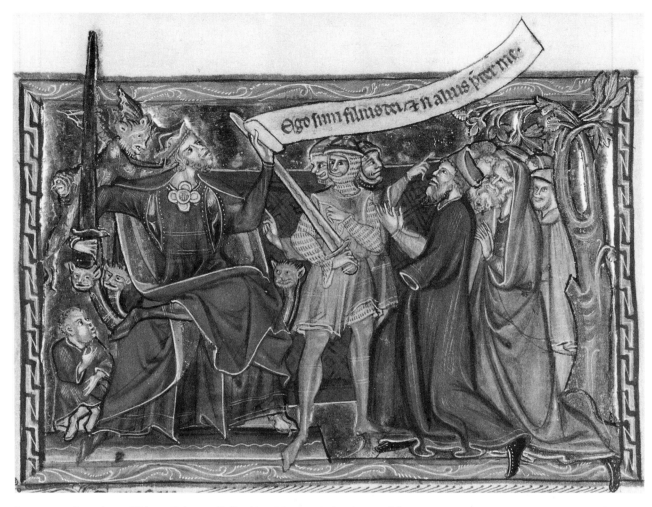

Figure 183. Apocalypse. Lisbon, Calouste Gulbenkian Museum MS L.A.139, fol. 35v. Commentary Illustration for Rev. 13:4 (photo: The Conway Library, Courtauld Institute of Art, London).

quence of illustrations for Rev. 13, the worshipers of the dragon and the beasts, as well as Antichrist and his followers, are portrayed exclusively as Jews.[201]

No longer stressed as apostate, heretic, or pagan, Antichrist is perceived in the thirteenth century as the last and greatest opponent of Christ and the Church in the days before Judgment. In the Gulbenkian Apocalypse (fig. 184), an ugly caricatured Antichrist, with his usual attributes of pointed crown, upright sword, and demon at his ear, stands at the left unfurling a scroll on which is inscribed his blasphemy, "Christ is not God"; in contradiction of Antichrist's claim, Christ appears at the right as God the Creator, holding the sun and moon. In an image that anticipates the sentiments of the Franciscan Spiritual Peter

Olivi (ca. 1248–98), who called upon the friars to missionize among the Jews in preparation for the imminent final battle between Antichrist and the Church,[202] a mitered bishop kneels within the beleaguered church, guarded by a formidable Franciscan friar. Turning their backs on the friar's warnings, Antichrist's Jewish followers reiterate his blasphemies on their fingers.

A sense of impending crisis caused by the Mongol invasions of eastern Europe in 1236–42 provided a clear and unmistakably strong impetus for the rash of apocalyptic expectations just before midcentury. Matthew Paris's earliest quotation of the Joachist verse in the *Liber additamentorum* follows a description of the ravages in eastern Europe in a letter from

Vienna in 1242 and is preceded by an explanatory statement: "In these times also, on account of the terrible rumors of this kind, verses announcing the coming of Antichrist were spread about."[203] All Europe trembled before the Mongol hordes, who were interpreted as the unleashing of the peoples of Gog and Magog, the dreaded precursors of Antichrist.

Although the illustrations of 20:7–9 in the English illustrated Apocalypse eschew direct associations with the Mongols, the commentary illustration in Gulbenkian (fig. 185) demonstrates how the enchaining of Satan in the form of a winged demon bound within a cave at the left becomes Antichrist com-

manding two Jewish disciples in pointed caps representing Gog and Magog, already seducing "the peoples of the four corners of earth."[204] Although Gog and Magog are not identified as Jews in the Berengaudus text, their Jewish character probably stems from the legend of the Ten Lost Tribes of Israel who became confused in the twelfth century with the apocalyptic peoples of Gog and Magog who would support Antichrist in the final conflict. A terrible and mysterious mythical Jewish horde was believed to be hidden somewhere in the East, awaiting the signal of Antichrist to pour out its annihilating force upon Christendom from its secret mountain retreat within

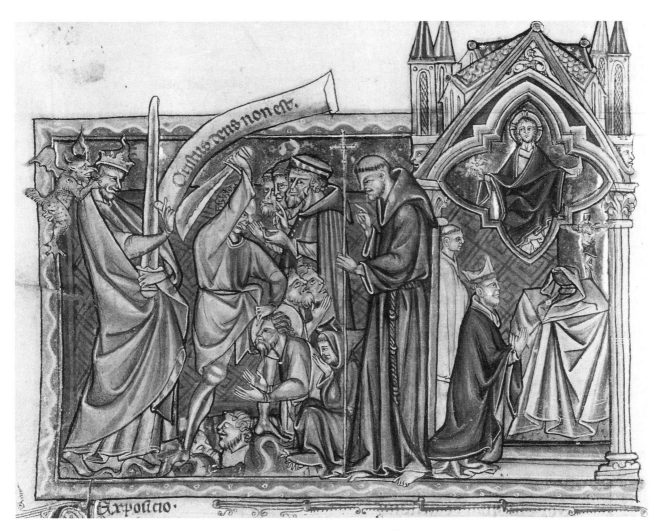

Figure 184. Apocalypse. Lisbon, Calouste Gulbenkian Museum MS L.A.139, fol. 36v. Commentary Illustration for Rev. 13:5 (photo: The Conway Library, Courtauld Institute of Art, London).

the Caspian Mountains.[205] The association of the Jews with Antichrist assumed frightening proportions when it was linked with the Mongol invasions of eastern Europe in the 1240s. Matthew Paris refers to the identification of the Mongols with the Ten Tribes of Israel in the *Chronica majora*[206] and reports a rumor that Jews planned to furnish arms and supplies to the Mongols.[207]

In 1241, the Mongols breached the frontiers of eastern Europe. Although this terrible assault on Christendom remained very distant from England, Matthew Paris gives a fuller account of the Tartar invasions than those provided by most Continental writers of the period.[208] As rumor and panic spread following the devastations of 1240–1, Matthew carefully collected and recorded a remarkable number of eyewitness accounts of the Mongol atrocities.[209] Much of the material apparently came from Benedictine houses on the Continent that had sheltered eastern European refugees.[210] The trail of horror and death left across eastern Europe between 1238 and 1242 quickly demolished the widespread Christian belief that the ferocious Tartars were the legendary people led by Prester John who had come to destroy the Saracens.[211] With impartial savagery, the Mongols slaughtered Christians and Muslims alike, and many Westerners soon became convinced that these were godless pagans who had been loosed upon the world as an apocalyptic punishment for the sins of mankind and a harbinger of the impending end of time.

A people of barbarous race and mode of life called Tartars emerged from the ends of the earth . . . taking forcible possession of the country and remaining for a time, multiplied like locusts, and have now come forth, not without God's foreseen judgment to reproach and chasten his people, but not, I hope, laid up for the total loss of Christendom at the end of time.[212]

The full horror of the Mongol devastation made its visual impact felt in a drawing by Matthew Paris made to accompany a vivid account of their ravages, which he then embellished by adding more sadistic and horrifying details of his own invention:

In consequence of heresy and many other sins among us Christians, the angry Lord has become a hostile devastator and formidable avenger. I say this because a monstrous tribe of inhuman men, whose law is lawlessness, whose wrath is fury, the rod of God's rage, is passing through

and dreadfully ravaging endless lands, killing and exterminating by fire everyone in their way . . . all perished alike by different kinds of death. The Tartar chief with his dinner guests and other cannibals fed upon their carcasses as if they were bread and left nothing but the bones for the vultures.[213]

Like many of the firsthand witnesses to the shocking bestiality and devastations wrought by the Mongol invasions, Matthew Paris and other chroniclers saw the Tartars as the legendary ferocious people, Gog and Magog, who had been locked up by Alexander and who, when unleashed, would bring an end to the world.[214] For Christendom, the Mongols signified the unknown darkness and unspeakable depravity beyond the edges of civilization. In such prophetic works as the *Carmen de invasione Tartarorum*, their savage atrocities sounded the trumpets of the approaching Last Judgment.[215] Paris's illustration is given over to the visual documentation of their purported cannibalism, the most disgusting and horrifying aspect that linked them with the people of Antichrist, Gog and Magog. Based on the prophetic descriptions of Pseudo-Methodius, contemporary reports repeatedly called into evidence Mongol eating habits to support their belief that the Tartars were unleashed as an apocalyptic plague upon mankind: "They eat frogs, dogs, serpents, and all things alike,"[216] or worse, "The men are inhuman and of the nature of beasts, rather to be called monsters than men, thirsting after and drinking blood, tearing and devouring the flesh of dogs and human beings."[217] The Tartar threat suddenly turned a vague eschatological apprehension into an obsessive belief in the imminent end of the world.

As the Mongol terror began to fade, its place was immediately taken by a fierce new tribe called Khorezmians, who suddenly destroyed the fragile peace in the Holy Land achieved only a few years earlier by Richard of Cornwall. In 1244, the Khorezmians attacked Jerusalem and massacred all its Christian inhabitants. Matthew Paris bears witness to the gory massacre with a vivid illustration to accompany his account of the battle.[218] A dark sense of impending doom pervades his reaction to the loss of Jerusalem, and in the margin, he adds an ominous commentary on the apocalyptic signs of the end of the world in Matthew 24:2:

Mark that those threatening words of the Lord are now

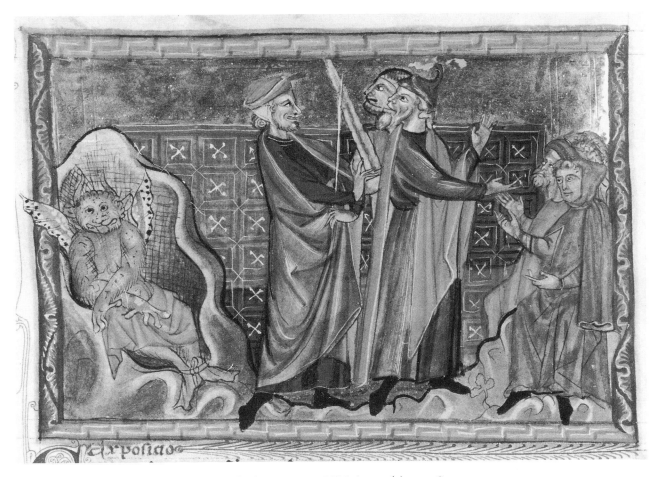

Figure 185. Apocalypse. Lisbon, Calouste Gulbenkian Museum MS L.A.139, fol. 70v. Commentary
Illustration for Rev. 20:7 (photo: The Conway Library, Courtauld Institute of Art, London).

fulfilled, thus indeed as never before in the holy city of Jerusalem. "Not one stone," he said, "shall be left upon another."[219]

While the Gothic cycles of Apocalypse illustrations make no direct reference to such contemporary atrocities portending the end, they are nevertheless pervaded by a new sense of destructive violence in response to the apocalyptic connections made by Matthew Paris and others.

The new thirteenth-century apocalyptic experience can be seen as operating within an ideological construction of western European hegemony locked in battle against the alien Other – against heterodoxy, Judaism, and Islam. As an ideological construction itself, the pictured Apocalypse served as a powerful metaphorical frame within which later me-

dieval Latin Christian identity was collectively defined on the level of allegory. Thus, the medieval reader was initiated to comprehend the allusive prophetic text as mandate for a global strategy of appropriation, a divine command toward a series on interconnected movements – Church reform, anti-Judaism, and the Crusades, calculated to insulate the Christian West from the dangers of internal collapse and heterodoxy, as well as to extend its dominance beyond Europe into the Middle East. At the same time as the individual believer could locate him- or herself within a privileged and powerful cultural collectivity, the illustrated text provided an experience capable of defining and nurturing the private subjectivity of the solitary reader seeking spirituality through an imaginary pilgrimage or sacrament, un-

233 ■

derstanding the meaning of apocalyptic prophecy within the intellectual parameters staked out through the medieval strategies of exegesis and appropriated through the art of memory.

Transactional Experiences Encoded in the Imaged Text

Although an arguably characteristic production of the Gothic age, the English illustrated Apocalypse in at least one sense still belongs to the twelfth-century world of reflections. The Berengaudus commentary provides a spiritual exposition in the old monastic tradition of *lectio divina*, where reading Scripture opened the door to religious experience.[1] A passage from *Ancrene Riwle*, dating from about 1200, admonishes nuns to observe this monastic practice:

Often, dear sisters, you ought to pray less that you may read more. Reading is good prayer. In reading, when the heart feels delight, devotion arises, and that is worth many prayers. St. Jerome said, "Let holy reading be always in thy hand."[2]

Based on the Rule of Benedict, *lectio divina* entailed both reading and meditation, and *meditatio* involved total memorization, inscribing the sacred text in the body and in the soul. In his *Didascalicon*, Hugh of St. Victor further defines the difference between *lectio* and *meditatio* by observing that "the start of learning thus lies in *lectio* [that is, study], but its consummation lies in meditation."[3] By the thirteenth century, the term *lectio divina* tends to disappear from the reader's cultural lexicon and is replaced by *lectio spiritualis* to distinguish devotional practice from academic study.[4]

The illuminated Gothic Apocalypse responds in several striking ways to new conceptions of spiritual life in which the reading of Scripture and biblical exegesis give way to unmediated devotion and prayer. As the new cycles of pictures plot the narrative flow of the visions moment by moment, they offer the reader a concrete visual stimulus to share John's experiences, just as the contemplation of the crucifix served to evoke the Gospel in its literal sense to the friars who in their meditations sought to share the sufferings of Christ.[5] With the formulation of pictorial cycles given over to a complete visual replication of the text, the English Gothic Apocalypse offered the reader a powerful visual experience capable of transforming reading into a devotional meditation in which the soul's memory is nurtured by the inner eye.

By the thirteenth century, spiritual exposition of Scripture alone had ceased to offer a satisfactory outlet for religious feeling. Under the influence of the Aristotelians, who placed new values on what could be known through perception, the senses, especially sight, played an increasingly important role in spiritual understanding and religious experience.[6] The rediscovery of Aristotle's works on natural philosophy in the Oxford schools, particularly among the Franciscans, led to a recognition of sight as the highest of the human senses.[7] As we have already noted, with Grosseteste, the first medieval commentator on the *Posterior Analytics*, the eye becomes the epistemological center of human knowledge, albeit at the lowest, initial level of cognition. Sensory experience provides the raw material from which the intellect

grasps the reality of universals and thus its understanding of God.[8] But the cognitive path between *sensibilia* and *intelligibilia* was more often provided by images in art rather than by those in nature, and visual representation, along with poetic metaphor, was promoted as a means both useful and necessary to the understanding of doctrine by no less a figure than Thomas Aquinas.[9]

Whereas earlier exegetical tradition was built upon the professed superiority of spiritual interpretation, allegory was already fulfilling a new function for some of its late twelfth-century proponents. No longer regarded as learned tracts addressed exclusively to schoolmen, scriptural glosses were read not so much to instruct the mind as to kindle devotion.[10] An important forerunner of the new visual concreteness was Richard of St. Victor (d. 1174), whose works were well known on both sides of the Channel.[11] Although his commentary on the Apocalypse was still cast in the twelfth-century mode of spiritual exegesis, his graphic imagination broke new ground in its vivid focus on concrete images and visual perception. As the most eloquent spokesman of the new literature of contemplation, Richard offers "the first full and systematic interpretation of Revelation as a linear narrative centering upon the quality of John's visions and directed toward the spiritual education of the reader."[12] The experiences of John, the seer, become as central to the narrative as the visions themselves. The exegete of St. Victor insists upon the substance and necessity of John's images, for "sometimes invisible things are shown forth through signs like things perceived by the senses."[13] Richard then explains the significance of John's perception of sensible things in terms that anticipate the Aristotelian view of the thirteenth century: "It was necessary for our weakness, which is able to grasp the highest only through the lowest, the spiritual only through the corporeal, to learn the unknown, not through the more unknown, but through the known."

Most important, Richard of St. Victor, in his apocalyptic concern with a contemplative Church near the end of time, addresses himself to an extension of the Benedictine ideal, serving the lives of religious men and women living near the end of the last age. He offers what Barbara Nolan has called "a phenomenology of personal vision to be experienced by those who await the opening of the seventh seal."[14] In writing for those who aspired to the heights of spiritual vision, he outlined a life to be lived in expectation of vision and promising participation in the divine spirit by means of prayer, virtue, devotion, and meditation. Richard's epistemology was at the same time mystical and practical, as he wrote guidebooks for "those to whom it is given to see face to face, who, contemplating the glory of God when his face is unveiled, see truth without a covering in its simplicity, without a mirror or enigma."[15] In the prologue to his commentary on the Apocalypse, Richard describes how John saw his visions on four levels: On the first, he perceives simple phenomena as he merely opens his eyes to the visible world; then outward appearances suggest greater significance; on the third and fourth levels, his modes of vision are spiritual rather than physical, when John "sees with his heart" to discover the "truth of hidden things" in forms and figures; in the final vision, John sees the glory of God "face to face," divine reality in supernatural contemplation.[16]

The revelatory process of optical perception described by Richard of St. Victor is reiterated throughout the miniatures and glosses of the thirteenth-century illustrated Apocalypse, culminating in the new image introduced at the end of the Berengaudus cycle in which John beholds the Lord in a full and direct vision, unmediated by angels (see figs. 171–4). The seer's last revelation is anticipated in Add. 35166 (fig. 168), where the angel flying down from the clouds to show John the River of Life becomes the Lord leaning out from his celestial frame. He confronts the seer in a literal pictorial evocation of the commentary on 22:1, which reveals the ultimate splendor of John's vision by quoting I Corinthians 13:12: "Now we see a dim reflection in a mirror, but we shall see [him] face to face."[17] In the elaborate series of pictures appended to Lambeth 209, the power of "seeing" provides further impetus to spiritual understanding and moral perfection, ending with a dramatic image of the Holy Face (fig. 229), accompanied by Innocent III's prayer to the Veronica ("ut te tunc facie ad faciem").[18] The English illustrated Apocalypse inspires the thirteenth-century reader to contemplate the prospect of the ultimate vision of God, under the guidance and tutelage of St. John. An analogous experience is evoked in the last illustration of *La Estoire de Seint Ædward le Rei* (fig. 186), where the king, having been admitted to the celestial throne by St. Peter, *janitor coeli* and patron

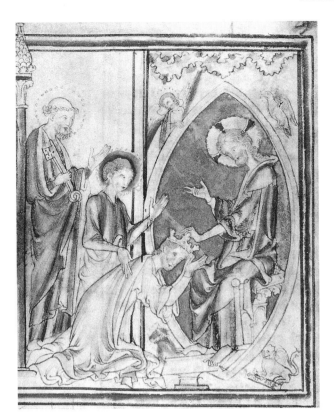

Figure 186. *La Estoire de Seint Ædward le Rei.* Cambridge University Library MS Ee.3.59, p. 53. King Edward Kneeling before the Lord, accompanied by St. Peter and St. John (detail) (photo: The Syndics of Cambridge University Library).

of the Confessor's church at Westminster, is presented to the Lord by his spiritual mentor and guide.[19] Beyond the oft-quoted Bernardine concessions to a wider audience for whom concrete imagery was an inescapable necessity, images are now endowed not only with legitimacy, but also with the potency to access visionary experience itself.[20]

Nowhere is the linkage between art and inner vision more vividly delineated in the thirteenth-century experience of the illustrated Apocalypse than in the opening folios of Lambeth 209 (figs. 187 and 188). On the verso page facing the image of John sleeping on Patmos, we see a representation of another dream vision. Based on one of the *Miracles of the Virgin* of Gautier de Coinci,[21] a Benedictine monk is painting a statue of the Virgin, who appears suddenly to have come alive; she offers him an apple, perhaps referring to Christ as the fruit of her womb.[22] The legend tells of a devout monk who knelt before an image of the

Virgin long after the other brothers had retired, fervently praying that the Virgin would present her Son to him, "keeping the face of the Virgin Mary in his mind's eye" ("virginis Marie vultum habitumque sibi conformans in mentis suis oculis"). One night, the monk fell asleep, and the Virgin appeared to him in a dream directly inspired by his meditation in front of the image. In the concluding moralization, the monk is praised for having painted for himself *(in animo depingenti)* the picture of the Virgin that he had wanted to see.[23] The representation of the monk painting the statue[24] stands as a pictorial metaphor for an inner vision inspired by art, an image held in the mind's eye through an act of imagination. Based on a psychological model first enunciated by Gregory the Great,[25] the spiritual benefits for prayer and devotion provided by images painted in the imagination were promoted from time to time throughout the Middle Ages.[26] In Lambeth 209, the juxtaposition of the monk's vision with John sleeping on Patmos is particularly revealing to the reader, for it promises visual access to the invisible through art as well as miracles and visionary prophecy. For the owner of the book, Eleanor de Quincy, the ecstatic perceptions of a visionary saint and devout monk could thus be appropriated to a laywoman's private devotion (see fig. 217).

In the mystical theology of Richard of St. Victor, as in the *Celestial Hierarchies* of Pseudo-Dionysius the Areopagite, on which his ideas were modeled and which were newly translated with a commentary by Robert Grosseteste, metaphors of vision like vision itself, whether represented in art or experienced in life, provided a means through which the contemplative might be brought to a realization of the divine presence. In this way, the illustrated Apocalypse could serve as Richard's symbol or *collectio* of *visibilia* to enable the reader to share John's visions on a perceptual level and lead the eye, intellect, heart, and soul to experience and understand on a spiritual plane. John thus assumes unprecedented importance in the new cycles of Apocalypse illustrations, acting as intermediary between the events of his visions and his readers, guiding their responses by his example.[27] Clearly designed as a book of devotion, sometimes additionally equipped with the pictorial apparatus of spiritual encyclopedias, the text, gloss, and images of the English Apocalypse direct its readers to meditation.[28] The Berengaudus commentary, as well as the

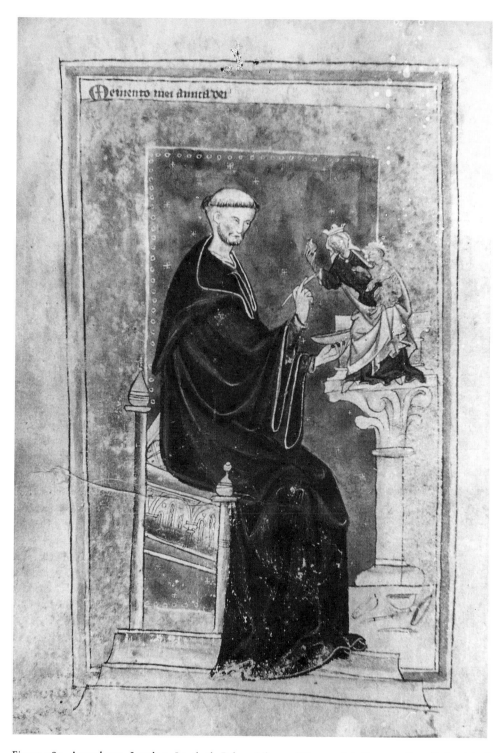

Figure 187. Apocalypse. London, Lambeth Palace Library MS 209, fol. ii verso. Benedictine Monk Painting a Statue of the Virgin and Child (photo: The Conway Library, Courtauld Institute of Art, London).

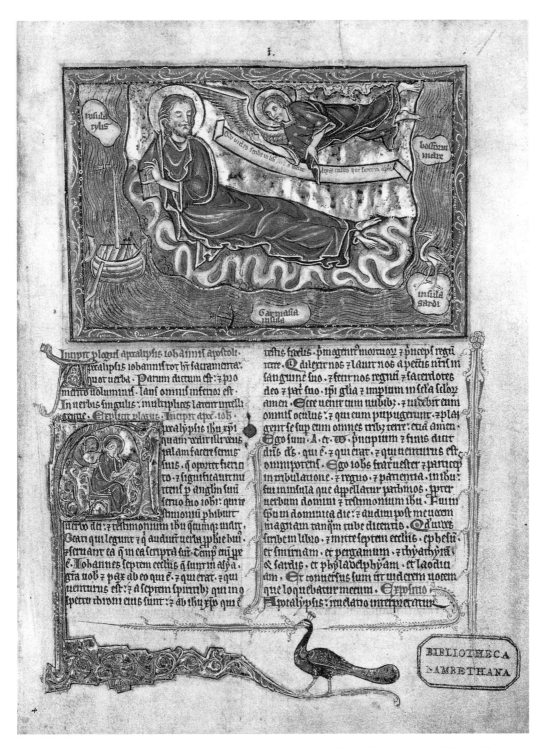

Figure 188. Apocalypse. London, Lambeth Palace Library MS 209, fol. 1. John on Patmos (photo: The Conway Library, Courtauld Institute of Art, London).

French prose gloss, intensified the reading of the Apocalypse as a linear narrative pertinent to the spiritual lives of thirteenth-century men and women. The glosses place the reader in that "patch of darkness" between the present and the end of time, where the righteous are already being tested by the coming power of Antichrist.

At the end of the commentary in the Trinity Apocalypse, Berengaudus prays that he and his readers may join God's army in spiritual combat both now and in the fullness of time:

Give us the weapons of the virtues to protect us, so that with Him as leader and flag bearer, we might be defended from the outer and inner enemies, so that we might deserve to be partakers of everlasting life.[29]

The rallying cry at the end of the gloss suddenly turns the reader from contemplation to action, following Langton's view that "the word of the Lord must be turned into deed, we must act upon what we have read or heard [or seen]."[30] Like the mystical theology of Richard of St. Victor, the English illustrated Apocalypse has one foot in the old Augustinian world of mirrors and reflections in its allegorical exegesis, as the other is venturing into the later medieval world of personal vision and religious activism, seeking the unveiling of the eye, heart, and mind through the reading of words and the contemplation of images.

Despite its firm grounding in monastic Latin *lectio*, the illustrated Berengaudus-glossed Apocalypse quickly gained an increasingly attentive audience among lay readers. Just as the illuminated Psalter was adopted as a private prayer book by aristocratic men and women in the Gothic period, the *Apocalypsis depictus* similarly served the spiritual needs of lay piety from the second half of the thirteenth century to the end of the Middle Ages. In a strategy that can be described as a lay appropriation of what had been an exclusively clerical access to God, an exact imitation of clerical forms of piety is undertaken to ensure individual salvation.[31] An interior life of contemplation was still reserved to a small elite class among the laity, but mechanisms for the cultivation of the spiritual self were now available outside the monastery or priesthood. By the early thirteenth century, Jacques de Vitry could vigorously assert that

In my judgment it is not only those who renounce the

world and go into religion who are *regulares*, but all the faithful of Christ who serve under the Gospel's rule and live by the orders of the single greatest Abbot or Father of all.[32]

In a similar vein, the contemporary *Ancrene Riwle* declares that its interior rule is not reserved for those who belong to a religious order, "but is part of what God commands; therefore it remains always the same, without change, and all are bound to follow it always and unchangingly."[33] The central mechanism for the cultivation of the spiritual self was of course reading. Already in the twelfth century, Hugh of St. Victor asks the reader to expose him- or herself to the light emanating from the page, so that by the light of wisdom, the self can be discovered in the "mirror of parchment."[34]

Although documentation is sparse, the few Apocalypse manuscripts bearing evidence of their thirteenth-century ownership or use suggest that patronage tended to be fairly equally divided among clerical and lay owners. Thus, although the partially erased inscription in the Cambrai Apocalypse reveals ownership by an abbey, and a manuscript containing the same Latin glossed text and cycle of illustrations was made sometime between 1264 and 1267 for the countess of Winchester, as witnessed by a portrait bearing her coat of arms in Lambeth 209 (fig. 217).[35] Heraldic evidence links the unillustrated French Apocalypse prefacing Douce 180 to Edward I (see fig. 19) and suggests that the illustrated Latin version that follows was also produced for a royal patron; the Trinity Apocalypse was probably produced for Eleanor of Castile sometime between 1265 and 1270.[36] An erased inscription confirms that Giles de Bridport, Bishop of Salisbury, gave an illustrated Apocalypse (Add. 42555) to Abingdon Abbey between 1258 and 1263.[37] Lambeth 434 and Eton 177 were both owned by nunneries,[38] and the fragmentary and unfinished French metrical Apocalypse in Cambridge, Fitzwilliam MS McClean 123, may have belonged originally to the convent at Nuneaton.[39] Evidence for the fourteenth century reveals similar patterns of readership. However, all the Apocalypses made for lay owners are now provided with vernacular texts, whereas those destined for clerical readers remain in Latin.[40] By the fifteenth century, the list of known patrons is dominated by very powerful laymen and women: Amadeus VIII of Savoy, Charles the Bold of Burgundy, Margaret of York, and the

Duc de Berry.[41] With the singular exception of the Savoyard Apocalypse in the Escorial, the fifteenth-century aristocratic productions contain vernacular texts, but the Berengaudus commentary is still very much alive in translation.

Although the evidence provided by surviving manuscripts is far from conclusive, the patterns of patronage and ownership that can be plotted over almost three centuries suggest that the Gothic illustrated Apocalypse was probably created initially for the use of clerics but was quickly adopted by highly privileged lay readers. In the preponderantly Latin texts of the thirteenth century, the inclusion of commentaries that give a strongly ecclesiological interpretation of Revelation, stressing the struggle and eventual triumph of the Church over heresy, laxity, and materialism, tends to confirm that the English cycles were first conceived for a clerical readership.[42] On the other hand, despite the inclusion of glosses, the illustrated Apocalypses were clearly not intended for theological instruction. As Michael Camille points out, an emerging group of lay readers were willing to use and understand Latin, as the Psalter became the private prayer book of wealthy men and women in the thirteenth century.[43] We must keep in mind that since the thirteenth century, reading was culturally defined as a competence reserved to the clergy and to those taught by them. The *vita clericorum* became the ideal *forma laicorum*, but it was a model by which they were inevitably demoted into a category of *illiterati* to be instructed and thus controlled by clerics.[44] The appearance of prefatory picture cycles and more elaborate visual cues at the Psalm divisions can be linked to the increasing engagement of *illiterati* (those not literate in Latin) in reading. Illustrations very probably aided those who could not read Latin to learn.[45] Although the strict alignment of pictures above the text columns might suggest that the illustrated Apocalypse could also have served as a Latin primer for lay readers, this usage does not account for lavishly illustrated vernacular versions such as Trinity for owners who can be safely presumed literate in Anglo–Norman. The Gothic illustrated Apocalypse appears to have been created for cultivated rather than professional readers both in and out of the Church, and for those whose Latin as well as Anglo–Norman literacy was directed into channels of devotion and piety rather than learning or recreation.[46] The apparent inter-

changeability of language appears no longer to reflect restricted or specialized usage or readership, but rather to have been tailored to the wishes and needs of the patron. In the case of the Abingdon Apocalypse commissioned by Giles de Bridport either for his own use or for that of the Benedictine abbey to whom he gave it, the text is in Latin, but the Berengaudus commentaries have been translated into Anglo–Norman.[47] The Gothic Apocalypse thus constitutes a new discourse of devotional practice that spans a broad social front; developments that might be characterized as concessions to a lay audience can also be documented in the clerical sphere.[48] As John Fleming aptly characterized the phenomenon, the thirteenth century was less a period in which religion became popular than one in which the popular became religious.[49]

Within the larger context of technologies for cultivating the self that emerged in the thirteenth century, the newly imaged Apocalypse created visual and visionary experiences that constitute a discourse of subjective perception and inner vision that lies at the core of the later medieval constellation of values we can associate with the ideology of individualism. Centering on the personal and private rather than the communal and public, the question now posed to the reader-viewer is no longer how to become dead to the world but alive to the possibilities of using human desires, memories, and experiences to spiritual advantage.[50] Just as the early thirteenth-century *Ancrene Riwle* recycles older monastic ideals into a new moral theology, the Gothic Apocalypse transforms the traditionally self-negating solitary life into a highly self-conscious journey through human experience. It was not without an acute awareness of the Apocalypse's self-reflexive image of itself as a "little book" (Rev. 10) that Augustine called his treatise on the religious life not a rule but a *libellus*, a little book in which he urged his readers to look at themselves "as in a mirror."[51] Following on the heels of such explorations of "inwit" or personal conscience as in the *Ancrene Riwle*, the Gothic Apocalypse joins the complementary practice of the "new" sacrament of confession promulgated after Lateran IV, which demanded of every Christian the frequent examination of conscience and its dependence upon an image of an accessible and merciful God.[52] Central to the concept of frequent confession was the relatively new belief that the internal and highly subjective acts of

the penitent are as important in the reassessment and realignment of individual spiritual goals as any official and external act of the priest or the Church.[53] As we shall see in the last chapter, the Gothic Apocalypse is but a part of a sweeping transformation of cultural discourse, a paradigmatic shift from public to private in which the function of power is expanded to constitute the self through the institutional control of psychosomatic processes.

THE THIRTEENTH-CENTURY APOCALYPSE AND THE ART OF MEMORY

In no other illuminated medieval book are the text and pictures so strictly synchronized to the degree of duplication or redundancy as in the thirteenth-century Apocalypse.[54] In Fr. 403, for example, the first illustration (fig. 189) is corrected from the Morgan model (see fig. 11) to conform to a new text division at Rev. 1:12 by turning John awkwardly around because the first line beneath the illustration reads: "Et ge me returnai" ("And I turned around").[55] In the normal reading process, whether for theological instruction, entertainment, or personal meditation, text and picture in such close visual proximity would constitute two mutually incompatible codes vying for the reader's attention and comprehension of meaning.[56] In seeking to find pictorial equivalents for subtle verbal ideas, as Camille rightly suggests, the artist does not evoke the descriptive surface of the text but attempts to encode significant elements of the narrative, on the principle of Barthes' "iconic syntagm," where a single textual detail that can be appropriated for the visual image is selected and made to function as the mnemonic trigger for its complete ingestion.[57] However, the conflict between the discursive text and figural gesture of recognition is a modern one that, once made, becomes immediately redundant again. The text-image conflict finds a more appropriate and compelling resolution in the medieval experience of the art of memory as memory was understood and cultivated in the thirteenth and fourteenth centuries.

In the medieval Augustinian sense, "memory" denotes far more than its modern psychological meaning, for it is applied to everything believed to be present to the soul.[58] As Frances Yates set forth almost a quarter century ago, the medieval idea of artificial memory rests largely on the brief description and rules set down in the fifth century from the classical legacy of rhetoric in Martianus Capella's *Rhetorica ad Herennium*:

For as what is written is fixed by the letters on the wax, so what is consigned to memory is impressed on the places [of memory], as on wax or on a page; and the remembrance of things is held by images as though they were letters.[59]

However, as Mary Carruthers more recently argues, the earliest medieval *artes memorativae* belong to the thirteenth century.[60] Memory again became an art, as opposed to an elementary skill, ca. 1230–40, when the art of memory was given its crucial intellectual impetus by the translation into Latin of Aristotle's *De anima* and its related writings, including the work on memory and recollection. Indeed, in their commentaries on Aristotle's *De memoria* both Albertus Magnus and Thomas Aquinas commended the memory section of *Ad Herennium* as the prime example of the practical application of Aristotle's general precepts on memory.[61]

Attested by large numbers of surviving manuscripts, mostly dating from the twelfth through the fourteenth centuries,[62] the popularity of the Ciceronian work ascribed to "Tullius" can be attributed to two interdependent ideological factors that become most apparent in the works of the great scholastics. The medieval transformation of the classical art of memory can be linked to the thirteenth-century appropriation of Aristotelian teachings on the primacy of sense perception as well as to emerging patterns of individual responsibility for piety and morality. The conflicting polarities of the material world and spiritual salvation are brought together and resolved in images serving the art of memory.

For both Albertus Magnus and Thomas Aquinas, the concept of memory rested on the fundamental epistemological position in Aristotle's *De memoria et reminiscentia* that recollection involved the seeing of internal pictures that are implanted upon the memory.[63] In the oft-quoted terms of Aquinas, "Man cannot understand without images [*phantasmata*]; the image is a similitude of a corporeal thing, but understanding is of universals that are to be abstracted from the particular."[64] Memory was supplied by the imagination, the image-making faculty of the mind and the sensitive part of the soul that is imprinted

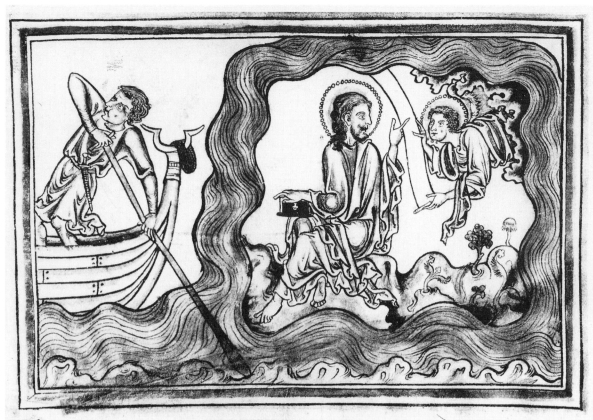

Et ge me returnai por uer la uoiz qui parla a moy: & ui fet chandelabres de or 7 en

Par les cheueus: la fagegent de religiun. Cil fut blanc: p femtete de nette bone uie come laine

Figure 189. Apocalypse. Paris, Bibliothèque Nationale MS fr. 403, fol. 3v. John on Patmos (Phot. Bibl. Nat. Paris).

with sense impressions. Memory is thus bound to the intense particularities of the sensible world.[65] As Aquinas advised his readers,

We remember less easily those things which are of subtle and spiritual import; and we remember more easily those things which are gross and sensible. And if we wish to remember intelligible notions more easily, we should link them with some kind of phantasms, as Tullius teaches us in his Rhetoric.[66]

However, artificial memory is further and most importantly understood not simply as a concession to human ignorance, but as a corrective to moral weakness. Although the moral interpretation of artificial memory was probably already in place, its shift from the realm of rhetoric to ethics was canonized in the

thirteenth-century scholastic system that treated memory as a part of Prudence. In *De Bono*, Albertus Magnus writes that

The *ars memorandi* pertains to the moral life. Since the act of human life consists in particulars, it is necessary that it should be in the soul through corporeal images; it will not stay in the memory save in such images.[67]

Even though Roger Bacon was more interested in the psychological and physiological aspects of memory, in the *Opus maius*, he too ascribed a moral dimension to what he called the *virtus memorativa*.[68]

Through vernacular translations of the memory section of *Ad Herennium*, such as the *Trattato della memoria artificiale* made by Bono Giamboni, the art of memory, fostered and recommended by the friars,

243 ∎

began to appear as a lay devotional discipline in the thirteenth century. As Yates argues, surely Albertus Magnus was addressing laypersons as well as preachers when he concluded that the *ars memorandi* pertained to "the moral man and to the orator."[69] In the Gothic period, several French translations of the immensely popular *Ad Herennium* were illustrated with mnemonic diagrams.[70] Although it was not until the later Middle Ages that handbooks furnished with incongruously conglomerative but exemplary illustrations *(Sacherbilder)*[71] came into widespread use, diagrammatic mnemonic images already appear in thirteenth-century English manuscripts in such representations as the Cherub inscribed with the virtues (fig. 218) and the Allegory of Penitence and Faith (fig. 228) appended to the Lambeth Apocalypse.

Whereas a careful distinction must be maintained between pictorial art and the art of memory, which is an invisible art of the imagination, the cultivation of the art of memory encouraged and inspired the creation of visual images in works of art and literature, and the proliferation of new imagery in the thirteenth and fourteenth centuries can be seen as related to a renewed emphasis on memory.[72] In his *Bestiaires d'amours*, Richard de Fournival (d. 1260) delineates unequivocally the threads connecting the soul, memory, the senses, and the arts:

God . . . has given to man a powerful force of the soul that is called memory. This memory has two doors, sight and hearing, and to each of these doors there is a path by which one can reach them; those paths are painting and speech. Painting serves the eye, speech the ear.[73]

The text illustration represents Lady Memory standing before her castle between two open doors, one revealing an eye, the other an ear.[74] In the art of memory, visual images could serve as potent simulacra, arousing spiritual intentions and at the same time also functioning as genuinely mnemonic devices. As the reader is invited to look at sacred texts with the eyes of memory, the effort to create memorable similitudes encouraged renewed variety and invention in book illustration.

One of the most striking examples of an effort to provide stimuli to both eye and ear can be seen in the Trinity Apocalypse in which the cycle of illustrations is rendered as a sequence of speaking pictures dominated by the charisma of voices. Where the transmission of sound is identified by the mouth and

ear, the miniatures render the spoken word visible as well as audible. As in the representation of the Rejoicing in Heaven (fig. 190), reading is still conceived in terms of hearing and speaking.[75] Heads embodying voices from heaven emerge from the clouds, their utterances ballooning from their mouths into cartoon bubbles, as the reader's gaze is riveted on a dramatic auditory cue given by the frontal staring figure of John pulling back his veil so that he can hear the heavenly voices as well as see the celestial vision. Such insistently literal representations of words on a speech scroll provide the kind of carefully fabricated aural-visual synaesthesia advised by Bono Giamboni when he added to his translation of the memory section of *Ad Herennium* that images should not be mute or silent – they must speak.[76] A similar phenomenon can be observed, albeit on a much smaller scale, in the Douce Apocalypse, where thirteen of its ninety-seven illustrations carry Anglo–Norman inscriptions,[77] thus providing a critical bilingual access to the Latin text.

Conversely, according to Cicero, auditory perceptions are retained best when attached to visual ones.[78] Material presented acoustically is turned into visual form so frequently and persistently in Apocalypse illustration that, even when the subject itself is sound, the phenomenon amounts to a recognizable trope, such as the figures blowing trumpets *(tubarum)* to represent the voices of a huge crowd *(turbarum)* (see fig. 143).[79] In another but related vein, most ancient and medieval memory systems advise attaching to words the appearance, facial expression, and gestures of the person speaking.[80] The Gothic Apocalypse thus renders the narrative as a graphic unfolding of direct discourse in which John registers a wide range of reactions to his own perceptual experiences. As he is literally "bowled over" by the Woman in the Sun fleeing through the frame (fig. 87) or shields his eyes from the brilliance of his vision (fig. 129) in the Getty manuscript, he becomes an ideal speaker, a mnemonic catalyst, who himself creates strong visual images that will fix the impression of his words in the memory.

As we shall see when we enumerate the rules of artificial memory, no biblical text lent itself more admirably to this purpose in the context of private individual devotion than the Apocalypse. Indeed, the Trinity Apocalypse freely paraphrases the Berengaudus commentary itself by advising the reader that "to

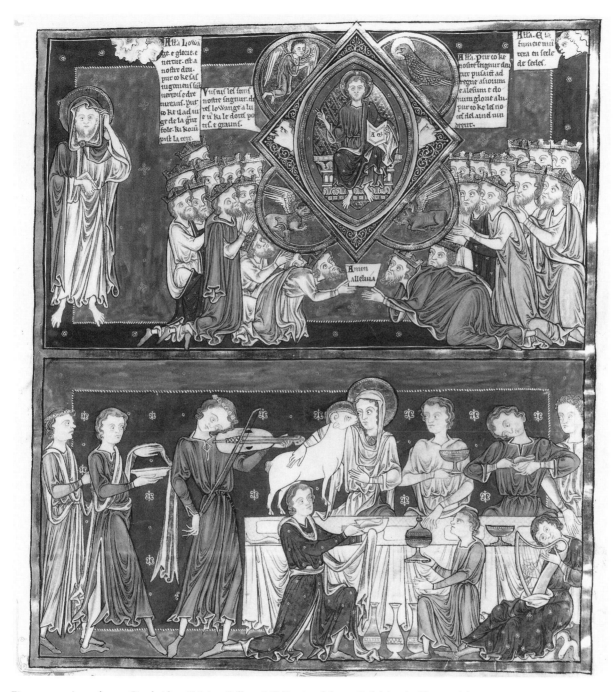

Figure 190. Apocalypse. Cambridge, Trinity College MS R.16.2, fol. 22. Rejoicing in Heaven (photo: The Master and Fellows of Trinity College, Cambridge).

read and hear [God's commands] are of no benefit without remembering [them]."[81] For Richard of St. Victor and Boncompagno da Signa, figurative texts such as the Apocalypse, in their description of visible things for the signification of invisible things, provided the means of bridging the gulf between earthly sense and suprasensible realities.[82]

In the thirteenth and fourteenth centuries, the art of memory becomes central to the experience of reading the illustrated English Apocalypse and can be seen as the controlling principle of its form as artificial memory works on principles of visualization, association, and order. Indeed, Carruthers has argued that as early as the twelfth century, Hugh of St. Victor advised that images of a written text are impressed upon the memory as they appear in the particular codex from which they were first memorized, including their location on the page (recto, verso, top, middle, bottom), the shapes and colors of the letters themselves, and the appearance of each page, including marginalia and illuminations, to make a clear visual image.[83] Because memory, as defined by its medieval exponents, was by nature spatial and visual, the function of text illustration was not duplicative and therefore not redundant. Visual images created an effortless access to the mind's eye of imagination and hence memory. In contrast to modern memorization of lists and words, medieval memories were "vast storehouses of visual images, disposed in structured places, systematized and concrete."[84] Memory does not replace the reading of the text, for what is held in the memory are not words but their moral meaning. In this context, pictures could prove useful even for an individual who must rely on the literacy of others for access to the text, perhaps explaining why aristocratic *illiterati* such as Eleanor de Quincy commissioned Latin versions of the pictured Apocalypse, presumably to be read under the guidance and tutelage of a clerical advisor.

Because "Tullius" would have the reader translate *propria* into metaphors for the purpose of remembering, Albertus Magnus advises that fantastic or farfetched *metaphorica* are to be used as memory images, for the prodigious moves the memory more powerfully than the ordinary. Exciting *imagines agentes* should be chosen because they stir the emotions.[85] To this end, the rich metaphorical language of Revelation becomes an inexhaustible reservoir of evocative words to be transmuted into pictorial im-

ages, which in turn can fire the pious imagination to memory of the moral meanings evoked in its glosses. As Brigitte Cazelles observed, the exegete's choice of explicative verbs *(designatur, demonstrat, significat, figuratur)* establishes a semantic equivalency between thing and word, aligning metaphor with a doctrinal or moral reality.[86] The graphic experience of potent similitudes becomes even more explicit in the juxtaposition of images with inscriptions and legends in Apocalypses such as Morgan 524 or Trinity R.16.2 where "memory for words" is invoked in conjunction with memory images. A parallel case can be cited in Joachim of Fiore's use of *figurae*. Far more than mere illustrations, they function as central embodiments of Joachim's theological thought. Frequently the *figurae* serve to crystallize ideas and do so in ways that Joachim himself acknowledged to be clearer than words.[87] Each wondrous or terrifying figure and object can become a mnemonic trigger for the soul's imagination. The selection of visual details signals the meaning of the text, and the vividness of their orchestration is imprinted on the memory. When Aquinas called for images that caused the emotions to "cleave with affection" to the things remembered, images chosen for their memorable qualities in the classical art of the Roman orator were transmuted by medieval piety into "corporeal simulacra" of "subtle and spiritual intentions."[88] In the same way, the pictorial cycles in the Gothic Apocalypses provide an "affective" dimension to the narrative, causing them to be compared to contemporary romances and, in the vertical hierarchy of the page, to assume a place of dominance over the glossed text where they function as *imagines agentes*. However, it is clearly the moral and doctrinal thrust of the commentaries rather than the textual narrative alone that is intended to be imprinted on the soul through the art of memory.

The Apocalypse is above all allegorical, thus favoring an interior appropriation of its reading experience. The image of John devouring the book from Rev. 10 (figs. 68 and 69) evokes Augustine's oft-quoted metaphorical description of the memory as the "belly of the mind."[89] From Victorinus to Joachim of Fiore, John's ingestion of the book is interpreted as committing it to memory.[90] The Berengaudus interpretation of this passage as "divine Scripture turned in the mind"[91] has been connected with the Augustinian metaphor in a single, albeit dis-

agreeably dyspeptic image by Hugh of St. Victor: "One must often turn [these things] over in the mind and regurgitate from the stomach of one's memory to taste them, lest by long inattention they disappear."[92]

Perhaps the most striking mnemonic component of the Apocalypse beyond visual metaphors is its numerical structure built on sequences of sevens (the Churches of Asia, Seals, Trumpets, and Vials), as well as lesser numerical clusters, such as the four Beasts, twenty-four Elders, and four angels holding the winds, creating an interior textual order that not only facilitates the reader's concentration but triggers artificial memory. Based on a theory of association relating to a serial ordering of things, objects become images, positioned and carefully ordered in space. In the *Summa*, Thomas Aquinas dictates that "it is necessary that a man should place in a considered order those things which he wishes to remember, so that from one remembered [point] progress can easily be made to the next."[93] The sevenfold structure of John's visions offers a ready-made mnemonic order, which the English Apocalypse transforms into sequences of memorable images, thus intensifying the reader's absorption in the art of memory.[94] With equal mnemonic purpose, the designer of the illustrated Apocalypse introduces a new composite representation of the seven Churches (see fig. 29) to coincide with the text, "From John to the seven churches of Asia," which is glossed with a long excursus on the paramount significance of the number seven for the structure of Revelation as a whole, citing its reiteration in the seven churches, the candelabra, stars and lamps, the horns and eyes of the Lamb, the seal, trumpets, thunders, and angels with vials, as well as the dragon and beast having seven heads.[95] In a parallel vein, the newly isolated representation of the triumphal Lamb (see fig. 37) embodies an image of the sevenfold historical structure of the Berengaudus commentary in which the seven horns signify the seven eras of the Church and the elect of the kingdom of God; the hieratic compartmentalized structure of the composition graphically renders the four Beasts and twenty-four Elders as the Church in all its orders.[96] In this connection, it is interesting to note that in the picture-book Apocalypses exemplified by Morgan M.524, full texts abruptly replace abbreviated legends and captions at Rev. 17, coinciding with the end of the last sevenfold

sequences and thus at a point in the narrative where the memory would encounter difficulty for lack of such ordered mnemonic devices.

In complex images, such as those in Rev. 4 and 5 (see, for example, fig. 31), various kinds of enumerated figures, such as the four Beasts and twenty-four Elders, are carefully compartmentalized to maintain their distinction as well as enumeration in the reader's memory. As an extension of their ordered structure, the Gothic Apocalypses divide the text into many more illustrated glossed segments than had been the case in earlier medieval traditions. Although surpassed in this respect by the *Bible moralisée*, the English cycles are occasionally broken into as many as one hundred text illustrations, perhaps responding to the dictum of Martianus Capella: "If the material is lengthy, being divided into parts it may more easily stick [in the memory]."[97] Echoing the advice of Quintilian to "divide the text," Hugh of St. Victor thus considered longer works as a number of short series joined together; as a separate series, a virtually limitless number can be retained in the memory: "We ought, in all that we learn, to gather brief and dependable abstracts to be stored in the little chest *(arca)* of our memory."[98] In turn, the division of the text into increasingly smaller segments of text causes a pictorial repetition of the same protagonists from one illustrated episode to the next, so that such figures as the Woman in the Sun and the Dragon in Rev. 12, for example, become indelibly fixed in the reader's visual memory or imagination, thus imprinting their spiritual meaning on the soul.

The illustrated Apocalypse thus can be seen to function on one important level as an "architectural mnemonic" structured according to the *Rhetorica ad Herennium*. In most thirteenth-century manuscripts, figures are silhouetted against a plain vellum ground, thus ensuring the reader's perception that the images appear "like writing" within the frame. The Lambeth, Gulbenkian, and Trinity Apocalypses, however, impose figures against colored, paneled grounds, thus reifying the Ciceronian metaphor of mental "backgrounds" resembling tablets on which images are inscribed.[99] By alternating the colors of the background panels, the book designer offers the reader an arrangement of images in series that can be more easily fixed in a certain order in the memory.

The memory structure of the Gothic Apocalypse is comprised of several layers, for the art of memory

not only propelled the formation and structure of the picture cycles in the thirteenth-century English Apocalypse, but also influenced its text. In the context of such urgings for brevity to facilitate memory as we encounter in the *Didascalicon* of Hugh of St. Victor,[100] the summaries and paraphrases that appear in the Morgan picture-book recension as well as the abbreviated vernacular texts in Eton 177 and Lambeth 434 can be seen as aides-memoire. Following another strategy, mnemonic versification provides the impulse for the compilation of a number of rhymed versions of the Apocalypse, among which the illustrated French metrical version proved to be immensely popular.[101] William Giffard, who between 1292 and 1302 composed an Anglo-Norman rhymed Apocalypse in octosyllabic couplets for the nuns of Shaftesbury Abbey, advised his readers:

From this you will hear the meaning along with the words. Clearly it will help to place them well into the memory![102]

As a book of private devotions, the new illustrated Apocalypse was designed for silent reading[103] and frequent meditation, following the Aristotelian dictum quoted by Aquinas: "Meditation preserves memory."[104] In some cases, the moralizing dimension of the reader's experience is extended by the addition of picture cycles to aid the pious reader's intense effort to hold in memory the scheme of salvation, the complex network of virtues and vices, and their rewards and punishments, in accordance with the purpose of artificial memory propounded by Aquinas.[105] To this end, the late thirteenth-century French Burckhardt-Wildt Apocalypse is provided with a pictorial prologue that includes mnemonic diagrams of the Trees of Virtues and Vices as well as the Bernardine exegesis on the Song of Songs.[106] The Eton Apocalypse contains a more extensive prefatory cycle comprising ten sets of typologies to accompany the Ten Commandments and Virtues.[107] The series of twenty-eight pages of full-page illustrations that follow the illustrated Apocalypse in Lambeth 209 reveals a similar pattern of devotional intentions for the book.[108]

The illustrated Gothic Apocalypse represents a continuation and development of the new piety promoted among monastic readers by Anselm and Bernard in the twelfth century and extended to laymen and laywomen by the friars in the next. The first illustration in Anselm's *Prayers and Meditations* made ca. 1160 for the Benedictine nuns of Littlemore near Oxford[109] clearly reveals its grounding in the medieval art of memory.[110] A veiled woman kneels before an image of Christ standing within a mandorla frame to evoke the prayer subtitled *Oratio ad Christum cum mens vult eius amore fervere* ("Prayer to Christ, the mind warmed with love for his face"), which opens the collection, containing the words "Ostende mihi faciem tuam . . . Exhibe praesentiam tuam" ("Show me your face. Reveal your presence"). As Pächt astutely observed, this is equivalent to the function assigned to pictorial representation given in a passage from Gregory: "We know that you asked for a picture of the Savior not in order to venerate it like an idol, but, warmed by his love, you want to see his image in order to hold it in your memory."[111] To the same end, the image of John kneeling before the Lord at the end of the thirteenth-century illustrated Apocalypse (see figs. 171–4) provides a self-reflexive paradigm to the reader. Similar images occur in the Gothic Psalter, a sacred text that was committed to memory by clerics and laypersons alike.[112] For example, in an English Psalter from Lacock Abbey dating from ca. 1260 (fig. 191),[113] an Augustinian nun gazes into her open book as the text before her is transformed into an image of the Trinity, imprinting in her memory not the words of Psalm 109 ("The Lord said to my lord: 'Sit at my right hand' "), but its typological meaning of the triune godhead.

In much the same way, the cycles of illustration in the English Apocalypses are designed to imprint the memory with the significance of the text given in the commentary. Although the structuring principles of the art of memory serve as the driving force throughout the cycles, a few examples can demonstrate their use of selection, isolation, repetition, enumeration, and emotional engagement as the pictorial images break from tradition to achieve their new goals. The illustration for the glossed text of 8:3–5 (see fig. 58) unfolds as a cyclical narrative to maintain the hermeneutic function of the angel as a figure of Christ, first censing the altar that represents the Church with incense signifying the Gospels and then pouring a censer that represents the hearts of his disciples filled with the fire of the Holy Spirit over the earth.[114] Severing the traditional alliance between the Fourth Trumpet and the Voice of the Eagle, the image of the baleful messenger of 8:13 is isolated (see fig. 60) to signify Christ and his apostles and to fix

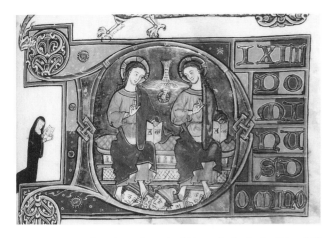

Figure 191. Psalter from Lacock Abbey. Oxford, Bodleian MS Laud. lat. 114, fol. 148. Initial to Psalm 109: The Trinity (photo: The Bodleian Library, Oxford).

in the reader's memory the visual metaphor of the eagle flying through the heavens, as Christ first preached the Gospels in Judea and the apostles then preached to peoples throughout the world; the three woes inscribed on the messenger's scroll signify the persecutions suffered by the Church from heretics, pagans, and Antichrist.[115]

The mnemonic and exegetical direction taken by Gothic designers is most apparent in the new images added to the traditional cycles. For example, in Rev. 12, the designer disrupts the narrative to insert an illustration of the Woman in the Sun being provided with eagle's wings by an angel (see figs. 95 and 97) to fix the reader's attention on the exegete's interpretation of this passage as the Church receiving and accepting the two Testaments.[116] To infuse the image with emotional power, the woman is being equipped with wings as if with protective armor before a battle. With the first appendage already in position, the woman looks back apprehensively at the menacing dragon as she gestures acceptance of the second. When she escapes her pursuer in the next episode, the woman carries a book representing the two Testaments from the commentary. The expanded Gothic sequence of illustrations for Rev. 12 then ends with a new illustration (fig. 98) representing the woman's offspring battling the dragon's seven heads in response to the gloss's exhortation to wage war against the seven cardinal vices.[117]

As the glossed illustrations focus on doctrinal and ethical matters bearing upon the reader's salvation,

the images also consistently stress the spiritual aspect of experiencing and absorbing the meaning of the text. Thus, for example, the text passage for 15:2–5 is isolated from the first verse in a few Apocalypse manuscripts to accommodate a special representation of the harpers plucking their instruments as they stand on the sea of glass mixed with fire (fig. 123), for the musicians signify the spiritual understanding of Scripture, and the lake suffused with fire signifies the mixture of the spiritual and intellectual in divine Scripture.[118] In Morgan, the harpers have been given wings to promote the idea of spirituality stressed in the gloss; in Trinity, where the commentary interprets the harps to signify mortification of the flesh, the musicians, among whom a Franciscan friar figures prominently in the center, are tonsured and wear clerical garb.

The affective power of pictures imprinting the memory with pious ethical principles is nowhere better demonstrated than in the newly configured, horrendous image of Satan cast into the double-headed hell mouth (fig. 160) that stands above a short excerpt from the Berengaudus commentary on 20:9 that reads: "This will be accomplished when our Lord says 'Go ye cursed into the everlasting fire which was prepared for you by the devil and his angels' "(Matt. 25:41). This is followed by 20:10: "And they are tormented day and night in everlasting eternity," glossed with the prayer that would then come to the lips of the devout reader: "From which torment may the mercy of our Redeemer, who lives and reigns with the Father and the Holy Spirit for ever and ever, deliver us."[119]

In contrast, the penultimate miniature in the Gothic Berengaudus cycles (see figs. 169 and 170) follows a very old tradition in its representation of John kneeling at the feet of the angel, but in doing so addresses a potential problem inherent in a book dominated by dramatically absorbing pictures. The illustration offers a graphic demonstration of John's misguided attempt to worship the messenger of his visions, as the commentary reinforces the visual reference to human weakness by admonishing the reader: "As we have so diligently maintained in the text of this book, it is not to be gazed at in vain,"[120] that is, for pleasure or entertainment, or to be turned from its intended purpose. Here the pious reader is reminded that the illustrated glossed Apocalypse offers direct and indirect visual access to John's visions

for the purpose of meditative reading and the "memorization" of their meaning. Beyond its admonitory message, the image of the seer kneeling before the angel, followed by the last representation of John adoring the Lord (see figs. 171–4), invokes a more profound aspect of the thirteenth-century art of memory touched upon, albeit obliquely, by Grosseteste. While conceding that in the conditions of ordinary life, the essence of God as he is in himself is not immediately visible, citing the scriptural dictum of John 1:18 that "No man has seen God at any time," Grosseteste asserts that human nature possesses the capacity for the direct vision of God when the body is no longer a hindrance and the affections are properly ordered, a condition achieved only fleetingly by a few privileged mystics, such as St. John, who live above human nature and share the contemplative capacities of angels: "Their contemplation and activity are a single expression of a simplicity of spiritual life to which our fragility can aspire but never attain in this life," but at the same time "angelic" represents the highest capacity of human nature.[121] Thus, having been inspired by the images on the sacred page, the eye of the mind thus becomes an "interior eye" that can inscribe their salvific messages on the soul's memory.

In the illustrated Apocalypse, the constant reiteration of the author's presence in the figure of John offers the reader not only a personification of the human powers of vision and prophecy, but also of a prodigious memory constantly stimulated by sense perception. We are invited to pass through the looking glass of the narrator's memory into the remembered world of his vision.[122] All the stimuli necessary to the art of memory are supplied down to the requisite dimension of emotional response, as John visibly reacts to his visions with a wide range of affective gestures. John's liminal position outside the frame constitutes another kind of spatial metaphor of temporal distance, as the reader is reminded that the events described in the text are remembered from the author's past experience, the dream vision on Patmos. By the same token, the reader's desire to fix the purport of John's visions within his or her own memory is promoted by the mnemonic power of the images. As prescribed in the *Rhetorica ad Herennium*, the memory is stimulated by images that are intensely charged with emotion.[123] Thus, Getty's marginal portrayal of John visibly reacting to his visions with a wide range of affective gestures thus opens the door to the reader's memory.

In the Getty Apocalypse, the liminal world between vision and text is further inhabited by a unique series of historiated initials in which the interpolated figures extend and expand the kinds of miming signals conveyed by the extramural presences of John.[124] Not only does John serve as a visionary conduit for the reader's perception, but small figures in the initials frequently also mimic the words "Et vidi," or "I saw." Beneath the representation of the Harvest, for example, a figure leans on his staff, cupping his ear and pointing to his eye as he gazes up at the seer witnessing the vision within the frame. Similarly, on fol. 23 when John registers his apprehension on seeing the beast emerge from the sea by protectively wrapping himself more tightly within his mantle, a small figure in the initial below claps his hand to his forehead in a gesture of anguished surprise. Like the large framed miniatures accompanied by St. John visibly reacting to their extraordinary content, many of the historiated initials also engage the reader in interpretive and mnemonic responses to the text.

Functioning on the simplest cognitive level is a category of mnemonic image in which words rather than actions or ideas are literally mimed (*imagines verborum*).[125] On fol. 22v (fig. 192), for example, the historiated initial contains two caricatured profile heads grimacing in anger and turned in opposite directions to cue the reader's memory to the key word "iratus" in the adjacent text. The image has been pulled out of context to denote a generic meaning of "anger" in human discourse quite independently of its reference to the dragon's rage in Rev. 12:17. In a similar instance on fol. 18, two wrestlers struggle against one another, graphically referencing the word "dimidium" in the first line of the text, thus denoting "halved" or "divided" in another, unrelated sense of fight or struggle. The image of the grappling men works at odds with the pair of recumbent dead witnesses within the framed miniature above them, but the contextual rupture with Rev. 11:11 ("After three-and-a-half days God breathed life into them and they stood up") further serves to fix a salient word of the text ("Post diebus tres et *dimidium*") in the reader's memory.

More frequently, the Getty initials constitute rebuslike images that pun visually on certain words or themes in the text, engaging in a mnemonic pictorial

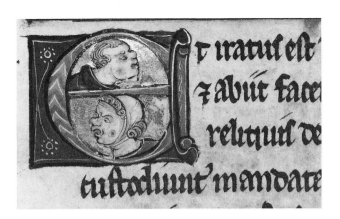

Figure 192. Apocalypse. Malibu, J. Paul Getty Museum MS Ludwig III.1, fol. 22v. Historiated Initial: Grimacing Heads (photo: Collection of the J. Paul Getty Museum, Malibu, California).

strategy similar to that encountered in the Cuerdon Psalter of ca. 1270 in which each psalm has an initial that "pictures" significant words of the text.[126] It is interesting to note that in the case of the Cuerdon Psalter, as perhaps with the Getty Apocalypse as well, a Latin text is apparently intended for memorization by a layreader.[127] Such images are not iconographical, nor do they illustrate or explain the content of a particular text, but instead serve to make each page memorable, reminding the reader that the text contains matter to be committed to memory. A striking instance of the rebuslike punning strategy occurs in the Getty Apocalypse on fol. 10v (fig. 193) where we see a woman pushing and pulling at a man who is protesting and struggling against her, a memorable image not only because the woman literally has the upper hand, but also because the pair appear to have no logical relationship to the adjacent text. However, as the man looks and gestures toward the word "thuribulum" (censer), the reader soon realizes the intended pun, *turbulum*, whose lexical denotation of anger, exasperation, or disturbance is graphically mimed in unexpected and even parodic gendered terms by the figures in the initial.[128]

Sensitivity to the polysemy of words is not only a basic component of the genre of allegory, the medieval reader perceived the pun as a tool of sacred wit. As Walter Ong argued, multidimensional conceits functioned as a normal means of dealing with the mysteries of Christianity.[129] In the most familiar instance of wordplay used for serious effect, Thomas Aquinas turns a verbal conceit to serve as a variant

on one of the paradoxes consequent upon the Incarnation of the Word of God: "Verbum caro panem verum / Vero carnem efficit."[130] In the Getty Apocalypse, puns are similarly used where semantic coincidence penetrates to startling relations in the real order of things to trigger the reader's memory of the text.

In the Getty manuscript, the initials become a kind of "living alphabet," vivid images easily fixed in the reader's memory. Thus, the text dealing with the Eternal Gospel (14:6–7) is introduced by a figure sowing grain (fig. 194) from the Calendar iconography for October in contemporary Psalters.[131] The sower's punning strategy draws the reader's eye to the word "evangelium" (gospel) in the third line of the adjacent text by pictorially miming the word *evagandus* (spreading or scattering). Although such simple mnemonic puns are still readily accessible to the modern reader, some of the pictorial puzzles in the Getty manuscript do not lend themselves to easy solution, and upon recovery seem forced or strained to modern readers unaccustomed to the playful lexical convolutions so frequently encountered in medieval discourse. Such a "difficult" case might be seen in the initial on fol. 21v (fig. 195) in which the medieval reader would have encountered the familiar figure of a man warming himself before a fire from the Calendar representation for the month of February. As the figure pokes the fire and lifts one foot to be warmed, he creates a directional line of action that focuses on the word "persecu-tus," which breaks at that point, alerting the reader to the pun intended by his pointing gestures, because *perscrutus* can denote "poking about." In this oblique but not

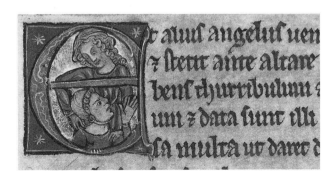

Figure 193. Apocalypse. Malibu, J. Paul Getty Museum MS Ludwig III.1, fol. 10v. Historiated Initial: Man and Woman Struggling (photo: Collection of J. Paul Getty Museum, Malibu, California).

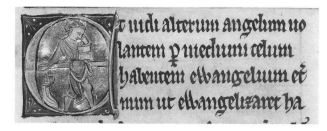

Figure 194. Apocalypse. Malibu, J. Paul Getty Museum MS Ludwig III.1, fol. 27. Historiated Initial: Sower (photo: Collection of the J. Paul Getty Museum, Malibu, California).

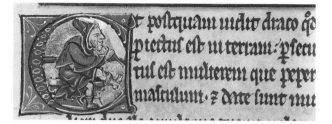

Figure 195. Apocalypse. Malibu, J. Paul Getty Museum MS Ludwig III.1, fol. 21v. Historiated Initial: Man Warming Himself before a Fire (photo: Collection of the J. Paul Getty Museum, Malibu, California).

untypical medieval way, a key word can be fixed in the reader's memory by the image.

Another instance of this type appears to occur in the familiar but contextually enigmatic representation of the Fool holding the club and round bread as identifying attributes on fol. 23v (fig. 196).[132] In the context of Rev. 13:2 in which the dragon hands over his power to the beast, the God-denying Fool from Psalms 13 and 52 seems to make no sense, but serves instead as a rebuslike mnemonic image referencing the word "virtutem" at the end of the first line of text and to which the figure's glance and gestures are directed. By virtue of his bicolored tunic, which is an unusual attribute in the thirteenth century, the Fool's *varietatem*, or varicolored attire, fixes the word *virtutem* in the reader's mind by means of a visual pun.

Our last examples form a related group of figures engaged in shooting arrows on fols. 8v, 12, and 13v (see fig. 197). All are taking aim, that is, *telum conlineare* or *telo petere*. The key word here is *telo* (arrow or missile), which sounds like or rhymes with *celo*. The same text-image configuration occurs in three separate unrelated instances: Rev. 6:14 ("et

celum recessit") on fol. 8v, where a man standing in the left margin aims an arrow at the line in which the word occurs; 8:10 ("et cecidit de celo stella") on fol. 12, where the text is introduced by an historiated initial (fig. 197) in which a boar and hunter converge on the line containing the word "celo"; and 9:1 ("et vidi stellam de celo cecidisse") on fol. 13v, where a hunter aims at an analogous lexical quarry in the adjacent text. Whereas in the last example the particularization of the archer as a crossbowman *(balistarius)* might serve to extend the rebuslike pun to include a reference to "stella" by way of the synonymous "astra," the inclusion of the boar in the image on fol. 12 references a clearer mnemonic target. Thus, in the same way that Hugh of St. Cher's *ursus* was intended to call up *umbra* in the psalm text because the words start with the same initial letter,[133]

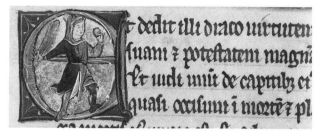

Figure 196. Apocalypse. Malibu, J. Paul Getty Museum MS Ludwig III.1, fol. 23v. Historiated Initial: A Fool (photo: Collection of the J. Paul Getty Museum, Malibu, California).

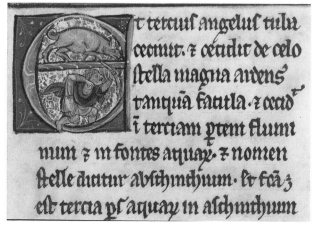

Figure 197. Apocalypse. Malibu, J. Paul Getty Museum MS Ludwig III.1, fol. 12. Historiated Initial: Boar and Archer (photo: Collection of the J. Paul Getty Museum, Malibu, California).

the reader of the Getty Apocalypse might be prompted by the image of the boar to remember "absinthium," a salient word that occurs twice in the text by recalling the image of *aper*.

By virtue not only of its framed miniatures, but also of its historiated initials and marginal figures of St. John, the Getty manuscript offers one of the most revealing glimpses into the medieval charisma of the thirteenth-century English illuminated Apocalypse. It was the act of looking at pictured visions that gave such books their value and power. The manuscript's images served not only as a record of things seen, as well as a present object of sight, but also provided the viewer-reader with optical instructions for the acts of looking, reading, and remembering to be engaged in the perception and absorption of the book. In a sense, the illuminated Apocalypse was perceived and used by medieval readers as an instrument of salvific power. In all its pictorial complexity, the images in the Getty Apocalypse reveal a profound belief in the power of vision as an active principle, a belief in the power of images as embodying more than simple representations of text.

In conjunction with or even apart from its meditative aspects, the Gothic illustrated Apocalypse was also remembered by visually referencing more mundane mnemonic structures in the lower margins of the page. Although the obsessive colonizing of the liminal zones surrounding the text that was to characterize fourteenth-century marginalia had barely begun in England in the 1260s in such isolated early experiments as the Rutland Psalter, the designers of Lambeth 209 and the Abingdon Apocalypse had already begun to explore the periphery of the page to promote the art of memory. As we have already observed, the contemporary Getty Apocalypse exploits a more traditional liminal site by locating mnemonic images within its historiated initials. As the precocious marginal images in the Lambeth and Abingdon manuscripts draw the reader's eye to the outer limits or fringes of the monumentally illustrated written page, they freely gloss, trope, parody, and problematize the text.[134] The lexical world of scriptural revelation becomes memorable through a series of jarring juxtapositions in which John's visions occupy a place of hierarchical domination over a distracting but familiar register filled with migrant beasts, birds, insects, and grotesque hybrids from the medieval Bestiary. Confronted by the matrix of visual signs

comprising the manuscript page, the reader is obliged to consider and explore the gap, antagonism, or "difference" between text and image. By addressing the apparent *aporia* posed by the new visual code introduced in the margins, the reader's anxiety over the absence of meaning and the problem of signifying nothing is resolved by playing a game in which ambiguity and subversion create the text-image encounter that makes not only the text but also its meaning memorable. Although some of the rare marginal images in the thirteenth-century Apocalypse are no longer accessible to the cultural and linguistic comprehension of a modern reader, we can isolate a few obvious and telling instances that can serve to demonstrate how they work.

If we begin with the magnificently plumaged peacock appearing in the bottom margin of the first page in a number of thirteenth-century Apocalypses (see fig. 188), we are initially greeted by a bird whose name and legendary character help fix the illuminated page indelibly in the reader's memory. Just as the name *pavo* can aid in recalling the name "Patmos" through the simple mnemonic device of beginning with the same letter,[135] the derivation of the name given in the Bestiary from the bird's terrible, unexpected cry, striking the listener with fear *(pavor)*,[136] can elicit remembrance of the angel's voice shouting "like a trumpet" behind John on Patmos. Shown in profile with its tail lowered in a fully painted representation resembling its Bestiary "portraits," the apocalyptic peacock could be perceived by the cultivated medieval reader as a symbolic image resonant with meaning appropriate to a prophetic text intended for meditation:

The sapphire color of the breast denotes the desire for heaven in the human mind, the rose color on the wings denotes the love of contemplation. The length of the tail signifies the length of future life. . . . There is a green color on the tail, so that the end might accord with the beginning [that is, its green head]."[137]

As the peacock in the Apocalypse bas-de-page faces left, the bird faces the word "Patmos" two lines above and provides an elegant closure to the gesture of the winged angel in the framed miniature at the top of the page.

A similar strategy of mnemonic signification can be observed in a number of other marginal images in the Abingdon Apocalypse. On fol. 24v, for ex-

ample, an eagle bites at the flourishing pattern beneath the text for Rev. 9:7–12. By virtue of beginning with the same first letter, the eagle *(aquila)* serves to fix the reader's memory on the names *Abaddon* and *Apollon* ascribed in the text to the king of the locusts, the angel of the abyss *(angelum abyssi)*. According to the explanation *in malo* given in the *Aviarium*, "earthly power is symbolized by the word 'eagle.' "[138] As the passage ends with the ominous warning, "that was the first of the woes; there are still two more to come," the predatory bird reminds the reader that the first *Ve* was signaled by the eagle from 8:13 isolated within a framed representation at the top of the page (fig. 60). The butterfly in the bas-de-page on fol. 29 evokes an analogous wordplay in which the *papilio* might attach itself to the gloss's "profeter as poeples," while at the same time evoking another connotation of the Anglo-Norman *pavillon/ paveillon* in the sense of "tent," referring to the temple to be measured in the text (11:1–2). In terms of visual proximity, the butterfly is literally conjoined with the last word of the text, *verge*, and thus might also function as a rebuslike image, fixing the critical text word *verge/virga* (measuring rod) in the reader's memory by virtue of its variegated wings *(virgatus)*.

Among Abingdon's marginalia, several bas-de-page designs comprise pairs of images confronted in relationships of binary opposition. Beneath the commentary on the sixth trumpet, for example, the head of a black man faces a song bird (fig. 198). Living at the edge of the known medieval world, the Ethiopian *(Ethiops)* gazes up at the word *Eufrates* in the fourth line of the text from the bottom. Not only does the image evoke the name on the simplest lexical level, the Ethiopian conjures up a whole world of pagans that Augustine designated as "beyond the river," because they were not yet baptized.[139] Within the context of the commentary on 9:13–16, the association of the river and the black man further evokes the frequently cited episode from Acts 8:26–40 of the conversion of the Ethiopian eunuch, with its attendant lexical reference to "Euphrates."[140] Philip's baptism of the Ethiopian eunuch was seen to mark the beginning of the Christian evangelization of the world at large and consequently provides a visual mnemonic key to one of the central themes of the commentary on the sixth trumpet, namely, the dissemination of the Gospels. Abingdon's striking marginal vignette pairing the Ethiopian with a songbird

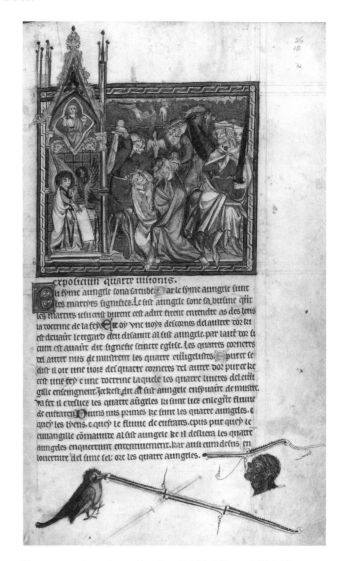

Figure 198. Apocalypse. London, British Library MS Add. 42555, fol. 26. Bas-de-page Illustration: Songbird and Ethiopian Eunuch (photo: The British Library).

further evokes the text's reference to the release of the angels enchained in the Euphrates (9:14). For the thirteenth-century reader, the idea of the black African released from "darkness" through conversion held out a more concrete reality of being released from actual slavery. In the age of the later Crusades, the new religious order of Trinitarians pursued the express mission of ransoming captives (both black and white) being held by the Muslims in North Africa.[141] The Trinitarians arrived in England a few years before the friars, making their first foundation

at Hounslow near London and at Moatenden (Kent) in 1224.[142] As Abingdon's marginal image vaults the reader into his contemporary world, the apocalyptic text is made more immediately compelling and thus even more memorable. The songbird *(avis)* not only alludes to the greeting *(Ave)* disseminated through the spread of the Gospels, enunciating their four messages with one voice *(une voiz)*, as referenced in the commentary, penetrating to the farthest points of the earth, including Ethiopia,[143] it signals the freedom extended to the Ethiopian captive. The sixth trumpet's mandate to release the angels enchained in the Euphrates is thus mnemonically tied to the contemporary antislavery mission of the new Trinitarian Order.

Abingdon's marginal structures of binary opposition can be seen to parallel the medieval construction of story or sermon along the rhetorical lines set forth by Augustine, who argued that God had "embellished the world with antitheses like a splendid poem."

The so-called antitheses are indeed the most beautiful of the embellishments of speech, one could call them in Latin *opposita* or better yet *contraposita*. . . . And just as such a confrontation of opposites makes the beauty of style, so the beauty of the universe is fashioned through confrontations of opposites, in a style which does not deal in words but in things. . . . And so should you consider the works of the Almighty in pairs, the one confronting the other.[144]

The confronted images in the lower margin of fol. 15 (fig. 199) can be seen to stimulate the art of memory in a similar way beneath the commentary on the opening of the fourth seal. By virtue of an association with Ishmaelites, the winged headgear of the caricatured man signals a visual mnemonic reference to the key word "Israel" in the text above: "By the four parts of the earth is signified the whole land of Israel," destined for destruction.[145] The Ishmaelite sticks out his tongue, making a vulgar gesture that registers not only his rejection of the New Testament, but its memorization as well. For his malign presence is offset by the stork that, despite the Bestiary's claim that it has no tongue,[146] "reproves those who do not believe that Christ appeared incarnate, and who do not fear the coming judgment of the Lord."[147] As an ancient harbinger of spring as well as a Christological symbol, the stork can be seen to herald the advent

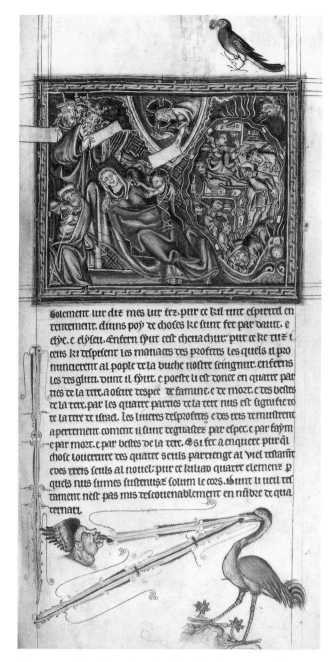

Figure 199. Apocalypse. London, British Library MS Add. 42555, fol. 15. Commentary Illustration: Nativity and Destruction of Israel; Bas-de-page Illustration: Man Wearing Winged Headgear and a Stork (photo: The British Library).

of Christ, pictorially evoked in the Nativity scene within the framed miniature above and in response

to the beginning of the commentary on the opposite verso.[148]

Several among Abingdon's mnemonic marginalia allude to the text more indirectly. Instead of operating on the level of simple word-illustration or shared initial letters, an image such as the large burnished silver fish at the bottom of fol. 46 fastens the reader's memory on the text's explication of the meaning of the Lamb on Mount Sion as Jesus Christ by means of the familiar symbol based on the Greek anagram *ichthys*.[149] Similarly, by a somewhat more circuitous route, the reader's attention is drawn to the word *blasphemias*, which occurs three times in the accompanying text, by a small merman holding a conch to his ear. Presumably, the image would conjure up the Bestiary tale of the Sirens who deceive sailors by their seductive songs and against whom mariners are advised to stop their ears.[150] In a striking extension of the marginal vignette over a whole opening on fols. 80v–81, a barking dog chases a bristling hedgehog onto the next page. Metaphorically exemplifying the vigilant reader, the watchful dog is visibly tethered to the admonitory text, "Blessed is he who guards the prophetic words of this book" (22:6). Characterized in the Bestiary as a treacherous robber, Abingdon's hedgehog is covered with fruit stuck to his spines as evidence of his clever thievery.[151] Now chased onto the next page bearing the commentary on the River of Life, the hedgehog *(ericius/echinus)* acquires another, more literal role in memorializing the words *euwe vive* (living waters) as well as *Ezekiel* from the text above.

That the Abingdon Apocalypse was designed to be ingested within the reader's memory seems to be emphatically announced in the insistent and dramatic repetition of the angel's command to "devour the book" in the framed illustration for Rev. 10 (fig. 200). The entire page is dominated by the outsized scroll that stiffly extends into the left margin behind the great angel who turns his back to the reader as he instructs the seer: "Take the book and eat it." Indeed, the reader must make a critical trope by turning the book in order to decipher the inscription, reminding him that the text is to be "turned in the mind," that is, committed to memory. The angel's command is then repeated within the frame as John takes the book, initiating another turn within the reader's hands and mind.

In contrast, the isolated vignettes drawn in the

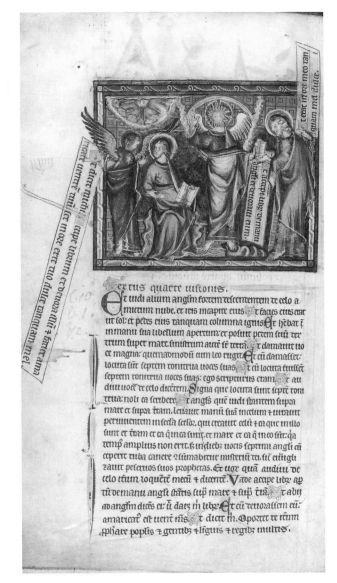

Figure 200. Apocalypse. London, British Library MS Add. 42555, fol. 27v. Angel with the Book (photo: The British Library).

lower margin of two adjacent pages in the closely related Lambeth 209 seem to have engaged the art of memory only as an afterthought. Although seemingly independent of one another, both liminal images make the text memorable by pointedly undermining its meaning.[152] Thus, an ugly and ungainly bristling hedgehog at the bottom of fol. 8 appears to mimic the soft, fleecy Lamb embraced by the Lord in the framed miniature at the top of the page.

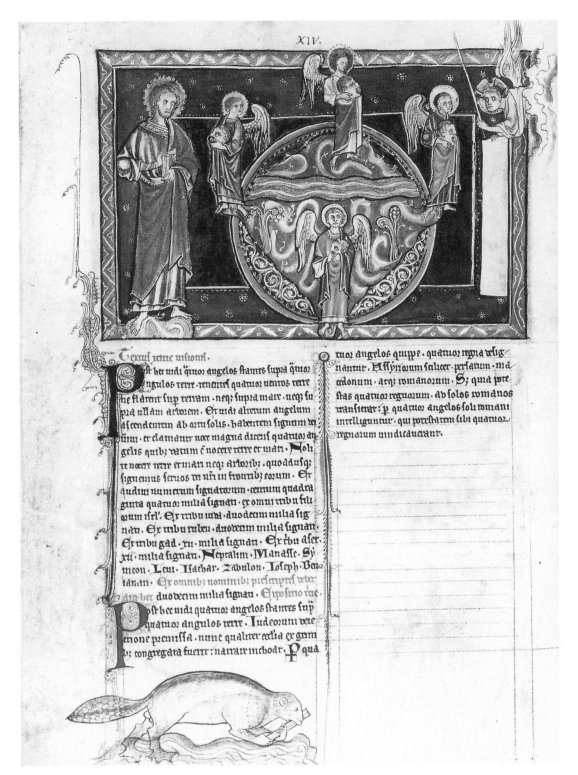

XIV.

Texcus xerce uisionis. Post hec uidi qtuor angelos stantes supra quor
angulos terre tenentes quatuor uentos terre
ne flarent sup terram. neqz supra mare. neqz su
pra ullam arborem. Et uidi alterum angelum
ascendentem ab ortu solis. habentem signum uei
uint. et clamauit uoce magna dicens quatuor an
gelis quibz datum e nocere terre et mari. Noli
te nocere terre et mari neqz arboribz. quoaddusqz
signemus seruos dei nri in frontibz eorum. Et
audiui numerum signatorum. centum quadra
ginta quatuor milia signati. ex omni tribu fili
orum isrl. Ex tribu iuda. duodecim milia sig
nati. Ex tribu ruben. duodecim milia signati.
Ex tribu gad. xii. milia signati. Ex tribu aser.
xii. milia signati. Neptalim. Manasse. Sy
meon. Leui. Isachar. Zabulon. Ioseph. Ben
iamin. Ex omnibz nominibz prescriptis uber
dia bet duodecim milia signati. Expositio uer.
Post hec uidi quatuor angelos stantes sup
quatuor angulos terre. Iudeorum uere
nomine premissa. nunc qualiter ecclia ex gen
t congregata fuerit narrare inchoat. P qua

tuor angelos quippe. quatuor regna relig
nantur. Assyriorum salicet. persarum. ma
cedonum. atqz romanorum. Sz quid pote
stas quatuor regnorum. ad solos romanos
translata: p quatuor angelos soli romani
intelliguntur. qui potestatem sibi quatuor
regnorum uindicauerant.

Figure 201. Apocalypse. London, Lambeth Palace Library MS 209, fol. 7v. Four Winds; Bas-de-page: Beaver (photo: The Conway Library, Courtauld Institute of Art, London).

Shown in profile, striding poses, both animals gaze up at Christ, but the diabolical, dark, untidy, quill-armored hedgehog stands as a subversive antithesis to the celestial, luminous, pure white Lamb. On the facing verso (fig. 201), a large beaver stands in the water at the bottom of the page, destructively gnawing on a tree branch in defiance of the angel's command not to do any damage on the land or at sea or to the trees (7:3). By subverting the efforts of the four angels suppressing the winds at the four corners of the earth, the beaver appears in an unfamiliar role to serve as a memorable antimodel. At the same time, his biting on the hard wood might allude to the difficulty of remembering a particularly indigestible segment of text enumerating the names of the twelve tribes of Israel. In the Abingdon manuscript, the beaver can be seen as a similarly subversive but memorable antimodel in his ubiquitous medieval role appropriated from the Bestiary as the animal hunted for his testicles (fig. 202). At the bottom of the page devoted to the Temple Opened in Heaven and the Woman in the Sun, the tiny beaver offers a troping gesture of self-emasculation to reference the text's *arca testamentum* by drawing the reader's eye to the beaver's *testes* and in so doing further provides a pictorial overturning of *masculum*, which appears four lines directly above the small sketch.

Our last example in the Abingdon Apocalypse draws its mnemonic power from the obvious antagonism or "difference" between the images in the miniature at the top of the page and those in the marginal vignette. Aligned along the right edge of fol.

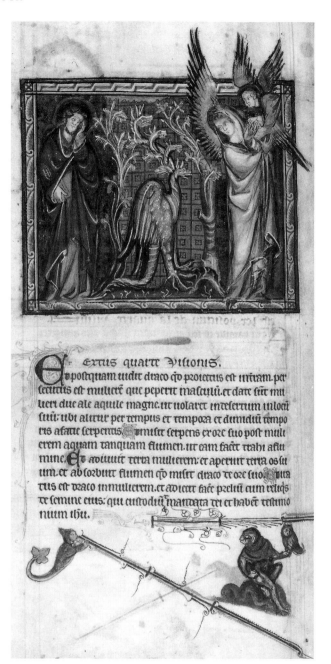

Figure 202. Apocalypse. London, British Library MS Add. 42555, fol. 33v. Bas-de-page Illustration: Beaver Biting Off His Testicles (photo: The British Library).

Figure 203. Apocalypse. London, British Librry MS Add. 42555, fol. 35v. Woman Given Wings; Bas-de-page: Ape with an Owl (photo: The British Library).

35v (see fig. 203) beneath the large framed representation of the woman being given great eagle's wings (12:13–14), an ape holding an owl is seated in the lower margin. Each an outcast in its own domain,

the "benighted" bird of evil omen perches on the fist of the sinful ape in a grotesque parody of the knight with his falcon.[153] Although explicitly set forth only in Hildegard of Bingen's reference, the idea of the ape's envy of bird's flight must have been widely known in the Middle Ages; the simian pursuit of birds forms a recurrent theme from the twelfth century on.[154] As Abingdon's seated and hence earthbound ape mimics the turning gesture of the standing woman now fitted with wings in the framed illustration at the top of the page, his disgruntled stance mocks the frustration of the dragon, whose textual transformation into a *serpens* (from *draco*) robs him of the ability to fly in pursuit of the woman, thus linking him with the *simius* below. The heavy, plumage-laden, inert owl further undermines the ape's aspirations to the buoyant locomotion of the angel poised in flight at the upper right, completing the subversive vignette imaged in the margin, which again tropes the illustrated text to serve the art of memory.

Although the late twentieth-century viewer obviously cannot share the intensely concentrated meditative focus of the medieval devotional reader, the narrative opacities and texual redundancies of the Gothic Apocalypse cycles begin to dissolve when they are seen in their contemporary context of the art of memory. The immense and sudden popularity of illuminated Apocalypses from the mid-thirteenth century to the end of the Middle Ages can be perceived as paradigmatic of an important cultural shift in which books became the major instruments of solitary meditation for cleric and layperson alike, and reading became a private, introspective process of silent perception most closely akin to late twentieth-century strategies of deconstruction.

THE BOOK AS LITURGY AND SACRAMENT

Liturgy is not only what is written in a liturgical book; it also inheres in the visual elements of a ritual space.[155] In the Gothic illustrated Apocalypse, pictures, like those in a Psalter or Book of Hours, create a sacred space, comparable to the way that a relic or consecrated host converts a private chamber into a makeshift oratory.[156] On a broader and more profound level, for the dedication of a new church, John's descriptions of heavenly architecture from

Rev. 21 were traditionally invoked in the rite of sacralizing a new space of worship: "I saw the holy city, the new Jerusalem, descending from heaven, prepared by God."[157] As John's Apocalypse presents its message to the reader within a liturgical context, his narrative describing the coming eschatological drama evokes not only sacred space, but sacred time. His visions came on the Lord's day (1:10), that is, *in sacro tempore*. He experienced revelation at a time when he was spiritually partaking in the Sunday worship of a congregation from whom he was physically absent. In the words of one liturgical scholar, "Through the Spirit he was enabled to pierce the surface of human ordinances which had formed Christian worship, and to discover the divine purpose and heavenly realities lying behind them."[158] Thus, cultic time is the proper time both for receiving visions and reading them.[159] As explained by Clifford Flanigan, rather than confronting a dichotomy between past and future in the Apocalypse, the reader experiences a "liturgical sense of time, in which past and present seem inextricably mixed, so that what is expected in the future is experienced in the present celebration of the cult."[160] In the Apocalypse, ritual celebration is not only oriented toward the future, it is the actual experience of that future.

Although the text of Revelation was seldom used for the medieval lessons in the eucharistic celebration or in the Divine Office, ritual plays a uniquely pervasive role in John's Apocalypse narrative, as his vision of what is to come is identical to what is happening at the present moment in a heavenly liturgy. Indeed, one of the chief concerns of the book is to describe the ritual actions of a heavenly liturgy.[161] Thus, the narrative flow of the Gothic picture cycle is periodically stopped by the insertion of liturgical set pieces in which John invites the reader to become a spectator if not a participant in the recitation of doxologies and hymns as well as ritual actions. Doubly evoked in word and image, their epideictic rhetoric of praise and ceremony thus marks not only a moment of special intensity in sacred time, but also a zone of absolute reality, the symbol of an invisible center.[162]

The first and most dramatic revelation of the heavenly liturgy unfolds in the illustrations for Rev. 4–5.[163] Introduced by the door opened in heaven and an angelic invitation to "Come up and see what will come in the future," the intoning of the triple *Sanctus*

by the four Beasts is visualized as a bilaterally symmetrical framed image of the Lord in Majesty enthroned and worshiped by the twenty-four Elders (fig. 204): "Holy, holy, holy is the Lord God, the Almighty; he who was, who is, and who is to come." Whereas the Berengaudus commentary stresses that John's vision constitutes a momentary glimpse into a ritual of perpetual celestial prayers and the celebration of masses without cease (sine intermissione),[164] the preface ("Vere dignum") that appears in mass books of the Roman rite from the late Middle Ages prays that "we," the contemporary celebrants of the rite, be allowed to attend the heavenly liturgy.[165] That the Sanctus holds out the possibility that each worshiper can become like John and "come up" into heaven to participate in the celestial ritual is echoed by the thirteenth-century liturgist William Durandus: "Here we sing the hymn of the angels because we have no doubt that through this sacrifice [the mass] earthly things are joined together with heavenly things."[166]

In the medieval liturgy, the Sanctus was frequently elaborated by a jubilant musical setting and performance, thus perhaps explaining the inclusion of a variety of musical instruments held by the small seated Elders in the lateral compartments of the English Gothic illustration accompanying the text for 4:1–8 (fig. 204), although no textual reference to them is made until 5:8.[167] Indeed, Jungmann has suggested that the use of musical instruments as well as the thirteenth-century custom of ringing bells during the singing of the Sanctus was also meant to evoke the idea of the celebration of a heavenly liturgy rather than the approach of the awesome consecration and elevation.[168] As Flanigan points out, one of the tropes for this part of the liturgy in the famous Winchester Troper directly engages present participants in the liturgical rite encoded in the Apocalypse:

> We, rising with you,
> We, now sitting with you in heaven as a sharer of the
> riches of the Kingdom,
> We, therefore, ask that when you come as judge to
> determine the merits of everyone,
> That you join us with the saints and angels,
> With whom we may sing to you.[169]

In its concluding prayer that "we" might be admitted into the company of angels, the Winchester Troper invokes the common participation of men and angels in the heavenly worship as one of the ideas central to the Apocalypse.[170] The joint cultus in heaven is clearly evoked in the Gothic visualization of the twenty-four Elders, representing earthly Church Fathers who, in the accompanying gloss,[171] adored the Lord at the end of Rev. 4 (fig. 32). Although no textual reference is made to the angels who kneel in the upper register, they provide a visible celestial counterpart to the laying down of crowns in response to the commentary.[172]

In a period in which the laity was increasingly relegated to the role of spectator to the liturgy, as the divine presence became exclusively contingent upon the words and actions of the priest rather than with those of the worshiping community, apocalyptic images of celestial worship acquired new power to engage the thirteenth-century reader in a private, spiritual liturgical discourse. Frontal and static, the iconic image of the Majesty from Rev. 4 (fig. 204) was obviously intended for extended contemplation by the reader-viewer and in turn might elicit something like a mental-spiritual imitation as the prayers and hymns of the Beasts and Elders are silently intoned from the text. In the anthropological reading of ritual as cultural performance, ritual acts are believed to possess power by virtue of the mimetic gestures they require.[173] Thus, the Sanctus could transport the faithful to heaven if it were sung in imitation of a celestial liturgy. As Flanigan put it, to do what is now done in the other world, or what will be done in future, is to be somehow incorporated into those present and future actions and thereby to become beneficiaries of their power.[174]

The apocalyptic liturgy of Rev. 4–5 that begins with the angelic invitation (4:1) and continues with the singing of the trishagion concludes with the congregation intoning a doxology to God and Christ, dominated by a hymn of praise to the Lamb. In the Getty Apocalypse (fig. 205), the Lamb is bleeding into a chalice, perhaps prompted by the sacramental reference in the commentary on 5:7: "The Lamb took the book from the right hand of the One seated on the throne, because Christ accepted humanity in his divine nature so that he could reveal the sacraments in divine Scripture."[175] A remarkably close thirteenth-century parallel is offered by the Alexander Apocalypse in which the Lamb stands on a vested altar bleeding into a chalice within an elongated mandorla frame in response to the commen-

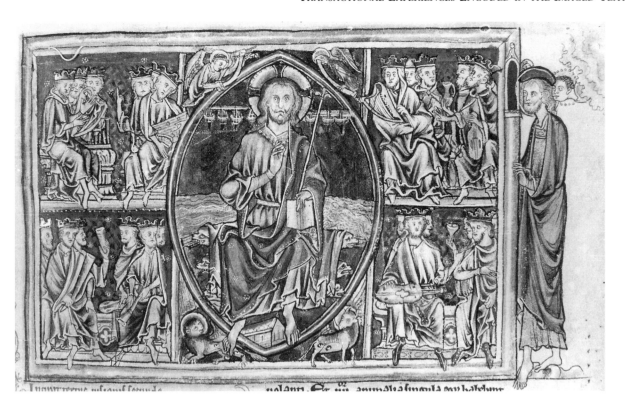

Figure 204. Apocalypse. London, Lambeth Palace Library MS 209, fol. 2. Majesty (photo: The Conway Library, Courtauld Institute of Art, London).

tary on 5:6–8, which sees the Lamb standing on the altar in his Church, mystically sacrificed as the Eucharist ("sub speciebus panis et vini").[176] The English and German illustrations were probably based on similar conceptions of the Eucharistic interpretation of the Lamb, as suggested by the quotation from the Gloria from the Canon of the Mass inscribed on the "book" in the Gulbenkian Apocalypse (fig. 206), "Angus Dei, qui tollis peccata mundi," a liturgical text also quoted by Bruno of Segni in his exposition on 5:6.[177] Since the *Agnus Dei* was introduced into the Roman liturgy at the end of the seventh century, the Lamb of God, frequently standing on the sealed book and bleeding into a chalice, was represented in Bibles, lectionaries, and missals, as well as on Eucharistic patens.[178] A particularly compelling English Gothic precedent can be seen in the *Vere dignum* initial in a missal dating ca. 1200 from Lesnes Abbey (fig. 207).[179] In the Getty Apocalypse, the solemnity of the liturgical moment is signaled by John dropping to his knees as he witnesses the vision from outside the frame.

This appropriation of imagery from the missal, a priest's book not used by the laity, can be seen as a transactional experience in which the communion service celebrated at the altar has been transported into the private space of a book used for the devotional meditation of an individual layreader. Following the preliminary prayers and offering, the Common Preface ("Vere dignum") opens the most sacred part of the mass, the Canon ("Te igitur"), whose solemn words of consecration leads to the Eucharist itself. In the Sacramentary of Pope Innocent III, the "Vere dignum" is prefaced by an image of the apocalyptic Majesty adored by the four Beasts from Rev. 4.[180] As Christopher de Hamel observes, this page in a typical late medieval missal will usually fall open of its own accord, partly because the priest needed to read this page every time he used the book and partly because it has the most elaborate, and frequently the only illustration in the manuscript.[181] Serving as a vehicle for the sacrament, the book's picture cannot simply illustrate a text that is intended to recreate the holiest moment of the religious rite,

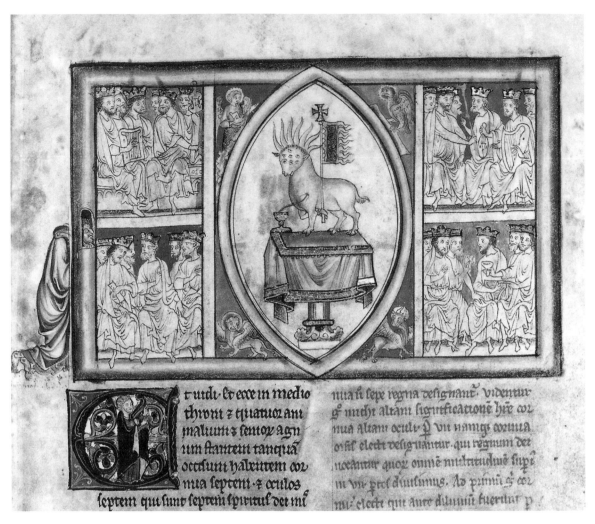

Figure 205. Apocalypse. Malibu, J. Paul Getty Museum MS Ludwig III.1, fol. 5. Vision of the Lamb (photo: Collection of the J. Paul Getty Museum, Malibu, California).

the image becomes an icon, itself regarded as the holy object it represents, a subject of literal veneration, as the priest recites the triple *Sanctus*.[182] Thus, if the *Sanctus* is to transport the faithful into the heavens, it must be sung by all the faithful, who thus imitate heavenly worship.[183] Like most of the liturgy, however, the *Sanctus* was assigned to a choir or chanted only by the celebrant, thus precluding lay participation,[184] hence partly accounting for its private appropriation in the text-image discourse of the Gothic Apocalypse.

Indeed, the most important way in which the ritual experience was encoded in the thirteenth-century book lies in its implicit invitation to experience the book as sacrament. Just as John was commanded to eat the book in the powerfully multivalent passage of Rev. 10, the later medieval reader could regard the Apocalypse as the ultimate Gospel to be devoured and ingested like the Eucharist. In the Cloisters Apocalypse (fol. 16v), John is represented accepting the book from the hands of a priestly angel as if he were taking the host. In graphic demonstration of Jerome's assertion that the Apocalypse is full of sacraments,[185] Gothic Apocalypse cycles are filled with pictorial allusions to the Eucharist in images of the covered ciborium or chalice standing on a vested

altar (see, for example, fig. 71). In most representations, a pair of tall lighted tapers and an altar lamp further signal the presence of consecrated bread. As Miri Rubin points out, the essence of the eucharistic rite lay in seeing the host; thus, lights were thus required for the duration of the mass, and in some instances two additional candles were lit during the elevation.[186] However, the most literal pictorial reference to the comprehension of the Book of Revelation as ingesting the Eucharist appears in a contemporary German manuscript of the Alexander Apocalypse in Cambridge University Library MS Mm.5.31, where representations of the Franciscan exegete taking communion and writing his commentary under the inspiration of the Lamb are juxtaposed at the head of the prologue that quotes Jerome's sacramental allusion.[187]

For the laity, the English Apocalypse evoked another contemporary idea of the Eucharist as a purely visual experience.[188] Because actual reception was discouraged, the new devotion to Christ present in the sacrament was satisfied increasingly by the elevation of the host, a rite that became commonplace by the mid-thirteenth century.[189] However, the new ritual practice was directed, not toward the restoration of the community of faithful and the unity of the reformed Church, but toward the arousal of personal devotion.[190] The gesture of elevation came to mark the moment of consecration, offering to those present its miracle of transubstantiation into the body of Christ.[191] At the moment of elevation, the faithful came as close as humanly possible to "seeing" Christ, alive and present,[192] as illustrated in an early English Book of Hours where the image of Christ blessing and raising the host appears in the mind's eye of a devout laywoman kneeling before the altar (fig. 208).[193] As set forth in the statutes of Coventry of 1224, the moment of elevation is stressed as

Figure 206. Apocalypse. Lisbon, Calouste Gulbenkian Museum MS L.A.139, fol. 5v. Adoration of the Lamb (photo: The Conway Library, Courtauld Institute of Art, London).

Figure 207. Missal from Lesnes Abbey. London, Victoria and Albert Museum MS L.404–1916, fol. 76. Canon of the Mass (photo: The Board of Trustees of the Victoria and Albert Museum).

preeminence of visual experience. When Louis IX once admonished his English cousin not to neglect sermons for too frequent masses, Henry replied that "he would rather see his friend more often than hear others speak of him."[195] A striking example of what Henry III may have had in mind is given in a contemporary illustration of an episode from the legend of his spiritual model, Edward the Confessor, in which the last Anglo-Saxon king saw Christ in the flesh when St. Wulfstan raised the host at mass.[196] As

Figure 208. Book of Hours. Vienna, Osterreichisches Museum für angewandte Kunst Cod. lat. XIV, fol. 25. Initial to Matins: Woman Kneeling before Vision of Christ Holding the Eucharist (photo: Museum für angewandte Kunst, Vienna).

an encounter with God: "And now we can say that this is our God . . . he is seen here on earth everyday when he is elevated by the hands of the priest."[194]

For the thirteenth century, seeing became an increasingly important instrument of spiritual and religious experience. William Rishanger relates an anecdote concerning Henry III that reveals the new

the thirteenth-century theologian William of Auxerre described the rite, "the priest elevates the body of Christ in order that all the faithful might see it and seek whatever is necessary for salvation."[197] In a sermon for the Sunday after Epiphany in 1375, Bishop Thomas Brinton of Rochester asserted that after seeing God's body no need for food would be felt, oaths would be forgiven, eyesight would not fade, sudden death would not strike, nor would one age, and one would be protected at every step by angels.[198] As Rubin observes, this is just one version of the ubiquitous list of *merita missae* that proliferated in pastoral discourse from the thirteenth century on.[199]

Just as the visual aspects of the liturgy were expanded by multiplying ritual gestures, vestments, and images at the altar, however, increasingly more of the liturgy was taking place behind the sanctuary partition.[200] Devout but disadvantaged laymen and laywomen thus depended all the more on what John Beleth (d. 1182) called the "layperson's book . . . pictures and ornament."[201] Representations of the elevation became common not only in the decoration of the text of the mass in missals, but also in other devotional books.[202] In a fourteenth-century English Book of Hours, for example, a full-page prefatory miniature shows the Butler family at mass, gazing in adoration at the host.[203] A further example imaging the Eucharist in an English book of private devotions appears in a Miscellany of ca. 1310–20, which includes prayers in Latin and instructions on the mass in Anglo-Norman, accompanied by thirteen miniatures with explanatory captions, showing the priest at various stages of the ritual.[204] As Rubin has suggested, the aim of such illustrated books for the laity was to build a "horizon of images, a vocabulary of associations, a train of symbols which followed from the recurrent visual stimuli created by ritual or by private reading."[205]

Just as the sight of the host or chalice alone was believed to bestow spiritual benefits upon the pious viewer,[206] the illustrated Apocalypse could serve as a convenient substitute for eucharistic reception, particularly for aristocratic laypeople in the privacy of their chambers.[207] A pictorial documentation of this idea might be seen in the prefatory page of the Amesbury Psalter (fig. 209) where an aristocratic nun or widow kneels and raises her hands to receive visually and hence spiritually the chalice held by the apocalyptic Lord in Majesty surrounded by the four Beasts

Figure 209. Amesbury Psalter. Oxford, All Souls College MS 6, fol. 6. Nun or Widow Kneeling before Christ in Majesty (photo: The Warden and Fellows of All Souls College, Oxford).

in the great image from Rev. 4 above, presumably projected in her mind's eye from the open book before her.[208]

THE BOOK AS PROPHECY: SPATIALIZATIONS OF TIME

At the same time as the imagination of the individual reader is visually stimulated to cultivate the art of memory and to nurture vicarious experiences of the liturgy, the Gothic Apocalypse requires that the reader to come to terms with the prophetic dimensions of the book. As A. I. Gurevich observed, the

medieval experience of time was an eschatological process.[209] The fate of humankind unfolded in two temporal categories at once – on an empirical, transient plane of earthly existence and on another, spiritual level for the realization of an eternal, divinely ordered plan. Within the world view of medieval Christianity, only biblical or sacral time possessed true reality, for it was the only temporal dimension of human experience that belonged to the category of the divine archetype. Within this medieval ontological framework, Augustine argued that the ability to measure the duration of time is given to the human spirit, and it is in the soul alone that perceptions of time, past, present, and future, inhere. Human time is thus an inner reality, and the human spirit alone perceives it.[210]

The Apocalypse is a text obsessed with notions of temporality, for its narrative is directed toward the end of time. Not only is the text full of temporal intervals, gaps, and ruptures, causing enigmatic disjunctions in the narrative, but there exists an inevitable temporal hiatus between the end of the apocalyptic narrative and the ultimate end that it prophesies. This displacement and deferral constitute a realm of temporal difference in which Paul de Man locates the discourse of allegory.[211] In the words of Susan Stewart,

[I]n allegory the vision of the reader is larger than the vision of the text. . . . To read an allegorical narrative is to see beyond the relations of narration, character, desire. To read allegory is to live in the future, the anticipation of closure beyond the closure of the narrative. . . . The locus of action is not in the text but in the transformation of the reader. Once this transformation is effected, the point of view is complete, filled out to the edges.[212]

In a semiotic sense, however, allegory and Apocalypse are nonetheless antithetical: Allegory involves the encoding of meaning, whereas the Apocalypse narrative offers itself as a divinely inspired decoding of hidden truths. For the medieval reader, the disjunction collapses only with the recognition of ruptures in time, enabling allegorical exegesis to become another apocalyptic narrative premised on the semiotic antioriority of written Scripture.[213] I shall now explore some pictorial strategies encountered in Gothic manuscript cycles that deal with the problematic of time in Apocalypse narrative in terms of both representation and reader response.

In many thirteenth-century English illuminated manuscripts, the ambiguous time span of the revelatory experience recounted in the text is initially cast within two concentric narrative frames: The outer frame consists of voyage and exile in which distance signifies duration, visible to the reader-viewer as an illustrated *Life* of St. John preceding and following the Apocalypse; the inner frame is a dream of fleeting brevity, evoked by the first illustration revealing the seer asleep on Patmos.[214] The reader is thus invited to experience the Apocalypse narrative as an interior pilgrimage, involving departure, exile, and return. But much of what he or she encounters constitutes a contradiction, an antagonism between what Bakhtin would call the timeless form-generating principle of the whole as dream-vision and the diachronic, linear, divisible form of its illustrated parts,[215] each beginning with "I saw" or "I heard" and signaling a recent history accessible to the reader as well as to the visionary author. For the thirteenth century, which Jacques Le Goff characterizes as newly centered in narrative time,[216] each image acquires a fully historical potential, but, in the manner of visually realized *exempla*, illustrated episodes depend on the time of meaning and the private memory of spiritual and moral conscience.

Most Gothic Apocalypses contain not only a cycle of narrative pictures accompanying the text, but the somewhat older, twelfth-century Berengaudus commentary as well. In juxtaposing text and gloss, the compiler creates a state of noncoincidence representing a temporal fracture between "then" and "now." The split or gap itself functions as a signifying or semiotic structure, and the gloss serves as an intermediate passage between past illumination (text) and present interpretation.[217] Its placement on the page along with a pictorial illustration renders visible the lacuna between moments of past and present understanding. I would argue that one of the most important functions of the illustrations is to create a third, authoritative, pictorial discourse in which the temporal rupture between text and gloss is healed, enabling the reader to experience the narrative in a kind of allegorical time warp.

In the Morgan representation of the Third Seal (fig. 45), for example, the horse's progress slows to a walk. He butts his head against the frame, making it clear that the rider, who holds the scales precariously suspended from one finger, has no real

destination. In the Lambeth version (fig. 46), in contradiction of the horse's quickened pace, the rider turns backward and holds the scales behind him, thus immobilizing the figures into a state of chiastic inertia. The horseman now looks outward and directly engages the viewers gaze, demanding to be read on an allegorical rather than narrative level,[218] consonant with the command given to John on the left to "Come and see," that is, to understand the prophecies that are read in this book on a spiritual level (spiritualiter). The accompanying commentary then informs the reader-viewer that the opening of the third seal refers not to the future, but to the past, to the Law and those who lived under the Law, the scales signifying Old Testament justice that cries out, "Life for life, eye for eye, tooth for tooth," and the black horse symbolizing the darkness and harshness of Mosaic Law.[219] In the Lambeth miniature, the face of the figure representing Old Testament justice is partly obscured by a cowl in response to the exegetical references to "Moses who had a veil over his face," signifying Judaic blindness to the future possibility of divine forgiveness or grace.

The foregrounding of spatialized time in the interpretive reading of the illustrated Gothic Apocalypse can be seen even more explicitly in the illustration of the commentary on this passage in the Gulbenkian Apocalypse (fig. 210) where the reader-viewer is invited to "see" the opening of the third seal as a present vision of past suffering and future redemption at the end of time.[220] On the left, an Old Testament king pronounces the sentence "Anima pro anima," as a pictorial inventory of ruthless punishments under the Law spills toward the center. Hierarchically separated both in time and space from the harshness of Mosaic justice, the Lord of the Last Judgment appears in the mandorla above, holding the scales of a new justice, tempered by Christ's Passion on the cross, signified by the wound in his side.[221] Through the intercession of the apostles led by Peter at the upper right, the kneeling figures below become the future beneficiaries of the Lord's mercy following the new era sub gratia. The compartmentalized, hierarchical image thus evokes temporal ruptures not only between the eras sub legem and sub gratia, past and future, but also between the present time of allegorical reading and the end of time at the Last Judgment.

Similar hermeneutic responses are frequently prompted by enigmatic disjunctions within the Apocalypse narrative itself. Their duration is sometimes calibrated very precisely, creating a measured but opaque hiatus as, for example, in the interval of 1260 days during which the Woman in the Sun escaped into the desert in Rev. 12 (see fig. 87). The rescue, variously encoded as refuge, exile, or flight into solitude, is pictorially expressed by compartmentalizing, shifting, or marginalizing the image. Central to the pictorial structuring of the text passage is its implied relationship to the larger narrative of the whole chapter, for the woman's three-and-a-half years in the desert is interjected as only a temporary respite in the ongoing struggle against the dragon. The designer of the Trinity Apocalypse expands the image into superposed registers (fig. 89) to express the simultaneity as well as the separation of the rescue of the child and the escape of the woman, as they transpire in the differentiated hierarchical spaces of heaven and earth. Analogous to Trinity's segregation of the woman in a lower register are various strategies of marginalization observable in other manuscripts where a second figure either flees or disappears into a liminal space beyond the frame, as in the Getty Apocalypse (fig. 87), or becomes literally exiled in the outer margin, as in the later French Cloisters version. While the Douce figure looks back apprehensively at the momentary diversion of the dragon, the narrative suspense is somewhat differently sustained in the Burckhardt-Wildt picture cycle (fig. 88) by the woman's gesture of thrusting her open book into the margin beyond the frame, alerting the reader that there is more to follow. In the Lambeth Apocalypse (fig. 90), the image has actually been shifted into the next picture frame, where it merges with another temporal interlude, the ensuing battle in heaven. By grafting the two spatiotemporal intervals within the same frame, the images are conjoined in a paratactic structure expressing an extended "meanwhile." The woman gazes beyond her open book at Michael's combat with the dragon, as if she were witnessing its inscribed narrative. Although the resulting pictorial merger of episodes contradicts the text, the interjection of the Woman in the Sun into the subtext of the Battle in Heaven provides an interpretive link, through her identification with the Virgin, to the commentary's explanation of the archangel's victory over the dragon as Christ's subjugation of the devil through his Incarnation and

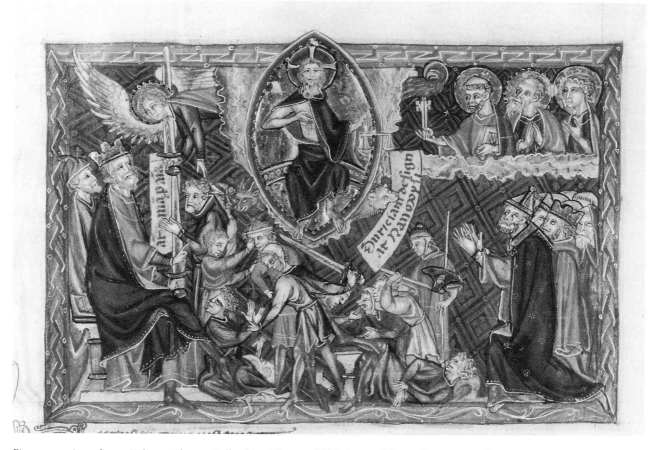

Figure 210. Apocalypse. Lisbon, Calouste Gulbenkian Museum MS L.A.139, fol. 10. Commentary Illustration for the Third Seal (photo: The Conway Library, Courtauld Institute of Art, London).

Passion.[222] The image thus acquires a new focus within the metahistory of human salvation paralleling the rescue of the woman and child.

Although of similarly precise duration, the thousand-year reign initiated by the first resurrection requires a pictorial signification not only of its provisional nature, but also of its indeterminacy in terms of actual time. Thus, in contrast with the early Carolingian representation in the Trier Apocalypse (fig. 156), where the only hint of transition is given in the lingering visibility of the imprisoned dragon's tail, the traditional judges in the eccentric Gothic image (see fig. 157) now appear to be debating about the meaning of the temporal respite. In a curiously disconcerting and comfortless image, presumably intended to evoke the blessed joy of those who share in the thousand-year reign of Christ, the judges are divided into two confronted and contentious groups. The foremost judge on the right enumerates the points of his argument on the fingers of one hand, and his opponent gestures toward the resurrected souls of the martyrs below. Conceivably, the illustration alludes to the contemporary controversy of 1254–6 during which Joachim of Fiore's theory of the first resurrection was brought into notorious dispute and disrepute by Gerardo of Borgo San Donnino. In his polemic against the pseudo-Joachite position, William of St. Amour formulated his rejection of the idea of a future earthly kingdom of Christ by falling back on the old Augustinian conception of the ages of the world according to which humankind was then living in the sixth and last earthly age before the Last Judgment.[223] The Gothic image thus alerts the reader to the conservative Augustinian

view espoused in the accompanying commentary, which sees the metaphorical hiatus as a period of unknown duration extending from Christ's Passion to the end of the world.[224]

In the thirteenth-century Apocalypse picture cycles, visual effects of closure are given at the ends of the numbered sequences, such as the seven Seals and seven Vials, where repetition creates a recurrent backward movement that causes time to appear to be standing still, rendering the visionary narrative transcendent and beyond time. This is particularly evident in the representation of the last of the seven Vials (figs. 133 and 134) where the angel pours his vial on a cloud bank over the ruins of Babylon, as a voice, embodied either as an angel or the Lord, shouts from the celestial sanctuary, "The end has come." The pouring of the last vial not only brings the serial destruction wrought by the vial-bearing angels to an end (conclusion), it also heralds the God-ordered (in both senses of "command" and "unfolding of divine plan") end (destruction) of Babylon, which in turn serves as a metaphor for the collapse of a fractured world at the end of time. The long serial sequence of vials being poured constitutes an extended preparation, building an expectant momentum that ends by leaving the reader on the edge of a narrative precipice, clinging to the announcement that the destruction of Babylon, which was promised in Rev. 14 but will not materialize until Chapter 18, has already occurred. However, most Gothic designers are at a loss to convey the idea of time warp that would facilitate the reader's realization of the zig-zag path taken by the narrative in Rev. 17 and 18, as it caroms between past, present, and future. In Add. 35166 (fig. 133), however, John makes a textually unscheduled appearance to point the way. The seer holds his pilgrim's staff upside down in a gesture acknowledging the collapse of the city before him, but the reversal also signals only a temporary halt in his journey, for he is witnessing the destruction of one city (Babylon) in order that he might continue his pilgrimage to another (heavenly Jerusalem). In the Getty version (fig. 134), John looks back as he walks away, signaling the end of his serial experiences of seeing the vials poured. But, more significantly, the change of pilgrim's direction takes him on a journey into time so that the angel can show him the past and future of what he has just witnessed. The last frame of Rev. 16 thus concludes

with the destruction of Babylon as a *fait accompli*, only to be followed by the vision of the still-to-be-destroyed city now transmogrified into the Great Harlot.

Images of the Heavenly Jerusalem create for the reader another mode of shifting temporality, as distancing devices place the celestial city beyond the reach of both John and the reader, spatializing the temporal gap between the earthly Jerusalem that has been lost by the Crusaders and the prophetic promise of heavenly renewal, an image-structure of words and signs that will achieve reification only at the end of time. In the image of the celestial city, first seen as descending, the temporal space between the writing of prophecy and its future fulfillment is visualized in a number of ways. In a second illustration in Douce, for example, John is seated with his pen poised above an open book that is still blank, ready to obey the command to write, that is, to transcribe into his own book what has already been written in the divine archetype. The Morgan designer ingeniously encodes this element of the narrative by showing John penning his signature in the text inscribed in the space that separates him from his vision (fig. 163). The representation in Fr. 403 (fig. 211) provides one of the most eloquent images of the temporal gap between the inscription of prophecy and its fulfillment, as we see John carefully transcribing his text onto a long scroll held by the commanding angel at the left, as the Lord delivers the promised city, replete with its heavenly "bill of lading." The visual narrative thus becomes focused on the elegantly framed empty space between the two scrolls where the temporal gap between the two texts constitutes the dramatic center of the illustration.

The second image of the Heavenly Jerusalem, now raised atop a high mountain (fig. 165), stresses its remoteness and distance from the seer who first sees the city approaching earth as if it were a distant star or planet and then realizes that he must cross a chasm and scale a mountain in order to reach it. Just as the earthly Jerusalem had been severed from the Christian West in 1244, the heavenly city seems equally distant and unattainable. However, the distancing devices that place the city beyond the reach of both John and the reader function effectively as metaphors of time, spatializing the temporal gap that separates the present from the future. Thus, the prophetic nature of the vision is underscored by the di-

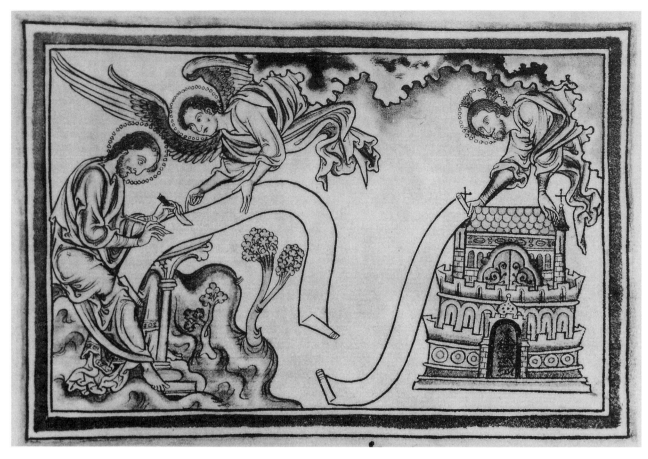

Figure 211. Apocalypse. Paris, Bibliothèque Nationale MS fr. 403, fol. 41. Heavenly Jerusalem Descending (Phot. Bibl. Nat. Paris).

vine command: "Write this: that which I am saying is sure and will come true," reminding the reader that the heavenly Jerusalem and the renewal of creation exist only as a prophetic promise, an image-structure of words and signs, evoked quite literally in Morgan (fig. 163) as the holy city is raised on a mountain of text. Only in the Trinity Apocalypse (fig. 166) is its realization represented as immediate and immanent, but the shifting temporality of present and future experience is nevertheless maintained by Trinity in the dramatic disparity in perspective between John, who sees the vision as if it were a great enframed mural, and the viewer who gazes down into the city's square-framed center, as if from a great and distant height, grasping its visual structure in terms of a diagrammatic sign laid out on a pilgrim's itinerary or map.[225]

Finally, the illustrations of the Gothic Apocalypse constitute a recognition of the complex temporality of reading the text. At the end of the narrative, when the seer attempts to worship the angelic messenger of his visions, the pictorial representation of John's *faux pas* (see figs. 169–70) serves as an effective admonition to the reader of the consequences of misreading, or not reading allegorically, for the art of interpretation depends upon a proper understanding of time.[226] As the pilgrim-seer draws nearer to God, he betrays his flawed human understanding by failing to realize that no interpretation of Scripture or human events can be accepted as final until the journey has come to an end, when John and the reader see the ultimate vision at the end of time, beyond the narrative. Thus, the representation of John kneeling before the Lord (see figs. 171–4) was uniquely cre-

ated in the thirteenth century to serve as the last picture in the English Gothic cycles. In a dramatically powerful image, the pilgrimage ends with the seer's ultimate reward as he now confronts his Lord alone, gazing up at Christ in a vision no longer mediated by the text. John kneels before the Lord as the receptor of the epilogue's ultimate promise: "I shall indeed be with you soon." In the Gulbenkian Apocalypse (fig. 173), the pilgrim reaches yearningly for a heavenly realm that lies beyond the boundaries of his vision, the insurmountable temporal distance expressed in the spatial gap between the two figures.

In Douce 180 (fig. 174), the scene takes on the sadness and nostalgia of farewell, as the Lord recedes from John's vision behind the multiple barriers of distancing frames. As in the Douce illustration on an earlier folio, there are again two books, but one is no longer blank, signaling the fulfillment and end of John's authorial mission. The figures of the angel and seer move from right to left against the grain of the text, creating a sense of retrospective closure, for the book that has already been written in a timeless eternity becomes available to John only through the agency of the angel standing behind him. As he holds his pen poised above an open inkpot, the Evangelist's futile gesture signifies that he cannot have written the divine archetype but only the replica held by the angel. However, the open books and John's unresolved gesture of yearning evoke a state of incompletion and expectation, the reception of a promise not yet fulfilled. Thus, like John, the reader can only experience the vision in a present moment of eschatological time, poised between an eternal past and an eternal future.

Like the earlier thirteenth-century Parisian *Bible moralisée*, the English illustrated Apocalypse embodies a Gothic conception of the Book of Revelation as a medieval *summa*, an encyclopedia of God's word and a *speculum* of God's work. For Thomas Celano, Franciscan theologian and biographer of St. Francis, the Apocalypse contained everything ("Liber . . . in quo totum continetur").[227] It describes and encompasses a world beyond time, an unknown part of Creation as exciting and challenging to the medieval imagination as the later twentieth-century's exploration of outer space. The Apocalypse was perceived as a cosmic book in which the totality of God's universe is potentially present, a metaphor of infinity.[228]

Picturing Other Visions

Expanding the Reader's Experience of the Book in Three Appended Cycles of Illustration

Beyond the sparse evidence of inscriptions, donor portraits and heraldry, three thirteenth-century Apocalypses contain additional pictorial cycles that reveal, at least potentially and indirectly, something more about the readership and usage of these remarkable books. Notwithstanding the stern admonition at Revelation's end that nothing was to be added or taken away (Rev. 22:18–19), the thirteenth-century English Gothic apocalyptic discourse fell victim to the pervasive medieval practice of appending narrative preludes and sequels to any and all texts. As we have already seen with the paradigmatic enframing of the Apocalypse within an illustrated Life of St. John, such pictorial addenda had the effect of further undermining the reader's expectations of a beginning, middle, and end.[1] Although the pictorial addenda shift their terms of discourse beyond the Book of Revelation, they refocus the reader's attention on the same external ideological centers of Church reform, anti-Judaism, the Crusades, and eschatological visions that dominated the illustrated Apocalypse. The new cycles form ancillary but coherent pictorial programs focused on "seeing" images as a visionary experience within the context of the illustrated Apocalypses for which they were designed, and hence become critical to understanding the reader's experience of the book in its thirteenth-century incarnation.

Fourteen folios of pictures now appear at the end of Lambeth 209; a short cycle of five illustrations orig-

inally served as a preface to the French Burckhardt-Wildt Apocalypse; and Eton 177 is prefaced by twelve pages of pictures laid out in distinctive patterns of roundels. Although much of the imagery is unique to these Apocalypse manuscripts, the supplementary picture cycles focus and enlarge the scope and purpose of the book by adding material normally attached to Psalters, such as scenes of Christ's Passion, pictures of saints, and typological imagery. In the wake of Lateran IV, the clergy and laity alike found need for a wide variety of devotional and instructional books, ranging from learned Latin treatises to vernacular manuals outlining the Articles of Faith, the Commandments, the Vices and Virtues, the Sacraments, and memorized prayers.[2] Indeed, with the vernacular translation and adaptation of theological compendia, such as the twelfth-century *Elucidarium* of Honorius Augustodunensis into the Anglo-Norman *Lumière as lais* by Peter Peckham, ca. 1267, and the *Speculum ecclesiae* of St. Edmund of Abingdon into the vernacular *Mirour de Seinte Eglyse* at midcentury, along with the appearance of the *Ancrene Riwle* and the Anglo-Norman *Manuel des péchés* by William of Waddington, ca. 1260, the lines between clerical and lay readership of such works became blurred.[3] The appearance of the Gothic illustrated Apocalypse in England about 1250 coincides with a second wave of popular theological and devotional works responding to the conciliar demands of Lateran IV. On one level, the illustrated Apocalypse appears to have functioned, along with

the Psalter and new Books of Hours, as a pictured text for private devotional reading in which the illustrations aided comprehension, meditation, instruction, and memory. On another level, as we shall see, the additional picture cycles created for the thirteenth-century Apocalypses engage those functions in special ways that respond to the uniquely visionary character of St. John's text insofar as they further seek to shape the reader's experience of the book to the picturing of visions.

Although the picture cycles appended to the thirteenth-century Apocalypses obviously originate in the tradition of prefacing Psalters with extended series of Old and New Testament scenes unaccompanied by texts, the newly created sequences of ancillary images also relate to Gothic picture books. Such compilations of pictures constitute an ill-defined and largely unexplored manuscript genre represented by a few scattered English and French examples dating from the thirteenth century, but the miscellaneous and clearly devotional character of these collections of iconic and allegorical images sets them apart from the narrative sequences that normally preface Psalters. Their nonnarrative content is typical of a class of spiritual florilegium known as *soliloquia*, deeply felt, subjective meditations used as vehicles of self-examination and mystical elevation in which the mediation between the reader and God is accomplished through the contemplation of images.[4] Whereas it is not always possible to determine whether these rare picture books represent detached fragments or were designed as independent pictorial compilations, all were clearly intended for clerical rather than lay usage, thus pointing to devotional and mnemonic purposes rather than providing aids for comprehension by an illiterate or semiliterate reader.

Among English examples, the best known is the small-scale fragment of eighteen tinted drawings in Fitzwilliam MS 370, dating from c. 1260–80.[5] Probably incomplete at the beginning, the picture cycle now comprises the Death and Coronation of the Virgin, Christ displaying his wounds at the Last Judgment, the Throne of Mercy (Trinity), and scenes from the lives of various saints; each picture is captioned with a headline in red or blue Lombardic capitals. Although clearly appended to a preexisting text already prefaced by a picture cycle, the five images added on pages originally left blank at the end of the

Westminster Psalter[6] can also be considered relevant to the strategy of pictorial additions to the thirteenth-century Apocalypses. Executed over forty years after the completion of the manuscript, the unframed tinted drawings were evidently intended to supplement the devotional images from the Life of Christ at the beginning of the Psalter for a Benedictine readership, because the book was always in the possession of the abbey. Following special prayers to St. Edward the Confessor, St. Benedict, and St. Peter, the drawings represent a crusader kneeling before St. Edward the Confessor on facing pages, followed by St. Christopher (fig. 213) and St. Edmund of Abingdon; the brief cycle ends with a representation of the Veronica accompanied by the indulgenced prayer of Innocent III to be recited before the image of the Holy Face. The last three representations occur again in the cycle appended to the Lambeth Apocalypse.

As in the creation of the Gothic illustrated Apocalypse itself, the idea of adding picture cycles seems to have been initiated for clerical readers and then adopted for a lay audience. It is not until the fourteenth century that the needs of lay readers are addressed directly through the addition of such texts as the *Lumière as lais* or the *Evangile de l'enfance*. The additional cycles surviving from the thirteenth century tend to be complex, requiring comprehension on a sophisticated conceptual level and perhaps assuming explanation and instruction by a clerical advisor. This clearly seems to have been the case for Lambeth 209 in which a cycle of supplementary pictures was made for Lady Eleanor de Quincy between 1264 and 1267.

LAMBETH 209

Although the series of additional pictures in Lambeth 209 form two gatherings separate from the illustrated Latin Apocalypse, they were executed and inscribed by some of the same artists and scribes who worked on the rest of the book.[7] Whether conceived as a component of the original plan or not, the project for the pictorial addition appears to have been carried out only slightly later.[8] The series begins with a full-page representation of St. Christopher, followed by the Life of John, and two miracles of the Virgin in eight double-registered scenes. The first additional quire then ends with a full-page representa-

tion of St. John writing on Patmos. The last quire opens a uniform sequence of full-page illustrations with the Virgin and Child, followed by a Cherub inscribed with the Virtues, *Noli me tangere*, Sts. Lawrence, Margaret, Catherine, and Edmund the Martyr, the Crucifixion, two archbishops, an allegorical scene of Faith and Penitence, ending with the Holy Face. Because the double-tiered narrative scenes in the penultimate quire differ markedly in format and character from the full-page devotional and allegorical images in the last gathering, it seems probable that they were not intended to form a continuous series, but were to be divided into an enframing set of prefatory and epilogue images at the beginning and end of the book. In the absence of a pictorial *vita*, the authorial images dealing with St. John would seem more appropriately placed antecedent to the illustrated Apocalypse, following the precedent established in the Berengaudus archetype, whereas the representation of Lady de Quincy's devotion to the Virgin and Child, followed by iconic and allegorical images, would constitute a similarly purposeful sequel.

The appended sequence in Lambeth 209 is headed by St. Christopher (fig. 212), the powerful giant who earned his living by carrying travelers across a river and one day carried a small child so heavy he caused the ferryman to bend beneath his burden, for it was the Christ Child who carried the weight of the whole world's sins. Venerated in the Middle Ages as the patron saint of travelers and wayfarers, St. Christopher's aid and protection were invoked particularly by pilgrims and crusaders. In the Lambeth representation, Christopher stands in water filled with fish, his trousers tied at the knees, and his staff ending in an oar-paddle,[9] so that he stands as a metaphorical paradigm for the crusader or missionary carrying Christ across the seas. St. Christopher is clearly invoked in this role in the series of drawings added to the Westminster Psalter (fig. 213) where he follows a pair of images on facing pages representing a Crusader kneeling before St. Edward the Confessor, as if leading the way and providing safe journey to the cross-bearing knight.[10] In the Westminster Psalter, St. Christopher carries a *tau*-shaped walking stick similar to that carried by John throughout the Getty Apocalypse, denoting his role as pilgrim. Thus, the series begins with an invocation for protection on a journey *outremer*. In the thirteenth century, it was

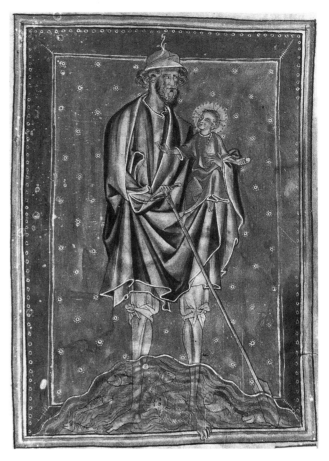

Figure 212. Apocalypse. London, Lambeth Palace Library MS 209, fol. 40. St. Christopher (photo: The Conway Library, Courtauld Institute of Art, London).

enough to have seen his great figure at the main entrance of a church to be assured of a safe return: "Christophorum videas, postea tutus eas."[11] A similar inscription has been uncovered below the thirteenth-century wall painting of St. Christopher that can still be seen near the entrance to the south transept of Westminster Abbey.[12] In the latter example, however, the power of the image is directly invoked by the term *species* attached to the figure of the saint, a term used in contemporary theories of vision to denote the power of likeness that enabled the viewer's gaze to gain power from its object.[13] Thus, from the outset, the series of full-page pictures appended to the Lambeth manuscript invoke the scopic regime of the reciprocal powers of image and vision.

In Lambeth 209, the pious reader's "journey"

then moves through an extended sequence of scenes from the life of John (fols. 40v–45), reinforcing the idea that John's liminal experience of Revelation on Patmos generated a text to be experienced as a spiritual "Crusade" or pilgrimage by all its subsequent readers. The series of illustrations appended to Lambeth 209 constitutes one of the most extensive pictorial cycles of the Life of John, comprising twenty scenes in double registers on ten pages, exceeded only by the twenty-four scenes in Trinity R.16.2. Because the illustrated Apocalypse in Lambeth 209 depends on the Metz prototype, there was no provision for an illustrated *vita* in the model. That its inclusion in the cycle of additional pictures was clearly an after-

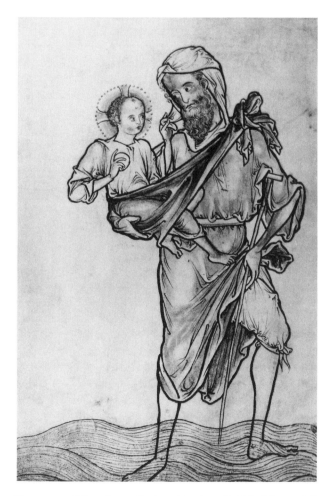

Figure 213. Westminster Psalter. London, British Library MS Roy. 2.A.XXII, fol. 220v. St. Christopher (photo: The British Library).

thought, inspired by the Morgan or Westminster paradigms, is evident from the illogical merger of events prior and subsequent to John's exile. Episodes that were traditionally separated by the intervention of the illustrated Apocalypse are now joined in a single continuous narrative; the seer's voyage to Patmos and his return to Ephesus are represented on the same page without a break in the upper and lower registers. Notwithstanding its unorthodox narrative structure, the illustrated Life of John nevertheless functions to authenticate the authorship of the book and would have been most likely designed as a traditional component of a pictorial preface rather than as an endnote. As the narrative extends beyond John's revelation on Patmos, a series of miracles and the ultimate ascension of his soul to heaven graphically demonstrate the enormous spiritual and salvific power that flowed from the seer's visionary experience.

On the following verso, the reader-viewer's peregrination then proceeds to a short narrative unfolding the first of two miracles of the Virgin (fig. 214), which shifts the journey from the apocalyptic experience and subsequent miracles of St. John to a military crusade in which the martyr, St. Mercurius, is restored to life to kill the pagan emperor Julian the Apostate. In the first scene, Mercurius rises from his sarcophagus to receive a coat of mail from the Virgin; at the upper right, an angel flies down bearing a shield emblazoned with a crusader's red cross[14] and a lance with pennon; at the left, another angel supplies him with a helmet, sword, and horse. In the final battle scene in the lower register, the martyred knight in armor, guided by the Virgin behind him and the hand of God above, charges toward the enemy, piercing Julian with his lance. The emperor falls backward from his horse in an emblematic gesture signifying the fall of Pride.

The inclusion of these episodes from the legend of St. Mercurius apparently had nothing to do with the celebration of this Byzantine soldier-saint, because he had no cult in the West. Here as elsewhere, the images focus on his posthumous celebrity as the divinely appointed executioner of Julian the Apostate.[15] The story of Mercurius circulated in England during the thirteenth century in anthologies of miracles of the Virgin as well as in such disparate texts as the *Speculum historiale* of Vincent of Beauvais, the *Gemma ecclesiastica* of Gerald of Wales, and the *Ma-*

nuel des péchés,[16] but no earlier illustration is known. Indeed, as is reported in the various contemporary collections, the major focus of the story is the miracle of the Virgin; the best known version is given in *Les miracles de Nostre Dame* of Gautier de Coincy (d. 1236).[17] Introduced as "un myracle trop mervilleuz," Gautier's legend is cast in the guise of a moralizing *exemplum*, demonstrating how pride personified by the pagan emperor was overcome through the power of the Virgin. Where the moral lesson and the intercessionary power of the Virgin are evoked through the force of prayer and devotion, her image plays a central role. To save his city of Caesarea, St. Basil preached a sermon to the people and prayed for three days "devant l'image Nostre Dame," and through the miracle of St. Mercurius, she delivered the city:

> La mere au roy qui tout justise
> Ainsi s'ymage, ansi s'eglyse,
> Ansi sa cite delivera.[18]

The kinds of miraculous powers bestowed on St. John through the experience of his visions are now transferred to the fervent spiritual contemplation and prayers before the image of the Virgin, already evoked in Lambeth's flyleaf representation of the devout monk "painting" the image of the Virgin in his mind's eye.[19]

The relevance of the miracle of St. Mercurius as a crusader image addressing the Muslim threats to Caesarea and all the other coastal cities that formed the dwindling remnant of the Latin Crusader Kingdom of Acre could hardly be lost on a mid-thirteenth-century reader.[20] Julian's trappings are charged with devils' heads, and his troops, although still on the attack, have fallen in a dense mass of bodies beneath the advancing Christian knight. The image of the single equestrian knight facing a formidable army and plunging a long lance through one of the enemy constitutes an obvious pictorial reprise on the apocalyptic episode of the Battle against the Beast (see fig. 152). More importantly, however, the arming of St. Mercurius forms an elaborate pictorial extension of the legend that can be perceived as a military allegory based on Ephesians 6. Medieval commentators developed St. Paul's identification of the various pieces of military equipment – the hauberk of justice, the shield of faith, the helmet of salvation, and the sword of the spirit that is the word of God, to adjust God's weapons to the needs of the

medieval knight.[21] With the conferring of God's armor by the Virgin and angels, the resurrected martyr becomes a *miles christianus,* comparable to the knight confronting the vices in Harley MS 3244, in which each item of equipment is labeled as a virtue. As in the Lambeth and Harley allegories, some medieval glossators even included a horse, as well as sword and lance.[22] The particular popularity of emblematic armor and military metaphors in thirteenth-century England guaranteed ready accessibility to this kind of moralizing significance for the contemporary reader-viewer, just as the miracles of the Virgin were discernible without benefit of text.[23] Thus, the knight kneeling with his horse, banner, and helmet behind him among the group of miniatures added to the Westminster Psalter (Roy. 2.A.XXII, fol. 220) can also be seen to evoke a chivalric allegory of spiritual armor. Finally, and more directly, the Lambeth image of St. Mercurius being armed by the Virgin and angels resonates with the pictorial allegory of the Shield of Faith (fig. 228), where Lady de Quincy is being armed by angels to combat sin and temptation.

The following story of Theophilus appears as the first in Gautier de Coincy's collection of the Miracles of the Virgin. As in the Lambeth illustration, it is three times as long, comprising six instead of two episodes.[24] Unlike the obscure Mercurius legend, however, the Theophilus story enjoyed a very wide currency in the West, beginning in the eleventh and twelfth centuries when it was used as an *exemplum* in sermons in honor of the Virgin.[25]

In the first Lambeth episode, the pious and virtuous tonsured clerk Theophilus, having modestly declined to become bishop, now longs for the power he had refused and seeks help from a magician who could speak with devils. As in Gautier's version, the gullible clerk is seduced by Jews, caricatured as wicked and venal, who offer him money bags. Prodded by a magician and devil, Theophilus then enters into a pact with Satan, clasping his hand, as he gives over a sealed charter in which he agrees to deliver up his soul to hell in exchange for the glory of the world. In the midst of power and honor, Theophilus is then filled with remorse and despair. In the third episode (fig. 215), he prostrates himself before the image of the Virgin placed on a vested altar next to a small crucifix, demonstrating the same exaggerated pose adopted by John as he knelt before the First

Figure 214. Apocalypse. London, Lambeth Palace Library MS 209, fol. 45v. Miracles of the Virgin: Resurrection and Arming of St. Mercurius; Defeat of Julian the Apostate (photo: The Conway Library, Courtauld Institute of Art, London).

Figure 215. Apocalypse. London, Lambeth Palace Library MS 209, fol. 46v. Miracles of the Virgin: Theophilus Praying before a Statue of the Virgin; Mary Interceding with Christ (photo: The Conway Library, Courtauld Institute of Art, London).

Vision in the Apocalypse (fig. 11). The efficacy of his penitential prayer is proleptically visible in the presence of a nimbed but wingless angel who stands in the church door, warding off the devil with a pike. He seems to rise from Theophilus's prostrated form as if his soul rose from his body to protect him from further spiritual harm. In the lower register, Theophilus kneels at the left before an apocalyptic vision of the Lord in Majesty. Accompanied by an angel and St. Peter, the Virgin intercedes with her son by baring her breast in a gesture that simultaneously reminds him of his humanity and her nurturing love.[26] Here the designer appears to have conflated the Theophilus legend with another of Gautier de Coincy's miracles in which a lapsed Cistercian who became abbot of a Benedictine house had a vision in which the Virgin interceded with Christ by baring her breast.[27] In the Lambeth image, her prayer is inscribed on the frame: "My dear son, hear my prayer. Think of Theophilus who is in prison." Christ answers, "Mother, I grant your wish. Go and purchase the contract."[28] Thus, instead of the more traditional merger of image-text utterances in the form of a speech-scroll, the entire visualization of the Virgin's intercession is embraced by her prayer. The Virgin then rescues the charter, while one of the angels behind her drives a lance through the devil's mouth (fig. 216) in an unmistakable pictorial trope on the apocalyptic episode of Michael Battling the Dragon (see fig. 84) where the Woman in the Sun (the Virgin) leads the archangel's assault. In contrast with the tender, entreating character of the Virgin in the previous scene, the crowned Queen of Heaven now assumes the role of an aggressive combatant. Also armed, she wields a bundle of birch rods in a threatening gesture to coerce the forfeiture of the charter from the devil enthroned within a hell mouth. Again eschewing the traditional speech-scroll, the Virgin's command dominates the image as a rubric inscribed in the upper margin: "Return the contract, villain! God owes you his malice for you are filled with villainy. God confounds your life. Give it up immediately, I command you through my powerful son." The medieval Faustus legend concludes with the Virgin, again accompanied by an angel, restoring the charter, still affixed with its prominently displayed episcopal seal. A grateful Theophilus kneels in church, the sacred site of his first prayer, next to an altar temporarily bereft of its miracle-working image.

The last four episodes in the pictorial narrative unfold as binary pairs of images in double registers on facing pages. In a sequence evoking a causal relationship, two representations of prayer and intercession on the verso face a subsequent pair of scenes in which we see the resulting rescue and restoration of a sealed document. As in the preceding legend of Mercurius, Gautier stresses its moral significance by ending the story with a discourse on the triumph of humility over vainglory and pride. Similar homiletic and didactic concerns might thus account for the selection and coupling of the Mercurius and Theophilus stories as we find them in Ælfric's sermon on the Assumption of the Virgin.[29] Within the context of the Lambeth Apocalypse, however, the critical agency that binds the two legends is the role of the image of the Virgin in the intercession and the power of the image to mediate between the human and divine. The pivotal scenes in the center of the Theophilus narrative first show the remorseful Theophilus prostrate before a statue of Mary who "comes to life," raising her hand to acknowledge his petition as he prayed "touz jors a nus genouz devant l'image de Nostre Dame."[30] Juxtaposed in the lower register, it is the sight of another powerful image, his mother's breast, that reawakens Christ's mercy in a subsequent moment of salvific triumph. To demonstrate that it was indeed the power of the image on the altar that came to Theophilus's rescue, the last scene shows the chastened cleric kneeling before the altar vacated by the Virgin's sacred effigy, as she appears in her full-scale figural persona to return the annulled contract.

The power of the carved and painted image of the Virgin is evoked at the very beginning of the Lambeth Apocalypse in the frontispiece (fig. 187) representing a black-garbed monk applying colors to a small statue of the Virgin and Child raised on a pedestal, similarly bringing it to life through prayer and meditation. Mary bends toward him, responding to his prayer inscribed above, "Beloved of God, remember me" ("Memento mei amica dei"). The importance of imagery in thirteenth-century England cannot be overestimated, as witnessed by Matthew Paris's pictorial documentation of celebrated images of the Virgin and Christ created for St. Albans by the Benedictine sculptor, Walter of Colchester, most notably, the representation of the Virgin and Child that served as a frontispiece to the *Historia Anglorum* in which the artist-chronicler appears as a small pros-

Figure 216. Apocalypse. London, Lambeth Palace Library MS 209, fol. 47. Miracles of the Virgin: The Virgin Rescues the Charter from the Devil and Returns It to Theophilus (photo: The Conway Library, Courtauld Institute of Art, London).

trate figure next to his prayer.[31] Thus, the remarkable frontispiece in the Lambeth Apocalypse stands as a striking reminder of the power of visual images to generate the efficacy of prayer, as dramatically demonstrated in the miracles of Mercurius and Theophilus.

Introduced by the guiding image of St. Christopher, patron saint of pilgrims and travelers, the diachronic sequence of half-page narrative scenes setting forth the Life of John and the miracles of St. Mercurius and Theophilus evokes the idea of a journey only in the binding sense of metamorphosis. As each figure travels through time and space, he moves from one state of being to another – John's apocalyptic experiences on Patmos transform the preacher into a worker of miracles; Mercurius is resurrected from the dead to become a heroic victor over the pagan emperor; Theophilus, the repentant sinner, is redeemed. All are transformed through a power galvanized by seeing visions or images with the inner eye of the imagination and spiritual devotion.

Directly following the end of the Theophilus legend on the next verso, the first gathering of Lambeth's additional picture cycle ends with an abrupt shift to a full-page representation of St. John (fig. 14) seated on an ornate Gothic chair, writing in an open codex on a desk raised on an elaborately carved pedestal. As we are informed by the rubric in the upper margin, "Hic scribit sanctus iohannes apocalipsim post exilium suum," as well as by the sea surrounding his island prison, John is writing the Apocalypse on Patmos, inspired by an angel who flies down behind him. The full-page miniature in which John is already intently writing down all that he has seen "in a book" resembles the kind of Evangelist portrait that would more normally serve as a frontispiece to his Gospel, as suggested by the long scroll hanging from his desk inscribed with the incipit of his Gospel ("In principium erat verbum"). To the same end, the abrupt shift from Anglo-Norman to Latin in the inscriptions signals a claim to the lexical authenticity of Scripture. The portrait merging John's roles as seer on Patmos and Evangelist thus serves as a graphic demonstration of the Berengaudus gloss on 1:2 in which the exegete pointedly identifies the author of the Apocalypse as the writer of the Gospel, "for he guaranteed the testimony of the word of God when he said," "In principio erat verbum. . . ."[32] As John faces the next recto page, the authenticating author

portrait should logically face the incipit of the Apocalypse. Having established the nature of the book's experience as pilgrimage, Crusade, vision, and spiritual transformation, the first gathering of additional pictures seems to be preparing the reader-viewer for the experience of the visionary text.

In its present position at the end of the book, however, the traditional authorial image faces the first folio of the last gathering of additional pictures carrying a full-page representation of the Virgin and Child, with a small veiled figure of Eleanor de Quincy kneeling outside the frame (fig. 217). In contrast with the narrative "pre-text" material in the pe-

Figure 217. Apocalypse. London, Lambeth Palace Library MS 209, fol. 48. Lady Eleanor de Quincy Kneeling before the Virgin and Child Enthroned (photo: The Conway Library, Courtauld Institute of Art, London).

nultimate quire, the remainder of the cycle changes character and is now given over to a miscellany of standing saints holding their attributes, interspersed with moral allegories and scenes from the Passion. The second part of the pictorial addendum thus comprises an independent and separate series of devotional images designed for the spiritual contemplation of the reader. Given the clearly disparate character of the two gatherings of pictures, they could have been more plausibly planned as an enframing preface and epilogue, with the first quire (now the eighth) inserted between the last flyleaf, with its image of the Benedictine monk painting a statue of the Virgin, and the first folio of the illustrated Apocalypse, so that the author portrait on fol. 47v faced the beginning of the text.[33] Indeed, it seems further possible, as Morgan and Brown have already suggested, that the Lambeth Apocalypse was originally made for someone else and then, almost immediately appropriated by Lady de Quincy by adding pictures, including one bearing her portrait.[34] Dressed in a mantle emblazoned with the distinctive lozenges of her husband Roger, second earl of Winchester (d. 1264),[35] Eleanor, perhaps a recent widow as suggested by her veil, now lays claim to the book and the spiritual benefits of its visionary content.

As it most likely introduced a concluding sequence of pictures, the representation reveals Eleanor de Quincy gazing up from her book, presumably the illustrated Apocalypse she has just finished "reading." She sees in her mind's eye a monumental image of the Virgin and Child enthroned within an elaborate architectural frame. Rather than serving as a dedication page, the full-page representation would have originally faced the last illustration in the Apocalypse (see fig. 173), thus responding to John's ultimate vision of the Lord with a similar spiritual perception. Prompted by the visionary experiences within the book, the reader's imagination now fastens upon the familiar but powerful image of the Mother and Child that wrought the miracles of the devout monk, St. Mercurius, and Theophilus in the prefatory pages. Moreover, the very elaborate architectural frame evokes the idea of monumental carved figures enshrined within a niche in a church, similar to the statues that provided the focus of thirteenth-century devotion in major centers of Marian pilgrimage, such as Our Lady of Walsingham, whose statue was provided with a gold crown in 1246 by Henry

III.[36] The visualization of Eleanor as a devout pilgrim remembering or imagining herself in the presence of such a powerful votive image thus creates a striking visual symmetry with the initial representation of St. Christopher at the beginning of the first series of additional pictures, by evoking the goal of her spiritual journey. Whether the standing pose of the Christ Child or the bird held by the Virgin had any special resonance as distinctive features of the particular cult figure to which Eleanor paid homage cannot be known, because the Marian statues belonging the major English shrines of the period have all disappeared.[37] Nonetheless, as Jeffrey Hamburger suggests, the rare standing pose of the active child looks forward to Christ's adulthood, thus reinforcing his mother's role as intercessor.[38] As the Virgin clasps a small bird to her bosom along with the Christ Child who clambers to return her embrace, the powerful figure of the mediatrix might be seen to be taking Eleanor's soul in the form of a familiar aviary guise to her bosom for protective safekeeping. Indeed, the Virgin and Child image may have been intended to invoke the presence of an ivory statuette similar to the French figure now in the Victoria and Albert Museum,[39] perhaps a small replica of a famous shrine figure now powerfully magnified in Eleanor's imagination, which Lady de Quincy might have actually owned and before which she would have prayed in her private chapel.[40]

With a turn of the page, the reader is then confronted by a diagrammatic representation of a Cherub (fig. 218) whose six wings are inscribed to denote forms of virtuous behavior, based on the moralizing tract *De sex aliis Cherubim*, variously ascribed to Clement of Llanthony (d. 1190) and Alain de Lille (d. 1203).[41] Symbolized as feathers on the wings of the angelic being described in Isaiah 6, the inscribed image lists the stages of penance from the first condition of *confessio* to the final aspect of *dilectio Dei*. Although based on a mystical vision, the commentary constitutes a practical epitome for the confessional that was circulated with and without illustration. In some examples of the later *Speculum theologiae*, compiled in the last quarter of the thirteenth-century by the Franciscan John of Metz, there is a brief explanatory text: "This Cherub, depicted in human form, has six wings which represent the six acts of morality by which the faithful soul must be redeemed if it wishes to come to God by

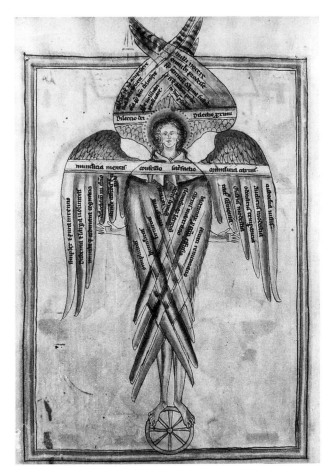

Figure 218. Apocalypse. London, Lambeth Palace Library MS 209, fol. 48v. Cherub Inscribed with the Virtues (photo: The Conway Library, Courtauld Institute of Art, London).

Lateran IV. Although adopted here for use by a lay-woman, the image originates in an iconographical tradition designed for clerical use, as witnessed by the late twelfth-century Cistercian example from Sawley Abbey and Harley 3244.[45]

On the facing recto (fig. 219), Mary Magdalene falls to her knees as she is the first to see the risen Christ (John 20:11–19). Holding his victorious cross-staff, Christ turns to command her, "Do not touch me." As the image appears out of its narrative context next to the Cherub, the message is unmistakably intended as an *exemplum* in which the penitent saint is rewarded with a privileged vision. Brought into dramatic focus by the powerful sweeping gesture of the resurrected Christ, whose angular form dominates the pliant curving forms of the twisting trees behind him, the rising movement of Magdalene's

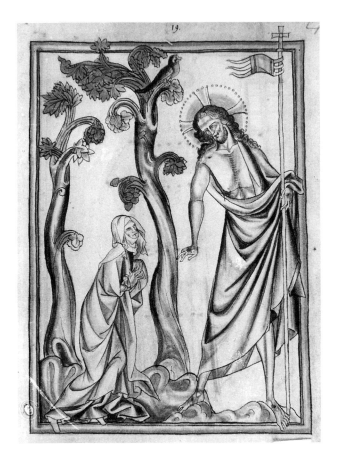

Figure 219. Apocalypse. London, Lambeth Palace Library MS 209, fol. 49. *Noli me tangere* (photo: The Conway Library, Courtauld Institute of Art, London).

increase of its virtues."[42] The six "moral acts" are written as titles on the wings of the Cherub[43]; the increments of virtue are inscribed on the five feathers of each wing.[44] Alain de Lille's *Cherub* constitutes a typical twelfth-century diagrammatic image acting primarily as a graphic token. Designed as an arbitrary, static referent to structure a moral argument, the diagrammatic word-image structure can effectively serve a mnemonic or lexical function for the illiterate or semiliterate reader. Juxtaposed with a representation of Mary Magdalene on the facing verso (fig. 219), the allegorical Cherub was obviously intended to serve as a practical mnemonic guide to confession, private penance, and the cultivation of moral virtue, responding to the conciliar demands of

surging body begins a steep ascent that ends with her gaze riveted on his radiantly nimbed face. The image thus focuses on the experience of vision, visual perception, and recognition, followed by faith, where Magdalene serves as a receptor and witness who, having not "recognized" Christ at first, suddenly "sees" him as the son of God and resurrected Lord.

As the unparalleled paradigm of the divine reward awaiting the penitent and contemplative saint, Mary Magdalene's first sighting of the resurrected Lord in the garden serves as a compelling dramatic sequel to the Cherub's frontal allegorical embodiment of confession, penance, and love of God on the facing verso. The painful delay in Magdalene's mistaking Christ for a gardener before she recognizes him is effectively conveyed by the conventional tree that first conceals his identify from her without concealing it from the viewer.[46] Within the context of the cultivation of the virtues, the strategy is an important one, for it serves to bring to the thirteenth-century viewer's mind the interpretation given to Magdalen's initial error by various medieval commentators. As formulated by Odo of Cluny,

This woman was not entirely mistaken when she thought the Lord a gardener. For just as the duty of a gardener is to eradicate harmful weeds so that good plants may be able to come forth, so the Lord Jesus daily eradicates vices from his garden . . . so that virtue may increase.[47]

Gregory the Great, as well as Alcuin, further observed that to Mary Magdalene, Christ was a spiritual gardener, planting virtue in her heart through seeds of love.[48] Among the many medieval writers to stress Magdalene's vision as a reward to the repentant sinner, Honorius Augustodunensis declares that "After defiling herself with much vileness, [she] bathed herself in the fountain of tears and deserved to be the first to see the risen Christ."[49] More directly to the point of the viewer's experience of gazing at the devotional images in Lambeth 209 is the gloss encountered in the *Bible moralisée*, where the Lord's first appearance to the weeping Magdalene signifies that "the Lord reveals many of his secrets to those who love his image most, in tears and penitence."[50] The accompanying illustration (fig. 220) shows Christ appearing in the clouds above two groups of figures devoutly gazing at a crucifix placed on an altar. Thus, as Henderson and Morgan suggest, Lady de Quincy, as the lay owner of the book contem-

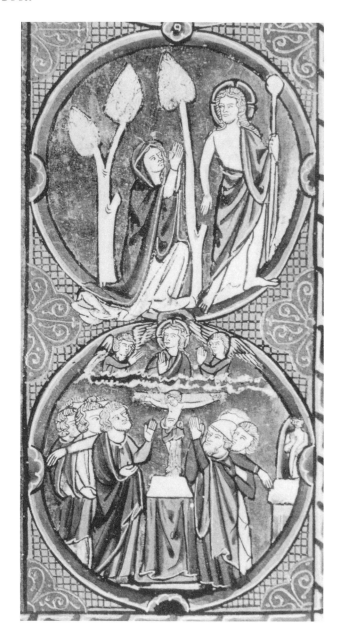

Figure 220. *Bible moralisée*. London, British Library MS Harley 1527, fol. 59v. *Noli me tangere*; Commentary Illustration for John 20:14–16 (photo: after Laborde 1911–27).

plating its imaged admonitions to virtue and penitence, is invited to see herself in the similarly veiled figure of Magdalene gazing upon the risen Christ.[51] The invitation to emulate this most celebrated of medieval saints is voiced again and again, typified by an anonymous Cistercian hagiographer who writes:

Happy is the one who heard all this concerning Mary Magdalene with pleasure. Happier the one who believed it and remembered it with devotion. Yet happier still is the one who . . . burned to imitate her.[52]

The next two openings constitute a series of hagiographical effigies of St. Lawrence, St. Catherine, St. Margaret (fig. 221), and St. Edmund (fig. 222). The first three figures make an abrupt shift from the narrative representation of *Noli me tangere* to an iconic mode of standing frontal figures holding attributes signaling that the figures are to be understood in a symbolic sense. As they confront the viewer in an act of transcendent self-revelation, they engage in "mute preaching" addressed to the reader.[53] Tonsured and dressed in a deacon's garb, St. Lawrence holds a gridiron and palm as emblems of his martyrdom. Similarly, St. Catherine of Alexandria is crowned, holding a scepter and a flaming wheel, and on the following verso, St. Margaret of Antioch holds a torch to signify one of her ordeals,[54] as in her customary guise she triumphs over the dragon under her feet. Analogous to the representations of saints appearing in Psalters and Books of Hours, the frontal figures directly engage the viewer's gaze as if to evoke the recitation of the litany, suffrages, or similarly targeted prayers, as in the series of saints in the later *Supplicationes variae*.[55] Under the influence of the Crusades, the two Eastern virgin martyrs, Catherine and Margaret, were often represented together as objects of popular devotion in the West from the twelfth century on. In a Byzantine icon from Mt. Sinai dating from the eleventh century,[56] they stand together, Catherine wearing a crown and Margaret with a veil, as they appear in the Lambeth effigies. In the wake of the Apocalypse cycle, St. Margaret offers a reprise on the Woman in the Sun, as she stands triumphant over the dragon, holding a torch-like flail as an emblem of her mastery over the beast.

Whereas the martyrs Lawrence, Catherine, and Margaret constitute standard fare amongst the saints pictorially invoked in thirteenth-century English Psalters, the image of St. Edmund (fig. 222), king and martyr, has few contemporary precedents, despite the widespread popularity of his cult.[57] Moreover, the equally abrupt return to a narrative mode in the representation of the Martyrdom of St. Edmund signals another shift in the viewer's intended response, perhaps from the passive recitation of memorized prayers to more active meditation on the spiritual

Figure 221. Apocalypse. London, Lambeth Palace Library MS 209, fol. 50v. St. Margaret (photo: The Conway Library, Courtauld Institute of Art, London).

significance of the image. As he appears in the contemporary prefatory picture cycle in John of Dalling's Psalter from St. Albans,[58] crowned, nude to the waist, and wearing breeches tied at the knees, St. Edmund turns around, making his body a passive target for the three Danes shooting arrows at him. Bound to a tree in a pose evoking that of Christ in traditional renderings of the Flagellation preceding the Crucifixion, St. Edmund provides a moving antecedent to the representation of Christ's death represented on the next verso. The resemblance between St. Edmund's martyrdom and Christ's Passion on the cross is invoked as a poignant refrain in the new vernacular account of the saint's life, *La Vie Seint Ed-*

Figure 222. Apocalypse. London, Lambeth Palace Library MS 209, fol. 51. Martyrdom of St. Edmund by the Danes (photo: The Conway Library, Courtauld Institute of Art, London).

The last piece of the puzzle then falls into place when we consider a contemporary, closely related representation of St. Edmund in the Gulbenkian Apocalypse (fig. 223), where the royal martyr, as defender of the faith, leads a group of righteous kings armed with swords, visualizing the Berengaudus commentary on the angel sounding the fifth trumpet.[61] As St. Edmund also holds a small crucifix to his heart, he reminds the reader of the Christomimetic nature of his martyrdom. The sudden shift in the Lambeth sequence thus brings into focus the realization that St. Edmund, "li seint rei, arme de creance e de fei,"[62] is turning his heart filled with profound faith as both target and shield toward his executioners to form a pictorial analogue to the subsequent allegorical image (fig. 228) in which a veiled woman holding the Shield of Faith fends off an attack by a devil aiming a bow and arrow. With a turn of the page, the idea of St. Edmund's martyrdom as the ultimate act of *imitatio Christi* then materializes before the reader's eyes in a monumental visualization of the Crucifixion.

In its complexity and symbolism, the Crucifixion scene in Lambeth (fig. 224) is extraordinary if not unique in thirteenth-century English art. The tortured bent body on the cross offers a dramatic exaggeration of the pathetic dead Christ typical of the period, so that the body slumps so far below the cross-arm that the nimbus has become detached from

mund le Rey, written in Anglo-Norman verse by Denis Piramus, ca. 1240:

> Quil out ensuivi la trace
> De Jhesu Crist, qui par sa grace
> Suffrit e morte e passiun
> Pur nus e nostre raanciun.[59]

An unexpected connection with St. Mercurius occurs earlier in a Bury St. Edmunds hagiography dating from ca. 1100 in which St. Edmund is compared to the martyr who triumphed over Julian the Apostate through a miracle of the Virgin.[60] St. Edmund might be thus perceived as an English counterpart to the more distant Early Christian saints Lawrence, Catherine, and Margaret who also emerged victorious over their pagan executioners through martyrdom.

Figure 223. Apocalypse. Lisbon, Calouste Gulbenkian Museum MS L.A.139, fol. 19v. Commentary Illustration for the Fifth Trumpet (photo: The Conway Library, Courtauld Institute of Art, London).

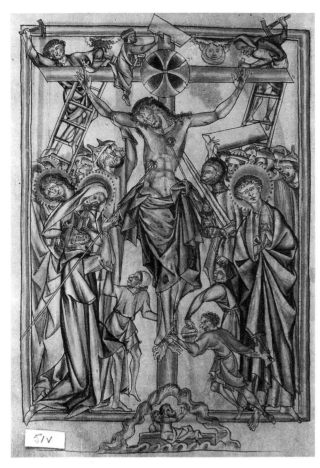

Figure 224. Apocalypse. London, Lambeth Palace Library MS 209, fol. 51v. Crucifixion (photo: The Conway Library, Courtauld Institute of Art, London).

Christ's head and remains isolated as a circular cruciform emblem at the intersection of the cross. The figure corresponds very closely to a drawing made by Villard de Honnecourt in his *Sketchbook* (fig. 225) of a famous image that can probably be identified as the huge gold and jewel-encrusted cross that Abbot Suger had raised above the entrance to the new choir of St. Denis.[63] Judging from a similarly renowned reliquary cross in the Treasury of San Marco, probably made in 1206 in Constantinople for Henry of Flanders, the *crucifixus dolorosus* was a new Byzantine type introduced into the West through the Crusades.[64] The distinctive formulation of affixing the body to the cross with three nails creates an equilateral triangle, which can be perceived as a symbol of

the Trinity[65] and hence a "shield of faith" analogous to the diagrammatic version occurring in Lambeth's allegorical illustration on fol. 53 (fig. 228). An indirect reference to the three-nailed Crucifixion as a shield is poignantly made in the *Ancrene Riwle*, ca. 1215–22:

This shield which covered his godhead was his dear body that was extended on the cross, broad as a shield above, in his outstretched arms, and narrow beneath, because, as is supposed, one foot was placed upon the other.[66]

The most distinctive feature of Suger's cross was the large gold "crown" or nimbus located at the intersection of the arms of the cross beneath the *titulus* containing a relic of the True Cross. Even more clearly than in Villard's drawing, the Lambeth representation documents the nature of the large flat enameled plate marked by a cross with flaring arms that constituted the "crown" of Suger's cross.[67] In the description of his great cross, Suger included the surrounding figures gazing in awe at the death of the Savior, most particularly the centurion holding a phylactery inscribed VERE FILIUS ERAT ISTE.[68] All witness the divinity of Christ expiring on the cross, thus conferring upon the Crucifixion the character of a cosmic theophany, a salvific drama that is fully played out again in the monumentally conceived Lambeth Crucifixion.

Contrasting with the more abstract allegorized Crucifixion images of the thirteenth century, such as those in the Psalter of Robert de Lindesey or the Amesbury Psalter, where the symbolic triumph of Church over Synagogue is expressed in personifications appearing in isolated compartments in the frame next to the Virgin and John, the same message in Lambeth is cast in more elusive but at the same time more highly pitched emotional terms. Here the place of the Church is taken by the centurion and Synagogue by the man with the sponge.[69] After piercing Christ's right side with his lance, Longinus recognized the son of God. Loudly proclaiming his belief, the blind centurion was cured by a drop of Christ's blood. According to the *Glossa ordinaria*,[70] Longinus stands for the new Church; he is there to teach men that with the Crucifixion the faith passed from the blind Jews to the gentiles who recover their sight. In the Lambeth scene, the Virgin hovers over the centurion, who falls to his knees as he gazes into Christ's wound with one eye closed and the other

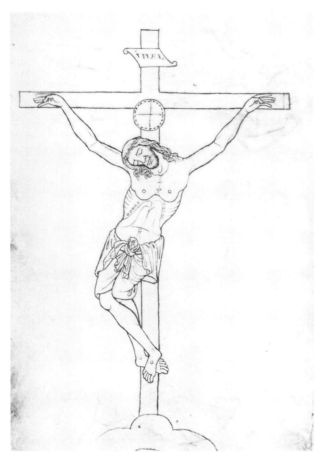

Figure 225. Villard de Honnecourt, *Sketchbook.* Paris, Bibliothèque Nationale MS fr. 19093, fol. 2v. Crucifix (Phot. Bibl. Nat. Paris).

open to signify the miracle of his restored vision.[71] On the other side, the man with the sponge, who is traditionally identified as a Jew, represents Synagogue, for, according to the *Glossa ordinaria* on Luke 23:36, the vinegar with which he filled his sponge signifies the old and now unsound doctrine of the Judaic Law.[72] Mary's relationship to the centurion establishes her allegorical role as the Church, in accordance with the traditional alignment of the personification of Ecclesia with the Virgin in Crucifixion scenes, as in the Amesbury and Robert de Lindesey Psalters. Indeed, Jacobus de Voragine cites a Marian sermon in which it was argued that, because at the Crucifixion all but Mary lost faith, the

Church took refuge in her heart, for she is then the Church.[73] John's association with the Synagogue is no less traditional but more obscure, based on the interpretation of John 20:1–9 given in the *Glossa ordinaria.*[74]

Whereas the man nailing the feet of Christ at the base of the cross appears occasionally in thirteenth-century English Psalter illustrations, the figures on ladders nailing Christ's hands to the cross-arms are almost without precedent. The rare occurrence of the image in the Toledo version of the *Bible moralisée* (fig. 226) tends to confirm the existence of a textual reference prior to the Meditations on the Life of Christ by the Pseudo-Bonaventure, probably dating from the 1290s, where we read: "Two ladders are set in place . . . which the evildoers ascend holding nails and hammers."[75] The small figure placing the signboard at the summit can be recognized as Pilate, for according to the Gospel of John 19:19–22, it was Pilate who wrote the title ("Jesus of Nazareth, King of the Jews") and put it on the cross, but the chief priests objected, saying, "Write not 'King of the Jews,' but that he said, 'I am King of the Jews,' to which Pilate replied, 'What I have written, I have written.' " This is possibly what was intended by the second larger scroll raised by the crowd of Jews beneath the cross at the right in the Lambeth representation. The only known medieval English precedent for this rare iconography is offered by the two figures of Pilate and the high priest who stand with their scrolls in a disputation scene above the title board on the twelfth-century cross from Bury St. Edmunds now in the Cloisters. In the *Glossa ordinaria*, the *causam* inscribed on the title board stands as testimony to the blindness and obstinacy of the Jews,[76] as in an interlinear gloss written in the Gospel of Mark at Bury St. Edmunds in the late twelfth century: "Wherever the three languages appear together in the title of the cross, these languages commemorate the faithlessness of the Jews in Hebrew, Greek, and Latin."[77] Moreover, the *Glossa ordinaria* may provide a clue to the significance of the detached nimbus inscribed with a cross beneath the title board above Christ's head in its quotation of Bede's interpretation of *titulus rex* that the "king" offers the Father his body on the cross just as the priest offers the host at the altar.[78] In the thirteenth-century *Bible*

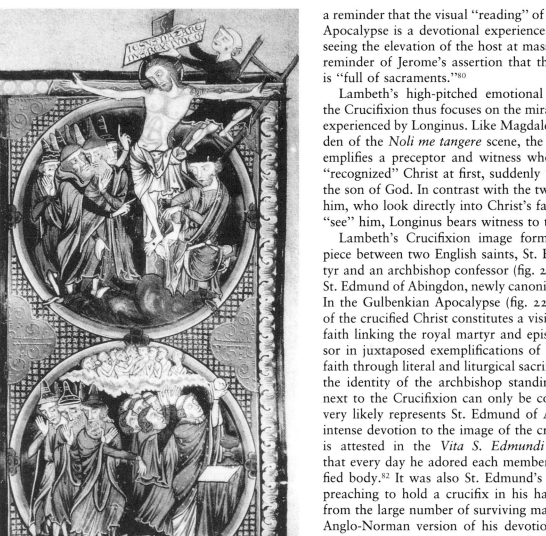

Figure 226. Bible moralisée. Toledo, Cathedral Treasury MS III, fol. 64. The Title Board Being Affixed to the Cross (above); Commentary Illustration: Elevation of the Host (below) (photo: after Laborde 1911–27).

a reminder that the visual "reading" of the illustrated Apocalypse is a devotional experience analogous to seeing the elevation of the host at mass, as well as a reminder of Jerome's assertion that the Apocalypse is "full of sacraments."[80]

Lambeth's high-pitched emotional rendering of the Crucifixion thus focuses on the miraculous vision experienced by Longinus. Like Magdalene in the garden of the *Noli me tangere* scene, the centurion exemplifies a preceptor and witness who, having not "recognized" Christ at first, suddenly "sees" him as the son of God. In contrast with the two Jews above him, who look directly into Christ's face but do not "see" him, Longinus bears witness to the faith.

Lambeth's Crucifixion image forms the centerpiece between two English saints, St. Edmund Martyr and an archbishop confessor (fig. 227), probably St. Edmund of Abingdon, newly canonized in 1246.[81] In the Gulbenkian Apocalypse (fig. 223), the image of the crucified Christ constitutes a visible symbol of faith linking the royal martyr and episcopal confessor in juxtaposed exemplifications of defending the faith through literal and liturgical sacrifice. Although the identity of the archbishop standing on fol. 52 next to the Crucifixion can only be conjectured, he very likely represents St. Edmund of Abingdon; his intense devotion to the image of the crucified Christ is attested in the *Vita S. Edmundi* that reports that every day he adored each member of the crucified body.[82] It was also St. Edmund's custom when preaching to hold a crucifix in his hand.[83] Judging from the large number of surviving manuscripts, the Anglo-Norman version of his devotional tract, the *Speculum ecclesiae*, was widely read.[84] An office for St. Edmund of Abingdon occurs frequently among the relatively few *memoria* included in English Books of Hours dating from the second half of the thirteenth century.[85] As in the very similar figure of the standing archbishop among the mid-thirteenth-century drawings added to the Westminster Psalter, the mitered figure wears a ring, which might be associated with the legend that St. Edmund symbolically betrothed himself to the Virgin by placing a ring on the finger of her statue.[86] His special devotion to her image might in part have inspired Lambeth's antecedent illustrations of the three miracles of the Virgin involving her statue in the frontispiece and the

moralisée (fig. 226), the commentary illustration shows a priest raising the host at mass, while a group of Jews turns away.[79] For the pious viewer, Lambeth's juxtaposition of Christ's body on the cross beneath the huge cross-inscribed host can thus serve as

Figure 227. Apocalypse. London, Lambeth Palace Library MS 209, fol. 52. St. Edmund of Abingdon (photo: The Conway Library, Courtauld Institute of Art, London).

first gathering of additional pictures. Indeed, the image before which Lady de Quincy reads her book (fig. 217) evokes a passage from a contemporary life of St. Edmund:

Whilst books lay before him . . . there was placed above them and facing him an image of the Blessed Lady in ivory of consummate workmanship. She was seated on a throne . . . thus he ever kept before his eyes the visible representation of those truths which the Scripture inwardly suggested to his mind.[87]

An almost identical frontal standing figure of an archbishop faces the reader on the next verso. Also wearing full pontificals, he, too, holds a processional staff surmounted by a crucifix, but the right hand raised in blessing does not bear a ring. Most likely this figure was intended to represent St. Thomas of

Canterbury, martyred in his cathedral in 1170. As Borenius points out, the standing effigy, mitered and wearing a dalmatic and pallium, blessing with his right hand and holding a tall cross-staff in the other, constitutes a standard type for Thomas Becket.[88] In Lambeth 209, his juxtaposition with the allegorical representation of the Shield of Faith on the opposite recto (fig. 228) invites the reader's meditation on Thomas's role as guardian and defender of the faith. He now holds the processional cross with which Edward Grim, his last loyal companion, had attempted to protect him against the attack made by the king's men. As in one of the earliest extant manuscript illustrations in Harley 5102 dating from about 1180, as well as in Matthew Paris's mid-thirteenth-century representation of the Martyrdom of Thomas of Canterbury in the *Chronica majora*, Edward Grim is traditionally shown in the act of thrusting or planting Becket's cross in the path of the assassin's sword to act as a shield breaking the force of the attack.[89] Thomas of Canterbury thus stands as a sentinel, holding his cross as a "shield of faith," serving as an exemplary witness to the power of faith allegorically represented on the opposite page. Presumably, it is the same processional cross held by St. Edmund of Abingdon in the prior illustration, where it signifies Becket's legacy of spiritual power to succeeding Primates of England. Indeed, Edmund holds a tall cross-staff as an insigne of office in Matthew Paris's drawing of the archbishop's consecration in the *Historia Anglorum*.[90]

Notwithstanding the temptation of the modern viewer to see nothing but redundancy in the almost identical images of the two sainted Archbishops of Canterbury back to back on the recto and verso of a single folio, the visual relationship literally evokes St. Edmund's spiritual emulation of St. Thomas Becket, as he is known to have constantly sought the counsel and consolation of his predecessor.[91] In the later annals of St. Albans, the chronicler reports that Edmund had a small private seal made for himself, bearing the image of Becket's martyrdom with the figure of the mitered Edmund praying below, inscribed with Thomas's words addressed to his supplicant successor: "Ut Edmundum doceat mors mea, ne timeat." Gazing upon this seal, the annalist continues, Edmund saw it as a mirror, the source he ought to pursue after the martyr's example.[92] In the Lambeth pictures, the effigy of St. Edmund literally

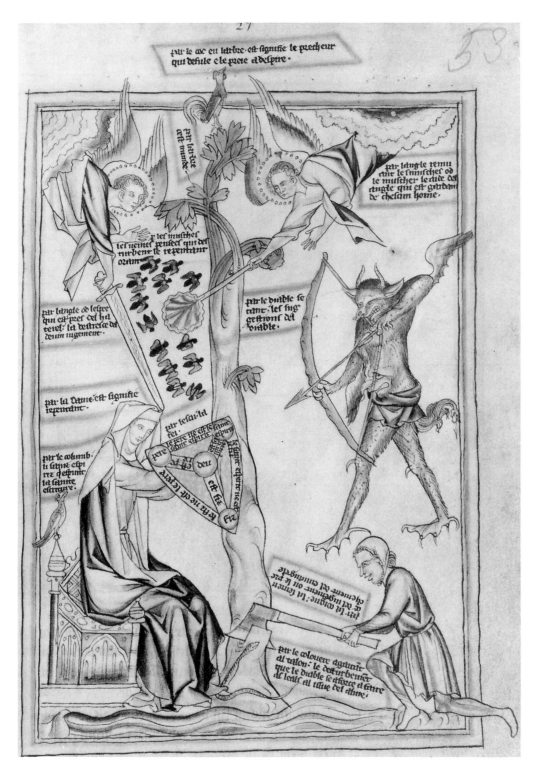

Figure 228. Apocalypse. London, Lambeth Palace Library MS 209, fol. 53. Allegory of Faith and Penitence (photo: The Conway Library, Courtauld Institute of Art, London).

"mirrors" that of St. Thomas, as on the obverse and reverse of a seal.

Standing at the end of the interrupted sequence of frontal standing saints, Thomas Becket and Edmund of Canterbury bring the procession of martyrs and confessors full circle, reminding the reader of the special role accorded to St. Lawrence by the English Church. Heading Lambeth's pictorial litany, the martyred deacon is tonsured and wearing a dalmatic, holding a palm and the instrument of his martyrdom, the gridiron, as an identifying attribute, as he appears in a thirteenth-century wall painting at Frindsbury (Kent) and in the contemporary Psalter Morgan MS M.756.[93] Reading Abbey possessed a relic of the Roman martyr encased in a casket shaped like a gridiron, which had been sent by Pope Vitalian to King Oswin in the seventh century with a letter acknowledging the king's conversion.[94] As commemorated by Bede in his *Ecclesiastical History*, the arrival of St. Lawrence's relics was associated with the conversion of the English people and with the episcopal organization of the English Church. Thus, in thirteenth- and fourteenth-century wall paintings, St. Lawrence sometimes appears with Sts. Edmund of Canterbury and Thomas of Canterbury.[95]

The penultimate image in the Lambeth series (fig. 228) is composed of a complex pictorial allegory of Penitence and Faith, executed on a separate leaf inserted into the quire before the last (blank) folio.[96] Contrasting with the more formal and dogmatic Latin character of the static and symmetrical Cherub on fol. 48v, the allegory unfolds as an active scene in which the personified and objectified forces of good and evil, each inscribed in Anglo-Norman, engage in spiritual warfare. A large tree representing the world ("Par larbre cest munde") divides the pictures vertically into two halves. At its summit is a crowing cock that signifies the preacher who urges his hearers to despise the world. At the left, an angel flies down from a cloud wielding a sword "that comes close to the nape of the neck, signifying the strictness of divine judgment." At the right, another angel flies down with a flabellum to chase away a swarm of huge flies, representing the vain thoughts that disturb the penitent in prayer. Below the guardian angel at the right, a hairy, horned demon aims a bow and arrow at a veiled woman seated on the other side of the tree; she shields herself against his attack with a shield emblazoned with a triangular

emblem signifying the Trinity. Thus, Penitence, personified by the woman ("Par la dame est signifie repentant"), protects herself with Faith, signified by the shield ("Par lescu la fei"), against the temptations of the devil. The contrition of the penitent is further protected by "the dove of the Holy Spirit expounding Holy Scripture." The serpent writhing under the woman's foot, "lying in wait," represents the devil's further disturbance of the souls of the faithful. At the right, a kneeling woodsman wields an axe against the trunk of the tree symbolizing the world in an act signifying "the sentence of judgment or the preaching of the Gospel." The meaning of the axe is made known to the devil by inverting the inscription on the placard so that it can be read from above. At the base flows a stream representing Holy Scripture promulgated by the preacher. Lambeth's complex allegory is thus focused on an implied narrative in which a number of angelic and diabolical forces converge from all directions on a dual target embodied in the veiled woman who personifies Penitence and is protected by the symbolic Shield of Faith. As in the image of the veiled Magdalene in the *Noli me tangere*, the aristocratic woman for whom the additional cycle was designed was presumably intended to see herself reflected in this figure.

Unlike the other images in Lambeth's enframing pictorial cycle, which function as devotional icons, narrative *exempla*, or pictorial diagrams, the Allegory of Penitence and Faith was obviously intended to be perceived and understood as an interactive synthesis of words and images closely analogous to the "reading" and absorption of the illustrated glossed Apocalypse. The reader-viewer is confronted with a complex agglomeration of visual images, each recognizable in its own right as tree, angel, sword, and so forth, but that cannot be comprehended literally or without an accompanying lexical gloss in the form of explanatory inscriptions, most of which appear to have been drawn from currently accessible compilations of scriptural exegesis, as in the case of the cock signifying a preacher from the *Glossa ordinaria*.[97] The reader's experience upon approaching the end of the manuscript is to be reminded of the visionary and allegorical terms in which the book as a whole is to be understood. The visible world is only an illusion to be traversed as a system of signs and symbols. Like John on Patmos, the veiled woman finds herself in a transitory, liminal world inhabited by angels and de-

mons, but, unlike the visionary on Patmos, she is guided by the voices of birds (cock and dove) preaching against the world and expounding Holy Scripture, rather than by what she sees. Indeed, the penitent woman looks inward behind her emblematized spiritual armor, absorbing the disparate images surrounding her into an internal vision of spiritual and moral understanding.

Outside the context of the Apocalypse, the image of spiritual warfare was used most frequently as an image of monastic discipline.[98] The battle cry against the forces of evil forms a sturdy thread that runs through the Rule of St. Benedict: "You are renouncing your own will to do battle under the Lord Christ, the true King, and are taking up the strong, bright weapons of obedience. We must prepare our hearts and bodies to do battle."[99] Based on Ephesians 6 ("Put on God's armor to resist the devil's tactics"), the image of the shield against the demon in the Lambeth allegory clearly evokes St. Paul's admonition in verse 16: "And always carry the shield of faith so that you can use it to put out the burning arrows of the evil one." The symbolic shield carried by the woman is emblazoned with an inscribed diagrammatic emblem of the Trinitarian doctrine familiar within English ecclesiastical circles by the second half of the thirteenth century. An elaborate representation of the *Scutum fidei* by Matthew Paris is included in the *Miscellanea* compiled by John of Wallingford at St. Albans shortly before 1258. Prefaced by a reference to Ephes. 6:16, arrows shot by two demons at the right and left bounce off the large triangular shield.[100] Although the symbolic shield appeared earlier in a more schematic form as a marginal drawing in the *Chronica majora*, the theological diagram was not Matthew's invention, but was more probably created by Robert Grosseteste to accompany his *Dicta* on the Shield of Faith, as it appears on fol. 14v in Durham Cathedral MS A.III.12, which dates before 1231.[101] Another spiritual battle in which the shield of faith is used as armor against sin occurs in an illustration prefacing a mid-thirteenth-century English copy of Peraldus's *Liber de vitiis* in which a Dominican friar kneels at the feet of Christ and an angel carries a scroll inscribed with a text from II Timothy 2:5, reflecting Pope Honorius III's description of the Order of Preachers as "the invincible athletes of Christ, armed with the shield of faith."[102] As Evans points out, the *Scutum fidei* was identified

with the Trinity by the Dominican Hugh of St. Cher in his commentary on Ephesians dating from the 1230s.[103]

Like the Cherub, the image of the Shield of Faith belongs to the repertory of iconography found in texts intended for clerical use rather than lay devotion, as witnessed by its isolated appearances in Grosseteste's *Dicta*, Matthew Paris's *Chronica majora*, John of Wallingford's *Miscellanea*, and in the compilation of texts in Harley 3244 very probably intended for Dominican use,[104] as well as in the commentary illustrations on Rev. 12:17–18 in the Gulbenkian and Abingdon Apocalypses, where the symbolic shield is suspended next to a bishop standing in prayer before an altar, and outside a demon aims an arrow at the Church. Along with Alain de Lille's Cherub, its appearance in the Lambeth cycle suggests the critical involvement of a clerical advisor in the design. One of the most striking metaphorical uses of the shield occurs in the *Ancrene Riwle*, as we have already seen, in an image evoking the power of the crucified Christ, where "he engaged in a tournament, and had for his lady's love, his shield everywhere pierced in battle, like a valorous knight." Elsewhere, the pious nun is advised, "if thou wish that the holy rood-staff should be thy shield, and that the Lord's painful sufferings should foil the devil's weapons . . . lift it high above the head of thy heart . . . hold it up against the enemy and show it to him distinctly."[105]

Coupled with the demonstration of the power of faith as a shield against moral and doctrinal attack is the importance of penitence and its attendant demand for penance *(satisfactio)* in acts of reparation and retribution. Thus, a means of remission of temporal penalties to be suffered in Purgatory is offered to the reader by turning to the last page on the reverse. Here the image of the Veronica (fig. 229) is accompanied by a special prayer composed by Innocent III, which, when recited in the presence of the image, carried an indulgence of ten days.[106] Among the large number of extraliturgical compositions inspired by the Holy Face in the later Middle Ages, the prayer of Innocent III is the oldest and appears for the first time in England at midcentury accompanying two painted drawings by Matthew Paris, the earliest pasted onto a binding strip in Arundel MS 157 to serve as the frontispiece for a Psalter probably intended for an Augustinian house in or near Oxford,

and a somewhat later version pasted in the *Chronica majora*, each accompanied by the same prayer inscribed below.[107] Judging from its further appearance in the Evesham Psalter given to the abbey by Henry of Worcester (d. 1263), and the end pieces in the Westminster Psalter and in the Italian *Supplicationes variae* made for Franciscan use,[108] the circulation of the Veronica and its prayer appears to have been confined to a narrow ecclesiastical circle of Benedictine and Augustinian houses in the 1250s and 60s. Other isolated occurrences in the commentary illustrations of the Gulbenkian and Abingdon Apocalypses tend to confirm this.[109]

Like all the English Gothic versions, Lambeth's Veronica conforms to the image introduced by Matthew Paris, based on the description by Gervase of Tilbury of the Roman relic as a bust portrait ("effigies a pectore superius") and configured as the apocalyptic Christ flanked by the Alpha and Omega.[110] Although the direct lexical references to the Lord of Revelation disappeared from all but Matthew's documentary version made for the *Chronica majora*, the image of the Holy Face alone nevertheless carries connotations of the Second Coming when the veil will be lifted and the faithful will see Christ "face to face," as given at the end of the accompanying prayer: "Ut te tunc facie ad facem securi videamus iudicem venientem super nos Dominum nostrum Jesum Christum." Alone among thirteenth-century English representations of the Veronica, the Lambeth icon presents itself as a miraculous image "made without human hands" *(acheiropoietos)* by referring to the cloth on which the imprinted face was made in the woven pattern occurring in the corner interstices surrounding the crucifer nimbus. The face is thus perceived as a reflection fixed in a mirror. As Ewa Kuryluk observes, "since God, the sun, could not be faced, he needed a medium through which his otherwise unbearable luminosity could be conveyed."[111]

The Veronica "portrait" and prayer constitutes the last spiritual vision in a whole series of pictures in which the power of the image is made paramount. In the wake of the Latin plundering of Constantinople's relics and icons, the *Vera Icon* can be seen as the ultimate paradigm of the new thirteenth-century cult of image authenticity and as the goal of a spiritual pilgrimage inaugurated under the protective aegis of St. Christopher.[112] As Matthew Paris informed

Figure 229. Apocalypse. London, Lambeth Palace Library MS 209, fol. 53v. Veronica (photo: The Conway Library, Courtauld Institute of Art, London).

the reader of the *Chronica majora*, the prayer should be recited in the presence of the image to gain its best effect: "Multi igitur eandem orationem cum pertinentiis memoriae commendarunt, et ut eos major accenderet devotio, picturis effigiarunt hoc modo." Beginning with the image of St. Christopher, the sight of whom was sufficient to guarantee safe return from a journey, the viewer then proceeds on a spiritual pilgrimage in which the faculty of sight and the operative force of images recur as powerful leitmotivs. The miracles of St. Mercurius and Theophilus are wrought through prayers addressed to the image of the Virgin. Eleanor de Quincy offers the book itself to the image of the Virgin. At the Crucifixion, Longinus's sight is restored as his lance pierces Christ's side, and Magdalene recognizes the resurrected Christ who offers a visual revelation of his divine nature but prohibits further sensory verification ("Do not touch me"), stressing the importance

of "seeing" God. In a similar vein, Alain de Lille explains the allegorical figure of the Cherub as a dual metaphor, for the angel signifies the total understanding of Scripture in its historical, allegorical, and tropological senses, because in eternity, the face of God is not veiled or hidden, but revealed and manifest, and "the angels always behold the face of my Father who is in heaven" (Matt. 18:10). Through the angel, "we shall be seeing face to face what we now see as only a dim reflection in a mirror, and shall then gain full understanding (I Cor. 13:12)." Alain makes it clear that he is not referring to prophecy but to the picture.[113] An allusion to "Videbimus eum faciem ad faciem" from I Cor. 13:12 also occurs in Innocent III's prayer to the Veronica ("ut te tunc facie ad faciem"), reinforcing the visual experience of spiritual enlightenment described by Alain de Lille.

Visual perception has become a powerful tool and ally in the exercise of active contemplation, as images provide the impetus to spiritual understanding and moral perfection. Alain de Lille concludes his excursus on the figure of the Cherub by saying

As this example makes evident to you, just as you see completely the total person of Christ, that is, the head with limbs, painted in visible form, so you can understand more easily those parts which are said to be invisible.[114]

More directly to the point of Lambeth's interlocking nexus of images is the prayer of St. Edmund of Canterbury to St. John the Evangelist: "O holy and blessed John, apostle and evangelist of God, who . . . was loved by him above all the rest, obtain for me from our Lord the gift which was granted to thee . . . with the ardent desire of seeing the much desired face of my Lord Jesus Christ."[115]

Evidence of another book planned for Lady de Quincy, either Eleanor or Maud, may appear in a note on fol. 2v of the *Vie de Seint Auban* (Dublin MS 177) written in Matthew Paris's hand in which he gives instructions for a set of miniatures probably intended as a short prefatory cycle for a Psalter: "In the countess of Winchester's book let there be a pair of images on each page thus," followed by a list of verses describing Sts. James the Great, John, Andrew, Thomas, Martin, Nicholas, Alban, Amphibalus, Leonard, Giles, Joachim, Anne, and Bartholomew.[116] The note appears beneath a rough unfinished sketch of the Virgin and Child, suggesting that Matthew

may have intended this as a model for the first or last page, to be followed or preceded by six pairs of saints on the remaining pages of the two bifolios. That the book was intended for the lady's own use is indicated by the inclusion of Sts. James the Great and John, heading the series as a pair on the first page, for they were the patron saints of the hospital at Brackley, which was heavily endowed by the De Quincy family.[117] Although the Psalter produced at St. Albans for the use of the monk John of Dalling gives an indication of the sort of book intended for the countess of Winchester, Paris's program is both very brief and simple in comparison with the nine pages of full-page illuminations in double registers in Roy. 2.B.VI, which includes Infancy and Passion cycles of five scenes, a Passion cycle of four scenes, the martyrdoms of Sts. Edmund, Alban, and Amphibalus, eight saints seated with attributes, and ends with an image of the Virgin and Child. Indeed, the St. Albans cycle has more in common with the additional pictures in the Lambeth Apocalypse than with Matthew Paris's list for the countess of Winchester's Psalter; Lambeth 209 and Roy. 2.B.VI both include representations of the Crucifixion, Martyrdom of St. Edmund, John the Evangelist, an archbishop saint (Edmund of Abingdon?), St. Catherine, and the Virgin and Child.

Given the extraordinary depth of religious commitment expressed in the devotional pictures appended to the Lambeth Apocalypse, they could well have been designed to meet the spiritual needs of a widow preparing herself for life within a nunnery, following the pattern of many noblewomen who chose to withdraw from the world after their husbands died.[118] Thus, the veil worn by Eleanor,[119] as well as that worn by Magdalene and the personification of Penitence, might signal Lady de Quincy's brief intention between 1264 and 1267 to enter a nunnery within the diocese of Winchester, such as Romsey Abbey dedicated to the Virgin and St. Elfleda or Nunnaminster, St. Mary's Abbey within Winchester itself. A particularly likely choice would have been the Cistercian priory of Sts. Mary and Magdalene at Wintney, which appears to have flourished under aristocratic patronage at midcentury and to which Maud de Quincy had made a major donation for the building of the dorter.[120]

The interlocking complexity of the pictorial program as well as the almost exclusively ecclesiasti-

cal readership for which this kind of imagery was developed suggests the involvement of a clerical designer. Indeed, the Lambeth Apocalypse would appear to represent a critical transition between an initial phase of clerical readership for the Gothic illustrated Apocalypse and its eventual appropriation by a devout aristocratic lay audience. The book may have been first commissioned for an ecclesiastical owner and then taken over by Eleanor de Quincy. Although she would most likely not have been able to read the Latin glossed text on her own, the pictures could have been explained and the text translated orally by her chaplain. The Apocalypse picture cycle could then have served as a sequence of mnemonic reminders that would enable Lady de Quincy to remember both the text and its meaning for the purposes of private meditation and devotion. The addition of enframing pictorial cycles at the beginning and end of the book rendered the experience of the illustrated Latin Apocalypse even more accessible to the needs of the pious lay reader.

THE BURCKHARDT-WILDT APOCALYPSE

Like the Lambeth Apocalypse, the slightly later French Burckhardt-Wildt manuscript was also originally provided with an additional cycle of pictures.[121] Unequivocally positioned as a preface to the Book of Revelation, the preliminary gathering comprises five full-page framed miniatures with blank reverses.[122] Following the first three pictures based on the Song of Songs,[123] a pair of diagrammatic images representing the Tree of Vices facing the Tree of Virtues form the last opening.[124] Although arguably emanating from northeastern France rather than from England and most probably designed for a French reader, the manuscript provides such a rare and even unique perspective on the thirteenth-century phenomenon of appending ancillary picture cycles to the Gothic Apocalypse that it will constitute a major focus of our present inquiry.

As in the cycle of miniatures appended to Lambeth 209, the subject of discourse in the first three pictures prefacing the Burckhardt-Wildt Apocalypse is the encounter between viewer and image as a simulacrum of the encounter between God and the soul. Inspired by Origen's early exploration of the tensions between *amor* and *allegoria* in the Song of Songs, the scriptural text was glossed throughout the Middle Ages as a contemplative book through which the reader sought to gain access to a personal encounter with God himself.[125] Following upon Origen's initial insistence that the literal carnality of the Song veils a spiritual meaning *(allegoria),* as the human body houses a soul, medieval expositors called upon the reader to search for a deeper truth in the overt eroticism of the text.[126] Yet the erotic desiring, seduction, and wounding nevertheless dominate the medieval reader's relationship with the text. Although Origen emphatically stresses the spiritual nature of the book, the flexibility and multivocality of medieval exegesis kept the text open to a play of erotic tensions, heightened rather than subsumed by allegorical reading.[127]

As attested by the ancient catalogues of monastic libraries, the Song of Songs attained singular importance in the Middle Ages as one of the most widely read and extensively interpreted books of the Bible.[128] It was the twelfth-century reliteralization of the text, however, that enabled the text to assimilate the lives of its readers, using the affective force of the Song's literal imagery to move them to virtuous action and self-discovery.[129] As the text was explored by its greatest twelfth-century exegete, Bernard of Clairvaux, the Songs became involved in a private spiritual journey to self-knowledge:

We read today in the book of experience. Turn inward to yourselves, and let each of you give heed to his own conscience about what is to be said. I would discover whether it has been given to any of you to say, from his own desire, "Let him kiss me with the kiss of his mouth."[130]

Above all, Bernard's *Songs* offer a spiritual marriage in which the self is fulfilled as a distinctive interiorized identity:

I do not think that the King has only one couch, but many. For there is not just one queen, but many; and there are many concubines, and maidens without number, and each finds her own secret with the Bridegroom, and says: "My secret is mine, my secret is mine."[131]

Through reading tropologically rather than allegorically, the twelfth-century reliteralization of Songs sought to awaken in readers a longing for God by encouraging them to identify their "bridal selves" with the Bride. Drawn from the same twelfth-century monastic tradition that produced the Berengaudus commentary on the Apocalypse, the resurgent inter-

est in Canticles is witnessed by a new outpouring of exegesis; Anselm of Laon, Bruno of Segni, Bernard of Clairvaux, Rupert of Deutz, Honorius Augustodunensis, Gilbert of Poitiers, William of St. Thierry, Gilbert of Hoyland, and Alain de Lille all produced commentaries on the Songs. Whereas twelfth-century exegetes incorporated traditional allegorical readings in the exposition, text and commentary formed a single discourse generated by a rhetorical synthesis of meanings. But as allegory was taken for granted, as something already known, the spiritual meaning of the Canticles was reliteralized by clothing it in the moving sensual rhetoric of the powerful original text.[132]

Although Origen's sense of the drama of Christ and the soul still dominates twelfth-century commentary, the Song is valued for the feelings it awakens and the example it sets. Evoking a response rooted in human sexuality, the new exegesis understands the text as an extension into the world of the reader who turned with increasing frequency to love songs as a guide to the spiritual life.[133] In a typical twelfth-century trope, Richard of St. Victor shifts the stress placed on the rhetorical force of the Canticle's images that awaken longings in the body and soul for the bliss of heaven. In the *Benjamin minor*, Richard characterizes the Song of Songs as a visionary book and compares its lovemaking to the vision of the heavenly Jerusalem, for it "describes invisible things through the forms of visible things, and imprints the memory of them on our minds through the beauty of their desirable appearance."[134] The perceived power of the *Canticum* to convey the whole of salvation history, culminating in the wedding feast beyond time, leads both Honorius Augustodunensis and Hugh of St. Victor to regard the Song as one of the holy books of the Bible dealing with eternal things. The poetic text is perceived as literal anagogy, a preview of heaven like St. John's apocalyptic vision of the Bride and the Lamb.[135] Indeed, glossed Canticles texts were frequently paired with the Apocalypse in twelfth-century manuscripts.[136] In Troyes MS 563, produced at Clairvaux in the second half of the twelfth century, a *Songs* commentary, written by Gilbert de Stanford in the new mystical and personal genre initiated by Bernard, was followed by a commentary on the Apocalypse attributed to the English Cistercian Robert Bridlington.[137] Thus, as we shall see, Burckhardt-Wildt's pictorial evocation of

the bridal soul yearning for God provides a contemplative pre-text and context for the reader's comprehension of the illustrated Apocalypse. With Christ as the Bridegroom and the soul as Bride, the tropology and mysticism of the prefatory images prepare the reader to experience John's apocalyptic visions in a similarly affective way.

Although the Bride of Songs is consistently indexed as an allegory of the Church or the Virgin throughout the Middle Ages, it is Origen's interpretation of the text's nuptials as Christ the Bridegroom who espouses the bridal soul that dominates the twelfth-century experience. As Astell points out, the central consciousness of the Song *ad litteram* is now feminine; readers are encouraged to identify the "bridal self" with the Bride, using the feminine *figura* as a way of evoking both the human soul and the affective side of human nature.[138] Although the *Sponsa* is often identified as the Church in pictorial representations heading the text of Canticles in twelfth-century Bibles, the Bride occasionally appears alone within the initial *(Osculetur me)* as a melancholy figure languishing with lovesickness, as in a Bible from St. Albans (fig. 230), dating ca. 1180.[139] Already veiled and crowned, the bridal soul, head in hand, poignantly tugs at the thin white thread referencing the vocality of her passionate cry given in the text, "O that you would kiss me with the kisses of your mouth," evoking the soul's yearning for God. A more explicit association with the soul can be seen in a contemporary French Canticles initial in the Manerius Bible,[140] where the Bride stands before the city, holding two scrolls presumably representing her petitions, her bridal veil suspended behind her, with a dove hovering at her lips. Although addressed as a dove in Songs 2:14, it is the soul (dove) that is speaking here, as conveyed in the graphic juxtaposition of spiritual symbol and embodied voice. In response to the reliteralization of the text in twelfth-century exegesis, representations of passionate carnal embrace, such as the tenderly kissing nuptial pair within the initial heading Bede's Commentary in Cambridge, King's College MS 19,[141] occasionally supplant the solemn dignity of the enthroned Christ and Ecclesia holding court in traditional images where the *Sponsus* and *Sponsa* appear together within a single frame. However, it is within the context of an older tradition represented by the heroically scaled narrative representation of the humble bride beseeching

with longing and desire the powerful *Sponsus* enthroned within the city, with the symbolic globe of the world at his feet, as in the eleventh-century Bible of St. Vaast,[142] that the idea of the individual soul rescued and redeemed by Christ the lover and bridegroom develops in the Burckhardt-Wildt sequence of miniatures. As expounded by William of St. Thierry, the allegory unfolds as a text written in the manner of a drama, in a dialogic style as if to be recited by characters with action.[143] As in the Rothschild Canticles, however, *Songs* is no longer treated as a pretext and context for allegory but as a dramatic account of inner experience.[144]

The first episode in the Burckhardt-Wildt narrative (fig. 231) unfolds within an outer textual framework that shifts the allegory of the bridal soul into the context of another allegory in which faithless Israel is redeemed by Christ. The legend around the frame paraphrases Jeremiah's lamentations over the destruction of Jerusalem:

> How lonely sits the city that was full of people! How like a widow she has become, she that was mistress of nations! She has become a vassal [1:1]. My enemy has walled me about and surrounded me with bitterness and tribulation and has made me dwell in darkness like the dead of long ago [3:7]. He has made my flesh so that I cannot escape; he has put chains on me [3:7].[145]

Thus, Israel, personified as a blindfolded woman,[146] lies naked in bed, as a devil pulls a rope around her neck. Although the abandoned floral chaplet on the ground marks her as the lost Bride of Canticles, it is also the fallen crown from Lamentations verses (5:16–17) not quoted:

> The crown has fallen from our head; woe to us, for we have sinned! For this our heart has become sick, for these things our eyes have grown dim.

As in the Lambeth additional miniatures, the pictorial allegory focuses on various aspects of vision. Cast in the guise of Israel, the individual soul is not only blind, "dwelling in darkness like the dead of long ago," but she can no longer be seen by the Lord who desires to look upon her again. At the right, Christ stands outside the city now ruled by satanic powers, as a devil guards the gate, blowing a trumpet of fire and holding a banner emblazoned with a green toad above. In one hand, the Lord holds a small blue disc symbolizing the world he created (which is lex-

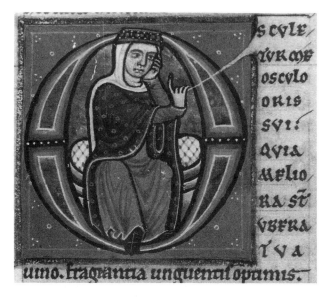

Figure 230. Bible of St. Albans. Cambridge, Corpus Christi MS 48, fol. 160v. *Sponsa* (photo: The Master and Fellows of Corpus Christi College, Cambridge, and the Conway Library, Courtauld Institute of Art, London).

ically indexed in another inscription) and raises his right hand in blessing, as he calls through the door: "Return, return, O Shulamite, return, return, that we may look upon you" (Songs 6:12).[147] As Michael Camille points out, Christ's words are inscribed upside down so that they will be perceived to emanate from the speaker, thus functioning as a graphic marker for the force of living speech, as distinguished from the deceitful text being written by the devil on the left.[148]

The image resonates directly with the twelfth-century exegesis on this passage by Honorius Augustodunensis:

> Shulamite, who is called captive, is the soul captured *(capta)* in sin and vice by the devil. From this captivity she is returned to Christ in four ways, namely, by penitence, confession, good works, and good exhortations.[149]

Whereas the image can also be seen to evoke Bernard's excursus on Synagogue as the blind rejected woman who consorts with devils outside the palace,[150] it is the bridal figure of the Shulamite introduced and expounded by Honorius Augustodunensis that dominates the discourse of the image, for she personifies the soul's yearning for God in the present

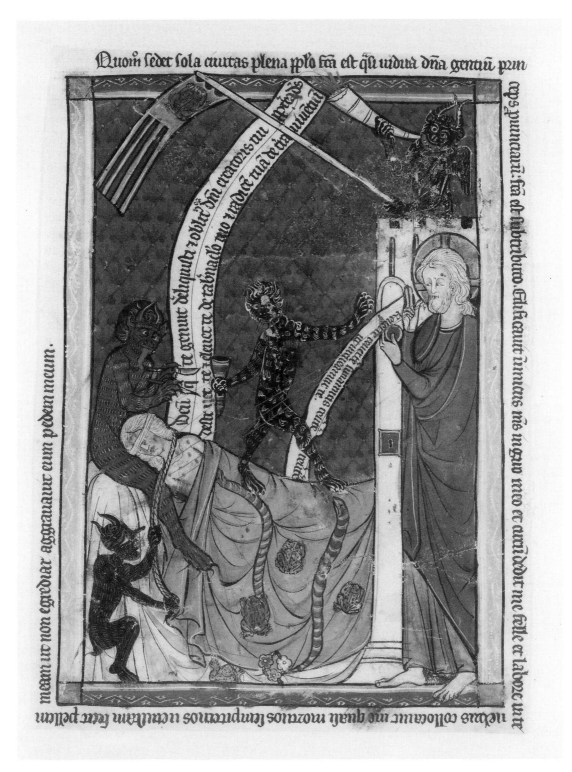

Figure 231. Apocalypse. Formerly Burckhardt-Wildt Collection, fol. 1v. Allegory of the Bridal Soul and Captive of Demons (photo: Sotheby's, London).

age *(sub gratia)* in a tropological reading that transcends allegory as it reaches into the affective regions of the reader's inner world.[151] Elaborating on the idea of Christ as the lover or bridegroom of the individual soul, the image reveals an allegory of Israel (the soul) as a faithless bride, indicated by the bridal chaplet lying discarded beneath her bed. Despite her husband's generosity, she becomes a harlot, lying naked in a bed representing carnal weakness, her body covered with sores and tormented by devils.[152] Anselm likened the sinful soul to a prostitute wallowing in vice and forgetting her heavenly lover.[153]

Honorius's faithless bride is now captive of the devil who sits at the head of her bed, writing a paraphrase of God's curse on the Jews who do not observe the Law from the Song of Moses (Dt. 32:17–18). In a cruel parody of the devil who records the sins and transgressions of humankind,[154] the devil writes upside down on a huge bandarole, as a signal to the reader of the perfidy of his deception, telling the woman that she has forsaken and forgotten the Lord who created her (Dt. 32:18), and that he will remove her from her tabernacle and her roots from the land of the living (Ps. 51:7).[155] The soul is now threatened by a scholar demon who quotes Scripture against her.[156] The inert, tormented body of the Bride has become a battleground between the scrivening devil and Christ the Bridegroom, as the two antagonists utter charges and challenges across a space dominated by another devil who tramples over the contested "territory," aiding the drawing up of the accusation and obstructing the Lord's plea for his Bride to return. Making a pivotal turn in the center of the framed image, the striding devil directly engages the viewer's attention, as if asking the reader to look into his/her own soul to resolve the conflict. The blindfolded Shulamite, however, cannot see or read what the devil has written and can only hear her divine Lover's call. In his accusations of faithlessness and perversity, God charges Israel with sacrificing to demons that were no gods, "unmindful of the God who created you" (Dt. 32:17–18). To punish her the Lord will send "the teeth of beasts . . . with the venom of things crawling in the dust" (32:14), represented in the Burckhardt-Wildt miniature as snakes and toads crawling over the woman's bed. Despite her perversity and faithlessness, however, God will forgive Israel and take her back. The adulterous *Sponsa-Anima* is won away from the power

of the devil by Christ who sheds his blood for her.[157]

The allegory of Christ as the redemptive bridegroom was first developed by St. Augustine,[158] and when the Augustinian *exemplum* was transformed into a brief narrative and allegorical exposition, the bride ceased to be the corporate body of Israel and became instead the individual soul. Thus, Christ the bridegroom stands at the door, looking through the window, blessing and holding the tiny globe as if he were a priest offering the Eucharistic host as the last rite to the dying sinner. As he calls for her return, his breath extends in three thin streams into the bedchamber, touching the harlot's sores with healing grace.[159] Although Christ's blessing gesture through the window is reminiscent of an initial to a Cistercian commentary on the Song of Songs in Oxford dating ca. 1200,[160] a closer pictorial exposition can be seen in the full-page tinted drawing at the beginning of a twelfth-century copy of the Songs commentary of Honorius Augustodunensis, in Munich Clm. 4550 (fig. 232),[161] which conflates the three episodes depicted in the Burckhardt-Wildt cycle into a single image. At the lower right, the veiled Shulamite kneels outside the city walls, holding a scroll inscribed "My beloved put his hand to the latch and at his touch my heart thrilled within me" (Songs 5:4),[162] as Christ's wounded hand is extended through the window to liberate her in response to the Honorian commentary:

The bridegroom Christ, enthroned in the glory of heaven, stretched his hand through the window as if abandoning the rulership of his heavenly realm. . . . He saved humanity from eternal death by his death on the cross, so that there is no higher glory than God's love. In the other world the human soul finds its wish in God's embrace, its final fulfillment in the kiss of peace.[163]

The bride's fulfillment thus forms the dominant focus of the miniature in the traditionally enthroned royal couple, labeled *Sponsa-Sponsus*, with the bridegroom restored to his celestial royal power, as the bride holds a book inscribed with the first verse: "Osculetur me osculo oris suis." The Lord's dual gesture of embracing his celestial bride with his right hand as his left is extended through the window and placed under the Shulamite's head, each accompanied by an inscription from 2:6, clarifies that they represent the two conditions of the same woman: "O that his left hand were under my head and that his right hand embraced me!"[164]

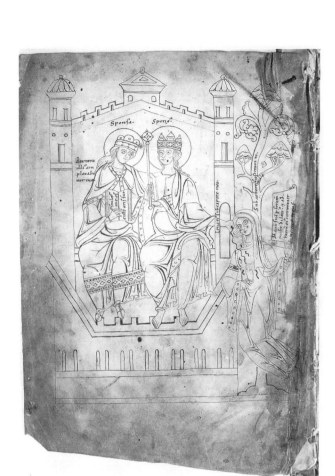

Figure 232. Honorius Augustodunensis, Commentary on Canticles. Munich, Bayerische Staatsbibliothek Clm. 4550, fol. 1v. Bride and Bridegroom Enthroned (photo: Bayer. Staatsbibliothek, Munich).

The potential or lingering eroticism of the Lord's gesture of thrusting his hand through the small aperture representing both the window of the nuptial chamber and the portal of the heavenly city is emphatically elided in the Burckhardt-Wildt image by transforming the action into the liturgical gesture of the priest raising and blessing the host at the elevation, thus evoking the symbolic sacrifice of Christ incarnate on the cross. Christ holds the host, which can also be "read" as the globe of creation, directly above a keyhole, a potentially erotic signifier, which the reader is affectively invited to identify as his/her inner self. Christ the Bridegroom holds the "key," but the disparity of size and shape also might cause the viewer to reflect upon the difficulties and obsta-

cles lying in the path of the soul's long pursuit of God *(quaere Deum),* bridged here by the Lord's desire for the *Sponsa* in the form of his utterance, "Return, return. . . ."

In the Burckhardt-Wildt sequence, the liberation appears in the facing miniature (fig. 233) in which the secondary, contextual allegory of the restoration of Israel is maintained by the legend around the frame:

When Israel went forth from Egypt, the house of Jacob from a people of strange language: Judea became his sanctuary, Israel his dominion [Ps. 113:1–2]. My soul has escaped like a bird from the snare; the snare is broken and we are free. Our help is in the name of the Lord who made heaven and earth [Ps. 123:7–8]. Behold me and my suffering, according to the diligent judgment in your name.[165]

As Camille points out, Bernard's exposition on Canticles had cited the same images of the released bird and the liberation of Israel.[166]

The bridal soul, now dressed in a white tunic, is rescued by Christ, who pulls her through the gate of the city in a gesture reminiscent of the Lord rescuing Adam and Eve from Satan in the Harrowing of Hell. Now freed of her blindfold, the Bride's gaze is locked with that of Christ, creating a critical conjunction of ascent and vision within the context of the ensuing Apocalypse that anticipates the angel's grasping of John's wrist as he directs his gaze toward the heavenly Jerusalem (see fig. 166). The restoration of the Bride's crown of flowers, indirectly signals the restoration of her soul to its virgin state, evoking the priest's words in the thirteenth-century pontifical for the consecration of virgins: "Come, bride of Christ, accept the crown that the Lord has prepared for you in eternity . . . as you are crowned by our Lord on earth, so by Christ in glory will you deserve to be honorably crowned in heaven."[167] In the Durandus version of the rite, the virgin's reply evokes the fulfillment of the promised vision pictured in the Burckhardt-Wildt image: "Behold, that which I desired, now I see; that which I hoped for, now I possess."[168] Now freed from her chains, the woman escapes from two black demons who pull at her dress and attempt to restrain her with a grapnel. Inscribed on a long speech scroll that divides the picture diagonally into two halves, good at the upper right and evil at the lower left, the woman pleads with the Lord to rescue her from her enemies and those who rise up against

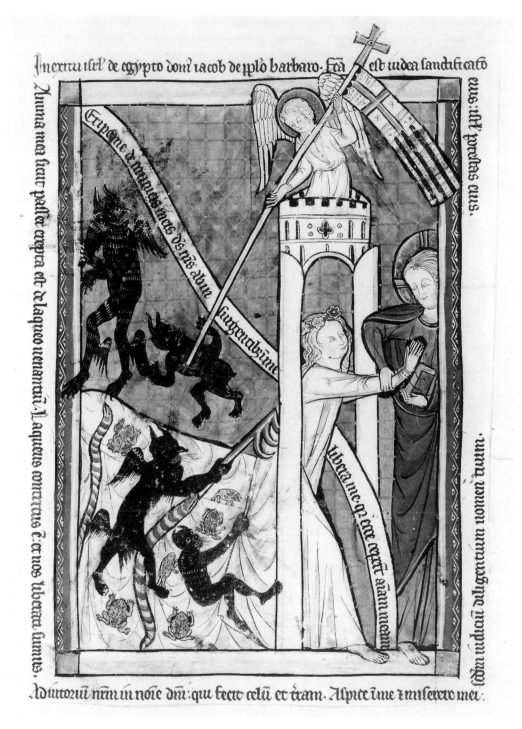

Figure 233. Apocalypse. Formerly Burckhardt-Wildt Collection, fol. 2. Rescue of the Bridal Soul by the Bridegroom (photo: Sotheby's, London).

her, for they have taken her soul: "Eripe me de in-imicis meis deus meus ab insurgentibus in me. Libera me, quia ecce ceperunt animam meam" (Ps. 58:2 and 4). The Bride breaks through the gate exactly at the point where the descending diagonal speech scroll reads "libera me."[169] The liberation of Israel is fur-ther stressed by the conquest of the city that had been overrun by demons, for Jerusalem is being reclaimed by the angel who stands in the turret above the gate, wielding a Crusader's banner emblazoned with a red cross against two more black demons who now flee. Faithless Israel or *Sponsa-Anima*, now rescued, gazes upon the face of the Lord and he upon her in a re-demptive reunion.

What had remained locked and inaccessible in the first image is now open. In the interpretation of Ber-nard of Clairvaux, the wall constitutes a barrier of sin that separates the sinner from Christ, and the opening in the wall thus serves as a point of transi-tion between heaven and earth.[170] As we see the *Sponsa* thrust her clasped hands into Christ's side, we now realize the true nature of the "key" that un-locked the door. In a gesture of *ostentio vulnerum* directed at both the Bride and the viewer, Christ guides her hands into the wound, evoking Songs 4:9: "You have wounded my heart, my sister, my spouse." Thus, Christ's side wound becomes the door through which the soul gains entry into para-dise, in an experience similar to that described by the Italian mystic Angela of Foligno (d. 1309): "And it seemed to my soul that it entered within that wound in the side of Christ."[171] The Burckhardt-Wildt image strikingly evokes Bonaventure's metaphors of mys-tical entry and penetration in his spiritual advice to nuns: "Draw near, O handmaid, with loving steps to Jesus wounded for you . . . neither let it be sufficient to put your hand into the wound in his side, but enter entirely by the door in his side and go straight through to the very heart of Jesus."[172] As Hamburger points out in quoting this text in connection with the Rothschild Canticles, the passage from wound to heart, from outside to inside, constitutes a meta-phorical transition from the physical to the spiri-tual.[173] Within the nuptial context of the apocalyptic Marriage of the Lamb, the Bride makes a similar penetrating gesture in the Douce Apocalypse (fig. 16), again evoking the salvific power of the wound.

The first two pictorial narratives in the Burck-hardt-Wildt cycle can in a sense be seen as a literal-ization and clarification of the twelfth-century allegorical image of the Shulamite devised by Ho-norius Augustodunensis to illustrate his commentary on Songs. By abandoning the unrelenting allegorical image of the captive Shulamite being rescued in the quadriga of Aminadab, whose four wheels repre-senting the Gospels draw her away from the blind-ness of her Judaic past, the thirteenth-century designer invokes Christ directly as her savior as he replaces the ambiguous Old Testament figure of Aminadab.[174] The redemption of Israel is no longer foregrounded, but now serves quite literally as a sub-text or secondary metaphor inscribed in the frame to dramatize the meaning of the rescued bridal soul. In the ingeniously designed new images created for the Burckhardt-Wildt cycle, the spirit of twelfth-century exegesis triumphs over the traditional iconographical program of ambiguous allegory.

The third scene (fig. 234) shows the woman, still crowned with a flower garland but now dressed in a red dress and blue robe lined with vair, seated on a mound with her hands raised in prayer as she ad-dresses the Lord, her bridegroom, who stands in a cloud, blessing her. Now unequivocally identified by the *titulus* on her speech scroll as the "soul in con-templation" *(anima in contemplatione),* the bride is filled with longing and desire for her now absent lover-savior, separated from him not only by her in-scribed utterance that divides the picture diagonally in half, but by the insuperable barrier that again di-vides heaven and earth. Filled with love, the Bride asks her Lord to sustain her with flowers and com-fort her with fruit, as she tells him that her soul melts with love when her beloved speaks (Songs 2:5–6).[175] Now abandoning the earlier texts from Lamentations and the Psalms, the third scene is enframed by Can-ticles verses in which the bridegroom addresses his reclaimed bride. Accompanied by a tiny angel play-ing a vielle, the Lord, now speaking from the remote distance of a celestial cloud at the upper right, de-clares his love and invites her to join him:

Come to my garden, my sister, my bride [5:1], so that him whom you prudently sought, you may find. Him whom you have ardently desired, you may see; him whom you have insistently demanded, you may welcome; him whom you have sweetly loved, you may cling to tenderly. Delight in me sweetly and, transformed by love, find rest in me always.[176]

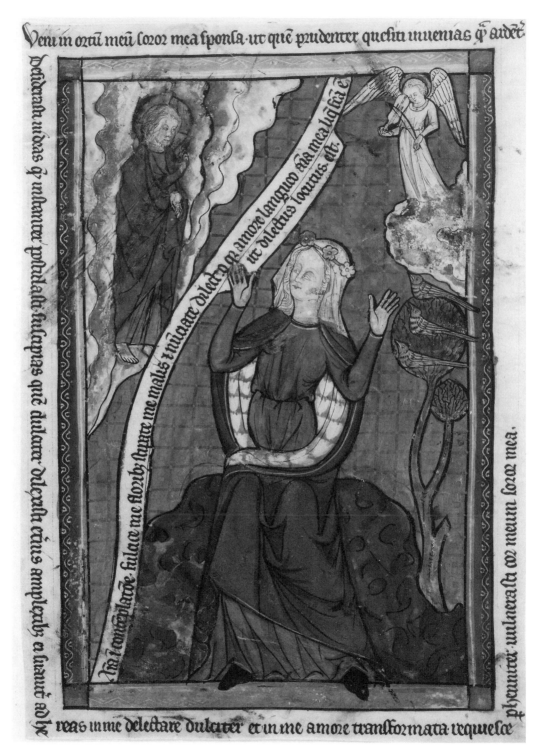

Figure 234. Apocalypse. Formerly Burckhardt-Wildt Collection, fol. 3v. Longing of the Bridal Soul for the Bridegroom (photo: Sotheby's, London).

As in the Rothschild Canticles, the *Sponsa* and Christ meet in a paradisaic garden, signaled by the turtle doves in the tree, where Christ comes to the Bride as if in an apparition.[177] The remoteness of the cloud-enframed Lord resembles that in the initial to Songs in the late twelfth-century Souvigny Bible (fig. 235),[178] where the hierarchical separation is intended to evoke the longing and lovesickness marking the beginning verses. The Bride holds a speech scroll inscribed: "Behold, you are beautiful, my love, and noble! Our bed is of flowers" (1:15), to which Christ responds, "Arise, my love, my beauty, my dove, and come."

In a sense, the narrative sequence in Burckhardt-Wildt thus ends with an image of the lovesick bride outside the city (heaven) next to the tree under which she was awakened (8:5), resembling the Shulamite on the right in the Canticles illustration of Honorius Augustodunensis (fig. 232).[179] But her longing is still left unfulfilled, for the triumphant pair of embracing fig-

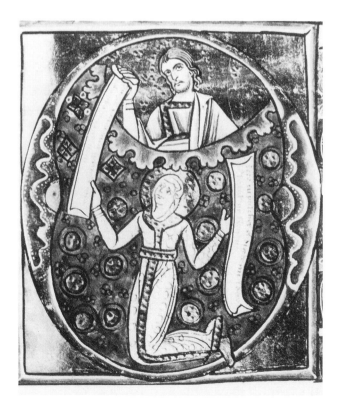

Figure 235. Souvigny Bible. Moulins, Bibliothèque municipale MS 1, fol. 235. Historiated Initial: *Sponsus* and *Sponsa* (photo: Garnier 1982–9).

ures, *Sponsus* and *Sponsa*, enthroned in the celestial Jerusalem, are not represented. The sequence ends with an image evoking the soul's yearning for God, completing the three stages of *anima*'s progress (humility, piety, and love), described in the exegesis of Bernard of Clairvaux.[180] Enframed within a Bernardine sermon on longing, the Book of Revelation is thus transformed into a monastic "literature of compunction, whose aim is to possess, to increase, and to communicate the desire for God."[181] Its foretaste of heaven gives direction and form to the eschatological order of monastic culture and theology by creating a desire for what is impossible to attain on earth.[182] Benedictine literature is filled with frequent meditations on the heavenly Jerusalem. St. Bernard describes the monastery as a Jerusalem in anticipation, a place of waiting and desire.[183] Within the Bernardine spiritual framework, monks keep the apostolic watch after the Ascension, but they know they will not see the Lord; they love without seeing, keeping their eyes on nothing but God, invisible yet present.[184] The third and last image in the Burckhardt-Wildt Songs cycle creates a visual realization of Bernard's mystical teaching that union with God is realized in desire itself.[185]

As the Burckhardt-Wildt cycle of three Songs images now stands, the narrative develops a discourse of transformation and spiritual metamorphosis, signaled among other things by the Bride's changes of costume. The woman is first naked and tormented by devils, then dressed in white as a bride and rescued. Having been brought through a gate by her celestial Bridegroom, the Bride has undergone a spiritual passage to a third state of being transformed by love. Indeed, the inscription beneath the supplicant soul in the third picture, where she is now dressed in red and blue, reads "et in me amore transformata." Although Christ assures his bride that she can see him whom she had ardently desired, the lovers are nevertheless dramatically separated in the sense of the perceived distance between heaven and earth. The contradiction between text and image in the third episode thus indexes a shift in the bridal soul's mode of seeing. As Camille has argued, the third miniature graphically references the kind of visionary experience described by William of St. Thierry in his commentary on Songs: "Enlightened by the grace of an interior visitation, often by the power of contemplation, the Bride follows after the bridegroom with

devout love until she attains the vision of heavenly peace."[186] Like John who ultimately sees Christ in the clouds at the end of the Apocalypse, the Bride's transformative journey culminates in a similar inner vision.

Transformed by love, the woman is no longer the Shulamite, but the soul of the reader-viewer in the present, who now "sees" with an inner eye. Another rupture serves to mark the transition from the context of Songs to the medieval present of the reader, as Christ's speech shifts from Canticles 5:1 to a paraphrase of a response from the rite of the consecration of virgins ("Him whom you have prudently sought, you may find"),[187] concluding with Canticles 4:9: "You have wounded my heart," reminding the viewer of the salvific wound in Christ's side that "opened the door" to the bridal soul in the previous miniature. The complexity of Latin exegesis, as well as the special attachment of thirteenth-century nuns to the Song of Songs, tends to suggest an audience of cloistered women for the Burckhardt-Wildt cycle.[188] The ultimate designation of the Bride as the "soul in contemplation" evokes the distinctive epithet *(anima contemplativa)* chosen by Abelard when he referred to Heloise as the *sponsa Dei* of Songs 3:1, first urging her to enter a convent and later in replying to her request that he compose for her community of nuns an adaptation of the Rule of Benedict.[189] Although the evidence is suggestive, however, there is no single compelling reason to locate the Burckhardt-Wildt within the confines of a women's cloister. In the words of a recent and very astute commentator on the Canticles in the Middle Ages,

The developmental processes involved in the spiritual life mirrored in the Song of Songs tend to constellate in a narrative line that allows every auditor to discover his personal myth and retell his own life story as a romance of rescue and ravishment, heroic labors and longing, seeking and finding.

The relationship Bernard fosters between his auditor and the [Bride] thus serves to make the Song of Songs an eminently occupiable text. Because of Bernard's example and instruction, medieval readers and writers could freely appropriate the bridal "ego." . . . Indeed, Bernard's widely circulated *Sermones super Cantica Canticorum* taught them to read the Song as "the book of our own experience" and provided a successful model for its reliteralization in courtly and devotional works alike.[190]

The first three images in the Burckhardt-Wildt se-

quence appropriate the narrative structure of the Songs text as a screen against which to retell the story in such a way that the rescued soul is not only emphatically gendered as feminine, but also dramatically embodied. In a strategy that moves from the Latin grammatical indexing of "soul," or *anima*, as feminine to a metaphorical construction of the soul's union with Christ as the visualized experience of a woman's body, the Burckhardt-Wildt episodes are inscribed in fully somatic terms. As the drama opens, the soul is visibly imprisoned within a woman's body, naked and inert, passive and acted upon, bound, blind, and helpless. In the ensuing rescue scene, the female body is now clothed in white and raised up, still a passive object of contention between two opposing forces pulling down to the left and up to the right. Only following her transformation effected by the soul's passage through the metaphorical gateway to enlightenment and salvation does the soul's body acquire visible weight and substance as she is now larger in scale and dressed in red and blue, in contrast to the earlier lack of substance conveyed by the transparency (absence of color) of the first two figures. Now liberated and active, the "soul" reaches upward on her own. Responding to the Bridegroom's invitation to join him in the celestial garden, the human voice of the new soul answers in a song that is both natural (signified by the birds) and artificial (signaled by the angel playing the vielle), as well as by her gestures of thankful prayer.

Although in the thirteenth century both men and women turned increasingly to conceptualize and describe the soul's union with God in terms of female images, male writers tended simply to slip into the metaphor to express the "childlike" or "womanly" dependence of the good Christian on a powerful, patriarchal God. As Carolyn Bynum points out, men often called attention to their adoption of the opposite gender as a term of self-description to stress the notion of gender reversal as an image of sacrificial exchange and renunciation of the world.[191] Indeed, the radically visible conversion from passive to active states in the Burckhardt-Wildt cycle might be seen in terms of how such a male description of the feminized soul urged conversion from passive submission to a virile, masculine rising to God.[192] The first Burckhardt-Wildt image serves as an unequivocal graphic representation of the traditional masculinist view of women struggling unsuccessfully to

overcome the flesh.[193] As Bynum further observes, however, women saw themselves reaching God not by reversing what they were, but by sinking more fully into it, most notably through suffering, so that the literal bodily terms in which the Burckhardt-Wildt images envision the soul might be seen as having been designed for an audience of women.[194] Women were more apt to somatize religious experience and to write in intense body metaphors as, for example, did Angela of Foligno when she wrote, "The soul is a creature who is the life of the flesh and of all the members of its body."[195] Moreover, the elaboration of the nuptial mysticism of bridal imagery tended to be much more common in women's writing in the thirteenth and fourteenth centuries, as well as more fully elaborated, than in the twelfth-century masculine discourse from which it originated.[196] Indeed, very concrete representations of the *Sponsa-Christi* idea flourished above all in convents for nuns.[197]

Whether the Burckhardt-Wildt cycle assumes a cloistered female reader-viewer whose life is predicated on a daily round of devotion intended to reinforce her identity as a *sponsa Christi*, which was demonstrably the case for the Rothschild Canticles,[198] remains more problematical, but the accretion of textual and pictorial references to liturgies and symbols normally accessibly only to such an audience suggests that the book could have been designed for a nun. Within the context of a pervasive medieval disposition to see men and women as versions of the same thing, moving toward a permeability or interchangeability of the sexes on a spiritual or metaphorical level,[199] we might also see a transition in gendered perception in the Burckhardt-Wildt miniatures as we move from the first image in which the inner experience of the soul is seen as a "battle" conceived in masculine terms of strong binary (male-female) oppositions to the second image in which the soul makes its "journey" to God in more feminine or androgynous "human" terms. Even when women saw themselves within the context of the traditional idea of asymmetrical genders, they tended to envision their distinctive physicality as useful in the soul's joining with a human Christ, as the body itself became a vehicle of transcendence.[200]

The last pair of full-page prefatory images in the Burckhardt-Wildt Apocalypse is given over to complex moralizing diagrams of the Tree of Vices and the Tree of Virtues, based on the twelfth-century tract *De fructibus carnis et spiritus* attributed to Hugh of St. Victor. In clearly visualized schemata, the author places before the reader's eyes two contrasting trees of good and evil, ultimately based on Christ's aphorism in Matt. 7:17 and Gregory's dictum that pride is the root of all evil.[201] Admirably suited to post-Lateran IV penitential requirements and their attendant need for mnemonic aids, the twelfth-century diagrammatic illustration from *De fructibus* rarely if ever stood alone, but appeared in countless devotional works throughout the later Middle Ages.[202] For example, in two twelfth-century manuscripts, it is appended to the *Dialogus de mundi contemptu vel amore* in which a cleric persuades a *conversus* of the superiority of the monastic life.[203] In the *Dialogus*, *De fructibus* is described as demonstrating in visible form the differences between light and darkness, right and left, spirit and flesh, humility and pride.[204] The same diagrams were later copied in the *Speculum virginum* designed for nuns.[205]

The arboreal image with its branches, roots, and leaves offered a conveniently shaped framework on which to hang complex classifications with the utmost clarity, setting out on two facing pages concisely and memorably the basic structure of a comprehensive ethical system. The Tree of Vices grows from the root of *Superbia*, branching into the seven principal vices and their subsidiary aspects; the Tree of Virtues grows from *Humilitas* into its branches of the seven theological and cardinal virtues together with their progeny.[206] Whereas many thirteenth-century versions tend to undermine or simplify the carefully constructed design of the original, the Burckhardt-Wildt allegories retain the intricate structure and full detail of the earliest copies, with numerous inscriptions that interpret the meaning of the two allegories.[207]

On the verso page,[208] the Tree of Vices springs from *Superbia*, the root of all evil, and the branches hang down toward the ground as they look for the base and turn away from the divine, as explained by the maxim inscribed in large gold letters on three broad horizontal bands: "The fruit of the flesh is the ugly road of pride." Seated at the base of the tree is a personification of Pride, a woman holding a large disc symbolically charged with the figure of a man falling from his horse, reflecting the familiar thirteenth-century cathedral iconography of Notre

Dame in Paris and Chartres.[209] Representing the self-criticism of the powerful, Pride was perceived in the twelfth and thirteenth centuries as "the sin of rebellion against God, the sin of exaggerated individuality," hence, a moral danger to the disciplined corporate structure of medieval society.[210] Behind her unfolds a series of bandaroles surrounded by small dragons, warning of the destructive power of pride.[211] The Tree of Virtues (fig. 236) stands on the recto page beside the tree of evil. Rooted in Humility, whose personification sits at the base holding a dove (her attribute) enframed within an emblematic disc, while two more doves appear at her feet, its branches reach upward to Christ and heaven. The maxim in large gold letters on three horizontal blue and red panels reads: "The fruit of the spirit is the narrow path of humility." More typical of the twelfth than the thirteenth century, when the religious life for the most part remained cloistered, the chief virtue was Humility, the guarantor of monastic obedience.[212]

As the branches reach upward, they burst into flower in contrast with the barren tree of vices. At the summit Christ, the New Adam, gathers the virtues toward him.[213] Flanking Christ, the inscription in gold letters introduces a new text not drawn from the Pseudo-Hugo tract.[214] The reference to Christ as the "king of the city" must allude to Jerusalem, as the two trees are labeled "Babylon" and "Jerusalem" in the schemata that accompany *De fructibus carnis et spiritus*. The secondary allegory of the two cities can be related by the reader to the Apocalypse, which then follows, with its unfolding of the epic destruction of wicked Babylon representing the world and all its evil and the triumph of the heavenly Jerusalem. The "King of the City" also alludes to the Bridegroom in the Song of Songs. Thus, the first moralizing allegory of the rescue of the soul in the guise of faithless Israel serves as a meaningful prelude to the juxtaposition of the two cities in the Trees of the Vices and Virtues.

In a typical medieval strategy of plotting out many paths to cover the same ground, the last two pages demonstrate diagrammatically how the upward-reaching journey to the Bridegroom is to be accomplished. Reiterated contrasts are made between rising and falling, as in the first two episodes drawn from the Songs. The contemplative soul of the third episode now holds the turtle dove as an emblem of her virtue, for the three turtle doves perched in the tree

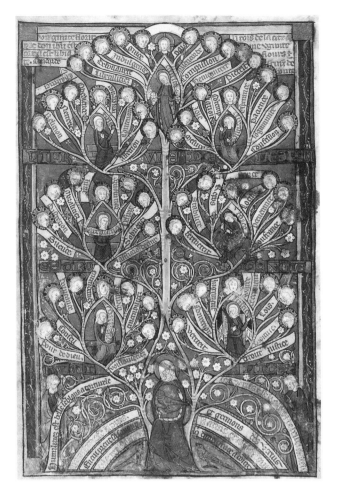

Figure 236. Apocalypse. Formerly Burckhardt-Wildt Collection, fol. 6. Tree of Virtues (photo: Sotheby's, London).

of paradise next to the contemplative soul have now migrated to the lap and feet of the veiled woman who personifies the generative virtue of Humility, as a prophet at the left proclaims, "Humility is beautiful, like a turtle dove." Not only does Christ call the bridal soul "my dove" (*columba mea*), drawing from the Songs text, women, above all nuns, were frequently described as doves in the later Middle Ages.[215]

Like the series of miniatures appended to the Lambeth Apocalypse, the two pictorial sequences prefacing the Burckhardt-Wildt manuscript comprise a mixture of Latin and Anglo-Norman textual sources in their lengthy inscriptions, although the allegorical Trees of the Virtues and Vices are normally given in

Latin, based on *De fructibus*. Also, like the Lambeth series, the imagery in the Burckhardt-Wildt prefatory cycle is both complex and sophisticated, relying on the reader's knowledge of the textual sources from which the images and inscriptions were drawn for a complete understanding of the allegory – again suggesting a clerical audience or clerical advisor to a lay reader. In its stress upon virginity as "the flower and fruit of goodness loved by the king of the city," which "flourishes through the gift of Christ," the text at the head of the Tree of Virtues suggests that the pictorial allegory may have been designed for a nun,[216] as was probably the case for the prefatory cycle in Eton 177, or a widow perhaps intending to enter the cloister in the case of Lambeth 209.

THE TYPOLOGICAL CYCLE IN THE ETON APOCALYPSE

At the beginning of Eton 177 are seven prefatory leaves containing a series of full-page miniatures laid out in roundels resembling designs for stained-glass windows. Described by James as *Figurae Bibliorum*, the first two pages of Old Testament scenes are followed by a series of typological pictures.[217] Whether the first eight leaves were included as an original component of the book or added somewhat later, they bear signs of heavy use, whereas the Apocalypse appears to have been handled less.[218] The well-thumbed pages comprise a condensed compendium of Old Testament typologies, articles of faith, the Commandments, and the Virtues, to be meditated upon and presumably memorized. As we shall see, however, the iconographical program can be linked with the Apocalypse that follows, suggesting that the prefatory leaves were expressly designed for this manuscript.

Twelve full-page compositions form a pictorial preface to the Eton Apocalypse. Each miniature consists of four roundels arranged in pairs symmetrically around a fifth encircled image, with two half-roundels at the right and left. The first two pages form an isolated pair on a separate bifolium (fols. 1v–2) with blank reverses, illustrating Genesis from Creation to the death of Abel, without inscriptions.[219] The remaining ten pages are given over to a series of typologies surrounding central roundels containing Christological scenes from the Nativity to the Cor-

onation of the Virgin. Three of the four surrounding roundels contain Old Testament types, and the fourth is inhabited by pairs of prophets; figures also appear in the half-roundels flanking the central antitype. The circular frames enclosing the three types and its New Testament antitype are inscribed with Latin verses; that surrounding the prophets gives quotations from their prophecies. Beneath each central medallion is a crowned, female seated figure representing one of the Virtues, who presides over one of the Ten Commandments inscribed at her feet in the lower margin.[220]

Whereas the inscribed texts in the surrounding frames of the types and antitypes are given in aphoristic verses, gnomic in their rhymed compression and word play, the pairs of Old Testament prophets speak in more somber Vulgate locutions, carrying the authority of centuries of scriptural use and interpretation in contrast with the other texts on the page. Through typologies and prophecies, the Old Testament is understood not only as history, but also as an elaborate code to understanding the New.[221] The complex network of relationships evoked by the images and texts in the Eton *Figurae Bibliorum* appears to have been created for a reader capable of understanding their inherent theological concepts, for otherwise the pictorial compendium remains almost incomprehensible. The series is designed for purposes of personal meditation, demanding time and silence as well as a degree of literacy and biblical erudition. As we shall see, to the educated medieval mind trained in image interpretation and recognition of half-quoted biblical texts, the parallels evoked by the Old Testament types inspired meditation on the most meaningful differences from as well as analogies to the Christological events they prefigure.

Although apparently based on widely circulated compendia of typologies such as the *Pictor in carmine*,[222] the complex interlocking pictorial schemes in the Eton prefatory miniatures are unique in their juxtaposition of the Commandments and Virtues within a series of typological designs. Moreover, the irregularities and disruptions in the twelve-page sequence of pictures reveal a design whose purpose or meaning is not always immediately apparent. In contrast with the systematic and comprehensive display in Burckardt-Wildt's *Arbor virtutum*, personifications of the Virtues appear only in the ten typological miniatures. With the single exception of Hope, who

holds a spray of blossoms on the last page, the Virtues have no attributes and are identified by inscription in only four of the illustrations. Thus, *Caritas* appears beneath the Nativity, Humility with the Baptism, and Patience with the Bearing of the Cross; the atlas figure holding up the representation of the Three Marys at the Tomb might be identified as Fortitude. Because the Virtues are perceived as aligned with and drawing sustenance from the Christological events they accompany, as in the traditional connection between Obedience and the Crucifixion (see fig. 244), the first two pages of Old Testament scenes from Genesis can be seen as representing an era *ante gratia*, whose own virtues, such as Truth and Righteousness, have no potency until they have been reconciled with those of the New Testament, as demonstrated in the last miniature (fig. 249). As in the thirteenth-century voussoirs on the south side of Chartres Cathedral and in the chapter house at Salisbury, the elegant crowns worn by the Virtues in the Eton manuscript signify that they belong to the world *sub gratia*.[223] Whether by accident or design, the blank pages on fols. 2v and 3 constitute a dramatic visual break, marking a theological chasm between the two dispensations.

If the Virtues are fixed in the history of human salvation *sub gratia* in a vertical hierarchical scheme, the inscriptions of the Ten Commandments beneath each figured personification belong to the world *sub legem*. Juxtaposed as binary oppositions between the New and Old dispensations and cast in contrasting codes (allegorical vs. literal, pictorial vs. lexical), both Virtue and Commandment engage the reader-viewer at the bottom of each page. In all but one instance, the enthroned Virtue rests upon the written Commandment as if upon an inscribed foundation. As she confronts the reader *en face*, each Virtue commands the space at the bottom of the page and initiates the upward journey of the viewer's gaze along the central axis. Drawn from Exodus, the Decalogue, like the Virtues, finds no place in the first two miniatures dealing with episodes from Genesis *ante legem* and thus the Ten Commandments begin with the typological series surrounding the Nativity of Christ. As Henry points out, the Commandments are inscribed in a peculiarly modified sequence.[224] Only part of the First Commandment is given at the beginning of the series, following the text of the Second

("Non facias tibi sculptile neque adorabis deos alienos"), so that the first two prohibitions relating to false worship comprise the first law, following a pre-Reformation sequence, but the second part of the First Commandment is repeated at the end of the series ("Non habetis deos alienos") as if it were a tenth Commandment. Although it is indeed possible that the first Law was divided in this way to emphasize the completion of the pattern of salvation invoked in the series of central roundels moving forward from the Nativity to the Coronation of the Virgin, as Henry suggests, the circularity initiated by the textual fracture of the First Commandment also stresses the centrality of imaging the one "true" God in the guise of Christ incarnate, as the series begins and ends with the representation of a sacred icon, the circular *imago clipeata* of Christ (see fig. 240), seen first on fol. 3 by Moses in the burning bush and last on fol. 7v by two women personifying Jews and gentiles embracing the cross (fig. 249).

Aside from such oblique allusions as the appearance of the *vultus domini* at the beginning and end of the series, the Ten Commandments cannot be said to be pictorialized. They exist and are perceived by the viewer exclusively as words, evoking their "literality" within a more broadly conceived medieval context.[225] The appended inscriptions in Eton 177 document a contemporary English interest in the Decalogue, responding to such declarations as those in the Statues of Worcester of ca. 1240 and the Synod of Lambeth in 1281, that the Ten Commandments along with the Credo, the seven Cardinal Sins and Virtues, the seven Sacraments and other instructional tracts should be explained to the congregation four times a year.[226]

The first two miniatures (figs. 237 and 238) comprise an isolated pair of facing pages on a separate bifolium given over to the illustration of the Creation and Fall of humankind. Unlike those in the succeeding typological pages, the roundel frames carry no inscriptions. Similar sequences of small medallions pictorially inscribed with the first Genesis scenes form a familiar component of thirteenth-century English Bibles (see fig. 239) and Psalters, as well as such compilations as Peter of Poitiers' *Compendium historiae* or Peter of Riga's *Aurora*.[227] As in the case of the twelfth-century Malmesbury voussoir medallions,[228] they comprise an historical preface dealing

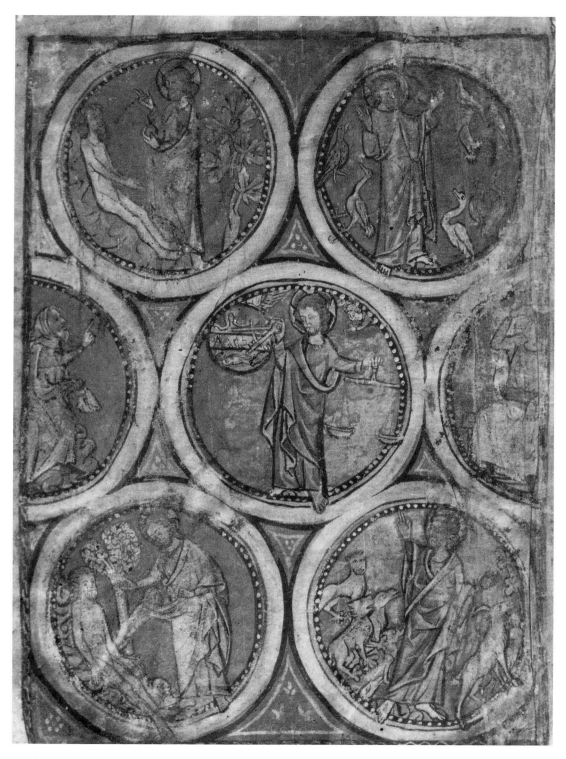

Figure 237. Apocalypse. Windsor, Eton College MS 177, fol. 1v. Creation (photo: The Provost and Fellows of Eton College and the Conway Library, Courtauld Institute of Art, London).

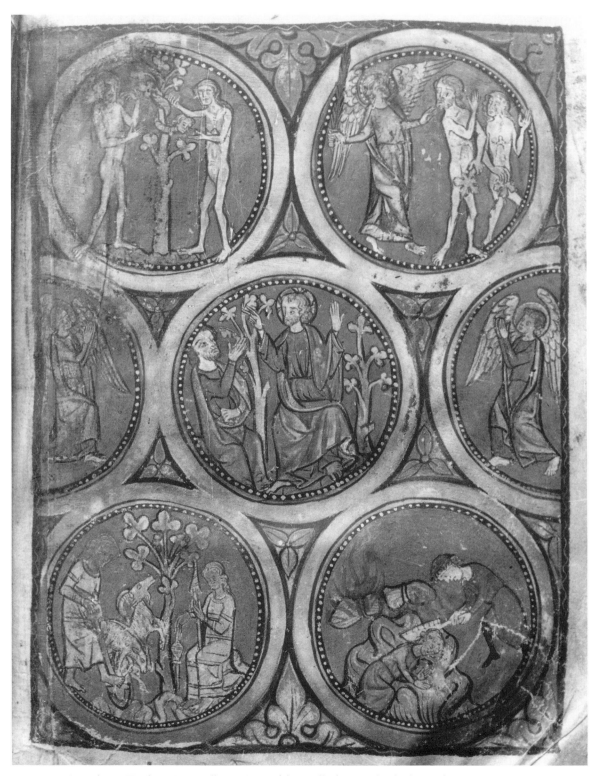

Figure 238. Apocalypse. Windsor, Eton College MS *177*, fol. *2*. Fall of Humankind (photo: The Provost and Fellows of Eton College and the Conway Library, Courtauld Institute of Art, London).

with Genesis through the death of Abel before moving on to the series of Old Testament types and New Testament antitypes.

The first set of Genesis roundels (fig. 237) centers around the image of the cross-nimbed Logos-Creator, tracing the sphere of the universe with a compass while holding the scales in his other hand, as in the contemporary Alnwick Bestiary.[229] At the same time that the scales convey the power of the Creator, they recall the weighing of souls at the Last Judgment, so that the moment of the earth's beginning can be seen proleptically to evoke its end.[230] Ultimately inspired by the Book of Wisdom 11:21 ("Omnia in mensura, et numero, et pondere disposuisti"), the ambidextrous Lord combines an old but distinctive late Anglo-Saxon tradition[231] in which Creation is seen as a judicious act of imposing order onto chaos. With the newer Gothic image exemplified by the *Bible moralisée*, Creation becomes a rational design of the geometer's art,[232] signaling the beginning of a divine plan that will unfold to the end of time.

The central roundel encloses an image of the Lord resting on the seventh day (Gen. 2:1–3), as in the historiated initial to Genesis in the Bible of Robert de Bello (fig. 239), where two seated figures representing the Trinity, based on the traditional representation of Ps. 109 (see fig. 191), provide a narrative transition between the end of God's six-day work of Creation and the ensuing drama of the Fall. Although sometimes identified as the prohibition to Adam or the accusation of Cain,[233] the two fully draped seated figures who turn toward one another in colloquy among two trees of the newly created terrestrial paradise more probably represent the omnipotent Lord in his dual guise as Creator and Logos resting on the seventh day and now being adored by Adam, who gazes at him in innocence and awe, joined by the two angels in the flanking half-roundels. Just as the Lord creates the first man in his own image in the first roundel on the facing verso, he now blesses the crowning work of his creation before the Fall. Forming a counterpart to the central roundel on the opposite verso, the Lord resting on the seventh day forms a distinctive but familiar component among the cyclical roundels illustrating early Genesis scenes in thirteenth-century Bibles.[234]

By placing the Apocalypse within a metahistorical scriptural frame, the designer of the book reifies for the reader Augustine's metaphor of God's twofold revelation: "God has written two books, the book of creation and the book of redemption."[235] Following the dictum of Alain de Lille, all of creation is literally given as a book, a picture, and a mirror.[236] The diachronic series of mirrors then enables the reader to perceive the Apocalypse as the culmination of the history of creation and salvation.[237] Within the metahistorical context implied by the overall structure of the Eton Apocalypse, God's work of the first six days of Creation can be read allegorically in the Augustinian sense of the six ages of the world as successive stages in the restoration of humankind after the Fall. Thus, the spatial calibration denoted by the Creator's compass at the center of the first page becomes a signifier for temporal measure as well, as it activates a metahistorical clock. Within the hexaemeral allegory in which the septenary of Genesis signified the totality of time, God's rest on the seventh day was variously interpreted by exegetes from Augustine to Grosseteste as the end of history, the age of universal perfection, linked with the seventh age, the age of the Apocalypse.[238] For Augustine, the seventh age was transferred beyond terrestrial life, but without taking it altogether out of time and history, just as the sixth age was identified with an historical period of infinite duration, extending from the Incarnation to the Second Coming.[239] The end of time is thus not perceived as a return to the extratemporal era of Genesis or Paradise revisited, but rather as the transformation of existence to a higher plane achieved through Christ's sacrifice. The Eton Creation pages thus form an atemporal frame for the unfolding of the sixth age, from the Incarnation to the Ascension; this in turn opens onto the Apocalypse, which initiates the seventh and final age in the opening of the seven-sealed book.

Turning now to the narrative of the surrounding roundels depicting the Fall and its aftermath, the Lord's ambiguous gesture during the creational Sabbath can be simultaneously read as blessing and prohibition, as he points upward with one hand to the Tree of Knowledge and with the other makes a gesture of rejection toward the roundel showing the angel expelling the guilty pair from Paradise. In the surrounding roundels, the narrative unfolds in a normal sequence from left to right, from top to bottom. Beginning at the top left, Adam and Eve eat the fruit from the forbidden tree, having been tempted by a

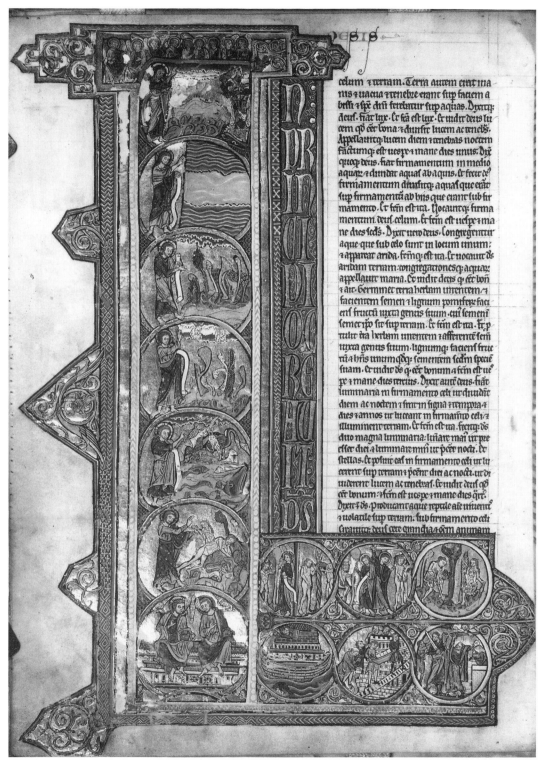

The text column in the image reads (medieval Latin abbreviated script, Genesis):

celum z terram. Terra autem erat ina
nis z uacua z tenebre erant sup faciem a
bissi z spc diii ferebatur sup aquas. Dixitq;
deus. fiat lux. Et fca est lux. Et uidit deus lu
cem qd ecc bona. z diuisit lucem ac tenebs.
Appellauitq; lucem diem z tenebras noctem
factumq; est uespe z mane dies unus. Dix
itq; deus. fiat firmamentum in medio
aquaç z diuidat aquas ab aquis. Et fecit dc
firmamentum diuisitq; aquas que eant
sup firmamentu ab his que erant sub fir
mamento. Et fcm est ita. Uocauitq; firma
mentum deus celum. Et fcm est uespe z ma
ne dies scds. Dixit uero deus. Congregentur
aque que sub celo sunt in locum unum:
z appareat arida. frctq; est ita. Et uocauit ds
aridam terram: congregationesq; aquaç
appellauit maria. Et uidit deus q; ecc bon
z ait. Germinet terra herbam uirentem z
facientem semen z lignum pomiferç faci
ens fructu iuxta genus suum. cui semeni
semet ipo sit sup terram. Et fcm est ita. Et p
tulit terra herbam uirentem z afferente sem
iuxta genus suum. lignumq; faciens fruc
tum z uns unumqdq; sementem sedm speciê
suam. Et uidit ds q; ecc bonum z fcm est uesp
z mane dies tercius. Dixit aute deus. fiant
luminaria in firmamento celi ut diuidat
diem ac noctem z sint in signa z tempora z
dies z annos ut luceant in firmamento celi z
illuminent terram. Et fcm est ita. Fecitq; ds
duo magna luminaria: luminare mai ut pre
esset diei z luminare min ut pecc nocti. Et
stellas. Et posuit eas in firmamento celi ut lu
cerent sup terram z pecc diei ac nocti. ut di
uiderent lucem ac tenebras. Et uidit deus qd
ecc bonum. Et fcm est uespe z mane dies qrt
Dixit z ds. producant aque reptile aie uiuentis
z uolatile sup terram. sub firmamento celi
firauitq; deus cete grandia z ocm animam

Figure 239. Bible of Robert de Bello. London, British Library MS Burney 3, fol. 5v. Historiated Initial to Genesis (photo: The British Library).

double-headed serpent whose deceit is conveyed by his duplicitous metamorphosis from beast to angel. In the opposite frame, the fallen couple is expelled from Paradise by an angel wielding a sword, a figure who will reappear in the cycle to sheath his sword at the Crucifixion (fig. 244). The lower roundels show Adam and Eve toiling on earth at the left and Cain murdering Abel with a jawbone at the right. Although the jawbone, with its connotations of bestial violence, offers a very old but still ubiquitous iconography in thirteenth-century English art,[240] the goat eating leaves from a tree between Adam digging and Eve spinning constitutes a singular pictorial invention equally rich in associative meaning. Aligned on a vertical axis with the Tree of Knowledge in the upper roundel, the rampant goat serves as a reminder of the original sin of eating and, indeed, when juxtaposed with the sheep placidly grazing at left, it stands for all sinners to come.[241] Both Jerome and Isidore of Seville, as well as the Bestiary attributed to Hugh of St. Victor, call the goat a "lascivious animal."[242] More importantly, however, the image anticipates the typological representation of the Scape-Goat that accompanies the Eton Ascension (fig. 247), looking forward to the Incarnation that follows, so that the sacrificial beast becomes a symbol of Christ because he has taken on the sins of the world, following the traditional exegesis based on John 1:29 and rooted in Augustine.[243] In the context of the as-yet-unredeemed sinful state of Old Testament humankind, however, as well as the history of New Testament salvation that follows in the typological series, the intrusion of the scapegoat from Leviticus into the story of Adam and Eve after the Fall can also be read as a marker claiming their unregenerated domain for Synagogue, who is often represented holding a goat's head as attribute.[244] The typological sequence in Eton 177 culminates in the Unveiling of Synagogue (fig. 248) and the Triumph of the Church (fig. 249).

Whereas the pair of Creation pages appears to have been inspired by roundel illustrations in contemporary English Bibles and Psalters, the complex sequence of ten typological schemes very closely corresponds to a monumental cycle of inscribed images dating no later than ca. 1125, once visible in the Chapter House of Worcester Cathedral Priory.[245] Typological images in England go back to Bede who described such pictures brought from the Continent

to Monkwearmouth in the seventh century.[246] Pictorial typologies did not come into vogue, however, until the second half of the twelfth century under the influence of the schools, as witnessed by such ambitious programs as the twelve typological windows in the choir of Canterbury Cathedral, similarly inscribed with verses.[247] The largest known collection of types and antitypes in the treatise called the *Pictor in carmine*, probably compiled ca. 1200 in the Cistercian Abbey Dore, documents the intensity of interest in a diverse range of esoteric subjects in twelfth-century England.[248] By the time the Eton sequence came into being ca. 1260–70, typology and multiple exegesis no longer dominated theology in the schools but became a sort of hermeneutic art form spreading from monastic circles to the laity.[249] The Eton miniatures hark back to twelfth-century monastic programs but at the same time constitute a refocusing of old allegorical forms. As pictorial ideas are transferred from the corporate monastic spaces of the chapter house and cathedral choir into the private realm of the illuminated book, the typological images now serve a more personal devotional purpose, thus explaining the addition of moral categories in the Virtues and Ten Commandments. Although the symmetrical layout of roundels glowing with the dark jewellike red and blue hues of thirteenth-century windows might suggest the miniaturization of a monumental glass program, the small scale and lack of differentiation in shape between type and antitype, along with the close synchrony of text and image, bring the Eton pages into a closer relation to the earlier thirteenth-century Parisian *Bible moralisée*, as both rely for comprehension of their complex messages on the reader's perceptions of subtle pictorial detail and rhetorical nuance.

Newly introduced into the thirteenth-century discourse of the Eton roundels are pairs of spectatorial figures that were presumably absent in the Romanesque cycles. Two prophets occupy the lower left roundel on each page, and the central roundel is flanked by half-roundels containing two more gesturing onlookers or witnesses. In contrast with the stabilizing, frontal figures of the Virtues, the animated pairs of Old Testament prophets become semiotically aligned with the inscribed Commandments as they initiate "reading" from left to right.[250] The Eton prophets thus propel a forward momentum from the Old Dispensation to the New, as well as

forward through the historical sequence of episodes marking the Life of Christ from the Nativity beyond the Ascension. Unlike the episodic or narrative character of the Old Testament events visually described in the other three roundels on each page, the prophet-pairs convey their messages only verbally through spoken utterances. Although each of the four small roundels acquires prospective and retrospective meaning only through its contingency and literal spatial contiguity to the central image-event, the prophet roundels play a special and distinctive role in the overall typological discourse of the page. Serving as preceptors or guides as well as mediators linking the two eras, the prophets engage in a dialogue of word and gesture literally pointing to the New Testament event in the central roundel. They set up their own causal necessity, as they function at the level of the preordained, witnessing the inevitable temporal unfolding of the drama of human salvation. Not only do the prophets' names appear above their heads for purposes of identification, their inscribed utterances read in opposite directions, creating a distinctive dialogic closure of discourse. The closed system opens up only through their pointing gestures, as the figures direct the viewer's eye through a spatial gap in their discourse to the upper center, along a path opened by a break in the inscriptions within the frame. Unlike the figures enacting the Old Testament narrative episodes in the other three roundels, the prophets are privileged to foresee what has been promised, thus alerting the viewer to perceive the event-types as equally, but only retrospectively, prescient.

In contrast with the prophets, who hold books and scrolls that locate them within the Scriptural tradition lexically indexed by their inscribed prophecies, the gesturing figures occupying the half-roundels flanking the central image are mute and seem to serve as witnesses or spectators rooted in the present. Representing various classes of medieval society from king to tonsured cleric, but including only one woman, these figures gaze and point upward to the upper pair of typological roundels, as if to acknowledge their prefigurative meaning within the context of contemporary Christian belief. Their witnessing function is stressed not only by their pointing gestures but also, in one instance, by a man who points to his eyes as he gestures toward Moses leading the people across the Red Sea (fig. 242).

The typological series in Eton MS 177 begins with the Nativity (fig. 240), accompanied by typologies of Daniel's vision of the stone cut without human hands, the Burning Bush, and Aaron's Rod, with the prophets Balaam and Daniel standing in the fourth roundel; a crowned personification of Charity is seated below. The Second Commandment ("You shall adore no graven images") is inscribed in the lower margin. Bracketed by two kneeling figures in half-roundels at the right and left, the Nativity forms the centerpiece of complex interlocking parts. Above the Christ Child two angels flying out of the heavens point at the star of Bethlehem *(nuncia stella pre[ven]it),* as Balaam in the lower left roundel points upward announcing his prophecy: "A star will arise from Jacob and a man rises up from Israel."[251]

In the upper right roundel, Daniel sees the king's vision of the stone *(lapis angularis)* cut without human hands, a typology commonly invoked to presage the virgin birth of Christ, but here the Worcester inscription has been abbreviated at the end to read "This is God and not a stone *(Deus est et non lapis idem),*"[252] clearly referencing the Second Commandment inscribed below, so that Daniel's vision also alludes to the great image destroyed by the stone. A further allusion is made by the second figure of Daniel who stands next to Balaam at the lower left, declaring that "When he [the Messiah] comes, he will cease to anoint your holy of holies" (Dan. 9). In a similar vein, all the typological comparisons stress the miracle of the virgin birth.[253]

Most striking in the Eton roundels are not the traditional ways in which the Old Testament types are textually indexed, but rather the pictorial strategies through which they are visually demonstrated, making the patterns of typology for the Nativity clearly visible to the reader-viewer. Within a new framework of visual rhetoric, the upper left roundel sets up the idea of a narrative myth-screen pictorially structured in such a way that Daniel's vision can be perceived as a story potentially capable of being retold, translated, transformed into the event of the Nativity. The figure of the dreaming Daniel is thus supplanted by the Virgin, the first giving birth to a prophetic vision, the second to Christ himself. The unhewn stone, which is usually not visible in thirteenth-century representations,[254] dominates the pictorial center of the upper Eton roundel, just as the Christ Child commands the same position in the cen-

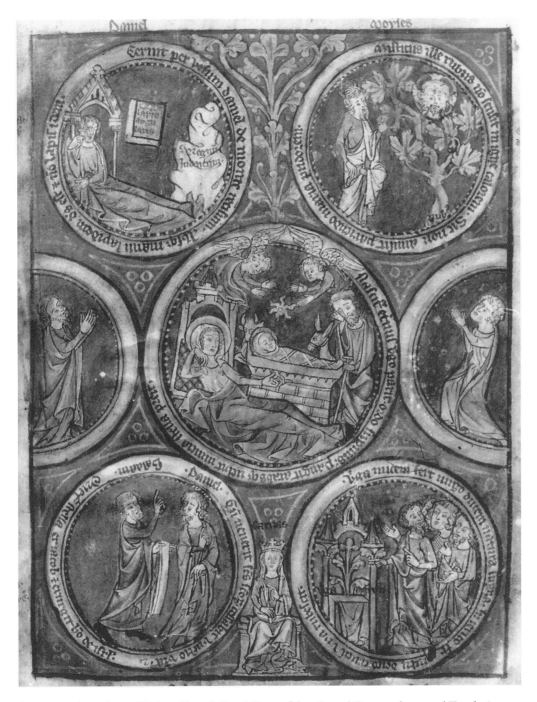

Figure 240. Apocalypse. Windsor, Eton College MS 177, fol. 3. Second Commandment and Typologies for the Nativity (photo: The Provost and Fellows of Eton College and the Conway Library, Courtauld Institute of Art, London).

tral roundel; indeed, the rectangular shape of the masonry base on which the crib is placed echoes the rectilinear form of Daniel's vision of the *lapis angularis*.

In contrast with most thirteenth-century representations of Moses before the Burning Bush,[255] all references to the law-giving are suppressed in the Eton roundel to stress the idea of Moses' vision, so that Christ appears as a purely iconic presence, an *imago clipeata* embedded within the branches, leaves, and flames of the miraculous bush. The two figures kneeling in the half-roundels below thus function on two levels: As they gaze upward, they serve as present witnesses to the prophetic alliances between the central Nativity and the Old Testament visions of Daniel and Moses; as they kneel with their hands clasped in adoration, they reverently acknowledge Christ's coming. Within the prophets' roundel below, it is Balaam who sees and points upward to another visible sign of Christ's Advent in the star that prefigured the star of Bethlehem; here the visible portents from both Testaments are merged above the head of the Christ Child in the center. At the lower right, in contrast with contemporary representations of Aaron's flowering rod in the *Bible moralisée*, the narrative referencing of the other rods has been erased to dramatize the singular miraculous sign. Moses no longer holds forth the transformed scepter of priesthood; the flowering rod spontaneously sprouts forth upon a canopied altar. Aaron's dual gesture of pointing simultaneously across to the flowering rod and upward to the Nativity scene functions as another kind of visible alignment of the Old with the New in much the same way as the Virgin's unusual gesture of pointing at the Child evokes the Byzantine formula of the *hodegetria*, or "pointing the way."

On the next page, the Presentation in the Temple (fig. 241) is prefigured most directly at the upper right by the traditional typology of Hannah dedicating her son Samuel to service in the temple.[256] A number of striking visual connections are made between type and antitype. The idea of the New Testament fulfillment of prophecy is visualized metaphorically as Christ's "filling" a space left vacant by his Old Testament predecessor, Samuel. The curtain that had presumably obscured the altar from our gaze has been dramatically pulled back and looped around the frame, suggesting that the sacred sacrificial space on the altar is "opened" but not filled by

Samuel's dedication to the temple.[257] The altar within the lower right roundel toward which Cain and Abel extend their offerings similarly remains empty, reiterating the same typological point of Christ's eventual sacrifice. Whereas the altar remains empty in the Old Testament prefiguration, Christ claims its sacred space in the Presentation, as the prophet Malachi declares in the roundel below: "The Lord whom you seek will suddenly come to his temple." Just as in the preceding representation of the Nativity, the arrival of the Messiah was announced by a celestial stellar light, the old temple is now illuminated by the light of two candles, presaged by the veil being pulled back to reveal the altar at Samuel's presentation, a gesture that will take on central importance at the end of the Eton cycle. The lights on the altar endow the Presentation scene with festal as well as liturgical significance.[258]

More important is the sacramental dimension given in the other two typological scenes whose traditional interpretation focuses on the Eucharist. The two prophets in the lower left roundel ("See the Lord standing upon the altar") draw the viewer's attention to the sacramental rendering of the Presentation scene in which the Christ child holds a tiny host as he is lifted onto the vested altar. Thus, Cain and Abel making their offerings above an altar reiterate for the second time the central ritual gesture of the Presentation. At the upper left, the Eucharistic allusion is repeated in the figure of Abraham the warrior dressed in mail, holding a cloth full of loaves, and a mitered Melchizedek holds a chalice and host (or cross-emblazoned paten).[259] On this page, the visionary dimension of "seeing" is dramatically visualized by contrasting blindness and insight. As Abraham makes his offering of bread in the upper left roundel, a visor is pulled down over his face, obscuring his vision of the gift transformed into the host and chalice of the Eucharist. Similarly, Samuel and Abel in the upper and lower right roundels gaze at an empty space, unable to envision the divine sacrifice that will come. In contrast, as Simeon gazes at the Christ Child, the visual recognition of the Messiah literally transforms him, as signaled by his glowing red nimbus, echoing the verse accompanying the Worcester cycle.[260]

Humility appears beneath the Baptism (fig. 242), which is accompanied by the standard typologies of the Crossing of the Red Sea and Noah's Ark, but the

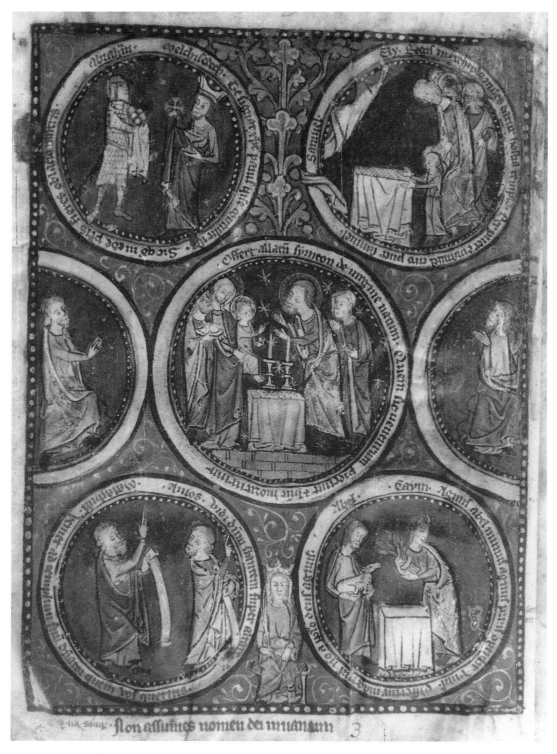

Figure 241. Apocalypse. Windsor, Eton College MS 177, fol. 3v. Third Commandment and Typologies for the Presentation in the Temple (photo: The Provost and Fellows of Eton College and the Conway Library, Courtauld Institute of Art, London).

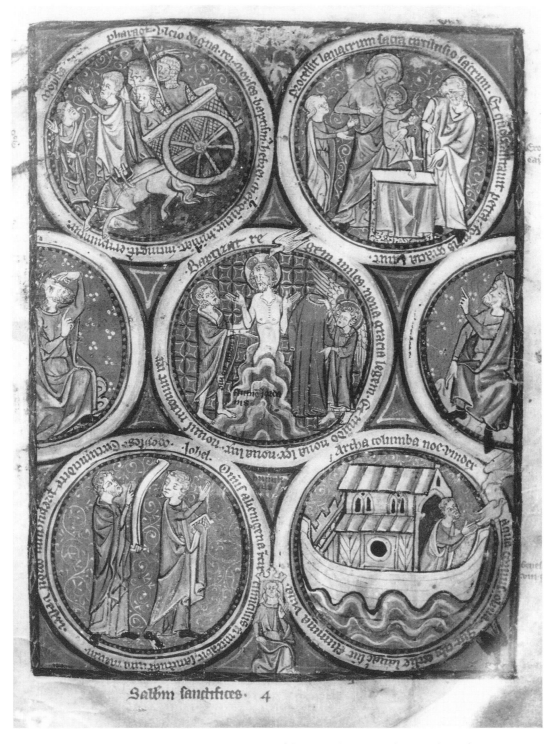

Figure 242. Apocalypse. Windsor, Eton College MS 177, fol. 4. Fourth Commandment and Typologies for the Baptism (photo: The Provost and Fellows of Eton College and the Conway Library, Courtauld Institute of Art, London).

representation of Zipporah circumcising her child (Exodus 4:25) as well as the pronouncements concerning God's command on circumcision uttered by the prophets in the lower roundel are rare. In a standard frontal representation of Christ standing in the Jordan, John the Baptist approaches from the left saying "You come to me" ("Tu venis ad me"). Reiterating the leitmotif of Christ as the bringer of light *(lucifer)* represented by the star of Bethlehem at the Nativity and the altar candles at the Presentation, the inscription invokes not only the "new Law" and the "new king," but also a *nova lux:* "The soldier baptizes the king; the new grace purifies the Law; there is a new law, a new light in the world."[261] In the lower right roundel, the Ark constitutes a dual reference, signaled by its inscription, to salvation and to the Church.[262] Noah stands in the portal of a basilical structure within the vessel, itself an ancient symbol of Ecclesia, as witness to the conflated episodes of the departure and return of the dove bearing an olive branch; the returning bird overlaps the frame in an oblique trajectory echoing the descent of the dove (Holy Spirit) at the Baptism, thus serving as symbol of reconciliation and new beginning.[263]

Identified by the notation "Exodus iiii" in the margin, the representation of Zipporah (Sephora) circumcising her son, presents some problems. The *mohel* (priest), not Zipporah, performs the rite with the scalpel, as the mother stands behind the child, awkwardly offering him her breast. The inscription suggests that the scene was more probably intended to represent the Circumcision of Isaac performed and attended by Abraham and Sarah, although it more normally serves as a typology for the Circumcision of Christ.[264] However, the rare gesture of the mother attempting to nurse the child,[265] unprecedented in circumcision scenes under both dispensations, appears to relate to the textual source underlying a line in Bonaventure's *Meditationes vitae Christae* in which he stresses the pain suffered by the Christ child at the circumcision to demonstrate the fullness of his humanity, describing how Mary suckled her son to comfort him.[266] He concludes that "from that time physical circumcision was abolished and we have baptism, with more grace and less pain," an association that closely corresponds to the Worcester-Eton verse, "And he who was castrated by the stone [circumcised] is washed in the font of grace." Similarly, the prophets in the lower roundel first para-

phrase God's command to Abraham and then Paul's admonition to the Romans 3:30: "The real circumcision is in the heart." Thus, in the Worcester-Eton scheme, the standard typological apparatus has been expanded to proclaim the *nova lex* of the central inscription in which the circumcision of the Old Law has been supplanted by Baptism as the ritual act of purification.[267]

If, as Henry suggests, the upper right roundel can be read as the Circumcision of Christ rather than of Isaac or Zipporah's son, the event then stands as a precursor to the Crucifixion, which Jerome called a "baptism of blood."[268] As Christ stands in the waters of the Jordan in the central roundel, his bared body and upraised hands evoke the potential bodily site for the "Man of Sorrows" who displays his wounds in this way after the crucifixion. Indeed, the connotation of blood seems almost inevitable within the sacramental context invoked by the Circumcision scene at the upper right. Instead of purifying Christ with the waters of the Jordan, John the Baptist reaches out for the Lord, just as the priest Simeon reaches out for the Christ Child in the Presentation scene on the opposite page, further evoking the idea of Christ's body as an object of future sacrifice. Just as Simeon recognizes the Messiah and is transformed by the sight, John gazes into Christ's face as he utters a cry of recognition – "You come to me!" At the same time, the Baptist's exclamation from Matt. 4: 14 draws the reader's attention to the virtue of Humility at the bottom of the page, for John is amazed that Christ would humble himself to be baptized by a mere mortal. As John also sees the dove of the Holy Spirit as a visible manifestation of the divine, Noah in the lower right roundel prefigures his vision as he sees the dove with the olive branch signaling his divine deliverance.

Whereas the Presentation and Baptism appear on facing pages offering opposing rituals undergone by Christ under the Old and New Law, the following pair of images provide contiguous events in the Passion narrative. On the verso, Christ Bearing the Cross (fig. 243) proceeds toward the Crucifixion. The verses stress the idea of sacrifice and humiliation: "Christ made the cross a noble altar on which he would suffer, truly crowned, spit upon [and] reviled."[269] In addition to reiterating the idea of Christ's body sacrificed on the altar as it was referenced indirectly on the first three pages, the modifi-

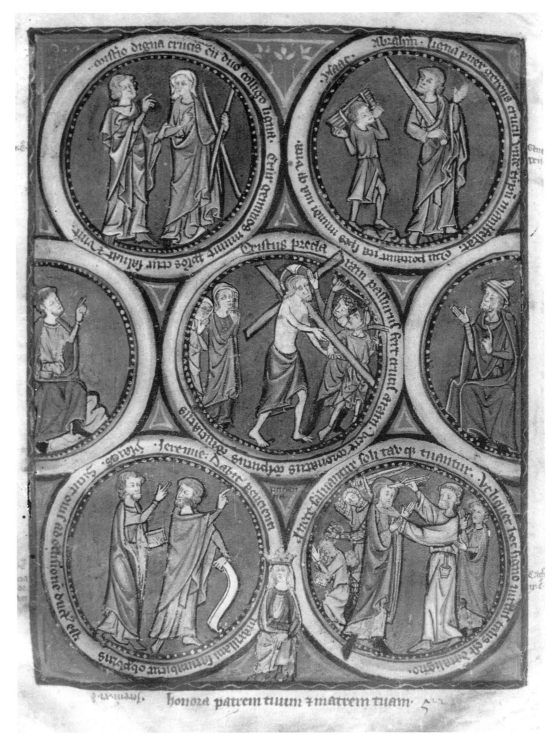

Figure 243. Apocalypse. Windsor, Eton College MS 177, fol. 4v. Fifth Commandment and Typologies for the Carrying of the Cross (photo: The Provost and Fellows of Eton College and the Conway Library, Courtauld Institute of Art, London).

cation was perhaps intended to link the image more directly with Patience personified at the bottom of the page in the kind of association made in the late thirteenth-century vernacular poem, the *Speculum Gy de Warewycke*, in which the knight is advised by his priest to remember Christ's silent endurance of agony, vile words, and shame as the perfection of the virtue.[270]

For the Carrying of the Cross, all three typological scenes are traditional and are given in the *Pictor in carmine* as well as in thirteenth-century French glass programs based on the *Glossa ordinaria*.[271] For the last typological scene, however, the Eton designer changed the Worcester verse to refer to the cross rather than the Crucifixion but presumably retained the original image of the *tau*-writer from Ezek. 9 marking the foreheads of one of the righteous Jews.[272] Whereas the *tau*-writer who walked the streets of Jerusalem seeking the penitent and righteous remnant who will escape the sword of the avenger is described as "a man clothed in linen" with the writing case suspended at his side, the Eton figure appears to be a tonsured friar dressed in Franciscan garb. As John Fleming has eloquently argued, not only Thomas of Celano and Bonaventure, but Francis himself cultivated his identification with the *tau*-marker, using it as the signature on all his letters and painting it on the walls of all the cells.[273] The *tau*-writer thus serves as a particularly fecund image within Eton's typological scheme, for it not only serves as precursor to Christ Bearing the Cross, but also can be seen as a link with the contemporary spiritual life of the individual reader as well as with the conversion of a remnant of the Jews when Synagogue is unveiled at the end of time at the conclusion of the Eton series. The image thus anticipates the eschatological as well as Christological fulfillment of the prophecy from Ezekiel inscribed around the frame: "They alone are saved from death and protected by the *tau*. As is clear, this power was given similarly to the *tau* as much as to the wood." The scene of the *tau*-inscription is nevertheless problematical, for in a purely visual sense, it is the *bearer* of the mark rather than the *tau*-writer who most closely resembles Christ. Thus, like Abraham in the upper right roundel, the *tau*-writer serves as the vehicle through whom salvific power is transmitted; they are further conjoined by the pointed instruments (sword and pen) by which they inscribe the respective signs of that power. In

both cases, in contrast with the cross displayed by the widow of Sarepta at the upper left, only the instruments rather than the powerful signs are visible to the reader.

Standing above the Commandment "Thou shalt not kill" and the virtue of Obedience, the Crucifixion (fig. 244) is developed as a complex allegorical scene in itself, with busts of Ecclesia and blindfolded Synagogue appearing at the left and right above the arms of the cross; the Virgin holding a chalice serves as a second personification of the Church. On the other side of the cross, the six-winged seraph who drove Adam and Eve from paradise returns his flaming sword to its sheath, signaling that Adam's debt has now been satisfied by Christ's sacrifice on the cross.[274] Departing radically from the traditional configuration of the Virgin and John flanking the cross, the symbolic image stressing the dogma of the Fall and Redemption evokes a rare iconography that occurs in the thirteenth-century glass programs at Rouen and Sens.[275] In place of the Worcester verses, a new inscription proclaims that "God released us unconditionally and redeemed us with [his] blood, in death without dignity, dying a malignant death." Within the framework of the conventional typology representing the Sacrifice of Isaac at the upper right, the Eton designer introduces an angel grasping Abraham's sword to stay the patriarch's hand, thus providing a visual as well as theological counterpart to the Seraph's gesture at the Crucifixion.

The image of the Brazen Serpent offers an equally conventional type for the Crucifixion in a formulaic rendering in which the horned Moses holds the tablets of the Law as he points to a dragon surmounting a columnar pedestal. Nevertheless, by adding a long serpentine tail winding around the vertical shaft, the Eton designer again alludes to Adam's sin in the garden and connects it visually with the dead Christ's legs twisted on the cross, echoing the *Glossa ordinaria*'s metaphorical assertion that Christ is the new serpent who vanquished the old one.[276] The Eton inscription reads: "Christ the serpent kills the fiery serpent" ("Serpens, serpentes, christus necat ignipotentes"). Comprising the third type is a rare representation of Elijah curing the Widow of Sarepta's son (I Kings 17:17–24). Reiterating the redemptive and salvific power of Christ's death on the cross, the accompanying inscription reads: "In the cross is life; God raises us now just as Elijah was a prefiguration

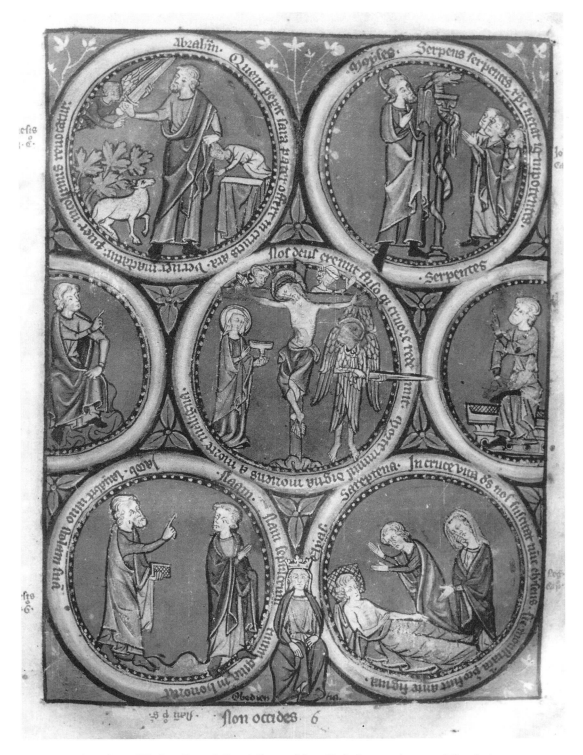

Figure 244. Apocalypse. Windsor, Eton College MS 177, fol. 5. Sixth Commandment and Typologies for the Crucifixion (photo: The Provost and Fellows of Eton College and the Conway Library, Courtauld Institute of Art, London).

to demonstrate the same thing."[277] In the *Ancrene Riwle*, the reader is explicitly invited to identify herself with the poor woman of Sarepta:

These two pieces of wood represent the one which stood upright and the one which crossed it, in the precious cross. With these two pieces of wood you should kindle the fire of love in your heart. . . . [I]f the true Elias, God Almighty, finds you diligently gathering those two pieces of wood, he will stay with you and multiply in you his precious grace, as Elias stayed with her and multiplied her food whom he found gathering two sticks in Sarepta.[278]

Accompanied by standard typologies, post-Passion scenes follow on the next three pages. The Resurrection (fig. 245) is represented by the three Marys and the Angel at the empty tomb. The pictorial analogy of the lion reviving its cubs is ultimately drawn from the Bestiary and also occurs as a typology for the Resurrection in the *Pictor in carmine* as well as in the Canterbury glass program. Notwithstanding the inscription inspired by the Bestiary text that the lion breathed life into its cub ("Reddit per flatum catulum leo vivificatum"), the roaring beast in the Eton roundel stands visually and conceptually closer to the symbolic window at Lyons, based on the type drawn in an Easter sermon by Honorius Augustodunensis:

It is said that the lioness gives birth to lifeless cubs, but that after three days the roaring of the lion brings them to life. Similarly, the Savior lay in the tomb as dead, but on the third day he rose awakened by the voice of his Father.[279]

Jonah coming out of the whale still constitutes a popular and obvious analogy for the Resurrection in the thirteenth century, but in the Eton roundel, the miraculous rescue is almost overpowered by the city of Nineveh dominating the shoreline, suggesting a literal visualization of the rubric in the *Pictor in carmine*: "The seamonster vomits up Jonah alive on the dry shore opposite Nineveh."[280] However, the architectural configuration also becomes visually resonant with the walled city of Gaza in the roundel at the lower right from which Samson escaped by tearing down the gates. In contrast with the roundel that repeats the episode of Samson at Gaza in the same position on the facing page (fig. 246), the biblical hero shouldering the gates is not immediately visible; only the Philistines are seen attacking the bat-

tlements. In an ingenious critical response to the explanatory text, the Eton designer transforms the personified virtue of "Fortitude" into a powerful surrogate for Samson, as the singular atlas figure raises the whole roundel containing Christ's tomb, thus linking the central and lower right roundels and literally pictorializing the verses: "Samson, enclosed within Gaza, escapes from his enemies; Christ the stone [referring back to the *lapis angularis* symbolizing the incarnate Christ and the Nativity], whom the stone covered, rises from the tomb."

For the Harrowing of Hell, which occupies the center of the facing page (fig. 246), a second image of Samson shows him carrying away the gates of Gaza at the lower right.[281] The leitmotif of the battlemented city is carried over from the previous verso to create visual analogues between the Resurrection and the Harrowing of Hell, as well as a cyclical continuity between the two Samson scenes occupying corresponding roundels on the facing pages at the lower right. As he carries the crossed gates on his shoulders, Samson can also be seen as a visual reprise of the earlier image of Christ carrying the cross; confirming the perception of this role for the viewer, Samson turns back, looking retrospectively toward an earlier event in the cycle.

The pair of facing pages dealing with Christ's Resurrection comprise a sequence of images visualizing metaphors of opening, release, and rescue. As the viewer looks horizontally across the row of upper roundels, resuscitative power is seen to be invested in a series of open mouths, as the whale releases Jonah, the lion roars its cub to life, the bear releases the lamb, and Samson pries open the jaws of the lion. As we move down to the roundels in the center of each page, the metaphor of opening then becomes one of emptying a container (vessel) of death, Christ's tomb, and "the kingdom of death" (Hell). In both cases, victory over death is signaled by a visible emblem, as the angel holds a palm branch and Christ holds a triumphal cross-staff. In the lower right roundels, which visualize Samson's escape from Gaza in two successive narrative episodes, the ongoing visible contrasts between opening and closure become even more dramatically evident. Like Christ's tomb, the enclosed city is guarded by soldiers; Samson's subsequent breaking down of the gates is then witnessed by a figure who stands within Gaza's open portal, pointing to the prefiguring sav-

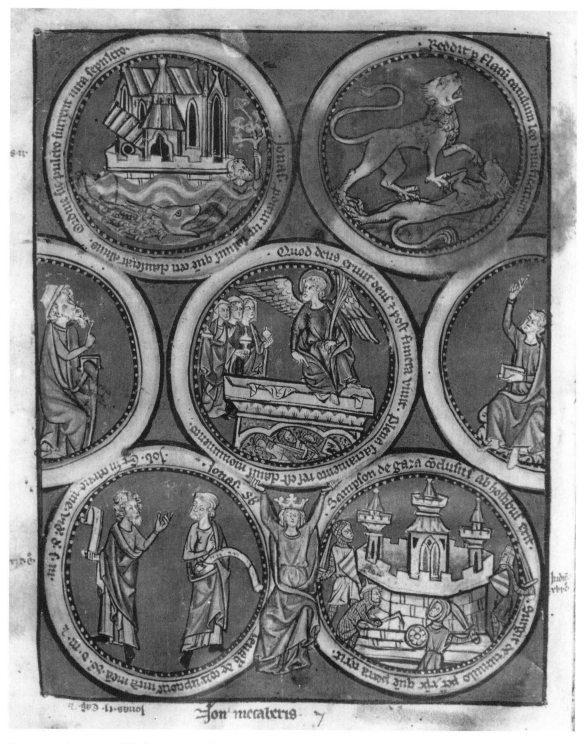

Figure 245. Apocalypse. Windsor, Eton College MS 177, fol. 5v. Seventh Commandment and Typologies for the Three Maries at the Tomb (photo: The Provost and Fellows of Eton College and the Conway Library, Courtauld Institute of Art, London).

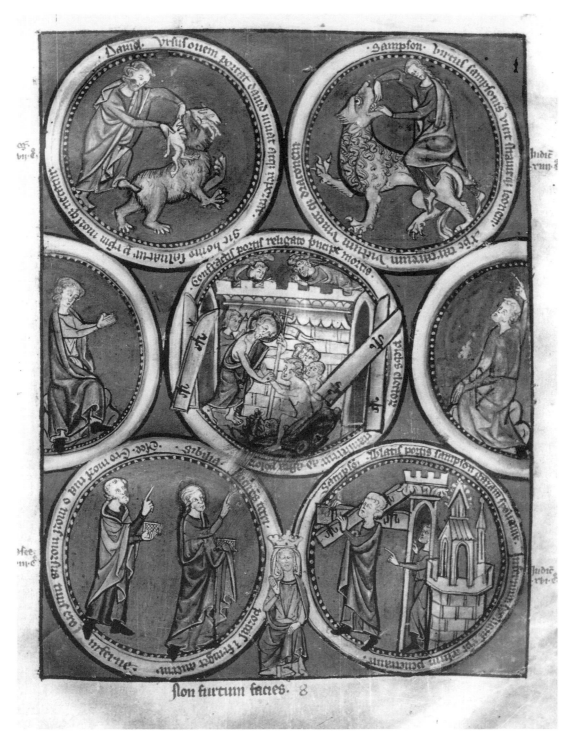

Figure 246. Apocalypse. Windsor, Eton College MS 177, fol. 6. Eighth Commandment and Typologies for the Harrowing of Hell (photo: The Provost and Fellows of Eton College and the Conway Library, Courtauld Institute of Art, London).

ior. With the visual linking of the lower right roundels on each page, the viewer then becomes aware of a further, perhaps more profound meaning of Fortitude's spectacular gesture of holding the central roundel containing the angel and the three Marys for, like Samson raising the gates of Gaza on his powerful shoulders, divine *Virtu* is lifting the lid of Christ's tomb.

The representation of the Ascension (fig. 247) departs from the more usual English rendering of the "disappearing Christ,"[282] thus offering a more obvious visual counterpart to its Old Testament *doppelgänger* in the ascending Enoch in the upper left roundel. The risen Lord still stands on earth, occupying a transitional realm between the infernal regions to which he descended and heaven to which he now ascends, as described in the Eton verses: "With the conquest of death and the army of Hell, Christ ascends to the heavens and returns the promised gift." Along with Enoch, Elijah offers an equally ubiquitous precursor for the Ascending Christ as he drives his chariot into the heavens.

Completing the set of typologies, the wild goat *(caper)* in the lower right roundel constitutes a multivalent image in which biblical and Bestiary allusions are uniquely conflated. Although the *Pictor in carmine* lists the scapegoat from Leviticus 6:20–2 as an Ascension type,[283] the image is rare. The Worcester text evokes this figure as a type for the Crucifixion, but the Eton verses have been changed to read: "This goat, reaching high, bearing another's guilt, signifies sins taken away, reaching for the heavens and the stars." Just as the last verse now resembles that for Elijah "reaching for the stars," the scapegoat's rampant pose echoes that of the galloping horse of the chariot above. The astral references are buttressed by the utterance of Habakkuk in the lower left roundel ("The sun has risen and the moon remains fixed in its place"), but David celebrates the Ascension more directly ("God ascends in jubilation and the Lord with a voice like a trumpet"). At the same time, the striking visual reference to the Bestiary image of the wild goat guarantees its signification as Christ.[284] Eton's rampant he-goat, however, also resembles the ram miraculously caught in a thicket and offered by Abraham as a substitute sacrifice for Isaac.[285]

The unmistakable symbol of the medieval perception of Judaism in the scapegoat aspiring toward the

heavens literally opens up the typological discourse beyond the Ascension as he points toward the Unveiling of Synagogue (fig. 248) on the opposite recto. The central roundel reveals the enthroned personification of what Blumenkranz has described as "Synagogue in Majesty."[286] Constructed by the Church as an image of Judaism, the personification of Synagogue traditionally served Christian art of the high Middle Ages as an antiimage, a pseudoidol created expressly for the purpose of being toppled at the moment of the Crucifixion.[287] In contrast with conventional midcentury English juxtapositions where Synagogue drops the tablets of the Law or overturns a vessel to signal her rejection of Christ's blood reverently gathered in a chalice by Ecclesia on the other side of the cross,[288] the Eton figure raises the tablets toward Moses at the left and hands the upright gold vessel presumably to Aaron at the right. A green sprig of leaves sprouts from the tablets, recalling the flowering of Aaron's rod as a harbinger of Christ's Nativity; now the Decalogue itself is renewed and transformed within the enlightenment and conversion of the Jews.[289] The inscription around the frame reads: "Veiled up to now in the obscure figure of the Law, Synagogue sees the truth by coming to the faith." Based on II Corinthians 3:12–18, the unveiling of Synagogue functions as an allegory of the displacement and abrogation of the Old Testament by the New:

Moses . . . put a veil over his face so that the children of Israel could not see the end of that which is abolished. And their minds were blinded, for until this day the same veil is still there when the Old Testament is being read, a veil never lifted, since Christ alone can remove it. . . . It will not be removed until they turn to the Lord.

In the interplay between *velatio* and *revelatio* in the commentary on Rev. 5 by Victorinus, the typological analogy of the two Testaments was applied to the Apocalypse: "The revelation of the Apocalypse is said to be revealed in the same way that the face of Moses was uncovered and revealed."[290] In the twelfth-century view of Honorius Augustodunensis, the unveiling of Synagogue links the Crucifixion to the Apocalypse, thus rationalizing the transiting sequence of the Eton pictures prefacing the illustrated Apocalypse. In his sermon on Quadragesima, Honorius explains that the covering of the tabernacle during Lent is like the veil placed over the hearts of

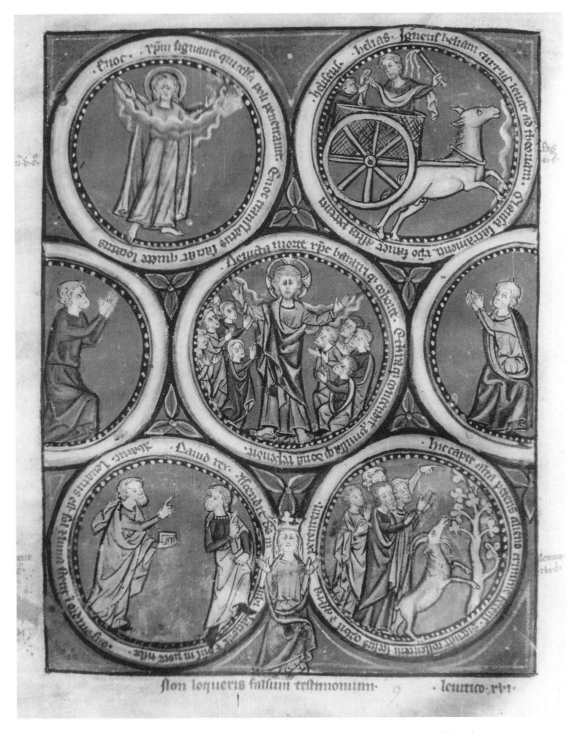

Figure 247. Apocalypse. Windsor, Eton College MS 177, fol. 6v. Ninth Commandment and Typologies for the Ascension (photo: The Provost and Fellows of Eton College and the Conway Library, Courtauld Institute of Art, London).

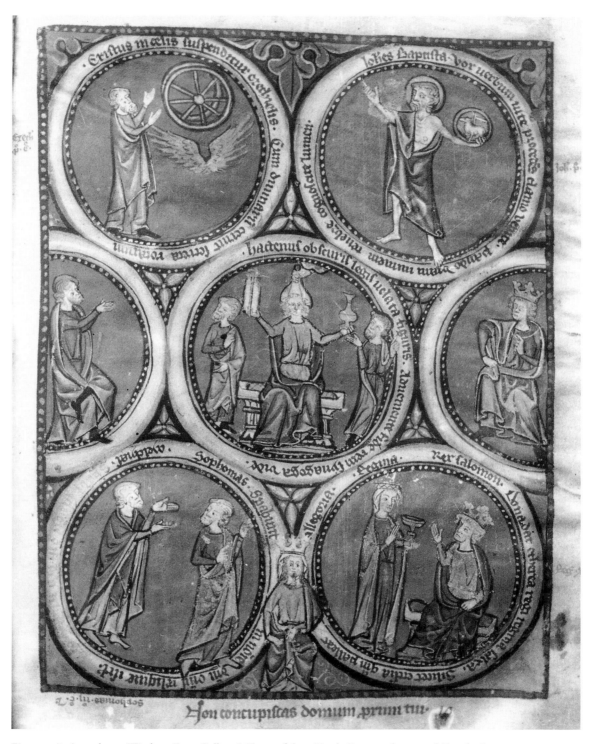

Figure 248. Apocalypse. Windsor, Eton College MS 177, fol. 7. Tenth Commandment and Typologies for the Unveiling of Synagogue (photo: The Provost and Fellows of Eton College and the Conway Library, Courtauld Institute of Art, London).

the Jews so that they could not see the splendid meaning of the Law, but through the Passion of Christ the veil will be lifted because, through his death, heaven and the book closed by the seven seals will be opened.[291] The eschatological tradition that began with Romans 11:25–7 in Paul's prophecy of the ultimate conversion of the Jews culminates in the new iconography embodied in Abbot Suger's "Anagogical Window" for St. Denis in which Christ, with the doves of the seven gifts of the Holy Spirit radiating from his body, crowns Ecclesia with one hand and lifts the veil of Synagogue with the other.[292]

Unlike the familiar images of the confrontation of Church and Synagogue, in which a personification of the Old Dispensation is rejected, representations of the unveiling of Synagogue are very rare.[293] The most revealing precedent for the Eton sequence occurs in an historiated initial in the Crawford Psalter made in Paris ca. 1220–40, in which Christ himself unveils Synagogue.[294] In the allegorical representation in St. Denis, the unveiling of Synagogue is not only related to the exegetical tradition of the Songs commentaries in which blind Judaism will turn to Christ before the Last Judgment,[295] but also to Rev. 5:6, for the Christ who crowns Ecclesia and rehabilitates Synagogue is the "Lamb with the seven horns, seven eyes, which are the seven spirits of God," symbolized by the seven doves radiating from his body.[296]

As in the preceding prefatory illustrations, the allegory of the Old Law unveiled is provided with prophetic types. At the upper left, Ezekiel beholds the vision of the wheels, distinctively superposed in an eight-spoked pair to evoke a literal image of the *rota in medio rotae*, which the exegetes of the *Glossa ordinaria* interpreted to signify the New Testament.[297] In a twelfth-century precedent for the juxtaposition of Ezekiel's vision and the Unveiling of Synagogue in the Floreffe Bible, the image of the wheels is inscribed: "By the double wheel is understood the Old and New Law."[298] In his early thirteenth-century tract, *Contra perfidium Judaeorum*, Peter of Blois admonished the Jews to open their eyes to the hidden spiritual meaning of the Old Law, the mystical New Law embedded in the Old like Ezekiel's wheel within wheels.[299] Thus, as described in the Eton-Worcester verses, "Ezekiel prophetically perceives Christ in the mysterious wheels suspended in heaven above," presumably propelled by the "spirit of the living crea-

tures" (Ezek. 1:21) represented by a pair of large green wings outspread below.

On the opposite side, John the Baptist, the last Old Testament prophet, acknowledges Christ as the Messiah as he holds a disc bearing the Lamb (John 1:29): "As the voice going before the living Word, I proclaim he has come. In the shadows you shall see the light." The inscribed allusion to Christ as light places Synagogue's unveiling in a context of "illumination" relating to the "lights" that appeared at the beginning of the Eton cycle with the star of Bethlehem at the Nativity (fig. 240) and the candles lighting the altar for the Presentation, similarly attended by the pulling back of the temple veil for the Presentation of Samuel (fig. 241). As he faces Ezekiel, the Baptist can be seen as if displaying the mystical core hidden in the wheel within wheels, having extracted the smaller but more precious disc from its hub. As the viewer's eye moves across the opened pages from the wheels of Elijah's chariot to Ezekiel's vision, it comes to rest on the Baptist's circular emblem as the goal of an interplanetary trajectory across the heavens. At the lower left, the two prophets Zephaniah and Malachi converse; the latter's prophecy has been erased, but Zephaniah's still reads: "They shall seek refuge in the name of the Lord, those who are left in Israel." Whereas Zephaniah is one of the last prophets of the restoration of Jerusalem where, after all repent, the people shall rejoice at the return of the Lord to save them and gather them home, Malachi, who exhorts Israel to repentance and faithfulness, is regarded by Christian interpreters as a prophet of the New Covenant.[300]

At the lower right, the Queen of Sheba offers a gold cup to King Solomon in a typology usually reserved for the pagan acknowledgment of Christ in the Adoration of the Magi.[301] However, the accompanying verses give the interpretation first offered by Isidore and followed by Bede: "The Queen of Sheba gives her heavenly gift to the king, which is, of course, an allegory of Ecclesia." According to Isidore,

Solomon prefigures the image of Christ who raised the house of God in the heavenly Jerusalem. . . . [T]he queen from the south who came to hear the wisdom of Solomon is to be understood as the Church, which is gathered from the utmost limits of the world to hear the voice of God.[302]

For Bede, the journey was like a bride's journey to her spouse.[303] In the twelfth-century *Hortus Delici-arum*, the Isidorian significance of Solomon and Sheba is enriched by a resemblance to the traditional visual configuration of Christ and the Virgin enthroned together in the Court of Heaven, with both Mary and the Queen of Sheba serving as types for the Church, coupled with the common interpretation of the Song of Solomon as alluding to Christ and his Church.[304] Thus, the Queen of Sheba not only represents a countertype to Synagogue in her allegorical personification of Ecclesia, but, as we shall see, her meeting with Solomon prefigures the Coronation of the Virgin on the following verso.

As the Unveiling of Synagogue faces the Ascension, the central figure can be seen to mimic the gestures of the risen Christ as she raises up the tablets of the Law and the gold vessel toward heaven, so that her whole being can be perceived to be uplifted with the raising of her veil. Within the typological context of the visual configuration as a whole, the upraised tablets, like the wheels of Ezekiel's vision, become transfigured as the New Dispensation, and the ritual vessel of Synagogue, like John the Baptist's paten bearing the image of the Lamb, becomes a new vessel for the Christian Eucharist.

The cycle ends with the Triumph of the Church (fig. 249), juxtaposed with the remaining segment of the First Commandment, "Thou shalt have no other gods." The traditional Coronation of the Virgin thus completes the allegorical narrative initiated on the preceding recto in a powerful gesture of substitution and transference. As Synagogue loses her veil, Ecclesia wins a crown; the tablets of the Law are supplanted by the Gospels, and the blood in the vessel gathered from the sacrifice on the cross is replaced by the resurrected Lord.[305] As in the Burckhardt-Wildt cycle, the lost Shulamite is reclaimed by her bridegroom. The process is similarly invoked by Gerhoh of Reichersberg who declared that the Virgin as the perfection of the Church embodies the most elect portion *(portio electissima)* of Synagogue, becoming the "Sponsa" of the Father; the idea of Mary inheriting the best part of Synagogue, which is the "prioris ecclesiae pars optima," is also given by Rupert of Deutz.[306] The revelation or truth *(rem)* that the unveiled Synagogue is invited to see in the Eton verses on the previous page is the Incarnation of Christ. In an eschatological sense, the union of Christ and the Church in the image of the Coronation of the Virgin signifies the return of Synagogue.[307]

In a striking departure from conventional formulas, Christ and the Virgin are enthroned in a chariot drawn by four winged beasts who surround them to form a Majesty in the midst of the quaternity of Evangelist symbols.[308] The meaning of Eton's strange quadriga is explained by Solomon, one of the prophets in the lower left roundel, as he quotes from the Song of Songs 6:11: "My soul was troubled in the chariot of Aminadab,"[309] which is interpreted in the *Glossa ordinaria* and the *Bible moralisée* as the bridegroom or Church preaching to an admiring Synagogue, and the four wheels of the quadriga represent the four Gospels being carried to the four parts of the world.[310] Elsewhere in the *Bible moralisée*, the meaning is made equally explicit in the pairing of the chariot of Aminadab carrying the Shulamite and the Bridegroom with the Conversion of Synagogue (fig. 250).[311] In a roundel in Suger's "Anagogical Window" for St. Denis, the Ark of the Covenant is drawn in the triumphant chariot from the Song of Songs, where it is labeled QVADRIGE AMINADAB, which the Evangelists must draw to the ends of the earth. Symbolizing the New Alliance under Christ, God the Father holds the crucified Christ on the cross behind the chariot, where the tablets of Moses and Aaron's rod were once visible within.[312]

Since Ambrose and Gregory the Great,[313] Song of Songs 6:12 was explained in connection with II Kings 6:3 in which Aminadab was commanded to transport the Ark of the Covenant to Jerusalem in a new cart. Within the conventional medieval allegorical framework, the chariot symbolizes the Church, and Aminadab becomes a type for Christ, as the Shulamite, who represents the Synagogue, is disturbed by the triumph of the Church.[314] The meaning is made even more explicit in a rare mid-twelfth-century illustration of the Canticles commentary of Honorius Augustodunensis in Vienna MS 942 (fig. 251), which shows the chariot surrounded by Evangelist symbols with four roundels; within, the Shulamite (inscribed SUNAMITIS), her veil blowing away in the wind, holds the victorious banner of the Church as AMINADAB SACERDOTOS leads the chariot.[315] On both sides of the horse near the reins are heads of prophets and apostles; the chariot is followed by Jews. The accompanying verse then explains that "the once captive Shulamite who had

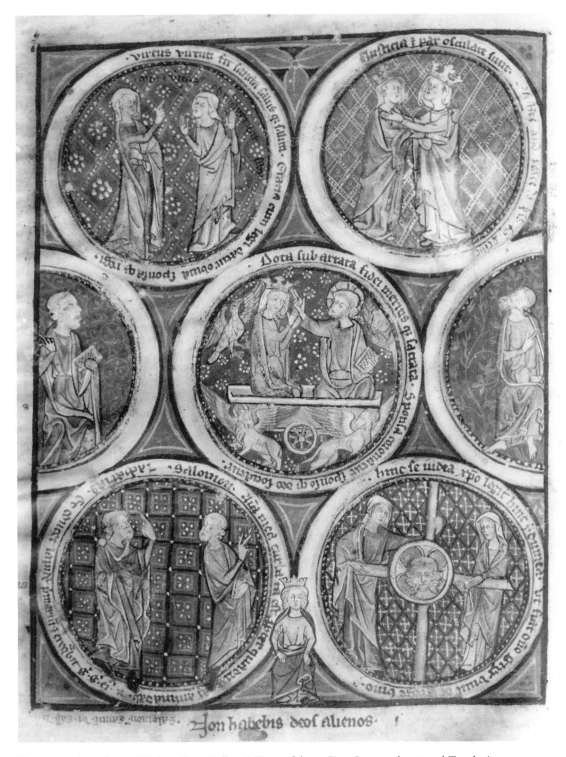

Figure 249. Apocalypse. Windsor, Eton College MS 177, fol. 7v. First Commandment and Typologies for the Coronation of the Virgin (photo: The Provost and Fellows of Eton College and the Conway Library, Courtauld Institute of Art, London).

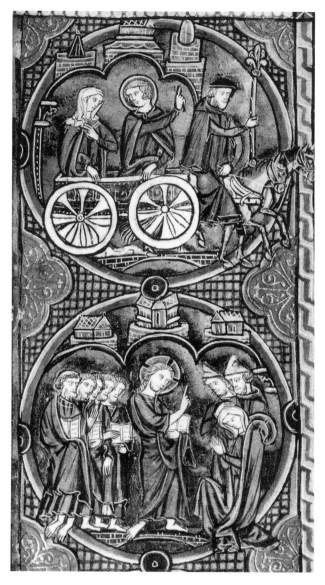

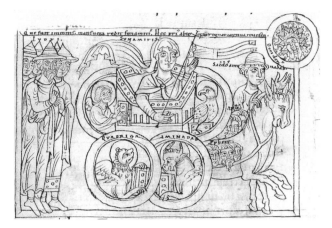

Figure 251. Honorius Augustodunensis, Commentary on the Song of Songs. Vienna, Nationalbibliothek MS 942, fol. 79. Sunamite in the Chariot of Aminadab (photo: Nationalbibliothek, Vienna).

Figure 250. Bible moralisée. Paris, Bibliothèque Nationale MS lat. 11560, fol. 86. Chariot of Aminadab (above); Conversion of Synagogue (below) (photo: after Laborde 1911–27).

been outcast and rejected, now reigns reconciled."[316] For Honorius, the Shulamite is Judaism converted; she becomes the Church who now carries the banner of Faith.[317] By shifting the traditional image of the Coronation of the Virgin to the quadriga of Aminadab, the imagery of the Triumph of the Church in Eton 177 is transformed into an allegory of the conversion of Israel as a victorious sequel to the unveil-

ing of Synagogue. As in the prefatory cycle in the Burckhardt-Wildt Apocalypse, the Shulamite, "for a long time captive of the devil," returns to Christ the bridegroom, as indicated by the verses in the surrounding frame: "The sacred vow is taken willingly and in faith. The bride is crowned by the bridegroom and is united with God."

The Coronation of the Virgin constitutes the ultimate theophany in Christian art, coming immediately after the Last Judgment, which it completes and consummates.[318] In the Eton series, however, the Coronation of the Virgin serves as a prelude to the Apocalypse, anticipating the joys of the heavenly Jerusalem. Thus, as Honorius Augustodunensis concludes, after the defeat of Antichrist, Christ will recall the Church, his bride, from her long exile in Babylon and install her in the heavenly Jerusalem.[319] As in the *Bible moralisée* (fig. 252), the *Sponsa* is the Church whose symbol is the celestial Jerusalem "descending from heaven like a bride dressed for her bridegroom."

In the Eton image, the central theme of reconciliation between the Old and New Testaments is then buttressed by allegorical scenes in the upper roundels at the left and right that contain personifications of the four Virtues from Psalm 85 (84):11, where Truth and Mercy meet together, and Righteousness and Peace kiss.[320] In the traditional exegesis of St. Jerome,[321] Truth and Righteousness are symbols of the Jews, whereas Peace and Mercy represent the gen-

tiles; they are brought together under one shepherd by Christ. By the twelfth century, the verse had been expanded into an elaborate disputation between the four sister Virtues concerning the plan for the future redemption for humankind through Christ.[322] Bernard of Clairvaux described them as the four daughters of God who fell out in a dispute over the fate of Adam, Righteousness and Truth demanding punishment, whereas Mercy and Peace pleaded for forgive-

ness; only when Christ took upon himself Adam's sins could the Virtues be reconciled.[323] A striking precedent for the complex allegorical imagery in Eton 177 occurs in the Great Lambeth Bible, where the meeting of the four Virtues appears in a pair of roundels beneath another pair containing the Ecclesia crowned and the unveiling of Synagogue, flanking the Tree of Jesse.[324]

In Eton 177, the idea of reconciliation and conversion then continues in the lower right roundel where two veiled women identified in the Worcester rubric as personifying Judea and the gentiles[325] literally embrace the cross as symbol of Christian faith, as they gaze upon the cross-nimbed bust of Christ within a disc at the intersection of the arms. The explanatory verses in the border stress the theme of reconciliation established above in the meeting of the Virtues: "Judaea on this side is linked to Idumea on that side by Christ, so that one flock is made from two separate flocks by the Lord."[326] The unification of the two peoples in the symbol of the cross thus fulfills the promise made by the verse accompanying the typology of the widow of Sarepta's sticks for the Carrying of the Cross (fig. 243): "The cross protects both peoples; the cross saves and unites." At the lower left, while Solomon signals the meaning of the quadriga of Aminadab above, Zechariah prophesies the restoration and unification of the Jewish community: "And he shall bring forward the first stone amid shouts of 'Grace, grace.'" Within the context of Zechariah's vision of the golden lamp stand and the two olive trees (Zech. 4:7), indirect but unmistakable allusions to Rev. 1 and 11 are then made.

As in Suger's "Anagogical Window" for St. Denis, with its strong apocalyptic elements, where the opening of the book in Rev. 5:6 is juxtaposed with the unveiling of Synagogue, the Eton Apocalypse allegories were not merely typological expositions of the two Testaments; they offered a way to elevate the spirit from the material to the immaterial world ("De materialibus ad immaterialia excitans").[327] The transcending revelatory experience intended by the allegorical images is clearly evoked in the prefatory verses given for the Worcester cycle:

Perceiving the figures pictured, man turns away from the world,
To see clearly what would be a mystery to him;
This distinguished house in its images of heaven,

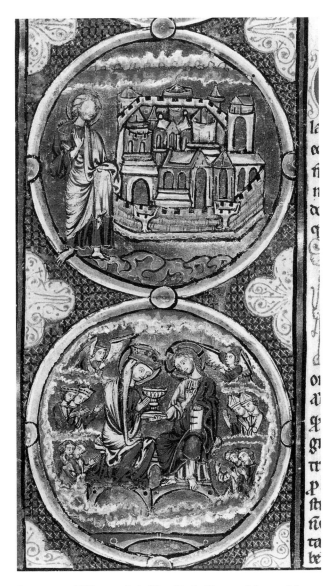

Figure 252. Bible moralisée. New York, Pierpont Morgan Library MS M.240, fol. 3v. New Jerusalem Descending (above); Commentary Illustration: Coronation of the Virgin (below) (photo: The Pierpont Morgan Library).

Is full of sacraments and documents of faith.
The historical [literal] meaning on this side, the
 allegorical on the other;
Here the law covers up, there grace reveals what is
 hidden.[328]

As in Lambeth's additional cycle, the last image placed before the reader's eyes is the face of Christ, frontally gazing back at the viewer from within its mirror frame. A sacred icon, wielded into position by the two veiled women, is now unveiled and offered for the viewer-reader's contemplation before embarking upon the next and last sequence of pictured visions. Coming at the end of Eton's complex series of pictorial typologies, the clipeate icon at the intersection of the cross has particular resonance as a visible sign *(semeion)* given to the prophets. In their prophetic visualizations of God in his glory, Moses, Solomon, and especially David saw "images before images."[329] The icon of Christ in circular form evokes a seal that not only marks his victory on the cross, but explains the relationship between the visible impression and its invisible prototype, as it was explained by Thomas Aquinas, thus causing the reader-viewer to contemplate the deepest implications of gazing at pictured visions within the book, as seals to be impressed upon the soul's memory.[330]

That the ensuing Apocalypse will constitute another journey is suggested by the momentum carried forward in the central chariot's wheel and echoed in the circular shape of the roundels on this and all the preceding pages. Indeed, the forward momentum created by the revolving and turning roundels first becomes visibly perceptible in the emphatically directional staging of Noah's ark accompanying the Baptism and is followed on the next page with the forward progress of the Bearing of the Cross. With Elijah's chariot and Ezekiel's wheels on the penultimate pair of pages, the impact of the rotary motion begins to be fully felt, only to be brought to a point of transitional or temporary stasis as the reader's vision focuses on the coronation chariot and ultimately on the *speculum* image of the Holy Face. Thus, within the proleptic typological structure as a whole, the metaphorical wheel of time comes to a halt with Christ, who colonizes and dominates the last Old Testament space now shared by the two peoples appropriated to the new faith.

■ ■ ■

Notwithstanding the great disparity in structure and content among the three cycles of illustration appended to the thirteenth-century Apocalypse, each in its own way seeks to shape the reader's experience of the book. As the lines between clerical and lay readership become blurred, the clearly meditative and devotional function of such compilations of images engage subjective experiences accessible across a broad spectrum of thirteenth-century society. Largely exemplary in character, the new compilations of pictures aided comprehension, meditation, instruction, and memory. Given the increasingly private and solitary character of reading and spiritual experience in the thirteenth century, the visual discourse of the expanded Apocalypse could offer the reader fuller access to a subjective, interiorized conception of "seeing" God. Whether the reader is invited to become an integral part of such visions in the visible guise of a particular and identifiable persona in the Apocalypse of Eleanor de Quincy or as a more generic and anonymous soul filled with longing and desire for God in the Burckhardt-Wildt cycle, the mediation between the reader and God is accomplished through the contemplation of images. In contrast with the affective sense of immediacy in the present experience, the Eton Roundels situate the reader-viewer within a large "historical" matrix of eschatological unfolding – the revelation of a divine plan inscribed in the whole text of Scripture of which the Apocalypse forms the last part. The ineluctable typological logic of its complex and interlocking configuration leads the reader to a resolution of tension between the New and Old Dispensations that now centers upon a metadiscourse that lies outside the reader's subjective experiences of longing and visual perception by addressing the moral and doctrinal strictures that bind the individual to a community of Christian believers, that is, to the Church. But, again, the reader is asked to contemplate that relationship within the framework of thirteenth-century realities. However their references are projected upon one allegorical screen or another, the ideological issues driving thirteenth-century Church reform, anti-Judaism, and the Crusades are never allowed to stray very far from the surface of the reader's consciousness, as he or she prepares to experience the pictured Apocalypse.

Epilogue

The Jagged Edge

At the end of my exploration of the Gothic illuminated Apocalypse, I feel obliged to ask what impelled the immediate production of so many varying responses to the archetype amongst the first generation of readers and designers? How can we explain a cultural process of constant, almost compulsive revision in the perception, conceptualization, and reception of the book? As a sacred text, the last book of the Bible was subjected to unprecedented textual and visual interpretation throughout the Middle Ages, but vested projects to explicate the text through imaging reached exponential levels of intensity during the last three centuries. The eighty-two manuscripts surviving from the entire Gothic period most probably represent only a small fraction of what was actually produced. Despite the solemn warning at the end of Revelation,

if anyone adds anything . . . God will add to him every plague mentioned in the book; if anyone cuts anything out of . . . this book, God will cut off his share of the tree of life and of the holy city, which are described in the book [22:18–19],

the impulse to edit, translate, delete, and add glosses proved irresistible. Like all medieval texts, the Book of Revelation was appropriated and absorbed as an experience without closure. While awaiting fulfillment at the end of time, the sacred text was ritually enacted again and again through reading its words and picturing its visions. The Apocalypse was a text left unfinished, ending on a jagged edge of unfulfilled expectation.

Because, as Michael Riffaterre reminds us, a written text is not the external equivalent of a remembered story, but "a bag of tricks, a limited system of incomplete and deficient visual symbols that aid readers in the rapid recovery of vastly more extensive remembered representations,"[1] the cycles of illustrations in the Gothic Apocalypse can create only an illusion of a remembered story in the mind's eye of the medieval reader. Although the reader must recognize the text as the inscription of memory, that is, John's recollection of his visions, as a sign system representing memory itself, with each newly revised set of images, nuances, and even subtexts of that memory shift and change. Notwithstanding its canonical status as a sacred text, as a dream-vision allegory, the Apocalypse was not perceived during the Middle Ages as a self-contained and self-sufficient work. Its symbols cannot control their decoding and ensure consistency from one reading performance to another, so that the identity of the text is constantly challenged and even undermined by the centrifugal tendencies of multiple interpretations. Unlike other biblical texts whose monumentality is secured by a recognition that the work as a shape endures and has an authority that cannot be touched without being changed altogether, the Apocalypse offers itself to the reader as an underdetermined "little book" *(libellus)* whose contents are opaque, untypical, and obscure

as to what the text is about. As Riffaterre points out, because the authority for the written text is inevitably the *un*written, the more original, deviant, or fantastic the utterance, the more necessary it is for readers to find some comparable or opposable utterance outside the text, in the memory,[2] or, I would argue, more importantly in visual images and signs that can comfortably inhabit the reader's imagination or mind's eye.

As Howard Bloch argues, the medieval period was involved in an intense debate about the nature and function of verbal signs; within the culture of the Book, "its epistemology was an epistemology of the Word and of words."[3] By the thirteenth century, the textualized languages of learned Latin and emergent vernacular created a world in which readers found increasing opportunities for reflective revision and detailed sequential analysis, while at the same time they could appropriate both lexical vehicles to express their innermost tensions and ideals.[4] Whether through reading or imaging lexical signs, the "performed text" represented a periodic enactment of the most basic values and innermost codes of medieval culture, an affirmation of that which was ideologically manifest elsewhere as "what everybody knows."[5] Like a life informed by texts, texts informed by pictures were always providing raw material for new interpretations, for, as Brian Stock points out, it was experience rather than a presupposed ideal to which language ultimately referred. In terms of the rhetorical strategies pursued in reading and picturing texts, the acting out in speech, gesture, or concrete action gave meaning to the present. In attempting to bridge what was seen as a radical separation between sense and reference, between surface and deep structure, editors, compilers, glossators, and pictorial designers worked within the more manageable realm of tropes, figures, operational definitions, and ad hoc interpretations.[6] As we have seen in the manuscript culture of the High Middle Ages, to paraphrase Bernard Cerquiglini, the production of the illustrated Gothic Apocalypse did not produce variants; it was variance itself.[7]

As illustrations mime the discourse of the text, they engage in an experimental playing out or miming of logocentric ideals. Premised on the medieval recognition of a radical discontinuity of time between the presence of the author and the reader, pictures constitute a deliberate attempt to conflate past and present, here and there, speaker, audience, and characters, in a transparency of meaning that can be felt to exist in some unmediated way beyond the text, beyond words. Because, like all early dream-visions, the Apocalypse exploits the distinction between the dream originally dreamed and the subsequent process of writing it down, the pictured text conflates the author's absence and presence by visualizing the imaginary making present of the *auctor* contained in the text ("I saw, I heard"). Thus, "the visual and immediate experience is retextualized, reread, and reinterpreted in such a way as to stress its still unresolved character."[8]

The medieval practice of glossing and illustrating texts acknowledges the way in which language itself both defies our access to final meaning and inscribes its own ability to keep generating meanings endlessly into the gaps it creates.[9] The text is open-ended; meaning is never ultimately determined by the constraints of the text. Within the manuscript experience, the intertextuality of text, image, and gloss heightens the reader's awareness of the subtle chemistry of the reading process, as text and reader interpenetrate in a mutual act of interpretation and transformation. As pictures call attention to the medieval reader's habit of collectively rewriting his own narration, and as writing creates more writing,[10] each cycle of images calls for new images. In the subtly adversarial relationship of text to audience, in which the reader is called upon to move from doubt to belief, from *tristia* to *gaudium*, illustrations constitute a major strategy of audience manipulation and participation in effecting a shift in the horizon of expectation.[11] Because allegory is, in Jauss's words, the "poetry of the invisible," the Apocalypse text offered a particularly challenging liminal world of multivalent imagery and twisted tropes. The reader must interpret this world of verbal and visual spaces and must read these images "as both likeness and unlikeness, as appealing guises masking his/her own features and projecting his/her own errant progress toward judgment."[12] If, as Travis observes, the image of the pilgrimage, that standard medieval metaphor of human life, can be usefully employed as a paradigm of the reader's experience, the transformation of the self engendered by reading the Apocalypse calls for a new "persona" each time it is reread and visually configured for a new reader. In the later Middle Ages, the imaged Apocalypse clearly became

a privileged locus of private meditation for elite read-
ers whose personal eccentricities and desires were
consciously addressed in uniquely designed manu-
scripts. As Stephen Nichols has argued, the manu-
script matrix was a place of "radical contingencies,
of chronology, anachronism, conflicting subjects and
representation."

The multiple forms of representation on the manuscript
page can often provoke rupture between perception and
consciousness. . . . In other words, the manuscript space
contains gaps through which the unconscious may be
glimpsed.
 The dynamic of the medieval manuscript matrix . . .
involves cognitive perception as two kinds of literacy: read-
ing text and interpreting visual signs. This double literacy
involves mimetic repetition to the extent that the visual art
repredicates the poetic text. . . . In consequence, illumi-
nated manuscripts double the potential for that rupture
between perception and consciousness.
 . . . [T]he manuscript matrix consists of gaps and in-
terstices, in the form of interventions in the text made up
of interpolations of visual and verbal insertions which may
be conceived, in Jacques Lacan's terms, as "pulsations of
the unconscious" by which the subject reveals and conceals
itself.[13]

Once the manuscript matrix of the medieval ex-
perience of Revelation gave way to a purely pictorial
vision stripped of its lexical signs, beginning with
Dürer's 1498 Woodcut Apocalypse, the complex
Gothic structure generated by the kinds of tensions
and desires we have described tended to collapse.
Lingering traces of the medieval Apocalypse can be
seen in isolated faint echoes in the work of such re-
tardataire northern painters as Memling, but the in-
tensity and vigor of the medieval enterprise have now
dissolved into nostalgic congeniality. Without the
lexical ambiguities of their elusive text, Apocalypse
images lost their power and potential meaning as
transformative experiences of pictured visions within
the framework of an emergent new European culture
on the threshold of a postmedieval era.

Census and Bibliography

Thirteenth-Century English Illustrated Apocalypses
Related to the Berengaudus Archetype

1. CAMBRAI, Bibliothèque municipale MS B.422 [olim 482]

ff. 108 + 17 bis (296 × 208 mm); 13th c. – English.

At one time belonged to an abbey, but the inscription of ownership has been erased (f. 6v); in the 15th c., belonged to the monastery of Bethléem near Louvain.

Apocalypse in Latin (ff. 1–6v); a long anonymous Latin commentary has been added in a contemporary 13th-c. script beginning on ff. 7–8v ("Johannes apostolus et evangelista, qui amoris privilegio in cena supra pectus Domini recumbit . . .") and resuming on fol. 9v. The manuscript originally consisted of only thirty-nine folios with the upper half of each folio, both recto and verso, occupied by a half-page illustration, but with no text below. When the lower half proved insufficient for the added commentary, whole and half-folios were intercalated to accommodate the text. However, the speech scrolls within the illustrations have been left blank.

Seventy-eight Apocalypse illustrations (ff. 1–107v): half-page framed tinted outline drawings on plain grounds.

Metz prototype: Metz recension, related to Metz Salis 38 and Lambeth 209.

Delisle and Meyer, *L'Apocalypse en français,* pp. lxxvii–lxxx, clxv–clxviii, no. 5, pl. IV; Sandler, *Peterborough Psalter,* pp. 100, 102, 104, 106–7, 139; Emmerson and Lewis, "Census," II, p. 372, no. 41; Morgan, *Early Gothic Manuscripts,* II, pp. 72–3, no. 109, figs. 56–9.

2. CAMBRIDGE, Trinity College MS R.16.2

ff. i + 32 (430 × 304 mm); 13th c. – English.

Royal Library in the 16th c.; Anne Sadleir gave the book in 1649 to Ralph Brownrig, bishop of Exeter (d. 1659), instructing him to give it to Trinity College, where it arrived in 1660.

Abridged Apocalypse with an abbreviated Berengaudus commentary in Anglo-Norman, double columns (ff. 2v–27); Life of John in Anglo-Norman.

Thirty illustrations of the Life of John (ff. 1–2 and 28–31v): full pages with painted scenes in three registers; seventy-two Apocalypse illustrations (ff. 2v–27): framed painted scenes of various sizes, often in double registers, several with inscriptions, on patterned grounds, with gold details.

Delisle and Meyer, *L'Apocalypse en français,* pp. cxxviii–cxxix, no. 39; James, *Western Manuscripts Trinity College, Cambridge,* II, pp. 369–82; James, *The Trinity Apocalypse* (London, 1909); Henderson, "Studies," II, pp. 117–37, figs. 9a–c, 10a–b, 11b, 11d –e; Brieger, *Trinity College Apocalypse* (facsimile); Henderson, "Studies," III, pp. 108–31, 138, 140–2; Otaka and Fukui, *Apocalypse anglo-normande* (facsimile); Emmerson and Lewis, "Census," II, pp. 376–7, no. 50; Morgan, *Early Gothic Manuscripts,* II, pp. 73–6, no. 110, figs. 60–6; Alexander and Binski, *Age of Chivalry,* pp. 349–50, no. 349.

3. LISBON, Museu Calouste Gulbenkian MS L.A. 139

ff. 76 (268 × 217 mm) – first quire (12 ff.) missing; 13th c. – English.

Probably belonged to Pope Clement IX (1667–9) and remained in the Rospigliosi family until the modern period; in the 19th c., acquired by Count Cesare Battaglini of Rimini through his wife, a Rospigliosi descendant of Clement

IX; in 1894, Conte Giacomo Manzoni; bought by Henry Yates Thompson in 1899 (MS 55) and sold in 1920 to Calouste Gulbenkian.

Apocalypse and abridged Berengaudus commentary in Latin, long lines (ff. 1–76v).

Seventy-eight Apocalypse illustrations, alternating with seventy-four illustrations of the Berengaudus commentary (ff. 1–76v): half-page framed painted scenes on patterned and gold grounds, with gold and silver details, and inscriptions.

Metz prototype: Metz recension, Gulbenkian subgroup related to Add. 42555.

Delisle and Meyer, *L'Apocalypse en français*, pp. v, xcviii–clxxii, no. 16, pls. VIII/1–2, IX/1, X/1–2, XI; James, *A Descriptive Catalogue of the Second Series of Fifty Manuscripts in the Collection of Henry Yates Thompson* (Cambridge, 1902), pp. 20–39, no. 55; Henderson, "Studies," II, pp. 98–100, fig. 6a; "Studies," III, pp. 137–40, figs. 46a–d; *Calouste Gulbenkian Museum, Catalogue* (Lisbon, 1982), p. 84, no. 498; S. Lewis, "Giles de Bridport," pp. 107–19; Emmerson and Lewis, "Census," II, p. 383, no. 62; S. Lewis, "*Tractatus adversus Judaeos*," pp. 343–66; Morgan, *Early Gothic Manuscripts*, II, pp. 108–10, no. 128, figs. 150–8.

4. LONDON, British Library MS Add. 35166

ff. 38 (288 × 220 mm); eighteen folios are lost; 13th c. – English.
At one time belonged to to the Blois family in Suffolk and then Rev. T. D. Turner of Beccles in Suffolk; purchased by the British Museum in 1898.

Life of John beginning with proconsul's letter (ff. 1–2v and 31–8v); Apocalypse with abridged Berengaudus commentary in Latin, double columns (ff. 3–30v); Rev. 10:8 to 16:7 missing.

Twenty illustrations of the Life of John (ff. 1–2v, 31–8v); 56 Apocalypse illustrations (ff. 3–30v): half-page framed tinted outline drawings on plain grounds, with gold and silver details; thirty-six illustrations missing.

Westminster prototype, related to Trinity B.10.2.

Delisle and Meyer, *L'Apocalypse en français*, pp. iv, lxxxiv–lxxv, no. 9; *Catalogue of Additions to the Manuscripts of the British Museum 1894–1899* (London, 1901), p. 194; Brieger and Verdier, *Art and the Courts*, pp. 91–2, no. 20, figs. 29, 30, 48, pls. 29–30; Emmerson and Lewis, "Census," II, pp. 385–6, no. 67; Morgan, *Early Gothic Manuscripts*, II, pp. 100–1, no. 125, figs. 130–2.

5. LONDON, British Library MS Add. 42555

ff. ix + 85 (330 × 215 mm); 13th c. – English.
Given to Abingdon Abbey by Giles de Bridport, bishop of Salisbury (1257–63); lent to Queen Joan of Scotland (1357–62); in the 18th c. belonged to the Clarke family of Shirehampton near Bristol; Rev. J. C. Knott bequeathed it

to his granddaughter Mrs. F. M. Linsdell from whom it was acquired by the British Museum.

Apocalypse in Latin with abridged Berengaudus commentary in French on alternate pages, long lines (ff. 5–82).

Seventy-nine Apocalypse illustrations (ff. 5 and versos of ff. 5–82) and seventy-seven commentary illustrations (rectos of ff. 6–82): half-page framed painted scenes on colored grounds, with gold details and inscriptions; many illustrations left unfinished at various stages of completion throughout. Four folios at the beginning and end were prepared with ruled compartments for scenes from the Life of John, two of which were roughly sketched in on ff. 83 and 84v. A 15th-c. ink drawing of St. Christopher appears on f. 3v.

Metz prototype: Metz recension, related to Gulbenkian L.A. 139.

R. Flower, "A New Thirteenth-Century Pictured Apocalypse," *British Museum Quarterly* 6 (1931–2): 71–3, pls. XXV–XXVI; id., "The Date of the Abingdon Apocalypse," *British Museum Quarterly* 6 (1931–2): 109–10; *Catalogue of Additions to the Manuscripts of the British Museum 1931–1935* (London, 1967), pp. 40–1; Henderson, "Studies," III, pp. 139, 142–5, figs. 42b, 47b; Lewis, "Giles de Bridport," pp. 106–19; Emmerson and Lewis, "Census," II, p. 387, no. 71; Morgan, *Early Gothic Manuscripts*, II, pp. 106–8, no. 217, figs. 142–9.

6. LONDON, Lambeth Palace Library MS 209

ff. ii + 54 (272 × 200 mm); 13th c. – English.
Lady Eleanor de Quincy (c. 1274); John, Lord Lumley (1534–1609); purchased by James I; entered Lambeth Palace Library in the 17th c.

Apocalypse and abridged Berengaudus commentary in Latin, double columns (ff. 1–39v).

Seventy-eight Apocalypse illustrations (ff. 1–39v): half-page framed scenes painted on patterned or colored grounds, with gold details; pictures are numbered with Roman numerals at the top of each page; six Antichrist scenes in lower margins of ff. 11v–13; thirteen full-page tinted outline drawings (ff. iiv and 40–53v): Monk painting a statuette of the Virgin and Child; Virgin and Child Enthroned; Seraph; *Noli me tangere*; St. Lawrence, St. Catherine, St. Margaret, St. Edmund, Crucifixion, two archbishops, Allegory of Faith, and the Veronica.

Metz prototype: Metz recension, related to Metz Salis 38 and Cambrai B.422.

Delisle and Meyer, *L'Apocalypse en français*, pp. cxxxii–cxxxiv, no. 44; *Burlington Fine Arts Club Exhibition* (London, 1908), p. 43, no. 87; Millar, "Les principaux manuscrits à peintures du Lambeth Palace Londres," *Bulletin de la Société française de reproductions de manuscrits à peintures* 8 (1924): 38–66, pls. XIV–XXXIV; James and Jenkins, *Descriptive Catalogue*, pp. 331–6, pls.

XVI, XXIIa–c, XXV, XXVIII; Henderson, "Studies," II, pp. 88–91, 93–104, 135–7, figs. 3b, 5a, 6b, 7b–d, 12b–d; Henderson, "Studies," III, pp. 129–45, figs. 42a, 44d, 45b–c; *L'Europe gothique XIIe-XIVe siècles* (Paris, 1968), p. 147, no. 239, pl. 74; Emmerson and Lewis, "Census," II, pp. 390–1, no. 78; Morgan, *Early Gothic Manuscripts*, II, pp. 101–6, no. 126, figs. 133–41; Alexander and Binski, *Age of Chivalry*, p. 390, no. 438; Morgan, *Lambeth Apocalypse* (facimile).

7. MALIBU, J. Paul Getty Museum MS Ludwig III.1 (83.MC.72)

ff. 41 (320 × 224 mm) – five folios lost; 13th c. – English.

Charles Fairfax Murray collection, 1849–1919; Malvern, Dyson-Perrins MS 10; sold to H. P. Kraus at Sotheby's in 1959; in 1975 to Dr. and Mrs. Peter Ludwig; sold to H. P. Kraus in 1983.

Apocalypse preceded by a prologue ["Piissimo Caesari . . ."] and an abbreviated Berengaudus commentary in rubric, ending with Rev. 19, in Latin, double columns (ff. 2–41v).

Two illustrations from an original series of eight from the Life of John (ff. 1–1v); eighty Apocalypse illustrations (ff. 2–41v): half-page tinted framed outline drawings on plain grounds with gold details; ten illustrations lost.

Westminster prototype: Getty recension, related to Escorial E.Vitr. V and Paris lat. 688.

Burlington Fine Arts Club Exhibition (London, 1908), pp. 43–4, no. 88, pl. 74; George Warner, *Descriptive Catalogue of the Illuminated Manuscripts in the Library of C. W. Dyson Perrins* (Oxford, 1920), pp. 34–40, no. 19, pl. X; James, *The Apocalypse in Latin, MS 10 in the Collection of Dyson Perrins*, facsmile (Oxford, 1927); Henderson, "Studies," II, pp. 115, 117; Henderson, "Studies," III, pp. 103–21, 124–31, 139–42, 144, figs. 42c, 43b-d, 44b; *Weltkunst aus Privatbesitz* (Cologne, 1968), no. D59, pl. 33; H. Kraus, *Monumenta Codicum Manu Scriptorum: An Exhibition Catalogue of Manuscripts* (New York, 1974), pp. 48–51, no. 20, + six col. pls.; Kraus, *In Retrospect: A Catalogue of 100 Outstanding Manuscripts Sold in the Last Four Decades by H. P. Kraus* (New York, 1978), pp. 82–5, no. 27, + five pls.; A. von Euw and J. Plotzek, *Die Handschriften der Sammlung Ludwig*, I (Cologne, 1979), pp. 191–98 incl. three col. pls.; Emmerson and Lewis, "Census," II, p. 392, no. 80; Morgan, *Early Gothic Manuscripts*, II, pp. 98–100, no. 124; Lewis, "Beyond the Frame," pp. 53–76.

8. METZ, Formerly Bibliothèque municipale MS Salis 38 [olim 1184]

ff. 33 (290 × 210 mm); 13th c. – English.

Destroyed in 1944; several folios had previously been mis-

bound or lost; a complete photographic reproduction of the illustrations is available in the British Library, Dept. of Manuscripts, facs. 57.

Pietro Antonio Crevicenna sold it in Amsterdam in 1793; purchased in 1847 by Baron Louis Numa de Salis (d. 1880) who bequeathed his manuscripts to the municipal library in Metz.

Apocalypse and abridged Berengaudus commentary in Latin, double columns (ff. 1–32v).

Sixty-six Apocalypse illustrations (ff. 1–32v): half-page framed tinted outline drawings on plain grounds with gold details; twelve illustrations lost.

Metz prototype: Metz recension, related to Cambrai and Lambeth 209.

Delisle and Meyer, *L'Apocalypse en français*, pp. iii, lxxx–lxxxi, no. 6; Haussherr, "Eine verspätete Apokalypsen-Handschrift," pp. 227–31, figs. 11, 13–14, 17, 19, 21; Emmerson and Lewis, "Census," II, p. 393, no. 82; Morgan, *Early Gothic Manuscripts*, II, pp. 70–2, no. 108, figs. 51–5.

9. NEW YORK, Pierpont Morgan Library MS M.524

2 vols., ff. 21 and 56 (272 × 195 mm) – 3 folios missing in vol. I, first leaves missing from vol. II; vol. I: 13th c. – English; vol. II: late 14th–early 15th c. – French.

Owned by Vicomte Blin de Bourdon in the late 19th c.; acquired by the Morgan Library in 1908.

Vol. I: Excerpts from the Apocalypse and Berengaudus commentary in Latin (ff. 1–21v); vol. II: A commentary in French added c. 1400, a unique text written specifically as an accompaniment to the illustrations.

Eighty-three Apocalypse illustrations (ff. 1–21v): tinted outline drawings on plain grounds in double registers on full pages, with long inscriptions, including three Antichrist scenes (ff. 7–7v); illustration of the Life of John (f. 21v, lower half); twelve illustrations of the Life of John lost at beginning and end.

Morgan prototype: Morgan recension, related to Auct. D.4.17, Add. 38121, and Manchester lat. 19.

Delisle and Meyer, *L'Apocalypse en français*, pp. lxiii–lxxvii, clv–clxiv, clxvi–clxvii, no. 3, pls. II–III; *Exhibition of Illuminated Manuscripts from the Pierpont Morgan Library* (New York, 1934), p. 23, no. 44, pl. 41; Henderson, "Studies," II, pp. 105–37, figs. 11c, 12a; Henderson, "Studies," III, pp. 109, 110, 111, 112, 113, 130, 131, 133, 134; Emmerson and Lewis, "Census," II, p. 397, no. 90; Morgan, *Early Gothic Manuscripts*, II, pp. 92–4, no. 122, figs. 113–17; Alexander and Binski, *Age of Chivalry*, p. 349, no. 348; S. Lewis, "Enigma of Fr. 403," pp. 31–42.

10. OXFORD, Bodleian Library MS Auct. D.4.17
[olim 3075]
ff. ii + 25 (270 × 190 mm); one folio lost after f.
17; 13th c. – English.

Inscriptions from the Apocalypse and Berengaudus commentary in Latin.

Thirteen illustrations of the Life of John (ff. 1–2v, 22v–23v); seventy-nine Apocalypse illustrations (ff. 3–22v): tinted outline drawings on plain grounds in double registers, with long inscriptions, including three Antichrist scenes (ff. 7–7v); four illustrations missing on lost folio between ff. 17–18.

Morgan prototype: Morgan recension, related to Morgan 524, Add. 38121, and Manchester lat. 19.

Delisle and Meyer, *L'Apocalypse en français*, pp. ii, lxxii–lxxiii, no. 2; Henderson, "Studies," II (1967), pp. 105–37; Henderson, "Studies," III, pp. 109–13; Alexander and Kauffmann, *English Illuminated Manuscripts*, pp. 79–80, no. 49, pl. 26; Pächt and Alexander, *Illuminated Manuscripts*, III (1973), p. 41, no. 438, pls. XXXIX–XL; A. and W. Hassall, *Treasures from the Bodleian Library* (New York, 1976), pp. 81–4, pl. 18; Emmerson and Lewis, "Census," II, p. 399, no. 95; Morgan, *Early Gothic Manuscripts*, II, pp. 113–14, no. 131, figs. 165–70.

11. OXFORD, Bodleian Library MS Douce 180
ff. 12 + pp. 97 (312 × 215 mm); one folio lost;
13th c. – English.

Lord Edward, later Edward I (1272–1307) and his wife Eleanor of Castile (d. 1291); William Wilson of the Minories (London) in the early 19th c.; sold to Francis Douce in 1833.

Glossed French prose version of the Apocalypse with prologue (ff. 1–12v); Apocalypse and abridged Berengaudus commentary in Latin, double columns (pp. 1–97).

Prologue illustration (f. 1): historiated initial with portraits of Edward I and Eleanor of Castile; ninety-seven Apocalypse illustrations (pp. 1–97): half-page framed tinted outline drawings on plain grounds, with gold and silver details, in various stages of completion (two illustrations lost; two illustrations omitted (defective model).

Westminster prototype: Paris-Douce recension, related to Paris lat. 10474.

Delisle and Meyer, *L'Apocalypse en français*, pp. cxx–cxxi, cclxxiv–cclxxv, no. 28; M. R. James and C. Hornby, *The Apocalypse in Latin and French*, facsimile (London, 1922); A. and W. O. Hassall, *The Douce Apocalypse* (London, 1961); Henderson, "Studies," III, pp. 113–31, 136, 139, 140–45, figs. 42d, 44a, 44c; Henderson, "An Apocalypse Manuscript in Paris: B.N. MS lat. 10474," *Art Bulletin* 52 (1970): 22–31; Pächt and Alexander, *Illuminated Manuscripts*, III, p. 43, no. 469, pls. XLIII–LXV; Hassall, *Treasures*, pp. 89–92, pl. 20; Klein, *Endzeiterwartung und Ritterideologie*, facsimile (Graz 1983); *The Douce Legacy*

(Oxford, 1984), no. 65; Emmerson and Lewis, "Census," II, pp. 400–1, no. 98; Morgan, *Early Gothic Manuscripts*, II, pp. 141–5, no. 153, figs. 260–3; Alexander and Binski, *Age of Chivalry* (1989), pp. 351–2, no. 351; Wright, "Sound in Pictured Silence," pp. 239–74.

12. OXFORD, Bodleian Library MS Tanner 184
pp. 78 (274 × 198 mm); folios misbound; correct
order: pp. 1–8, 55–66, 19–54, 67–78; 13th c. –
English.

Apocalypse and abridged Berengaudus commentary in Latin, double columns (pp. 1–78).

Seventy-eight Apocalypse illustrations: half-page framed tinted outline drawings on plain grounds (pp. 1–78).

Metz prototype: Metz recension, Tanner subgroup, related to Magdalene 5 and Canonici Bibl. 62.

Pächt and Alexander, *Illuminated Manuscripts*, III (1943), p. 43, no. 463, pl. XLIIa–b; Sandler, *Peterborough Psalter* (1974), pp. 100, 102, 104, 106–7, 132, 138, 139, figs. 308–9, 312, 315–25; Emmerson and Lewis, "Census," II (1985), p. 402, no. 100; Morgan, *Early Gothic Manuscripts*, III (1988), pp. 69–70, no. 107, figs. 50–1.

13. PARIS, Bibliothèque Nationale MS fr. 403
ff. ii + 50 (320 × 225 mm); 13th c. – English.

In the late 14th-c. collection of Charles V of France; purchased by John, Duke of Bedford, in 1424; acquired by Louis de Gruthuyse of Bruges (d. 1492), and finally returned to France under Louis XII.

Glossed French prose version of the Apocalypse in double columns (ff. 3v–43).

Fourteen illustrations of the Life of John (ff. 1–3, 43v–44v): full pages with two registers of tinted outline drawings on plain grounds; seventy-six Apocalypse illustrations (ff. 3v–43): half-page framed tinted outline drawings on plain grounds, with gold details.

Morgan prototype: Morgan recension, related to Morgan 524 and Auct. D.4.17.

Delisle and Meyer, *L'Apocalypse en française au XIIIe siècle (Paris MS fr. 403)*, 2 vols., facsimile (Paris 1900–1); *Le Livre anglais* (Paris, 1951), p. 13, no. 15; Breder, *Die lateinische Vorlage des altfranzösischen Apokalypsen-Kommentars des 13. Jahrhunderts, Paris, B.N. Ms fr. 403* (Münster, 1960); Henderson, "Studies," II, pp. 91–3, 97, 104, 105–37, figs. 8a–d; Henderson, "Studies," III, pp. 109, 113, 129, 130, 131, 140; *La Librarie de Charles V* (Paris, 1968), p. 59, no. 123, pl. 9; Otaka and Fukui, *Apocalypse [Bibliothèque Nationale, Fonds français 403]*, facsimile (Osaka, 1981); Emmerson and Lewis, "Census," II, pp. 405–6, no. 107; F. Avril and P. Stirnemann, *Manuscrits enluminés d'origine insulaire de la Bibliothèque Nationale* (Paris, 1987), pp. 79–80, no. 123, pls. F and XLII; Morgan, *Early Gothic Manuscripts*, II, 63–6, no. 103, figs. 34–

9; Alexander and Binski, *Age of Chivalry*, pp. 348–9, no. 347; S. Lewis, "Enigma of Fr. 403," pp. 31–42.

14. PARIS, Bibliothèque Nationale MS lat. 10474
ff. 48 (285 × 182 mm); one folio lost; 13th c. – English.

In the 16th c., owned by Pierre de Noalhes; belonged to the Jesuit College at Lyons; in 1794 in the Bibliothèque Nationale.

Apocalypse and abridged Berengaudus commentary in Latin, double columns (ff. 2–47v).

Eighty-eight Apocalypse illustrations (ff. 2–46v): half-page framed tinted outline drawings on plain grounds; only ff. 1–6v are finished; those on ff. 7–22v have gold details applied; outline drawings only from f. 23 on; two illustrations lost; two illustrations omitted (defective model).

Westminster prototype: Paris-Douce recension, related to Douce 180.

Delisle and Meyer, *L'Apocalypse en français*, pp. cxxxvi–cxxxviii, no. 50; Henderson, "An Apocalypse Manuscript in Paris: B.N. MS lat. 10474," *Art Bulletin* 52 (1970): 22–31, figs. 1, 3, 5, 8, 11, 13, 15–17, 20, 23–4; Brieger and Verdier, *Art and the Courts*, pp. 94–5, pls. 34–5; Emmerson and Lewis, "Census," II, p. 408, no. 114; Avril and Stirnemann, *Les Manuscrits*, pp. 102–7, no. 146, pls. F, LV, LVI; Morgan, *Early Gothic Manuscripts*, II, pp. 145–7, no. 154, figs. 264–9.

15. WINDSOR, Eton College Library MS 177
ff. xii + 98 (276 × 190 mm); one folio lost; 13th c. – English.

Originally belonged to a nunnery; Stuart Bickerstaffe in 1690; given to Eton College by George Henry Pitt in 1817.

Abridged Life of John in French (pp. 1–8); glossed French prose version of the Apocalypse with prologue in Anglo-Norman, long lines (pp. 8–98); pp. 45–6 are misbound.

Two illustrations from Genesis [Creation and Fall] (ff. i–ii); ten illustrations of the Virtues with Old and New Testament typologies (ff. iii–xii): full-page painted illustrations consisting of five full and two half-roundels, with Latin inscriptions in the circular frames, on grounds alternately blue and red; seven illustrations of the Life of John (pp. 1–7); ninety-one Apocalypse illustrations (pp. 8–98): almost full-page framed painted scenes on plain grounds, with gold details; two illustrations lost.

Morgan prototype, related to Lambeth 434.

James, *Descriptive Catalogue of the Manuscripts in the Library of Eton College* (Cambridge, 1895), pp. 95–108; Delisle and Meyer, *L'Apocalypse en français*, pp. lxxxv–lxxxvi, no. 10; James, "On Two Series of Paintings," pp. 99–115; *Burlington Fine Arts Club Exhibition* (1908), p. 42, no. 85, pls. 72–3; *Exhibition of English Medieval Art, Victoria and Albert Museum* (London, 1930), no. 160; Alexander and Kauffmann, *English Illuminated Manuscripts*, pp. 83–4, no. 53; Emmerson and Lewis, "Census," II, p. 381, no. 58; Morgan, *Early Gothic Manuscripts*, II, pp. 119–22, no. 137, figs. 176–9; Henry, *Eton Roundels*.

Notes

INTRODUCTION

1. See Appendix.
2. Delisle and Meyer, *L'Apocalypse en français.*
3. Moxey, *Practice of Theory*, pp. xi–xii, 61.
4. Ibid., p. xiii.
5. Hay, "Subject, Nature, and Representation," p. 6
6. Moxey, "Semiotics and the Social History of Art," p. 216.
7. Bryson, "Semiology and Visual Interpretation," p. 72.
8. Moxey, *Practice of Theory*, p. 61; id., "Semiotics and the Social History of Art," pp. 209–18.
9. Mitchell, *Picture Theory*, pp. 4–5.
10. Bal, "On Looking and Reading," p. 291.
11. Mitchell, *Picture Theory*, p. 16.
12. Cambridge, Magdalene College MS 5, fol. i verso; R. H. Robbins, *Secular Lyrics*, pp. 93–4.
13. Saenger, "Silent Reading," pp. 367–414, however, tends to see this transformation in terms of a sharp contrast between orality and literacy, occurring somewhat later, in the early fourteenth century, whereas Carruthers, *Book of Memory*, pp. 170–3, argues more persuasively that silent as well as audible reading was practiced throughout the Middle Ages. See inf., pp. 242–59.
14. John of Salisbury, *Metalogicon* I.24, p. 65; Hugh of St. Victor, *Didascalicon* III.7, ed. Taylor, p. 91: "Trimodum est lectionis genus: docentis, discentis, vel per se inspicientis."
15. See Illich, *Vineyard of the Text*, pp. 82, 86–8, 95.
16. Bryson, *Word and Image*, p. 3.
17. See Bäuml, "Varieties and Consequences of Medieval Literacy and Illiteracy," pp. 260–2.
18. See Hahn, "Purification," pp. 71–2, who cites Augustine, *Confessions* VI.3.3; the famous episode of Ambrose's silent reading as evidence of his profound understanding is discussed by Vance, *Mervelous Signals,* p. 21.
19. See Saenger, "Silent Reading," p. 399.
20. On the limiting and restraining function of illustration in medieval manuscripts, see Gellrich, *Idea of the Book*, pp. 19–20; see also inf., p. 214.
21. Ellul, *Humiliation of the Word*, p. 97.
22. See Bryson, *Word and Image*, p. 4.
23. Anselm of Havelberg, *Dialogus* 2.19 (*PL* 188: 1193).
24. John of Salisbury, *Metalogicon* I.24, p. 66.
25. See Morrison, *History as a Visual Art*, pp. 240–1.
26. Rupert of Deutz, *Commentarium in Apocalypsim* VII.12 (*PL* 169: 1050); see Morrison, *History as a Visual Art*, p. 206.
27. Bryson, *Word and Image*, p. 3.
28. See Rajchman, "Foucault's Art of Seeing," pp. 92–9.
29. Camille, Review of Hans Belting, *Bild und Kult*, p. 515.
30. See Jay, "In the Empire of the Gaze," pp. 175–204.
31. Mitchell, *Iconology*, p. 43.
32. See Jonas, *Phenomenon of Life*, pp. 135–56.
33. See Lindberg, *Studies in the History of Medieval Optics*, pp. 338–68; id., "Lines of Influence," pp. 66–83; id., "Alhazen's Theory of Vision," pp. 321–41.
34. Plotinus, *Enneads* V.1.6, trans. MacKenna, p. 374.
35. Michaud-Quantin, *Études*, pp. 113–14 and 128–9, who also includes the Greek notion of *eidos* within

the semantic field constructed for *species* in the Middle Ages.

36. Hugh of St. Victor, *Didascalicon* VII. 9 (*PL* 176: 810).

37. See Michaud-Quantin, *Études*, p. 117, who cites Vitalis de Furno's characterization of species, "secundum quod est species vel similitudo vel imago repraesentans rem . . . in quantum est sensibilis vel imaginabilis vel intelligibilis." See also Delorme, "Le cardinal Vital du Four," p. 324.

38. Grosseteste, *De lineis*, quoted by Crombie, *Robert Grosseteste*, p. 110; see also pp. 144–54; McEvoy, *Philosophy of Robert Grosseteste*, pp. 312–13.

39. Bacon, *De multiplicatione specierum* II.1, in *Opus maius*, I, pp. 458, 463; also *Part of the Opus tertium*, p. 22; see Michaud-Quantin, *Études*, pp. 118–19; Tachau, *Vision and Certitude*, pp. 4–6.

40. Bacon, *Opus maius* IV.2.1, quoted by Tachau, *Vision and Certitude*, pp. 6–7; also *De multiplicatione specierum* II.1. Thus, species are not material replicas, but powers or forms diffused from one point to another through the matter already there; see *Opus maius* V.1.9; also Peckham, *Perspectiva communis* I.27: "Every natural body, visible or invisible, diffuses its power radiantly into other bodies. . . . And since action in a straight line is easier and stronger for nature, every natural body, whether visible or not, must multiply its species in a continuous straight line; and this is to radiate."

41. See Williams, "Roger Bacon and His Edition," pp. 57–73; Easton, *Roger Bacon*, pp. 30–1 and 78–9; Bacon's annotated translation, *Secretum secretorum*, appears in *Opera hactenus inedita*, V.

42. See Michaud-Quantin, *Études*, pp. 126–7.

43. As pointed out by Tachau, *Vision and Certitude*, pp. 10–11.

44. Michaud-Quantin, *Études*, pp. 120–1.

45. On the doctrine of the Eucharist, Gratian, *Concordia discordantium canonum* III.2.34 ("De consecratione"): "Post consecratione non substantia panis et vini sed species remanet." After having affirmed that in the Eucharist, "Sacramentum et res sunt species panis et vini," Peter Lombard, *Sententiae* IV.8.6–7, continues: "After the consecration, there is no longer the substance of bread and wine; although the *species* subsist . . . they are in effect the *species* of bread and wine. . . . One sees one reality, one intellectually recognizes another."

On the image of St. Christopher in the late thirteenth-century Italian manuscript of the *Supplicatione variae* (Florence, Biblioteca Laurenziana Plut. XXV.3, fol. 383), see Belting, *Das Bild und sein Publikum*, p. 217 and fig. 85, who points out that according to the inscription beneath the drawing, it was not the Christ Child in the image, but the *species* of the saint ("Christofori sancti speciem") that was to engage the pious spectator's gaze.

46. See L. E. Lynch, "Doctrine of Divine Ideas and Illumination," pp. 161–73; Crombie, *Robert Grosseteste*, pp. 104–11, 116–19, 128–34. Grosseteste's theology of vision was first formulated around 1232 in *De operatione solis*; see McEvoy, "Sun as *res* and *signum*," pp. 38–91.

47. Jay, "Rise of Hermeneutics," p. 62.

48. Goldberg, *Mirror and Man*, p. 122, who cites Miller, "Mirrors of Dante's *Paradiso*," p. 266; also Schleusener-Eichholz, *Das Auge im Mittelalter*, I, pp. 141–3.

49. See Jay, "Rise of Hermeneutics," pp. 62–3.

50. Illich, *Vineyard of the Text*, pp. 19–20.

51. Mitchell, *Iconology*, pp. 31–4.

52. Ibid., pp. 39 and 42.

53. Foucault, *Order of Things*, p. 37.

54. See Jay, "Sartre, Merleau-Ponty, and the Search for a New Ontology of Sight," pp. 163–9.

55. Tachau, *Vision and Certitude*, p. 18, who cites Bacon, *De signis*; see also Pinborg, "Roger Bacon on Signs," pp. 403–12; Maloney, "Semiotics of Roger Bacon," pp. 120–54.

56. Jay, "In the Empire of the Gaze," p. 187.

57. Foucault, *Order of Things*, pp. 32–3.

58. Ibid., p. 17.

59. Ibid., p. 26.

60. Mitchell, *Iconology*, p. 43.

61. Ibid., p. 16.

62. Foucault, *Order of Things*, p. 32.

63. Mitchell, *Iconology*, p. 16.

64. Baldwin of Canterbury, *Tractatus* 11 (*PL* 204: 530): "Oculus discretionis sine luce devotionis, aut oculus devotionis sine luce discretionis, minus videt."

65. See Southern, *Robert Grosseteste*, pp. 40–3 and pp. 187–90. In annotating his copy of Augustine's *City of God* (Oxford MS Bodl. 198), he inscribed his symbol for imagination (a six-petaled flower) next to passages that illustrated the capacity of this faculty to create images. On Grosseteste's marginal symbols, see Hunt, "Manuscripts Containing the Indexing Symbols of Robert Grosseteste," pp. 241–55.

66. Augustine, *De Genesi ad litteram* XII.7.16 (*PL* 34: 459–66).

67. Reeves, *Influence of Prophecy*, p. 16.

68. See Carruthers, *Book of Memory*, p. 231, who discusses the mnemonic aspects of Robert Holcot's commentary on the minor prophets, as delineated by Smalley, *English Friars and Antiquity*, pp. 172–8.

69. See inf., pp. 40–3, for an extended discussion and

analysis of the Berengaudus commentary and French prose gloss, which constitute the basic exegetical components of the two archetypal versions of the English Gothic Apocalypse; see also S. Lewis, "Exegesis and Illustration," pp. 259–75.

70. *PL* 17: 848: "In spiritu se fuisse dicit, quia tanta mysteria, quae sequuntur, non carnalibus, sed spiritualibus oculis videri poterant."

71. Formerly attributed to Gilbert of Poitiers (see Berger, *La Bible française*, p. 88), the Apocalypse prologue was introduced ca. 1220 in the Parisian glossed Bible; see Lobrichon, "Une nouveauté," p. 113. However, Delisle and Meyer, *L'Apocalypse en français*, p. cclvii, correctly argued that the prologue is an integral part of the French prose gloss.

72. Delisle and Meyer, *L'Apocalypse en français*, pp. cclix–cclx:

> Dunt cest livere, entre les autres liveres del Novel Testament, est dit prophecie, pur ceo ke seint Johan vit en espirit e denuncia les secrez Jhesu Crist e de seinte Eglise, ke en grant partie sunt aempli, e ore sunt en present e uncore sunt a venir. Mes, pur ceo ke seint Johan les vit en espirit, e seinte Escripture destincte treis maneres de visiuns, bon est a entendre coment il les vit en espiriz, kar une veue est corporele, kant nus veum aucune chose des oilz corporeus, une autre est espiritele ou ymagenerie, kant nus veum en dormant ou en veillant ymaginations de aucune rien dunt autres choses sunt signefiez. . . . La terce manere de vision si est apele intellectuele, kant li Seinz Espiriz enlumine le entendement del alme de home, e le fait veer des oilz espiritelz la verite des secrez Dampnedeu. . . .
>
> E seint Johan, en ceste manere, vist ne mye solement les figures, mes entendi les signefiances.

73. Augustine, *De Genesi ad litteram* XII.13.18 (CSEL, p. 196).

74. Ibid., XII.9.20 (CSEL, p. 189), as pointed out by Kruger, *Dreaming in the Middle Ages*, p. 41.

75. Foucault, *Order of Things*, p. 41.

76. Jerome, *Epistola* LIII.8 (*PL* 22: 549): "Parum dixi pro merito voluminis. Laus omnis inferior est: in verbis singulis multiplices latent intelligentiae."

77. See McGinn, "Symbols of the Apocalypse," p. 268.

78. Hanning, " 'I Shal Finde It in a Maner Glose,' " p. 29.

79. Sturges, *Medieval Interpretation*, pp. 4–5.

80. Quoted by Smeyers, *La miniature*, p. 99, who gives a number of references on pp. 98–100; see also Illich, *Vineyard of the Text*, pp. 108–9.

81. On some important aspects of the exegetical function of illustrations in twelfth- and thirteenth-century English manuscripts, see Henderson, "Narrative Illustration," pp. 19–35.

82. For a discussion of this problem, see Camille, "Book of Signs," pp. 138–41.

83. Camille, "Seeing and Reading," pp. 31–3; id., "Book of Signs," p. 143. For a further exploration of this problem, see inf., pp. 73–5.

84. Illich, *Vineyard of the Text*, p. 54.

85. Augustine, *De Trinitate* XV.19, in *Augustine: Later Works*, p. 145.

86. Lowe, "Handwriting," p. 223.

87. As pointed out by Noakes, *Timely Reading*, pp. 22–3.

88. See Bauckham, "*Figurae* of John of Patmos," pp. 107–25.

89. Barthes, "Introduction à l'analyse structurale des récits," p. 5, cited by Culler, *Structuralist Poetics*, p. 192. For a more traditional formulation, see Fletcher, *Allegory*, p. 18.

90. Quilligan, *Language of Allegory*, p. 28.

91. Fletcher, *Allegory*, p. 73.

92. Quilligan, *Language of Allegory*, p. 235.

93. See Fletcher, *Allegory*, pp. 87, 98, 102–5.

94. See Eliade, *Traité d'histoire des religions*, p. 191.

95. Clifford, *Transformations*, p. 86.

96. Levi, *Of Fear and Freedom*, p. 67.

97. As pointed out by Curtius, *European Literature*, pp. 496–7.

98. Ibid., pp. 204–5; Frye, *Anatomy of Criticism*, p. 89.

99. E. de Bruyne, *Études*, II, p. 36; Fletcher, *Allegory*, pp. 234–5, who further observes that for Augustine, *De doctrina* II.7–8, the very obscurity of Scripture was seen as a source of pleasure.

100. Clifford, *Transformations*, p. 38.

101. De Man, *Allegories of Reading*, pp. 205–7.

102. Quilligan, *Language of Allegory*, p. 24.

103. Frye, *Anatomy of Criticism*, p. 90; Fletcher, *Allegory*, pp. 304–6, 321–3.

104. Clifford, *Transformations*, p. 53.

105. Ibid., p. 43.

106. See Illich, *Vineyard of the Text*, p. 111.

107. British Library MS Add. 62925, fol. 99v. See Morgan, *Early Gothic Manuscripts*, II, pp. 78–82, no. 112; Millar, *Rutland Psalter*.

108. H. White, *Tropics of Discourse*, p. 4.

109. See Iser, "Reading Process," pp. 51–9.

110. Noakes, *Timely Reading*, p. xii.

111. Fish, "Literature in the Reader," pp. 70–100.

112. Eagleton, *Literary Theory*, pp. 196–7.

113. Owens, "Representation, Appropriation and Power," p. 10.

114. See Moxey, *Practice of Theory*, p. 46.

115. Bryson, "Semiology and Visual Interpretation," p. 72; Moxey, *Practice of Theory*, pp. 31–6.
116. See Owens, "Representation," pp. 10 and 21.

CHAPTER 1

1. J. Collins, "Symbolism of Transcendence," pp. 5–22.
2. See Foucault, "What Is an Author?" p. 115.
3. Barthes, *Image – Music – Text*, p. 145.
4. Foucault, "What Is an Author?" pp. 119–20.
5. See Laborde, *La Bible moralisée*, pls. 693–7.
6. Fletcher, *Allegory*, p. 35.
7. As pointed out by Camille, "Seeing and Reading," p. 27 and fig. 1, who demonstrates that the drawings in Oxford, Corpus Christi MS 157, pp. 382 and 383, serve as graphic evidence for the preeminence of the spoken word in the twelfth century, where the chronicle is presented as information transmitted directly by an oral witness. See also Kauffmann, *Romanesque Manuscripts*, pp. 87–8.
8. See Clanchy, *From Memory to Written Record*, pp. 203–8, who discusses the pervasive mistrust of texts over the testimony of witnesses in the twelfth and thirteenth centuries, as well as the importance of visible physical tokens, such as seals, bearing witness; see also S. Lewis, *Art of Matthew Paris*, pp. 71–5 et pass., on the documentary illustrations of the St. Albans chronicler.
9. On the problematic of the subject in medieval narrative and culture, see Vitz, *Medieval Narrative*, pp. 2 et pass.
10. Ibid., 38.
11. This expansion of Foucault's discussion of author function is proposed by Nehamas, "Writer," pp. 265–91.
12. See ibid., p. 287.
13. The foregoing analysis is based on an exploration of the paradox of autobiography in Guillaume de Lorris's *Roman de la Rose* by Vitz, *Medieval Narrative*, pp. 41–4.
14. De Man, *Allegories of Reading*, p. 17.
15. Barthes, *Image – Music – Text*, p. 143.
16. Ibid., p. 148.
17. See Clifford, *Transformations*, pp. 29–34.
18. See J. S. Russell, *English Dream Vision*, pp. 136–7.
19. Vitz, *Medieval Narrative*, pp. 2, 85.
20. See Piehler, *Visionary Landscape*, pp. 4–5, 19.
21. See McEvoy, *Philosophy of Robert Grosseteste*, pp. 246–7, 325–6, 357, on Grosseteste's *Commentary on the Celestial Hierarchy*. Defined as purely unembodied, intellectual beings, angels represent the highest spiritual intelligence to which human nature can aspire but never attain on earth.
22. See Clifford, *Transformations*, p. 52.
23. See J. S. Russell, *English Dream Vision*, pp. 121–4.
24. On the use of spatial dichotomies of desire in the medieval definition of selfhood in Guillaume's *Rose*, see Vitz, *Medieval Narrative*, pp. 64–91.
25. Bernard of Clairvaux, *Sermo de S. Andrea* (PL 183: 511); see Leclercq, *Love of Learning*, p. 86.
26. Foucault, "What Is an Author?" pp. 124, 126.
27. See Mütherich, "Manoscritti romani," p. 61, fig. 33.
28. In Valenciennes MS 99, the first illustration, accompanied by the rubric "Ubi sanctus Iohannis accepit septem sigillis signatum a domino," originally stood in isolation facing a blank page. The text that now appears on fols. 2v–3 was added in the twelfth century. See Omont, "Les manuscrits illustrés," p. 83 and pl. XIV. Following a similar iconographic tradition, the Bamberg Apocalypse shows John receiving a sealed codex from Christ.
29. Trier MS 31, fol. 1v; see Laufner and Klein, *Trierer Apokalypse*.
30. The double-registered composition facing the incipit appears with only slight variations in all the Beatus recensions. The upper scene is usually accompanied by the legend "Ubi angelus ad homino librum accipit," and the inscription in the lower frame reads: "Ubi primitus angelus Iohannes cum angelo locutus est." Neuss, *Die Apokalypse*, p. 137, correctly argued that the third figure at the right also represents John.
31. See Minnis, *Medieval Theory*, pp. 72–5. According to Thomas Aquinas (*Summa Theologiae* Iᵃ 1, 10, responsio), God is the *auctor* of things and can use things to signify, whereas human *auctores* are authors of words and use words to signify.
32. Smalley, *Study of the Bible*, p. 297.
33. *Alberti Operi*, ed. Borgnet, XXXVIII, p. 468, quoted by Minnis, *Medieval Theory*, p. 79.
34. Russel's version, Oxford, Merton College MS 172, fol. 52, as given by Minnis, *Medieval Theory*, p. 81: "Indeed, the efficient cause is quadruple in this book, namely, God, Christ, the angel, and John. God is the principal and primary efficient cause; Christ the secondary; the angel the mediate; and John the immediate." See also Smalley, "John Russel O.F.M.," pp. 277–320.
35. For example, in the Berengaudus commentary dating ca. 1130–40 in Durham Cathedral Library MS A.I.10, fol. 170; see Kauffmann, *Romanesque Manuscripts*, fig. 129. Similar representations appear in the Apocalypse initials in a St. Albans Bible dating from 1180 in Cambridge, Corpus Christi MS 48, fol. 246v, and the Lothian Bible, ca. 1220, in Morgan MS M.791, fol. 367; see Kauffmann, *Romanesque Man-*

uscripts, pp. 82 and 115, nos. 47 and 91.

36. John is shown writing in a number of thirteenth-century Bibles, e.g., Manchester, John Rylands MS lat. 140, fol. 270v; British Library MS Burney 3 (Bible of Robert de Bello), fol. 506v; Cambridge University Library MS Ee.2.23, fol. 385v; Oxford, Bodleian MS lat. bibl. e. 7, fol. 401; Cambridge, Emmanuel College MS 116, fol. 326; Oxford, Bodleian MS Auct. D.1.17, fol. 381; Cambridge, Corpus Christi MS 49, fol. 438; see Morgan, *Early Gothic Manuscripts*, I, pp. 80, 110, 112, 115, nos. 32, 63, 65, 69; II, pp. 161, 162, 171, nos. 163, 164, 169.

37. Cambridge, Corpus Christi MS 4, fol. 276, ca. 1150, from Christ Church, Canterbury; see Kauffmann, *Romanesque Manuscripts*, pp. 97–8, no. 69.

38. See Minnis, *Medieval Theory*, p. 91, who quotes from the preface to the *Postilla super Psalterium*.

39. *Praefatio Gilberti Pictaviensis in Apocalypsim Ioannis*, in *Biblia Sacra cum Glossa Ordinaria* (Antwerp, 1634), VI, 1452, quoted by Minnis, *Medieval Theory*, p. 170.

40. See Morgan, *Early Gothic Manuscripts*, II, pp. 118–19 and 152–54, nos. 135 and 159. On modes of writing in initials, see Eleen, *Illustrations of the Pauline Epistles*, pp. 63–5.

41. *Major Latin Works of John Gower*, pp. 49–288; see Minnis, *Medieval Theory*, pp. 168–71, who demonstrates how the work was influenced by the Apocalypse.

42. In Bodleian MS Auct. D.4.17, the Life of John is given in double registers on seven folios preceding and following the illustrated Apocalypse: John preaching and the baptism of Drusiana (fol. 1); John before the proconsul and sent to Rome (fol. 1v); John before Domitian and then boiled in oil (fol. 2); John condemned to exile and his voyage to Patmos (fol. 2v); John's return to Ephesus (fol. 22v); miracles of sticks and stones, and Temple of Diana destroyed (fol. 23); the cup of poison and John's death (fol. 23v). An identical series appears in Morgan 524; see Morgan, *Early Gothic Manuscripts*, II, figs. 165, 166.

43. Ælfric, *Homilies of the Anglo-Saxon Church,* pp. 59–61.

44. On enframing devices in medieval art and narrative, see Howard, *Idea of the Canterbury Tales*, pp. 159, 188–94.

45. See Freyhan, "Joachism," p. 225.

46. See inf., pp. 59–61. The idea of linking the Apocalypse to John's legend might have remote origins in the Old Latin prologue of Leucius that was used for the Gospel of John. See Lipsius, *Die apokryphen Apostelgeschichten*, pp. 65–6, 445–9, 496.

47. Barthes, *Image – Music – Text*, p. 147.

48. Morgan MS M.644, fol. 231v; see Williams and Shailor, *Spanish Apocalypse*; Neuss, *Die Apokalypse*, pp. 220–1 Similar inscriptions also occur in the Facundus Beatus (Madrid, B.N. MS 31), fol. 262; the Valladolid Beatus, fol. 189v; and in Paris lat. 1366, fol. 155v.

49. Fols. 631v, 633, 633v; see Morgan, *Early Gothic Manuscripts*, I, pp. 123–4, no. 75.

50. Foucault, "What Is an Author," p. 123.

51. Also dating from the thirteenth century are separate leaves now in Berlin and Moscow that once belonged to an Apocalypse manuscript now lost; see Emmerson and Lewis, "Census," II, pp. 371 and 394, nos. 39 and 84; Ivanchenko and Henderson, "Four Miniatures," pp. 97–106. Fourteenth-century survivals are clearly dependent upon the same thirteenth-century models, and no new cycles are introduced. Related to the Morgan prototype, Manchester MS lat. 19, B.L. Add. 38121, and the Wellcome and De Ricci Apocalypses have the same cycles for the *vita*. Descending from Getty, the Savoyard Apocalypse in the Escorial has a Life of John; and the brief pictorial *vita* in Add. 35166 is copied in Trinity B.10.2 and Paris. lat. 688. Although the Life of John all but disappears from the later medieval Apocalypses, a single illustration of John being boiled in oil appears at the beginning of two early fifteenth-century Apocalypses (Chantilly 28 and Morgan 133), both containing abridged Berengaudus commentaries in French; see Emmerson and Lewis, "Census," II, pp. 377–8, 395–6, nos. 52, 88.

52. See Minnis, *Medieval Theory*, p. 20.

53. Although the writer of the Apocalypse has traditionally been identified with John the Apostle and Evangelist, who was the author of the Gospel and Epistles, modern scholarship argues that common authorship is precluded not only by a wide diversity in style and outlook, but also a difference in language. Because both works were probably written in the same decade, sharing many metaphors, John the Apostle and John of Ephesus (the "Divine") presumably came from the same cultural tradition. See Cross and Livingstone, *Oxford Dictionary of the Christian Church*, pp. 1182–3. For a survey and critical analysis of the modern scholarship on the authorship and date of the Apocalypse, see A. Y. Collins, *Crisis and Catharsis,* pp. 25–83.

54. *PL* 17: 844: "Hic locus aperte demonstrat non ab alio Joanne, sed ab illo qui Evangelium scripsit, hunc librum esse compositum. Qui et in coena supra pectus Domini, in quo erant omnes thesauri sapientiae et scientiae absconditi, recubuit, de quo immensum fontem sapientiae haurire meruit. Perhibuit ergo testimonium Verbo Dei, quando dixit: 'In principio erat Verbum, et Verbum erat apud Deum, et Deus erat Verbum [John 1:1].' Berengaudus begins his com-

mentary (*PL* 17: 843) with a declaration that St. John the Apostle and Evangelist was the author of this book of Revelation, while acknowledging that "there exist others that were not composed by him but by another." Dionysius of Alexandria argued against the apostolic authorship of the Apocalypse on grounds of style and content, believing it to be the work of some other John. Similarly, Eusebius, *History of the Church* III.39.4, concluded that there were two Johns living in Ephesus at the same time, referring to "John the Elder" and "John the Presbyter."

55. *Prologus in Apocalypsim B. Johannis Apostoli* in *Alberti Operi*, XXXVIII, p. 469, quoted by Minnis, *Medieval Theory*, p. 133.

56. See Arns, *La technique du livre d'après Saint Jérome*, pass., esp. pp. 173–82; Foucault, "What Is an Author," pp. 127–9.

57. Morgan, *Early Gothic Manuscripts*, I, pp. 123–4, no. 75, and II, pp. 127–9, no. 143. Other examples of the image occur in Berlin, Staatsbibliothek MS theol. lat. fol. 8, fol. 483v (see Achten, *Das christliche Gebetbuch im Mittelalter*, p. 66, no. 30); St. Petersburg Public Library MS Q.v.1, 277, fol. 357 (Mokretsova and Romanova, *Les manuscrits enluminés français 1200–1270*, p. 111).

58. Fol. 17v: "Iacob qui obdormivit supra petram significat iohannem evangelistam qui supra pectus domini in cena obdormivit et vidit secreta celestia qui postea in apocalipsi manifestavit." See Haussherr, "Christus-Johannes-Gruppen," fig. 1. As Haussherr (pp. 139, 143) points out, the exegesis on Genesis 28:10–22 identifying Jacob with John the Evangelist *recumbens super pectus Christi* is based on Bruno of Segni, *Expositio in Genesim* 28 (*PL* 164: 208–9), but the association with the revelation of heavenly mysteries in the Apocalypse goes back to Bede. Haussherr (pp. 140, 141) further observes that the corrector of the version in Add. 18719, fol. 9, perceived the reference to the Apocalypse as a "theological error" and erased the words "in apocalipsi."

59. Haussherr, "Christus-Johannes-Gruppen," pp. 139 and 145, fig. 5. The commentary in Vienna 1179 differs from the other versions in its substitution of a moralizing allegory for the identification with John at the marriage feast at Cana.

60. *PL* 17: 844–5.

61. *PL* 94: 494: "Et vocavit Joannem de nuptiis, et ipse reliquit conjugem, et secutus est eum: et propter hoc amavit eum Jesus plus omnibus discipulis. . . . Postea vero nocte illa, in qua fuit traditus, dormitavit beatus Johannes in sinu illius, et vidit secreta coelestia, quae postea scripsit, et vocavit Apocalypsim." See Greenhill, "Group of Christ and St. John," pp. 406–16, who argues convincingly that the later well-known *Andachtsbild* of Christ and St. John as well as its manuscript antecedents allude to the calling of John *de nuptiis* at Cana rather than the Last Supper, citing medieval sources from Jerome and Augustine to Rupert of Deutz who refers to the opinion "held by almost everyone" that John was the bridegroom at Cana (*PL* 169: 284). The story of John leaving his spouse goes back to the apocryphal *Acts of John*; see James, *Apocryphal New Testament*, p. 269.

62. See *Meditations on the Life of Christ*, pp. 140, 147, 148, which reproduces the illustration of the calling of John from a fourteenth-century copy (Paris B.N. MS ital. 115, fol. 82v) inscribed "When the wedding is over Jesus calls John and speaks to him in secret."

63. See Pächt, "Illustrations," p. 82.

64. Admont, Stiftsbibliothek MS 289, fol. 56; see Pächt, "Illustrations," pp. 73–4; Wentzel, *Die Christus-Johannes-Gruppen*, pp. 7–8. The inscription on the frame reads: "Tu leve conjugis pectus respuisti supra pectus domini Jhesu recumbens."

65. British Library MS Burney 3, fol. 440; see Morgan, *Early Gothic Manuscripts*, I, fig. 219. Cf. Greenhill, "Group of Christ and St. John," p. 412, who misreads the second scene as well as the direction in which the sequence proceeds; Morgan (p. 109, no. 63) misidentifies the scene as the Woman taken in Adultery.

66. See Gottlieb, *Window in Art*, pp. 204–9, who cites Origen and Sicardus.

67. *PL* 17: 1010: "Nam per coelum Ecclesia designatur." A similar allegorical image in which Christ offers John a substitute bride in the guise of the personified Church occurs in the fourteenth-century *Les louanges de monseigneur Saint Jean l'Evangeliste*, St. Petersburg Public Library MS Fr. O.v.I 1, fol. 9v. The accompanying rubric reads: "Comment Seint Jehan fut appele de Jesus-Christ des noces et mariage espirituel qui contient toute purete." See Laborde, *Les principaux manuscrits*, I, pp. 18–19 and pl. XI; Wentzel, *Die Christus-Johannes-Gruppe*, p. 8; Pächt, "Illustrations," p. 78.

68. See Mâle, *Religious Art in France*, pp. 297–300.

69. Cambridge, St. John's College MS H.6, fol. 11v; see Kauffmann, *Romanesque Manuscripts*, p. 112, no. 86, fig. 245.

70. James and Jenkins, *Descriptive Catalogue*, II, pp. 483–4.

71. Morgan, *Lambeth Apocalypse*, pp. 53–5, lists all the possible literary sources; see James, *Apocryphal New Testament*, pp. 228–70; and Hennecke, *New Testament Apocrypha*, II, pp. 188–259.

72. As pointed out by Morgan, *Lambeth Apocalypse*, pp. 54–5; see Ordericus Vitalis, *Ecclesiasticae historiae*, I, pp. 288–99.

73. Morgan, *Lambeth Apocalypse*, p. 53. See Ælfric, *Homilies of the Anglo-Saxon Church*, pp. 58–77.

74. The *Golden Legend* was probably compiled as a lectionary of readings on saints' feast days sometime between 1255 and 1270. The earliest surviving manuscript of the South English Legendary (Bodleian MS laud. 108) dates from 1280–90 and represents the collection in an unfinished state. On the Life of John, see *South English Legendary*, pp. 594–609.

75. *Golden Legend*, pp 278–80, which closely follows the *Rationale divinorum officiorum* of the late twelfth-century liturgist John Beleth (*PL* 202: 128–30); see Vauchez, *Laity in the Middle Ages*, p. 129.

76. Among the thirteenth-century manuscripts, the Morgan group and Trinity provide eight scenes; Eton and Lambeth 434 have only seven, but conflate the last two in one frame; in Getty and Add. 35166, the cycle is condensed into two and four episodes, respectively.

77. Whereas the Morgan group concludes John's Life in five or six scenes, Add. 35166 and Trinity expand the epilogue to sixteen scenes; Eton and Lambeth 434 omit the second installment of the *vita* altogether; and in Getty, this part of the manuscript is lost, but, judging from the later copy in the Escorial, it had only four scenes at the end. Included among a number of full-page illustrations added at the end of its Apocalypse text, Lambeth 209 gives a continuous sequence of twenty episodes in double registers, further attesting to the circulation of a pictorial model comprising from twenty to twenty-four half-page scenes.

78. See Otaka and Fukui, *Apocalypse anglo-normande*.

79. Ælfric, *Homilies of the Anglo-Saxon Church*, I, p. 61: "and the cruel Domitian was slain in the same year by the hand of his senators; and they unanimously resolved that all his decrees should be annulled."

80. See Ladner, "*Homo Viator*," pp. 233–59.

81. See Illich, *Vineyard of the Text*, p. 25, who also cites Leclercq, "Monachisme et pérégrination," pp. 33–52.

82. See Sumption, *Pilgrimage*, p. 173, who cites the *Liber S. Jacobi, Codex Calixtinus*, ed. W. M. Whitehill (Santiago de Compostela, 1944), I.17, pp. 152–3, and Thomas of London, *Instructorium peregrinorum*, Paris, B.N. MS lat. 2049, fols. 229–30, which asserts that the staff is the pilgrim's third leg, forming the number of the Trinity, which then battles against the forces of evil.

83. The episode of King Edward giving his ring to St. John disguised as a pilgrim is also illustrated in *La Estoire de Seint Ædward le Rei*, Cambridge University Library MS Ee.3.59, p. 47, accompanied by the following verses:

> Ne trove ren en sa aumonere,
> L'anel prent k'a sun doi ere.
> E le dune al demandant,
> Ki desparut de meintenant;
> Johan de Ewangeliste fu
> Desguisez e descuneu.

See Luard, *Lives of Edward the Confessor*, p. 16.

84. Freedberg, *Power of Images*, p. 99.

85. Turner and Turner, *Image and Pilgrimage*, p. 2; see also Turner, *Process, Performance and Pilgrimage*, pp. 16–23. For a discussion of their application to the visionary experience, see K. L. Lynch, *High Medieval Dream Vision*, pp. 47–9.

86. See Fletcher, *Allegory*, p. 354.

87. Boethius, *Consolation of Philosophy*, quoted by K. L. Lynch, *High Medieval Dream Vision*, p. 48.

88. See Piehler, *Visionary Landscape*, p. 13.

89. Although Beatus commentaries on the Apocalypse dating as early as the tenth century actually include a *mappamundi*, they were intended primarily to illustrate the widespread preaching of the apostles in response to a passage in the *Prologus de ecclesia et synagoga*; see Neuss, *Die Apokalypse*, pp. 62–5; Beatus of Liébana, *In Apocalypsin libri duodecim*, p. 117. More recently, however, the world maps have been interpreted as constituting a *peregrinatio in stabilitate* for their monastic audiences; see Moralejo, "Las islas del sol," pp. 46–8; id., "El mapa de la diáspora apostólica," pp. 331–2.

90. See inf., pp. 221–4 Cf. Klein, *Endzeiterwartung*, pp. 171–84.

91. See Illich, *Vineyard of the Text*, pp. 23–5, 59.

92. See Kieckhefer, "Major Currents in Late Medieval Devotion," pp. 76, 81.

93. Bonaventure, *Itinerarium mentis in Deum*, prologue 3, pp. 32–3.

94. Ibid., 7.2, pp. 96–7.

95. See Cousins, "Humanity and the Passion of Christ," p. 383.

96. *PL* 17: 1052: "Ille servat verba prophetiae, id est mandata Dei, qui ea operando implet, et in meditatione eorum assiduus est."

97. Trexler, *Christian at Prayer*, p. 39, based on *De oratione et speciebus illus*. In his tract, Peter the Chanter visualized all six prayer positions from the Bible in a series of illustrations, arguing that his ideas of prayer were more easily shown *(demonstrata)* than described in words; see Trexler, pp. 47–50.

98. Fleming, *From Bonaventure to Bellini*, pp. 126–8, interprets the staff or walking stick in the form of a majuscule Greek *tau* or *gamma* as the emblem of the *tau*-writer.

99. *PL* 217: 683ff. or Mansi, *Sacrorum Conciliorum*, XXII, pp. 968ff. See Fleming, *From Bonaventure to Bellini*, pp. 114–15.

100. See, for example, fol. 171v in the Lothair Gospels (Paris, Bibliothèque Nationale MS lat. 266); Müth-

erich and Gaehde, *Carolingian Painting*, pl. 26.

101. Based on Jerome's widely circulated redaction of the Victorinus commentary on 5:5–7; *Commentarium in Apocalypsim*, pp. 12–13. See Van der Meer, *Maiestas Domini*, pp. 161–6; Hoffmann, *Taufsymbolik*, pp. 25–6, 52; Christe, "Trois images carolingiennes," pp. 83–4; Kessler, *Illustrated Bibles,* pp. 73–6. Davis-Weyer, "Aperit quod ipse signaverat testamentum," pp. 67–74. Cf. Croquison, "Une vision eschatologique carolingienne," pp. 105–29, whose identification of the bearded man on the throne in the Carolingian Bible illustrations as John the Evangelist offers a suggestive but less than convincing argument.

102. *PL* 17: 913: "Nam et Moyses velamen habebat super faciem suam, eo quod splendor vultus ejus, id est, spiritalis intelligentia in lege a lippientibus oculis non posset videri."

103. See Kantorowicz, *King's Two Bodies*, p. 69, who cites the figure of the veiled Caelus in the sarcophagus of Junius Bassus. Bede, *De tabernaculo* (*PL* 91: 447), interpreted the veil of the temple as the twofold nature of Christ.

104. Seiferth, "Veil of Synagogue," pp. 385–7, who cites Suger's allegorical windows in St. Denis; see Grodecki, "Les vitraux allégoriques," pp. 24–6; Hoffmann, "Sugers 'anagogisches Fenster,' " pp. 59–66.

105. *PL* 17: 951.

106. *PL* 114: 422: "Joannes significat Synagogam, quae prior venit ad monumentum sed non intravit, quia prophetias de incarnatione et passione audivit, sed et mortuum credere noluit. Petrus Ecclesiam, quae cognovit carne mortuum, viventem credidit Deum, post quem et in Judaea in fine intrabit."

107. Gregory the Great, *Homilia* XXII (*PL* 76: 1175): "Per Joannem nisi Synagoga, quid per Petrum nisi Ecclesia designatur?" Hugh of St. Victor, *Miscellanea* 1.96 (*PL* 177: 525): "Potest ergo convenienter per Johannem, qui prior venit, posterior intravit, Synagoga; per Petrum autem, qui posterius venit, sed prius intravit, Ecclesia gentium designari." Also Sicardus (d. 1215), *Mitrale* 6.15 (*PL* 213: 359): "Hi [Saints Peter and John] sunt duo populi: Petrus significat gentes, quae posterius venerunt ad notitiam passionis, sed tamen ex primis crediderunt. Johannes Synagogam quae in lege et prophetis prius audivit Domini passionem, sed nondum credere in mortuum voluit." See Seiferth, *Synagogue und Kirche*, pp. 17–18.

108. *PL* 17: 937.

109. On London, Society of Antiquaries MS 59, see Morgan, *Early Gothic Manuscripts*, I, pp. 94–5, no. 47, fig. 157; on Cambridge University Library MS Dd.8.2, see Sandler, *Gothic Manuscripts*, II, pp. 34–5, no. 29.

110. This sudden shift also occurs momentarily for the ep-isode of John being boiled in oil in Lambeth 209, but then the figure reverts to his Christlike appearance in the last two episodes.

111. Add. 35166, fols. 34–36v.

112. Wormald, "Some Illustrated Manuscripts," p. 248.

113. Ibid., pp. 259–63. See Kauffmann, *Romanesque Manuscripts*, pp. 66–7, 72–4, nos. 26 and 34; Morgan, *Early Gothic Manuscripts*, I, pp. 57–60 and 67–8, nos. 12 and 22.

114. Wormald, "Some Illustrated Manuscripts," pp. 256, 262.

115. See Vaughan, *Matthew Paris*, pp. 159–81. On the autograph version of the *Vie de Seint Auban*, which survives in Dublin, Trinity College MS 177, see James et al., *Illustrations to the Life of St. Alban*; Mc-Culloch, "Saints Alban and Amphibalus," pp. 761–85; Lewis, *Art of Matthew Paris*, pp. 9–10, 380–7 et passim. Morgan, "Matthew Paris," pp. 85–8, iden-tifies the ladies as Isabella, wife of Hugh of Aubeney, Earl of Arundel, and Sanchia of Provence, second wife of Richard of Cornwall. A life of St. Richard Wych was composed for Isabella of Arundel by his Dominican confessor, Ralph of Bocking; see J. C. Russell, *Dictionary of Writers*, p. 106.

116. On the later thirteenth-century copy of *La Estoire de Seint Ædward le Rei* in Cambridge University Library MS Ee.3.59, see M. R. James's facsimile edition for the Roxburgh Club, 1920. Matthew used the same format and technique for his unfinished *Lives of the Offas* (Cotton MS Nero D.I), which, although not a hagiographical work, was closely related to the foun-dation of St. Albans abbey and was hence regarded as a quasi-sacred book associated with its charters, patron saints, and relics. See Lewis, *Art of Matthew Paris*, pp. 10, 165, 389–90; Vaughan, *Matthew Paris*, pp. 42–8.

117. Four leaves with eight pictures surviving from a thir-teenth-century copy of the *Vie de Saint Thomas de Cantorbéry* were recently sold at Sotheby's and are now on loan deposit in the British Library; see Back-house and De Hamel, *Becket Leaves*; Meyer, *Frag-ments d'une vie de Saint Thomas de Cantorbéry*; and Morgan, *Early Gothic Manuscripts*, I, pp. 107–8, no. 61, suggests that this manuscript could have been the model from which Matthew Paris copied the text and provided the illustrations; also Morgan, "Matthew Paris," pp. 85–96, where the leaves are dated ca. 1240.

118. See Lewis, *Art of Matthew Paris*, pp. 381–7.

119. See Freyhan, "Joachism," pp. 237–42.

120. See *La Vie de Seint Auban*, p. 7, lines 233–50. The rubric at the left reads:

> Here Alban sees through the window
> Amphibalus who stayed behind.

He wants to show him in good faith
His dream full of secrets.
(*Ci veit auban par la fenestre.*
De Amphibal estut sun estre.
Mustrer li veut en bon fei
De sun sunge tut le segrei.)

121. Cf. Freyhan, "Joachism," p. 232, who sees the Alban image as the "predecessor of this motif."
122. See Lewis, *Art of Matthew Paris*, pp. 27–33, 436.
123. See inf., pp. 295–6.
124. See S. Lewis, "Giles de Bridport," pp. 107–19.

CHAPTER 2

1. Noakes, *Timely Reading*, pp. 77–8.
2. Delisle and Meyer, *L'Apocalypse en français*.
3. I first proposed the following analysis in "Exegesis and Illustration," pp. 259–75.
4. This group of important manuscripts was first identified by Laing, "Corpus-Lambeth Stem," pp. 17–18.
5. Emmerson and Lewis, "Census," I, pp. 370–409, nos. 38–117.
6. The text is printed in its entirety in *PL* 17: 843–1058. Following the first editor of the Berengaudus commentary, Cuthbert Turnstall, Bishop of Durham (1548), Migne included the text among the works of St. Ambrose (*PL* 17: 843–1058). Since the eighteenth century, however, because the author referred to the end of the Lombard kingdom (*PL* 17: 914) and depended upon Augustine, Jerome, Gregory the Great, and even Ambrose, as well as Bede and Ambrosius Autpertus, the name Berengaudus had been identified with a Benedictine writer from the abbey of Ferriers who was mentioned as having been invited in 859 to study at St. Germain in Auxerre; see Moreau, "Berengaud," cols. 358–9. More recent scholarship now rightly argues for a much later date in the twelfth century; see Prigent, *Apocalypse 12*, pp. 38–9.
7. Although the so-called French prose gloss became dominant among the illuminated Apocalypses produced in the later Gothic period, only three extant manuscripts date from the thirteenth century.
8. On the layout of the glossed page, see Rouse and Rouse, "*Statim invenire*," pp. 207–9; De Hamel, *History of Illuminated Manuscripts*, figs. 78, 97–98, 104; Lobrichon, "La Bible d'un maître dominicain de Paris," pp. 181–3.
9. As pointed out by Noakes, *Timely Reading*, p. 80.
10. Illich, *Vineyard of the Text*, p. 99.
11. The various prototypes and recensions of the Berengaudus archetype will be discussed in my forthcoming study, *Picturing Visions*.
12. *PL* 17: 1057 (as in Lambeth MS 358): "Quisquis

nomen auctoris scire desideras, litteras expositionum in capitibus septem Visionem primas attende. Numerus quatuor vocalium, quae desunt, si Graecas posueris, est LXXXI."
13. Levesque, "Berengaud," col. 1610.
14. See Migne's introduction to his edition of the commentary in *PL* 17: 843–4.
15. See Stegmüller, *Repertorum Biblicum*, pp. 196–7, no. 1711.
16. See Lobrichon, "Une nouveauté," p. 109, who regards Berengaudus as a contemporary of Anselm of Laon. For an analysis of twelfth-century Apocalypse commentaries, see Kamlah, *Apokalypse und Geschichtstheologie*.
17. Berger, "Les préfaces," p. 69, no. 311.
18. See Steinhauser, *Apocalypse Commentary of Tyconius*.
19. Christe, "Ap. IV–VIII,1 de Bède à Bruno de Segni," p. 146.
20. Joachim's exposition of Scripture, however, was still a spiritual one, following in the tradition not only of Rupert of Deutz, but also of Bede and Berengaudus. See Smalley, *Study of the Bible*, pp. 287–9; and McGinn, *Calabrian Abbot*, pp. 86–9, 123–38.
21. See Christe, "Apocalypses anglaises," pp. 84–6; Gibson, "Place of the *Glossa ordinaria* in Medieval Exegesis," pp. 5–27; id., "Twelfth-Century Glossed Bible," pp. 232–44.
22. Lambeth Palace Library MS 119, as noted by Morgan, *Lambeth Apocalypse*, pp. 25–6, who cites James and Jenkins, *Descriptive Catalogue . . . Lambeth Palace*, pp. 196–8.
23. Cambridge, Corpus Christi MS 134 (Peterborough or Pentney), Gonville and Caius MS 301 (Canterbury), Pembroke MS 85 (Bury St. Edmunds), Trinity B.I.16 (Canterbury); Durham Cathedral MS A.I.10; Lambeth MSS 358 (Canterbury) and 359; Oxford, Bodleian Library, Douce MS 330 (Lesnes), Auct. D.4.15 (Kyme); Oxford, New College MS 64, St. John's College MS 73 (Reading), Trinity College MS 34 (Kingswood); and Longleat House MS 2 (St. Benet Holme). See also Ker, *Medieval Libraries*, pp. 12, 58, 59, 64. According to the *Indiculus* of Walter the Chanter, St. Albans owned a copy of the Berengaudus commentary in the twelfth century; see Hunt, "Library of the Abbey of St. Albans," p. 270. Copies of the full commentary continued to be produced in England in the fourteenth and fifteenth centuries, e.g., Cambridge, Gonville and Gaius MS 142 and Eton College MS 24. On later, albeit fifteenth-century appropriations of twelfth-century texts, see Constable, "Popularity of Twelfth-Century Spiritual Writers," pp. 4–23; id., "Twelfth-Century Spirituality," pp. 27–60.
24. Berlin, Staatliche Museen Preussischer Kulturbesitz,

Kupferstich-kabinett MS theol. lat. fol. 224, fols. 224ff.; see *Glanz alter Buchkunst*, pp. 46–7; Rose, *Verzeichnis der lateinischen Handschriften*, II, no. 350; Ker, *Medieval Libraries*, p. 297.

25. See Michael, "Illustrated Apocalypse Manuscript at Longleat House," pp. 340–3.

26. See also Klein, *Endzeiterwartung*, p. 177.

27. See G. R. Evans, "Exegesis and Authority, " pp. 96–7; also inf., pp. 214–5.

28. Evans, "Exegesis and Authority," p. 93.

29. See S. Lewis, "Giles de Bridport," pp. 107–19.

30. There seems to be no evidence, however, to support Christe's suggestion ("Apocalypses anglaises," p. 85) that the Berengaudus commentary was already accompanied in the twelfth century by a Romanesque cycle that in turn inspired the mid-thirteenth-century English archetype. The sole extant illustrated copy from the twelfth century contains only a frontispiece with two scenes in double registers; see Michael, "Illustrated Apocalypse Manuscript at Longleat House," pp. 340–3.

31. See Morse, *Truth and Convention*, pp. 198–9.

32. Quoted in ibid., *Truth and Convention*, p. 200, from Philippe de Mézières, *Le songe du vieil pelerin*, lines 222–3.

33. On the *Bible moralisée*, see Laborde, *Bible moralisée*; Haussherr, "Sensus litteralis," pp. 356–80; Emmerson and Lewis, "Census," III, pp. 460–4, nos. 153–8.

34. In edition B, the *Bible moralisée*, now expanded to three volumes, provided the model for the Toledo-Morgan version and its copy in the Oxford-Paris-Harley manuscripts. The manuscript in the Treasury of Toledo Cathedral contains the Bible from Genesis to Rev. 19:15–16, and the remainder is preserved in Morgan MS M.240. A copy is now divided between the Bodleian Library in Oxford (MS Bodl. 270b), the Bibliothèque Nationale in Paris (MS lat. 11560), and the British Library (MSS Harley 1526–7). This version was in turn copied in Add. 18719 as well as in several vernacular editions, including Paris fr. 166–7.

35. On English precedents for the pictorial expression of exegetical ideas in twelfth- and thirteenth-century Psalter illustration, see Henderson, "Narrative Illustration," pp. 19–35.

36. Hindman, "Roles of Author and Artist," pp. 27–62, adduces persuasive evidence for the late fourteenth and early fifteenth centuries in France.

37. These groups will be fully analyzed in *Picturing Visions*.

38. For a detailed discussion, see Parkes, "Influence of the Concepts," pp. 115–41; see also Minnis, "Late Medieval Discussions," pp. 385–421.

39. Parkes, "Influence of the Concepts," pp. 127–38;

Minnis, "Late Medieval Discussions," p. 386; and Guenée, "Lo storico e la compilazione," pp. 57–76.

40. On the medieval usage and meaning of the terms, see Rouse, "*Ordinatio* and *Compilatio* Revisited," pp. 113–34; also Hathaway, "*Compilatio*," pp. 19–44.

41. Although Hindman, "Roles of Author and Artist," pp. 34–8, deals with a later medieval period, it is becoming increasingly evident that the workshop practices she describes are also applicable to thirteenth-century England.

42. On the implications of ruling for the compositional aspects of miniatures in the fifteenth century, see Bryne, "Manuscript Ruling and Pictorial Design," pp. 118–35.

43. In a mid-thirteenth-century German Bible (Copenhagen, Royal Library MS Gl. Kgl. Saml. 4, 2°), at the end of a long series of historiated initials in which figures are engaged in the production of the illuminated book (ruling, writing, and correcting text), a *pictor* introduces the Apocalypse on fol. 208 by filling his page with an image, thus signaling not only the last stage in making the manuscript, but also the singular visual character of the concluding book of Scripture. I am grateful to Erik Petersen for bringing this example to my attention in his paper, "The Bible as Subject and Object of Illustration," given at the Oxford Symposium on the History of the Book, July 1990. A reproduction of four of the initials in this manuscript appears in Jackson, *Story of Writing*, p. 79. Note that, in contrast to the scribes and other makers of the book who are tonsured and presumably clerical, the painter is a secular artisan wearing a tight-fitting cap held by a chin strap. See also Alexander, *Medieval Illuminators*, pp. 22–3 and fig. 33, who sees the image as a self-portrait of the illuminator, "once again understanding the connection between the signature and prayer for salvation at the Last Judgment."

44. Emmerson and Lewis, "Census," II, p. 404, no. 106; I shall discuss Fr. 375 more fully in *Picturing Images*. On model books, see Scheller, *Survey of Medieval Model Books*; id., "Towards a Typology," pp. 17–20.

45. See Louant, "Un fragment d'Apocalypse," pp. 233–9.

46. Emmerson and Lewis, "Census," II, p. 372, no. 41.

47. On maquettes and dummies with layouts or drawings, see Alexander, *Medieval Illuminators*, p. 56.

48. See De Hamel, *Glossed Books of the Bible*, p. 85; Branner, "The Copenhagen Corpus," pp. 108–9.

49. De Hamel, *Glossed Books*, pp. 55–6.

50. A complete list of the rubrics is given by James, *Western Manuscripts . . . Trinity College, Cambridge*, I, pp. 297–300, no. 217. On the practice of providing

written notes for the illuminator, see Berger and Dur-rieu, "Les notes pour l'enlumineur," pp. 1–30, who give examples from the fourteenth and fifteenth centuries. Notes in Latin, however, are very rare. For a recent discussion of this and other practices, see Stones, "Indications écrites et modèles picturaux," pp. 321–49.

51. Preliminary marginal drawings first appear in the early thirteenth century, but examples are fairly rare. Most recently, Alexander, "Preliminary Marginal Drawings," pp. 307–19, lists fifty-three examples, extending the number earlier compiled by Martin, "Les ésquisses des miniatures," pp. 17–45; see also Hindman, "Roles of Author and Artist," pp. 42–5. As Alexander points out, our only evidence is the end product, the manuscript itself, in which the artists' aims would have been to conceal their working methods, to make the whole operation seem "natural and inevitable." On the practice of using waste products for preliminary drawings, see Scheller, "Towards a Typology," pp. 15–17. On written instructions and marginal sketches, see Alexander, *Medieval Illuminators*, pp. 63–71.

52. Delisle and Meyer, *L'Apocalypse en français*.

53. Pächt, "Illustrations," p. 68.

54. Ibid. On the process by which texts in a manuscript culture inevitably change with each new manuscript produced, see Zumthor, *Essai de poétique médiévale*, pp. 70–5; id., "Intertextualité et mouvance," pp. 8–16.

55. See Bal, *Reading Rembrandt*, pp. 34–5.

56. Thomas Aquinas, *De veritate* III.2c, cited by Eco, *Aesthetics of Thomas Aquinas*, pp. 166–70.

57. Eco, *Aesthetics of Thomas Aquinas*, pp. 165–8.

58. Bonaventure, *Commentarium in III Sententiarium* 37.1, in *Opera omnia*, III, p. 810.

59. Grosseteste, *De generatione sonorum*, quoted by de Bruyne, *Etudes*, III, p. 152: "Cum similitudo vel exemplar lucidioris est essentiae quam ipsa res cujus est similitudo, nobilior et clarior et apertior est rei in sua similitudine vel exemplari cognitio."

60. See Jauss, *Toward an Aesthetic of Reception*, p. 28.

61. Ibid., p. 105; see also Fowler, *Kinds of Literature*, pp. 48–52.

62. Jauss, *Toward an Aesthetic of Reception*, pp. 28–32.

63. See Holub, *Reception Theory*, p. 66.

64. Ibid., pp. 61–2.

65. Jauss, *Toward an Aesthetic of Reception*, p. 19, argues that "it is only through the process of its mediations that the work enters into the changing horizon-of-experience of a continuity in which the perpetual inversion occurs from simple reception to critical understanding, from passive to active reception, from recognized aesthetic norms to a new pro-

duction that surpasses them."

66. See Holub, *Reception Theory*, p. 41.

67. Jauss, *Toward an Aesthetic of Reception*, p. 89.

68. See Leff, *Dissolution of the Medieval Outlook*, p. 8.

69. Freyhan, "Joachism," p. 218, was the first to assert that Morgan 524 served as the ancestral model for all the Berengaudus cycles; see also Haussherr, "Eine verspätete Apokalypsen-Handschrift," pp. 226–7. Klein, *Endzeiterwartung*, pp. 159–60, recently enlarged upon Freyhan's idea to postulate the existence of a seminal formulation similar but not identical to Morgan, but to which Morgan 524 stands closest and from which all other thirteenth-century English Apocalypses descend directly or indirectly. In contrast, Brieger, *Trinity College Apocalypse*, p. 5, designated Trinity as the archetype, whereas Henderson, "Studies," III, p. 135, proposed two prototypes in Trinity and Morgan. Poesch, Review of Brieger, *Trinity College Apocalypse*, p. 202; and id., "Revelation 11:7 and Revelation 13:1–10," p. 33, n. 14, suggested two similarly related prototypes in Morgan and Metz. A detailed analysis of the problem will be forthcoming in *Picturing Visions*.

70. Freyhan, "Joachism," p. 225. On the relationship of the Life of St. John to the Berengaudus commentary, see sup., pp. 28–30.

71. Among the Apocalypses that omit the *vita* are the six manuscripts of the Metz version, Paris-Douce, and all the Corpus-Lambeth manuscripts.

72. On imbrication as functional syntax, see Barthes, *Image – Music – Text*, pp. 103–4.

73. On temporality as a structural category of narrative, see ibid., pp. 98–104.

74. J. Collins, "Apocalypse," p. 9.

75. McGinn, "John's Apocalypse," p. 16.

76. Ibid., p. 7.

77. Whitman, *Allegory*, p. 78.

78. Ibid., p. 84.

79. Anselm, *Prayers and Meditations*, p. 89. See Southern, *St. Anselm and His Biographer*, pp. 34–47, on the significance of Anselm's form of prayer.

80. See Barthes, *Image – Music – Text*, pp. 113–14.

81. Illich, *Vineyard of the Text*, p. 116.

82. Ibid., p. 119.

83. Quoted by Clifford, *Transformations*, p. 64; on the book as a cosmic symbol, see Curtius, *European Literature*, pp. 310–32.

84. A. Y. Collins, *Crisis and Catharsis*, pp. 111–16; McGinn, "John's Apocalypse," p. 15.

85. See Henderson, "Studies," I–II, pp. 116–17; Freyhan, "Joachism," pp. 225–6, 228; M. D. Legge, *Anglo-Norman Literature*, pp. 236–9.

86. Freyhan, "Joachism," p. 225. For a discussion of the similarities between romance and saints' lives, see

Bloomfield, "Episodic Motivation and Marvels," pp. 113–19 and n. 47, which cites further literature.

87. John of Garland, *Parisiana Poetria,* pp. 99–103. John of Garland was an Englishman who taught grammar at the University of Paris during the first half of the thirteenth century.

88. Jauss, *Toward an Aesthetic of Reception,* pp. 83–7.

89. See also Barthes, "Introduction to the Structural Analysis of Narrative," pp. 264–5.

90. See Sturges, *Medieval Interpretation,* pp. 21–3.

91. See Clifford, *Transformations,* p. 12.

92. See Bakhtin, *Dialogic Imagination,* pp. 151–8.

93. See J. D. Evans, "Episodes," p. 130.

94. See Haidu, "Episode as Semiotic Module," p. 680; Wittig, *Stylistic and Narrative Structures,* p. 133.

95. J. D. Evans, "Episodes," p. 130.

96. Haidu, "Episode as Semiotic Module," pp. 663–4; see also Clifford, *Transformations,* p. 19.

97. See J. D. Evans, "Episodes," pp. 126, 131.

98. See Haidu, "Episode as Semiotic Module," p. 655.

99. Fletcher, *Allegory,* p. 109; see also Bloomfield, "Episodic Motivation," p. 121. On semantic gaps requiring the reader's participation in supplying what is missing in the text, see Sturges, *Medieval Interpretation,* p. 2.

100. Ryding, *Structure in Medieval Narrative,* pp. 43–5.

101. Ibid., p. 48.

102. Bloomfield, "Episodic Motivation," p. 108.

103. H. White, "Value of Narrativity," p. 4.

104. Ibid., pp. 4–5.

105. See Bloom, *Map of Misreading,* p. 91.

106. H. White, "Value of Narrativity," p. 19.

107. See Rajchman, "Foucault's Art of Seeing," p. 95.

108. Vitz, *Medieval Narrative,* p. 111.

109. Ibid., pp. 111–12.

110. White, "Value of Narrativity," p. 20.

111. See Hahn, "Purification," p. 75.

CHAPTER 3

1. Medieval departures from the authority of Aristotle in matters of narrative are discussed by Ryding, *Structure in Medieval Narrative.*

2. These will be discussed in Pt. II, Chap. 6.

3. Lot, *Etude sur le Lancelot en prose.*

4. Ryding, *Structure in Medieval Narrative,* p. 16.

5. As pointed out in ibid., p. 26, who cites J. R. R. Tolkien, "Beowulf, the Monsters and the Critics," *Proceedings of the British Academy* 22 (1936), pp. 271–2; Curtius, "Zur Interpretation des Alexisliedes," p. 124.

6. Kellermann, *Aufbaustil und Weltbild Chrestiens von Troyes,* pp. 94–5.

7. See inf., pp. 79–81.

8. See Ryding, *Structure in Medieval Narrative,* pp. 38, 62.

9. For a further discussion of *Ad Herennium* in connection with the art of memory, see inf., pp. 242–50.

10. Geoffroi de Vinsauf, *Documentum de modo et arte dictandi et versificandi,* II.3, p. 46: "Descriptions extend the material. For when this brief sentence is expressed: 'That woman is beautiful,' let a description of her beauty be placed therein and that brevity will become expanded."

11. Vitz, *Medieval Narrative,* pp. 178–83.

12. An analysis and discussion of the major Berengaudus prototypes will be given in my forthcoming book, *Picturing Visions.* For purposes of the present study, a description and bibliography for each of the thirteenth-century English Apocalypse manuscripts discussed is given in the Appendix.

13. See Smith, "Narrative Versions," pp. 221–4.

14. For a useful discussion of Peircian terms, see Bryson and Bal, "Semiotics and Art History," pp. 189–91; also Iversen, "Saussure v. Peirce," pp. 82–94.

15. Bryson and Bal, "Semiotics and Art History," pp. 206–7.

16. On this kind of self-reflection, see Habermas, *Knowledge and Human Interests,* as well as Moxey, "Semiotics and the Social History of Art," pp. 216–17.

17. Bryson and Bal, "Semiotics and Art History," pp. 207–8.

18. On the probable connections between the English Gothic Apocalypse and the *Bible moralisée,* see inf., pp. 199–204.

19. Smith, "Narrative Versions," p. 217.

20. *Picturing Visions* will address problems of archetypes, prototypes, and the reception of the Gothic Apocalypse in England, France, Flanders, and Germany from 1250 to 1500.

21. I am indebted to Michael Camille for his ideas about the processes of iconographical change from text to image, based on a paper he read at the Warburg Institute in June 1984. See also Schapiro, *Words and Pictures.*

22. PL 17: 1020: "Domini nostri Jesu Christi misericordia largiente, ad sextam visionem pervenimus, quae brevior est caeteris."

23. In the Metz group, all the manuscripts signal these structural divisions by marking not only the incipits, but also each and every text and gloss, "Textus primus visionis" and "Expositio primus visionis," and so forth. Although they were probably implicit in the archetypal design, none of the other thirteenth-century manuscript groups adopts these textual markers.

24. See inf., pp. 64–6.
25. Berengaudus deviates from the exegetical tradition in regarding Rev. 5 instead of Rev. 4 as the beginning of the section on the seven Seals, which then extends through 8:5 instead of 8:1.
26. This stands in contrast to the commentary of Bruno of Segni where the fifth part begins at 14:14 with the Harvest and Vintage.
27. See Fineman, "Structure of Allegorical Desire," p. 49.
28. *PL* 17: 874.
29. Ibid.: 843.
30. The English translations attempt to approximate as closely as possible the syntax and narrative structure of the Latin Vulgate placed before the thirteenth-century reader. They are based on the Douai-Reims Bible (1899), as well as the *Jerusalem Bible* (New York, 1966) and the 1954 translation by R. A. Knox. Capitulations reflect those in the *Biblia Vulgata* (Stuttgart, 1983).
31. As pointed out by Klein, *Endzeiterwartung*, p. 99. A vestige of this idea also survives in the disappearing boat stern in Add. 35166 (fig. 27). The small sailboat in the lower corner of the Metz-Lambeth illustration can be seen as another, more remote vestigial survival from the *vita*, but here the ship has arrived with its anchor dropped rather than departing as in Morgan. An even clearer vestige of the Life of John occurs in Corpus Christi 20 (fig. 13) where the Patmos scene is treated in cyclical style, with the ship being rowed away at the left as John is deposited on shore. In the Metz and Corpus Christi versions, references to the voyage survive despite the omission of the preceding illustrated *vita*.
32. Bede, *Ecclesiastical History of the English People*, pp. 289–94; see K. L. Lynch, *High Medieval Dream Vision*, p. 47. For a more general account of the genre in connection with the Apocalypse, see J. S. Russell, *English Dream Vision*, pp. 21–49.
33. Augustine, *De doctrina christiana* I.10.10, quoted by Hahn, "Purification," p. 75.
34. See Piehler, *Visionary Landscape*, p. 73.
35. *PL* 17: 848: "In spiritu se fuisse dicit, quia tanta mysteria, quae sequuntur, non carnalibus, sed spiritalibus oculis videri poterant." As Freyhan, "Joachism," p. 233, n. 2, pointed out, among Augustine's categories of vision *(visio corporalis, visio spiritalis, and visio intellectualis)* in his *De Genesi ad litteram* XII.11, John's vision was clearly of the spiritual order.
36. Macrobius, *Commentary on the Dream of Scipio* I.3.18–20, p. 92; cf. id., *Commentarii in Ciceronis somnium Scipionis*, p. 30. On the wide medieval circulation of this text, see Stahl (ed.), *Commentary*, pp. 39–55. Matthew Paris also used the conventional image of the sleeping figure experiencing his vision *in

somnis* for his mid-thirteenth-century portrayal of the vision and stigmata of St. Francis; see S. Lewis, *Art of Matthew Paris*, pp. 318–19 and fig. 201.
37. Macrobius, *Commentary on the Dream of Scipio*, pp. 86–7.
38. Alcher de Clairvaux, *De spiritu et anima* (PL 40: 795), as quoted by K. Lynch, *High Medieval Dream Vision*, p. 50.
39. K. Lynch, *High Medieval Dream Vision*, p. 56.
40. On the continued influence of late antique dream theory in the twelfth and thirteenth centuries, see Kruger, *Dreaming in the Middle Ages*, pp. 58–69.
41. John of Salisbury, *Policraticus*, pp. 87–94, quoted by K. Lynch, *High Medieval Dream Vision*, pp. 64–5.
42. See Bologna, *Illuminated Manuscripts*, p. 79. Dating from the first quarter of the ninth century, Rome, Biblioteca Vallicelliana MS B.25.II, contains the Acts of the Apostles, the Epistles, and the Apocalypse with the commentary of Bede. The inscription on the dedication miniature on fol. 2 indicates that the manuscript was written or commissioned by "Juvenianus subdiaconus" for San Lorenzo fuori le mura in Rome. See Messerer, "Zum Juvenianus-Codex," pp. 59–68; *Karl der Grosse*, pp. 283–4, no. 461. Mütherich, "Manoscritti romani," p. 85, n. 33, locates the model for the image in an earlier ninth-century dream-image of an angel appearing to Emperor Constantine in Munich Clm. 22053, fol. 2.
43. See Neuss, *Die Apokalypse*, pl. CLIIIa.
44. Dating ca. 1150–60, Cambridge, Corpus Christi MSS 3–4 were produced for Dover Priory; see Kauffmann, *Romanesque Manuscripts*, pp. 97–8, no. 69.
45. *PL* 17: 848: "Vox Domini post nos est, quia nos quasi servi fugitivi sumus: Dominus autem post tergum nostrum clamat, ut nos revocet. Post se ergo Joannes vocem audivit; quia mysteria quae tunc ei revelata sunt, nondum perfecte cognoverat."
46. Morgan 524 illustrates material from 1:9–11, but there is no text apart from the quotation from 1:11 inscribed on the angel's scroll; Douce 180, Paris lat. 10474, and Add. 35166 give the text for 1:1–3. In Add. 35166, the text for 1:1–3 is followed by an excerpt from the end of the commentary on 1:3 ("the time is near"), but the closely related Getty Apocalypse includes 1:1 and 9–11 and a drastically abbreviated text for Rev. 2 through 3. The Metz manuscripts provide the text for 1:1–12, breaking off in the middle of the verse at "who had spoken to me," but leave no room for the commentary. Trinity is the only manuscript that contains the complete text for Rev. 1 through 3, but the extended text is headed by a composite illustration showing John on Patmos, the Seven Churches, and the First Vision in three separate compartments.

47. First on fol. 2v for Rev. 1:4–8 and again on fol. 5v for 1:17–20; see Laufner and Klein, *Trierer Apokalypse*. The seven Churches are represented together in the frontispiece to the Apocalypse in the ninth-century San Paolo Bible, and in the Beatus manuscripts between the Lord in the Clouds (1:7) and the First Vision (1:12). In the *Bible moralisée*, the seven Churches uniquely appear with John on Patmos in the first illustration (fig. 28).

48. *PL* 17: 845–6.

49. Ibid.: 845: "Per septem Ecclesias, una Ecclesia catholica designatur."

50. The *Bible moralisée* also begins the text for the First Vision in the middle of Rev. 1:12.

51. Beginning with the Carolingian cycles in the ninth century, the tradition continues unbroken into the thirteenth-century cycles for the *Bible moralisée*. In the English Gothic Berengaudus manuscripts, which already contain a composite rendering of the seven Churches for Rev. 1, the serial repetition of church buildings with their angelic personifications would have seemed visually redundant. Medieval Apocalypse manuscripts traditionally contain either a composite representation of the seven Churches for Rev. 1 or serial illustrations for Rev. 2 through 3, but rarely both. Only in the expanded Westminster manuscripts, such as Paris-Douce, are the letters to the seven Churches fully illustrated along with their glossed texts.

52. Freyhan, "Joachism," p. 226.

53. Most earlier medieval illustrations of the seven letters simply reduce the idea to a repetitive series of church buildings, accompanied by John writing his missives, as in the *Bible moralisée*. Outside Trier, Bodl. 352, the *Bible moralisée*, and the Paris-Douce recension of the English Gothic Apocalypse rarely is an attempt made to pictorialize the content of the individual letters.

54. In contrast, the closely related Add. 35166 breaks 1:12 in the middle, as well as omitting all text for Rev. 2 through 3. In the fourteenth century, the designer of the Cloisters Apocalypse solved the problem by moving the miniature so that it follows the First Vision with a half-leaf inserted between them to accommodate the full text of Rev. 2 through 3.

55. *PL* 17: 850: "In quorum medio Christus stare visus est."

56. Ibid.: "Septem candelabra aurea septem Ecclesias designant."

57. The Lord's face like the sun "shining with all its force" (1:16) is perceived as another figure of Ecclesia; ibid.: 852: "Per faciem Ecclesia . . . designatur."

58. Ibid.: 850.

59. Ibid.: 855: "Unde et tanquam mortuus cecidit, quia in comparatione Dei se nihil esse perspexit. Ad pedes cecidit, quia incarnationis ejus mysterium, quod per pedes figuratur, se nullo modo comprehendere posse perspexit."

60. See Trexler, *Christian at Prayer*, pp. 40, 51, and illustrations of Mode 7. Elsewhere, Peter explains that the prostrate supplicant puts his face to the earth because he fears to raise his eyes to heaven: "Species ista depingitur que orantem habet significare iacentem in terra super pectus suum, et facie sua osculando terram, tementem oculos ad celum levare."

61. For example, Trier MS 31, fol. 4v; and Bodleian MS Bodl. 352, fol. 5v (Haimo of Auxerre, *Commentary on the Apocalypse*).

62. See Garnier, *Le Langage de l'image*, I, p. 196–7.

63. Leroquais, *Les pontificaux manuscrits*, IV, fig. 61 (Paris BN MS lat. 9479, fol. 38v); Reynolds, "Image and Text," pp. 27–38 and fig. 3.

64. The closest precedent for the knotted configuration of the *zona aurea* can be found in Vat. lat. 39, fol. 156, where it is looped around the waist. In the Morgan and Westminster recensions (see figs. 11 and 30), a more traditional mantle is worn over the long tunic. In the Berengaudus gloss (*PL* 17: 851), the golden girdle signifies the patriarchs and righteous men who came before the Law. The *Bible moralisée* interprets it as the *cordis castitas*; see Breder, *Die lateinische Vorlage*, p. 3.

65. *PL* 17: 847.

66. The stars and the sword are interpreted in the gloss as all the elect from the beginning of time divided into seven parts representing the seven ages and those who are born at the end of the world to battle against Antichrist (*PL* 17: 851–2). But other elements, such as the keys of death and the underworld (1:18), which signify the power of the Son of God (*PL* 17: 855: "Per clavem ergo potestas Filii Dei intelligitur"), appear only randomly in Getty, Douce 180, and Eton 177. In the Metz and Westminster recensions, the Son of man holds a book, whereas in Trinity and Morgan, it is a long scroll inscribed with the text of 1:17–18. Because the double-edged sword signifies the two Testaments (*PL* 17: 852), the figure of the Lord in Getty holds both an open codex and a key.

67. See Piehler, *Visionary Landscape*, p. 19; K. Lynch, *High Medieval Dream Vision*, p. 69.

68. *PL* 17: 852: "Per faciem Ecclesia, sicut post resurrectionem futura est, designatur; et ideo per faciem, quia tunc Deum, sicut dicit Apostolus, justi facie ad faciem videbunt [I Cor. 13:12]."

69. Ibid.: 850: "Cum vox non oculis, sed auribus percipiatur? Sed Johannes in spiritu positus, spiritalibus oculis ea quae sequuntur, videre promeruit. . . . Aliter: ille competenter verba Dei audit qui quod au-

69. ... dierit, oculis mentis intueri non desinit, ut ea opere impleat."

70. Ibid.: 874: "Ratio deposcit ut post septem epistolas, quas ad septem Ecclesias, quae unum catholicam designant, Joannes direxit, in quibus fideles instituuntur, qualiter ad virtutum celsitudinem conscendere debeant, ejusdem Ecclesiae status atque sublimitas manifestius describatur."

71. Ibid.: 874–83.

72. Ibid.: 874: "Per ostium, Christus intelligitur, qui dicit: 'Ego sum ostium: per me si quis introierit, salvabitur' [John 10:9]. . . . Joannes evangelista personam eorum in hoc loco gerit, qui per Joannem Baptistam in Christum crediderunt, et multi eo tempore exstiterunt, qui Joannem Christem aestimabant."

73. Although the rod of justice does not occur in Berengaudus or any other commentary for Rev. 4 of which I am aware, a reference is made to the "virga aequitatis" in the Berengaudus commentary on 20: 11, glossing the text on the Last Judgment, quoted from Psalm 44(43):6, but this scepter is not represented in the Berengaudus illustrations for 20:11.

74. Some typical mid-thirteenth-century examples can be cited in the genealogy of English kings in Matthew Paris's *Historia Anglorum*; Cotton Claudius B.VII, fol. 224; Roy. 2.B.VI, fol. 11v (Edward the Confessor); Cambridge, University Library MS Kk.4.25, fol. 18v (Alexander); Cotton Claudius B.VI, fol. 9v.

75. Oxford, Bodleian MS Auct. F.32, fol. 1; see Temple, *Anglo-Saxon Manuscripts*, p. 41, no. 11, and fig. 41.

76. Christ is thus recognized in the *Bible moralisée*, Bodleian MS 270b, fol. 22, in a dual representation, first recumbent in the sepulcher and then seated on a large book, a sign of the truth of his total transcendence, while tonsured clerics offer fleurs-de-lis, "the flowers of his divinity." See Garnier, *Le Langage de l'image*, II, p. 332.

77. The contexts and meanings of the fleur-de-lis are discussed by Garnier, *Le Langage de l'image*, II, pp. 206–7, 220–1, 350–1, and 382, where he further considers the image as a symbol of the alliance between the human and divine in connection with a complex diagrammatic representation of the Creation in a twelfth-century copy of Honorius Augustodunensis, *Clavis physicae* in Paris, B.N. MS lat. 6734, fol. 3v.

78. Otaka and Fukui, *Apocalypse anglo-normande*, p. 187: "Par la verdisur de la jaspe . . . la deite . . . de Crist." As Morgan, *Early Gothic Manuscripts*, II, p. 33, points out, green is normally used sparingly in English manuscript painting of this period.

79. B.L. MS Cotton Galba A.XVIII, fol. 2v; Temple, *Anglo-Saxon Manuscripts*, pp. 36–7, no. 5, and fig. 33.

80. Paris, Bibliothèque Nationale MS lat. 6, vol. IV, fol. 105v; see Klein, "Der Apokalypse-Zyklus der Roda-Bibel," fig. 5. Among the early medieval cycles, only Trier (fol. 16v) and Bamberg (fol. 11v) contain independent illustrations for 4:9–11. Most early Apocalypses, like Valenciennes, observe the old capitulation in the Alcuin Bible, which combines 4:9–11 with the first five verses of Rev. 5. See D. de Bruyne, *Sommaires*, p. 553. The *storia* in the Beatus text merges 4:6–11 with the whole of Rev. 5.

81. *PL* 17: 887–8.

82. The isolation of the ceremonial offering of crowns at the end of Rev. 4 finds a precedent in the *Bible moralisée* (MS Harley 1527, fol. 120v), where the Elders fall in similar descending patterns flanking the enthroned Lord; see Laborde, *La Bible moralisée*, IV, pl. 591. MS Harley 1527, fol. 120v, reads: "Hoc quod procidebant ante thronum significat sanctos homines se humilitantes."

83. The text in the Getty recension ends with 4:11, but the next segment begins with 5:2, presumably reflecting the archetype. An early precedent for this text-image alignment can be seen in Trier MS 31, fol. 16v, where a huge sealed book next to the Lord enthroned corresponds to the text for 4:9 through 5:3 on the facing page.

84. *PL* 17: 888: "Liber vero scriptus intus et foris non solum Vetus Testamentum, sed et Novum significat, qui intus scriptus est secundum allegoriam, foris secundum historiam."

85. Ibid.: "Hic igitur liber vetus et novum Testamentum in se continet; quia spiritalis intelligentia in Veteri Testamento nihil est aliud, quam Novum Testamentum."

86. Ibid.: "Non inconvenienter post descriptam Ecclesiae formam apertio libri ponitur, per quam apertio divinarum Scripturarum designatur; quia postquam a sanctis apostolis caeterisque praedicatoribus Ecclesia in gentibus fundata est, libri Veteris ac Novi Testamenti secundum apostolicam fidem a sanctis doctoribus expositi sunt."

87. Ibid.: 889: "Videbant namque antiqui Patres, quorum typum Johannes in hoc loco tenet, Veteris Testamenti librum, et non videbant: videbant secundum litteram, et non videbant secundum spiritalem intelligentiam."

88. Ibid.

89. Ibid.: "Per leonem igitur de tribu Juda Christus intelligitur."

90. Ibid.: "Per angelum igitur fortem hi designantur, qui, desiderantes adventum Christi, interrogabant quo tempore venturus esset."

91. In most half-page cycles, the vision of the Lamb taking the book is represented on the next verso page,

as in Lambeth 209, Douce 180, and the Getty Apocalypse.

92. See Flett, "Significance of Text Scrolls," pp. 45–9.
93. See Wallis, "Inscriptions," p. 12.
94. Ibid., p. 14.
95. Flett, "Significance of Text Scrolls," p. 53, who argues against their dismissal as "semantic enclaves" or "interference" by Wallis, "Inscriptions," p. 1, and by Camille, "Seeing and Reading," p. 38.
96. As a consequence of the reversal of the illustrations for 4:9–11 and 5:2–5 in the archetype, the Vision of the Lamb occurs on a recto page facing the Adoration of the Elders from 4:9–11; thus, the Lamb faces left.
97. *PL* 17: 890: "Per thronum et quatuor animalia et seniores una Ecclesia cum cunctis suis ordinibus designatur."
98. MS Harley 1527, fol. 212; see Laborde, *La Bible moralisée*, IV, pl. 592.
99. Mély, "La sainte Lance," pp. 108–9, reproduces the text of Paris lat. 1423, which gives a contemporary account of the transference of the Lance from Constantinople to Paris.
100. See Runciman, "Holy Lance," pp. 208–9.
101. *PL* 17: 890: "Agnus ergo librum de dextra sedentis super thronum accepit; quia homo Christus a sua divinitate accepit."
102. Ibid.
103. In Morgan, the open book partially obscures the figure of the Lord and is inscribed "Ante me non est formatus" on one side and "deus post non erit" on the other. This text is not quoted from Berengaudus, but is similar in intent to the commentary on 5:7, which quotes from John 14:10: "Ego in Patre et Pater in me est."
104. *PL* 17: 890: "Quaerendum nobis est, quomodo ante reserationem sigillorum liber aperiri potuerit. Sed spiritualiter intelligendum est."
105. Although abandoned in the Berengaudus cycles, this important idea had a long history going back to the Carolingian cycles, where in the Trier Apocalypse, an image of the Lamb with the book was inserted above each of the first six Seals. In Valenciennes, the Lamb is repeated below each horseman. The tradition survives in the *Bible moralisée*, where the visionary content of the first six Seals has been relegated to the peripheral space in the roundels surrounding the Lord holding the Lamb and the open book in his lap within a central vesica frame, as in Harley 527, fols. 122v–124v. In its serial representation of the seven Seals, the *Bible moralisée* retains the Lamb as the central image.
106. John's mimicking gesture can be seen most clearly in Douce on pp. 15, 16, and 18. The closely related version in Paris lat. 10474 uniquely adds the Lamb as

an upright figure within an elongated semicircular appendage attached to the left side of the frame.
107. *PL* 17: 895: "Per arcum autem, qui procul sagittas a se mittit et vulnerat, vindicta Domini potest designari."
108. Ibid.: "Sessor vero equi Dominus est, qui sanctis suis aeternaliter praesidet."
109. Ibid.: 904: "Per equum rufum justi, qui post diluvium usque ad legem fuerunt, designantur."
110. Ibid.: 905 and 913: "Sigilli tertii apertio ad legem et ad eos qui sub lege fuerunt pertinet. . . . Per equum nigrum . . . obscuritatem legis . . . sive duritiam designat . . . statera vero aequitatem judicii legalis demonstrat: 'Animam pro anima, oculum pro oculo, dentem pro dente.' "
111. Ibid.: 913. On the anti-Judaic aspect of this and other illustrations, see inf., pp. 215–21.
112. Ibid.: 920; see Freyhan, "Joachism," p. 224; Klein, *Endzeiterwartung*, p. 108; S. Lewis, "Tractatus adversus Judaeos," p. 560.
113. *PL* 17: 920–1: "Hell follows this horse because it will swallow those who have contempt for the threats of the prophets. . . . By the fourth part of the earth is meant all of the land of Israel, which will be killed by the sword, famine, death."
114. Alternatively, the interpretation from Berengaudus might have been added *ex post facto* to explain the presence of a flaming bowl that had been copied into the archetype from an early model; however, no precedents survive. In this case, the flaming bowl would have been substituted for the more traditional sword to stress another lethal force from 6:8 and thus intended to represent plague, based on 15:7 and 15:9, where the seven bowls of plague are filled with "flames and the anger of God."
115. *PL* 17: 915.
116. Ibid.: 921.
117. Ibid.: 922.
118. Degenhart and Schmitt, *Corpus der italienische Zeichnungen*, I, pp. 7–15, pl. 15; Ciaranfi, "Disegni e miniature nel codice laurenziano," pp. 345–6 and fig. 26.
119. *PL* 17: 922: "Binas stolas tunc percipient, cum post resurrectionem animae, cum corporibus gloriam coelestis patriae sine fine possidebunt." Cf. *PL* 117: 1031.
120. On the merging of worshipers with the saint's image, see Camille, *Gothic Idol*, pp. 125–6; B. Ward, *Miracles and the Medieval Mind*, p. 94. Becket's tomb was surrounded by a stone wall provided with holes so that pilgrims might reach through and touch the coffin; see Benedict of Peterborough, *Miracula S. Thomae Cantuariensis* 2.31, p. 82.
121. *PL* 17: 923–4: "Sigilli sexti apertio ad Judaeorum

dejectionem . . . et ad gentium vocationem pertinet. . . . Per terram in hoc loco Judaei designantur: terrae motus factus est magnus quando a Romanis haec gens est devestata. . . . Qualiter autem se in speluncis et petris montium absconderunt, Josephus [*De bello Judaico* VI.11] manifeste narrat, qui eversionem Jerusalem describit." See also S. Lewis, "*Tractatus adversus Judaeos*," pp. 560–2.

122. *PL* 17: 925.

123. Cassiodorus, *Expositio in Psalterium XCV* (*PL* 70: 682). The motif frequently occurs in Carolingian versions of the *Maiestas Domini*, where Christ is enthroned within a rhomboid frame, as in the Vivian Bible (Paris lat. 1, fol. 330v), based on diagrams of the world, such as that in Vienna B.N. Cod. 387, dating from 818; see Holländer, *Early Medieval Art*, pp. 76 and 84, figs. 59 and 64. See also Werckmeister, "Die Bedeutung der 'Chi'-Initialseite," p. 693, who gives a further Carolingian example in the Codex Aureus (Munich Clm. 14000, fol. 5), where the rhomboid figure is designated as *mundus tetragonus* on the surrounding frame.

124. Hugh of St. Victor, *De arca Noe mystica* XIV (*PL* 176: 700), quoted by Woodward, "Medieval *Mappamundi*," p. 335; see also Lecoq, "La 'mappemonde' du *De arca Noe mystica*," pp. 9–31. The large oval-shaped Higden map in MS Roy. 14.C.XII, fol. 9v, is reproduced and discussed by Woodward, "Medieval *Mappamundi*," pp. 312–13 and fig. 18.22.

125. *PL* 17: 925: "Ipse est sol de quo scriptum est: 'Vobis autem timentibus nomen meum orietur sol justitiae et sanitas in pennis ejus.' Ab ortu solis Christus descendit, id est . . . carnem immaculatam ex carne Virginis creavit."

126. In Getty, the flaming disc ends up at the bottom of the angel's scroll, having been literally transformed into a seal affixed to a document. Only in Trinity does the angel fly down from the sun positioned in the upper right corner to maintain the textual relationship between the angel and the sun and at the same time retain the sense of the gloss.

127. *PL* 17: 928–9.

128. The long text can barely be accommodated by the half-page format. Getty and Add. 35166 abbreviate their texts, omitting the last two or three verses; Douce 180 and Tanner 184 eliminate the Berengaudus gloss entirely for lack of space.

129. In Add. 35166, which does not illustrate the episode of John and the Elder, the commentary begins with 7:15, as in Metz, but then backtracks to 7:9 to interpret the stoles and palms of the saints, confirming that the reversal was configured in the archetypal conception.

130. *PL* 17: 929: "Per seniorem namque doctores Ecclesiae."

131. Ibid.: 931: "Nam sicut praeco ante regem aut principem mittitur, qui ejus adventum annuntiet; ita et Joannes, quia magna erant quae per angelos designabantur, eorum memoriam facere voluit, antequam ad eorum narrationem veniret."

132. Ibid.: 931–2.

133. Ibid.: 846: "In quarta [visione] septem angeli sunt visi tubes canentes."

134. Although the second, third, and fourth Trumpets are consolidated within a single miniature in Metz, the texts for verses 8–9, 10–11, and 12 are given independently under separate rubrics, followed by a commentary only on the second trumpet. Metz thus divides the archetypal illustration for 8:3–5 into two parts, which are then incorporated individually into the preceding and following illustrations, so that the representation of the altar being censed is paired with the distribution of the Trumpets for 8:2–4, and the illustration of the Censer Poured on the Earth is joined with the First Trumpet for 8:5–7. Morgan independently juxtaposes the same components for 8:5 and 8:6–7 to make room for the preceding miniature, which was given over entirely to the illustration of 8:3–4 to accommodate four additional angels with trumpets to pictorialize the gloss.

135. In Metz, only the text and commentary for 8:5 are given below an illustration that merges the Pouring of the Censer with the First Trumpet, whereas the text for 8:6–7 as well as the first few words of the gloss appear on a speech scroll held by the trumpeting angel. The text breaks at the point where the fourth book of the commentary begins, and in Lambeth and Gulbenkian, the hiatus is signaled by a label above the trumpeting angel that reads "liber quartus" to maintain a break that called for a separate page with its own illustration.

136. Owens, "Allegorical Impulse," p. 208.

137. *PL* 17: 937: "Aquila vero Christum et apostolos ejus demonstrat . . . quia Christus primum per Judaeam, apostoli vero ejus per universas gentes Evangelium praedicaverunt. . . . Ideoque tria vae posuit, ex quibus primum ad haereticos pertinet . . . secundum ad paganos . . . tertium ad Antichristum." In the *Bible moralisée*, where the eagle has been replaced by an angel in the accompanying illustration, a similar gloss is given in which the eagle signifies the preachers who will come to protect Holy Church from the great tribulations that will come with the advent of Antichrist; Harley MS 1527, fol. 127: "Hoc significat quod ecclesia debet eum munita contra tribulationes quas sustinebit in tempore antichristo."

138. Although Morgan gives two illustrations for these

episodes, the quoted texts suggest that the archetype treated 9:1–12 as a single illustrated passage. The first Morgan illustration gives a paraphrase of 9:1–10 with a bit of commentary on 9:1–2, and the second illustration is accompanied by glosses for 9:3 and 9:11. In Add. 35166, the verses are divided into 9:1–6 and 9:7–12, but in Add. 35166, verses 4–6 have been omitted. Douce and Abingdon give texts for 9:1–4 and 9:5–12; Douce is defective at the beginning of 9:5. In Metz where the fifth angel is conjoined with the eagle of 8:13, the text of 9:1 has been divided to match the realignment of elements from the archetypal illustration. For the fifth trumpet, the text for 9:1 reads: "And the fifth angel blew his trumpet, and he was given the key to the pit of the abyss"; the next illustration of the locusts is accompanied by a text beginning with the omitted part of 9:1 ("and I saw a star that had fallen from heaven onto the earth").

139. *PL* 17: 937–8.

140. *PL* 17: 942: "Possumus per alas verba haereticorum intelligere."

141. Morgan MS M.524, fol. 5v: "Angelus abyssi nomine abaddon idem exterminans rex et locustorum significat diabolum." Cf. *PL* 17: 942–3. On the frequent depiction of Satan as a Jew, see Trachtenberg, *Devil and the Jews*.

142. See sup., p. 70.

143. *PL* 17: 953: "Bestia haec Antichristum significat."

144. Harley MS 1527, fol. 129; see Laborde, *La Bible moralisée*, IV, pl. 600. The only other medieval precedent for the standing angels, although they do not hold weapons, occurs in the Beatus manuscripts.

145. *PL* 17: 943–4.

146. Ibid.: 943: "Vocem ergo unam ex quatuor cornibus altaris aurei audisse se dicit; quia una est fides una doctrina quamquatuor libri Evangeliorum docent."

147. Ibid.: 944–5.

148. Trinity R.16.2, fol. 10: "E io oi le numbre de eus." I am grateful to George Henderson for pointing out this unexpected text-image connection.

149. *PL* 17: 946–7: "Angelus fortis Dominum nostrum Jesum Christum designat. . . . Libellum igitur apertum in manu sua Dominus noster Jesus Christus tenere visus est; quia sensus divinarum Scripturarum doctoribus Ecclesiae ipse aperuit."

150. As pointed out by Gage, *"Lumen, Alluminar, Riant,"* p. 34. See MS Douce 180, p. 32; Klein, *Endzeitwartung*. Perhaps derived from Alain de Lille's linkage of smiling and light, the "smile that lights the face" had become commonplace in romances of the period. Gage, *"Lumen,"* p. 37, n. 26, refers to many examples in Georg Weise, *Die geistige Welt der Gotik* (Halle, 1939), pp. 88, 112ff., 265, and 447ff., and cites Dante, *Convivio* III.8.11: "What is a smile if

not . . . a light manifesting what is within?"

151. *PL* 17: 948.

152. Otaka and Fukui, *Apocalypse anglo-normande*, p. 196: "Par la buche en ki tutes savur sunt juges, poum entende les queors des apostles. Par le ventre, en ki tute le ordure del cors demurt, devum entendre la remembraunce des pecches."

153. *PL* 17: 946: "Per irim vero ejus misericordia designatur. . . . Irim in capite habebat, quia ejus divinitas ante incarnationem suam tantam misericordiam assumpserat." In addition to thirteenth-century manuscripts dependent on Morgan, only Add. 35166 reverses the curvature of the rainbow. Rare precedents can be cited in Vat. lat. 39, fol. 161v, and Bodl. 352.

154. Although a remarkable precedent for this image of John holding the book with one hand and reaching for a rod with the other can be seen in the *Bible moralisée*, the simultaneous gestures do not constitute a comparable conflation, because the rod refers to the gloss rather than 11:1–2. See MS Harley 1527, fol. 130v; Laborde, *La Bible moralisée*, IV, pl. 601.

155. *PL* 17: 950: "Per virgam vero saepe disciplina accipitur. . . . Per templum namque Ecclesia: per altare sancti et perfecti viri, qui in Ecclesia consistunt: per adorantes autem in eo caetera multitudo, quae eorum doctrina instruitur, designatur."

156. Ibid.: 951: "Per atrium ergo Judaei designantur: Judaei igitur foris erant per incredulitatem."

157. See sup., p. 35.

158. Wright, "Sound in Pictured Silence," p. 267.

159. *PL* 17: 951.

160. Ibid.: "Testes duos Dominus Eliam et Enoch vocat, qui adventum ejus secundum praecurrent, sicut Joannes praecurrit primum."

161. The phrase from Paul, II Thessalonians, had already been cited in connection with the witnesses by Victorinus, *Commentarius in Apocalypsim* (PLS 1: 147).

162. *PL* 17: 952.

163. II Thessalonians is usually interpreted in medieval exegesis as a reference to the destruction of Antichrist; see Emmerson, *Antichrist*, pp. 38, 171.

164. See Poesch, "Antichrist Imagery," pp. 164–6.

165. See Branner, *Manuscript Painting*, pp. 194–5. Garnier, *Le Langage de l'image*, II, p. 204 and figs. 283–5, cites three further examples illustrating the annihilation of Antichrist thunderstruck by divine power.

166. *PL* 17: 951: " 'Et civitatem sanctam calcabunt mensibus quadraginta duobus.' Subito saltum facit ad Eliam atque Enoch, qui temporibus Antichristi venturi sunt." A similar excursus on Antichrist is given for the same passage by Martin of León (d. 1221), *Expositio libri Apocalypsis* (PL 209: 358): "Mensibus

videlicet quadraginta duobus, id est tribus annis et dimidio, quibus regnabit Antichristus."

167. Christe, "Apocalypses anglaises," p. 88. Contrary to other suggestions, the subsequent commentary on the power of the Beast in Rev. 13 in which the exegete alludes to Antichrist's disciples and false miracles is not sufficiently detailed to account for these scenes; cf. Nolan, *Gothic Visionary Perspective*, pp. 80–1, who cites *PL* 17: 970.

168. The best edition of Adso's *Libellus* is Sackur, *Sibyllinische Texte*, pp. 104–13.

169. See McGinn, "Portraying Antichrist," pp. 1–48, esp. pp. 13–18.

170. MS Vat. lat 39, fol. 162; see Morello and Stockmann, *Neues Testament*; also Emmerson, *Antichrist*, pp. 117–18. In the Beatus tradition, Antichrist is portrayed as a human figure who slays the witnesses himself, e.g., St. Sever Apocalypse, Paris lat. 8878, fol. 155, where he is crowned. In the *Liber Floridus,* Antichrist is portrayed outside the Apocalypse cycle as a crowned, sceptered ruler enthroned above a Leviathan.

171. See Poesch, "Revelation 1:7 and Revelation 13:1–10," pp. 23–4. Destroyed in 1870, the *Hortus Deliciarum* is known only from nineteenth-century drawings; see Straub and Keller, *Herrade de Landsberg*, pl. LXII. The surviving inscriptions on fols. 241v–242v indicate that the Antichrist scenes are derived from "diverse sources."

172. Cf. Freyhan, "Joachism," p. 218, who argues that the Antichrist cycle in Morgan was present in the archetype but was omitted in the other prototypes with a half-page format because the illustrations failed to correspond to the text. However, as Klein, *Endzeiterwartung*, p. 80, points out, the Morgan cycle was accommodated to a fully glossed text with only minimal changes in Fr. 403. Nevertheless, Klein maintains that the Morgan cycle served as the archetype and that a decisive single revision accounts for the Metz, Getty, and Trinity cycles.

173. *PL* 17: 953. See Poesch, "Antichrist Imagery," pp. 120–1; Emmerson, *Antichrist*, pp. 110–11.

174. MS Harley 1526, fol. 29; Laborde, *La Bible moralisée*, III, pl. 472. See Poesch, "Antichrist Imagery," pp. 164–6; Klein, *Endzeiterwartung*, p. 76.

175. *PL* 17: 954: "Sic et vos a foris quidem paretis hominibus justi, intus autem pleni estis rapina et iniquitate." Vestiges of the extramural placement of the dead witnesses can also be seen in the Metz illustration of the massacre (fig. 77).

176. *PL* 17: 954.

177. Ibid.: 955.

178. See Schapiro, "Image of the Disappearing Christ," pp. 135–52. Trinity shifts the narrative into a cyclical mode, showing the two witnesses standing resurrected before they disappear into the clouds.

179. *PL* 17: 956: "Reliqui vero qui in timore sunt missi, electos caeteros designant, qui videntes conversionem Judaeorum atque divinam Scripturam in illis esse completam, in timore Dei atque amore proficient, Deumque pro eorum conversione laudare non desistent."

180. Ibid.: 956: "Per septimum angelum . . . praedicatores sancti qui in fine mundi nascituri sunt, designantur."

181. Ibid.: 957.

182. See S. Lewis, *Art of Matthew Paris*, p. 156 and fig. 88; another, more detailed representation is given in the *Chronica majora*, Corpus Christi MS 16, in the lower right margin on fol. 150.

183. Ibid. 17: 958: "Possumus etiam per templum vetus Testamentum intelligere: per arcam sacramenta quae de Christo in veteri Testamento continentur. Veniente quippe Christo in carne, apertum est vetus Testamentum, atque spiritalis intelligentia."

184. Ibid.: "Possumus per templum Dei beatam Mariam intelligere: per arcam vero Testamenti Christum, qui ex ea carnem assumpsit. Templum autem Dei non ideo apertum dicitur, quod uterus beatae virginis Mariae in pariendo Dominum apertus sit."

185. Ibid.: 960: "Possumus per mulierem in hoc loco et beatam Mariam intelligere, eo quod ipsa mater sit Ecclesiae; quia eum peperit, qui caput est Ecclesiae. . . . Draco igitur stetit ante mulierem, ut cum peperisset, filium ejus devoraret: quia in exordio nativitatis Christi eum per Herodem ministrum suum interficere voluit."

186. Ibid.: "Per caudam . . . Antichristus designatur. Tertiam igitur partem stellarum coeli cauda draconis traxisse visa est; quia Antichristus multos ex iis, qui ab hominibus electi putabantur, et qui in Ecclesia velut stellae in coelo, scientia et intellectu refulgent, decipiet atque in perditionis foveam demerget."

187. Freyhan, "Joachism," p. 243. Poesch, "Antichrist Imagery," pp. 219–20, notes that the Berengaudus commentary may derive from a passage in Gregory's *Moralia in Job* 32.22–6, concerning the tail of the Behemoth, which he likened to the tail of the dragon, and that a similar reference is given in the Beatus commentary; indeed the seventh head of the dragon is placed on the end of its long curving tail in the Beatus manuscripts, e.g., Paris lat. 1366, fol. 102v. In the *Figurae* of Joachim of Fiore, the tail of the dragon is associated with the time of Gog and Magog and the last Antichrist.

188. *PL* 17: 960: "Hoc tunc impletum est, quando quadragesima die postquam resurrexit, ascendit in coelum."

189. See inf., pp. 267–8.

190. MS Harley 1527, fol. 134v; see Laborde, *La Bible moralisée*, IV, pl. 605. See *PL* 17: 961.

191. Otaka and Fukui, *Apocalypse anglo-normande*, p. 199: "Ceste femme signefie Seinte Eglise. En cest liu poum entendre le munde par le cel."

192. MS Vat. lat. 39, fol. 163; see Morello and Stockmann, *Neues Testament.*

193. Getty gives almost all of the long Berengaudus commentary on 12:1; Douce gives the gloss on 12:1 and half the commentary of 12:2 before running out of space.

194. *PL* 17: 958–9. Douce also seems to allude to the Berengaudus interpretation of the moon's illumination of the night in the concentric rings of dark-edged clouds brightened by the sun's rays.

195. As represented by the *Liber Floridus*, Wolfenbüttel, Bibliothek Herzog August, MS Guelf. 1. Gud. lat. 2, fol. 15. Some twelfth-century representations show only the huge figure of Michael trampling and impaling the dragon, a scene that has a long pictorial tradition that developed outside the Apocalypse cycles; see Alexander, *Norman Illumination*, pp. 85–98 and pls. 17–20.

196. *PL* 17: 961: "Consequens est ut qualiter per passionem suam diabolum vicit, subjungat. Michael qui interpretatur, quis ut Deus, Christum significat. Praelium in coelo factum est, id est, propter coelum, pro salute videlicet omnium electorum praeliatus est Michael cum dracone."

197. Ibid.: "Pugnavit et contra angelos Michaelis, quando apostolos Christi et per Judaeos et per paganos tandiu persecutus fuit, usque dum eos interficeret."

198. A similar configuration of two angels holding an open codex illustrates this passage in the Reims sculpture cycle; see Kurmann, "Le portail apocalyptique," pp. 259 and 275, no. 38, fig. 34.

199. In Trinity, fol. 13v, the voice appears as a small profile head in the upper right corner, with a speech scroll inscribed with the text of 12:10. Eton's miniature (MS 177, p. 42) for 12:10 focuses on an angel flying out of the clouds, proclaiming the message of victory from 12:10 and gesturing toward John who stands at the left, as the vanquished dragon cringes and cowers, curling into a harmless ball at the lower right.

200. *PL* 17: 962.

201. See S. Lewis, *Art of Matthew Paris*, pp. 275–80.

202. Camille, *Gothic Idol*, pp. 18–19 and 64–5. As Peter Brown, *Cult of Saints*, p. 108, has so eloquently put it, spirit possession, exorcism, and other supernatural ritual expressions were not "some rare aberration of popular religion," but "the regular verbs in a stable grammar of the impingement of the supernatural in society that stretches from the New Testament deep into the Middle Ages."

203. MS Harley 1527, fol. 135: "Per duas alas aquile que dantur mulieri significant duo testamenta per que docetur ecclesia facere poeniam et se a serpente nequissimo elongare."

204. *PL* 17: 964: "Per aquilam Christum possumus intelligere: duae vero alae duo sunt Testamenta. Duae igitur alae datae sunt mulieri, quia duo Testamenta Ecclesia accepit."

205. Because the successive images occurred on a recto page followed by a verso in the archetype, they did not give the same impression of redundancy as in Morgan where almost identical miniatures are assembled in registers. The need to address this redundancy probably explains the elimination of the flying figure in the first illustration in Getty where the two scenes occur on facing pages, as well as in Trinity where they would have been given in cyclical style as in Paris-Douce.

206. Because the commentary (Breder, *Die lateinische Vorlage*, p. 28) warns those who fail to guard themselves against mortal sin, the *Bible moralisée* shows the dragon standing next to the sea facing a group of men with their hands raised in fright, but no battle ensues; see Vienna, Nationalbibliothek MS 1179, fol. 231v.

207. *PL* 17: 965: "Reliqui de semine Ecclesiae electi sunt, qui in fine mundi nascituri sunt. Quaemadmodum autem hoc praelium diabolus peragat, in sequentibus manifestatur. Per arenam maris multitudo reproborum, qui eo tempore futuri sunt, designatur."

208. The addendum begins, "Since the gloss has ended, this letter is offered," and notes that the text of the letter has not been given in its entirety because there is not enough space ("epistola sequentes que non donum ibi finitur propter artitudinem loci").

209. This text, whose source is unknown to me, is unique to Paris-Douce.

210. *PL* 17: 959–60, 965.

211. Ibid.: 965: "Haec bestia Antichristum significat . . . septem vero capita septem vitia principalia designant . . . in enumeratione vitiorum Prudentium sequi."

212. Vienna, Nationalbibliothek MS 1179, fol. 231v; cf. MS Harley 1527, fol. 135, where they hold a rod or scepter (Laborde, *La Bible moralisée*, IV, pl. 606).

213. *PL* 17: 967: "Deus dabit Antichristo potestatem, sed ipsam potestatem in tantum permutabit in malum, ut tota diabolica esse credatur et sit."

214. The text divisions for 13:1–3 are very irregular in the Berengaudus manuscripts. Whereas all include the representation of the dragon surrendering his power and authority to the sea beast, the accompanying

glossed text varies from one group of manuscripts to the next.

215. *PL* 17: 967: "Virtutem suam diabolus, quae tota mala est, Antichristo dabit; quia in illo habitabit et per eum quidquid nequitia diaboli excogitare potest, operabitur."

216. Ibid.: "Quomodo draconem, id est diabolum, adorabunt, quem non videbunt? Sed adorabunt Antichristum illi, qui per terram designantur, et in Antichristo diabolum, dicentes nullum esse Antichristo similem, nec esse qui ejus fortitudini possit coaequari."

217. Ibid.: 971: "Potest fieri ut sicut nos habemus characterem Christi, id est crucem, qua signamur; ita habeat Antichristus proprium characterem."

218. See Emmerson, *Antichrist*, pp. 40–1, 136.

219. *PL* 17: 972: "De hoc numero multi multa dixerunt, pluraque nomina repererunt, in quorum litteris hic numerus invenitur. Tamen si aliquod ex iis nominibus Antichristus possideat, praevidere non potuerunt: sed de re tam incerta nihil audeo definire."

220. See Breder, *Die lateinische Vorlage*, p. 29.

221. *PL* 17: 968: "Faciet bellum cum sanctis, quosdam blandiendo, quosdam terrendo, et ad ultimum eis pessima tormenta inferendo, ut eos in errores suos inducat: sed fieri non potest, ut in errorem inducantur electi. Vincet autem illos non superando, sed interficiendo."

222. Rothwell, *English Historical Documents,* p. 643.

223. *PL* 17: 970: "Legimus in libro Job diabolum ex permissione Dei ignem fecisse de coelo descendere, et oves Job puerosque consumpsisse. Quod ergo illic per semetipsum fecit, hoc per Antichristum et sequaces ejus extremeo tempore faciet."

224. Ibid.: 970–1: "Quod autem bestiam plagam gladii habuisse dixit, et vixisse, potest fieri ut arte diabolica fingat se Antichristus mori et resurgere, ut hoc facto facilius homines decipiat: quod Simon magus fecisse dicitur."

225. Harley MS 1527, fol. 77; see Camille, *Gothic Idol*, fig. 15. Although the roundel serves as an illustration of Acts 17:23, Camille (pp. 21–2) points out that the image embodies St. Paul's stricture from I Corinthians 8:4, repeated by Durandus in the thirteenth century (*Symbolism of Churches*, p. 44): "We know that an idol is nothing in the world and there is no God but one."

226. *PL* 17: 971: "Characterem ergo Antichristi in dextera manu habebunt; quia opera maligna doctrinae Antichristi congruentia exercebunt."

227. Otaka and Fukui, *Apocalypse anglo-normande*, p. 202: "Par main oeveres sunt entendus. . . . Par le frunt, le penseie est suvent juge." The illustration closely resembles the miniature in the *Bible moralisée* (Vienna, Nationalbibliothek MS 1179, fol. 233v) in

which the beast is seated at the right, presiding over the encoding, as a kneeling figure is touched on the hands by one of the beast's henchmen, and a man in a close-fitting cap marks the foreheads of the others with a stylus.

228. See L. K. Little, "Pride Goes before Avarice," pp. 16–49; Camille, *Gothic Idol*, pp. 258–9.

229. Alain de Lille, *De planctu naturae*, prosa 6, pp. 488–9.

230. In an independent departure from the major thirteenth-century paradigm, this aspect becomes the major focus in Eton 177, where a small figure of the beast stands on shelves of goods, as his henchman behind the counter waves a sword and holds up his hand, refusing to sell to a group of men who point to their foreheads. The illustration appears above an abbreviated paraphrase of 13:16–17.

231. For example, see Lateran Council IV, canon 68, in Rothwell, *English Historical Documents*, p. 672.

232. *PL* 17: 972: "In monte igitur Sion Agnus visus est, quia in coelesti beatitudine cum sanctis suis Christus consistit."

233. Probably based ultimately on a classical source, the dorsal figure in the Berengaudus cycles resembles Moses standing *a tergo* before the Lord in an early twelfth-century historiated initial in the Stavelot Bible. On the early medieval occurrence of this type of "reverse orans," see Dynes, "Dorsal Figure," pp. 41–8 and fig. 9.

234. *PL* 17: 972.

235. The composition is known from a drawing, now in the Archivio San Pietro, as well as from the sixteenth-century fresco copy in the Vatican Grottoes. See Waetzoldt, *Die Kopien*, pp. 13 and 71–2, nos. 943–55 and fig. 490; Grisar, "Die alte Peterskirche zu Rom," pp. 270–3. As Schumacher, "Altchristliche Giebelkomposition," pp. 137 and 148, observed, the Eucharistic symbol of the blood of the Lamb flowing into the chalice probably alludes to the doctrine of transubstantiation codified at the Fourth Lateran Council in 1215.

236. Thus, Metz includes the first four verses of this chapter but gives a gloss only for 14:1, illustrating what John saw. In contrast, Morgan combines the archetypal illustration for the first verse with the next pictorial episode for 14:2–5 by simply juxtaposing them in textual sequence from left to right.

237. *PL* 17: 972: "Saepe per Joannem praesentis vitae fidelis demonstratur."

238. Ibid.: 972–7.

239. Ibid.: 974: "Sancti viri in hac terra positi, gloriam sanctorum in coelis commorantium oculis mentis assidue conspiciunt, atque ut ad eorum societatem quandoque perveniant."

240. In Metz, the scroll has been left blank, but the beginning of the text is given in Gulbenkian, Paris lat. 10474, Getty, and Trinity.

241. In Vat. lat 39, fol. 164v.

242. See Freyhan, "Joachism," pp. 220–4, who further observed a parallel in the *Bible moralisée* where not only is the attribute of the book missing, but the text also omits the reference to the "evangelium aeternum." It should be pointed out, however, that, although this omission occurs in Harley 1527, the earlier version in Vienna 1179, fol. 233v, contains an illustration that shows the first angel holding an open book to accompany a text that includes the "eternal Gospel." When Freyhan argued that the book reappears to become a standard attribute in fourteenth-century English Apocalypse illustration, he failed to observe that this tends to occur only in manuscripts that descend from the Corpus-Lambeth model where the angel simply pointed to the Lord enthroned, whereas the later manuscripts descending from the Berengaudus archetype either retain the scroll, as in Cloisters, or leave the angel empty-handed, as in Trinity B.10.2.

243. *PL* 17: 977–8: "Nam sicut superius cum mala Antichristi narrare vellet ab adventu Christi inchoavit, persecutionesque quas Ecclesia a diabolo passa est. . . . Iste quippe angelus Christum et apostolos ejus, caeterosque Christi praedicatores significat."

244. *Expositio in Apocalypsim* (*PL* 165: 684): "Opera enim illorum sequuntur illos; quae quidem digna memoria, magnum eis ante conspectum Domini testimonium ferent."

245. *PL* 117: 1112: "Scribe in corde tuo."

246. Henderson, "Studies," I-II, p. 119, cites English precedents for the motif in the Shaftesbury Psalter, fol. 168v, and the angels with the cloth between them in the Grimbald Gospels, fol. 114v.

247. *PL* 17: 980: "Duae falces unam significationem habent: designant enim illum ignem quo universus mundus delendus est . . . [quia] in fine temporum per ignum delebitur. . . . Unus Christus per duos angelos, et una exterminatio per duas falces figuratur." In some apparent confusion, the two sickles in the first illustration are used in successive actions for the harvest, but the dual character and single destructive function of the angels and sickles are repeated in the succeeding illustration of the Vintage to stress this aspect of the gloss.

248. Harley 1527, fol. 139: "Hoc significat quod Christus in die iudicii bonos a malis segregabit, et illos qui erunt [ut] frumentum reponet in horreum suum, et illos qui erunt ut stipula, ponet in ignem." Cf. Breder, *Die lateinische Vorlage*, p. 32.

249. *PL* 17: 982: "Lacus vero, quem infernum vocamus, ideo lacus irae Dei dicitur."

250. The second Vintage miniature was lost before the destruction of the Metz manuscript in 1945 but can be seen in Lambeth 209 and Cambrai 422.

251. *PL* 17: 981: "Blandus itaque justis, terribilis apparebit in justis."

252. See Illich, *Vineyard of the Text*, p. 58.

253. Pliny, *Natural History* V.17.169, p. 116.

254. Illich, *Vineyard of the Text*, p. 57.

255. *PL* 17: 983: "Sicut superius antequam ad narrationem septem angelorum tubis canentium veniret, eorum mentionem facere studuit; ita et hic antequam ad septem angelorum phialas habentium narrationem veniat, eorum mentionem facit, ut indicet magna mysteria in eorum visione contineri."

256. Ibid.: "Mare igitur vitraeum mistum est igni; quia divina Scriptura mista est spiritalibus intellectibus."

257. Ibid.: 984–5.

258. Ibid.: 985–6: "Si per templum coelestis patria, et per septem angelos praedicatores designantur. . . . Per zonas autem aureas, quibus circa pectora praecincti narrantur, praedicatorum sapientia intimatur: quae corda sanctorum intra se ita concludit, ut extra ipsam per diversos errores evagari non sinat."

259. Ibid.: 987: "Templum igitur coelestis patriae modo fumo est plenum; quia electi in hac vita positi, dum oculos mentis suae ad contemplanda coelestia attollunt, obscurantur quadam caligine, quam transmeare non possunt: quam obscurationem fumum vocat."

260. Ibid.: "Per istud unum animal Christum intelligamus," and 17: 889: "Per leonem . . . Christus intelligitur."

261. See Isidore of Seville, *Etymologiae* (*PL* 82: 434); Pseudo-Hugo of St. Victor, *De bestiis* (*PL* 177: 57).

262. *PL* 17: 964: "Per aquilem Christus possumus intelligere."

263. *Der Physiologus*, cap. 6 on Ps. 102:5. See also Jerome, *Commentariorum in Abdiam prophetam* (*PL* 25: 1103); Isidore of Seville, *Etymologiae* XII (*PL* 82: 460). On the eagle's victory over Satan, Pseudo-Ambrose, *Sermo XLVI* (*PL* 17: 718ff.).

264. Raby, *Oxford Book of Medieval Latin Verse*, p. 238, no. 165, lines 16–18.

265. Henderson, "Studies," III, p. 142.

266. Although the Metz gloss focuses exclusively on the second angel, this aspect of the illustration tends to be overpowered by elements representing 16:4–7, again suggesting the compression of a more expansive archetypal cycle.

267. Freyhan, "Joachism," p. 220, described this textual aberration as a scribal error, whereas it is actually a common variant text that appears among the most

authoritative early medieval editions, such as the Alcuin Bible and the Fuldensis; see also Klein, *Endzeiterwartung*, p. 134.

268. *PL* 17: 990: "Possumus per angelum quartum angelum illius populi intelligere, qui videns justo Dei judicio populum iniquum esse damnatum, laudat sententiam justissimam Dei omnipotentis."

269. In Paris lat. 10474 and Trinity B.10.6, which contain corrected Vulgate texts for 16:5, the angel no longer holds a vial but a scroll as he sits or stands on the waters.

270. *PL* 17: 989.

271. In Paris-Douce, however, the altar disappears, leaving only the great angel with his scroll declaiming to the Lord in heaven; in Getty, the altar is retained, but its angelic voice has been lost, as the "fourth" angel stands alone with his vial at the right, gesturing toward the angel pouring the third vial.

272. *PL* 17: 992: "Sextus iste angelus . . . significat enim martyres sanctos . . . per flumen magnum Euphraten persecutores videlicet Ecclesiae Dei."

273. Ibid.: "Per reges multitudinem gentium, quae ad fidem Christi confluxit, possumus intelligere. . . . Sed quomodo ab ortu solis venisse dicuntur, id est, a Christo, qui per solem designatur."

274. Ibid.: "Via itaque regibus siccata aqua praeparata est." This detail is pointed out in Douce by Wright, "Sound in Pictured Silence," p. 251. Like Getty and Paris-Douce, Trinity attempts a similar visible signifier by dividing the river into two inchoate but emphatically separated clusters of waves.

275. Ibid.: 992–3: "Spiritus vero tres immundi discipulos designant Antichristi . . . Nam et ranarum vox rauca et turpis impiissimam eorum praedicationem blasphemiis plenam designat."

276. Ibid.: 994: "Per templum Ecclesia intelligitur."

277. Ibid.: "Per septimum istum angelum praedicatores sancti, qui temporibus Antichristi futuri sunt, designantur. . . . Vox magna vox est praedicatorum sanctorum."

278. Ibid.: 996: Quae super aquas multas sedere dicitur; quia ex multitudine gentium, quae per aquas designantur, civitas diaboli construitur."

279. As in the window of the choir apse of Lyons Cathedral, ca. 1220, and the choir window of Auxerre Cathedral, ca. 1230, where *Luxuria* regards herself in a mirror; see Katzenellebogen, *Allegories of the Virtues and Vices,* p. 83, n. 1.

280. *Enneads* II.5.5.

281. On the Plotinian reading of the Narcissus myth, see Kristeva, *Tales of Love*, pp. 103–9, who bases her analysis on Hadot, "Le mythe de Narcisse," pp. 81–108.

282. *PL* 17: 996: "Angelus vero phialam habens, praedicatores sanctos designat: Joannes autem typum tenet omnium fidelium."

283. Ibid.: 995–6.

284. As quoted by Camille, *Gothic Idol*, p. 304, from the *Gemma ecclesiastica*.

285. As Camille points out, fear of the female look is exemplified in the medieval metamorphosis of the myth of Medusa and the Gorgons represented in a small group of thirteenth-century English Bestiaries. In the Canterbury manuscript, the Medusa becomes a "beautiful harlot" who guards a single eye, resembling a mirror, that turns those who look at it to stone.

286. *PL* 17: 997–8: "Ebria erat; quia ultio sanguinis sanctorum ita eam damnabilem fecerat, et a misericordia Dei alienam, ut non esset digna quatenus aliquo modo suae saluti posset consulere. . . . Mirantur fideles, cum vident reprobos tantum a timore Dei alienos, ut sine aliqua trepidatione et innocentibus plurima mala ingerant."

287. Albertus Magnus, *Postilla in Isiam* 47:20, as cited by Carruthers, *Book of Memory*, pp. 142–3.

288. In Trinity, which regularly consolidates two or more archetypal illustrations to head its longer text divisions, the events of 18:1–3 and 18:4–11 appear as contiguous scenes within a single wide frame.

289. *PL* 17: 1001–2: "Angelus namque iste Christum significat, qui de coelo ad terram descendere dignatus est. . . . Vox Christi doctrina est Evangelii."

290. Although the text is complete in the Vienna *Bible moralisée*, with six illustrated segments, Harley and Toledo have only four; Harley omits verses 7–8 and 11–17, and Toledo is missing verses 3 and 8–16.

291. *PL* 17: 1007: "Iste angelus Christum significat, qui fortis esse dicitur; quia fortitudinem Christi quanta sit, humana mens comprehendere non potest; per lapidem vero molarem magnum omnis multitudo impiorum designatur."

292. Ibid.: "Spiritaliter itaque ista omnia intelligenda sunt."

293. *Ancrene Riwle*, trans. Salu, p. 147; see Georgianna, *Solitary Self*, pp. 125–6.

294. *PL* 17: 1009: "Per tubas igitur multas electi qui ante diluvium fuerunt, et qui post diluvium usque ad illud tempus quo Lex data est, designantur." Only one of the thirteenth-century recensions, however, shows exactly seven trumpets to correspond to the number given by Berengaudus.

295. Ibid.: "Potest per fumum fama designari. . . . Fumus ergo Babylonis in saecula saeculorum ascendit, quia haec fama ab ore fidelium nunquam recedet."

296. Ibid.: "Per viginti quatuor seniores, patres qui sub

Lege fuerunt designantur. Quibus conjunguntur quatuor animalia, per quae novum Testamentum figuratur."

297. The representation of the Marriage of the Lamb created for the Berengaudus cycle isolates and expands the small nuptial scene in the upper register of the illustration in the *Bible moralisée* (Toledo Cathedral Treasury, III, fol. 190) into a full-scale miniature for 19:6–8, transforming the broad horizontal band dividing the two registers into a long draped table. See Laborde, *La Bible moralisée,* IV, pl. 662.

298. In the Alexander Apocalypse (Cambridge University Library MS Mm.5.31, fol. 131v), the Lamb stands on a similar mound clearly labeled "Mons Syon."

299. See Molin and Mutembe, *Le rituel du marriage,* pp. 198, 219–20. Some rites, however, include the nuptial kiss before the benediction and giving of the ring.

300. Guillelmus Peraldus, *Summus de virtutibus et vitiis,* p. 2, tr. IV, c. 12 (ed. Lyons, 1668, I, p. 177): "Amorem ei promissit . . . cum ad missam in praesentia Dominici corporis osculum ei dedit, ad minus secundum consuetudinem aliquarum Ecclesiarum. Osculum enim signum est amoris et pacis."

301. See Molin and Mutembe, *Le rituel du marriage,* pp. 159–66. Even before it was incorporated into the nuptial mass, the giving of the ring was part of the familial rite of marriage, taking place in the house of the groom.

302. *Summa Theologiae,* q. 44, a. 2; *Manuale ad usum percelebris ecclesie Sarisburiensis,* p. 58. The ancient rite of *velatio* is similarly represented in the illustration for Causa XXX, Quaestio V, can. 3, in several fourteenth-century French copies of Gratian's *Decretals;* see Melnikas, *Corpus,* III, pp. 998–9 and figs. 23–8; see also Duby, *Histoire de la vie privée,* II, p. 137, who reproduces a similar illustration in Dijon, Bibl. mun. MS 341.

303. The Alexander Apocalypse similarly eschews all references to the banquet to concentrate on the gesture *coniunctio dextrarum* to solemnize the nuptials of Christ and Ecclesia evoked in the commentary; Alexander Minorita, *Expositio in Apocalypsim,* p. 395: "Nuptiae in sacro eloquio nuncupantur Christi et Ecclesia coniunctio."

304. Molin and Mutembe, *Le rituel du marriage,* p. 249.

305. Causa XXX, Quaestio V, can. 6: "Sine publicis nuptiis nulus ducat." See Melnikas, *Corpus,* III, p. 1143. In the fourteenth-century French manuscripts, however, the *convivium* is usually depicted in connection with Causa XXXVI; see Melnikas, *Corpus,* III, pp. 1159–63.

306. *PL* 17: 1009: "Tres ergo voces semel alleluia decantaverunt; quia fidem sanctae Trinitatis doctrinamque

Evangelii, quae a magna tuba, id est, a Christo processit."

307. Ibid.: 1010: "Uxor ejus praeparavit se, id est, Ecclesia quae uxor Agni dicitur." In the Alexander Apocalypse, the bride is literally transformed into the figure of Ecclesia, as she wears a crown and holds a cross-banner, responding to a similar commentary on 19:8.

308. See S. Lewis, "Giles de Bridport," pp. 107–19. On the Church as the bride of Christ in the twelfth and thirteenth centuries, see Gillen, "Bräutigam und Braut," cols. 318–24; Schiller, *Ikonographie,* IV/1, pp. 94–106.

309. As L. J. Friedman, *Text and Iconography,* p. 6, points out, the author announces at the outset that "poez veoir ci apres point et escrit les articles de nostre foi par letres et par ymages."

310. Langlois, *La vie spirituelle,* IV, pp. 19–20.

311. St. Petersburg Public Library MS Lat. Q.v.I, 78, fol. 190. See Mokretsova and Romanova, *Les manuscrits enluminés français 1270–1300,* pp. 194–231, no. XIII. The illustrated *Credo* is given on twenty large miniatures on facing folios interleaved in a Missal made for the usage of Saint Nicaise, Reims. Laborde and Lauer, "Un projet de décoration," p. 79, surmised that the iconography of the marriage banquet was derived from romance illustration.

312. In The Hague and St. Gall Block Book versions of the *Biblia pauperum,* the last image illustrating the "Crown of Eternal Life" represents the angel showing John the Bride of the Lamb: "Sponsus amat sponsam Christus nimis et speciosam." See Cornell, *Biblia Pauperum,* p. 53.

313. In Getty and Douce 180, John has shifted to a standing pose. In Douce, although he still holds his pen, John has lost his book, rendering his pose illogical or meaningless.

314. For a discussion of the early iconography of the Army of Heaven, see Denny, "Romanesque Fresco," pp. 197–201.

315. *PL* 17: 1012: "Per exercitus qui de celo processisse Christum sequentes visi sunt, sancti qui in fine mundi nascituri, et contra Antichristum pugnaturi sunt."

316. Ibid.: 1010.

317. Ibid.: 1012–13: "Per gladium vero divinam Scripturam . . . intelligere debemus. . . . Per virgam ferream Evangelium diximus fuisse designatum; reget ergo Christus gentes in virga ferrea, quando per doctrinam sanctorum et Judaeos ad fidem suam convertet, et electos ab erroribus Antichristi defendet."

318. In Morgan, however, the cloud-framed army has been moved down to the ground line to make room for six lines of text.

319. *PL* 17: 1013: "Hic vero non crux, sed locus poena-

rum, in quem impii retrudendi sunt, designatur. Eamdem quippe significationem habet torcular in hoc loco, quam et lacum superius diximus habuisse, in quem botri vinae terrae, per quos impii designantur, demersi fuisse leguntur. Sed et ipsa calcatio torcularis eamdem significationem habet, quam et illic calcationem lacus habuisse diximus; significat namque ultimam demersionem impiorum in infernum."

320. Ibid.: "Per aves autem fideles omnes . . . designantur. . . . Coena vero Dei quid aliud est, nisi exterminatio impiorum?"

321. Ibid.: 1014: "Hic demonstrat non ad adventum Domini secundum ea . . . sed potius ad illud tempus, in quo per sanctos suos contra Antichristum praeliaturus est."

322. Fletcher, *Allegory*, pp. 157–60, 189, 344.

323. Trier, fol. 64, and Valenciennes, fol. 36.

324. Vienna, Nationalbibliothek MS 1179, fol. 242; see Laborde, *La Bible moralisée*, pl. 694.

325. *PL* 17: 1014.

326. Ibid.: 1015: "Tres namque sunt damnationes diaboli. . . . Angelus itaque iste Christum significat."

327. Ibid.: "Angelus itaque iste Christum significat: descensio ejus de coelo est incarnatio ejus. . . . Per catenam vero magnam ejus potestas designatur."

328. See Vienna, Nationalbibliothek MS 1179, fol. 243v, which shows Christ enthroned in heaven, surrounded by saints and resurrected souls, as the wicked lie dead in the jaws of hell below.

329. *PL* 17: 1016: "Per sedes namque coelestis patria, per sedentes vero super eas sanctorum animae designantur."

330. On the sword as an attribute of Justice, see Kahsnitz, "Justitia," col. 468.

331. In Paris lat. 10474, they occupy the extreme right and left sides of the composition, but still point and gesticulate toward the resurrected figures in the center; in Trinity, even the souls, now represented as small tunic-garbed figures at the right, continue the debate, echoing the oratorical gestures of the enthroned judges.

332. See inf., pp. 226–8, 268–9.

333. See Lerner, "Refreshment of the Saints," pp. 124–5.

334. Augustine, *City of God* 20.7.

335. See Lerner, "Refreshment of the Saints," pp. 109–15.

336. *PL* 17: 1017: "Tempus itaque a passione Christi usque ad finem mundi resurrectio prima vocatur."

337. Although Add. 35166 gives more of 20:9 and breaks off at "in stagnum ignis," it repeats this part of verse 9 on the next page and begins at the same point as the other recensions, thus confirming that this is where the break was made in the archetype.

338. On the traditional round contours of Jerusalem in Crusader maps, see Kühnel, *From the Earthly to the Heavenly Jerusalem*, pp. 138–41. It also takes the form of a circle in the thirteenth-century Psalter in British Library MS Add. 28681, fol. 9.

339. Add. 35166 eschews the hell mouth in favor of a flaming hole in the ground into which three men armed with pikes thrust the seven-headed dragon along with the spotted beast, thus ensuring pictorial consistency with its antecedent depiction of the Defeat of the Beast.

340. *PL* 17: 1020.

341. Ibid.

342. The text for the Berengaudus illustration of the Last Judgment gives not only the last five verses of Rev. 20 but the first verse of chapter 21 as well. The eccentric ligation of chapters does not correspond to an earlier capitulation and appears to be peculiar to the English Gothic redaction. Because there is no pictorial reference to the new heaven and new earth in the Berengaudus miniature, the text was apparently divided in this way to enable the next illustrated segment to begin with 21:2

343. *PL* 17: 1020: "Domini nostri Jesu Christi misericordia largiente ad sextam visionem pervenimus, quae brevior est caeteris."

344. Ibid.: 1020–1: "Libri multi ad reprobos: unus qui est vitae, ad electos pertinet. . . . Multos ergo libros reprobi possident, quia multis modis Deum offendunt; electi vero unum librum habent, quia unum Deum colunt, unum fidem catholicam confitentur."

345. Lubac, *Corpus Mysticum*, p. 322.

346. See Morris, *Discovery of the Individual*, pp. 146–7.

347. *PL* 17: 1023: "Civitas Jerusalem Ecclesia est ex omnibus justis constructa: de coelo descendet; quia Domino ad judicium veniente."

348. In the Metz recension, the text simply breaks off at 21:11 ("lapide preciosa ornata") and omits the rest of the chapter. Morgan adopts another strategy by omitting the middle of the text, giving 21:9–19 and 21:24–7. Add. 35166 manages to include 21:9–21 (ending with "sunt per singulas"), whereas Eton-Lambeth compresses the gist of Rev. 21:9–21 into a short paraphrase. Although Douce's text extends over two pages, the segment is still incomplete, ending with 21:21. Among the thirteenth-century recensions only Paris lat. 10474 and Trinity carry a full text. Paris lat. 10474 continues the text for 21:9–27 onto the next folio and even includes a short commentary, relegating the next illustrated text to the second column; Trinity not only contains a complete text for Rev. 21, but also includes 22:1–7 as well, accompanied by an elaborate, almost full-page composite illustration to serve for both.

349. *PL* 17: 1032: "Superius in quinta visione Joannes dicit septem angelos habentes septem phialas sibi fuisse demonstratos, et in sequentibus unum ex illis civitatem diaboli damnationemque ejus sub specie mulieris meretricis sibi ostendisse: similiter et hic unum ex eisdem septem angelis dicit sibi civitatem Dei sub figura Jerusalem demonstrasse . . . significant namque praedicatores, qui fuerunt, et erunt usque in finem: Joannes vero typum tenet caeterorum fidelium."

350. Ibid.: 1038: "Angelus qui loquebatur cum Joanne, in hoc loco Christum significat, qui modo regit omnes gentes in virga ferrea. . . . Diximus superius per virgam ferream disciplinam Evangelii esse designatum."

351. Douce (p. 92), however, refers to their elevated position by showing both John and the angel climbing stairs.

352. Conversely, Freyhan, "Joachism," p. 231, argues that the square mountain in Metz evolved from the large solid block of text in Morgan.

353. The intrusion of a late Beatus model for this image was first noticed by James; see Brieger, *Trinity College Apocalypse*, p. 11.

354. As, e.g., that in The Hague, Koninklijke Bibliotheek MS 69, dating from ca. 1170; see Boase, *Kingdoms and Strongholds*, p. 62 and pl. 40.

355. See Lewis, *Art of Matthew Paris*, pp. 355–6 and figs. 215 and 218. On the other hand, the maplike representation of the heavenly Jerusalem in Trinity most likely reveals the intervention of a later Beatus model. As in the early Valenciennes version, as well as in the *Liber Floridus*, John and the angel appear below or next to the city as a smaller but necessary adjunct to the illustration of 21:15–27. The exclusive appearance of this illustration in Eton-Lambeth and Trinity suggests that an alternative representation could be substituted for the archetypal illustration only in manuscripts that did not conform to its half-page format.

356. *PL* 17: 1051: "Sed omnem dulcedinem atque suavitatem illud transcendet, quod videbunt Deum facie ad faciem."

357. Ibid.

358. Ibid.: 1052–3: "Sed si diligenter scripturam libri hujus inspexerimus, non in vanum esse factum intuebimur; nam cum ei demonstrasset angelus Christum in sua sede sedentem, quatuorque animalia, et viginti quatuor seniores, nequaquam dicitur angelum adorare voluisse. . . . Ubi vero ventum est ad eum locum, in quo ei ab angelo demonstratum est, qualiter sponsa Christi, id est Ecclesia, Christo conjuncta est. . . . Igitur Joannes bis angelum adorare voluit, quia binas conjunctiones Ecclesiae cum Christo ei demonstravit."

359. See Garnier, *Le Langage de l'image*, II, pp. 120–6.

360. *PL* 17: 1052.

361. On the recognition of the complex temporality of reading somewhat later in Dante's *Commedia*, see Noakes, *Timely Reading*, pp. 41–53.

362. *PL* 17: 1055: "Christus veniens in mundum, universam mundi faciem illuminavit: qui non incongruenter lucifer vocatur." Precedents for Berengaudus's reference to Job 38:32 ("Luciferum in tempore suo") can be found in Hrabanus Maurus, *Allegoriae in sacram scripturam* (*PL* 112: 989) and Garnerus of St. Victor, *Gregorianum* 7.44 (*PL* 193: 43).

363. *PL* 17: 1052: "Ille servat verba prophetiae, id est mandata Dei, qui ea operando implet, et in meditatione eorum assiduus est."

364. New York, Morgan MS M.240, fol. 1v: "Angelus in caelo clamans significat praedicatores. Aves significant bonos christianos qui semper tendunt in altum ad bona caelestia contemplanda."

365. *PL* 17: 1023.

366. Schiller, *Ikonographie*, V, p. 246, also notes a number of visual correspondences but does not explore their implications. On the possible influence of the *Bible moralisée* on the Oscott Psalter, see Morgan, *Early Gothic Manuscripts,* II, p. 138.

367. MS Harley 1527, fol. 121; see Laborde, *La Bible moralisée*, IV, pl. 592.

368. Vienna, MS 1179, fol. 231v, and MS Harley 1527, fol. 135; see Laborde, *La Bible moralisée*, IV, pl. 606.

369. See Breder, *Die lateinische Vorlage*, p. 32: "Et hoc significat, quod Christus in die iudicii bonos a malis et illos, qui erunt ut frumentum, reponet in horreum et illos, qui erunt ut stipula, ponet in ignem."

370. Toledo Cathedral Treasury MS III, fol. 190; MS Harley 1527, fol. 147; see Laborde, *Bible moralisée*, IV, pls. 618 and 662.

371. Binski, *Painted Chamber at Westminster*, pp. 87–8, observes a related instance of two Old Testament images that reveal a similar specificity of borrowing from the *Bible moralisée*.

372. See Haussherr, "Sensus litteralis," pp. 366–7; Emmerson and Lewis, "Census," III, no. 153. The manuscript contains 156 Apocalypse illustrations on fols. 302–11v, but the text and illustrations are lost after Rev. 12. The text is written in a fine hand on 311 folios (410 × 280 mm) of beautifully prepared vellum, with elegantly flourished initials and headings. Add. 18719 is clearly copied from the same model as that for the Oxford-Paris-London version, but the rectangular frames allow an absolutely regular alignment of the text and picture; the text, with very few abbreviations, is much more legible than the royal versions. Figures often overlap the inner square

frames, suggesting that the drawings were made from a model with roundel frames. Unlike the royal copies, Add. 18719 is written and illustrated on every recto and verso, suggesting that the ink drawings were never intended to be painted. Nevertheless, the cost of the vellum alone would have made this an expensive project. The drawing hands differ in quality, with varying degrees of finish and detail. The Apocalypse illustrations were drawn by some of the less accomplished hands.

373. I shall present the case for St. Victor as the point of origin for the *Bible moralisée* in *Picturing Visions*.

374. Robert of Flamborough, *Liber poenitentialis*, p. 7. Poore lived, taught, and preached in Paris from 1208 to 1213; see Kaeppel, "Un recueil de sermons," pp. 183–5.

375. De Hamel, *Glossed Books*, p. 13; see Ker, *Medieval Libraries*, p. 252.

376. De Hamel, *Glossed Books*, pp. 62–3.

CHAPTER 4

1. See Whitman, *Allegory*, p. 26.

2. Althusser, *Lenin and Philosophy*, pp. 152–70; see also Moxey, "Semiotics and the Social History of Art," pp. 209–18.

3. See Holly, "Past Looking," p. 392; Gretton, "New Lamps," p. 70.

4. See Lacan, *Four Fundamental Concepts of Psycho-Analysis*, p. 96; Holly, "Past Looking," p. 389; Gretton, "New Lamps," p. 67.

5. Holly, "Past Looking," p. 395, who cites Bryson, *Vision and Painting*, p. xiii.

6. Althusser, *Lenin and Philosophy*, pp. 167–8.

7. See Eagleton, *Literary Theory*, p. 173.

8. Althusser, *Lenin and Philosophy*, p. 153.

9. Lévi-Strauss, *Structural Anthropology*, p. 229. In an even broader sense, H. White, *Tropics of Discourse*, p. 5. points out that, as a product of efforts to come to terms with problematical domains of experience, discourse serves as a model of metalogical operations in general cultural praxis.

10. A. Y. Collins, *Crisis and Catharsis*, p. 141.

11. Ibid., p. 154.

12. Ibid.

13. See McGinn, "Symbols of the Apocalypse," pp. 270, 279.

14. See S. Lewis, *Art of Matthew Paris*, pp. 248–51.

15. Brentano, *Two Churches*, pp. 106–7; also Powicke, *Henry III*, p. 265.

16. See Southern, *Robert Grosseteste*, pp. 237–44.

17. See Marsh, *Epistolae*, pp. 88, 198–9.

18. Gibbs and Lang, *Bishops and Reform*, p. 146.

19. Bacon, *Compendium studii philosophiae*, pp. 398–402.

20. Peckham, *Registrum epistolarum*, II, pp. 694–7.

21. *Die Apokalypse des Golias*, ed. Strecker; T. Wright (ed.), *Latin Poems*, pp. 1–20, 271–92; *Apocalypse of Golias*, pp. 253–61.

22. On the Goliardic tradition, see Raby, *History of Secular Latin Poetry*, pp. 214–27; Walsh, "Golias and Goliardic Poetry," pp. 1–7.

23. See Newman, "Structure of Vision," pp. 113–23, who sees its structure based on the Augustinian analysis of the three kinds of vision: corporeal, spiritual, and intellectual.

24. Ibid., pp. 122–3.

25. Statutes of Salisbury IV.2 (1257): "Cum inter totius orbis ecclesias ecclesia Saresbiriensis in divino officio et ministris tanquam sol in rota claruerit adeo ut, radios suos unique diffundens, defectus supleverit aliarum." See Powicke and Cheney, *Councils and Synods*, II, 1, pp. 552–3.

26. On St. Edmund of Abingdon, see inf., pp. 289–90.

27. See Brentano, *Two Churches*, pp. 175, 221, 347.

28. Malden, "A Contemporary Poem," p. 210.

29. Brieger, *English Art*, pp. 2–4.

30. B.L. MS Add. 42555, fol. 6:

> Par set eglises nus est demustre une sule eglise, pur les set duns del seint esprit, par ki duns relut el mund cele seincte eglise.... Regne deu est dit leglise deu, kar deu iesu crist fist le regne deu de genz, quant il les establi teus en quels il of sun pere, e of le seint esprit deygna habiter e regner. Memes cels sunt par le regne demustrez, par quels les prestres. Duns sunt les prestres deu, les esliz deu.

Cf. *PL* 17: 845, 847.

31. On Giles de Bridport's tomb relief, see Roberts, "Tomb of Giles de Bridport," p. 582 and fig. 42. Other examples include a Psalter in St. John's College, Cambridge, MS K.26, fol. 22v (see James, *Descriptive Catalogue ... St. John's College, Cambridge*, pp. 264–270, no. 231); Boethius, *De consolatione*, Oxford, Bodleian Library, MS Digby 174, fol. 11 (see Pächt and Alexander, *Illuminated Manuscripts in the Bodleian Library*, III, no. 457, pl. XLI); and a Psalter in Venice, Biblioteca Marciana, MS lat. I.77, fol. 28 (see *Mostra storia nazionale della miniatura*, no. 464).

32. See S. Lewis, "Giles de Bridport," p. 112.

33. The gesture also occurs in the Angel Choir in Lincoln Cathedral. See Gardner, *English Medieval Sculpture*, pp. 117–21, 144–5, figs. 222 and 274; Stone, *Sculpture in Britain*, pp. 125–7, 130–3, and pl. 98.

■ Notes

34. Moorman, *Church Life in England*, p. 217.
35. Powicke and Cheney, *Council and Synods,* II, 2, p. 747.
36. *PL* 17: 989.
37. With the aid of ultraviolet light, the inscription has been deciphered to read:

> Iste liber est ecclesie conventualis beate marie Abbendonie ex dono domini Egidii Sarum episcopi et memoriale ipsius quicumque ipsum librum a dicta ecclesia alienaverit vel ipsum inde defraudaverit anathema sit, que sentencia lata fuit per predictum dominum episcopum.

Curses on thieves and careless borrowers commonly accompanied book inscriptions from several Benedictine houses, but as Ker, *Medieval Libraries*, p. xvii, points out, the traditional positions for inscriptions are the flyleaf facing the front page of text and the head or foot of the first page. Thus, the eccentric placement of the episcopal curse on fol. 57v tends to confirm an intentional linkage with the commentary illustration. Among the books from Abingdon Abbey listed by Ker as having *ex libris* inscriptions, those dating before the fifteenth century are given either on the first flyleaf (Cambridge, Corpus Christi MS 25) or on the first folio (Cambridge, Corpus Christi MS 28; Paris, B. N. MS lat. 1792); see James, *Descriptive Catalogue . . . Corpus Christi College, Cambridge,* pp. 48, 60; Lauer, *Bibliothèque Nationale,* II, p. 178.
38. Powicke and Cheney, *Councils and Synods,* II, 2, p. 171; Grosseteste, *Epistolae,* p. 161.
39. Moorman, *Church Life in England,* p. 226.
40. Ibid., p. 230; see Powicke and Cheney, *Councils and Synods,* II, 1, pp. 29, 82, 142, 171, 296.
41. Powicke and Cheney, *Councils and Synods,* II, 1, pp. 126, 151, 178.
42. Ibid., pp. 56, 151, 178; Grosseteste, *Epistolae,* p. 159.
43. "De continentiis clericorum" and "De concubinis clericorum," Statutes of Salisbury IV, 12–13 (1257), in Powicke and Cheney, *Councils and Synods,* II, 2, pp. 555–6. However, Giles was simply reinforcing statutes that had already been issued by Richard le Poore in 1217 and 1219; cf. *Councils and Synods,* p. 62.
44. See McCulloch, *Medieval Latin and French Bestiaries,* p. 95; T. H. White, *Bestiary,* pp. 28–9. The Bestiary illustrations almost invariably represent the beaver in a contorted pose of self-emasculation, as he is shown in the Abingdon drawing, but a hunter is usually also represented, e.g., Oxford, MS Bodl. 764, fol. 14. See S. Lewis, "Giles de Bridport," pp. 115–16. On the further mnemonic aspects of the image, see inf., p. 258.

45. See Robertson, "Frequency of Preaching," pp. 376–88.
46. See Boyle, "Fourth Lateran Council," pp. 30–43; Paul Meyer discussed some manuscript versions in *Romania* 8 (1879): 325–32.
47. Moorman, *Church Life in England,* pp. 77–9.
48. Ibid., pp. 373–5, 392.
49. Ibid., p. 398.
50. See Wright, "Sound in Pictured Silence," pp. 261–3.
51. See S. Lewis, "Giles de Bridport," pp. 116, 118, and fig. 17. The Franciscan friars in Gulbenkian are often replaced by bishops in the Abingdon version.
52. Powicke and Cheney, *Councils and Synods,* II, 1, p. 321, "De lectione librorum sacrae scripturae," which appears at the end of the statutes of Walter de Cantilupe for Worcester, 1240: "Ab octavis Pasce legitur Apocalipsis, id est tribus septimanis, et cantatur in feriis, quoniam sancto Iohanni revelatum est de morte agne; hoc etiam sancti apostoli predicabant." However, as Morgan, *Lambeth Apocalypse,* p. 31, points out, the reading may have comprised only Rev. 1 through 8:16 and was probably intended to be read from a breviary, but he bases his argument on a version of the Sarum Breviary dating from 1531; see Procter and Wordsworth, *Breviarium ad Usum Insignis Ecclesiae Sarum,* I, pp. dcclxviii–dccccxvi.
53. Moorman, *Church Life in England,* p. 98; Dickinson, *Ecclesiastical History of England,* p. 383.
54. Moorman, *Church Life in England,* p. 182.
55. Giles is listed as having "possibly studied at Oxford" in Emden, *Biographical Register,* I, p. 204.
56. *PL* 217: 714; see also Rothwell, *English Historical Documents,* pp. 644–5.
57. *PL* 206: 1127; Congar, "Pour une histoire sémantique," pp. 88–98.
58. See G. R. Evans, "Exegesis and Authority," pp. 96–7.
59. Ibid., p. 98.
60. *PL* 149: 1377.
61. Thomas Aquinas, *Catena aurea,* quoted by G. R. Evans, "Exegesis and Authority," p. 106.
62. Smalley, *Study of the Bible,* pp. 275–81.
63. Grosseteste, *Hexaemeron* B on Gen. 1:4, quoted by Callus, "Robert Grosseteste," p. 85.
64. Callus, "Robert Grosseteste," pp. 84–5.
65. Bacon, *Opus minus,* quoted by A. G. Little, "Franciscan School at Oxford," p. 809.
66. Smalley, *Study of the Bible,* pp. 279–80.
67. Ibid., p. 285.
68. See Châtillon, "Le mouvement théologique," pp. 881–904.
69. See Branner, *Manuscript Painting,* p. 16; Smalley, *Study of the Bible,* pp. 219–21; D'Esneval, "La division de la Vulgate," pp. 559–68.

■ 372

70. For a full analysis of the relationship between the Latin commentary in Vienna 1179 and the French prose gloss in Fr. 403, see Breder, *Die lateinische Vorlage*. Breder (p. 82) surmises that the French prose gloss does not represent a vernacular translation of the abbreviated Latin commentary in the *Bible moralisée* and that it was based on a longer text that served as the source for both.

71. See Fox, "Earliest French Apocalypse," pp. 448–50.

72. Grosseteste, *Commentarius in Posteriorum Analyticorum libros* I.17, pp. 240–1:

> Dico ergo quod est lux spirtualis, que superfunditur rebus intelligibilibus et oculo mentis, que se habet ad oculum interiorem et ad res intelligibiles sicut se habet sol corporalis ad oculum corporalem et ad res corporales visibiles.

73. Benjamin, *One-Way Street*, p. 359.

74. Innocent III in a letter to the Archbishop of Sens and the Bishop of Paris, dated July 15, 1205; see Grayzel, *The Church and the Jews*, pp. 114–15, no. 18.

75. As pointed out by Blumenkranz, "Augustin et les juifs," pp. 225–41, the idea of the Jews' conversion to Christianity at the end of time goes back to Augustine, *De civitate Dei* 18.46 and 20.29, pp. 343–5 and 503–5; *Tractatus adversus Judaeos* (PL 42: 51–64); and *Sermo* CC.2 (PL 38: 1030); see Cohen, *Friars and the Jews*, p. 20. Referring to the anti-Jewish violence that surged through Western Europe during the Second Crusade, Bernard of Clairvaux, in a letter written "To the English People" (*Letters of St. Bernard*, no. 391), cautioned against the persecution of the Jews, for "we are told by the Apostle (Romans 11:26) that when the time is ripe all Israel shall be saved." For the thirteenth century, see Peter of Blois, *Contra perfidiam Judaeorum* (PL 207: 863–4). The thirteenth-century English tract, *Pictor in carmine*, CXXXV ("Reliquie Israel ad Christum convertuntur") gives eight different Old Testament typologies for the conversion of the remnant of the Jews; see James, "Pictor in carmine," p. 166. Cohen, *Friars and the Jews*, pp. 246–7, and Cutler, "Innocent III and the Distinctive Clothing of the Jews," pp. 92–116, argue that the conversion of the Jews was regarded as indispensable in preparing the way for the Second Coming.

76. See Langmuir, *History, Religion, and Antisemitism*, pp. 295–305.

77. See Watt, "English Episcopate, the State, and the Jews," pp. 137–47. Roth, *History of the Jews*, pp. 39–54.

78. Baron, *Social and Religious History*, X, p. 102; Richardson, *English Jewry*, p. 186; Roth, *History of the Jews*, pp. 41, 54.

79. Grosseteste, *Epistolae V*, p. 33. The letter was written by Grosseteste when he was Archdeacon of Leicester in 1231 to the widow of the count of Winchester, at a time when some of the barons were trying to rid their estates of Jews, following the example of Simon de Montfort, Lord of Leicester. The countess of Winchester planned to offer the displaced Jews shelter on her estate and had appealed to Grosseteste for guidance. See L. M. Friedman, *Robert Grosseteste and the Jews*, pp. 12–18; also Southern, *Robert Grosseteste*, pp. 244–9.

80. Richardson, *English Jewry*, pp. 187–92.

81. Powicke, *Henry III*, pp. 516–17.

82. Baron, *Social and Religious History*, p. 101.

83. These aspects are dealt with only briefly by other twelfth-century commentators in the interpretation of Rev. 16:2 (First Vial). Bruno of Segni, *Expositio in Apocalypsim* V.16 (PL 165: 691–2), for example, says that the images of Simon Magus, Arius, and other "sons of the devil" were worshiped by the Jews who still awaited their Messiah, and, quoting Romans 7:11, the apostles therefore preached to the Jews and others who were seduced into error.

84. *PL* 196: 823–4:

> Primus itaque angelus phialam suam effudit, quando primus praedicatorum ordo Judeae destructionem suam ob culpam perfidae venturam praedixit. Et quia post ipsam primitivam praedicationem in Judaea factam statim ejus reprobatio destructio atque dispersio facta est . . . et in eos qui adoraverunt imaginem [bestiae], id est Judaeos, qui Antichristo configurantur. . . . Primus ergo angelus, ordo praedicatorum primitivus; effusio phiala, comminatio ultionis divinae; terra, Judeae; vulnus saevum ac pessimum, reprobatio ad desolatio Judaeorum.

85. Written in England in 1210 or 1211, Guillaume's Bestiary provides moral lessons for thirty-seven animals and birds. The Anglo-Norman text has been edited by Reinsch and translated by Druce. Fr. 14969 is one of two among the twenty English and French copies of this text that contain illustrations for the moralizing texts. In style and technique, the illustrations are closely related to those in Lambeth 209. See Muratova, "Les miniatures," pp. 141–8; S. Lewis, "*Tractatus adversus Judaeos*," pp. 549–60.

86. Peter of Blois, *Contra perfidiam Judaeorum* XXIV (*PL* 207: 851–3), sees the destruction of Jerusalem and the subsequent sufferings of the Jews as a punishment for their rejection of Christ, citing Eusebius, *History of the Church* 2.6.

87. *Pictor in carmine* CXXXII ("Titus et Vespasianus obsessem Jerusalem depopulantur"); James, "Pictor in carmine," pp. 147, 165.

88. Peter of Blois, *Contra perfidiam Judaeorum* XXXII (*PL* 207: 865).

89. MS Bodl. 482, fol. 1ᵈ, quoted by Smalley, *Study of the Bible*, pp. 170–1; see Morey, *Bartholomew of Exeter*, pp. 109, 164.

90. *PL* 17: 905.

91. Ibid.: 914.

92. Ibid.: 913.

93. Ibid.: 920–1, 923, 990–1.

94. Ibid.: 920–1.

95. Ibid.: 920.

96. See S. Lewis, "*Tractatus adversus Judaeos*," pp. 543–66.

97. *PL* 17: 923.

98. Ibid.: 924.

99. For this illustration, the designer of the Gulbenkian Apocalypse drew upon the additional text given in the Abingdon manuscript, which expands the idea into an elaborate paratactic juxtaposition of the conversion of Rome and the Roman destruction of Jerusalem. See S. Lewis, "*Tractatus adversus Judaeos*," pp. 561–2, 565–6. In the Cambridge Alexander Apocalypse (University Library MS Mm.5.31, fols. 25v–26), the Third Horseman for 6:5 is represented by the Emperor Titus on a black horse. He holds a scale that extends over the width of two folios, from which are suspended six containers, each holding five Jews' heads, on the left, and one container holding a single coin marked with a cross on the right, inscribed "Titus qui habuit staterem hanc tres bilibros, id est triginta iudeos vendidet uno denario." The commentary on 6:6 (Alexander Minorita, *Expositio in Apocalypsim*, pp. 96–7) reads: "Per istam stateram in novo Testamento designata era tribulatio Judaeorum a rege Romanorum."

100. See S. Lewis, "*Tractatus adversus Judaeos*," p. 562, n. 109.

101. Augustine, *Enarratio in Psalmum LII* (*PL* 36: 614): "Dixerunt qui eum crucifixerunt: 'Non est Deus' . . . hoc ipsum dicunt ipsi Judaei." Cassiodorus, *Expositio in Psalmum XIII* (*PL* 70: 104): "Videns populus Judaeorum Christum humiliter in assumpta carne venisse, insipienter dixit: 'Non est Deus' "; Remigius of Auxerre, *Enarratio in Psalmum XIII and LII* (*PL* 131: 208, 407); Peter Lombard, *Commentarium in Psalmum LII* (*PL* 191: 501): "Ille dicit: Non est Deus. Vel insipiens, id est Judaeos, dixit in corde suo, id est studio deliberatae malitiae: Hic homo non est Deus."

102. Millar, *Thirteenth-Century York Psalter*, pl. VI. In the *Bible moralisée*, Paris lat. 11560, fol. 5v, the moralizing text for Psalm 13:1 reads: "In psalmo isto Dominus Deus in persona sua ut in persona Iesu Christi loquens vituperat insipientiam et duriciam Ju-

daeorum qui negabant cotidie Christum et desiderabant eum et non credebant," and is accompanied by an illustration of Christ preaching to Jews in pointed hats, who argue with him and depart with a scroll representing the Old Law. See Laborde, *La Bible moralisée*, III, pl. 229.

103. The royal gesture is reminiscent of the sentiment attributed to Louis IX by Joinville, *Life of St. Louis*, p. 175, where the king is reported to have said, "No one, unless he is an expert theologian, should venture to argue with [the Jews]. But a layman, whenever he hears the Christian religion abused, should not attempt to defend its tenets, except with his sword, and he should thrust it into the scoundrel's belly as far as it will enter."

104. *PL* 17: 990–1.

105. See Synan, *The Popes and the Jews*, pp. 119–20; Cohen, *Friars and the Jews*, pp. 13, 82–3, 97; Chazan, *Daggers of Faith*. Throughout the commentary illustrations in the Gulbenkian Apocalypse, Franciscan friars appear frequently in the role of preachers and missionaries.

106. Browe, *Die Judenmission im Mittelalter*, p. 173.

107. Augustine, *Tractatus adversus Judaeos* X.15 (*PL* 42: 64).

108. *PL* 17: 988.

109. Paris, *Chronica majora*, III, p. 226; id., *Historia Anglorum*, II, p. 326. In both cases, Matthew added a sketch of the building in the margin: Cambridge, Corpus Christi MS 16, fol. 86; B.L. MS Roy. 14.C.VII, fol. 121. See Martin, "*Domus conversorum*," pp. 15–24. Built "in the New Street by the Temple," on the present site of the Public Record Office in Chancery Lane, the foundation was probably suggested to the king by his clerical advisers; the order was countersigned by Peter des Roches, Bishop of Winchester, and William Mauclerc, Bishop of Carlisle. On the social realities of Jewish conversion, see Stacey, "Conversion of the Jews," pp. 263–83.

110. *Contra Judaeos* survives in Bodleian MS Bodl. 91, fol. 140, and has been edited by A. G. Little, "Friar Henry," pp. 153–4.

111. A. G. Little, "Friar Henry," p. 150.

112. McGinn, *Visions of the End*, p. 149, who points to a new element in anti-Muslim apocalyptic in the growing number of revelations ascribed to Islamic rather than Christian sources.

113. Vauchez, *Laity in the Middle Ages*, pp. 48–50.

114. Southern, *Making of the Middle Ages*, p. 56; Keen, *Pelican History of Medieval Europe*, p. 186.

115. See Runciman, "Decline of the Crusading Idea," pp. 637–43.

116. Throop, *Criticism of the Crusade*, pp. 87, 161; Runciman, "Decline of the Crusading Idea," p. 647.

117. Paris, *Chronica majora*, IV, p. 9; V, p. 196.

118. Giffard, *Register*.

119. Daniel, "Apocalyptic Conversion," pp. 127–54.

120. *PL* 17: 1013: "Iste angelus praedicatores qui in fine mundi futuri sunt, significat . . . per solem vero Christum intelligere debemus. Angelus igitur in sole stetit; quia praedicatores sancti in Christo ita solidabuntur, ut ab ejus fide nulla vi persecutionum avelli possint." The king and other laymen respond to the gloss on 19:18, which interprets those who gather together at the great feast as "princes of the earth and the people who are subject to them."

121. Congar, "L'Eglise et cité de Dieu," pp. 193–201; Leclercq, *Love of Learning*, pp. 66–71; Bredero, "Jerusalem dans l'Occident médiéval," pp. 259–72. On the mystical conception of the monastery itself as a representation of the heavenly Jerusalem, see Konrad, "Das himmlische und das irdische Jerusalem," pp. 533–4.

122. Peter the Venerable, *Letters*, I, p. 152; see also Bernard of Clairvaux, *Opera*, VIII, p. 437.

123. *Opus tripartitum*, in *Fasciculus rerum expetendarum et fugiendarum*, II (London, 1690), pp. 185–206, cited by Siberry, *Criticism of Crusading*, p. 15.

124. Siberry, *Criticism of Crusading*, p. 85.

125. Niger, *De re militari*, p. 335.

126. Siberry, *Criticism of Crusading*, pp. 134–42, 145–9.

127. Because Gerard of Borgo San Donnino possessed a copy in 1248, *Super Hieremiam prophetam* must have been written before that date, but how much earlier is uncertain. Until the mid-nineteenth century, it was accepted as an authentic work by Joachim of Fiore. Marjorie Reeves has challenged older scholars who thought the work orginated in Franciscan circles, arguing that it was produced by Joachim's disciples in his own Cistercian order in South Italy; see Reeves, *Influence of Prophecy*, pp. 150–1, 518–19; id., "Abbot Joachim's Disciples," pp. 355–71. However, Simoni, "Il *Super Hieremiam*," pp. 13–46, has argued for a Franciscan origin; cf. also Töpfer, *Das kommende Reich*, pp. 108–15.

128. *Super Hieremiam prophetam* (Cologne, 1577), 11, pp. 151–2; 20, pp. 284–5; Throop, *Criticism of the Crusade*, p. 174; Daniel, "Apocalyptic Conversion," pp. 140–1.

129. See Daniel, "Apocalyptic Conversion," p. 140; *Super Hieremiam*, praefatio, p. 4; 31–2, pp. 361–3.

130. William of Tripoli, *De statu Saracenorum*, pp. 573–98.

131. See Runciman, "Decline of the Crusading Idea," p. 642; Throop, *Criticism of the Crusade*, p. 127.

132. Conversion of nonbelievers had been a cherished goal of St. Francis, who began the work of evangelization and established a Franciscan mission in the Holy Land, where the Dominicans also soon became active. See Throop, *Criticism of the Crusade*, pp. 127–8.

133. Adam Marsh, *Epistolae*, I, p. 416.

134. See Haussherr, "Zur Darstellung zeitgenössischer Wirklichkeit," pp. 213–14.

135. Bacon, *Opus maius,* III, pp. 120–2:

> The Greeks and . . . many other schismatics also persist in their error because the truth is not preached to them in their own language, and the Saracens too, to say nothing of the pagans, Tartars and other unbelievers throughout the world. Nor is war effective against them, since the Church is sometimes defeated in its Crusades, as often happens overseas, and especially in the last expedition of the king of France, as everyone knows. Elsewhere, if Christians are victorious, no one stays behind to defend the conquests. Nor are unbelievers converted in this way, but killed and sent to hell. Because of this violence, those who survive the wars together with their children are more and more embittered against the Christian faith because of this violence and are alienated indefinitely from Christianity and stirred up to do all harm possible to Christians. Thus the Saracens and pagans in many parts of the world are becoming impossible to convert, especially those across the sea.

See also id., *Compendium studii*, p. 402.

136. See Tyerman, *England and the Crusades*, pp. 89–94; id., "Some English Evidence," pp. 168–74; Lloyd, *English Society and the Crusade*, pp. 12–13.

137. The role of Eleanor of Castile in the Trinity Apocalypse will be fully explored in *Picturing Visions*.

138. Cambridge, Trinity College MS R.16.2, fol. 14v; see Otaka and Fukui, *Apocalypse anglo-normande*.

139. *PL* 17: 992: Per reges multitudinem gentium, quae ad fidem Christi confluxit, possumus intelligere. . . . Sed quomodo ab ortu solis venisse dicuntur, id est, a Christo, qui per solem designatur."

140. See Forey, "Crusading Vows," pp. 229–41.

141. *Calendar of Charter Rolls 1226–1257*, p. 135. On the king's vacillating crusading commitments, see Forey, "Crusading Vows," pp. 229–41.

142. Rutebeuf, *Onze poemes*, pp. 86–94; id., *Gedichte*, p. 40.

143. Heer, *Medieval World*, p. 143; Thomas Aquinas is often credited with writing this service, especially the hymns *Laude Sion* and *Pange lingua*.

144. See Belting, "Die Reaktion der Kunst," pp. 35–53.

145. J. W. Legge, *Sarum Missal*, p. 202.

146. Durandus, *Symbolism of Churches*, p. 13.

147. Augustine, *Enarratione in Psalmos* CXXXVI.22.

148. Aelred of Rievaulx, *Collations* 14.8; Guibert of Nogent, *Moralia in Genesin*, prologue (*PL* 156: 26); see

Morris, *Discovery of the Individual*, pp. 148-9; id., "Individualism and Twelfth-Century Religion," p. 204.

149. Peter Abelard, *O quanta qualia*, quoted by Morris, *Discovery of the Individual*, p. 152.

150. Durandus, *Symbolism of Churches*, pp. 12–13, 15.

151. See S. Lewis, *Art of Matthew Paris*, pp. 355–6 and fig. 215.

152. McGinn, *Visions of the End*, p. 36.

153. Southern, "Aspects of the European Tradition," p. 173.

154. The Corpus-Lambeth archetype also has a separate text segment beginning with this text, but it is not illustrated.

155. Delisle and Meyer, *L'Apocalypse en français*, p. 128.

156. *PL* 17: 845: "If time is viewed from the Advent of Christ to the end of the world, it seems long, but, if seen in comparison with earlier periods, it is short."

157. Ibid., 1056: "Id est, tempus quod post resurrectionem futurum est, in quo omnes sancti cum Christo sine fine regnabunt."

158. Delisle and Meyer, *L'Apocalypse en français*, pp. 130–1.

159. See S. Lewis, *Art of Matthew Paris*, pp. 102–4 and fig. 56.

160. Paris, *Chronica majora*, I, p. 81, n. 1; also in the *Liber additamentorum* (in *Chronica majora*, VI, p. 80). This short prophetic verse turns up in several contemporary English manuscripts, but the crisis date usually given is 1260. Bloomfield and Reeves, "Penetration of Joachism," pp. 787–8, list the following examples: on the end flyleaf of a Gilbertine Bible, Cambridge, St. John's College MS N.1, where it is ascribed to Joachim; at the end of another Bible, MS Harley 1280, fol. 427; MS Roy. 10.B.XII, fol. 43, from Bury St. Edmunds; Oxford, Oriel College MS 76, fol. 147; Lambeth MS 477, fol. 26; Exeter Cathedral Library MS 3514, fol. 6. Another codex from Bury St. Edmunds (MS Roy. 8.C.IV, fol. 66) contains a similar, equally well-known short prophecy entitled "Prophecie Joachim."

161. Paris, *Chronica majora*, V, p. 197; see S. Lewis, *Art of Matthew Paris*, pp. 104–6.

162. "Forte nos sumus, ad quos devenerunt seculorum finis," quoted by Schaller, "Endzeit-Erwartung," p. 928; also in February 1249, the emperor wrote: "His diebus novissimis, quibus mundum ex his, que accidunt, fore non ambigimus in extremis, rerum ordo vertitur"; Huillard-Bréholles, *Historia Diplomatica*, VI, pt. 2, p. 705. In 1233, Gregory IX wrote to John of Vicenza: "Cum simus [nos], in quos fines seculorum secundum apostorum [Paulus] devenerunt"; Huillard-Bréholles, *Historia Diplomatica*, IV, pt. 1, p. 446.

163. See McGinn, *Visions of the End*, pp. 170–1.

164. Ibid., pp. 168ff.

165. Thomas Aquinas, *Summa Theologiae*, quoted by Schaller, "Endzeit-Erwartung," p. 929; see Benz, "Joachism Studien," III, pp. 52–116; Seckler, *Das Heil in der Geschichte*, pp. 223ff. Roger Bacon, in an introductory summary of the *Opus maius*, written in 1266–7, as quoted by Southern, "Aspects of the European Tradition," pp. 172–3: "If only the Church would examine the prophecies of the Bible, the sayings of the saints, the sentences of the sibyl and other pagan prophets . . . it would without doubt be able to provide usefully against the coming of Antichrist." Dante, *Convivio*, I, p. 222: "Noi siamo gia nel'ultima estade del secolo."

166. Frederick received the imperial golden eagle from Philippe Auguste in 1214 after his defeated rival Otto IV of Brunswick had left it lying on the battlefield at Bouvines; see S. Lewis, *Art of Matthew Paris*, p. 256.

167. McGinn, *Visions of the End*, pp. 168–72. The best general study of this literature is Graefe, *Die Publizistik in der letzten Epoche Kaiser Friedrichs II*; also Schaller, "Endzeit-Erwartung," pp. 924–47.

168. McGinn, *Visions of the End*, pp. 173–4, translated from Huillard-Bréholles, *Historia Diplomatici*, V/1, p. 327.

169. Holder-Egger, "Italienische Prophetien des 13. Jahrhunderts," pp 165–8; see Reeves, *Influence of Prophecy*, pp. 311–12; Töpfer, *Das kommende Reich*, pp. 169–70, 172–3; Lerner, "Medieval Prophecy and Religious Dissent," pp. 15–16, nn. 38 and 53.

170. Southern, "Aspects of the European Tradition," pp. 172–6.

171. Reeves, *Influence of Prophecy*, pp. 6–10.

172. Ibid., p. 12.

173. Ibid., pp. 42–3; also Southern, "Some New Letters of Peter of Blois," p. 414.

174. Reeves, *Influence of Prophecy*, p. 46.

175. For reactions of contemporary theologians to Joachim's prophecies, see McGinn, "Abbot and the Doctors," pp. 31–47; id., *Calabrian Abbot*, pp. 207–34.

176. See Freyhan, "Joachism," pp. 219–25.

177. *PL* 17: 977–8: "Nam sicut superius cum mala Antichristi narrare vellet, ab adventu Christi inchoavit, persecutionesque quas Ecclesia a diabolo passa est. . . . Iste quippe angelus Christum et apostolos ejus, caeterosque Christi praedicatores significat."

178. Morgan, *Lambeth Apocalypse*, p. 34, has suggested that the scandal may have motivated a modification of the commentary text for 14:6–7 in the Lambeth, Gulbenkian, and Abingdon Apocalypses, where a long passage explicating the Eternal Gospel is deleted, concluding that after the condemnation of Gerardo of Borgo San Donnino in 1257, the commentary was

edited to avoid a sensitive issue. However, in a number of other Apocalypse manuscripts dating from 1260s, such as Getty and Paris lat. 10474, the Berengaudus explication of the Eternal Gospel is retained, tending to isolate the deletion strategy to a single text rescension copied from Lambeth to Gulbenkian.

179. See sup., pp. 184–6.
180. See Lerner, "Refreshment of the Saints," pp. 124–5.
181. Augustine, *City of God* 20.7.
182. See Lerner, "Refreshment of the Saints," pp. 109–15.
183. *PL* 17: 1017: "Tempus itaque a passione Christi usque ad finem mundi resurrectio prima vocatur."
184. Freyhan, "Joachism," p. 229, nn. 1–2; Walberg, *Deux versions inédites,* p. 18.
185. *Histoire littéraire de la France,* XXXIII, p. 339.
186. *PL* 209: 359–61.
187. Grosseteste, *Memorandum* 25–6, pp. 361–2.
188. Southern, *Robert Grosseteste,* pp. 281–4.
189. Grosseteste, *Epistolae,* pp. 434–5. In a further letter of 1253, Grosseteste asks whether the pope who persists in the destruction of souls whom Christ had come to save could not properly be called Antichrist himself; see Matthew Paris, *Chronica majora,* V, p. 402.
190. Quoted by Southern, "Aspects of the European Tradition," pp. 172–3.
191. See Freyhan, "Joachism," p. 230.
192. See sup., pp. 108–16.
193. *PL* 17: 952–3.
194. Ibid.: 951: "Testes duos Dominus Eliam et Enoch vocat, qui adventum ejus secundum praecurrent, sicut Joannes praecurrit primum."
195. Ibid.: 965: "Haec bestia Antichristum significat . . . septem vero capita septem vitia principalia designant . . . in enumeratione vitiorum Prudentium sequi." See sup., pp. 132–3.
196. *PL* 17: 967: "Deus dabit Antichristo potestatem, sed ipsam potestatem in tantum permutabit in malum, ut tota diabolica esse credatur et sit." See sup., pp. 133–6.
197. See sup., pp. 136–7.
198. *PL* 17: 968: "Faciet bellum cum sanctis, quosdam blandiendo, quosdam terrendo, et ad ultimum eis pessima tormenta inferendo, ut eos in errores suos inducat: sed fieri non potest, ut in errorem inducantur electi. Vincet autem illos non superando, sed interficiendo."
199. See Cutler, "Innocent III," pp. 92–116; and Cohen, *Friars and the Jews,* p. 247.
200. *PL* 17: 967.
201. For example, fols. 34, 35, 35v, 36, 36v, 37v, 38v, 39v, and 40v; see also Emmerson, *Antichrist,* pp. 134–5.

202. Cited by Cohen, *Friars and the Jews,* p. 247.
203. Paris, *Chronica majora,* VI, p. 80. At the end of a letter to Gerald of Bordeaux, MS Cotton Nero D.I, fols. 85v–86v; see S. Lewis, *Art of Matthew Paris,* pp. 103–4. Bloomfield and Reeves, "Penetration of Joachism," p. 787; Schaller, "Endzeit-Erwartung," p. 937.
204. *PL* 17: 1018. A Jewish characterization of Gog and Magog is emphatically stressed in the caricatured figures that appear in both the Lisbon and Abingdon illustrations.
205. See Trachtenberg, *Devil and the Jews,* p. 39; Anderson, *Alexander's Gate,* pp. 70–3, 81; Cary, *Medieval Alexander,* p. 130.
206. Paris, *Chronica majora,* IV, p. 77: "Creduntur isti Tartari, quorum memoria est detestabilis, fuisse de decem tribubus, qui abierunt, relicta lege Mosaica, post vitulos aureos; quas etiam Alexander Macedo primo conatus est includere in praeruptis montibus Caspiorum molaribus bituminatis."
207. Ibid., p. 131. On his map of the Crusader Kingdom, which appears on fol. iii verso in MS 26, Matthew inscribed the "Caspian Mountains" with the following legend: "Here dwell the Jews whom God locked up at the request of King Alexander [and] who will go forth on the eve of the day of judgment and will massacre all manner of peoples." In the *Historia Anglorum* legend, these destructive peoples are called Gog and Magog; see S. Lewis, *Art of Matthew Paris,* p. 349 and figs. 214 and 217.
208. Saunders, "Matthew Paris and the Mongols," p. 117; see S. Lewis, *Art of Matthew Paris,* pp. 284–9.
209. Four documents are quoted in Paris, *Chronica majora,* IV, pp. 131–3; seven more firsthand accounts are reproduced in the *Liber additamentorum* (in ibid., VI, pp. 75–84).
210. Paris, *Chronica majora,* V, p. 655; see Saunders, "Matthew Paris and the Mongols," pp. 130–1.
211. Bigalli, *I Tartari e l'Apocalisse,* pp. 26, 28.
212. Paris, *Chronica majora,* pp. 112–13. Hilpert, *Kaiser- und Papstbriefe,* pp. 153–4, points out that this document is not preserved elsewhere and was very probably interpolated by Matthew Paris, who used fragments of the alleged letter of Frederick I to Saladin, which had been inserted into many English chronicles, to embellish his text.
213. Paris, *Chronica majora,* pp. 270–7. Hilpert, *Kaiser- und Papstbriefe,* pp. 160–4, has demonstrated that the most sadistic and offensive passages in Ivo's letter were fabricated by Matthew Paris. Cambridge, Corpus Christi College MS 16, fol. 166; see S. Lewis, *Art of Matthew Paris,* fig. 180.
214. *Annales de Waverleia,* in *Annales Monastici,* II, p. 324: "Quaesivi ubi esset terra illorum; dixerunt quod

erat ultra quosdam montes, et juxta populum qui vocatur Gog; et eo credo quod ille populus est Gog et Magog." See Bezzola, *Die Mongolen*, pp. 54–5; Anderson, *Alexander's Gate*, pp. 14, 49, 52, 74, 77.

215. Bezzola, *Die Mongolen*, pp. 105–8.

216. Paris, *Chronica majora*, ed. Luard, III, p. 449.

217. Anderson, *Alexander's Gate*, p. 46, quotes Pseudo-Methodius: "Comedebant enim hic omnes cantharo speciem omnem coinquinabilem vel spurcebilem, id est canes, mures, serpentes, morticinorum carnes, aborticia informabilia corpora, et ea que in alvo necdum per leniamenta coaculata sunt vel ex aliqua parte membrorum producta conpago formam figmenti possit perficere vultum vel figuram expremere et haec iumentorum necnon etiam et omne speciem ferarum inmundarum. Mortuos autem nequaquam sepeliunt, sed sepe comedent eos."

218. Cambridge, Corpus Christi College MS 16, fol. 170v; see S. Lewis, *Art of Matthew Paris*, fig. 182.

219. Paris, *Chronica majora*, IV, pp. 345–6.

CHAPTER 5

1. On the practice of *lectio divina*, which involved both reading and meditation *(meditari aut legere)*, see Leclercq, *Love of Learning*, pp. 16, 89–90.

2. *Ancrene Riwle*, ed. Morton, IV, p. 287. On the devotional program, see Ackerman, "Liturgical Day in Ancrene Riwle," pp. 734–44.

3. Hugh of St. Victor, *Didascalicon* III.7–10, pp. 92–3. This passage is discussed by Carruthers, *Book of Memory*, p. 162.

4. On the demise of *lectio divina*, see Illich, *Vineyard of the Text*, pp. 64–5; Sieben, "De la lectio divina à la lecture spirituelle," cols. 487–9.

5. As Smalley, *Study of the Bible*, p. 283, remarked, St. Francis took an extreme position in not wishing his friars to have the private use of books; see "Intentio Regulae," *Documenta Antiqua Franciscana*, p. 93. Jordan of Saxony advised a Dominican nun to read only the book "which is ever in your mind's eye," not the Bible, but the crucifix, "where you look upon Jesus our Saviour stretched out on the cross as a parchment, written in purple, illuminated with his holy blood."

6. See Smalley, *Study of the Bible*, pp. 293, 308.

7. See Callus, "Introduction of Aristotelian Learning," pp. 229–81; A. G. Little, "Franciscan School at Oxford," pp. 803–74; Camille, "Illustrations in Harley MS 3487," pp. 31–44.

8. See McEvoy, *Philosophy of Robert Grosseteste*, pp. 329–30.

9. As pointed out by Freyhan, "Joachism," p. 234, who quotes the *Summa Theologiae* I.I, quaestio 1, 9:

> Ad primum ergo dicendum, quod poetica utitur metaphoris propter repraesentationem; representatio enim naturaliter homini delectabilis est. Sed sacra doctrina utitur metaphoris propter necessitatem et utilitatem. . . . Ad secundum dicendum, quod radius divinae revelationis non destruitur propter figuras sensibiles quibus circumvelatur, ut dicit Dionysius, sed remanet in sua veritate; ut mentes, quibus fit revelatio, non permittat in similitudines permanere, sed elevet eas ad cognitionem intelligibilium.

Also *Summa* II.II.173.3:

> Utrum visio prophetica semper fiat cum abstractione a sensibus.
>
> Conclusio. Ea visio prophetica, quamens prophetae illustratur lumine intelligibile, aut speciebus intelligibilibus formatur, non fit cum abstractione a sensibus, sed eademque quae, rapiente divina virtute, in somno vel contemplatione rerum divinarum per imaginarias formas efficitur.

See also Eco, *Aesthetics of Thomas Aquinas*, pp. 163–89.

10. Smalley, *Study of the Bible*, pp. 243–6.

11. Richard, a Scot who became prior of the Benedictine abbey of St. Victor in Paris, maintained contact with England through his letters and writings to the end of his career. A St. Albans copy of *Benjamin minor* dating from the last decade of the twelfth century is preserved in Oxford, Bodleian MS Laud. Misc. 409; see Morgan, *Early Gothic Manuscripts*, I, pp. 51–2, no. 4. An inscription on fol. 1 records that the book was given to St. Albans by Abbot William of Trumpington (1214–35). A twelfth-century copy of *Benjamin minor* in Cambridge, Corpus Christi MS 309, is inscribed: "Incipit lib. ricardi anglici superioris S. Victoris parisius de patriarchis."

12. Nolan, *Gothic Visionary Perspective*, p. 21; Tavard, "Apostolic Life and Church Reform," pp. 2–3, 12.

13. *PL* 196: 687.

14. Nolan, *Gothic Visionary Perspective*, p. 30.

15. *Adnotationes mysticae in Psalmos CXIII* (*PL* 196: 337); Richard of St. Victor, *Selected Writings on Contemplation*, p. 242.

16. *PL* 196: 686.

17. See sup., pp. 194–6.

18. See inf., pp. 293–4. On the image of the Veronica in thirteenth-century England, see S. Lewis, *Art of Matthew Paris*, pp. 126–30; id., "*Tractatus adversus Judaeos*," pp. 565–6; F. Lewis, "Veronica Image," pp. 100–6.

19. The accompanying text of Matthew Paris reads:

> Li roi s'en part de ceste vie:

Des angeles grant cumpainie . . .
Seint Pere, sis chers amis,
La porte ovre de Parais.
Seint Johan si druz demeine,
Devant la Maïsté le meine,
De ki en terre out memoire;
E Deu lui dune mut grant gloire;
Sun regne li grante e dune,
E meudre k'avant out curune.

See Luard, *Lives of Edward the Confessor*, pp. 18–19.

20. Hamburger, "Visual and the Visionary," p. 181.
21. Mussafia, "Über die von Gautier de Coincy bentüzen Quellen," pp. 24–5. On the other images based on the miracles of the Virgin in the epilogue illustrations of Lambeth 209, see inf., pp. 293–4. An interesting pictorial analogy to the Lambeth image can be cited in a later thirteenth-century northern French manuscript of Gautier de Coincy's *La vie et les miracles de notre dame* in St. Petersburg (Public Library MS Fr. F.v.XIV,9, fol. 40) in which the monastic author is writing his book before a statue of the Virgin and Child placed on an altar; see Mokretsova and Romanova, *Les manuscrits enluminés français 1270–1300*, p. 107.
22. Heslop, "Romanesque Seal of Worcester Cathedral," pp. 75–6, proposes that, as it appears on the first known seal of Worcester Cathedral Priory before 1178, the image of the Virgin holding the apple perhaps derives from an English manuscript illustration of the metaphor *fructus ventris tui* in Anselm's prayer to the Virgin, as in Admont MS 289, fol. 21; see Pächt, "Illustrations," p. 83 and fig. 23a.
23. As pointed out by Ringbom, "Devotional Images," p. 163. However, as Freedberg, *Power of Images*, p. 30, conjectures, it was not the Virgin abstractly, or purposefully returning to earth to do a specific miracle; it was the Virgin "in the image." As Egbert, *Medieval Artist at Work*, p. 60, points out, painters specializing in the application of polychromy and gilding to statues were highly regarded and sometimes paid more than the sculptors.
24. The representation also has some reference to the reality of contemporary workshop practice. As Freedberg, *Power of Images*, p. 84, observes, it is significant that many consecration rites involve the last stages of completing an image, that is, painting the drapery and flesh colors of a statue, thus "bringing it to life."
25. Gregory the Great, *Liber regulae pastoralis* X (*PL* 77: 45): "Bene autem dicitur, depicta erant; quiadum exteriorem rerum intrinsecus species attrahuntur, quasi in corde depingitur, quidquid fictis imaginibus deliberando, cogitatur."

26. Aelred of Rievaulx, *Tractatus de Jesu puero duodenni*, in Bernard of Clairvaux, *Oeuvres complètes*, VI, p. 369, quoted by Ringbom, "Devotional Images," p. 169, n. 40: "Sentio . . . quam familiariter . . . in orationibus tuis sanctis ab ipso Jesu soleas sciscitari, cum ante oculos tui illa dulcis pueri versatur imago: cum illum speciosissimum vultum spirituali quadam imaginatione depingis."
27. Nolan, *Gothic Visionary Perspective*, p. 55.
28. Ibid., pp. 68–9.
29. Cambridge, Trinity College Ms R.16.2, fol. 27v: "E nus doint les armes des vertues, par lesqueus nus, garni od lu, dustre e baneur, seums defenduz des enemis foreins e de ceus dedeins, ke nus deservuns estre parceneres de lavie pardurable."
30. On Genesis 3:19, quoted by Smalley, *Study of the Bible*, p. 249, from Oxford, Lincoln College MS 15, fol. 109v: "Per hoc innuit quod verbum Dei debet converti in opus ut quandoque operemur secundum quod audivimus et legimus."
31. Vauchez, *Laity in the Middle Ages*, p. xviii.
32. Jacques de Vitry, *Liber duo quorum prior orientalis . . . alter occidentalis historiae* (Douai, 1597, p. 357, quoted and trans. by Chenu, *Nature, Man and Society*, pp. 221–2).
33. Quoted by Georgianna, *Solitary Self*, pp. 20–1.
34. See Illich, *Vineyard of the Text*, pp. 21, 23.
35. See Morgan, *Early Gothic Manuscripts*, II, p. 104.
36. As I shall argue in detail in *Picturing Visions*.
37. See S. Lewis, "Giles de Bridport," pp. 107–9.
38. See Morgan, *Early Gothic Manuscripts*, II, pp. 53, 121.
39. Morgan, *Early Gothic Manuscripts*, II, p. 194.
40. Documented lay readers are almost exclusively female, whereas the clerical owners are men. Ecclesiastical patrons continue to appear early in the fourteenth century, with John London, monk of Crowland Abbey, as owner of Cambridge, Magdalene MS 5, and other probable monastic owners for Canonici Bibl. lat. 62 and the Dublin Apocalypse indicated by the inclusion of the Bernardine Meditations; see Sandler, *Gothic Manuscripts*, II, pp. 53, 101–2. An "Apocalypsis depictus" is listed among the books left to St. Paul's Cathedral in the last testament of Ralph de Baldock, Bishop of London and Chancellor of England, in 1313; see Cavanaugh, "Study of Books Privately Owned," p. 65. In the same year, a lavishly illustrated Apocalypse was made in Paris for Isabella of France, queen of Edward II, and a few years later a less ambitious manuscript was produced in England for Lady Johanna de Bohun; see S. Lewis, "Apocalypse of Isabella of France," pp. 252–4. Also dating from the early fourteenth century is an elegant Apocalypse belonging to a member of the Welles fam-

ily; on MS Roy. 15.D.II, see Sandler, *Gothic Manuscripts*, II, p. 39. The last testament of Jeanne de Leybourne (d. 1367), Countess of Huntingdon, bequeathed an illustrated French metrical Apocalypse first owned by Henry de Cobham to St. Augustine's Abbey, Canterbury; see Sandler, *Gothic Manuscripts*, II, p. 113.

41. On the Savoy Apocalypse in the Escorial, and Morgan MSS M. 68 (Charles the Bold), 133 (Duc de Berry), and 484 (Margaret of York), see Emmerson and Lewis, "Census," II, pp. 380, 395–6, nos. 57, 87–9; see also S. Lewis, "Apocalypse of Margaret of York," pp. 77–88.

42. Klein, *Endzeiterwartung*, p. 177.

43. Camille, "Seeing and Reading," p. 39.

44. See Illich, *Vineyard of the Text*, pp. 85–6; Grundmann, "Literatus-illiteratus," pp. 1–65.

45. Fourteenth-century inscriptions on fols. 30v and 185 in Leiden, Bibliotheek der Rijksuniversiteit MS lat. 76A, record that Louis IX learned to read from this Psalter in his childhood; see Morgan, *Early Gothic Manuscripts*, I, pp. 60–2, no. 14.

46. See Parkes, "Literacy of the Laity," pp. 555–77.

47. See S. Lewis, "Giles de Bridport," pp. 115–66. Although clerics read the Bible in Latin, they often used vernacular glosses, which served as the most frequent form of religious moral instruction. From the twelfth century on, students in the schools annotated their biblical texts in the vernacular; see Leclercq, "Les traductions de la Bible," pp. 265, 273.

48. See Hamburger, "Visual and Visionary," p. 166.

49. Fleming, *Introduction to Franciscan Literature*, p. 179.

50. See Georgianna, *Solitary Self*, pp. 6–7.

51. Augustine, *Letters*, V, pp. 43–4.

52. See Dobson, *Origins of "Ancrene Wisse,"* who dates the English text in the first quarter of the thirteenth century rather than a century earlier; also Georgianna, *Solitary Self*, p. 3.

53. Georgianna, *Solitary Self*, p. 81; Rusconi, "De la prédication à la confession," pp. 67–85.

54. See S. Lewis, "English Gothic Illuminated Apocalypse," pp. 1–32.

55. On the relationship of Fr. 403 to the Morgan model, see S. Lewis, "Enigma of Fr. 403," pp. 31–42.

56. As pointed out by Camille, "Book of Signs," p. 138.

57. Barthes, *Elements of Semiology*, p. 64; Camille, "Book of Signs," p. 140.

58. See Coleman, *Ancient and Medieval Memories*, pp. 101–11.

59. Martianus Capella, *De nuptiis Philologiae et Mercurii*, pp. 268–70; see Yates, *Art of Memory*, pp. 51–5. On the Aristotelian and Ciceronian traditions, see McKeon, "Art of Invention," pp. 723–39.

60. Carruthers, *Book of Memory*, pp. 122–55. However, in contrast to Yates's terms "Ciceronian mnemonic" or "art of memory," Carruthers (p. 71) prefers to designate the system described in the *Rhetorica ad Herennium* III as the "architectural mnemonic."

61. On the Christian Neoplatonic assimilation of Aristotle's theory of intellect and its scholastic evolution culminating in the magisterial teaching of Thomas Aquinas, see Coleman, *Ancient and Medieval Memories*, pp. 327–460.

62. Yates, *Art of Memory*, p. 54; Leonardi, "I codici di Marziano Capella." Thirteenth-century English copies survive in Cambridge University Library MS Ii.6.6, fols. 47–88; Cambridge, St. John's College MS 100, from the Cistercian Swineshead Abbey (Lincs.); and Roy. 15.C.XI. On the medieval commentaries, see J. O. Ward, "From Antiquity to the Renaissance," pp. 25–67.

63. See Sorabji, *Aristotle on Memory*. Among thirteenth-century English commentaries on Aristotle's *De memoria* is that by Adam of Whitby in Paris, B.N. MS lat. 16149, fols. 51–62; see J. C. Russell, *Dictionary of Writers*, p. 10.

64. Thomas Aquinas, *In Aristotelis . . . de memoria et reminiscentia*, p. 91. On the Aristotelian aspects of the thirteenth-century idea of the art of memory, see Yates, *Art of Memory*, pp. 61, 70–1, 77, et passim; Carruthers, *Book of Memory*, pp. 122–3, 152–3; also Hajdu, *Das mnemotechnische Schrifttum*, pp. 61–5.

65. Yates, *Art of Memory*, p. 71.

66. Aquinas, *In Aristotelis . . . de memoria et reminiscentia*, p. 93.

67. Albertus Magnus, *De bono*, in *Opera omnia*, XXVIII, p. 249, quoted by Yates, *Art of Memory*, p. 67.

68. Werner, "Die Psychologie, Erkenntnis- und Wissenschaftslehre des Roger Bacons," p. 481; Hajdu, *Das mnemotechnische Schrifttum*, p. 69.

69. Yates, *Art of Memory*, pp. 88–90.

70. On an illustrated manuscript copied in 1282 at Acre, now in Chantilly, Musée Condé MS 590, see Folda, *Crusader Manuscript Illumination*, pp. 181–2 and pls. 24–5, 29, 31–2.

71. For example, the *Tractatus de arte memorativa* (Vienna Cod. 5393, fol. 328v), dating from ca. 1480–90, which begins:

> Iste imagines sunt posite pro exemplificatione / non quid sibi quisque debeat incorporare, quia valde erraret / sed unus studeat unam quamque applicare rem vivam et materiem, quam imago hic representat.

See Volkmann, "Ars memorativa," pp. 124–30, on Vienna Cod. 5393, fols. 328v–339v, which consists of

three pages of text and eleven full-page tinted drawings exemplfying various figures.

72. Yates, *Art of Memory*, pp. 79–84, 101–4.

73. *Li Bestiaires d'amours di Maistre Richart de Fornival*, pp. 4–5:

> Et pour chu Diex . . . a donne a homme une vertu de force d'ame ki anon memoire. Ceste memoire si a.ij. portes, veir et oir, et a cascune de ces .ij. portes si a un cemin par ou on i puet aler, che son painture et parole. Painture sert al'oel et parole al'oreille.

74. As pointed out by Kolve, *Chaucer and the Imagery of Narrative*, p. 381, no. 27, fig. 8. Richard's autograph manuscript was illustrated, as indicated by the author's declaration, "Je vous envoie en cest escrit et peinture et parole." See also Solterer, "Letter Writing and Picture Reading," pp. 131–47.

75. Protagonists' speeches, as well as the frequent inscriptions, captions, and legends that occur elsewhere throughout the Trinity Apocalypse evoke an earlier pattern of text-image equivalency in which both picture and script serve as conventional signs for the spoken word in a lingering oral tradition. See Clanchy, *From Memory to Written Record*, pp. 214–18; Camille, "Seeing and Reading," pp. 28, 31–3; S. Lewis, *Art of Matthew Paris*, p. 49.

76. As pointed out by Carruthers, *Book of Memory*, pp. 229–30.

77. See Wright, "Sound in Pictured Silence," pp. 253–60.

78. Cicero, *De oratore* II.87.37.

79. On the illustrations for Rev. 19:1–10, see sup., pp. 172–6.

80. As Carruthers, *Book of Memory*, p. 94, points out, all the rhetorical handbooks contain detailed advice on declamatory gesture and expression.

81. Trinity MS R.16.2, fol. 2v: ". . . kar lire e oïr ne valent seinz retenir." See Otaka and Fukui, *Apocalypse anglo-normande*, p. 183. The Berengaudus passage (*PL* 17: 845) reads: "For there are many who hear or read God's commands, but it will benefit them nothing if they are present in body but absent in mind."

82. Richard of St. Victor, *Benjamin minor*, pp. 74–5; Boncompagno of Signa, *Rhetorica novissima*, p. 281: "Celestia etiam et terrestria ad invicem transumi videntur, sicut per visiones intelligimus prophetarum, et in Apocalypsi Johannis plenius intuemur." I am indebted to Mary Wack for bringing the existence of this mystical tradition to my attention. In his *Rhetorica novissima* of 1235, Boncompagno uniquely reassigns to memory the contemplative function of the conversion to spiritual understanding. However, from Plato through Augustine to Honorius Augus-

todunensis, the memory of eternal things transcends the mutability and deception of the senses, making a direct connection to the divine, as a witness of the soul's immortality. Again, this insight comes from Mary Wack, who cites Augustine, *Confessions* 10.12, and Honorius Augustodunensis, *Clavis physicae*, p. 187: "Eternarum divinarumque rerum memoria."

83. Carruthers, *Book of Memory*, pp. 81, 264, quotes her translation of the preface to Hugh of St. Victor's *Chronica*, compiled ca. 1130, also called *De tribus maximus circumstantiis gestorum*: "Therefore it is a great value for fixing a memory-image that when we read books, we study to impress on our memory through our mental-image-forming power *[per imaginationem]* not only the number and order of verses or ideas, but at the same time the color, shape, position, and placement of the letters, where we have seen this or that written, in what part, in what location (at the top, the middle, or the bottom) we saw it positioned, in what color we observed the trace of the letter or the ornamental surface of the parchment. Indeed I consider nothing so useful for stimulating the memory as this." See also Illich, *Vineyard of the Text*, p. 106.

84. Howard, *Idea of the Canterbury Tales*, p. 147.

85. Albertus Magnus, *De bono*, pp. 247–8 and 251–2, quoted by Yates, *Art of Memory*, pp. 66–7.

86. Review of Otaka and Fukui, *Apocalypse anglo-normande*, p. 333.

87. See Bauckham, "*Figurae*," p. 109. In his commentary on Peter Lombard's *Sentences* (V.9.1.2), Thomas Aquinas noted that paintings in churches have three effects – to instruct, to improve our memory of the mystery of the incarnation and examples of the saints, and to excite devotion, which is stimulated more effectively by sight than by hearing. See Gilbert, "Statement of the Aesthetic Attitude," pp. 138–9.

88. Yates, *Art of Memory*, p. 76.

89. Augustine, *Confessions* 10.8, p. 210.

90. Joachim of Fiore, *Expositio in Apocalypsim* (Venice, 1527), fol. 141v: "in ventre memorie servaturus." Victorinus, *Commentarius in Apocalypsim*, *PLS* 1: 143: "Accipere libellum et comedere ostensione sibi facta memoriae est mandare." A succinct but characteristic thirteenth-century locution is given by Alexander Minorita, *Expositio in Apocalypsim*, p. 161: "Et devoravit eum, id est memoriae commendavi."

91. *PL* 17: 949: "Liber igitur dum devoraretur . . . quia divina Scriptura dum in mente revolvitur."

92. Hugh of St. Victor, *Didascalicon*, trans. Taylor, p. 94. This passage is further commented on by Carruthers, *Book of Memory*, pp. 165–7, who argues that medieval metaphors using digestive activities were so powerful and tenacious that "digestion"

should be considered another basic functional model for the complementary activities of reading and recollection, reminding us that the monastic custom of reading during meals is described in some texts as an explicit literalizing of the metaphor of consuming a book as one consumes food. For a further discussion of Hugh of St. Victor's contributions to mnemonic theory, see Zinn, "Hugh of Saint Victor and the Art of Memory," pp. 211–34; Illich, *Vineyard of the Text*, pp. 33–50.

93. Aquinas, *Summa Theologiae* II, quaestio XLIX, art. I, quoted by Yates, *Art of Memory*, p. 74; see also Kemp, "Visual Narratives," pp. 103–5.

94. Similarly, a diagram illustrating the wheels of memory in Peter of Poitiers' *Compendium historiae* is based on Hugh of St. Victor's enumeration of the septenaries (virtues, vices, gifts of the Holy spirit, etc.) in which memory is aided by enumerating, differentiating, and comparing them one by one. See J. B. Friedman, "Les images mnémotechniques," p. 182 and fig. 7; Hugh of St. Victor, *Six opuscules spirituels*, p. 100; Wach, "Hugh of St. Victor on the Virtues and Vices," pp. 25–33.

95. *PL* 17: 845–6.

96. Ibid.: 890.

97. *De nuptiis Philologiae et Mercurii*, p. 270, quoted by Yates, *Art of Memory*, p. 51.

98. Hugh of St. Victor, *Didascalicon* III.11, trans. Taylor, p. 94. See Carruthers, *Book of Memory*, pp. 79, 82–3, 96, 174; Illich, *Vineyard of the Text*, p. 105.

99. Martianus Capella, *Rhetorica ad Herennium* III.18.31. See Carruthers, *Book of Memory*, pp. 72ff., for further discussion.

100. Hugh of St. Victor, *Didascalicon* III.12, trans. Taylor, p. 94.

101. As M. D. Legge, *Anglo-Norman Literature*, pp. 237–8, points out, these versions were obviously not literary efforts at poetry, for the versifiers did no more than divide the prose text into lines of equal length rhyming in couplets. On the twelfth-century use of versification and précis, see Riché, "Le rôle de la mémoire," pp. 143, 148.

102. *Anglo-Norman Rhymed Apocalypse*, p. 3, lines 87–8: "Des ci orrez le significance od l'estoire / Bien eit ke les mettra en la memoire!"

103. *De nuptiis*, p. 270: "[When memorizing] the matter should not be read out in a loud voice, but meditated upon with a murmer." See Yates, *Art of Memory*, p. 51; and Carruthers, *Book of Memory*, pp. 170–3, 184.

104. *Summa Theologiae* II, II, quaestio XLIX, art. 1; see Yates, *Art of Memory*, p. 75.

105. See Yates, *Art of Memory*, p. 95.

106. See Camille, "'Him Whom You Have Ardently Desired'," pp. 137–60; see inf., pp. 296–309.

107. See Morgan, *Early Gothic Manuscripts*, II, pp. 119–22, no. 137; Henry, *Eton Roundels;* see inf., pp. 309–36.

108. See Morgan, *Early Gothic Manuscripts*, II, pp. 101–6, no. 126; id., *Lambeth Apocalypse*, pp. 49–66; see inf., pp. 273–96.

109. Oxford, Bodleian MS Auct. D.2.6, fol. 156. See Pächt, "Illustrations," pp. 68–83 and fig. 15a; Kauffmann, *Romanesque Manuscripts*, pp. 103–4, no. 75; Shepard, "Conventual Use," pp. 1–4.

110. On Anselmian meditation as an expression of memory, see Coleman, *Ancient and Medieval Memories*, pp. 157–68.

111. Gregory the Great, *Epistola* LII (*PL* 77: 982), considered by some to be an eighth-century interpolation; see Pächt, "Illustrations," p. 82.

112. Riché, "Le role de la mémoire," pp. 135, 137.

113. See Morgan, *Early Gothic Manuscripts*, II, pp.149–50, no. 157. If indeed the Psalter was made for Lacock Abbey, the Augustinian nun might be identified as Beatrice of Kent, abbess from 1256–69; see J. C. Russell, *Dictionary of Writers*, p. 23.

114. *PL* 17: 931-2.

115. Ibid.: 937.

116. Ibid.: 964.

117. Ibid.: 965.

118. Ibid.: 983.

119. Ibid.: 1020.

120. Ibid.: 1052.

121. McEvoy, *Philosophy of Robert Grosseteste*, pp. 60, 357, who quotes Grosseteste, *Commentary on the Celestial Hierarchy*.

122. Howard, *Idea of the Canterbury Tales*, pp. 139, 149.

123. Martianus Capella, *Rhetorica ad Herennium*, III.36-7, ed. Caplan, pp. 215–21.

124. See Lewis, "Beyond the Frame," pp. 53–76.

125. On medieval memory systems involving memory for words and *imagines verborum*, see Carruthers, *Book of Memory*, pp. 226–7.

126. Morgan MS M.756, probably made in Oxford, ca. 1270; see Morgan, *Early Gothic Manuscripts*, II, pp. 157–9, no. 162. For an analysis of the rebuslike historiated initials in the Cuerdon Psalter and their function in a medieval memory system, see Carruthers, *Book of Memory*, pp. 227–8, 245–7 and figs. 10–13.

127. On fol. 10v, a layman and -woman, presumably the first owners of the book, are represented kneeling in adoration of the Virgin and Child enthroned; see Morgan, *Early Gothic Manuscripts,* fig. 312. Elsewhere in Cuerdon's historiated initials, Dominican figures appear frequently, suggesting that a preacher

friar played an advisory role in the design of the book.

128. The topos of the "woman on top" offers a potent, if often humorous, image of unthinkable medieval disorder. For a discussion of sex-role reversal in preindustrial Europe, see Davis, *Society and Culture*, pp. 124–51.

129. Ong, "Wit and Mystery," p. 323; Quilligan, *Language of Allegory*, pp. 161–2.

130. The vesper hymn *Pange lingua* was written for the office of Corpus Christi, where it still occurs in the Roman Breviary. See Ong, "Wit and Mystery," pp. 316–17.

131. On the mnemonic use of traditional images from the Calendar and Bestiary, see Carruthers, *Book of Memory*, pp. 126–7. On the iconography of the Labors of the Months, see Webster, *Labors of the Months;* Tuve, *Seasons and Months*; Mâle, *Religious Art in France*, pp. 67–78.

132. On the iconography of the Fool, see Gifford, "Iconographical Notes," pp. 336–8; Meier, "Die Figur des Narren," pp. 1–5; Osteneck, "Narr Tor," cols. 314–16.

133. For a discussion of a similar but more complex mnemonic use of common initial letters, see Carruthers, *Book of Memory*, pp. 128–9, who analyzes Hugh of St. Cher's use of *ursus* to evoke *umbra* in his commentary on Psalm 22:4 ("in medio umbrae mortis").

134. See Camille, *Image on the Edge*, pp. 9–10 et passim.

135. See Carruthers, *Book of Memory*, pp. 128–9.

136. McCulloch, *Medieval Latin and French Bestiaries*, p. 153. The *Aviarium* I.55 cites Isidore, *Etymologiae* XII.7.48: "Pavo nomen de sono vocis. . . ."

137. Hugh of Fouilloy, *Medieval Book of Birds,* pp. 248–9. This text is given in the contemporary English Bestiary in Ashmole 1511, fols. 72v–73v; see *Bestiarium*, pp. 160–2.

138. Hugh of Fouilloy, *Book of Birds*, pp. 250–1.

139. Augustine, *De Genesi ad litteram* 8, p. 242.

140. On the image of the Ethiopian, see Devisse, *Image of the Black*, II/1, pp. 10–11, 95–7.

141. Pope Innocent III approved the Rule of the new order in 1198; 186 captives were ransomed in Morocco in 1199. Shortly after 1200, the pope gave the founder, John of Matha, the Roman monastery of San Tommaso in Formis, where a mosaic medallion representing the Order's official seal stands in the narthex over the entrance to the church: On a gold ground, Christ extends his hands to two shackled slaves, one black and one white, accompanied by the inscription: "Signum ordinis sanctae Trinitatis et captivorum." See Devisse, *Image of the Black*, pp. 140–8. The most recent and accessible history of the idiosyncratic or-

der is given by Gray, *Trinitarian Order*, pp. 10–15; older studies include P. Deslandres, *L'Ordre des Trinitaires pour le rachat des captifs*, 2 vols. (Toulouse-Paris, 1903); R. P. Antonin, *Les origines de l'ordre de la Très Sainte Trinité* (Rome, 1925).

142. Eight Trinitarian priories and hospitals were founded in England in the thirteenth century at Easton Royal, Hertford, Hounslow, Knaresborough, Moatenden, Oxford, Thelsford, and Totnes; see Gray, *Trinitarian Order*, p. 105.

143. See T. H. White, *Bestiary*, p. 103.

144. Augustine, *De civitate Dei* 11.19, cited by Kemp, "Visual Narratives," p. 108.

145. MS Add. 42555, fol. 15: "Par les quartre parties de la tere nus est signifie tote la tere de israel. Les liveres des profetes e des reis demustrent apertement comment il sunt deguastez par espee e par faym e par mort a par bestes de la tere." On headwings as a badge identifying the Ishmaelites, see Mellinkoff, "Demonic Winged Headgear," p. 367. On the further association of the Ishmaelites with Saracens as well as Jews, see Southern, *Western Views of Islam*, pp. 16–18.

146. T. H. White, *Bestiary*, p. 117.

147. Hugh of Fouilloy, *Medieval Book of Birds*, pp. 212–13: "Ciconia illos reprehend[it] qui Christum in carnem advenisse non credunt, et iudicium Domini futurum non pertimescunt." This assertion is apparently based on Jeremiah 8:7: "The stork in the heavens knows her appointed times . . . but my people know not the judgment of the Lord."

148. MS Add. 42555, fol. 14v: "Louverture del quatre sel partient as profetes ki profeterent . . . lavement de iesu crist." Durandus, *Rationale divinorum officiorum*, p. 431, refers to Christ as a stork because of the way it leads the rest in flight: "Vir enim iste beatus Christus est regulam Ciconii caput ut membra." See also Cast, "Stork and the Serpent," pp. 248–50.

149. MS Add. 42555, fol. 46: "Li aygnel nus est demustre iesu crist."

150. See McCulloch, *Medieval Latin and French Bestiaries*, pp. 166–9; see also Guillaume le Clerc, *Bestiary*, lines 1097–1102, p. 37.

151. See McCulloch, *Medieval Latin and French Bestiaries*, pp. 124–5. Whereas the Bestiary illustrations normally show the hedgehog climbing a tree or rolling on the fruit, the less common scene of barking dogs attacking a hedgehog appears in a bas-de-page sketch in the fourteenth-century Queen Mary Psalter (MS Roy. 2.B.VI, fol. 98). The moralizations stemming from Isidore, *Etymologiae* 12.3.7 all agree that humankind should care for its spiritual fruits lest the devil carry them off.

152. See Camille, *Image on the Edge*, p. 26.

153. See Janson, *Apes and Ape Lore*, pp. 166–77 and 181–2, who cites similar fourteenth-century representations in the margins of the Luttrell Psalter (Add. 42130, fol. 13) and the Smithfield Decretals (Roy. 10.E.IV, fol. 49v).

154. See Janson, *Apes and Ape Lore*, pp. 77–8, 176. According to Hildegard, when the ape observes a bird in flight, he leaps and tries to fly but becomes enraged in frustration.

155. Flanigan, "Apocalypse and the Medieval Liturgy," p. 333.

156. Kieckhefer, "Major Currents in Late Medieval Devotion," pp. 100–1.

157. See Flanigan, "Apocalypse and Medieval Liturgy," pp. 333–4, who quotes a responsory from the matins office for the occasion and for the annual commemoration of church dedications; see also sup., p. 224.

158. Piper, "Apocalypse of John," p. 19.

159. See Thompson, "Cult and Eschatology," pp. 343–4.

160. Flanigan, "Apocalypse and Medieval Liturgy," pp. 340–1.

161. Ibid., pp. 338–9; also Thompson, "Cult and Eschatology," pp. 334–42.

162. See Eliade, *Cosmos and History*, pp. 12–17; id., *The Sacred and Profane*, pp. 73–6; Fletcher, *Allegory*, pp. 121, 350.

163. See Mowry, "Revelation 4–5 and Early Christian Liturgical Usage," pp. 75–84; Thompson, "Cult and Eschatology," p. 335.

164. *PL* 17: 885–6.

165. "It is truly meet and just, right and beneficial to our salvation, that we should at all times and in all places give thanks to you, O holy Lord, Father Almighty and everlasting God, through Christ our Lord. Through whom the angels praise your majesty, the dominions worship it, the powers stand in awe, the heavens and the heavenly hosts and the blessed seraphim join together in celebrating their joy. With whom we, your supplicants, pray you to join our voices also praising you and saying: Holy, holy, holy Lord God of Hosts. Heaven and earth are full of your glory. Hosanna in the highest." Quoted by Flanigan, "Apocalypse and Medieval Liturgy," p. 344.

166. Quoted from *De praefatione* by Sinding–Larsen, *Iconography and Ritual*, p. 24.

167. Only Burckhardt-Wildt, Abingdon, and the French metrical version correct this error in text-image alignment by representing the Elders empty-handed in their illustrations for 4:1–8.

168. Jungmann, *Mass of the Roman Rite*, II, p. 131, n. 22.

169. *Winchester Troper*, pp. 65–6, cited and translated by Flanigan, "Apocalypse and Medieval Liturgy," p. 347.

170. See Piper, "Apocalypse of John," pp. 10–12.

171. *PL* 17: 887: "Per viginti quatuor seniores, Patres Novi Testamenti accipi possunt."

172. Ibid.: 887–8: The crowns signify good works on earth corresponding to the saints glorifying God in heaven.

173. Geertz, *Interpretation of Cultures*, pp. 112–13.

174. Flanigan, "Apocalypse and Medieval Liturgy," p. 349.

175. *PL* 17: 890: "Agnus ergo librum de dextera sedentis super thronum accepit; quia homo Christus a sua divinitate accepit, ut sacramenta divinarum Scripturarum reseraret."

176. Cambridge University Library MS Mm.5.31, fol. 22; Alexander Minorita, *Expositio in Apocalypsim*, pp. 79, 81: "Non enim vidit Agnum mortuum, sed 'tanquam occisum', quia sub speciebus panis et vini idem Agnus . . . in medio Ecclesiae suae cotidie occiditur mystice et immolatur. . . . Ipse enim Agnus, qui in caelo et in medio Ecclesiae unum habet corpus . . . quo stat, scilicet in altari, et in medio Ecclesiae suae."

177. *PL* 165: 631; this text is not quoted in the Berengaudus commentary.

178. See Schiller, *Iconography*, II, pp. 118–21, figs. 397, 400, who cites the ninth-century Alcuin Bible (Bamberg, Staatsbibliothek MS 1, fol. 339v), and the Fulda Lectionary (Aschaffenburg, Hofbibliothek MS 2), ca. 980. See also Hughes, *Medieval Manuscripts for Mass and Office*, pp. 39, 88–9. The Lamb adored by angels continues as a Eucharistic image in thirteenth-century liturgical books to illustrate the Common Preface to the Mass, "Vere dignum et justum est," as in the Pontifical of Reims, ca. 1250 (Rouen, Bibliothèque municipale MS 370, fol. 36v); see Leroquais, *Les pontificaux manuscrits*, pl. XXVIII. On the iconography of patens, see Elbern, "Der eucharistische Kelch," pp. 172–84 and figs. 127, 130, 131.

179. London, Victoria and Albert Museum MS L. 404-1916; see James, *Descriptive Catalogue . . . Collection of Henry Yates Thompson*, pp. 30–7, no. 7; *Missale de Lesnes*; Harthan, *Illuminated Manuscripts*, p. 18, no. 6.

180. The preface illustration to Lothair of Segni, *De sacro altaris mysterio*, is reproduced in Sinding–Larsen, *Iconography and Ritual*, fig. 25.

181. De Hamel, *History of Illuminated Manuscripts*, p. 190.

182. Ibid., pp. 190–1.

183. Flanigan, "Apocalypse and Medieval Liturgy," p. 349.

184. Ibid., p. 350.

185. Jerome, *Epistola* LIII.8 (*PL* 30: 548–549): "Apocalypsis Joannis tot habet sacramenta, quot verba."

186. Rubin, *Corpus Christi*, pp. 60–1. In the late twelfth century, Innocent III (Lothair of Segni), *De mysteriis missae* (*PL* 217: 811) recommended that two candlesticks be placed at the corners of the altar with a taper and a cross between them, and two additional lights to be lit before the altar during the elevation. The statutes of an English diocese of 1222 required at least two lights during the mass; Powicke and Cheney, *Councils and Synods*, II, 1, c.25, p. 144: "Tempore quo missarum sollempnia peraguntur accendantur due candele vel una ad minus cum lampade." The synodal council of Exeter of 1287 (*Councils and Synods*, II, 2, c.4, p. 990) also stipulated that "they will have at least two lights for the honor of the sacrament." By the end of the thirteenth century, Durandus, *Rationale divinorum officiorum* 4.6.5 and 6.85.5, considered a lighted altar to be an established custom.

187. Cambridge University Library MS Mm.5.31, fol. 1v; Alexander Minorita, *Expositio in Apocalypsim*, pp. lviii, 6.

188. Moorman, *Church Life in England*, p. 76; see Macy, *Theologies of the Eucharist*, pp. 85–92, who remarks (p. 119), "never in the history of the Church has the sacrament been received as infrequently as in the twelfth to fourteenth century."

189. See Browe, "Die Elevation in der Messe," pp. 20–66. Major works on this subject include Browe, *Die Verehrung der Eucharistie*; id., *Die häufige Kommunion*; Dumoutet, *Le désir de voir l'hostie*; id., *Le Christ selon la chair*; and id., *Corpus Domini*. As Rubin, *Corpus Christi*, p. 56, points out, by midcentury the elevation of the host was a standard feature of missal rubrics. Its entry into the Roman missal was mediated through the liturgical books of the new mendicant Orders, the Franciscan missal of 1243, and the Dominican missal of 1256.

190. Morris, *Discovery of the Individual*, p. 12.

191. See Rubin, *Corpus Christi*, pp. 55–7.

192. See Macy, *Theologies of the Eucharist*, pp. 88, 92; Dumoutet, *Christ selon le chair*, pp. 113–80.

193. See Morgan, *Early Gothic Manuscripts*, II, pp. 66–7, no. 104.

194. Powicke and Cheney, *Councils and Synods* II, 1, c.3, p. 210: "Nunc autem possumus dicere quod hic est deus noster . . . hic in terris cotidie videtur dum per manus sacerdotum elevatur."

195. William of Rishanger, *Chronica monasterii Sancti Albani*, pp. 74–5:

> Contigit autem aliquando Sanctum Lodowicum, Francorum regem, cum eo super hoc conferentem dicere, quod non semper Missis, sed freqentius sermonibus, audiendis esse vacandum. Cui faceta urbanitate respondens, ait, se malle amicum suum saepius videre, quam de eo loquentem, licet bona dicentem, audire.

196. The miracle of the Eucharist is illustrated in the last of three miniatures depicting the Life of St. Edward the Confessor, dating from the second half of the thirteenth century, which had been inserted into an abbreviated Domesday Book in London, Public Record Office MS E36/284; see Morgan, *Early Gothic Manuscripts*, II, pp. 91–2, no. 121, fig. 88. It is also illustrated in the late thirteenth-century copy of the *La Estoire de Seint Ædward le Rei* in Cambridge University Library MS Ee.3.59, p. 37, where in closer rapport with the text the priest holds up the Christ Child instead of the host:

> Quant leva li chapeleins
> Le cors Deu entre ses meins,
> Le veit li reis tut en semblant
> D'un jonure e bel enfant,
> Sa beneicun ki dune au rei.

See Luard, *Lives of Edward the Confessor*, p. 12.

197. *Summa de officiis*, quoted by Dumoutet, *Le désir de voir l'hostie*, p. 49: "Sacerdos elevat Corpus Christi ut omnes fideles videant et petant quod prosit ad salutem."

198. Brinton, *Sermons*, no. 48, pp. 215–16.

199. Rubin, *Corpus Christi*, p. 63.

200. See Waddell, "The Reform of the Liturgy," pp. 95–7.

201. Beleth, *Summa de ecclesiasticis officiis*, c. 85e, 35–8: "Nunc pauca descenda sunt de laicorum scriptura. Scriptura autem laicorum in duobus consistit: In picturis et ornamentis."

202. See Rubin, *Corpus Christi*, pp. 131–3.

203. Baltimore, Walters Art Gallery MS W.105, fol. 15, produced for the Butler family of Wem (Salop), ca. 1340. See Wieck, *Time Sanctified*, p. 222, no. 112, pl. 13; Sandler, *Gothic Manuscripts*, II, pp. 130–1, no. 117.

204. Paris, B.N. MS fr. 13342. See Wormald, "Some Pictures of the Mass," pp. 39–45, pls. 37–42; Sandler, *Gothic Manuscripts*, II, pp. 67–8, no. 58. The Elevation of the Host appears across a double opening on fols. 46v–47.

205. Rubin, *Corpus Christi*, p. 105, who adds, "Teaching attempted to anticipate and to create clusters of images which would come to mind through habit and repetition."

206. Browe, "Elevation," pp. 56–62; id., *Verehrung*, pp. 55–69.

207. On substitutes for eucharistic reception, see Macy, *Theologies of the Eucharist*, pp. 93ff.; Leclercq, "Dévotion privée," pp. 149–83.

208. See Morgan, *Early Gothic Manuscripts*, II, pp. 59–61, no. 101.

209. See Gurevich, *Categories of Medieval Culture*, pp. 110–14; see also Maddox, "Semiosis of *Assimilatio*," pp. 252–71.

210. Augustine, *De civitate Dei* XII and XIII.14–20; for an extended discussion of Augustine's theory of time, see Ricoeur, *Time and Narrative,* I, pp. 19–53.

211. De Man, *Blindness and Insight*, p. 207: "It remains necessary, if there is to be allegory, that the allegorical sign refer to another sign that precedes it. The meaning constituted by the allegorical sign can then consist only in the *repetition . . .* of a previous sign to be pure anteriority." For further discussions of the allegorical aspects of the text, see sup., pp. 13–14.

212. Stewart, *On Longing*, pp. 3–4.

213. Noakes, *Timely Reading*, pp. 73–80.

214. For a discussion of the role of the illustrated Life of St. John in Gothic Apocalypse cycles, see sup., pp. 25–32.

215. Bakhtin, *Dialogic Imagination*, p. 158.

216. Le Goff, *Medieval Imagination*, pp. 78–80.

217. See Noakes, *Timely Reading*, pp. 77–8.

218. On the semiotic potential of frontality, see Schapiro, *Words and Pictures*, pp. 37–49.

219. *PL* 17: 913.

220. See S. Lewis, "*Tractatus adversus Judaeos*," pp. 549–50.

221. On the significance and importance of this image in thirteenth-century England, see S. Lewis, "Giles de Bridport," pp. 112–13; Roberts, "Relic of the Holy Blood" pp. 135–42.

222. *PL* 17: 961.

223. See Lerner, "Refreshment of the Saints," pp. 109–15, 124–5. Augustine, *De civitate Dei* XX.7, saw the thousand-year kingdom of Christ in Rev. 20:1–6 as a figure for the life of the Church in the present. For a further discussion of this image see sup., pp. 184–6.

224. *PL* 17: 1017: "Tempus itaque a passione Christi usque ad finem mundi resurrectio prima vocatur."

225. For a mid-thirteenth-century itinerary showing Jerusalem in this way, see S. Lewis, *Art of Matthew Paris*, pp. 354–6 and fig. 215.

226. See Noakes, *Timely Reading*, pp. 41–50.

227. Thomas of Celano, *Dies irae*, p. 254.

228. See Gellrich, *Idea of the Book*, p. 18 et pass.

CHAPTER 6

1. On the medieval practice of adding preludes and sequels, see Ryding, *Studies in Medieval Narrative*, pp. 11–12.

2. See G. H. Russell, "Vernacular Instruction of the Laity," pp. 98–119; Boyle, "Fourth Lateran Council," pp. 30–43.

3. See Boyle, "Fourth Lateran Council," p. 35. *L'Elucidarium et les lucidaires*, ed. Lefevre; *Mirour de Seinte Eglyse*, ed. Wilshere; *Le manuel des péchés*, ed. Arnould; Robertson, "Manuel des Péchés," pp. 429–37; Laird, "Character and Growth of the Manuel des Pechiez," pp. 253–306. Cf. Morgan, *Lambeth Apocalypse*, pp. 91–4, who insists on maintaining rigid linguistic distinctions between clerical and lay readers.

4. See Hamburger, *Rothschild Canticles*, p. 22.

5. Cambridge, Fitzwilliam Museum MS 370; see Sandler, *Gothic Manuscripts*, II, p. 27, no. 17; James, "English Picture-Book," pp. 23–32, pls. IX–XVII, where all the pictures are reproduced; Wormald and Giles, *Descriptive Catalogue . . . Fitzwilliam Museum*, I, pp. 374–6.

6. British Library MS Roy. 2.A.XXII, fols. 219v–221v, ca. 1250. See Morgan, *Early Gothic Manuscripts*, II, p. 49, no. 95; Alexander and Binski, *Age of Chivalry*, p. 200, no. 9.

7. See Morgan, *Lambeth Apocalypse*, p. 73. The foregoing discussion is in no sense intended to cover the same ground as Morgan's iconographical analyses of the individual pictures but rather approaches the cycle as a coherent imaged discourse on visual perception and vision experience rooted within the ideological matrix of thirteenth-century culture.

8. Morgan, *Lambeth Apocalypse*, p. 49.

9. Heading a later prefatory series for the Psalter in Venice, Biblioteca Marciana MS lat. I.77, fol. 1, the ferryman also holds an oar, whereas the Fitzwilliam picture-book of 1270, fol. 8, shows him as a pilgrim with a walking stick; see Morgan, *Early Gothic Manuscripts*, II, pp. 164–6, no. 166; James, "English Picture Book," pl. XIVa.

10. British Library MS Roy. 2.A.XXII, fols. 220v–221v.

11. Mâle, *Religious Art in France*, p. 270. The paintings usually occur on the north wall opposite the main entrance on the south where the huge figure of St. Christopher could be seen fully, in many cases only from outside the building. Of the hundreds of effigies that at one time adorned the walls of English churches, Whaite, *St. Christopher*, p. 13, reported that over sixty were then known to exist in fair condition.

12. "SANCTI XPOFORI SPECIEM QVICVMQVE TVETUR ILLAM NEMPE DIE NULLO LANGVORE TENETVR." See Peers and Tanner, "Some Recent Discoveries," pp. 162–3; Tristram, *English Medieval Wall Painting, Thirteenth Century*, pl. 11.

13. An identical text appears below the figure of St. Christopher in the thirteenth-century *Supplicationes variae* in Florence (Bibl. Laurenzaiana MS Plut. 25.3, fol. 386), where the presence of two small spectators draws attention to the implied impact of the image on the viewer. See Degenhart and Schmitt, *Corpus der italienischen Zeichnungen*, pl. 17d; Belting, *Das Bild und Kult*, p. 344. On thirteenth-century theories of vision, see sup., pp. 6–10.

14. This figure has frequently been identified as St. George, but the red cross insigne probably has little significance beyond identifying the saint as a crusading knight. See Morgan, *Lambeth Apocalypse*, pp. 56–7; on the legend of St. Mercurius, see Binon, *Essai sur le cycle de saint Mercure*.

15. Kastner, "Merkurius von Cäsarea," col. 13. Lambeth's legendary narrative is later represented in some English manuscripts dating from the fourteenth century: Roy. 10.E.IV, fols. 214v–216v; Roy. 2.B.VII, fols. 222v, 223 (Queen Mary's Psalter); and in Cambridge, Fitzwilliam Museum MS 48, fol. 151v–153 (Carew-Poyntz Hours), where the saint is inscribed "George." See Warner, *Queen Mary's Psalter*, pls. 233d, 234a; James, *Catalogue of Manuscripts in the Fitzwilliam Museum*, p. 116.

16. Gerald of Wales, *Gemma ecclesiastica* XXVI, pp. 93–4. The story appears in English Marian legendaries, such as those of Nigel of Canterbury (late 12th century) in Latin verse and John of Garland (c. 1248); see H. L. D. Ward, *Catalogue of Romances*, II, pp. 691, 699; Nigel of Canterbury, *Miracles of the Virgin Mary*, pp. 30–3. For the major Anglo-Norman collections of the Miracles of the Virgin, see Adgar, *Le Gracial*; Everard of Gately, "Miracles de la Vierge," pp. 27–47; and Kjellman (ed.), *La deuxième collection anglo-normande des miracles de la sainte Vierge*.

17. Adapted from Latin originals, the fifty-eight verse tales depict Mary as a powerful mediatrix; see Gautier de Coinci, *Les Miracles de Nostre Dame*, IV, pp. 1–30, under the title, "De Saint Basile." The legend seems to have originated in the *Vitae Patrum* (*PL* 73: 1003), where the Virgin appears to St. Basil in a dream rather than as a statue.

18. Gautier de Coinci, *Miracles de Nostre Dame*, IV, lines 203–19, 233–9, 547–9. The image of the Virgin, albeit in another context, played an equally critical role in Byzantine versions of the legend; see Der Nersessian, "Two Miracles of the Virgin," pp. 157–63.

19. See sup., p. 237.

20. Whatever slight currency the legend of St. Mercurius had in Western art seems to have been associated with the Crusades. In a fresco at Poncé-sur-Loire, St. Julien, he is shown with Sts. George and Demetrius in battle against the Saracens; see Deschamps and

Thibaut, *La peinture murale en France*, pp. 124–6.

21. As pointed out by M. Evans, "Illustrated Fragment," pp. 19–20.

22. *Glossa ordinaria ad Ephesios* VI (*PL* 114: 600). M. Evans, "Illustrated Fragment," p. 19, also cites an anonymous twelfth-century sermon ascribed to Hildebert of Lavardin, which adds a sword *(verbum evangelii)*, lance *(legis testimonium)*, and horse *(corpus nostrum)*; see *PL* 171: 867.

23. As M. Evans, "Illustrated Fragment," p. 20, points out, the *Similitudo militis*, which provided the first systematic comparison between the knight's arms and the spiritual weapons of the faithful, was composed in Canterbury or Llanthony, ca. 1110–30; see Southern and Schmidt, *Memorials of St. Anselm*, pp. 97–102. An illustrated text on spiritual warfare was included on the Beatus page of the early twelfth-century Albani Psalter; see Pächt et al., *St. Albans Psalter*, pp. 149–51, 163 and pl. 41.

24. In Gautier de Coinci's *Miracles de Nostre Dame*, the Theophilus story occupies 2092 lines vs. 768 lines for the Mercurius miracle; see König (ed.), I, pp. 50–175.

25. Mâle, *Religious Art in France*, p. 261. For the history of the legend, see Plenzat, *Die Theophiluslegende*. Honorius Augustodunensis recounted the legend in his *Speculum ecclesiae* as a model sermon for the Feast of the Assumption; *PL* 172: 993. As early as the eleventh century, the miracle of Theophilus received solemn consecration in the Office of the Virgin:

> Tu mater es misericordiae
> De lacu faecis et meseriae
> Theophilum reformans gratiae.

Ulysse Chevalier, *Poesies liturgiques traditionelles de l'Église catholique en Occident*, XII (Tournai, 1893), p. 134, quoted by Mâle, *Religious Art in France*, p. 261. Rutebeuf used it for a mystery play, *Le miracle de Theophile*, ed. Frank. Equally popular were representations of the Theophilus legend in medieval art from the twelfth century on; see Fryer, "Theophilus, the Penitent," pp. 287–333; also Faligen, "Des formes iconographiques," pp. 1–14. Among the miracles of the Virgin only the Theophilus story is commemorated in French cathedral imagery; the legend is carved twice at Notre Dame in Paris and is included among the windows at Chartres, Laon, Beauvais, Troyes, and Le Mans; see Cothren, "Iconography of Theophilus Windows," pp. 308–41. The legend is given in eight small scenes by W. de Brailes in leaves for a Psalter in Cambridge, Fitzwilliam Museum MS 300, dating ca. 1230–60 and in nine scenes by the same Oxford artist in a series of historiated initials in a Book of Hours (MS 49999); see Morgan, *Early*

Gothic Manuscripts, I, p. 118, no. 72a, and pp. 119–21, no. 73.

26. On the Marian image of the bared breast, see Morgan, "Texts and Images in Marian Devotion," pp. 95–7, where the gesture is limited to examples of the Virgin's role as intercessor at the Last Judgment, as in the Huth Psalter (MS Add. 38116, fol. 13v) and the Gulbenkian Apocalypse, fol. 73v; see also Morgan, *Lambeth Apocalypse*, p. 55.

27. H. L. D. Ward, *Catalogue of Romances*, II, p. 635, summarizes the miracle from a thirteenth-century collection in MS Add. 15723, fol. 87v.

28. All the inscriptions in this manuscript are fully transcribed in Morgan, *Lambeth Apocalypse.*

29. Ælfric, *Homilies of the Anglo-Saxon Church*, I, pp. 450–3, gives an abbreviated version of the Theophilus story included with a more extended account of St. Mercurius; the early thirteenth-century "Adgar" translations from a Latin original belonging to St. Paul's (MS Egerton 612) are cited by H. L. D. Ward, *Catalogue of Romances*, II, p. 709; also MS Add. 18346 from the fourteenth century (Ward, p. 646). In the Sarum Breviary (Proctor and Wordsworth, *Breviarium ad Usum Insignis Ecclesiae Sarum*, III, pp. 785–8), the first lesson for September 9 refers to the Mercurius legend only indirectly before recounting the story of Theophilus.

30. The image of the Virgin plays a crucial role in several other miracles in Gautier's collection, e.g., Gautier de Coinci, *Miracles de Nostre Dame*, III, pp. 23–4, 42–50; IV, pp. 110–33, 378–411.

31. See S. Lewis, *Art of Matthew Paris*, pp. 424–5.

32. *PL* 17: 844. See sup., p. 53.

33. Morgan, *Lambeth Apocalypse*, p. 101, raises the possibility that some material may have intervened between fol. ii and fol. 1, because marks made by the original cover on the last flyleaf do not extend to fol. 1.

34. Ibid., p. 73. While raising such a possibility, however, the authors do not pursue its ramifications, but rather proceed on the tacit assumption that the entire project was designed for a lay reader, which might not have been the case.

35. Eleanor has here appropriated the emblazoned costume first used by Margaret de Quincy, Countess of Winchester, 1207–35, on her seal now affixed to Brackley Charter B.180 in Oxford, Magdalene College; see Birch, *Catalogue of Seals*, II, nos. 6700–1; Blair, "Armorials on English Seals," p. 20 and pl. XVc; Henderson, "Romance and Politics," pp. 33–4; Alexander and Binski, *Age of Chivalry*, pp. 251–2, no. 141. The De Quincy arms are given by Matthew Paris in the *Chronica majora*, MS 16, fol. 50, marking the death of the first earl in 1220. For a full dis-

cussion of the identity of the figure on fol. 48 in Lambeth 209, see Morgan, *Lambeth Apocalypse*, pp. 74–9.

36. See Dickinson, *An Ecclesiastical History of England*, pp. 369–71.

37. Although the standing pose of the child is rather rare, English examples can be cited in the so-called Chichester Roundel and in the representation of the Adoration of the Magi in the Gulbenkian Apocalypse. As Morgan, *Lambeth Apocalypse*, p. 70, suggests, the pose may have originated in France, judging from its occurrence in ivory figurines such as the Ste. Chapelle Virgin; see Gaborit-Chopin, *Ivoires du moyen âge*, figs. 198–9.

38. Hamburger, *Rothschild Canticles*, p. 101 and n. 109.

39. London, Victoria and Albert Museum Inv. 200-1867; see Gaborit-Chopin, *Ivoires du moyen âge*, p. 205, no. 204.

40. Morgan, "Texts and Images of Marian Devotion," p. 81, points out that images of the Virgin in sculpture or painting must have been an important focus of laypeople's devotion, because inventories of English parish churches usually list an "ymago beate Marie cum tabernaculo."

41. *PL* 210: 266–80; on the question of attribution, see D'Alverny, *Alain de Lille*, pp. 154–5, who suggests that Alain could have used the work of the English Augustinian to which he then added a prologue on the vision of Isaiah.

42. "Cherubim iste in humana depictus effigie sex habet alas que sex actus morum representant. Quibus debet fidelis anima redimi si ad deum per incrementa virtutum voluerit pervenire." See Sandler, *Psalter of Robert de Lisle*, p. 80 and n. 141, based on the early fourteenth-century Howard Psalter (B.L. Arundel 83, Pt. I, fol. 5v), bound with the Robert de Lisle Psalter; the image also appears in a Miscellany that includes a manual for the use of priests in Cambridge, University Library MS Gg.4.32, fol. 11.

43. Confession, Making Amends, Purity of Body, Purity of Mind, Love of One's Neighbor, Love of God. Similar representations of the six-winged Cherub inscribed with moral qualities occur in manuscripts dating from the late twelfth century on; see Katzenellenbogen, *Allegories of the Virtues and Vices*, p. 62. Most are French, but a few English examples may be cited. The Cherub marked with the virtues also appears in Matthew Paris's drawings of St. Francis receiving the stigmata in the *Chronica majora*, where it is based on Celano, but there is no textual basis for it in the chronicle.

44. For example, under Making Amends are restraint in hearing, modesty in seeing, withdrawal from smelling, temperance in tasting, and refraining from touch-

ing. The cherub of the *Speculum theologiae* stands on a wheel whose spokes are sometimes inscribed with the seven works of mercy but in Lambeth have been left blank.

45. Cambridge, Corpus Christi MS 66, see Kauffmann, *Romanesque Manuscripts*, p. 123, no. 102, text fig. 42; on Harley 3244, see Morgan, *Early Gothic Manuscripts*, I, pp. 127–8, no. 80; two late thirteenth-century examples occur in books made for use in Notre-Dame, Paris (Paris MS lat. 17251, fol. 128) and St. Victor (MS lat. 14500, fol. 150; Add. 18325, fol. 113v).

46. For a discussion of these kinds of perceptual-cognitive problems, see Ringbom, *Medieval Iconography*, pp. 48–50.

47. Odo of Cluny, *Sermo II* (*PL* 133: 720), quoted by Garth, *Saint Mary Magdalene*, p. 87.

48. Gregory the Great, *Homiliae XL in Evangelia* II.25 (*PL* 76: 1192); Alcuin, *Commentarium in Joannem* VII.41 (*PL* 100: 990).

49. Honorius Augustodunensis, *Speculum ecclesiae* (*PL* 172: 881).

50. MS Harley 1527, fol. 59v: "Quod dominus noster primo Marie flexti apparuit significat quod illis dominus plura de secretis suis manifestat qui eum plus diligunt imagis in lacrimis et penitentia."

51. Henderson, "Studies," I–II, p. 136; Morgan, *Lambeth Apocalypse*, p. 59, relies mainly on the Magdalene figure's fashionable costume to make the connection.

52. *Life of Saint Mary Magdalene*, p. 81. On the multifaceted spirit of medieval devotion to Mary Magdalene, see Saxer, *Le culte de Marie Madeleine*, pp. 327–50.

53. See Schapiro, *Words and Pictures*, pp. 29, 32.

54. See Kimpel, "Margareta von Antiochen," cols. 495, 498.

55. Florence, Laurenziana MS Plut. 25.3, fols. 383, 384, and 385v, where the standing saints are grouped in analogous triads; see Degenhart and Schmitt, *Corpus der italienische Zeichnungen*, I, pls. 16–17.

56. Sotiriou and Sotiriou, *Icones de Mont Sinai*, I, fig. 50.

57. By the eleventh century, the Feast of St. Edmund figured prominently in the monastic calendars of southern England, as well as in those of York and Hereford. Over sixty churches were dedicated to the royal martyr, the most celebrated being the Benedictine foundation of Bury St. Edmunds, where his tomb was enshrined.

58. MS Roy. 2.B.VI; see Morgan, *Early Gothic Manuscripts*, I, pp. 133–4, no. 86. Another, somewhat more distant, representation occurs in the Grandisson Psalter (Add. 21926, fol. 12); see Morgan, *Early Gothic Manuscripts*, II, pp. 162–4, no. 165.

59. Piramus, *La Vie Seint Edmund le Rey*, lines 2517–20, p. 208.

60. Herman of Bury, *De miraculis Sancti Ædmundi*, p. 36: "Ecce! martyr Aedmundus, potentia signorum, mirificus, aequiparatur Mercurio martyri ulciscenti injuriarum blasfemias apostatae Juliani, in genitricem Dei Basiliumque virum Domini."

61. Lisbon, Gulbenkian Museum MS L.A.139, fol. 19v: "Quintus angelus defensores ecclesiae orthodoxe fidei designat. Tuba cecinerunt quando pro defensione fidei omnibus nobis laboraverunt."

62. Piramus, *Seint Edmund le Rey*, lines 2365–6, p. 203.

63. Hahnloser, *Villard de Honnecourt*, pp. 350–1; see Verdier, "La grande croix," pp. 1–31; id., "What Do We Know of the Great Cross?" pp. 12–15.

64. See Hahnloser, "Der Schrein des unschuldigen Kindlein," pp. 218–23. The reliquary is documented in another drawing by Villard; see Hahnloser, *Villard de Honnecourt*, pl. 15.

65. As suggested by Cames, "Recherches sur les origines du crucifix," pp. 194–6; Hewitt, "Use of Nails in the Crucifixion," p. 33.

66. *Ancrene Riwle, The Nun's Rule*, p. 296.

67. Verdier, "La grande croix," pp. 5–8 and fig. 15, who illustrates an enameled plate, now in the St. Louis Art Museum, decorated with a cross very similar to that shown in the Lambeth illustration.

68. Ibid., pp. 17–21.

69. See Mâle, *Religious Art in France*, p. 190.

70. *In Matthaeum* XXVII.54 (*PL* 114: 176): "In centurione fides Ecclesiae designatur, quae velo coelestium mysteriorum per mortem Domini reserato, Jesum Filium Dei tacente Synagoga confirmat."

71. This gesture is unusual, for normally Longinus touches his eyes to signify the miracle, as in Munich Clm. 835, fol. 26, and Add. 49999, fol. 47v. In the fourteenth-century Psalter of Yolande de Soissons, fol. 332v, Longinus has one eye closed and the other open, but he points to the open eye to indicate his cure.

72. *In Lucam* XXIII.36 (*PL* 114: 347–8): "Acetum erant Judaei, a vino patriarcharum degenerantes."

73. Mâle, *Religious Art in France*, p. 191, who cites Jacobus de Voragine, *Mariale*, I, *Sermo* 3.

74. *In Joannem* XX.4 (*PL* 114: 422): "Joannes significat Synagogam, quae prior venit ad monumentum sed non intravit, quia prophetias de incarnatione et passione audivit, sed et mortuum credere noluit."

75. *Meditations on the Life of Christ*, p. 333. Morgan, *Lambeth Apocalypse*, p. 66, hypothesizes that the Pseudo-Bonaventure text was probably based on Passion meditations written ca. 1250–75. However, the appearance of the pictorial iconography in the Parisian *Bible moralisée* (Toledo Cathedral MS III, fol.

64; Laborde, *La Bible moralisée*, pl. 644), where the moralization is centered on the two thieves at the base of the cross ("Duo latrones duos populos significant iudeorum et gentium") suggests that it is earlier, but the significance of the two ladders is not clear.

76. *In Matthaeum* XXVII.37 (*PL* 114: 174–5) and *In Lucam* XXIII.38 (*PL* 114: 348): "Ergo velint, nolint Judaei."

77. Quoted by Longland, "Pilate Answered," pp. 410–29; Hoving, *King of the Confessors*, pp. 323–4.

78. *In Marcum* XV.26 (*PL* 114: 238): "Bene enim simul est rex et pontifex, cum eximiam Patri suae carnis hostiam offerret in altari crucis."

79. Toledo Cathedral MS III, fol. 64: "Quod iudei contradixerunt scripture et pilatus confirmativit significat quod iudei fidei christi contradixerunt et pagani eam admisserent et retinuerunt." The image is discussed in connection with the Bury St. Edmunds Cross by Sass, "Pilate and the Title for Christ's Cross," pp. 5–10.

80. See sup., pp. 259–65. For a further discussion of the Crucifixion as a liturgical image, see Sinding-Larsen, "Some Observations on Liturgical Imagery," pp. 200–1 et pass.

81. The Lambeth figure wearing full pontificals can be identified as an archbishop by his cross-staff and pallium; see Mayo, *History of Ecclesiastical Dress*, pp. 171–3.

82. Wallace, *Life of St. Edmund*, pp. 101–2, 470–2, which transcribes MS Bodl. 57, fol. 6v. According to Matthew Paris, *Liber additamentorum*, VI, p. 384, after Edmund's death a sapphire engraved with a figure of the crucifix, which had belonged to him, came into the possession of St. Albans where it was kept as a relic.

83. Wallace, *Life of St. Edmund*, p. 129.

84. See H. W. Robbins, *Saint Edmund's 'Merure de Seinte Eglise'*, pp. vi–xi, for a list of manuscripts. Resembling a manual of moral and pastoral theology, the *Speculum* advances from elementary religious instruction to mystical teachings on knowledge of the self and the contemplation of God.

85. As pointed out by Morgan, *Lambeth Apocalypse*, p. 58, n. 45.

86. For the representation in the Westminster Psalter, MS Roy. 2.A.XXII, fol. 221, see James, "Drawings of Matthew Paris," pl. XXVIII. The episode is reported in Matthew Paris's *Vita Sancti Edmundi* under rubric II, "Qualiter anulo quodam ymaginem Virginis subarravit," in Lawrence, *St. Edmund of Abingdon*, pp. 224–5; Wallace, *Life of St. Edmund*, pp. 50–2; the Franciscan author of the Lanercost Chronicle, who was in Oxford about twenty years after Edmund's death, mentions the story as common knowledge;

Chronicon de Lanercost, p. 36. See also Henderson, Review of Morgan, *Lambeth Apocalypse*, p. 529.

87. Wallace, *Life of St. Edmund*, p. 99.

88. Borenius, *St. Thomas Becket in Art*, p. 18 and pl. II, fig. 3, who cites the thirteenth-century wall paintings preserved in Hauxton Church and at Hadleigh, where it is inscribed "Beate Thomae."

89. Matthew Paris, *Historia Anglorum* (MS Roy. 14.C.VII, fol. 122); see S. Lewis, *Art of Matthew Paris*, fig. 45; *HA* 2:367. On Harley 5102, see Morgan, *Early Gothic Manuscripts*, I, pp. 88–9, no. 40. An almost identical representation appears in a copy of Peter of Poitiers, *Compendium veteris testamenti*, dating from ca. 1244 in Eton College MS 96, fol. 21; see Borenius, "Some Further Aspects," pp. 182–3 and pl. XLIX, fig. 3; James, *Descriptive Catalogue of Manuscripts . . . Eton College*, pp. 35–7. A bas-de-page illustration of Becket's martyrdom where the cross is shown bearing a crucified corpus in the Luttrell Psalter, MS Add. 42130, fol. 51, is reproduced in Backhouse and De Hamel, *The Becket Leaves*, fig. 5. Another unmistakable evocation of the association of Thomas Becket with the distinctive processional cross bearing a crucified corpus can be seen in the lower right wing of an ivory triptych made for John Grandisson, bishop of Exeter (1327–69), in the British Museum, MLA 1926.7-12; see Alexander and Binski, *Age of Chivalry*, pp. 466–7, no. 596.

90. See S. Lewis, *Art of Matthew Paris*, pp. 87–9 and figs. 44–6.

91. See Wallace, *Life of St. Edmund*, pp. 569–70, who quotes the *Vita* composed by the monk Eustace of Christ Church, Canterbury, in MS Cotton Jul. D.VI, fol. 141: "Datum est enim ei in spiritu nosse hanc fuisse beati Thome predecessoris sui vocem consilii et consolationis."

92. *Annales Henrici quarti, regum Angliae*, III, p. 392; see Wallace, *Life of St. Edmund*, pp. 332–6, who reproduces an engraving of St. Edmund's small private seal between pp. 332–3.

93. Tristram, *English Medieval Wall Painting: Thirteenth Century*, p. 289, and pl. 116b; Brieger, *English Art*, fig. 66b.

94. Bede, *Historia ecclesiastica* III.29, p. 319.

95. On Frindsbury and Abbots Langley, for example, see Tristram, *English Medieval Wall Painting: Thirteenth Century*, p. 289; Caiger-Smith, *Early Mediaeval Mural Paintings*, pp. 146, 151.

96. See Morgan, *Lambeth Apocalypse*, p. 112. Michelle Brown notes that it may have been separately executed, as the inscriptions appear to have been written by the first scribe of the Apocalypse text (Scribe A) or a closely related hand. Although there may have been a leaf, now missing, between fols. 48 and 49,

the relationship between the Cherub on fol. 48v and the representation of *Noli me tangere* would suggest that the two images were designed to form a contiguous pair.

97. *PL* 113: 1114 (on Prov. 30:31): "Gallus, scilicet praedicatores."

98. M. Evans, "Illustrated Fragment," p. 17, who quotes, among others, Peter Damian, *Liber qui dicitur dominus vobiscum* (*PL* 145: 247).

99. Prologue to the Rule of St. Benedict, 3; see *Regula*, p. 2.

100. See S. Lewis, *Art of Matthew Paris*, pp. 195–6 and fig. 110.

101. See ibid., pp. 193–5 and figs. 113 and 113A; Thomson, *Writings of Robert Grosseteste*, pp. 14–15, 226. A triangular diagram of the Trinity also appears on fol. 43v in MS Cotton Faustina B.VII; see Watson, *Catalogue of Dated and Datable Manuscripts . . . British Library*, p. 102, no. 530; Morgan, *Early Gothic Manuscripts*, I, pp. 91–2, no. 43b. Another early version of the Shield of Faith appears at the end of a copy of Anselm's *Treatises on the Faculties of the Mind* in MS Cotton Cleopatra C.XI, fol. 77v, probably executed at the Cistercian Abbey of Dore, ca. 1220–30; see Morgan, *Early Gothic Manuscripts*, I, pp. 106–7, no. 60.

102. *Monumenta Ordinis Fratrum Praedicatorum Historica*, XV (Rome, 1933), pp. 90–1; see M. Evans, "Illustrated Fragment," pp. 14–68; Morgan, *Early Gothic Manuscripts*, I, pp. 127–8, no. 80, figs. 267–70; Hinnebusch, *The Early English Friars Preachers*, p. 280; S. Lewis, *Art of Matthew Paris*, pp. 494–5, n. 119.

103. M. Evans, "Illustrated Fragment," p. 24: "Fides dicitur scutum, quia sicut scutum unum est, et est triangulum, ita fides est de unitate substantiae et trinitate personarum."

104. In addition to the Peraldus text, the Harley manuscript contains the Meditations of St. Bernard, Grosseteste's *Templum Domini*, exempla, and sermons.

105. *Ancrene Riwle*, trans. Morton, pp. 220–1; *Ancrene Riwle*, trans. Salu, p. 130.

106. To which Innocent IV added a further indulgence of forty days for reciting the hymn *Ave facies praeclara*; Pearson, *Die Fronica*, p. 69; Corbin, "Les offices de la Sainte Face," pp. 27–8. See S. Lewis, *Art of Matthew Paris*, pp. 126–31.

107. See S. Lewis, *Art of Matthew Paris*, pp. 126–31 and pls. IV and V.

108. The Veronica also appears in a late thirteenth-century Psalter from Norwich in Lambeth MS 368, fol. 95v. Inserted on a bifolium before Psalm 109, the prayer carries the increased indulgence of forty days granted by Innocent IV; see Morgan, *Early Gothic Manuscripts*, I, pp. 185–6, no. 181.

109. See S. Lewis, "*Tractatus adversus Judaeos*," pp. 565–6.

110. Gervase of Tilbury, *Otia Imperiale* 3.25, quoted by Dobschütz, *Die Christusbilder*, pp. 282–93.

111. Kuryluk, *Veronica and Her Cloth*, p. 165. On the image's dependence upon crystallized patterns of reading and belief, see Barasch, "Frontal Icon," pp. 31–44.

112. See Belting, "Die Reaktion der Kunst," pp. 45–7. On the Roman relic as pilgrimage goal, see Bolton, "Advertise the Message," pp. 117–30.

113. *PL* 210: 271: "Caetera quoque quae haberi aliter dicuntur, non ad prophetiam, sed ad picturam referenda sunt."

114. Ibid.: 272: "Ut autem exemplar hoc evidentius tibi fiat, totam personam Christi, id est caput cum membris, in forma visibili depinxi, ut cum totam videris, quae de invisibili parte dicuntur, facilius intelligere possis."

115. Wallace, *Life of St. Edmund*, pp. 469, 586, who quotes from the *Vita beati Edmundi*, MS Cotton Jul. D.VI, fol. 156v: "Sancte et beate Joannes apostole et evangelista dei qui . . . inter ceteros magis dilectus . . . desiderio videndi desiderabilem faciem domini nostri Jesu Christi."

116. Although James et al., *Illustrations to the Life of St. Alban*, p. 17, assumed that the countess in question was Matilda (Maud), the earl's second wife, it is equally possible, if not more probable, that Matthew was referring to Eleanor de Quincy who married Roger de Quincy in 1254. The illustrated manuscript of the *Life of St. Alban* was probably not finished until 1252, and Matthew's note could have been written any time before he died in 1259. See S. Lewis, *Art of Matthew Paris*, p. 387. Because the manuscript was made for the abbey, the notes referring to lending the book to aristocratic ladies and other matters would more likely date from 1254–9 than earlier. As Morgan, *Early Gothic Manuscripts*, I, p. 132, has pointed out, the note does not imply that Matthew himself planned to execute the images for the book, but that he was giving instructions on the iconography to lay artists. Cf. Paul Binski, "Abbot Berkyng's Tapestries and Matthew Paris's Life of St. Edward the Confessor," *Archaeologia* 109 (1991): 94.

117. *Complete Peerage*, XII, p. 751, n. j. Inscribed MARGARETE DE QUINCI COMITESSE, a large seal appended to a Brackley charter of ca. 1220 shows Margaret de Quincy, the first countess of Winchester, under a canopy. When she died in 1235, her heart was buried before the altar of the Hospital of St. James and St. John at Brackley.

118. Sandler, *Psalter of Robert de Lisle*, pp. 12–13, has

convincingly demonstrated a similar intention to account for the addition of an analogous pictorial cycle to the Psalter in Arundel 83 by Robert de Lisle, ca. 1339.

119. On the veiled wimple as a signal of widowhood, see J. Evans, *Dress in Medieval France*, p. 23, n. 2; however, Henderson, "Studies," I–II, p. 103, sees it merely as fashionable dress.

120. See J. C. Cox, "Religious Houses," p. 149. Wintney possessed a handsome volume, MS Cotton Claud. B.III, containing the rule of Benedictine nuns in Latin and English in parallel columns; the calendar at the end enters the names of benefactors, prioresses, and sisters of the convent, as well as the obits of six bishops of Winchester beginning with Godfrey de Lacy (1189–1205).

121. Although the foregoing discussion was clearly inspired by the fine study by Michael Camille, "Him Whom You Have Ardently Desired," pp. 137–60, I shall move beyond his emphasis on Bernard of Clairvaux to the commentaries of Honorius Augustodunensis and others to explore how themes of eroticism, seeing, and vision are exploited to prepare the reader for the experience of the Apocalypse.

122. De Hamel, *Apocalypse*, p. 2, notes that the full-page pictures must have come at the front, as a very small numeral "6" appears in the upper right-hand corner of the last miniature. Offsets on the first two pictures show that they faced one another as fols. 1v and 2, and the third miniature on fol. 3v faced either a blank page or an image now lost.

123. In contrast with ibid., p. 44, and De Winter, "Visions of the Apocalypse," p. 415, who describe the first scene as an *Ars moriendi*, Camille, "Him Whom You Have Ardently Desired," pp. 137–53, rightly argues that the imagery evokes twelfth-century commentaries on the Canticles.

124. Notwithstanding the tiny numeral "5" in the top right-hand corner of the reverse of the Tree of Virtues and the trace of a number "6" in the top right-hand corner of the Tree of Vices (see De Hamel, *Apocalypse*, pp. 8–9), the Tree of Vices should appear on the left, in accordance with the designation "sinistra" given in the pseudo-Hugo text; see Katzenellenbogen, *Allegories of the Virtues and Vices*, p. 66.

125. Astell, *Song of Songs*, pp. 39–40. Origen's work was widely known throughout the West through the translation of Jerome; see Origen, *Homiliae in Canticum canticorum*, pp. 26–60; Rousseau, *Origène, Homélies sur le Cantique des cantiques;* Ohly, *Hohelied-Studien*, pp. 20–1. As Matter, *Voice of My Beloved*, p. 35, points out, over forty manuscripts of the Latin translation of Origen's *Homilies* dating from the sixth to the fifteenth century are extant, and the

Commentary exists in about thirty manuscripts dating from the eleventh century on.

126. Astell, *Song of Songs*, p. 2.

127. See Matter, *Voice of My Beloved*, pp. 32–3.

128. Leclercq, *Love of Learning*, p. 106; Courcelle, *Les lettres grecques*, pp. 364–7.

129. See Astell, *Song of Songs*, pp. 7–8, 18–22.

130. Bernard of Clairvaux, *Sermo in Cantica canticorum* I.1 (*PL* 183: 794).

131. Ibid., IV.9, quoted by Morris, *Discovery of the Individual*, pp. 155–6.

132. Astell, *Song of Songs*, pp. 17–18; Matter, *Voice of My Beloved*, pp. 7–8, argues that Songs by its very nature constitutes a subgenre that internally participates and shares in its own exegetical transformation.

133. See Astell, *Song of Songs*, pp. 20–2; Matter, *Voice of My Beloved*, p. 38.

134. *PL* 196: 10–11, quoted by Astell, *Song of Songs*, p. 35.

135. Astell, *Song of Songs*, pp. 32–3.

136. See Lobrichon, "Conserver, réformer, transformer le monde?" pp. 82–3.

137. See Leclercq, "Le commentaire de Gilbert de Stanford," p. 210.

138. Astell, *Song of Songs*, pp. 10–13.

139. On Cambridge, Corpus Christi MS 48, see James, *Descriptive Catalogue . . . Corpus Christi, Cambridge*, I, pp. 94–8; Kauffmann, *Romanesque Manuscripts*, p. 115, no. 91; Cahn, *Romanesque Bible Illustration*, pp. 259–60, no. 29.

140. Paris, Bibliothèque Ste. Geneviève MS 9, fol. 258v; see Schiller, *Ikonographie*, IV, 1, fig. 137; Boinet, "Les manuscrits peintures," pp. 21–9; Cahn, *Romanesque Bible Illustration*, p. 279, no. 99.

141. See Kauffmann, *Romanesque Manuscripts*, text fig. 40; Pächt et al., *St. Albans Psalter*, pp. 160–1.

142. Arras, Bibliothèque Municipale MS 559, II, fol. 141v; see Cahn, *Romanesque Bible Illustration*, fig. 68 and pp. 266–7, no. 51; see Boutemy, "La Bible enluminée de Saint-Vaast à Arras," pp. 67–81; Cahn, *Romanesque Bible Illustration*, pp. 266–7, no. 51.

143. William of St. Thierry, *Exposition on the Song of Songs*, Preface 8, p. 9, as pointed out by Camille, "Him Whom You Have Ardently Desired," p. 142.

144. See Hamburger, *Rothschild Canticles*, p. 71.

145. "Quomodo sedet sola civitas plena populo facta est quasi vidua domina gentium princeps provinciarum; facta est sub tributo. Edificavit inimicus meus in giro ut circumdedit me felle et labore in tenebris collocavit me quasi mortuos sempiternos vetustam. fecit pellem meam ut non egrediar aggravavit eum pedum meum."

146. On the blindness of Synagogue, see Seiferth, *Synagogue und Kirche*, pp. 48–51.

147. "Reverte, reverte, sunamitis, reverte, reverte ut intueamur te."

148. Camille, "Devil's Writing," p. 356, who further notes how Bernard of Clairvaux in his commentary privileges sound over sight: "The coming of the Holy Spirit was perceived first by hearing, then by sight."

149. *PL* 172: 464: "Sunamitis, quod dicitur captiva, est anima in peccatis et vitiis a diabolo capta. Haec ab illa captivitate quatuor modis ad Christum revertitur, scilicet per poenitentiam, per confessionem, per bonam operationem, et per bonam exhortationem." However, the interpretation of this passage as Synagogue before the advent of Christ, captured by devils and despised by God, is very old, going back to Cassiodorus, *Expositio in Cantica canticorum* (*PL* 70: 1093): "Revertere, O Synagoga, ab infidelitate ad fidem, revertere ab odio ad dilectionem. Sunamitis interpretatur captiva vel despecta. Talis erat Synagoga ante adventum Christi, captiva videlicet vinculo diaboli, et despecta a Deo: quia Christum ad salutem suam missum non cognovit." See also Rabanus Maurus, *Allegoriae in sacram scripturam* (*PL* 112: 1061).

150. *Sermones in Cantica canticorum* XIV (*PL* 183: 840–1): "Caeca ... Synagoga foris epulatur cum amicis suis daemonibus quibus satis placet.... Foris haeret [Israel] in littera." See Schlauch, "Allegory of Church and Synagogue," p. 454.

151. See Matter, *Voice of My Beloved*, pp. 63–5, 74.

152. Gilbert of Hoyland, *Sermon on the Song of Songs*, I.2.5, p. 59.

153. Anselm of Canterbury, "Meditations on Lost Virginity," *Opera*, II, pp. 80–3. Hugh of St. Victor, *Soliloquium de arrha anima* (*PL* 176: 951–70) also refers to the soul as having become a harlot.

154. According to Caesarius of Heisterbach, *Homilies* III, "we rightly call the Devil 'scribe,' for he writes down our sins." See Halm, "Der schreibende Teufel," pp. 235–48; see also Rasmussen, "Der schreibende Teufel," pp. 455–64.

155. "Deus qui te genuit dereliquisti et oblitus est domini creatoris tui propterea deus destruet te et elevet te de tabernaculo tuo et radicem tuam de terra viventium."

156. As pointed out by Camille, "Devil's Writing," pp. 355–6.

157. As Woolf, "Theme of Christ the Lover-Knight," pp. 3–4, points out, the expression of God's relationship to Israel in nuptial imagery runs throughout the Old Testament, e.g., Hos. 2:14–20 and Ezek. 16.

158. Eighth Homily on John's Gospel (*PL* 35: 1452) and again in expounding Psalm 44 in *Enarrationes in Psalmos* (*PL* 36: 494–514).

159. On Christ as *medicus*, see Gregory, *Moralia in Job* XXIV.2 (*PL* 76: 287), and Bernard of Clairvaux,

Sermo VI in vigilia Nativitatis Dominum (*PL* 183: 109). The iconographic scheme resembles Elijah resurrecting the widow's son in the Passion window in Le Mans Cathedral; see Mâle, *Religious Art in France*, fig. 101.

160. See Camille, "Him Whom You Have Ardently Desired," fig. 10; Pächt and Alexander, *Illuminated Manuscripts in the Bodleian Library*, III, pp. 28–9, no. 280; Gilbert of Hoyland, *Treatises, Epistles and Sermons*, p. 183.

161. On Munich, Bayerische Staatsbibliothek Clm. 4550, see Swarzenski, *Die Salzburger Malerei*, p. 95; Schiller, *Ikonographie*, IV/1, pp. 102–3. For a discussion of the eight surviving manuscripts containing the pictorial program devised by Honorius for his Songs commentary, see Curschmann, "Imagined Exegesis," pp. 153–4.

162. "Manum suam per formen misit dilectus et ad tactum eius intremuit venter meus."

163. *PL* 172: 390–1, 436; see Endres, *Honorius Augustodunensis*, pp. 134–5.

164. On the wall next to the window: "Leva eius sub capite meo." Next to the enthroned bride: "Dextera illius amplexabitur me."

165. "In exitu israel de egypto domus iacob de populo barbaro. facta est iudea sanctificatio eius, israel potestas eius. Anima me sicut passer erepta est de laqueo venantium. Laqueius contritus est, et nos liberati sumus. Adiutorium nostrum in nomine domini, qui fecit celum et terram. Aspice in me et miserere mei, secundum iudicium diligentium nomen tuum."

166. Camille, "Him Whom You Have Ardently Desired," p. 145; Bernard, *On the Song of Songs*, III, p. 52.

167. As suggested by Hamberger in another context for the Rothchild Canticles, citing Metz, *La consécration des vierges*, pp. 442–3, XXII.6 and 16: "Veni sponsa Christi, accipe coronam, quam tibi Dominus praeparavit in aeternam.... Accipe coronam virginalis excellentiae, ut sicut per manus nostras coronaris in terris, ita a Christo gloria, et honore coronari merearis in coelis."

168. Ibid., p. 445, XXIII.8: "Ecce, quod concupivi iam video, quod sperava, iam teneo."

169. As pointed out by Camille, "Him Whom You Have Ardently Desired," p. 146, who further observes that the artist erased the bottom end of the door jamb to make room for the scroll.

170. See Hamburger, *Rothschild Canticles*, p. 81, who quotes Bernard of Clairvaux, *Sermones in Cantica canticorum* 56.2.3.

171. In the Rothschild Canticles, fols. 18v–19, the *Sponsa* thrusts a lance toward the full-length figure of Christ, who turns toward her and points to the wound in his side. On the meaning of the wound as the gateway

to the *cor salvatoris*, see Hamburger, *Rothschild Canticles*, p. 72.

172. *De perfectione vitae ad sorores* VI.2, quoted from Bonaventure, *Holiness of Life*, pp. 63–4. On a further metaphorical image of the wound in the Gulbenkian Apocalypse, see sup., p. 210.

173. Hamburger, *Rothschild Canticles*, p. 73.

174. For a discussion of the potential ambiguity inherent in the illustrations designed by Honorius Augustodunensis, see Curschmann, "Imagined Exegesis," pp. 153–60.

175. "Anima in contemplatione. fulcice me floribus stepate me malis et nunciate dilecto quia amore langueo. anima mea liquifacta est ut dilectus loctus est."

176. "Veni in ortum meum soror mea sponsa, ut quem prudenter quesiti invenias quam ardentur. Desiderasti videas quia instanter postulasti. Suscipias quam dulciter dilexisti eternis amplexibus ei suaviter adhereas in me delectare dulciter et in me amore transformata, requiesce perhenniter, vulnerasti cor meam soror mea."

177. See Hamburger, *Rothschild Canticles*, p. 108.

178. Moulins, Bibliothèque municipale MS 1, fol. 235. See Cahn, *Romanesque Bible Illustration*, pp. 273–4, no. 76; Labrousse, "Etude iconographique," pp. 402–3.

179. In the Salzburg drawing, the trunk of the tree is inscribed: "Sub arbore malo suscitavi te."

180. Camille, "Him Whom You Have Ardently Desired," p. 139, argues that the three images complete the three stages of anima's progress (humility, piety, and love), described in the exegesis of Bernard of Clairvaux; see also Leclercq, "Le commentaire de Gilbert de Stanford," p. 215. As Camille observes (p. 147), a similar sequence of three episodes illustrates the Songs in the Rothschild Canticles, made in French Flanders ca. 1300, Yale University, Beinicke Library MS 404, fol. 25.

181. Leclercq, *Love of Learning*, pp. 83–5.

182. In the words of the Bernardine *Meditations* (PL 184: 508), "Yesterday in shadows, today in the splendor of light; yesterday in the lion's mouth, today in the hand of the deliverer; yesterday at the gates of hell, today in the delights of paradise."

183. Bernard of Clairvaux, *Epistola* 64 (PL 182: 169): "There one can find a Jerusalem associated with the heavenly one through the heart's complete devotion." See Leclercq, *Love of Learning*, pp. 67–9.

184. Leclercq, "Le mystère de l'Ascension," pp. 81–8.

185. Bernard of Clairvaux, *Sermo de S. Andrea* II.5 (PL 183: 511), quoted by Lecercq, *Love of Learning*, p. 86: "He who wishes to merit reaching the threshold of eternal life, God asks of him only a holy desire."

186. Camille, "Him Whom You Have Ardently Desired,"

p. 149, who quotes from the *Sermon on the Song of Songs*, p. 119.

187. See Metz, *La consécration des vierges*, p. 445.

188. See Camille, "Him Whom You Have Ardently Desired," pp. 152–3, who points to the compelling contemporary example of Dame Juliana of Mount Cornillon, who is reported to have memorized more than twenty of St. Bernard's sermons on the Song of Songs, earlier cited by Leclercq, *Monks and Love*, p. 52.

189. McLaughlin, "Abelard's Rule," p. 284; see Herde, "Das Hohelied," p. 1050; Van den Eynde, "Chronologie des écrits d'Abélard," pp. 337–49.

190. Anstell, *Song of Songs*, p. 77.

191. Bynum, "And Woman His Humanity," pp. 268–9.

192. Ibid., p. 269.

193. Bynum, "Religious Women," p. 136.

194. Bynum, "And Woman His Humanity," pp. 274, 277; id., "Female Body," pp. 162–71.

195. Quoted by Bynum, "Female Body," p. 170, from Angela of Foligno, *Le livre de l'expérience des vrais fidèles: Texte latin publié d'après le manuscrit d'Assise*, eds. M.-J. Ferré and L. Baudry (Paris, 1927), pp. 138–40.

196. Bynum, *Jesus as Mother*, pp. 140–1.

197. Herde, "Das Hohelied," p. 1057.

198. Hamburger, *Rothschild Canticles*, p. 3.

199. See Bynum, "Female Body," p. 186; id., "And Woman His Humanity," p. 277.

200. Bynum, "And Woman His Humanity," p. 279; Hamburger, *Rothschild Canticles*, p. 4.

201. *Moralia* XXXI.45; for a discussion of arboreal imagery in medieval diagrammatical expositions, see M. Evans, "Geometry of the Mind," pp. 38–9.

202. See O'Reilly, *Studies in the Iconography of the Virtues and Vices*, pp. 83–5, 98, 326–30.

203. Bultot, "L'Auteur et la fonction littéraire," pp. 151–2.

204. "Proinde forma quadam visibili differenciam lucis et umbre, sinistre et dextere, carnis et spiritus, superbie et humilitatis ostendam." See ibid., p. 153.

205. Greenhill, *Die geistigen Voraussetzungen*, pp. 78–88.

206. Like the Vices forming the roots of the Tree of Life and Death illustrating Robert de l'Omme's *Miroir de vie et de mort,* dating from 1276, each personification is characterized by an identifying gesture. On Paris, Bibliothèque Ste. Geneviève MS 220, see Boinet, "Les manuscrits à peintures," pl. 15 and pp. 56–7; Mâle, *Religious Art in France,* p. 110. For the text see Långfors, "Le miroir de vie et de mort," pp. 511–31.

207. As, for example, the *Arbor vitiorum* and *Arbor virtutum* in Salzburg, Studienbibliothek MS Sign. V.1.H.162, fols. 75v–76, see Frisch, "Ueber die Salz-

burger Handschrift," pp. 67–71; cf. the Leipzig version on pl. XVI.2. Later, more simplified versions in the *Speculum virginum* are illustrated by Camille, "Him Whom You Have Ardently Desired," figs. 16–17.

208. In contrast with De Hamel, *Apocalypse*, pp. 8–9, who reconstructs the pair in the reverse order, the Tree of Vices should appear at the left, as in other manuscripts, in accordance with the designation "sinistra" given in the pseudo-Hugo text; see Katzenellenbogen, *Allegories of Virtues and Vices*, p. 66.

209. Katzenellenbogen, *Allegories of Virtues and Vices*, p. 76.

210. Bloomfield, *Seven Deadly Sins*, pp. 74–5; L. K. Little, "Pride Goes before Avarice," pp. 31–7.

211. "Orguel est ligermons. de la mort est li trons. Per au larme e nauree et de grace robee. Et par i de ces fruis sont tuit le vii destruit."

212. Benedict of Nursia, *Regula monachorum* 5, 7, 28, pp. 35–52, 138. See L. K. Little, "Pride Goes before Avarice," pp. 39–45.

213. Although the label behind Christ is blank, this figure in *De fructibus* is traditionally labeled "Novus Adam" in contrast to the "Vetus Adam" at the summit of the Tree of Vices.

214. "Virginite florit par le don ihesu crist car il est libiate. Li rois de la cite aime virignite flours et fruis de bonte."

215. Herde, "Das Hohelied," p. 971.

216. As suggested by Morgan, "Burckhardt-Wildt Apocalypse," p. 162, as well as by Camille. On the other hand, an equally plausible argument could be made that the book was made for Renaud de Bar, Prince-Bishop of Metz, or Eleanor, daughter of Edward I, who married Count Henry III de Bar in 1294.

217. Unlike the appended cycles in the Lambeth and Burckhardt-Wildt Apocalypses, the prefatory illustrations in the Eton manuscript are executed by another hand in a different but related style. Because the first eight leaves are physically distinct from the quire structure of the Apocalypse, with a blank verso separating them, both James, *Descriptive Catalogue of the Manuscripts . . . Eton College*, p. 95, and Ker, *Medieval Manuscripts*, II, pp. 772–3, suggested that the two parts of the manuscript were orginally independent and bound together only in the late seventeenth century. However, the close correspondence in the size of the miniatures and the use of some identical colors in both parts of the Eton codex indicate that they most probably originated from the same place at the same time; see Morgan, *Early Gothic Manuscripts*, II, pp. 119–20.

218. Henry, *Eton Roundels*, p. 18.

219. Ibid., p. 19, suggests that the Genesis sequence may have been added after the completion of the rest of the cycle.

220. The foregoing discussion is in no sense intended to duplicate the efforts of Avril Henry's comprehensive iconographical study of the individual pictorial elements comprising the ensemble of roundels on each page. My analysis will deal mainly with questions of narratological coherence within the cycle as a whole and its relation to the illustrated Apocalypse as well as with questions of iconography not raised or fully resolved by Henry. See Henry, Reviewed by Sandler, pp. 796–7.

221. See Henry, *Biblia pauperum*, pp. 8–9; id., *Eton Roundels*, p. 17; for a general discussion of typological imagery, see Bloch, "Typologisches Kunst," pp. 127–42.

222. See James, "Pictor in carmine," pp. 141–66.

223. See Green, "Virtues and Vices," p. 158.

224. See Henry, *Eton Roundels*, p. 20.

225. Although a rare example of the visualization of the Commandments survives in bas-de-page *exempla* in the Princeton manuscript of the *Manuel des Péchés* made for Joan Tateshal sometime between 1280 and 1295 (see Bennett, "Book Designed for a Noblewoman," pp. 163–82), representations of the *decem legis mandata* are usually laid out as composite designs on a single folio, belonging to the same category of diagrammatic imagery as the *Arbor virtutem*; see Laun, *Bildkatechese*, pp. 10–14; Schiller, *Ikonographie*, IV/1, p. 121. The earliest known example in the *Verger de soulas* (Paris MS fr. 9220, fol. 14) from Picardie dates ca. 1290–1300 (see Omont, *Les manuscrits peintures en France*, p. 35, no. 66) and resembles the Decalogue scheme in the somewhat later English version in the Psalter of Robert de Lisle (Arundel 83, Pt. 2, fol. 127v); see Sandler, *Psalter of Robert de Lisle*, pp. 44 and 126, pl. 6. Only the singular mid-fourteenth-century *Concordiae caritatis*, created by the German Cistercian abbot Ulrich of Lilienfeld, includes typological readings of the Decalogue, each on a separate page (Lilienfeld, Zisterzienstift MS 151, fols. 239v–248v); see Laun, *Bildkatechese*, p. 63.

226. Jungmann, *Katechetik*, p. 14. Compendia such as the *Lumière as lais* that included the Commandments, Virtues, Credo, and the Sacraments, along with other brief catechetical tracts, respond to this practice. See Meyer, "Pierre de Peckham," pp. 325–32; Langlois, *La vie spirituelle*, pp. 66–119.

227. For example, the Lothian Bible (Morgan M.791), fol. 4v; the Bible of Robert de Bello (MS Burney 3), fol. 5v; Rutland Psalter (Add. 62925), fol. 8v; Huth Psal-

ter (Add. 38116), fol. 8v; Universal Chronicle (MS Cotton Faustina B.VII), fol. 44v.

228. See Strohm, "Malmesbury Medallions," p. 185.

229. Alnwick Castle, Collection of the Duke of North-umberland MS 447, fol. 2; see Morgan, *Early Gothic Manuscripts*, II, pp. 85–6, fig. 91; Millar, *Thirteenth-Century Bestiary*.

230. As suggested by Henry, *Eton Roundels*, p. 105.

231. See Wormald, "English Eleventh-Century Psalter," pp. 8–9, who cites three other contemporary Anglo-Saxon examples: Roy. 1.E.VII, fol. 1v; the Eadui Gospels (Hanover, Kestner Museum WM XXIa 36), fol. 9v; and a Psalter from Bury St. Edmunds in Vat. Reg. lat. 12, fol. 68v; see also Heimann, "Three Illustrations from the Bury St. Edmunds Psalter," pp. 46–56.

232. Vienna, Nationalbibliothek MS 2554, fol. 1; see J. B. Friedman, "Architect's Compass," pp. 419–29.

233. James, *Descriptive Catalogue of the Manuscripts . . . Eton College*, p. 95; Morgan, *Early Gothic Manuscripts*, II, p. 120; cf. Henry, *Eton Roundels*, p. 107.

234. For example, Cambridge, University Library MS Dd.8.12, fol. 12; Oxford, Bodleian Library MS Auct. D.4.8, fol. 17; the Bible of William of Devon (Roy. 1.D.I), fol. 5; Morgan MS Glazier 42, fol. 6; Oxford, All Souls MS 2, fol. 6; and Ripon Cathedral MS 1, fol. 5.

235. Augustine, *De Genesi ad litteram* (PL 34: 245).

236. *PL* 210: 579: "Omnis mundi creatura / Quasi liber, et pictura / nobis est, et speculum."

237. Such an ordering process responds literally to the dictum of Hugh of St. Victor, *Didascalicon* V.2; see Illich, *Vineyard of the Text*, pp. 32–3.

238. See Ladner, *Idea of Reform*, pp. 222–38; McEvoy, *Philosophy of Robert Grosseteste*, pp. 416–17; F. E. Robbins, *Hexaemeral Literature*, p. 72 and no. 2; Jones, "Some Introductory Remarks," pp. 157–8, 191–8.

239. See Ladner, *Idea of Reform*, pp. 230–1.

240. See Schapiro, "Cain's Jawbone," pp. 205–12; Henderson, "Cain's Jaw-Bone," pp. 108–14.

241. In an allusion to the separation of the sheep from the goats in Matt. 25:32, Gregory, *In Primum Regum expositiones IV* 5.9 (PL 79: 286), asserts that "Per haedos, peccatores significantur."

242. Jerome, *In Mattheum* 25.31 (PL 26: 196); Isidore of Seville, *Etymologiae* XII.1 (PL 82: 426); Pseudo-Hugo of St. Victor, *De bestiis* III.16 (PL 177: 89).

243. Augustine, *Sermo XIX*.3 (PL 38: 133) and *Contra Faustum* XVIII.6 (PL 42: 347; Hrabanus Maurus, *Allegoriae in sacram scripturam* (PL 112: 952, 954); Rupert of Deutz, *De Trinitatis* III.6 (PL 167: 616).

244. See Wehrhahn-Stauch, "Bock," col. 316.

245. See James, "On Two Series of Paintings," pp. 99–110; Wilson, "On Some Twelfth-Century Paintings,"

pp. 132–48. Although Tristram, *English Medieval Wall Painting: Twelfth Century*, pp. 155–6, notes that the upper arcade still retains traces of painting, it is impossible to determine whether the scenes were painted on the vaults or depicted in glass windows. Although the painted or glass images were destroyed when the large Perpendicular glass panels were inserted into the Norman structure in the late fourteenth century, a record of their subjects survives in a set of verses added ca. 1200 on the last leaf of a copy of St. Jerome's commentary on the Psalms, MS F.81 in the Cathedral Library at Worcester; see Floyer and Hamilton, *Catalogue of Manuscripts . . . Worcester Cathedral*, p. 41. Written under the title *Versus capituli in circuitu domus*, the Worcester Chapter House verses describe the same forty subjects as those in Eton 177; in twenty-five cases, the verses are identical, whereas the others refer to the same typologies.

The Worcester cycle or its model was copied many times, as attested by the selection of images and verses inscribed on the Morgan, Balfour, and Warwick ciboria, all very probably made in the same workshop and dating from the third quarter of the twelfth century; see Stratford, "Three English Romanesque Enamelled Ciboria," pp. 204–16. Shortly before the destruction of the Chapter House at Worcester, many of its typological scenes were copied in the misericords carved for the new choir stalls made in 1379; see T. Cox, "Twelfth-Century Design Sources," pp. 165–78. A few decades later, ca. 1396–1407, Johannes Siferwas incorporated a selection of the Worcester typological images and verses in a series of full-page miniatures painted for the Sherborne Missal; see Rickert, *Painting in Britain*, pp. 163–5, pl. 165; Herbert, *Sherborne Missal*.

246. Bede the Venerable, *History of the Abbots of Wearmouth and Jarrow*, III, pp. 375–6; Meyvaert, "Bede and the Church-Paintings," pp. 63–77.

247. The typological program in the thirteenth-century choir stall of Peterborough Cathedral is also lost but preserved in pictorial copies in the fourteenth-century Peterborough Psalter (Brussels, Bibl. Roy. MS 9961–2); see Sandler, *Peterborough Psalter*; James, "On the Paintings Formerly in the Choir at Peterborough," pp. 178–94; Sandler, "Peterborough Abbey," pp. 36–49.

On the resurgence of scholarship in the great age of monasticism during which the typological tradition flourished, see Knowles, *Evolution of Medieval Thought*, pp. 69–149. On the Canterbury glass program, see Caviness, *Early Stained Glass*, pp. 115–16, 168–74; id., *Windows of Christ Church*, pp. 77–156. Although, like that at Worcester, most of the Canter-

bury glass has been lost, the verse inscriptions have survived in three manuscripts: the fourteenth-century roll in MS C246 in the Cathedral library at Canterbury; Cambridge, Corpus Christi MS 400; and Oxford, Corpus Christi MS 256.

248. James, "Pictor in carmine," pp. 141–66. Toward the end of the thirteenth century, the closely related *Rota in medio rotae* was compiled in a Benedictine monastery in Austria and disseminated in unillustrated manuscripts from the fourteenth and fifteenth centuries; see Röhrig, "Rota in medio rotae," pp. 7–113. Under the impact of the new scholasticism, the great symbolic compositions of the Gothic stained-glass windows in France dominated the first half of the thirteenth century, culminating in the extended glass program in the choir of the upper basilica at Assisi, ca. 1240–60; see Wentzel, "Die ältesten Farbfenster," pp. 45–72; Haussherr, "Der typologische Zyklus," pp. 95–128. As Mâle, *Religious Art in France,* pp. 41–2, 140–55, has shown, however, much of the typological allegory was drawn from the *Speculum ecclesiae* of Honorius Augustodunensis, written at the beginning of the twelfth century but still widely read in the thirteenth.

249. Esmeijer, *Divina Quarternitas*, p. 58; Röhrig, "Rota in medio rotae," p. 55. In such compendia as the *Biblia pauperum* formulated in the late thirteenth century, the role of typological and visual exegesis was being taken over by emblem books in which the old themes continued to survive; Schmidt, *Die Armenbibeln*, pp. 77–87, dates the lost ancestor of all three manuscript families of the *Biblia pauperum* ca. 1250; cf. Cornell, *Biblia pauperum*, pp. 152–3.

250. Indeed, as Henry, *Eton Roundels*, p. 20, points out, the continuous propulsion of the striding prophets seems to evoke the processional sequence of prophesying figures from the Latin liturgical plays known under the collective title of the *Ordo prophetarum*; see Young, *Drama of the Medieval Church*, II, pp. 125–71;

251. This and all the other inscribed texts are transcribed in Henry, *Eton Roundels*, pp. 144–53. The star of Bethlehem was frequently associated with the star of Jacob prophesied by Balaam (Numbers 24:17); see Schiller, *Iconography*, I, p. 96. The Magi were even called the descendants of Balaam by Gregory of Nyssa (*PG* 44: 6).

252. Both distinctive locutions, *lapis angularis* and *regum Iudaeorum*, stem from Augustine, *Enarrationes in Psalmos* XLVII.2.34–8 and XCVII.14.25. The Worcester inscription reads: "Deus est et homo lapis idem / Qui de matre patrem, que nescit de patre matrem."

253. With Daniel 2:45, the mother of God is invoked as the "unhewn mountain:" "Just as you saw that a stone was cut from a mountain by no human hand . . . a great God has made known to the king . . . the coming of the Kingdom of God." According to a canon text of the orthodox Nativity liturgy, as the stone was separated from the mountain, Christ was separated from the Virgin, without the hand of man; see Onasch, *Das Weinachtsfest*, p. 179. At Canterbury, the typology was inscribed: "Ut regi visus lapis est de monte recisus, sic gravis absque viro virgo patit ordine miro"; see Caviness, *Windows of Christ Church*, p. 85. Similarly, in a standard thirteenth-century formula where Moses sees Christ visible within the burning bush, the border inscription declares that, just as the bush was not consumed by the flames, so also was the virginity of Mary left intact at the birth of Christ; see Harris, "Mary in the Burning Bush," pp. 281–6; Vetter, "Maria im brennenden Dornbusch," pp. 237–53. Aaron's rod sprouting forth blossoms was also commonly read as a type for the virgin birth; see Origen, *Homilia in Numerum* IX.7 (*PG* 12: 632).

254. For example, in the socle relief at Amiens; see Mâle, *Religious Art in France,* fig. 105.

255. See, for example, the historiated initial on fol. 21 in the Glazier Psalter (Morgan MS Glazier 42); Morgan, *Early Gothic Manuscripts*, II, fig. 212.

256. Also at Worcester, as well as in the *Pictor in carmine* XVI and the *Biblia pauperum*, the scene is frequently represented in thirteenth-century English Bibles and Psalters, for example, Morgan M.791, fol. 74v; Morgan M.43, fol. 15v; Bodleian MS Auct. D.4.8, fol. 144; and Cambridge, Jesus College MS Q.A.11, fol. 68v.

257. There is some evidence that the Eton designer modified his model to stress the unveiling of the empty altar by omitting the pictorial references of Hannah's offerings, although no mention of them is made in the Worcester inscription. As T. Cox, "Twelfth-Century Design Sources," pp. 169–70, pl. LII, points out, in the late fourteenth-century choir seats, Hannah carries a wine amphora that, along with the oxen and measures of flour depicted at Peterborough and Canterbury, constituted her offering. Above the miniature in the Peterborough Psalter, as well as in the elaborate representation in the Canterbury glass, one reads: "Significat Dominum Samuel puer, amphora vinum. . . ." See Caviness, *Early Stained Glass*, fig. 60.

258. As the Purification of the Virgin (February 2) was celebrated in the Western Church as Candlemas (*festum candelarum* or *luminum*), a candlestick on the altar or carried by one or two of the figures assisting at the ceremony became customary in late twelfth-

and thirteenth-century representations of the Presentation, as in the north choir aisle window at Canterbury; see Caviness, *Early Stained Glass*, pp. 133–4. See Schorr, "Iconographic Development of the Temple Presentation," p. 27.

259. A typological image for the Last Supper is given in the *Biblia pauperum* and the Verdun Altar, where the priest-king of Salem appears alone before a vested altar. See Röhrig, *Der Verduner Altar*, pp. 71–2; Buschhausen, *Der Verduner Altar*, p. 44 and pl. 19. Abraham's meeting with Melchisedek appears in another panel as a type for the Adoration of the Magi; Röhrig, *Der Verduner Altar*, pp. 66–7 and fig. 11. The Eton miniature thus offers a composite image based on Gen. 14:18–20, as in a Mosan Psalter fragment in Berlin, Staatliche Museen MS 78.A.6, fol. 2. The inscription reads: "Te signat christe panis quem contulit iste / Sic quod in ede patris fieres ablacio matris."

260. "Hostia preclara christus puer, agnus et ara / His presentatur symeon vidit et recreatur." The Eton inscription, in contrast, reads: "Offert allatum symeon de virgine natum / Quem sic venturum precinit et hunc moriturum."

261. Throughout the Middle Ages commentators on Job 38:32 designated the "bringer of light" as Christ. Hrabanus Maurus, *Allegoriae in sacram scripturam* (*PL* 112: 989): "Lucifer est Christus, ut in Job: 'Producis Luciferum in tempore suo,' id est, Christum in plenitudine temporis." Also Garnerus of St. Victor, *Gregorianum* VIII.44 (*PL* 193: 43): "Luciferi nomine Unigenitus Dei designatur. . . . Qui natus ex Virgine velut Lucifer, inter tenebras nostrae noctis apparuit, quia fugata obscuritate peccati, aeternum nobis mane nuntiavit."

262. "Archa columba noe vindex aqua corvus oliva / Sunt [tipus] ecclesie lavacri sunt flumina viva."

263. Going back to Ambrose, the Crossing of the Red Sea forms an old typology for the removal of sin through Baptism, representing the beginning of a new life, as announced in the inscribed verses proclaiming the "baptism of the Jews" *(baptismus hebrei)*. Moses stands in prayer, triumphant over a horse pulling a chariot filled with doomed Egyptians as it plunges into the sea.

264. See James, "On Two Series of Paintings," p. 102.

265. Indeed, the image of the Virgin baring her breast occurs in the introductory verses transcribed from the Worcester chapter House: "Stat cum prole pia virgo depicta Maria / Lactans infantem celi terraque tonantem / Cum quia mamillam genitrix dedit esaurienti / Pro genitrice dabit maxillam percutienti."

266. See *Meditations on the Life of Christ*, p. 44. However, in the unique fourteenth-century Italian repre-

sentation of the Virgin performing the circumcision (Paris MS ital. 115, p. 42), she does not offer the child her breast. T. Cox, "Twelfth-Century Design Sources," p. 171, cites English examples in a roof boss at Salle, Norfolk, and in the glass of St. Peter Mancroft, Norwich.

267. Bernard of Clairvaux, *Sermo in Circumcisione Domini* (*PL* 183: 189).

268. *PL* 25: 342–44, 1517.

269. On the evidence of the twelfth-century ciboria, the representation of Christ Carrying the Cross probably follows the Worcester model very closely, but the Eton verses have been changed Cf. James, "On Two Series of Paintings," p. 102.

270. *Speculum Gy de Warewycke*, ll. 569–71:

> For we scholde ensaumple take
> To be suffraunt [i.e., patient] in everi stede
> Riht as oure Lord himselve dede.

See O'Reilly, *Studies in the Iconography of the Virtues and Vices*, pp. 265–6.

271. James, "Pictor in carmine," p. 161, no. XCIX; Mâle, *Religious Art in France*, p. 147; *Glossa ordinaria* (*PL* 113: 606–7). See Green, "Typological Crucifixion," pp. 20–3.

272. This scene was called for in the *Pictor in carmine* and was depicted in one of the lost typological windows at Canterbury.

273. See Fleming, *From Bonaventure to Bellini*, pp. 99, 112, 114–15.

274. Mâle, *Religious Art in France*, pp. 193–4. The idea of the Crucifixion's vindication of Adam's guilt was by this time both ancient and well entrenched in twelfth- and thirteenth-century exegesis; see the *Glossa ordinaria in Marcam* XV; Honorius Augustodunensis, *Hexaemeron* VI; Vincent of Beauvais, *Speculum historiale* I.56 and VII.45; *Golden Legend* LIII.

275. See Mâle, *Religious Art in France*, p. 188; Grodecki, *Gothic Stained Glass*, pp. 86–7, 111–12, 259, figs. 74 and 99. Although two Cherubim flank the Crucifixion in the prologue miniature in the contemporary Bible of William of Devon (MS Roy. 1.D.I, fol. 1), and the following Genesis initial (fol. 4v) carries a conventional sequence of roundels leading from Creation to the Crucifixion (see Morgan, *Early Gothic Manuscripts*, II, p. 152 and fig. 298), no direct English precedent can be found for the Eton image.

276. *PL* 113: 415.

277. In the Eton roundel, the presence of the widow "Sereptena" deviates from the biblical narrative, which specifies that she did not witness the miraculous resuscitation. Her reappearance, however, reminds the viewer of her first encounter with Elijah in the upper

left roundel on the opposite page. She first held the prefiguration of Christ's cross as an emblem of her faith in its salvific power; the story now concludes with a demonstration of that power as Elijah raises her son. Most importantly, she is there to witness the event. At the lower left, Jacob points to Christ's blood being caught in a chalice by Ecclesia, declaiming, "He washes his garments in wine" (Gen. 49:11), perhaps also in reference to the red tunic held by the angel at the Baptism, as Nahum points to the resurrection of the widow's son.

278. *Ancrene Riwle*, trans. Salu, pp. 177–8.

279. Mâle, *Religious Art in France*, p. 152 and fig. 21, who cites the Easter sermon in *Speculum ecclesiae* (*PL* 172: 935).

280. James, "Pictor in carmine," p. 163: "Cetus Jonam evomit vivum in siccum litus contra Nineven."

281. In a typology that in the thirteenth century offered a symbol of the Resurrection, as at Chartres, based on the *Glossa ordinaria* (*PL* 113: 532; see Mâle, *Religious Art in France*, p. 151 and fig. 102), the episode also served as a type for the *Descensus*, as in the *Bible moralisée*; Oxford, Bodl. 270b, fol. 117v, where the lower roundel is explained: "Hoc significat quod christus spoliato inferno; cum spoliis in ammabus sanctis celorum regna ascendendo penetravit." See Laborde, *La Bible moralisée*, pl. 117. The Eton verses read: "Ablatis portis sampson gazam spoliavit / Infernum spolians christus celum penetravit" (Henry, *Eton Roundels*, p. 20).

282. See Schapiro, "Image of the Disappearing Christ," pp. 135–52. The "disappearing" Christ may have been given in the Worcester model, as suggested by the verse: "Quo caput ascendo, mea membra venite sequendo." In the twelfth-century Balfour Ciborium (see Stratford, "Ciboria," fig. 33), Christ's head is disappearing into the clouds as his body is clearly levitating upward off the ground.

283. James, "Pictor in carmine," p. 163: "Hircus emissarius portans peccata populi vadit in desertum." Cf. Hrabanus Maurus, *Allegoriae* (*PL* 112: 954–5): "Hircus est Christus ut in Levitico hircus emissarius peccate populi portabat."

284. See, for example, MS Roy. 12.C.XIX, fol. 31v; Payne, *Medieval Beasts*, p. 41; McCulloch, *Medieval Latin and French Bestiaries*, pp. 120–1.

285. As evoked in a twelfth-century drawing of the Crucifixion as symbol for Synagoge opposite the widow of Sarepta who personifies Ecclesia; see Schiller, *Iconography*, II, p. 139 and fig. 431. Synagogue frequently carries or is accompanied by a he-goat embodying the sin-offering from Leviticus. In this respect, however, the Eton image is clearly based on the Bestiary account of the wild goat, which, when injured, sought a medicinal herb *(dittany)*; Payne, *Medieval Beasts*, p. 41.

286. Blumenkranz, *Le juif médiévale*, p. 110.

287. See Camille, *Gothic Idol*, p. 178.

288. As in the Missal of Henry of Chichester (Manchester, John Rylands University Library MS lat. 24, fol. 153); see Morgan, *Early Gothic Manuscripts*, II, fig. 20; see also Edwards, "Some English Examples," p. 73, who cites the inscription on the reliquary of St. Eleutherius at Tournai, ca. 1243, where the figure overturning the chalice is described as "turning scornfully from the Savior whose precious blood she rejects"; see Warichez, *La Cathédrale de Tournai*, p. 79.

289. Abrahams, "Decalogue in Art," p. 19, cites an illustration in a French Hebrew manuscript from the end of the thirteenth century (MS Add. 16639, fol. 741v) in which Moses holds the tablets of the Law in the scene of the budding of Aaron's rod.

290. Victorinus, *Commentarius in Apocalypsim*, p. 130: "Modo ergo facies Moysi aperitur et revelatur ideoque apocalypsis revelation dicitur." The unveiling of Moses thus provided a dramatic full-page allegorical image that served as the frontispiece to the Apocalypse in two great ninth-century Carolingian Bibles in Paris and Rome, and even more appropriately, as the last page in the Moutier-Grandval Bible, B.L. MS Add. 10546, fol. 449; see Van der Meer, *Maiestas Domini*, pp. 164–5; Kessler, *Illustrated Bibles from Tours*, pp. 73–4 and pls. 107–9.

291. Honorius Augustodunensis, *Gemma animae* III.46 (*PL* 172: 657): "Hoc velamen est adhuc super corda Judaeorum positum, et ideo non valent videre splendidum legis sensum. . . . Ideo et in passione Christi velum templi scinditur, quia per ejus mortem in nobis coelum et liber septem signaculis clausus aperitur."

292. See Seiferth, "Veil of Synagogue," pp. 385–7; Grodecki, "Vitraux allégoriques," pp. 19–35; Hoffmann, "Sugers 'anagogisches Fenster,' " pp. 57–88. Another variant of the symbol of the veil as an expression of eschatological expectation occurred in another window (now lost) at St. Denis in which Christ lifts the veil covering the head of Moses as he addresses the Israelites.

293. See, for example, Grodecki, "Vitraux allégoriques," p. 32, who cites Tours, Bibliothèque Municipale MS 193, a mid-twelfth-century French Missal where Ecclesia presents a chalice and host, whereas Synagogue offers the Tablets of the Law to a blessing Christ, as the hand of God above removes her veil. In the Lambeth Bible's distinctive rendering of the Tree of Jesse (Lambeth Palace Library MS 3, fol. 198), the veil is lifted as Synagogue stands between Moses and Aaron; see Kauffmann, *Romanesque Manuscripts*, fig. 195; Dodwell, *Great Lambeth Bible*, p. 26.

294. Cited and illustrated by Blumenkranz, "Géographie historique," p. 1147. The image is accompanied by a marginal legend, "Deus aufert velamen ab oculis sinagoge."

295. Hoffmann, "Sugers 'anagogisches Fenster,'" p. 71 and n. 198, who cites William of St. Denis; see Mâle, *Religous Art in France,* fig. 125.

296. Grodecki, "Vitraux allégoriques," p. 34.

297. *PL* 114: 64. See Mâle, *Religious Art In France,* fig. 118.

298. As pointed out by Cornell, *Biblia pauperum,* p. 249; see Cahn, *Romanesque Bible Illustration,* pp. 210 and 265, no. 46. Ezekiel's vision serves as a typology for the ascension, heading John's Gospel.

299. *PL* 207: 856, cited by Schlauch, "Allegory of Church and Synagogue," pp. 460–1.

300. On Malachi as the prophet of the New Covenant, see Jerome, *Commentariorum in Malachiam prophetam* (*PL* 25: 1541–78).

301. As in the Canterbury windows or the Verdun Altar where the queen's servant kneels to underline the theological sense of the scene; see Watson, "Queen of Sheba," p. 19, who cites the commentaries of Isidore and Bede.

302. Isidore of Seville, *Allegoriae quaedam scripturae sanctae* 91–2 (*PL* 83: 113): "Solomon Christi praenuntiat figuram qui aedivicat domum Deo in coelesti Jerusalem . . . Regina Austri, quae venit ad audiendam sapientiam Salomonis, Ecclesia intelligitur."

303. Bede, *Quaestiones super Regem libros* III.5 (*PL* 93: 446).

304. See Watson, "Queen of Sheba," p. 117 and fig. 42.

305. The rare scenes of the Unveiling of Synagogue and the Triumph of the Church also appeared, accompanied by the same verses but without the typologies, on a retable that stood in the abbey church of Bury St. Edmunds, suggesting a Benedictine source for the imagery.

306. Gerhoh of Reichersberg, *De gloria et honore Filii Hominis* 10.1 (*PL* 94: 1105; Rupert of Deutz, *De operibus Spiritu Sancto* 1.7 (*PL* 167: 1577), cited by Verdier, *Le couronnement,* p. 37.

307. Verdier, *Le couronnement,* pp. 33–4.

308. As in the miniature for the Canon of the Mass in the gradual and Sacramentary made for Weingarten Abbey ca. 1225 in the Morgan Library, but the association of the two themes is rare. See ibid., p. 17 and fig. 1; also cited is an English example in the tympanum of the south portal in the parish church at Quenington (Gloucestershire), ca. 1140.

309. *Glossa ordinaria* (*PL* 113: 1160): "Dum sic sponsus, vel ipsa Ecclesia, labores suos evangelicos Synagogae miranti praedicat: illa salubri poenitudine compuncta, profitetur se causa profanae caecitatis diutius

aberrasse." MS Bodl. 270b, fol. 132: "Archa significat sanctam ecclesiam, plaustrum cum quatuor rotis iiii evangelistas." According to I Kings 7:1 and II Kings 6:3, the Ark of the Covenant remained in the house of Aminadab after the Philistines had returned it; twenty years later it was taken from there to the temple in Jerusalem. Thus, the name Aminadab remained attached to the chariot, which in the High Middle Ages became an allegory of the Church.

310. Oxford, Bodleian Library MS 270b, fol. 132; see Laborde, *La Bible moralisée,* I, pl. 132.

311. Paris, B.N. MS lat. 11560, fol. 86: "Vox synagoge domini christe praedicat synagoga admirans labore evangelii."

312. See Mâle, *Religious Art in France,* fig. 126 and p. 180; Grodecki, "Vitraux allégoriques," pp. 27–9; Hoffmann, "Sugers 'anagogisches Fenster,'" pp. 65–9.

313. *PL* 79: 532 and *PL* 16: 290.

314. See Honorius Augustodunensis, *Expositio in Cantica canticorum* III (*PL* 172: 454–5; Peter Damian, *Sermo* XIV (*PL* 144: 573–4); Rupert of Deutz, *De Trinitate* (*PL* 167: 1126–7).

315. As pointed out by Grodecki, "Vitraux allégoriques," pp. 28–9, who discusses a closely related group of Salzburg miniatures dating from ca. 1150 in Vienna, B.N. MS lat. 942, and Munich, Clm. 5118 and Clm. 4550, to which can be added Baltimore, Walters Art Gallery MS 29; see *The Year 1200,* I, no. 280. See also Schiller, *Ikonographie,* IV/1, p. 103.

316. "QVE FUIT INMITIS MANSUETA REDIT SUNAMITIS. HEC PRIUS ABIECTA REGNAT CAPTIVE REVECTA."

317. Honorius Augustodunensis, *Sigillum Beatae Mariae* VI (*PL* 172: 512): "Anima mea turbavit me, id est aemulatio legis quam pro anima mea habui, ipsa docuit me facere, et hoc contingit propter quadrigas Aminadab, id est propter Christi Evangelia, ut a me repulsa, imo impulsa ruerent per mundi climata. O Sunamitis jam diu a diabolo captiva, revertere per fidem ad Christi mysteria."

318. As Verdier, *Le couronnement,* pp. 9–10, points out, the Last Judgment and Coronation form a monumental diptych of complementary images on the cathedral facades at Laon, Paris, and Amiens, echoing the facing pages of miniatures in the Ingeborg Psalter (Chantilly, Musée Condé MS 1695), fol. 33v–34.

319. Honorius Augustodunensis, *Speculum ecclesiae* (*PL* 172: 1077): "Tunc Ecclesia Christi sponsa, diu in peregrinatione Babylonis oppressa, de exilio Babyloniae a Sponso suo educetur et cum magno angelorum tripudio in civitatem Patris sui coelestem Hierusalem introducetur."

320. In the Canterbury windows and the Peterborough Psalter, they appear with the Visitation, accompanied

by similar verses; see Caviness, *Windows*, pp. 84–5.

321. Jerome, *Breviarium in Psalmos* (PL 26: 1077).

322. For example, Hugh of St. Victor, *Miscellanea* (PL 177: 623–5; Peter Comestor, *De adventu Domini* (PL 198: 1736–7). As Owst, *Pulpit and Literature*, pp. 90–1, points out, homiletic favorites of the thirteenth and fourteenth centuries, such as Grosseteste's *Chasteau d'amour*, the *Meditationes vitae Christi* attributed to St. Bonaventure, and the *Cursor mundi*, all helped to popularize this allegorical "interlude" of the Four Virtues for the benefit of English sermon audiences.

323. Bernard of Clairvaux, *Sermo in Festo Annuntiationis Beatae Virginis* (PL 183: 383–90).

324. Dodwell, *Canterbury School of Illumination*, pp. 89–90; id., *Great Lambeth Bible*, p. 26, who ascribes the manuscript on circumstantial evidence to Canterbury, ca. 1150. The meeting of the Virtues is illustrated in the ninth-century Utrecht Psalter (De Wald, *Utrecht Psalter*, pl. LXXVII), which was known to be at Canterbury ca. 1000, where it probably served as the model for the representation in the Anglo-Saxon Psalter now in the Vatican Library, MS Reg. lat. 12, fol. 92.

325. James, "On Two Series of Paintings," p. 104: "De Iudea et gentilitate."

326. The accompanying text was perhaps intended as an allusion to Mark 3:8: "From Judaea, Jerusalem, Idumaea . . . great numbers had heard of all [Christ] was doing and came to him."

327. See Grodecki, "Vitraux allégoriques," p. 35.

328. James, "On Two Series of Paintings," p. 100.

329. For an illuminating discussion of analogous Byzantine representations of the clipeate icon of Christ on the cross, see Corrigan, *Visual Polemics*, pp. 72–5 and fig. 86.

330. On Aquinas's metaphor of the seal impression, see Carruthers, *Book of Memory*, p. 55.

EPILOGUE

1. Riffaterre, "Mind's Eye," p. 30.
2. Ibid., p. 32.
3. Bloch, *Etymologies*, p. 12.
4. Ong, "Orality, Literacy, and Medieval Textualization," pp. 1–12.
5. Bloch, *Etymologies*, p. 15.
6. Stock, "Medieval Literacy," p. 27.
7. Cerquiglini, *Eloge de la variante*, p. 111.
8. Leicester, "Oure Tonges *Différance*," pp. 18–19.
9. See ibid., pp. 17, 24.
10. Travis, "Affective Criticism," p. 204.
11. Ibid., pp. 208–9.
12. Ibid., p. 213.
13. Nichols, "Philology in a Manuscript Culture," p. 8.

Bibliography

I. EDITIONS, FACSIMILES, AND TRANSLATIONS OF ANCIENT AND MEDIEVAL WORKS

Abelard, Peter. *Historia calamitatem.* Translated by Betty Radice. In *The Letters of Abelard and Heloise,* pp. 57–106. Harmondsworth: Penguin, 1974.

Adgar. *Le Gracial.* Edited by Pierre Kunstmann. Ottawa: Editions de l'Université d'Ottawa, 1982.

Ælfric. *The Homilies of the Anglo-Saxon Church: The Sermones Catholici or Homilies of Ælfric.* 2 vols. Edited and translated by Benjamin Thorpe. London: Ælfric Society, 1844.

Aelred of Rievaulx. *Opera omnia.* Edited by A. Hoste and C. H. Talbot. Corpus Christianorum, Continuatio medievalis I. Turnhout: Brepols, 1971.

Alain de Lille. *De incarnatione Christi.* Edited by J.-P. Migne. In *PL* 210: 577–80. Paris: J.-P. Migne, 1855.

De planctu naturae. Edited by Thomas Wright. In *The Anglo-Latin Satirical Poets and Epigrammatists of the Twelfth Century,* II, pp. 429–522. London: Rolls Series, 1872.

De sex aliis cherubim. Edited by J.-P. Migne. In *PL* 210: 266–80. Paris: J.-P. Migne, 1855.

Albertus Magnus. *Alberti operi.* 38 vols. Edited by Auguste Borgnet. Paris: Vivès, 1890–9.

Opera omnia. 37 vols. Edited by H. Kuhle et al. Aschendorff: Monasterii Westfalorum, 1900–78.

Alcher de Clairvaux. *Admonitio in librum de spiritu et anima.* Edited by J.-P. Migne. In *PL* 40: 779–832. Paris: Garnier fratres et J.-P. Migne, 1887.

Alcuin of York. *Commentaria in sancti Joannis Evangelium.* Edited by J.-P. Migne. In *PL* 100: 733–1006. Paris: J.-P. Migne, 1863.

Alexander Minorita. *Expositio in Apocalypsim.* Edited by Alois Wachtel. Momumenta Germaniae Historica, Quellen zur Geistesgeschichte des Mittelalters I. Weimar: H. Bhlaus, 1955.

Ambrose, St. *De virginitate.* Edited by J.-P. Migne. In *PL* 16: 279–316. Paris: Garnier fratres et J.-P. Migne, 1880.

Ancrene Riwle. Translated by M. B. Salu. Notre Dame, IN: University of Notre Dame Press, 1956.

Ancrene Riwle, The Nun's Rule. Translated by James Morton. London: Chatto and Windus, 1924.

An Anglo-Norman Rhymed Apocalypse with Commentary. Edited by Olwen Rhys. Anglo-Norman Text Society 6. Oxford: Blackwell, 1946.

Annales Henrici quarti, regum Angliae. Edited by H. T. Riley. In *Chronica monasterii S. Albani,* III, pp. 282–420. London: Rolls Series, 1866.

Annales Monastici. 5 vols. Edited by H. R. Luard. London: Rolls Series, 1864–9.

Anselm of Canterbury. *Opera omnia.* 2 vols. Edited by F. S. Schmitt. Stuttgart: Frommann, 1968.

Prayers and Meditations. Translated by Benedicta Ward. Harmondsworth: Penguin, 1973.

Anselm of Havelberg. *Dialogi.* Edited by J.-P. Migne. In *PL* 188: 1139–1248. Paris: Garnier fratres et J.-P. Migne, 1890.

Apocalypse of Golias. Translated by F. X. Newman. In *The Literature of Medieval England,* edited by D. W. Robertson, pp. 253–61. New York: McGraw-Hill, 1970.

Edited by Thomas Wright. In *The Latin Poems Commonly Attributed to Walter Mapes,* pp. 1–20, 271–92. Camden Society 17. London: 1841.

Die Apokalypse des Golias. Edited by Karl Strecker. Texte zur Kulturgeschichte des Mittelalters 5. Rome: N. Regenberg, 1928.

Augustine of Hippo, St. *Augustine: Later Works.* Translated by John Burnaby. Philadelphia: Westminster, 1955.

———. *City of God.* Translated by Henry Bettenson. Harmondsworth: Penguin, 1972.

———. *Confessions.* Translated by Edward B. Pusey. New York: Carleton, 1949.

———. *Contra Faustum Manichaeum libri XXXIII.* Edited by J.-P. Migne. In *PL* 42: 207–518. Paris: Garnier fratres et J.-P. Migne, 1886.

———. *De civitate Dei.* Edited by E. Hoffmann. Corpus Scriptorum Ecclesiasticorum latinorum 40. Vienna: Hoelder-Pichler-Tempsky, 1908.

———. *De Genesi ad litteram libri XII.* Corpus Scriptorum Ecclesiasticorum latinorum 27, pt. 1. Vienna: Hoelder-Pichler-Tempsky, 1894.

———. *De Genesi ad litteram libri XII.* Edited by J.-P. Migne. In *PL* 34: 245–466. Paris: Garnier fratres et J.-P. Migne, 1887.

———. *Enarrationes in Psalmos.* Edited by J.-P. Migne. In *PL* 36–7. Paris: J.-P. Migne, 1865.

———. *In Joannis Evangelium tractatus CXXIV.* Edited by J.-P. Migne. In *PL* 35: 1379–976. Paris: Garnier fratres et J.-P. Migne, 1902.

———. *Letters.* Translated by Wilfrid Parsons. Washington: Catholic University of America Press, 1956.

———. *Sermones de scripturis.* Edited by J.-P. Migne. In *PL* 38: 23–994. Paris: J.-P. Migne, 1865.

———. *Sermones de tempore.* Edited by J.-P. Migne. In *PL* 35: 995–1248. Paris: J.-P. Migne, 1865.

———. *Tractatus adversus Judaeos.* Edited by J.-P. Migne. In *PL* 42: 51–64. Paris: Garnier fratres et J.-P. Migne, 1886.

Bacon, Roger. *Compendium studii philosophiae.* Edited by J. S. Brewer. In *Opera quaedam hactenus inedita*, I, pp. 393–519. London: Rolls Series, 1859.

———. *Opera hactenus inedita Rogeri Baconi.* Edited by Robert Steele and F. Delorme. Oxford: Clarendon, 1920.

———. *Opus maius.* 3 vols. Edited by J. H. Bridges. Oxford: Clarendon, 1897–1900.

———. *Part of the Opus tertium of Roger Bacon.* Edited by A. G. Little. British Society of Franciscan Studies 4. Aberdeen: Aberdeen University Press, 1912.

Baldwin of Canterbury. *Tractatus varii.* Edited by J.-P. Migne. In *PL* 204: 403–572. Paris: J.-P. Migne, 1855.

Beatus of Liébana. *In Apocalypsin libri duodecim.* Edited by Henry A. Sanders. Papers and Monographs of the American Academy in Rome 7. Rome: American Academy, 1930.

Bede the Venerable. *Ecclesiastical History of the English People.* Translated by L. Sherley-Price. Harmondsworth: Penguin, 1968.

———. *Historia ecclesiastica gentis Anglorum.* Edited by B. Colgrave and R. A. B. Mynors. Oxford: Clarendon, 1969.

———. *History of the Abbots of Wearmouth and Jarrow.* 12 vols. Edited by J. A. Giles. London: Whittaker, 1843.

———. *Homiliae.* Edited by J.-P. Migne. In *PL* 94: 9–514. Paris: J.-P. Migne, 1862

———. *Quaestiones super Regem libros.* Edited by J.-P. Migne. In *PL* 93: 429–56. Paris: J.-P. Migne, 1862.

———. *De tabernaculo et vasis ejus ac vestibus sacerdotum.* Edited by J.-P. Migne. In *PL* 91: 393–498. Paris: J.-P. Migne, 1862.

———. *Variae quaestiones.* Edited by J.-P. Migne. In *PL* 93: 429–56. Paris: J.-P. Migne, 1862.

Beleth, John. *Rationale divinorum officiorum.* Edited by J.-P. Migne. In *PL* 202: 9–166. Paris: J.-P. Migne, 1855.

———. *Summa de ecclesiasticis officiis.* Edited by Herbert Douteil. Corpus Christianorum, Series latina continuatio mediaevalis 41A. Turnhout: Brepols, 1976.

Benedict of Nursia. *Regula monachorum.* Edited by R. Hanslik. Corpus Scriptorum Ecclesiasticorum latinorum 75. Vienna: Hoelder-Pichler-Tempsky, 1960.

Benedict of Peterborough. *Miracula S. Thomae Cantuariensis.* Edited by J. C. Robertson. In *Materials for the History of Thomas Becket, Archbishop of Canterbury*, II, pp. 21–279. London: Rolls Series, 1876.

Berengaudus. *Expositio super septem visiones libri Apocalypsis.* Edited by J.-P. Migne. In *PL* 17: 843–1058. Paris: Garnier fratres et J.-P. Migne, 1879.

Bernard of Clairvaux. *Epistolae.* Edited by J.-P. Migne. In *PL* 182: 67–715. Paris: Garnier fratres et J.-P. Migne, 1879.

———. *The Letters of Saint Bernard.* Translated by B. S. James. London: Burns and Oates, 1953.

———. *On the Song of Songs.* 4 vols. Cistercian Fathers Series. Kalamazoo, MI: Cistercian Publications, 1971–80.

———. *Opera.* 8 vols. Edited by Jean Leclercq et al. Rome: Editiones Cistercienses, 1955–79.

———. *Sermo in festo S. Andreae apostoli II.* Edited by J.-P. Migne. In *PL* 183: 509–14. Paris: Garnier fratres et J.-P. Migne, 1879.

———. *Sermones in Cantica canticorum.* Edited by J.-P. Migne. In *PL* 183: 785–1198. Paris: Garnier fratres et J.-P. Migne, 1879.

———. *Sermones de tempore.* Edited by J.-P. Migne. In *PL* 183: 35–360. Paris: Garnier fratres et J.-P. Migne, 1879.

Bestiarium: Die Texte der Handschrift MS. Ashmole 1511 der Bodleian Library, Oxford. Edited by Franz Unterkircher. Graz: Akademische Druck-und Verlaganstalt, 1986.

Biblia Sacra Vulgata. 2 vols. Edited by Robert Weber. 3rd rev. ed. Stuttgart: Deutsche Bibelgesellschaft, 1983.

Bonaventure. *Holiness of Life, being St. Bonaventure's Treatise.* Translated by L. Costello. St. Louis: Herder, 1928.

Itinerarium mentis in Deum. Edited by Philotheus Boehner. Saint Bonaventure, NY: Franciscan Institute, Saint Bonaventure University, 1956.

Opera omnia. 10 vols. Quaracchi: Collegii S. Bonaventurae, 1882–1902.

Boncompagno of Signa. *Rhetorica novissima.* Edited by A. Gaudenzi. Bibliotheca Iuridica Medii Aevi, II, pp. 249–97. Bologna: 1892.

Brinton, Thomas. *The Sermons of Thomas Brinton, Bishop of Rochester (1373–1389).* Camden 3rd ser. 85–6. Edited by A. Devlin. London: Royal Historical Society, 1954.

Bruno of Segni. *Expositio in Apocalypsim.* Edited by J.-P. Migne. In *PL* 165: 603–736. Paris: Garnier fratres et J.-P. Migne, 1904.

Expositio in Genesim. Edited by J.-P. Migne. In *PL* 164: 147–234. Paris: Garnier fratres et J.-P. Migne, 1881.

Caesarius of Heisterbach. *Dialogus miraculorum.* 2 vols. Edited by J. Strange. Cologne: H. Lempertz, 1851.

Calendar of Charter Rolls 1226–1257. London: Macie, 1903.

Cassiodorus. *Expositio in Cantica canticorum.* Edited by J.-P. Migne. In *PL* 70: 1055–106. Paris: J.-P. Migne, 1865.

Expositio in Psalterium. Edited by J.-P. Migne. In *PL* 70: 25–1056. Paris: J.-P. Migne, 1865.

Chronica monasterii S. Albani. 7 vols. Edited by H. T. Riley. London: Rolls Series, 1863–76.

Chronicon de Lanercost. Edited by Joseph Stevenson. Edinburgh: Impressum Edinburgi, 1839.

Cicero, Marcus Tullus. *De oratore.* 6th ed. Edited by O. Harnecker. Leipzig: B. G. Teubner, 1886.

Dante. *Convivio.* Edited by G. Businelli. Florence: Le Monnier, 1953.

Durandus, William. *Rationale divinorum officiorum.* 5 vols. Paris: Louis Vivès, 1854.

The Symbolism of Churches and Church Ornaments. Translated and edited by J. M. Neale and B. Webb. New York: Scribners, 1843.

L'Elucidarium et les lucidaires. Edited by Y. Lefèvre. Paris: E. de Boccard, 1954.

Eusebius of Caesarea. *The History of the Church.* Translated by G. A. Williamson. Harmondsworth: Penguin, 1965.

Everard of Gately. *Miracles de la Vierge.* Edited by Paul Meyer. In "Notice du MS Rawlinson Poetry 241," *Romania* 32 (1903): 27–47.

Garnerus of St. Victor. *Gregorianum.* Edited by J.-P. Migne. In *PL* 193: 1–462. Paris: J.-P. Migne, 1854.

Gautier de Coinci. *Les miracles de Nostre Dame.* 4 vols. Edited by V. Frederick König. Geneva–Lille: Droz, 1955–70.

Geoffroi de Vinsauf. *Documentum de modo et arte dictandi et versificandi.* Translated by Roger P. Parr. Milwaukee: Marquette University Press, 1968.

Gerald of Wales (Giraldus Cambrensis). *Gemma ecclesiastica.* Edited by J. S. Brewer. London: Rolls Series, 1862.

Gerhoh of Reichersberg. *De gloria et honore Filii Hominis.* Edited by J.-P. Migne. In *PL* 194: 1074–160. Paris, J.-P. Migne, 1855.

Giffard, Walter. *Register of Walter Giffard, Lord Archbishop of York, 1266–1279.* Edited by W. Brown. Durham: Andrews, 1904.

Gilbert of Hoyland. *Sermon on the Song of Songs.* Translated by L. C. Braceland. Cistercian Fathers Series 14. Kalamazoo, MI: Cistercian Publications, 1978.

Treatises, Epistles and Sermons. Translated by L. C. Braceland. Kalamazoo, MI: Cistercian Publications, 1981.

Glossa ordinaria (attributed to Walafrid Strabo). Edited by J.-P. Migne. In *PL* 113–14. Paris: Garnier fratres et J.-P. Migne, 1879.

The Golden Legend: see Jacobus de Voragine.

Gower, John. *The Major Latin Works of John Gower.* Edited by E. W. Stockton. Seattle: University of Washington, 1962.

Gratian. *Concordia discordantium canonum.* Edited by J.-P. Migne. *PL* 187. Paris: Garnier fratres et J.-P. Migne, 1891.

Gregory the Great. *Commentariorum in Librum I Regum.* Edited by J.-P. Migne. In *PL* 79: 17–468. Paris: Garnier fratres et J.-P. Migne, 1903.

Epistolae. Edited by J.-P. Migne. In *PL* 77: 431–1328. Paris: Garnier fratres et J.-P. Migne, 1896.

Expositio super Cantica canticorum. Edited by J.-P. Migne. In *PL* 79: 467–548. Paris: Garnier fratres et J.-P. Migne, 1903.

Homiliae XL in Evangelia. Edited by J.-P. Migne. In *PL* 76: 1075–1314. Paris: Garnier fratres et J.-P. Migne, 1878.

Liber regulae pastoralis. Edited by J.-P. Migne. In *PL* 77: 9–128. Paris: Garnier fratres et J.-P. Migne, 1896.

Moralia in Job. Edited by M. Adriaen. Corpus Christianorum, Series Latina 75. Turnout: Brepols, 1969.

Moralia in Job. Edited by J.-P. Migne. In *PL* 76: 9–782. Paris: Garnier fratres et J.-P. Migne, 1878.

Registrum epistolarum. 2 vols. Edited by D. Norberg. Corpus Christianorum, Series Latina 140–140A. Turnhout: Brepols, 1982.

Grosseteste, Robert. *Commentarius in Posteriorum Analyticorum libros.* Edited by Pietro Rossi. Florence: Olschki, 1981.

Epistolae. Edited by H. R. Luard. London: Rolls Series, 1861.

Memorandum. Edited by Servus Gieben. In *Collectanea Franciscana* 41 (1971): 361–2.

Die philosophischen Werke des Robert Grosseteste, Bischofs von Lincoln. Edited by Ludwig Baur. Münster: Aschendorff, 1912.

Guibert of Nogent. *Moralia in Genesin.* Edited by J.-P. Migne. In *PL* 156: 26–340. Paris: Garnier fratres et J.-P. Migne, 1880.

Guillaume le Clerc. *La Bestiaire: Das Tierbuch des normannischen Dichters Guillaume le Clerc.* Edited by Robert Reinsch. Leipzig: O. R. Reisland, 1892.

The Bestiary of Guillaume le Clerc. Translated by G. C. Druce. Ashford: Headley, 1936.

Haimo of Auxerre. *Expositio in Apocalypsin Joannis libri septem.* Edited by J.-P. Migne. In *PL* 117: 937–1220. Paris: Garnier fratres et J.-P. Migne, 1881.

Herman of Bury. *De miraculis sancti Ædmundi.* Edited by Thomas Arnold. In *Memorials of St. Edmund's Abbey*, I, pp. 26–92. London: Rolls Series, 1890.

Hildebert of Lavardin. *Sermones.* Edited by J.-P. Migne. In *PL* 171: 339–968. Paris: Garnier fratres et J.-P. Migne, 1893.

Honorius Augustodunensis. *Clavis physicae.* Edited by Paolo Lucentini. Rome: Edizioni di storia e letteratura, 1974.

Expositio in Cantica canticorum. Edited by J.-P. Migne. In *PL* 172: 347–496. Paris: Garnier fratres et J.-P. Migne, 1895.

Gemma animae. Edited by J.-P. Migne. In *PL* 172: 541–737. Paris: Garnier fratres et J.-P. Migne, 1895.

Hexaemeron. Edited by J.-P. Migne. In *PL* 172: 253–66. Paris: Garnier fratres et J.-P. Migne, 1895.

Sigilllum Beatae Mariae. Edited by J.-P. Migne. In *PL* 172: 495–518. Paris: Garnier fratres et J.-P. Migne, 1895.

Speculum ecclesiae. Edited by J.-P. Migne. In *PL* 172: 807–1108. Paris: Garnier fratres et J.-P. Migne, 1895.

Hrabanus Maurus. *Allegoriae in sacram scripturam.* Edited by J.-P. Migne. In *PL* 112: 849–1088. Paris: Garnier fratres et J.-P. Migne, 1878.

Hugh of Fouilloy. *The Medieval Book of Birds: Hugh of Fouilloy's Aviarium.* Translated and edited by Willene B. Clark. Medieval and Renaissance Texts and Studies 80. Binghamton, NY: Medieval and Renaissance Texts and Studies, 1992.

Hugh of St. Victor. *De arca Noe mystica.* Edited by J.-P. Migne. In *PL* 176: 681–701. Paris: Garnier fratres et J.-P. Migne, 1880.

Didascalicon. Edited by J.-P. Migne. In *PL* 176: 739–838. Paris: Garnier fratres et J.-P. Migne, 1880.

The Didascalicon of Hugh of St. Victor. Translated by Jerome Taylor. New York: Columbia University Press, 1961.

Miscellanea. Edited by J.-P. Migne. In *PL* 177: 469–900. Paris: Garnier fratres et J.-P. Migne, 1879.

Six opuscules spirituels. Edited by Roger Baron. Sources chrétiennes 155. Paris: Cerf, 1969.

Soliloquium de arrha animae. Edited by J.-P. Migne. In *PL* 176: 951–70. Paris: Garnier fratres et J.-P. Migne, 1880.

De tribus maximus circumstantiis gestorum. Edited by William M. Green. In *Speculum* 18 (1943): 484–93.

De tribus maximus circumstantiis gestorum. Translated by Mary Carruthers. In *The Book of Memory*, pp. 261–6. Cambridge: Cambridge University Press, 1990.

Innocent III (Lothair of Segni). *De mysteriis missae.* Edited by J.-P. Migne. In *PL* 217: 763–916. Paris: Garnier fratres et J.-P. Migne, 1890.

Sermo VII. "In concilio generali lateranensi habitus." Edited by J.-P. Migne. In *PL* 217: 679–88. Paris: Garnier fratres et J.-P. Migne, 1890.

Isidore of Seville. *Allegoriae quaedam Scripturae sanctae.* Edited by J.-P. Migne. In *PL* 83: 97–130. Paris: J.-P. Migne, 1862.

Etymologiae. 2 vols. Edited by W. M. Lindsay. Oxford: Clarendon, 1911.

Etymologiarum libri XX. Edited by J.-P. Migne. In *PL* 82: 9–728. Paris: Garnier fratres et J.-P. Migne, 1878.

Jacobus de Voragine. *The Golden Legend.* Translated and edited by Granger Ryan and Helmut Ripparger. New York: Longmans, Green, 1941.

Jerome. *Breviarium in Psalmos.* Edited by J.-P. Migne. In *PL* 26: 849–1382. Paris: Garner fratres et J.-P. Migne, 1844

Commentariorum in Abdiam prophetam. Edited by J.-P. Migne. In *PL* 25: 1097–118. Paris: Garnier fratres et J.-P. Migne, 1884.

Commentariorum in Malachiam prophetam. Edited by J.-P. Migne. In *PL* 25: 1541–78. Paris: Garnier fratres et J.-P. Migne, 1884.

Commentarius in Evangelium secundem Matthaeum. Edited by J.-P. Migne. In *PL* 26: 15–228. Paris: Garnier fratres et J.-P. Migne, 1844.

Epistolae. Edited by J.-P. Migne. In *PL* 22: 325–1191. Paris: Garnier fratres et J.-P. Migne, 1877.

Joachim of Fiore. *Expositio in Apocalypsim.* Venice: F. Bindoni and M. Pasyni, 1527.

Horae Apocalyptica, or a Commentary on the Apocalypse. 5th ed. Summary translated by E. B. Elliott. London: Seeley, 1862.

John of Garland. *The Parisiana Poetria of John of Garland.* Edited by Traugott Lawler. New Haven: Yale University Press, 1974.

John of Salisbury. *The Metalogicon of John of Salisbury.* Translated and edited by Daniel D. McGarry. Westport, CT: Greenwood Press, 1982.

Policraticus. Edited by C. C. J. Webb. Oxford: Clarendon, 1909.

John of Worcester. *The Chronicle of John of Worcester, 1118–1140.* Edited by J. R. H. Weaver. Oxford: Clarendon, 1908.

Joinville, Jean de. *The Life of St. Louis.* Translated by M. R. B. Shaw. Harmondsworth: Penguin, 1963.

The Life of Saint Mary Magdalene and of Her Sister Saint

Martha. Edited and translated by David Mycoff. Cistercian Studies 109. Kalamazoo, MI: Cistercian Publications, 1989.

Macrobius. *Commentarii in Ciceronis somnium Scipionis.* Edited by Ludwig van Jan. Quedlinburg and Leipzig: G. Bassii, 1848.

Commentary on the Dream of Scipio. Translated by William Harris Stahl. New York: Columbia University Press, 1952.

Manuale ad usum percelebris ecclesie Sarisburiensis. Henry Bradshaw Society 91. Chichester: Henry Bradshaw Society, 1960.

Le Manuel des Péchés. Edited by A. J. Arnould. Paris: Droz, 1940.

Marsh, Adam. *Epistolae.* Edited by J. S. Brewer. In *Monumenta Franciscana,* I, pp. 75–490. London: Rolls Series, 1858.

Martianus Capella. *De nuptiis Philologiae et Mercurii.* Edited by Adolphus Dick. Leipzig: B. G. Teubner, 1925.

De nuptiis Philologiae et Mercurii. Translated by W. H. Stahl and R. Johnson. In *Martianus Capella and the Seven Liberal Arts.* 2 vols. New York: Columbia University Press, 1977.

Rhetorica ad Herennium. Edited and translated by Harry Caplan. Cambridge, MA: Harvard University Press, 1954.

Martin of León. *Expositio libri Apocalypsis.* Edited by J.-P. Migne. In *PL* 209: 299–420. Paris: J.-P. Migne, 1855.

Meditations on the Life of Christ. Translated and edited by Isa Ragusa and Rosalie Green. Princeton: Princeton University Press, 1961.

Meditationes piissimae de cognitione humanae conditionis. Edited by J.-P. Migne. In *PL* 184: 485–507. Paris: Garnier fratres et J.-P. Migne, 1879.

Le Miracle de Theophile. 2nd ed. Edited by Grace Frank. Paris: Champion, 1949.

Mirour de Seinte Eglyse. Edited by A. D. Wilshere. Anglo–Norman Text Society 40. Oxford: Blackwell, 1982.

Missale de Lesnes. Edited by Philip Jebb. Henry Bradshaw Society 95. Worcester: Henry Bradshaw Society, 1964.

Nigel of Canterbury. *Miracles of the Virgin Mary.* Translated and edited by Jan Ziolkowski. Toronto: Pontifical Institute of Medieval Studies, 1986.

Niger, Ralph. *De re militari et triplici via peregrinationes Ieorosolimatine.* Edited by Ludwig Schmugge. Berlin: De Gruyter, 1977.

Odo of Cluny. *Sermo* II. Edited by J.-P. Migne. In *PL* 133: 713–21. Paris: Garnier fratres et J.-P. Migne, 1881.

Ordericus Vitalis. *Ecclesiastica historiae.* 5 vols. Edited by Augustus le Prevost. Paris: Renouard, 1838–55.

Origen. *Homiliae in Canticum canticorum.* Edited by W. A. Baehrens. Leipzig: Hinrichs, 1925.

Homiliae in Numeros. Edited by J.-P. Migne. In *PG* 12: 583–818. Turnout: Brepols, n.d.

Paris, Matthew. *Chronica majora.* 7 vols. Edited by H. R. Luard. London: Rolls Series, 1872–84.

La Estoire de Seint Ædward le Rei. Edited by K. Y. Wallace. Anglo-Norman Text Society 41. London, 1983.

La Estoire de Seint Ædward le Rei. Facsimile edited by M. R. James. Oxford: Roxburgh Club, 1920.

Historia Anglorum. 3 vols. Edited by Sir Frederick Madden. London: Rolls Series, 1866–9.

Liber additamentorum. Edited by H. R. Luard. London: Rolls Series, 1882.

La vie de seint Auban. Edited by A. R. Harden. Anglo–Norman Texts 19. Oxford: Blackwell, 1968.

Patrologiae cursus completus, Series latinae. 221 vols. Edited by J.-P. Migne. Paris: Garnier Fratres et J.-P. Migne, 1844–1905.

Peckham, John. *Perspectiva communis.* Edited and translated by David C. Lindberg. In *John Peckham and the Science of Optics,* pp. 60–271. Madison: University of Wisconsin Press, 1970.

Registrum epistolarum fratris Johannes Peckham. 3 vols. Edited by C. T. Martin. London: Rolls Series, 1882–5.

Peter Comestor. *Sermones.* Edited by J.-P. Migne. In *PL* 198: 1721–844. Paris: J.-P. Migne, 1855.

Peter Damian. *Expositio canonis missae.* Edited by J.-P. Migne. In *PL* 145: 879–92. Paris: J.-P. Migne, 1867.

Sermones. Edited by J.-P. Migne. In *PL* 144: 501–924. Paris: J.-P. Migne, 1867

Peter Lombard. *Commentarium in Psalmos.* Edited by J.-P. Migne. In *PL* 191: 61–1296. Paris: Garnier fratres et J.-P. Migne, 1880.

Sententiae in IV libris distinctae. 3rd ed. 2 vols. in 3. Grottaferrata: Editiones Collegii S. Bonaventurae ad Claras Aquas, 1971–81.

Peter of Blois. *Contra perfidiam Judaeorum.* Edited by J.-P. Migne. In *PL* 207: 825–70. Paris: J.-P. Migne, 1904.

Peter the Venerable. *Letters.* 2 vols. Edited by Giles Constable. Cambridge, MA: Harvard University Press, 1962.

Der Physiologus. Edited by Otto Seel. Zurich: Artemis, 1960.

Piramus, Denis. *La Vie Seint Edmund le rey.* Edited by Thomas Arnold. In *Memorials of St. Edmund's Abbey,* II, pp. 137–252. London: Rolls Series, 1892.

Pliny. *Natural History.* Translated by H. Rackham. Cambridge, MA: Harvard University Press, 1971.

Plotinus. *Enneads.* Translated by Joseph Katz. New York: Appleton-Century-Crofts, 1950.

The Enneads. Translated by Stephen MacKenna. 2nd ed. London: Faber and Faber, 1956.

Pseudo-Ambrose. *Sermo XLVI.* "De Salomone." Edited by J.-P. Migne. In *PL* 17: 716–22. Paris: Garnier fratres et J. –P. Migne, 1879.

Pseudo-Hugo of St. Victor. *De bestiis et aliis rebus.* Edited by J.-P. Migne. In *PL* 177: 9–164. Paris: Garnier fratres et J.-P. Migne, 1879.

Remigius of Auxerre. *Enarrationes in Psalmos.* Edited by J.-P. Migne. In *PL* 131: 149–844. Paris: Garnier fratres et J.-P. Migne, 1884.

Richard of St. Victor. *Adnotationes mysticae in Psalmos.* Edited by J.-P. Migne. In *PL* 196: 265–402. Paris: Garnier fratres et J.-P. Migne, 1880.

 Benjamin minor. Translated by G. A. Zinn as *The Twelve Patriarchs.* New York: Paulist Press, 1979.

 In Apocalypsim Ioannis libri septem. Edited by J.-P. Migne. In *PL* 196: 683–888. Paris: Garnier fratres et J.-P. Migne, 1880.

 Selected Writings on Contemplation. Edited by Claire Kirchberger. New York: Harper, 1957.

Richart de Fournival. *Li Bestiaires d'amours di Maistre Richart de Fornival.* Edited by Cesare Segré. Milan: Ricciardi, 1957.

Robert of Flamborough. *Liber poenitentialis.* Edited by J. J. Firth. Toronto: Pontifical Institute of Medieval Studies, 1971.

Rupert of Deutz. *De operibus Spiritus Sancti.* Edited by J.-P. Migne. In *PL* 167: 1571–828. Paris: Garnier fratres et J.-P. Migne, n.d.

 De Trinitate. Edited by J.-P. Migne. In *PL* 167: 198–1570. Paris: Garnier fratres et J.-P. Migne, n.d.

 In Apocalypsim Joannis apostoli. Edited by J.-P. Migne. In *PL* 169: 827–1214. Paris: Garnier fratres et J.-P. Migne, 1894.

Rutebeuf. *Gedichte.* Edited by A. Kressner. Wolfenbüttel: J. Zwissler, 1885.

 Onze poèmes concernant de Croisade. Edited by Julia Bastin and Edmond Faral. Paris: P. Geuthner, 1946.

Sicardus of Cremona. *Mitrale sive Summa de officiis ecclesiasticis.* Edited by J.-P. Migne. In *PL* 213: 9–434. Paris: Garnier fratres et J.-P. Migne, 1855.

The South English Legendary. Edited by C. d'Evelyn and A. J. Mill. Early Text Society 235. London: Oxford University Press, 1956.

Speculum Gy de Warewycke. Edited by G. L. Morrill. Early English Text Society 75. London: Paul, Trench, Trubner, 1898.

Super Hieremiam prophetam. Cologne, 1577.

Thomas Aquinas. *In Aristotelis libros de sensu et sensato, De memoria et reminiscentia commentarium.* 2nd ed. Edited by R. M. Spiazzi. Turin, Rome: Marietta, 1949.

 Summa theologiae. 60 vols. Cambridge: Blackfriars, 1964–.

Thomas of Celano. *Dies irae.* Edited by Joseph Connelly. In *Hymns of the Roman Liturgy,* p. 254. Westminster, MD: Newman, 1957.

Victorinus. *Commentarium in Apocalypsim.* Edited by J. Haussleiter. Corpus Scriptorum Ecclesiasticorum Latinorum 49. Vienna: Freytag, 1916.

 Commentarius in Apocalypsim. Edited by J.-P. Migne. In *PLS* 1: 103–76. Paris: Garnier fratres et J.-P. Migne, 1958.

Vincent of Beauvais. *Speculum historiale.* Speculum Quadruplex IV. Graz: Akademische Druck- und Verlaganstalt, 1965.

William Rishanger. *Chronica monasterii Sancti Albani.* 2 vols. Edited by H. T. Riley. London: Rolls Series, 1865–6.

William of St. Thierry. *The Works of William of St. Thierry.* 4 vols. Cistercian Fathers Series. Spencer, MA: Cistercian Publications, 1971–4.

William of Tripoli. *De Statu Saracenorum.* Edited by H. Prutz. In *Kulturgeschichte der Kreuzzeuge,* pp. 573–98. Berlin: E. S. Mittler, 1883.

William of Tyre. *Historia rerum in partibus transmarinis gestarum.* In *Recueil des historiens des croisades: Histoires occidentaux,* I, pt. 2, pp. 704–1134. Paris: Imprimeries royale, 1844.

The Winchester Troper. Edited by Walter H. Frere. London: Harrison and Sons, 1894.

II. ART HISTORY, HISTORY, LITERATURE, AND CRITICAL THEORY

Abrahams, Israel. "The Decalogue in Art." In *No Graven Images: Art and the Hebrew Bible,* edited by Joseph Gutmann, pp. 19–35. New York: Ktav, 1971.

Achten, Gerard, ed. *Das christliche Gebetbuch im Mittelalter.* 2nd ed. Berlin: Staatsbibliothek, 1987.

Ackerman, Robert W. "The Liturgical Day in Ancrene Riwle." *Speculum* 53 (1978): 734–44.

Alexander, J. J. G. *Medieval Illuminators and Their Methods of Work.* New Haven: Yale University Press, 1992.

 Norman Illustration at Mont St. Michel 966–1100. Oxford: Clarendon, 1970.

 "Preliminary Marginal Drawings in Medieval Manuscripts." In *Artistes, artisans et productions artistiques au moyen âge,* edited by X. Barral i Altet, III, pp. 307–19. Paris: Picard, 1990.

Alexander, J. J. G., and Paul Binski, eds. *Age of Chivalry: Art in Plantagenet England 1200–1440.* London: Weidenfeld and Nicolson, 1987.

Alexander, J. J. G., and C. W. Kauffmann. *English Illuminated Manuscripts 700–1500.* Brussels: Bibliothèque Royale Albert I, 1973.

Althusser, Louis. *Lenin and Philosophy and Other Essays.*

Translated by Ben Brewster. London: New Left Books, 1971.

Anderson, A. R. *Alexander's Gate, Gog and Magog, and the Inclosed Nations.* Cambridge, MA: Medieval Academy of America, 1932.

Arns, Avaristo. *La technique du livre d'après Saint Jérome.* Paris: E. de Boccard, 1953.

Astell, Ann W. *The Song of Songs in the Middle Ages.* Ithaca, NY: Cornell University Press, 1990.

Backhouse, Janet, and Christopher de Hamel. *The Becket Leaves.* London: British Library, 1988.

Bakhtin, Mikhail. *The Dialogic Imagination.* Translated by Caryl Emerson and Michael Holquist. Austin: University of Texas Press, 1981.

Bal, Mieke. *Narratology: Introduction to the Theory of Narrative.* Translated by Christine van Boheemen. Toronto: University of Toronto Press, 1985.

 "On Looking and Reading: Word and Image, Visual Poetics, and Comparative Arts." *Semiotica* 76 (1989): 283–320.

 Reading Rembrandt: Beyond the Word–Image Opposition. Cambridge: Cambridge University Press, 1991.

Barasch, Mosche. "The Frontal Icon: A Genre in Christian Art." *Visible Religion* 7 (1990): 31–44.

Baron, Salo W. *A Social and Religious History of the Jews.* 2nd rev. ed. 10 vols. New York: Columbia University Press, 1965.

Barthes, Roland. *Elements of Semiology.* Translated by Annette Laven and Colin Smith. New York: Hill and Wang, 1968.

 Image – Music – Text. Translated by Stephen Heath. New York: Hill and Wang, 1977.

 "An Introduction to the Structural Analysis of Narrative." *New Literary History* 6 (1974–5): 237–72.

Bauckham, Richard. "The *Figurae* of John of Patmos." In *Prophecy and Millenarianism: Essays in Honor of Marjorie Reeves,* edited by Ann Williams, pp. 107–25. London: Longman, 1980,

Bäuml, Franz H. "Varieties and Consequences of Medieval Literacy and Illiteracy." *Speculum* 55 (1980): 237–65.

Belting, Hans. *Bild und Kult: Eine Geschichte des Bildes vor dem Zeitalter der Kunst.* Munich: C. H. Beck, 1990.

 Das Bild und sein Publikum im Mittelalter. Berlin: Mann, 1981.

 "Die Reaktion der Kunst des 13. Jahrhunderts auf den Import von Reliquien und Ikonen." In *Il Medio Oriente e l'Occidente nell'arte del XIII secolo: Atti del XXIV. Congresso internazionale della storia dell'arte,* edited by Hans Belting, pp. 35–53. Bologna: Cooperativa Libraria Universitaria, 1982.

Benjamin, Walter. *One-Way Street and Other Writings.* Translated by Edmund Jephcott and Kingsley Shorter. London: New Left Books, 1979.

Bennett, Adelaide. "A Book Designed for a Noblewoman, an Illustrated *Manuel des Péchés* of the Thirteenth Century." In *Medieval Book Production: Assessing the Evidence,* edited by Linda L. Brownrigg, pp. 163–82. Los Altos Hills, CA: Anderson-Lovelace, 1990.

Benz, Ernst. "Joachism Studien, III. Thomas von Aquin und Joachim von Fiore." *Zeitschrift für Kirchengeschichte* 53 (1934): 52–116.

Berger, Samuel. *La Bible française au moyen âge.* Paris: Imprimerie nationale, 1884.

 "Les préfaces jointes aux livres de la Bible dans les manuscrits de la Vulgate." *Académie des Inscriptions et Belles-Lettres, Mémoires* 11/2 (Paris, 1902): 1–78.

Berger, Samuel, and Paul Durrieu. "Les notes pour l'enlumineur dans les manuscrits du moyen âge." *Mémoires de la Société Nationale des Antiquaires de France* 3 (1893): 1–30.

Bezzola, Gian Andri. *Die Mongolen in abendländischer Sicht, 1220–1270.* Bern, Munich: Francke, 1974.

Bigalli, Davide. *I Tartari e l'Apocalisse: Ricerche sull'escatalogia in Adamo Marsh e Ruggero Bacone.* Florence: La nuova Italia, 1971.

Binon, Stephane. *Essai sur le cycle de saint Mercure, martyr de Dèce et meurier de l'empereur Julien.* Paris: Leroux, 1937.

Binski, Paul. *The Painted Chamber at Westminster.* Society of Antiquaries, Occasional Paper 9. London: Society of Antiquaries, 1986.

Birch, W. de Gray. *Catalogue of Seals in the Department of Manuscripts in the British Museum.* 4 vols. London: British Museum, 1887–98.

Blair, H. "Armorials on English Seals from the Twelfth to the Sixteenth Centuries." *Archaeologia* 89 (1943): 1–26.

Bloch, Peter. "Typologisches Kunst." *Miscellanea Mediaevalia* 6 (1969): 127–42.

Bloch, R. Howard. *Etymologies and Genealogies: A Literary Anthropology of the French Middle Ages.* Chicago: University of Chicago Press, 1983.

Bloom, Harold. *A Map of Misreading.* New York: Oxford University Press, 1975.

Bloomfield, Morton W. "Episodic Motivation and Marvels in Epic and Romance." In *Essays and Explorations,* pp. 96–128. Cambridge, MA: Harvard University Press, 1970.

 The Seven Deadly Sins. East Lansing: Michigan State College Press, 1952.

Bloomfield, Morton W., and Marjorie Reeves. "The Penetration of Joachism into Northern Europe." *Speculum* 29 (1954): 772–93.

Blumenkranz, Bernhard. "Augustin et les juifs; Augustin et le judaisme." *Recherches augustiniennes* 1 (1958): 225–41.

——— "Géographie historique d'un thème de l'iconographie religieuse: Les représentations de Synagoga en France." In *Mélanges offerts à René Crozet*, II, pp. 1141–57. Poitiers: Société d'études médiévales, 1966.

——— *Le juif médiévale au miroir de l'art chrétien.* Paris: Etudes augustiniennes, 1966.

Boase, T. S. R. *Kingdoms and Strongholds of the Crusaders.* New York: Bobbs-Merrill, 1971.

Boinet, Amedée. "Les manuscrits à peintures de la Bibliothèque Sainte-Geneviève." *Bulletin de la Société française de reproduction de manuscrits à peintures* 5 (1921): 1–155.

Bologna, Giulia. *Illuminated Manuscripts: The Book before Gutenberg.* New York: Weidenfeld and Nicholson, 1988.

Bolton, Brenda M. "Advertise the Message: Images in Rome at the Turn of the Twelfth Century." In *The Church and the Arts,* edited by Diana Wood, pp. 117–30. Studies in Church History 28. Oxford: Blackwell, 1992.

Borenius, Tancred. *St. Thomas Becket in Art.* London: Methuen, 1932.

——— "Some Further Aspects of the Iconography of St. Thomas of Canterbury." *Archaeologia* 83 (1933): 171–85.

Boutemy, André. "La Bible enluminée de Saint-Vaast à Arras." *Scriptorium* 4 (1950): 67–81.

Boyle, Leonard E. "The Fourth Lateran Council and Manuals of Popular Theology." In *The Popular Literature of Medieval England*, edited by Thomas J. Heffernan, pp. 30–43. Knoxville: University of Tennessee Press, 1985.

Branner, Robert. "The Copenhagen Corpus." *Konsthistorik Tidskrift* 38 (1960): 97–119.

——— *Manuscript Painting in Paris during the Reign of St. Louis.* Berkeley: University of California Press, 1977.

Breder, Günther. *Die lateinische Vorlage des altfranzösischen Apokalypsen-Kommentars des 13. Jahrhunderts (Paris, B.N. MS Fr. 403).* Forschungen zur romanischen Philologie 9. Münster: Aschendorff, 1960.

Bredero, A. H. "Jerusalem dans l'Occident médiévale." In *Mélanges offerts à René Crozet*, I, pp. 259–72. Poitiers: Société d'études médiévales, 1966.

Brentano, Robert. *Two Churches: England and Italy in the Thirteenth Century.* Princeton: Princeton University Press, 1968.

Brieger, Peter. *English Art 1216–1307.* Oxford: Clarendon, 1957.

——— *The Trinity College Apocalypse.* London: Eugrammia, 1967.

Brieger, Peter, and Philippe Verdier. *Art and the Courts: France and England from 1259 to 1328.* 2 vols. Ottawa: National Gallery of Canada, 1972.

Browe, Peter. "Die Elevation in der Messe." *Jahrbuch für Liturgiewissenschaft* 9 (1929): 20–66.

——— *Die häufige Kommunion im Mittelalter.* Münster: Regensbergische Verlagsbuchhandlung, 1938.

——— *Die Judenmission im Mittelalter und die Päpste.* Rome: Herder, 1942.

——— *Die Verehrung der Eucharistie im Mittelalter.* Munich: M. Hueber, 1933.

Brown, Peter. *The Cult of Saints.* Chicago: University of Chicago Press, 1981.

Bruyne, Donatien de. *Sommaires, divisions et rubriques de la Bible latine.* Namur: A. Godienne, 1914.

Bruyne, Edgar de. *Etudes d'esthétique médiévale.* 3 vols. Bruges: De Tempel, 1946.

Bryne, Donal. "Manuscript Ruling and Pictorial Design in the Work of the Limbourgs, the Bedford Master, and the Boucicaut Master." *Art Bulletin* 66 (1984): 118–35.

Bryson, Norman. "Semiology and Visual Interpretation." In *Visual Theory: Painting and Interpretation*, edited by Norman Bryson et al., pp. 61–73. New York: HarperCollins, 1991.

——— *Word and Image: French Painting of the Ancien Regime.* Cambridge: Cambridge University Press, 1981.

Bryson, Norman, and Mieke Bal. "Semiotics and Art History." *Art Bulletin* 73 (1991): 174–208.

Bultot, Robert. "L'Auteur et la fonction littéraire de 'De fructibus carnis et spiritus'." *Recherches de théologie ancienne et médiévale* 30 (1963): 148–54.

Buschhausen, Helmut. *Der Verduner Altar.* Vienna: Tusch, 1980.

Bynum, Caroline Walker. "The Female Body and Religious Practice in the Later Middle Ages." In *Zone 3: Fragments for a History of the Human Body,* edited by Michael Feher, I, pp. 160–219. New York: Urzone, 1989.

——— *Jesus as Mother: Studies in the Spirituality of the High Middle Ages.* Berkeley: University of California Press, 1982.

——— "Religious Women in the Later Middle Ages." In *Christian Spirituality*, II, edited by Jill Raitt, pp. 121–39. New York: Crossroad, 1987.

——— ". . . And Woman His Humanity: Female Imagery in the Religious Writing of the Later Middle Ages." In *Gender and Religion: On the Complexity of Symbols*, edited by C. W. Bynum, pp. 257–88. Boston: Beacon Press, 1986.

Cahn, Walter. *Romanesque Bible Illustration.* Ithaca, NY: Cornell University Press, 1982.

Caiger-Smith, A. *Early Mediaeval Mural Paintings.* Oxford: Clarendon, 1963.

Callus, Daniel A. "The Introduction of Aristotelian Learn-

ing to Oxford." *Proceedings of the British Academy* 29 (1943): 229–81.

"Robert Grosseteste as Scholar." In *Robert Grosseteste, Scholar and Bishop*, edited by D. A. Callus, pp 30–61. Oxford: Clarendon, 1955.

Cames, Gérard. "Recherches sur les origines du crucifix à trois clous." *Cahiers archéologiques* 16 (1966): 85–202.

Camille, Michael. "The Book of Signs: Writing and Visual Difference in Gothic Manuscript Illumination." *Word and Image* 1 (1985): 133–48.

"The Devil's Writing: Diabolical Literacy in Medieval Art." In *World of Art: Themes of Diversity: Acts of the 26th International Congress of the History of Art*, edited by Irving Lavin, II, pp. 355–8. University Park: Pennsylvania University Press, 1990.

The Gothic Idol. New York: Cambridge University Press, 1989.

" 'Him Whom You Have Ardently Desired You May See': Cistercian Exegesis and the Prefatory Pictures in a French Apocalypse." In *Studies in Cistercian Art and Architecture*, edited by M. P. Lillich, III, pp. 137–60. Kalamazoo, MI: Cistercian Publications 1987.

"Illustrations in Harley MS 3487 and the Perception of Aristotle's *Libri naturales* in Thirteenth Century England." In *England in the Thirteenth Century: Proceedings of the 1984 Harlaxton Symposium*, edited by W. M. Ormrod, pp. 31–44. Woodbridge: Boydell, 1985.

Image on the Edge: The Margins of Medieval Art. London: Reaktion, 1992.

Review of *Bild und Kult*, by Hans Belting, *Art Bulletin* 74 (1992): 514–17.

"Seeing and Reading: Some Visual Implications of Medieval Literacy and Illiteracy." *Art History* 8 (1985): 26–49.

Carruthers, Mary. *The Book of Memory: A Study of Memory in Medieval Culture*. Cambridge: Cambridge University Press, 1990.

Cary, George. *The Medieval Alexander*. Cambridge: Cambridge University Press, 1956.

Cast, David. "The Stork and the Serpent: A New Interpretation of the Madonna of the Meadow by Bellini." *Art Quarterly* 32 (1969): 247–54.

Cavanaugh, Susan Hagen. "A Study of Books Privately Owned in England 1300–1450." Ph.D. diss., University of Pennsylvania, 1980.

Caviness, Madeleine Harrison. *The Early Stained Glass of Canterbury Cathedral*. Princeton: Princeton University Press, 1977.

The Windows of Christ Church Canterbury. London: Oxford University Press, 1981.

Cazelles, Brigitte. Review of *Apocalypse anglo-normande*, by Yurio Otaka and Hideka Fukui, *Romance Philology* 36 (1982): 331–4.

Cerquiglini, Bernard. *Eloge de la variante: Histoire critique de la philologie*. Paris: Seuil, 1989.

Châtillon, Jean. "Le mouvement théologique dans la France de Philippe Auguste." In *La France de Philippe Auguste: Le temps des mutations*, edited by Robert-Henri Bautier, pp. 881–904. Paris: Editions du Centre nationale de la recherche scientifique, 1982.

Chazan, Robert. *Daggers of Faith: Thirteenth-Century Christian Missionizing and Jewish Response*. Berkeley: University of California Press, 1989.

Chenu, M. D. *Nature, Man and Society in the Twelfth Century*. Translated by Jerome Taylor and Lester K. Little. Chicago: University of Chicago Press, 1968.

Christe, Yves. "Ap. IV–VIII,1 de Bède à Bruno de Segni." In *Études de civilisation médiévales: Mélanges offerts à Edmond-René Labande*, pp. 145–51. Poitiers: Centre d'Études supérieures de civilisation médiévale, 1975.

"Apocalypses anglaises du XIIIe siècle." *Journal des savants* (1984): 79–91.

"Trois images carolingiennes en forme de commentaires sur l'Apocalypse." *Cahiers archéologiques* 25 (1976): 77–92.

Ciaranfi, Anna Maria. "Disegni e miniature nel codice laurenziano 'Supplicationes variae'." *Rivista dell'Istituto nazionale d'archeologia e storia dell'arte* 1 (1929): 325–48.

Clanchy, M. T. *From Memory to Written Record*. London: Arnold, 1979.

Clifford, Gay. *The Transformations of Allegory*. London: Routledge, 1974.

Cohen, Jeremy. *The Friars and the Jews: The Evolution of Medieval Anti-Judaism*. Ithaca, NY: Cornell University Press, 1982.

Coleman, Janet. *Ancient and Medieval Memories: Studies in the Reconstruction of the Past*. Cambridge: Cambridge University Press, 1992.

Collins, Adela Yarbro. *Crisis and Catharsis: The Power of the Apocalypse*. Philadelphia: Westminster, 1984.

Collins, John J. "Apocalypse: Towards the Morphology of a Genre." *Semeia* 14 (1979): 1–20.

The Apocalyptic Imagination: An Introduction to the Jewish Matrix of Christianity. New York: Crossroad, 1984.

"The Symbolism of Transcendence in Jewish Apocalyptic." *Biblical Research* 19 (1974): 5–22.

The Complete Peerage. Rev ed. 12 vols. Edited by H. A. Doubleday and Lord Howard de Walden. London: St. Catherine, 1910–59.

Congar, Yves. "L'Église et Cité de Dieu chez quelques auteurs cisterciens à l'époque des croisades." In *Mélanges offerts à Étienne Gilson*, pp. 173–202. Paris: Librarie philosophique J. Vrin, 1959.

"Pour une histoire sémantique du terme 'magisterium'."

Revue des sciences philosophiques et théologiques 60 (1976): 85–98.

Constable, Giles. "The Popularity of Twelfth-Century Spiritual Writers in the Later Middle Ages." In *Renaissance Studies in Honor of Hans Baron*, edited by A. Molho, pp. 4–23. Florence: Sansoni, 1970.

—— "Twelfth-Century Spirituality and the Late Middle Ages." In *Medieval and Renaissance Studies*, edited by O. B. Hardison, pp. 27–60. Chapel Hill: University of North Carolina Press, 1971.

Corbin, Solange. "Les offices de la Sainte Face." *Bulletin des études portugaises* 11 (1947): 1–65.

Cornell, Henrik. *Biblia pauperum*. Stockholm: Thuletryck, 1925.

Corrigan, Kathleen. *Visual Polemics in Ninth-Century Byzantine Psalters*. Cambridge: Cambridge University Press, 1992.

Cothren, Michael W. "The Iconography of Theophilus Windows in the First Half of the Thirteenth Century." *Speculum* 59 (1984): 308–41.

Courcelle, Pierre. *Les lettres grecques en Occident de Macrobe à Cassiodore*. Paris: E. de Boccard, 1948.

Cousins, Ewart. "The Humanity and the Passion of Christ." In *Christian Spirituality*, II, edited by Jill Raitt, pp. 375–91. New York: Crossroad, 1987.

Cox, J. C. "Religious Houses." In *A History of Hampshire and the Isle of Wight,* II, edited by H. Arthur Doubleday and William Page, pp. 104–232. Westminster: Constable, 1903.

Cox, T. "The Twelfth-Century Design Sources of the Worcester Cathedral Misericords." *Archaeologia* 97 (1959): 165–78.

Crombie, A. C. *Robert Grosseteste and the Origin of Experimental Science 1100–1700*. Oxford: Clarendon, 1953.

Croquison, Jean. "Une vision eschatologique carolingienne." *Cahiers archéologiques* 4 (1949): 105–29.

Cross, F. L., and E. A. Livingstone, eds. *The Oxford Dictionary of the Christian Church*. 2nd ed. London and New York: Oxford University Press, 1974.

Culler, Jonathan. *Structuralist Poetics*. Ithaca, NY: Cornell University Press, 1975.

Curschmann, Michael. "Imagined Exegesis: Text and Picture in the Exegetical Works of Rupert of Deutz, Honorius Augustodunensis, and Gerhoch of Reichersberg." *Traditio* 44 (1988): 145–69.

Curtius, Ernst Robert. *European Literature and the Latin Middle Ages*. Translated by Willard R. Trask. Princeton: Princeton University Press, 1953.

—— "Zur Interpretation des Alexisliedes." *Zeitschrift für romanische Philologie* 56 (1936): 113–37.

Cutler, A. "Innocent III and the Distinctive Clothing of the Jews and Muslims." In *Studies in Medieval Culture*, edited by J. R. Sommerfeldt, III, pp. 92–116. Kala-

mazoo: Medieval Institute, Western Michigan University, 1970.

D'Alverny, Marie-Therèse. *Alain de Lille, textes inédits avec une introduction sur sa vie et ses oeuvres*. Paris: J. Vrin, 1965.

Daniel, A. R. "Apocalyptic Conversion: The Joachite Alternative to the Crusades." *Traditio* 25 (1969): 127–54.

Davis, Natalie Zemon. *Society and Culture in Early Modern France*. Stanford: Stanford University Press, 1975.

Davis-Weyer, Caecilia. "*Aperit quod ipse signaverat testamentum*: Lamm und Löwe im Apokalypsebild der Grandval-Bibel." In *Studies in Medieval Art, 800–1250: Festschrift für Florentine Mütherich*, edited by Katherina Bierbrauer et al., pp. 67–74. Munich: Prestel-Verlag, 1985.

Degenhart, Bernhard, and A. Schmitt. *Corpus der italienische Zeichnungen 1300–1450*. 2 vols. Berlin: Mann, 1968.

De Hamel, Christopher. *The Apocalypse*. Sotheby's sale catalogue. London: 1983.

—— *Glossed Books of the Bible and the Origins of the Paris Booktrade*. Woodbridge: D. S. Brewer, 1984.

—— *A History of Illuminated Manuscripts*. Boston: D. R. Godine, 1986.

Delisle, Léopold, and Paul Meyer. *L'Apocalypse en français au XIIIe siècle*. 2 vols. Paris: Firmin Didot, 1900–1.

Delorme, F. M. "Le cardinal Vital du Four: huit questions disputées sur le problème de la connaissance." *Archives d'histoire doctrinale du moyen âge* 2 (1927): 151–337.

De Man, Paul. *Allegories of Reading*. New Haven: Yale University Press, 1979.

—— *Blindness and Insight: Essays in the Rhetoric of Contemporary Criticism*. 2nd rev. ed. Minneapolis: University of Minnesota Press, 1983.

Denny, Don. "A Romanesque Fresco in Auxerre Cathedral." *Gesta* 25 (1986): 197–202.

Der Nersessian, Sirarpie. "Two Miracles of the Virgin in the Poems of Gautier de Coincy." *Dumbarton Oaks Papers* 41 (1987): 157–63.

Deschamps, Paul, and M. Thibaut. *La peinture murale en France au début de l'époque gothique*. Paris: Centre nationale de la recherche scientifique, 1963.

D'Esneval, A. "La division de la Vulgate latine en chapitres dans l'édition parisienne du XIIIe siècle." *Revue des sciences philosophiques et théologiques* 62 (1978): 559–68.

Deuchler, Florenz, et al. *The Cloisters Apocalypse*. 2 vols. New York: Metropolitan Museum of Art, 1971.

Devisse, Jean. *The Image of the Black in Western Art*. 2 vols. New York: Morrow, 1979.

De Wald, Ernest. *The Illustrations of the Utrecht Psalter*. Princeton: Princeton University Press, 1932.

De Winter, Patrick. "Visions of the Apocalypse in Medieval England and France." *Cleveland Museum of Art Bulletin* 70 (1983): 396–417.

Dickinson, J. C. *An Ecclesiastical History of England: The Later Middle Ages.* London: A. and C. Black, 1979.

Dobschütz, Ernst von. *Christusbilder: Untersuchungen zur christlichen Legende.* Leipzig: J. C. Hinrichs. 1899.

Dobson, E. J. *The Origins of "Ancrene Wisse."* Oxford: Clarendon, 1976.

Documenta Antiqua Franciscana. Edited by L. Lemmens. Quaracchi: Collegii S. Bonaventurae, 1901.

Dodwell, C. R. *The Canterbury School of Illumination 1006–1200.* Cambridge: Cambridge University Press, 1954.

The Great Lambeth Bible. London: Faber, 1959.

Duby, Georges. *Histoire de la vie privée.* 5 vols. Paris: Seuil, 1985.

Dumoutet, Edouard. *Le Christ selon la chair et la vie liturgique au moyen âge.* Paris: G. Beauchesne, 1932.

Corpus Domini: Aux sources de la piété eucharistique médiévale. Paris: G. Beauchesne, 1942.

Le désir de voir l'hostie et les origines de la dévotion au saint-sacrement. Paris: G. Beauchesne, 1926.

Dynes, Wayne. "The Dorsal Figure in the Stavelot Bible." *Gesta* 10 (1971): 41–8.

Eagleton, Terry. *Ideology: An Introduction.* London: Verso, 1991.

Literary Theory: An Introduction. Minneapolis: University of Minnesota Press, 1983.

Easton, Stewart C. *Roger Bacon and the Search for a Universal Science.* Oxford: Blackwell, 1962

Eco, Umberto. *The Aesthetics of Thomas Aquinas.* Translated by Hugh Bredin. Cambridge, MA: Harvard University Press, 1988.

Edwards, Lewis. "Some English Examples of the Medieval Representation of Church and Synagogue." *Transactions of the Jewish Historical Society of England* 18 (1953–5): 63–75.

Egbert, Virginia. *The Medieval Artist at Work.* Princeton: Princeton University Press, 1967.

Elbern, Victor H. "Der eucharistische Kelch im frühen Mittelalter. 2." *Zeitschrift des Deutschen Vereins für Kunstwissenschaft* 17 (1963): 117–88.

Eleen, Luba. *The Illustrations of the Pauline Epistles in French and English Bibles of the Twelfth and Thirteenth Centuries.* Oxford: Clarendon, 1982.

Eliade, Mircea. *Cosmos and History.* Translated by Willard R. Trask. New York: Harper, 1959.

The Sacred and Profane. Translated by Willard R. Trask. New York: Harper and Row, 1961.

Traité d'histoire des religions. Paris: Payot, 1949.

Ellul, Jacques. *The Humiliation of the Word.* Translated by Joyce Main Hanks. Grand Rapids, MI: Eardmans, 1985.

Emden, A. B. *A Biographical Register of the University of Oxford to A.D. 1500.* 2 vols. Oxford: Clarendon, 1957.

Emmerson, Richard K. *Antichrist in the Middle Ages: A Study of Medieval Apocalypticism, Art, and Literature.* Seattle: University of Washington Press, 1981.

Emmerson, Richard K., and Suzanne Lewis. "Census and Bibliography of Medieval Manuscripts ca. 800–1500. I." *Traditio* 40 (1984): 337–79; II. 41 (1985): 367–409; III. 42 (1986): 443–72.

Endres, J. A. *Honorius Augustodunensis: Beitrag zur Geschichte des geistigen Lebens im 12. Jahrhundert.* Munich: J. Kosel, 1906.

Esmeijer, A. C. *Divina Quaternitas: A Preliminary Study in the Method and Application of Visual Exegesis.* Amsterdam: Gorcum, 1978.

Evans, G. R. "Exegesis and Authority in the Thirteenth Century." In *Ad litteram: Authoritative Texts and Their Medieval Readers*, edited by Mark D. Jordan and Kent Emery, pp. 93–111. Notre Dame, IN: University of Notre Dame Press, 1992.

Evans, Joan. *Dress in Medieval France.* Oxford: Clarendon, 1952.

Evans, Jonathan D. "Episodes in Analysis of Medieval Narrative." *Style* 20 (1986): 126–41.

Evans, Michael. "The Geometry of the Mind." *Architectural Association Quarterly* 12 (1980): 32–55.

"An Illustrated Fragment of Peraldus's Summa of Vice: Harleian MS 3244." *Journal of the Warburg and Courtauld Institutes* 45 (1982): 14–68.

Faligen, E. "Des formes iconographiques de la légende de Théophile." *Revue des traditions populaires* 5 (1890): 1–14.

Faral, Edmond, ed. *Les arts poétiques du XIIe et du XIIIe siècle.* Paris: E. Champion, 1933.

Fineman, Joel. "The Structure of Allegorical Desire." *October* 12 (1980): 47–66.

Fish, Stanley. "Literature in the Reader: Affective Stylistics." In *Reader-Response Criticism: From Formalism to Post-Structuralism*, edited by Jane P. Thompkins, pp. 70–100. Baltimore: Johns Hopkins University Press, 1980.

Flanigan, C. Clifford. "The Apocalypse and the Medieval Liturgy." In *The Apocalypse in the Middle Ages,* edited by Richard K. Emmerson and Bernard McGinn, pp. 333–51. Ithaca, NY: Cornell University Press, 1992.

Fleming, John V. *An Introduction to Franciscan Literature of the Middle Ages.* Chicago: Franciscan Herald Press, 1977.

From Bonaventure to Bellini: An Essay in Franciscan Exegesis. Princeton: Princeton University Press, 1982.

Fletcher, Angus. *Allegory: The Theory of a Symbolic Mode.* Ithaca, NY: Cornell University Press, 1964.

Flett, Alison R. "The Significance of Text Scrolls: Towards

a Descriptive Terminology." In *Medieval Texts and Images in Manuscripts from the Middle Ages,* edited by Margaret M. Manion and Bernard Muir, pp. 43–56. Sydney: Craftsman House, 1991.

Floyer, J. K., and S. G. Hamilton. *Catalogue of the Manuscripts in the Chapter Library of Worcester Cathedral.* Oxford: Parker, 1906.

Folda, Jaroslav. *Crusader Manuscript Illumination at Saint-Jean d'Acre, 1275–1291.* Princeton: Princeton University Press, 1976.

Forey, A. J. "The Crusading Vows of the English King Henry III." *Durham University Journal* 65 (1973): 229–41.

Foucault, Michel. "What Is an Author?" Translated by Donald F. Bouchard and Sherry Simon. In *Language, Counter-Memory, Practice,* pp. 113–38. Ithaca, NY: Cornell University Press, 1977.

The Order of Things: An Archaeology of the Human Sciences. New York: Vintage Books, 1973.

Fowler, Alastair. *Kinds of Literature: An Introduction to the Theory of Genres and Modes.* Cambridge, MA: Harvard University Press, 1982.

Fox, J. C. "The Earliest French Apocalypse and Commentary." *Modern Language Review* 7 (1912): 445–68.

Freedberg, David. *The Power of Images: Studies in the History and Theory of Response.* Chicago: University of Chicago Press, 1989.

Freyhan, Robert. "Joachism and the English Apocalypse." *Journal of the Warburg and Courtauld Institutes* 18 (1955): 211–44.

Friedman, John B. "The Architect's Compass in Creation Miniatures of the Later Middle Ages." *Traditio* 30 (1974): 419–29.

"Les images mnémotechniques dans les manuscrits de l'époque gothique." In *Jeux de mémoire: Aspects de la mnémotechnie médiévale,* edited by Bruno Roy and Paul Zumthor, pp. 169–83. Montreal: Presses de l'Université de Montréal, 1985.

Friedman, Lee M. *Robert Grosseteste and the Jews.* Cambridge, MA: Harvard University Press, 1934.

Friedman, Lionel J. *Text and Iconography for Joinville's Credo.* Cambridge, MA: Medieval Academy of America, 1958.

Frisch, Ernst von. "Über die Salzburger Handschrift von Hugo von St. Victors *Opusculum de fructibus carnis et spiritus.*" In *Festschrift für George Leidinger,* edited by Albert Hartmann, pp. 67–71. Munich: H. Schmidt, 1930.

Frye, Northrop. *Anatomy of Criticism.* Princeton: Princeton University Press, 1957.

Fryer, Alfred C. "Theophilus, the Penitent, as Represented in Art." *Archaeological Journal* 92 (1935): 287–333.

Gaborit-Chopin, Danielle. *Ivoires du moyen âge.* Fribourg: Office du Livre, 1978.

Gage, John. "*Lumen, Alluminar, Riant*: Three Related Concepts in Gothic Aesthetics." In *Europäische Kunst um 1300: Akten des XXV. internationalen Kongresses für Kunstgeschichte*, VI, pp. 31–7. Vienna: H. Bohlau, 1986.

Gardner, Arthur. *English Medieval Sculpture.* Rev. ed. Cambridge: Cambridge University Press, 1951.

Garnier, François. *Le langage de l'image au moyen âge: Signification et symbolique.* 2 vols. Paris: Léopard d'or, 1982–9.

Garth, Helen Meredith. *Saint Mary Magdalene in Medieval Literature.* Baltimore: Johns Hopkins University Press, 1950.

Geertz, Clifford. *The Interpretation of Cultures.* New York: Basic Books, 1973.

Gellrich, Jesse M. *The Idea of the Book in the Middle Ages.* Ithaca, NY: Cornell University Press, 1985.

Genette, Gérard. *Narrative Discourse: An Essay in Method.* Translated by Jane E. Lewin. Ithaca, NY: Cornell University Press, 1980.

Georgianna, Linda. *The Solitary Self: Individuality in the Ancrene Wisse.* Cambridge, MA: Harvard University Press, 1981.

Gibbs, Marion, and Jane Lang. *Bishops and Reform 1215–1272.* London: H. Milford, 1934.

Gibson, Margaret T. "The Place of the *Glossa ordinaria* in Medieval Exegesis." In *Ad litteram: Authoritative Texts and their Medieval Readers,* edited by Mark D. Jordan and Kent Emery, pp. 5–27. Notre Dame, IN: University of Notre Dame Press, 1992.

"The Twelfth-Century Glossed Bible." *Studia Patristica* 23 (1989): 232–44.

Gifford, D. J. "Iconographical Notes Towards a Definition of the Medieval Fool." *Journal of the Warburg and Courtauld Institutes* 37 (1974): 336–42.

Gilbert, Creighton S. "A Statement of the Aesthetic Attitude around 1230." *Hebrew University Studies in Literature and the Arts* 13 (1985): 125–52.

Gillen, O. "Bräutigam und Braut." In *Lexikon der christlichen Ikonographie,* edited by E. Kirschbaum, I, cols. 318–24. Rome: Herder, 1968.

"Bräutigam und Braut." In *Reallexikon zur deutschen Kunstgeschichte,* edited by Otto Schmitt, II, cols. 1110–24. Stuttgart: J. B. Metzler, 1948.

Glanz alter Buchkunst: Mittelalterliche Handschriften der Staatsbibliothek Preussischer Kulturbesitz Berlin. Wiesbaden: Reichert, 1988.

Goldberg, Benjamin. *The Mirror and the Man.* Charlottesville: University Press of Virginia, 1985.

Gottlieb, Carla. *The Window in Art.* New York: Abaris, 1981.

Graefe, F. *Die Publizistik in der letzten Epoche Kaiser Friedrichs II.* Heidelberg: C. Winter, 1909.

Gray, Margaret. *The Trinitarian Order in England: Exca-*

vations at Thelsford Priory. BAR British Series 266. Oxford: Tempus Repartum, 1993.

Grayzel, Solomon. *The Church and the Jews in the Thirteenth Century.* Rev. ed. New York: Hermon, 1966.

Green, Rosalie B. "A Typological Crucifixion." In *Festschrift Ulrich Middeldorf,* edited by Antje Kosegarten and Peter Tigler, pp. 20–3. Berlin: De Gruyter, 1968.

"Virtues and Vices in the Chapter House Vestibule in Salisbury." *Journal of the Warburg and Courtauld Institutes* 31 (1968): 148–58.

Greenhill, Eleanor. *Die geistigen Voraussetzungen der Bilderreihe des Speculum Virginum.* Münster: Aschendorff, 1962.

"The Group of Christ and St. John as Author Portrait: Literary Sources, Pictorial Parallels." In *Festschrift Bernhard Bischoff zu seinem 65. Geburtstag,* pp. 406–16. Stuttgart: A. Hiersemann, 1971.

Gretton, Tom. "New Lamps for Old." In *The New Art History,* edited by A. L. Rees and F. Borzello, pp. 63–74. London: Camden, 1986.

Grisar, Hartmann. "Die alte Peterskirche zu Rom und ihre früheste Ansichten." *Römische Quartalschrift* 9 (1895): 237–98.

Grodecki, Louis. *Gothic Stained Glass 1200–1300.* Ithaca, NY: Cornell Univeristy Press, 1985.

"Les vitraux allégoriques de Saint-Denis." *Art de France* 1 (1961): 19–46.

Grundmann, Herbert. "Literatus-illiteratus: Der Wandel einer Bildungsnorm vom Altertum zum Mittelalter." *Archiv für Kunstgeschichte* 40 (1958): 1–65.

Guenée, Bernard. "Lo storico e la compilazione nel XIII secolo." In *Aspetti della letteratura latina nel secolo XIII,* edited by Claudio Leonardi and Giovanni Orlandi, pp. 57–76. Perugia: Regione dell'Umbria, 1983.

Gurevich, A. I. *Categories of Medieval Culture.* Translated by G. L. Campbell. London: Routledge, 1985.

Habermas, Jurgen. *Knowledge and Human Interests.* Translated by J. Shapiro. Boston: Beacon Press, 1972.

Hadot, Pierre. "Le mythe de Narcisse et son interprétation par Plotin." *Nouvelle revue de psychoanalyse* 13 (1976): 81–108.

Hahn, Cynthia. "Purification, Sacred Action, and the Vision of God: Viewing Medieval Narratives." *Word and Image* 5 (1989): 71–84.

Hahnloser, Hans R. "Der Schrein des unschuldigen Kindlein im Kölner Domschatz und Magister Gerardus." In *Miscellanea pro arte Hermann Schnitzler,* edited by Joseph Hoster and Peter Bloch, pp. 218–23. Düsseldorf: L. Schwann, 1965.

Villard de Honnecourt: Kritische Gesamtausgabe des Bauhüttenbuches MS. fr. 19093 der Pariser Nationalbibliothek. 2nd rev. ed. Graz: Academische Druck-u. Verlagsanstalt, 1972.

Haidu, Peter. "The Episode as Semiotic Module in Twelfth-Century Romance." *Poetics Today* 4 (1983): 655–81.

Hajdu, Helga. *Das mnemotechnische Schrifttum des Mittelalters.* Vienna: R. Leo, 1936.

Halm, Peter. "Der schreibende Teufel." In *L'Umanismo e il demoniaco nell'arte: Atti del II. Congresso internazionale di studi umanistici,* edited by Enrico Castelli, pp. 235–48. Rome: Bocca, 1953.

Hamburger, Jeffrey F. *The Rothschild Canticles: Art and Mysticism in Flanders and the Rhineland circa 1300.* New Haven: Yale University Press, 1990.

"The Visual and the Visionary: The Image in Late Medieval Monastic Devotions." *Viator* 20 (1989): 161–82.

Hanning, Robert W. " 'I Shal Finde It in a Maner Glose': Versions of Textual Harassment in Medieval Literature." In *Medieval Texts and Contemporary Readers,* edited by Laurie Finke and Martin Schichtman, pp. 27–50. Ithaca, NY: Cornell University Press, 1987.

Harris, E. "Mary in the Burning Bush." *Journal of the Warburg and Courtauld Institutes* 1 (1938): 281–6.

Harthan, John. *Illuminated Manuscripts.* London: HMSO, 1983.

Hathaway, Neil. "*Compilatio*: From Plagiarism to Compiling." *Viator* 20 (1989): 19–44.

Haussherr, Reiner. "Christus-Johannes-Gruppen in der *Bible moralisée*." *Zeitschrift für Kunstgeschichte* 27 (1964): 133–52.

"Eine verspätete Apocalypsen-Handschrift und ihre Vorlage." In *Studies in Late Medieval and Early Renaissance Painting in Honor of Millard Meiss,* ed. Irving Lavin and John Plummer, pp. 219–40. New York: New York University Press, 1977.

"*Sensus litteralis* und *sensus spiritualis* in der *Bible moralisée*." *Frühmittelalterliche Studien* 6 (1972): 356–80.

"Der typologische Zyklus des Chorfenster der Oberkirche von S. Francesco zu Assisi." In *Kunst also Bedeutungsträger: Gedenkschrift für Günter Bandmann,* edited by Werner Busch et al., pp. 95–128. Berlin: Mann, 1981.

"Zur Darstellung zeitgenössischer Wirklichkeit und Geschichte in der *Bible moralisée* und in Illustrationen von Geschichtsschreibung im 13. Jahrhundert." In *Il Medio Oriente e l'Occidente nell'arte del XIII secolo: Atti del XXIV Congresso internazionale della storia dell'arte,* edited by Hans Belting, pp. 211–17. Bologna: Editrice CLUEB, 1982.

Hay, John. "Subject, Nature, and Representation in Early Seventh-Century China." In *Tung Ch'i-ch'ang International Symposium,* edited by Wai-Ching Ho, pp. 1–16. Kansas City: Nelson-Atkins Museum of Art, 1991.

Heer, Friedrich. *The Medieval World.* Translated by J. Sondheimer. New York: New American Library, 1963.

Heimann, Adelheid. "Three Illustrations from the Bury St. Edmunds Psalter and Their Prototypes." *Journal of the Warburg and Courtauld Institutes* 29 (1966): 46–56.

Henderson, George. "Cain's Jaw-Bone." *Journal of the Warburg and Courtauld Institutes* 24 (1961): 108–14.

——— "Narrative Illustration and Theological Exposition in Medieval Art." *Studies in Church History* 17 (1971): 19–35.

——— Review of *The Lambeth Apocalypse*, by Nigel Morgan, *Burlington Magazine* 134 (1992): 528–9.

——— "Romance and Politics on Some Medieval English Seals." *Art History* 1 (1978): 26–42.

——— "Studies in English Manuscript Illumination." *Journal of the Warburg and Courtauld Institutes* 30 (1967): I–II. 71–137; III. 31 (1968): 103–14.

Hennecke, Edgar. *New Testament Apocrypha.* 2 vols. Translated by A. J. B. Higgins. Philadelphia: Westminster, 1963.

Henry, Avril. *Biblia pauperum.* Ithaca, NY: Cornell University Press, 1987.

——— *The Eton Roundels: Eton College MS 177.* Aldershot: Scolar Press, 1990.

Herbert, J. A. *The Sherborne Missal.* Oxford: Roxburghe Club, 1920.

Herde, Rosemary. "Das Hohelied in der lateinischen Literatur des Mittelalters bis zum 12. Jahrhunderts." *Studi medievali* 8 (1967): 957–1073.

Heslop, T. A. "The Romanesque Seal of Worcester Cathedral." In *Medieval Art and Architecture at Worcester Cathedral,* pp. 71–9. British Archaeological Association Conference Transactions 1. London: British Archaeological Association, 1978.

Hewitt, Joseph W. "The Use of Nails in the Crucifixion." *Harvard Theological Review* 25 (1932): 29–45.

Hilpert, H.-E. *Kaiser- und Papstbriefe in den Chronica majora des Matthaeus Paris.* Stuttgart: Klett-Cotta, 1981.

Hindman, Sandra. "The Roles of Author and Artist in the Procedure of Illustrating Late Medieval Texts." *Text and Image, Acta* 10 (1983): 27–62.

Hinnebusch, William A. *The Early English Friars Preachers.* Rome: S. Sabina, 1951.

Histoire littéraire de la France. 41 vols. Paris: Imprimerie nationale, 1733–1981.

Hoffmann, Konrad. "Sugers 'anagogisches Fenster' in St. Denis." *Wallraf-Richartz-Jahrbuch* 30 (1968): 57–88.

——— *Taufsymbolik im mittelalterlichen Herrscherbild.* Düsseldorf: Rheinland–Verlag, 1968.

Holder–Egger, O. "Italienische Prophetien des 13. Jahrhunderts." *Neues Archiv* 15 (1890): 323–86.

Holländer, Hans. *Early Medieval Art.* Translated by Caroline Hillier. New York: Universe Books, 1974.

Holly, Michael. "Past Looking." *Critical Inquiry* 16 (1990): 371–95.

Holub, Robert C. *Reception Theory: A Critical Introduction.* London: Methuen, 1984.

Hoving, Thomas. *King of the Confessors.* New York: Simon and Schuster, 1981.

Howard, Donald R. *The Idea of the Canterbury Tales.* Berkeley: University of California Press, 1976.

Hughes, Andrew. *Medieval Manuscripts for Mass and Office: A Guide to Their Organization and Terminology.* Toronto: University of Toronto Press, 1982.

Huillard-Bréholles, J.-L.-A., ed. *Historia diplomatica Frederici secundi.* Turin: Bottega d'Erasmo, 1963.

Hunt, R. W. "The Library of the Abbey of St. Albans." In *Medieval Scribes, Manuscripts and Libraries: Essays Presented to N. R. Ker,* edited by M. B. Parkes and Andrew G. Watson, pp. 251–77. London: Scolar Press, 1978.

——— "Manuscripts Containing the Indexing Symbols of Robert Grosseteste." *Bodleian Library Record* 4 (1953): 241–55.

Illich, Ivan. *In the Vineyard of the Text: A Commentary to Hugh's Didascalicon.* Chicago: University of Chicago, 1993.

Iser, Wolfgang. "The Reading Process: A Phenomenological Approach." In *Reader-Response Criticism: From Formalism to Post-Structuralism,* edited by Jane P. Thompkins, pp. 51–9. Baltimore: Johns Hopkins University Press, 1980.

Ivanchenko, O., and G. Henderson. "Four Miniatures from a Thirteenth-Century Apocalypse: A Recent Discovery." *Burlington Magazine* 122 (1980): 97–106.

Iversen, Margaret. "Saussure v. Peirce: Models for a Semiotics of Visual Art." In *The New Art History,* edited by A. L. Rees and F. Borzello, pp. 82–94. London: Camden, 1986.

Jackson, Donald. *The Story of Writing.* New York: Taplinger, 1981.

James, M. R. *The Apocryphal New Testament.* Oxford: Clarendon, 1924.

——— *A Catalogue of Manuscripts in the Fitzwilliam Museum.* Cambridge: Cambridge University Press, 1895.

——— *A Descriptive Catalogue of Fifty Manuscripts from the Collection of Henry Yates Thompson.* Cambridge: Cambridge University Press, 1898.

——— *A Descriptive Catalogue of the Manuscripts in the Library of Corpus Christi College, Cambridge.* 2 vols. Cambridge: Cambridge University Press, 1912.

——— *A Descriptive Catalogue of the Manuscripts in the Library of Eton College.* Cambridge: Cambridge University Press, 1895.

A Descriptive Catalogue of the Manuscripts in the Library of St. John's College, Cambridge. Cambridge: Cambridge University Press, 1913.

"The Drawings of Matthew Paris." *The Walpole Society* 14 (1925–6): 1–26.

"An English Picture-Book of the Late Thirteenth Century." *The Walpole Society* 25 (1936–7): 23–32.

La Estoire de Seint Ædward le Rei. Oxford: Roxburghe Club, 1920.

"On the Paintings Formerly in the Choir at Peterborough." *Proceedings of the Cambridge Antiquarian Society* 9 (1897): 178–94.

"On Two Series of Paintings Formerly at Worcester Priory." *Proceedings of the Cambridge Antiquarian Society* 10 (1898–1903): 99–110.

"Pictor in carmine." *Archaeologia* 94 (1951): 141–66.

The Western Manuscripts in the Library of Trinity College, Cambridge: A Descriptive Catalogue. 4 vols. Cambridge: Cambridge University Press, 1900–4.

James, M. R., and C. Jenkins. *A Descriptive Catalogue of the Manuscripts in the Library of Lambeth Palace.* 5 vols. Cambridge: Cambridge University Press, 1930–2.

James, M. R., et al. *Illustrations to the Life of St. Alban in Trinity College Library, Dublin, MS E.i.40.* Oxford: Clarendon, 1924.

Janson, H. W. *Apes and Ape Lore in the Middle Ages and Renaissance.* London: Warburg Institute, University of London, 1952.

Jauss, Hans Robert. *Toward an Aesthetic of Reception.* Translated by Timothy Bahti. Minneapolis: University of Minnesota Press, 1982.

Jay, Martin. "In the Empire of the Gaze." In *Foucault: A Critical Reader,* edited by David H. Hoy, pp. 175–204. Oxford: Blackwell, 1986.

"The Rise of Hermeneutics and the Crisis of Ocularcentrism." In *The Rhetoric of Interpretation and the Interpretation of Rhetoric,* edited by Paul Hernandi, pp. 55–74. Durham: Duke University Press, 1989.

"Sartre, Merleau-Ponty, and the Search for a New Ontology of Sight." In *Modernity and the Hegemony of Vision,* edited by David Michael Levin, pp. 143–85. Berkeley: University of California Press, 1993.

Jonas, Hans. *The Phenomenon of Life: Toward a Philosophical Biology.* New York: Dell, 1966.

Jones, Charles W. "Some Introductory Remarks on Bede's Commentary on Genesis." *Sacris Erudiri* 19 (1969–70): 115–98.

Jungmann, Josef A. *Katechetik.* 2nd ed. Freiburg: Herder, 1955.

The Mass of the Roman Rite. Translated by Francis A. Brunner. New York: Benziger, 1955.

Kaeppel, Thomas. "Un recueil de sermons prêchés à Paris et en Angleterre." *Archivum Fratrum Praedicatorum* 26 (1956): 161–91.

Kahsnitz, R. "Justitia." In *Lexikon der christlichen Ikonographie,* edited by E. Kirschbaum, II, cols. 466–72. Rome: Herder, 1970.

Kamlah, Wilhelm. *Apokalypse und Geschichtstheologie.* Historische Studien 285. Berlin: E. Ebering, 1935.

Kantorowicz, Ernst. *The King's Two Bodies: A Study in Medieval Political Theology.* Princeton: Princeton University Press, 1957.

Karl der Grosse: Werk und Wirkung. Düsseldorf: Schwann, 1965.

Kastner, K. G. "Merkurius von Cäsarea." In *Lexikon der christlichen Ikonographie,* edited by E. Kirschbaum, VIII, cols. 10–13. Rome: Herder, 1976.

Kazenellenbogen, Adolf. *Allegories of the Virtues and Vices in Medieval Art.* New York: Norton, 1964.

Kauffmann, C. M. *Romanesque Manuscripts 1066–1190.* London: Harvey Miller, 1975.

Keen, Maurice. *The Pelican History of Medieval Europe.* Harmondsworth: Penguin, 1969.

Kellermann, W. *Aufbaustil und Weltbild Chrestiens von Troyes Percevalroman.* Beiheft zur Zeitschrift für romanische Philologie 88. Halle: M. Neimeyer, 1936.

Kemp, Wolfgang. "Visual Narratives, Memory and the Medieval *Ésprit du system.*" In *Images of Memory: On Remembering and Representation,* edited by Suzanne Küchler and Walter Melion, pp. 87–108. Washington, DC: Smithsonian Institution Press, 1991.

Ker, N. R. *Medieval Libraries of Great Britain: A List of Surviving Books.* 2nd ed. London: Royal Historical Society, 1964.

Medieval Manuscripts in British Libraries. 2 vols. Oxford: Clarendon, 1977.

Kessler, Herbert L. *The Illustrated Bibles from Tours.* Princeton: Princeton University Press, 1977.

Kieckhefer, Richard. "Major Currents in Late Medieval Devotion." In *Christian Spirituality,* II, edited by Jill Raitt, pp. 75–108. New York: Crossroad, 1987.

Kimpel, S. "Margareta von Antiochen." In *Lexikon der christlichen Ikonographie,* edited by E. Kirschbaum, VII, vols. 495–500. Rome: Herder, 1974.

Kirschbaum, Engelbert. *Lexikon der christlichen Ikonographie.* 8 vols. Rome, Freiburg: Herder, 1968–76.

Kjellman, Hilding, ed. *La deuxième collection anglonormande des miracles de la sainte Vierge et son orginal latin.* Uppsala: Akademiska bokhandeln, 1922.

Klein, Peter K. "Der Apokalypse-Zyklus der Roda-Bibel und seine Stellung in der ikonographischen Tradition." *Archivo español de arqueologia* 45–7 (1972–4): 267–333.

Endzeiterwartung und Ritterideologie: Die englischen Bilderapokalypsen der Frühgotik und MS Douce 180.

Graz: Akademische Druck–u. Verlagsanstalt, 1983.

Knowles, David. *The Evolution of Medieval Thought*. New York: Vintage, 1962.

Kolve, V. A. *Chaucer and the Imagery of Narrative*. Stanford: Stanford University Press, 1984.

Konrad, Robert. "Das himmlische und das irdische Jerusalem im mittelalterlichen Denken." In *Speculum Historiale: Festschrift Johannes Spörl*, edited by Clemens Bauer et al., pp. 523–40. Freiburg, Munich: Alber, 1965.

Kristeva, Julia. *Tales of Love*. Translated by Leon S. Roudiez. New York: Columbia University Press, 1987.

Kruger, Steven F. *Dreaming in the Middle Ages*. Cambridge: Cambridge University Press, 1992.

Kühnel, Bianca. *From the Earthly to the Heavenly Jerusalem: Representations of the Holy City in Christian Art of the First Millenium*. Rome, Freiburg: Herder, 1987.

Kurmann, Peter. "Le portail apocalyptique de la cathédrale de Reims." In *L'Apocalypse de Jean*, edited by Yves Christe, pp. 245–317. Geneva: Droz, 1979.

Kuryluk, Ewa. *Veronica and Her Cloth: History, Symbolism and Structure of a "True" Image*. Cambridge, MA, Oxford: Oxford University Press, 1991.

Laborde, Alexandre de. *La Bible moralisée illustré*. 5 vols. Paris: Société de reproductions de manuscrits à peintres, 1911–27.

Les principaux manuscrits à peintures conservés dans l'ancienne Bibliothèque impériale publique de Saint-Pétersbourg. 2 vols. Paris: Société de reproductions de manuscrits à peintres, 1936–8.

Laborde, Alexandre de, and P. Lauer. "Un projet de décoration murale inspiré du Crédo de Joinville." *Memoires et Monuments Piot* 16 (1909): 61–84.

Labrousse, Michèle. "Etude iconographique et stylistique des initiales historiées de la Bible de Souvigny." *Cahiers de civilisation médiévale* 8 (1965): 397–412.

Lacan, Jacques. *The Four Fundamental Concepts of Psycho-Analysis*. Translated by Alan Sheridan. New York: Norton, 1978.

Ladner, Gerhart B. "*Homo Viator*: Medieval Ideas on Alienation and Order." *Speculum* 42 (1967): 233–59.

The Idea of Reform: Its Impact on Christian Thought and Action in the Age of the Fathers. Cambridge, MA: Harvard University Press, 1959.

Laing, Aileen H. "The Corpus-Lambeth Stem: A Study of French Prose Apocalypse Manuscripts." *Manuscripta* 21 (1977): 17–18.

Laird, Charlton. "Character and Growth of the Manuel des Pechiez." *Traditio* 4 (1946): 253–306.

Långfors, Arthur. "Le miroir de vie et de mort par Robert de l'Omme (1266): Modèle d'une moralité wallonne du XVe siècle." *Romania* 47 (1921): 511–31.

Langlois, Charles-Victor. *La vie spirituelle: Enseignements,* méditations et controverses. 4 vols. Paris: Hachette, 1928.

Langmuir, Gavin I. *History, Religion, and Antisemitism*. Berkeley: University of California Press, 1990.

Lauer, Philippe. *Bibliothèque Nationale, Catalogue général des manuscrits latins*. 3 vols. Paris: Bibliothèque nationale, 1939–52.

Laufner, Richard, and Peter Klein. *Trierer Apokalypse*. Graz: Akademische Druck-u. Verlaganstalt, 1975.

Laun, Christiane. *Bildkatechese im Spätmittelalter: Allegorische und typologische Auslegungen des Dekalogs*. Munich: Dissertationsdruck, 1979.

Lawrence, C. H. *St. Edmund of Abingdon*. Oxford: Abingdon, 1960.

Leclercq, Jean. "Le commentaire de Gilbert de Stanford sur le Cantique des cantiques." In *Analecta Monastica*, I, pp. 205–30. Studia Anselmiana 20. Rome: Pontificium Institutum S. Anselmi, 1948.

"Dévotion privée, piété populaire et liturgie au moyen âge." In *Etudes de pastorale liturgique*, pp. 149–83. Paris: Cerf, 1944.

The Love of Learning and the Desire for God. 2nd rev. ed. Translated by Catharine Misrahi. New York: Fordham University Press, 1974.

"Monachisme et pérégrination du IX au XII siècle." *Studia Monastica* 3 (1960): 33–52.

Monks and Love in Twelfth-Century France. Oxford: Clarendon, 1979.

"Le mystère de l'Ascension dans les sermones de S. Bernard." In *Collectanea Ordinis Cisterciensium Reformatorum*, pp. 81–8. Rome: Westmalle Typis Cisterciensibus, 1953.

"Les traductions de la Bible et la spiritualité médiévale." In *The Bible and Medieval Culture*, edited by W. Lourdaux and D. Verhelst, pp. 263–77. Louvain: Louvain University Press, 1979.

Lecoq, Danielle. "La 'mappemonde' de *De arca Noe mystica* de Hughes de Saint-Victor (1128–1129)." In *Géographie du monde au moyen âge et à la renaissance*, edited by Monique Pelletier, pp. 9–31. Paris: Comité des travaux historiques et scientifiques, 1989.

Leff, Gordon. *The Dissolution of the Medieval Outlook: An Essay on Intellectual and Spiritual Change in the Fourteenth Century*. New York: New York University Press, 1976.

Legge, J. Wickham. *The Sarum Missal Edited from Three Early Manuscripts*. Oxford: Clarendon, 1916.

Legge, M. D. *Anglo-Norman Literature and Its Background*. Oxford: Clarendon, 1963.

Le Goff, Jacques. *The Medieval Imagination*. Translated by Arthur Goldhammer. Chicago: University of Chicago Press, 1988.

Leicester, H. Marshall, Jr. "Oure Tonges *Différance*: Tex-

tuality and Deconstruction in Chaucer." In *Medieval Texts and Contemporary Readers,* edited by Laurie A. Finke and Martin B. Shichtman, pp. 15–25. Ithaca, NY: Cornell University Press, 1987.

Leonardi, Cesare. "I Codici di Marziano Capella." *Aevum* 33 (1959): 411–524; 34 (1960): 1–99.

Lerner, Robert E. "Medieval Prophecy and Religious Dissent." *Past and Present* 72 (1976): 3–24.

——— "Refreshment of the Saints: The Time after Antichrist as a Station for Earthly Progress in Medieval Thought." *Traditio* 32 (1976): 97–144.

Leroquais, Victor. *Les pontificaux manuscrits des bibliothèques publiques de France.* 4 vols. Paris: [n.p.] 1937.

Levesque, E. "Berengaud." In *Dictionnaire de la Bible*, edited by F. Vigoroux, I, pt. 2, cols. 1610–11. Paris: Letouzey et Ane, 1912.

Levi, Carlo. *Of Fear and Freedom.* New York: Farrar, Straus, 1950.

Lévi-Strauss, Claude. *Structural Anthropology.* Translated by Claire Jacobson and Brooke Grundfest Schoepf. New York: Basic Books, 1963.

Lewis, Flora. "The Veronica Image, Legend and Viewer." In *England in the Thirteenth Century: Proceedings of the 1984 Harlaxton Symposium,* edited by W. M. Ormrod, pp. 100–6. Woodbridge: Boydell, 1985.

Lewis, Suzanne. "The Apocalypse of Isabella of France: Paris, Bibl. Nat. MS Fr. 13096." *Art Bulletin* 72 (1990): 224–60.

——— "The Apocalypse of Margaret of York." In *Margaret of York, Simon Bening and the Visions of Tondal*, edited by Thomas Kren, pp. 77–88. Malibu: J. Paul Getty Museum, 1992.

——— *The Art of Matthew Paris in the Chronica Majora.* Berkeley: University of California Press, 1987.

——— "Beyond the Frame: Marginal Figures and Historiated Initials in the Getty Apocalypse." *The J. Paul Getty Museum Journal* 20 (1992): 53–76.

——— "The English Gothic Illuminated Apocalypse, *Lectio divina*, and the Art of Memory." *Word and Image* 7 (1991): 1–32.

——— "The Enigma of Fr. 403 and the Compilation of a Thirteenth-Century English Illustrated Apocalypse." *Gesta* 29 (1990): 31–43.

——— "Exegesis and Illustration in Thirteenth-Century Apocalypses." In *The Apocalypse in the Middle Ages*, edited by Richard K. Emmerson and Bernard McGinn, pp. 259–75. Ithaca, NY: Cornell University Press, 1992.

——— "Giles de Bridport and the Abingdon Apocalypse." In *England in the Thirteenth Century: Proceedings of the 1984 Harlaxton Symposium,* edited by W. M. Ormrod, pp. 107–19. Woodbridge: Boydell, 1985.

——— "*Tractatus adversus Judaeos* in the Gulbenkian Apocalypse." *Art Bulletin* 68 (1986): 543–66.

Lindberg, David C. "Alhazen's Theory of Vision and Its

Reception in the West." *Isis* 58 (1967): 321–41.

——— "Lines of Influence in Thirteenth-Century Optics: Bacon, Witelo, and Peckham." *Speculum* 46 (1971): 66–83.

——— *Studies in the History of Medieval Optics.* London: Variorum, 1983.

Lipsius, Richard A. *Die apokryphen Apostelgeschichten und Apostellegenden.* 2 vols. Braunschweig: Schwetschke, 1883.

Little, A. G. "The Franciscan School at Oxford in the Thirteenth Century." *Archivum Franciscanum Historicum* 19 (1926): 803–74.

——— "Friar Henry of Wodestone and the Jews." In *Collectanea Franciscana*, II, 150–6. London: Typis academicis, 1922.

Little, Lester K. "Pride Goes Before Avarice: Social Change and the Vices in Latin Christendom." *American Historical Review* 75 (1971): 16–49.

Lloyd, Simon. *English Society and the Crusade 1216–1307.* Oxford: Clarendon, 1985.

Lobrichon, Guy. "Conserver, réformer, transformer le monde? Les manipulations de l'Apocalypse au moyen âge central." In *The Role of the Book in Medieval Culture: Proceedings of the Oxford International Symposium 2*, edited by Peter Ganz, pp. 75–94. Turnhout: Brepols, 1986.

——— "La Bible d'un maître dominicain de Paris." In *Mise en page et mise en texte du livre manuscrit*, edited by Henri-Jean Martin and Jean Vezin, pp. 181–3. Paris: Cercle de la Librarie-Promodis, 1990.

——— "Une nouveauté: Les gloses de la Bible." In *Le Moyen Age et la Bible,* edited by Pierre Riché and Guy Lobrichon, pp. 95–114. Paris: Beauchesne, 1984.

Longland, Sabrina. "Pilate Answered: 'What I Have Written I Have Written'." *Bulletin of the Metropolitan Museum of Art* 26 (1968): 410–29.

Lot, Ferdinand. *Etude sur le Lancelot en prose.* Paris: H. Champion, 1918.

Louant, Armand. "Un fragment d'Apocalypse conservé aux Archives de l'État Mons." In *Album Archivaris Josef de Smet*, pp. 233–9. Bruges: Westvlaams Verbond van Kringen voor Heemskunde, 1964.

Lowe, E. A. "Handwriting." In *The Legacy of the Middle Ages*, edited by C. G. Cramp and E. F. Jacobs, pp. 197–226. Oxford: Clarendon, 1962.

Luard, H. R., ed. *Lives of Edward the Confessor.* London: Rolls Series, 1858.

Lubac, Henri de. *Corpus Mysticum.* Paris: Aubier, 1949.

Lynch, Kathryn L. *The High Medieval Dream Vision: Poetry, Philosophy and Literary Form.* Stanford: Stanford University Press, 1988.

Lynch, Lawrence E. "The Doctrine of Divine Ideas and Illumination in Robert Grosseteste, Bishop of Lincoln." *Mediaeval Studies* 3 (1941): 161–73.

McCulloch, Florence. *Medieval Latin and French Bestiar-*

ies. Chapel Hill: University of North Carolina Press, 1960.

"Saints Alban and Amphibalus in the Work of Matthew Paris: Dublin, Trinity College MS 177." *Speculum* 56 (1981): 761–85.

McEvoy, James. *The Philosophy of Robert Grosseteste.* Oxford: Clarendon, 1982.

"The Sun as *res* and *signum*: Grosseteste's Commentary on *Ecclesiasticus* ch. 43, vv. 1–5." *Recherches de théologie ancienne et médiévale* 41 (1974): 38–91.

McGinn, Bernard. "The Abbot and the Doctors: Scholastic Reactions to the Radical Eschatology of Joachim de Fiore." *Church History* 40 (1971): 31–47.

The Calabrian Abbot: Joachim of Fiore in the History of Western Thought. New York: Macmillan, 1985.

"John's Apocalypse and the Apocalyptic Mentality." In *The Apocalypse in the Middle Ages,* edited by Richard K. Emmerson and Bernard McGinn, pp. 3–19. Ithaca, NY: Cornell University Press, 1992.

"Portraying Antichrist in the Middle Ages." In *The Use and Abuse of Eschatology in the Middle Ages,* edited by W. Verbeke et al., pp. 1–48. Louvain: Louvain University Press, 1988.

"Symbols of the Apocalypse in Medieval Culture." *Michigan Quarterly Review* 22 (1983): 265–83.

Visions of the End: Apocalyptic Traditions in the Middle Ages. New York: Columbia University Press, 1979.

McKeon, Richard. "Art of Invention and Arts of Memory: Creation and Criticism." *Critical Inquiry* 1 (1975): 723–39.

McLaughlin, T. P. "Abelard's Rule for Religious Women." *Mediaeval Studies* 18 (1956): 241–92.

Macy, Gary. *The Theologies of the Eucharist in the Early Scholastic Period: A Study of the Salvific Function of the Sacrament According to the Theologians, c. 1080– c. 1220.* New York: Oxford University Press, 1984.

Maddox, Donald. "The Semiosis of *Assimilato* in Medieval Models of Time." *Style* 20 (1986): 252–71.

Malden, A. R. "A Contemporary Poem on the Translation of the Cathedral from Old to New Sarum." *Wiltshire Archaeological Society Magazine* 30 (1898): 210.

Mâle, Emile. *Religious Art in France: The Thirteenth Century.* Princeton: Princeton University Press, 1984.

Maloney, Thomas S. "The Semiotics of Roger Bacon." *Mediaeval Studies* 45 (1983): 120–54.

Mansi, J. D. *Sacrorum Conciliorum Nova et Amplissima Collectio.* 31 vols. Graz: Akademische Druck-u. Verlagsanstalt, 1960.

Martin, C. T. "The *Domus conversorum.*" *Transactions of the Jewish Historical Society* 1 (1893–4): 15–24.

Martin, Henry. "Les ésquisses des miniatures." *Revue archéologiques* 4 (1904): 17–45.

Matter, E. Ann. *The Voice of My Beloved.* Philadelphia: University of Pennsylvania Press, 1990.

Mayo, Janet. *A History of Ecclesiastical Dress.* New York: Holmes and Meier, 1984.

Meier, H. "Die Figur des Narren in der christlichen Ikonographie des Mittelalters." *Das Münster* 8 (1955): 1–5.

Mellinkoff, Ruth. "Demonic Winged Headgear." *Viator* 16 (1985): 367–81.

Melnikas, Anthony. *The Corpus of the Miniatures in the Manuscripts of Decretum Gratiani.* 3 vols. Rome: Institutum Gratiani, 1975.

Mély, Fernand de. "La sainte Lance." In *Exuviae sacrae Constantinopolitanae,* edited by Paul Edouard Didier Riant, III, pp. 23–163. Paris: E. Leroux, 1904.

Messerer, Wilhelm. "Zum Juvenianus-Codex der Biblioteca Vallicelliana." In *Miscellanea Bibliothecae Hertziana,* edited by Leo Bruhns et al., pp. 59–68. Munich: Anton Schroll, 1961.

Metz, René. *La consécration des vierges dans l'église romaine: Etude de l'histoire de la liturgie.* Paris: Presses universitaires de France, 1954.

Meyer, Paul. *Fragments d'une vie de Saint Thomas de Cantorbéry.* Paris: F. Didot, 1885.

"Pierre de Peckham, *La Lumière as lais.*" *Romania* 8 (1879): 325–32.

Meyvaert, Paul. "Bede and the Church-Paintings at Wearmouth-Jarrow." *Anglo-Saxon England* 8 (1979): 63–77.

Michael, Michael A. "An Illustrated Apocalypse Manuscript at Longleat House." *Burlington Magazine* 126 (1984): 340–3.

Michaud–Quantin, Pierre. *Etudes sur le vocabulaire philosophique du moyen âge.* Rome: Ateneo, 1970.

Millar, Eric G. *The Rutland Psalter.* London: Roxburgh Club, 1937.

A Thirteenth-Century Bestiary in the Library of Alnwick Castle. Oxford: Roxburgh Club, 1958.

A Thirteenth-Century York Psalter. Oxford: Roxburgh Club, 1952.

Miller, James I. "The Mirrors of Dante's *Paradiso.*" *University of Toronto Quarterly* 46 (1977): 263–79.

Minnis, Alastair J. "Late Medieval Discussions of *Compilatio* and the Role of the *Compilator.*" *Beiträge zur Geschichte der deutschen Sprache und Literatur* 101 (1979): 385–421.

Medieval Theory of Authorship: Scholastic Literary Attitudes in the Later Middle Ages. London: Scolar Press, 1984.

Mitchell, W. J. T. *Iconology: Image, Text, Ideology.* Chicago: University of Chicago Press, 1986.

Picture Theory: Essays on Verbal and Visual Representation. Chicago: University of Chicago Press, 1994.

Mokretsova, I. P., and V. L. Romanova. *Les manuscrits enluminés français du XIIIe siècle dans les collections soviétiques 1200–1260.* Moskow: Iskusstvo, 1983.

Les manuscrits enluminés français du XIIIe siècle dans les collections sovietiques 1270–1300. Moscow: Iskusstvo, 1984.

Molin, Jean-Baptiste, and Protais Mutembe. *Le rituel du marriage en France du XIIe au XIVe siècle.* Paris: Beauchesne, 1974.

Monumenta Franciscana. 2 vols. Edited by J. S. Brewer. London: Rolls Series, 1858–82.

Moorman, John H. *Church Life in England in the Thirteenth Century.* Cambridge: Cambridge University Press, 1946.

Moralejo, Serafin. "El mapa de la diáspora apostólica en San Pedro de Rocas: Notas para su interpretación y filiación en la tradición cartográfica de los 'Beatos'." *Compostellanum* 31 (1986): 315–340.

"Las islas del sol: Sobre el mappamundi del Beato del Burgo de Osma (1086)." In *Imagem do mondo na idade média: Actas do colóquio internacional,* edited by Ana Paiva Morais and Joao Amaval Frazao, pp. 41–61. Lisbon: Ministerio da Educaçao, Instituto de Cultura e lingua portuguesa, 1992.

Moreau, E. de. "Berengaud." In *Dictionnaire d'histoire et de géographie ecclésiastique,* edited by Alfred Baudrillart, VIII, cols. 358–9. Paris: Letouzey et Ane, 1935.

Morello, Giovanni, and Ulrich Stockmann. *Neues Testament: Codex Vaticanus latinus 39.* Zurich: Belser, 1984.

Morey, Adrian. *Bartholomew of Exeter.* Cambridge: Cambridge University Press, 1937.

Morgan, Nigel. "The Burckhardt-Wildt Apocalypse." In *Art at Auction: The Year at Sotheby's 1982–83,* pp. 162–9. London: 1983.

Early Gothic Manuscripts. 2 vols. London: Harvey Miller, 1982–88.

The Lambeth Apocalypse: Manuscript 209 in Lambeth Palace Library. London: Harvey Miller, 1990.

"Matthew Paris, St. Albans, London, and the Leaves of the 'Life of St. Thomas Becket.' " *Burlington Magazine* 130 (1988): 87–96.

"Texts and Images in Marian Devotion in Thirteenth-Century England." In *England in the Thirteenth Century: Proceedings of the 1989 Harlaxton Symposium,* edited by W. M. Ormrod, pp. 69–103. Stamford: P. Watkins, 1991.

Morris, Colin. *The Discovery of the Individual 1050–1200.* Toronto: University of Toronto Press, 1987.

"Individualism and Twelfth-Century Religion: Some Further Reflections." *Journal of Ecclesiastical History* 31 (1980): 195–206.

Morrison, Karl F. *History as a Visual Art in the Twelfth-Century Renaissance.* Princeton: Princeton University Press, 1990.

Morse, Ruth. *Truth and Convention in the Middle Ages: Rhetoric, Representation and Reality.* Cambridge: Cambridge University Press, 1991.

Mostra storia nazionale della miniatura, Palazzo Venezia. Florence: Sansoni, 1954.

Mowry, Lucetta. "Revelation 4–5 and Early Christian Liturgical Usage." *Journal of Biblical Literature* 71 (1952): 75–84.

Moxey, Keith. *The Practice of Theory: Poststructuralism, Cultural Politics, and Art History.* Ithaca, NY: Cornell University Press, 1994

"Semiotics and the Social History of Art: Toward a History of Visual Representation." In *Acts of the 27th International Congress of the History of Art,* V, pp. 209–18. Strasbourg: Société alsacienne pour le developpement de l'histoire de l'art, 1990.

Muratova, Xenia. "Les miniatures du manuscrit fr. 14969 de la Bibliothèque Nationale de Paris (Le Bestiaire de Guillaume le Clerc) et la tradition iconographique franciscaine." *Marche romane* 28 (1978): 141–8.

Mussafia, Adolfo. "Uber die von Gautier de Coincy benützen Quellen." *Denkschriften der K. Akademie der Wissenschaften, Wien, Phil.-hist. Cl.* 44 (1896): 1–58.

Mütherich, Florentine. "Manoscritti romani e miniatura carolingia." In *Roma e l'età carolingia,* pp. 79–86. Rome: Multigrafica, 1976.

Mütherich, Florentine, and Joachim Gaehde. *Carolingian Painting.* New York: George Braziller, 1976.

Nehamas, Alexander. "Writer, Text, Work, Author." In *Literature and the Question of Philosophy,* edited by Anthony Cascardi, pp. 265–91. Baltimore: Johns Hopkins University Press, 1987.

Neuss, Wilhelm. *Die Apokalypse des Hl. Johannes in der altspanischen und altchristlichen Bibel-Illustration: Das Problem der Beatus Handschriften.* Spanische Forschungen der Görresgesellschaft 2–3. Münster: Aschendorff, 1931.

Newman, F. X. "The Structure of Vision in 'Apocalypsis Goliae.' " *Mediaeval Studies* 29 (1967): 113–23.

Nichols, Stephen. "Philology in a Manuscript Culture." *Speculum* 65 (1990): 1–10.

Noakes, Susan. *Timely Reading: Between Exegesis and Interpretation.* Ithaca, NY: Cornell University Press, 1988.

Nolan, Barbara. *The Gothic Visionary Perspective.* Princeton: Princeton University Press, 1977.

Ohly, Friedrich. *Hohelied-Studien.* Wiesbaden: Steiner, 1958.

Omont, Henri. *Bibliothèque Nationale, Catalogue général des manuscrits français.* 11 vols. Paris: Bibliothèque nationale, 1868–1919.

"Les manuscrits illustrés de l'Apocalypse aux IXe et Xe siècles." *Bulletin de la Société française de reproduc-*

tions de manuscrits à peintures 6 (1922): 62–95.

Les manuscrits peintures en France du 13e au 16e siècle. Paris: Bibliothèque Nationale, 1955.

Onasch, Konrad. *Das Weinachtsfest im orthodoxen Kirchenjahr.* Berlin: Evangelische Verlaganstalt, 1958.

Ong, Walter J. "Orality, Literacy, and Medieval Textualization." *New Literary History* 16 (1984): 1–12.

——— "Wit and Mystery: A Revaluation in Medieval Latin Hymnody." *Speculum* 22 (1947): 310–41.

O'Reilly, Jennifer. *Studies in the Iconography of the Virtues and Vices in the Middle Ages.* New York: Garland, 1988.

Osteneck, V. "Narr Tor." In *Lexikon der christlichen Ikonographie,* edited by E. Kirschbaum, III, cols. 314–16. Rome: Herder, 1971.

Otaka, Yurio, and Hideka Fukui. *Apocalypse anglonormande.* Osaka: Centre de recherches Anglo-Normandes, 1977.

Owens, Craig. "The Allegorical Impulse: Toward a Theory of Postmodernism." In *Art After Modernism: Rethinking Representation,* edited by Brian Wallis, pp. 203–35. Boston: New Museum of Contemporary Art, 1984.

——— "Representation, Appropriation and Power." *Art in America* 70 (1982): 9–21.

Owst, G. R. *Pulpit and Literature in Medieval England.* Cambridge: Cambridge University Press, 1933.

Pächt, Otto. *Buchmalerei des Mittelalters.* Munich: Prestel-Verlag, 1984.

——— "The Illustrations of St. Anselm's Prayers and Meditations." *Journal of the Warburg and Courtauld Institutes* 19 (1956): 68–83.

Pächt, Otto, and J. J. G. Alexander. *Illuminated Manuscripts in the Bodleian Library, Oxford.* 3 vols. Oxford: Clarendon, 1966–73.

Pächt, Otto, et al. *The St. Albans Psalter.* London: Warburg Institute, University of London, 1960.

Parkes, M. B. "The Influence of the Concepts of *Ordinatio* and *Compilatio* on the Development of the Book." In *Medieval Learning and Literature: Essays Presented to Richard William Hunt,* edited by J. J. G. Alexander and M. T. Gibson, pp. 115–41. Oxford: Clarendon, 1976.

——— "The Literacy of the Laity." In *Literature and Western Civilization in the Medieval Period,* edited by D. Daiches and A. K. Thorlby, pp. 555–77. London: Aldus, 1973.

Payne, Ann. *Medieval Beasts.* London: British Library, 1990.

Pearson, Karl. *Die Fronica: Ein Beitrag zur Geschichte des Christusbildes im Mittelalter.* Strasbourg: Treubner, 1887.

Peers, Sir Charles, and Lawrence E. Tanner. "Some Recent Discoveries in Westminster Abbey, IV. A Note on the Inscription on the Christopher Painting in the South Transept." *Archaeologia* 93 (1949): 151–63.

Piehler, Paul. *The Visionary Landscape: A Study in Medieval Allegory.* London: Arnold, 1971.

Pinborg, Jan. "Roger Bacon on Signs: A Newly Discovered Part of the *Opus Maius.*" *Miscellanea Mediaevalia* 13 (1981): 403–12.

Piper, Otto A. "The Apocalypse of John and the Liturgy of the Ancient Church." *Church History* 20 (1951): 10–22.

Plenzat, Karl. *Die Theophiluslegende in den Dichtungen des Mittelalters.* Germanische Studien 43. Berlin: Ebering, 1926.

Poesch, Jesse. "Antichrist Imagery in Anglo-French Apocalypse Manuscripts." Ph.D. diss., University of Pennsylvania, 1966.

——— "Revelation 11:7 and Revelation 13:1–10: Interrelated Antichrist Imagery in Some English Apocalypse Manuscripts." In *Art, the Ape of Nature: Studies in Honor of H. W. Janson,* edited by Mosche Barasch and Lucy Freeman Sandler, pp. 15–33. New York: Abrams, 1981.

——— Review of *The Trinity College Apocalypse,* by Paul Brieger, *Art Bulletin* 50 (1968): 199–203.

Powicke, F. W. *Henry III and the Lord Edward.* 2 vols. Oxford: Clarendon, 1947.

Powicke, F. W., and C. R. Cheney, eds. *Councils and Synods with Other Documents Relating to the English Church.* 2 vols. Oxford: Clarendon, 1964.

Prigent, Pierre. *Apocalypse 12: Histoire de l'exégèse.* Beitrage zur Geschichte der biblischen Exegese 2. Tübingen: Mohr, 1959.

Procter, Francis, and Charles Wordsworth, eds. *Breviarium ad Usum Insignis Ecclesiae Sarum.* 2 vols. Cambridge: Cambridge University Press, 1879.

Quilligan, Maureen. *The Language of Allegory: Defining the Genre.* Ithaca, NY: Cornell University Press, 1979.

Raby, J. E. *A History of Secular Latin Poetry in the Middle Ages.* 2nd ed. Oxford: Clarendon, 1957.

——— *The Oxford Book of Medieval Latin Verse.* Oxford: Clarendon, 1961.

Rajchman, John. "Foucault's Art of Seeing." *October* 24 (1983): 89–117.

Rasmussen, Holger. "Der schreibende Teufel in Nordeuropa." In *Festschrift Matthias Zender,* edited by Edith Ennen and Gunther Wiegelmann, I, pp. 455–64. Bonn: Rohrscheid, 1972.

Reeves, Marjorie. "The Abbot Joachim's Disciples in the Cistercian Order." *Sophia* 19 (1951): 355–71.

——— *The Influence of Prophecy in the Later Middle Ages: A Study in Joachimism.* Oxford: Clarendon, 1969.

Reynolds, R. E. "Image and Text: The Liturgy of Clerical

Ordination in Early Medieval Art." *Gesta* 22 (1983): 27–38.

Richardson, H. G. *The English Jewry under the Angevin Kings.* London: Methuen, 1960.

Riché, Pierre. "Le rôle de la mémoire dans l'enseignement médiévale." In *Jeux de mémoire,* edited by Bruno Roy and Paul Zumthor, pp. 133–48. Montreal: Presses de l'Université de Montréal, 1985.

Rickert, Margaret. *Painting in Britain: The Middle Ages.* 2nd ed. Harmondsworth: Penguin, 1965.

Ricoeur, Paul. *Time and Narrative.* 3 vols. Translated by Kathleen McLaughlin and David Pellauer. Chicago: University of Chicago Press, 1984.

Riffaterre, Michael. "The Mind's Eye: Memory and Textuality." In *The New Medievalism,* edited by Marina Brownlee et al., pp. 29–45. Baltimore: Johns Hopkins University Press, 1991.

Ringbom, Sixten. "Devotional Images and Imaginative Devotions." *Gazette des Beaux-Arts* 73 (1969): 159–70.

Medieval Iconography and Narrative. Odense: Odense University Press, 1980.

"Some Pictorial Conventions for the Recounting of Thought and Experiences in Late Medieval Art." In *A Symposium: Medieval Iconography and Narrative,* edited by Flemming Andersen, pp. 38–69. Odense: Odense University Press, 1980.

Robbins, Frank E. *The Hexaemeral Literature: A Study of Greek and Latin Commentaries on Genesis.* Chicago: University of Chicago Press, 1912.

Robbins, H. W. *Saint Edmund's 'Merure de Seinte Eglise'.* Lewisburg, PA: University Print Shop, 1923.

Robbins, R. H. *Secular Lyrics of the XIVth and XVth Centuries.* 2nd ed. Oxford: Clarendon, 1934.

Roberts, Marion E. "The Relic of the Holy Blood and the Iconography of the Thirteenth-Century North Transept Portal of Westminster Abbey." In *England in the Thirteenth Century: Proceedings of the 1984 Harlaxton Symposium,* edited by W. M. Ormrod, pp. 129–42. Woodbridge: Boydell, 1985.

"The Tomb of Giles de Bridport in Salisbury Cathedral." *Art Bulletin* 65 (1983): 559–86.

Robertson, D. W. "Frequency of Preaching in Thirteenth-Century England." *Speculum* 24 (1949): 376–88.

"The *Manuel des Péchés* and an English Episcopal Decree." *Modern Language Notes* 60 (1945): 429–37.

Röhrig, Floridus. "*Rota in medio rotae:* Ein typologischer Zyklus aus Oesterreich." *Jahrbuch des Stiftes Klosterneuburg* 5 (1965): 7–113.

Der Verduner Altar. Vienna: Herold, 1955.

Rose, V. *Verzeichnis der lateinischen Handschriften der Königlichen Bibliothek zu Berlin.* 2 vols. Berlin: A. Ascher, 1901–5.

Roth, Cecil. *A History of the Jews in England.* 3rd ed. Oxford: Clarendon, 1964.

Rothwell, Harry, ed. *English Historical Documents, 1189–1327.* New York: Oxford University Press, 1975.

Rouse, Richard H., and Mary A. Rouse. "*Ordinatio* and *Compilato* Revisited." In *Ad litteram: Authoritative Texts and Their Medieval Readers,* edited by Mark D. Jordan and Kent Emery, pp. 113–34. Notre Dame, IN: University of Notre Dame Press, 1992.

"*Statim invenire:* Schools, Preachers and New Attitudes to the Page." In *Renaissance and Renewal in the Twelfth Century,* edited by Robert L. Benson and Giles Constable, pp. 201–25. Cambridge, MA: Harvard University Press, 1982.

Rousseau, Olivier. *Origène, Homélies sur le Cantique des cantiques.* Paris: Cerf, 1954.

Rubin, Miri. *Corpus Christi: The Eucharist in Late Medieval Culture.* Cambridge: Cambridge University Press, 1991.

Runciman, Steven. "The Decline of the Crusading Idea." In *Relazioni del X Congresso internazionale de scienze storiche,* III, pp. 637–52. Florence: Sansoni, 1955.

"The Holy Lance Found at Antioch." *Analecta Bollandiana* 68 (1950): 197–209.

Rusconi, Roberto. "De la prédication à la confession: transmission et contrôle de modèles de comportement au XIIIe siècle." In *Faire croire: Modalités de la diffusion et de la réception des messsages religieux du XIIe au XVe siècle,* pp. 67–85. Collection de l'Ecole française de Rome 51. Rome: Ecole française de Rome, 1981.

Russell, G. H. "Vernacular Instruction of the Laity in the Later Middle Ages in England: Some Texts and Notes." *Journal of Religious History* 2 (1962–3): 98–119.

Russell, Josiah Cox. *Dictionary of Writers of Thirteenth-Century England.* London: Longmans, 1936.

Russell, J. Stephen. *The English Dream Vision: Anatomy of a Form.* Columbus: Ohio State University Press, 1988.

Ryding, William W. *Structure in Medieval Narrative.* The Hague: Mouton, 1971.

Sackur, Ernst. *Sibyllinische Texte und Forschungen.* Halle: M. Niemeyer, 1898.

Saenger, Paul. "Silent Reading: Its Impact on Late Medieval Script and Society." *Viator* 13 (1982): 367–414.

Sandler, Lucy Freeman. *Gothic Manuscripts 1285–1385.* 2 vols. London: Harvey Miller, 1986.

"Peterborough Abbey and the Peterborough Psalter in Brussels." *Journal of the British Archaeological Association* 33 (1970): 36–49.

The Peterborough Psalter in Brussels and Other Fenland

Manuscripts. London: Harvey Miller, 1974.

The Psalter of Robert de Lisle. London: Harvey Miller, 1983.

Review of *The Eton Roundels,* by Avril Henry, *Speculum* 68 (1993): 796–7.

Sass, Else Kai. "Pilate and the Title for Christ's Cross in Medieval Representations of Golgotha." *Hafnia: Copenhagen Papers in the History of Art* (1972): 4–67.

Saunders, J. J. "Matthew Paris and the Mongols." In *Essays in Medieval History Presented to Bertie Wilkinson,* edited by T. A. Sandquist and M. R. Powicke, pp. 116–132. Toronto: University of Toronto Press, 1969.

Saxer, Victor. *Le culte de Marie Madeleine en occident des origines à la fin du moyen âge.* 2 vols. Paris: Société des fouilles archéologiques et des monuments historiques de l'Yonne, 1959.

Schaller, Hans Martin. "Endzeit-Erwartung und Antichrist-Vorstellungen in der Politik des 13. Jahrhunderts." In *Festschrift für Hermann Heimpel,* II, pp. 924–94. Göttingen: Vandenhoeck and Ruprecht, 1972.

Schapiro, Meyer. "Cain's Jawbone That Did the First Murder." *Art Bulletin* 24 (1942): 205–12.

"The Image of the Disappearing Christ." *Gazette des Beaux-Arts* 6 (1943): 135–52.

Words and Pictures: On the Literal and the Symbolic in the Illustration of a Text. The Hague: Mouton, 1973.

Scheller, Robert W. *A Survey of Medieval Model Books.* Haarlem: Erven F. Bohn, 1963.

"Towards a Typology of Medieval Drawings." In *Drawings Defined,* edited by Walter Strauss and Tracie Felker, pp. 13–33. New York: Abaris, 1987.

Schiller, Gertrud. *Iconography of Christian Art.* 2 vols. Translated by Janet Seligman. New York: Graphic Society, 1972.

Ikonographie der christlichen Kunst. 5 vols. Gütersloh: G. Mohn, 1966–90.

Schlauch, Margaret. "The Allegory of Church and Synagogue." *Speculum* 14 (1939): 448–64.

Schleusener-Eichholz, Gudrun. *Das Auge im Mittelalter.* 2 vols. Münster Mittelalterschriften 35. Munich: Fink, 1985.

Schmidt, Gerhard. *Die Armenbibeln des XIV. Jahrhunderts.* Graz-Cologne: H. Bohlaus, 1959.

Schorr, Dorothy C. "The Iconographic Development of the Temple Presentation." *Art Bulletin* 28 (1946): 17–32.

Schumacher, Walter. "Altchristliche Giebelkomposition." *Mitteilungen des deutschen archäologischen Instituts, Römische Abteilung* 67 (1960): 133–49.

Seckler, Max. *Das Heil in der Geschichte: Geschichtstheologisches Denken bei Thomas von Aquin.* Munich: Kosel, 1964.

Seiferth, Wolfgang S. *Synagogue and Church in the Middle Ages: Two Symbols in Art and Literature.* Translated by Lee Chadeayne and Paul Gottwald. New York: Ungar, 1970.

Synagogue und Kirche im Mittelalter. Munich: Kosel, 1964.

"The Veil of Synagogue." In *Horizons of a Philosopher: Essays in Honor of David Baumgart,* edited by Joseph Frank et al., pp. 378–90. Leiden: Brill, 1963.

Shepard, Dorothy. "Conventual Use of St. Anselm's Prayers and Meditations." *Rutgers Art Review* 9 (1988): 1–4.

Siberry, Elizabeth. *Criticism of Crusading 1095–1274.* Oxford: Clarendon, 1985.

Sieben, Herman J. "De la lectio divina à la lecture spirituelle." In *Dictionnaire de spiritualité,* IX, cols. 487–496. Paris: Beauchesne, 1975.

Simoni, F. "Il *Super Hieremiam* e il Goachimismo francescano." *Bollettino dell'Istituto Storico Italiano per il Medio Evo* 82 (1970): 13–46.

Sinding-Larsen, Staale. *Iconography and Ritual: A Study of Analytical Perspectives.* Oslo: Universitetsforlaget, 1984.

"Some Observations on Liturgical Imagery of the Twelfth Century." *Institutum Romanum Norvegiae, Acta ad archaeologicam et artium historia pertinentia* 8 (1978): 193–212.

Smalley, Beryl. *The English Friars and Antiquity in the Early Fourteenth Century.* Oxford: Blackwell, 1960.

"John Russel O.F.M." *Recherches de théologie ancienne et médiévale* 23 (1956): 277–320.

The Study of the Bible in the Middle Ages. 2nd rev. ed. Oxford: Blackwell, 1952.

Smeyers, Maurice. *La Miniature.* Typologie des sources du moyen âge occidental 8. Turnhout: Brepols, 1974.

Smith, Barbara Herrnstein. "Narrative Versions, Narrative Theories." In *On Narrative,* edited by W. J. T. Mitchell, pp. 209–32. Chicago: University of Chicago Press, 1981.

Solterer, Helen. "Letter Writing and Picture Reading: Medieval Textuality and the *Bestiaire d'amour.*" *Word and Image* 5 (1989): 131–47.

Sorabji, Richard. *Aristotle on Memory.* Providence: Brown University Press, 1972.

Sotiriou, G., and M. Sotiriou. *Icones de Mont Sinai.* 2 vols. Athens: 1958.

Southern, Richard W. "Aspects of the European Tradition of Historical Writing: 3. History as Prophecy." *Transactions of the Royal Historical Society* 22 (1972): 159–80.

The Making of the Middle Ages. New Haven: Yale University Press, 1953.

Robert Grosseteste: The Growth of an English Mind in

Medieval Europe. Oxford: Clarendon, 1986.

St. Anselm and His Biographer. Cambridge: Cambridge University Press, 1963.

"Some New Letters of Peter of Blois." *English Historical Review* 53 (1938): 412–24.

Western Views of Islam in the Middle Ages. Cambridge, MA: Harvard University Press, 1962.

Southern, R. W., and F. S. Schmidt. *Memorials of St. Anselm.* London: Oxford University Press, 1969.

Stacy, Robert C. "The Conversion of the Jews to Christianity in Thirteenth-Century England." *Speculum* 67 (1992): 263–83.

Stegmüller, Frederick. *Repertorium Biblicum Medii Aevi.* 6 vols. Madrid: Instituto Francisco Suárez, 1960.

Steinhauser, Kenneth B. *The Apocalypse Commentary of Tyconius: A History of Its Reception and Influence.* Frankfurt: P. Lang, 1987.

Stewart, Susan. *On Longing: Narratives of the Miniature, the Gigantic, the Souvenir, the Collection.* Baltimore: Johns Hopkins University Press, 1984.

Stock, Brian. "Medieval Literacy, Linguistic Theory, and Social Organization." *New Literary History* 16 (1984): 13–29.

Stone, Lawrence. *Sculpture in Britain: The Middle Ages.* Baltimore: Penguin, 1955.

Stones, Alison. "Indications écrites et modèles picturaux, guides aux peintres de manuscrits enluminés aux environs de 1300." In *Artistes, artisans et productions artistiques au moyen âge,* edited by X. Barral i Altet, III, pp. 321–49. Paris: Picard, 1990.

Stratford, Neil. "Three English Romanesque Enamelled Ciboria." *Burlington Magazine* 126 (1984): 204–16.

Straub, A., and E. Keller, eds. *Herrade de Landsberg, Hortus Deliciarum.* Strasbourg: Truebner, 1879–99.

Strohm, Paul. "The Malmesbury Medallions and Twelfth-Century Typology." *Mediaeval Studies* 33 (1971): 180–7.

Sturges, Robert S. *Medieval Interpretation: Models of Reading and Literary Narrative 1100–1500.* Carbondale: Southern Illinois University Press, 1991.

Sumption, Jonathan. *Pilgrimage: An Image of Medieval Religion.* London: Faber and Faber, 1975.

Swarzenski, Georg. *Die Salzburger Malerei.* 2nd ed. 2 vols. Stuttgart: A. Hiersemann, 1969.

Synan, Edward A. *The Popes and the Jews in the Middle Ages.* New York: Macmillan, 1965.

Tachau, Katherine H. *Vision and Certitude in the Age of Ockham: Optics, Epistemology and the Foundations of Semantics 1250–1345.* Leiden: Brill, 1988.

Tavard, George H. "Apostolic Life and Church Reform." In *Christian Spirituality,* II, edited by Jill Raitt, pp. 1–11. New York: Macmillan, 1987.

Temple, Elzbieta. *Anglo-Saxon Manuscripts 900–1066.* London: Harvey Miller, 1976.

Thompson, Leonard. "Cult and Eschatology in the Apocalypse of John." *Journal of Religion* 49 (1969): 330–50.

Thomson, S. Harrison. *The Writings of Robert Grosseteste.* Cambridge: Cambridge University Press, 1940.

Throop, Palmer A. *Criticism of the Crusade: A Study of Public Opinion and Crusade Propaganda.* Amsterdam: Swets and Zeitlinger, 1940.

Töpfer, Bernhard. *Das kommende Reich des Friedens.* Berlin: Akademie-Verlag, 1964.

Trachtenberg, Joshua. *The Devil and the Jews: The Medieval Conception of the Jews and Its Relation to Modern Antisemitism.* New Haven: Yale University Press, 1943.

Travis, Peter W. "Affective Criticism, the Pilgrimage of Reading, and Medieval English Literature." In *Medieval Texts and Contemporary Readers,* edited by Laurie A. Finke and Martin B. Shichtman, pp. 201–15. Ithaca, NY: Cornell University Press, 1987.

Trexler, Richard C. *The Christian at Prayer: An Illustrated Prayer Manual Attributed to Peter the Chanter.* Binghamton, NY: Medieval and Renaissance Texts and Studies, 1987.

Tristram, E. W. *English Medieval Wall Painting: The Thirteenth Century.* Oxford: Oxford University Press, 1950.

English Medieval Wall Painting: The Twelfth Century. Oxford: Oxford University Press, 1944.

Turner, Victor. *Process, Performance and Pilgrimage: A Study in Comparative Symbology.* New Delhi: Concept, 1979.

Turner, Victor, and Edith Turner. *Image and Pilgrimage in Christian Culture: Anthropological Perspectives.* Oxford: Blackwell, 1978.

Tuve, Rosamund. *Seasons and Months.* Cambridge: Brewer, 1974.

Tyerman, Christopher. *England and the Crusades 1095–1588.* Chicago: University of Chicago Press, 1988.

"Some English Evidence of Attitudes to Crusading in the Thirteenth Century." In *Thirteenth-Century England, Proceedings of the Newcastle upon Tyne Conference 1985,* edited by P. R. Coss and S. D. Lloyd, pp. 168–74. Woodbridge: Boydell, 1987.

Vance, Eugene. *Mervelous Signals: Poetics and Sign Theory in the Middle Ages.* Lincoln: University of Nebraska Press, 1986.

Van den Eynde, Damien. "Chronologie des écrits d'Abélard à Héloise." *Antonianum* 37 (1962): 337–49.

Van der Meer, Frederick. *Maiestas Domini: Théophanies de l'Apocalypse dans l'art chrétien.* Vatican City: Pontificio istituto di archeologia cristiana, 1938.

Vauchez, André. *The Laity in the Middle Ages: Religious Beliefs and Devotional Practice.* Translated by Margaret Schneider. Notre Dame, IN: University of Notre Dame Press, 1993.

Vaughan, Richard. *Matthew Paris.* Cambridge: Cambridge University Press, 1958.

Verdier, Philippe. *Le couronnement de la Vierge.* Montreal, Paris: Institut d'études médiévales, 1980.

——. "La grande croix de l'abbé Suger à Saint-Denis." *Cahiers de civilisation médiévale* 13 (1970): 1–31.

——. "What Do We Know of the Great Cross of Suger at Saint-Denis?" *Gesta* 9 (1970): 12–15.

Vetter, Ewald. "Marie im brennenden Dornbusch." *Das Münster* 10 (1957): 237–53.

Vitz, Evelyn Birge. *Medieval Narrative and Modern Narratology: Subjects and Objects of Desire.* New York: New York University Press, 1989.

Volkmann, Ludwig. "Ars memorativa." *Jahrbuch der kunsthistorischen Sammlungen in Wien* 3 (1929): 111–200.

Wach, Joachim. "Hugh of St. Victor on the Virtues and Vices." *Anglican Theological Review* 31 (1949): 25–33.

Waddell, Chrysogonus. "The Reform of the Liturgy from a Renaissance Perspective." In *Renaissance and Renewal in the Twelfth Century,* edited by Robert L. Benson and Giles Constable, pp. 88–109. Cambridge, MA: Harvard University Press, 1982.

Waetzoldt, Stephan. *Die Kopien des 17. Jahrhunderts nach Mosaiken und Wandmalereien in Rom.* Vienna: Schroll, 1964.

Walberg, Emmanuel. *Deux versions inédites de la légende de l'Antichrist.* Lund: C. W. Gleerup, 1928.

Wallace, Wilfrid. *The Life of St. Edmund of Canterbury from Original Sources.* London: Paul, Trench, Trubner, 1893.

Wallis, Mieczyslaw. "Inscriptions in Paintings." *Semiotica* 9 (1973): 1–28.

Walsh, P. G. "Golias and Goliardic Poetry." *Medium Aevum* 52 (1983): 1–7.

Ward, Benedicta. *Miracles and the Medieval Mind: Theory, Record and Event 1000–1215.* Rev. ed. Philadelphia: University of Pennsylvania Press, 1987.

Ward, H. L. D. *Catalogue of Romances in the Department of Manuscripts in the British Museum.* 3 vols. London: British Museum, 1883–1910.

Ward, John O. "From Antiquity to the Renaissance: Glosses and Commentaries on Cicero's *Rhetorica.*" In *Medieval Eloquence: Studies in the Theory and Practice of Medieval Rhetoric,* edited by James J. Murphy, pp. 25–67. Berkeley: University of California Press, 1978.

Warichez, Joseph. *La Cathédrale de Tournai.* Brussels: Nouvelle société d'éditions, 1930.

Warner, George. *The Queen Mary's Psalter.* London: British Museum, 1912.

Watson, A. G. *Catalogue of Dated and Datable Manuscripts c. 700–1600 in the Department of Manuscripts, the British Library.* 2 vols. London: British Museum Publications for the British Library, 1979.

Watson, Paul F. "The Queen of Sheba in the Christian Tradition." In *Solomon and Sheba,* edited by James P. Pritchard, pp. 115–45. New York: Praeger, 1974.

Watt, J. A. "The English Episcopate, the State and the Jews: The Evidence of the Thirteenth-Century Conciliar Decrees." In *Proceedings of the Newcastle upon Tyne Conference 1987,* edited by P. R. Coss and S. D. Lloyd, pp. 137–47. Woodbridge: Boydell, 1988.

Webster, J. C. *The Labors of the Months in Antique and Medieval Art.* Princeton: Princeton University Press, 1938

Wehrhahn-Stauch, L. "Bock." In *Lexikon der christlichen Ikonographie,* edited by E. Kirschbaum, I, cols. 314–16. Rome: Herder, 1968.

Wentzel, Hans. "Die ältesten Farbfenster in der Oberkirche von S. Francesco zu Assisi und die deutsche Glasmalerei des XIII. Jahrhunderts." *Wallraf-Richartz Jahrbuch* 14 (1952): 45–72.

——. *Die Christus-Johannes-Gruppen des XIV. Jahrhunderts.* Stuttgart: P. Reclam, 1960.

Werckmeister, K.-O. "Die Bedeutung der 'Chi'-Initialseite im Book of Kells." In *Das erste Jahrtausend,* edited by V. H. Elbern, II, pp. 687–710. Düsseldorf: L. Schwann, 1964.

Werner, Karl. "Die Psychologie, Erkenntnis-und Wissenschaftslehre des Roger Bacons." *Sitzungsberichte der Akademie der Wissenschaften, Wien, Phil.-hist. Cl.* 93 (1879): 467–576.

Whaite, H. C. *St. Christopher in English Medieval Wall Painting.* London: E. Benn, 1929.

White, Hayden. *Tropics of Discourse: Essays in Cultural Criticism.* Baltimore: Johns Hopkins University Press, 1978.

——. "The Value of Narrativity in the Representation of Reality." In *On Narrative,* edited by W. J. T. Mitchell, pp. 1–23. Chicago: University of Chicago Press, 1981.

White, T. H. *The Bestiary: A Book of Beasts.* New York: Putnam, 1960.

Whitman, Jon. *Allegory: The Dynamics of an Ancient and Medieval Technique.* Cambridge, MA: Harvard University Press, 1987.

Wieck, Roger S. *Time Sanctified: The Book of Hours in Medieval Life and Art.* New York: George Braziller, 1988.

Williams, John, and Barbara Shailor. *A Spanish Apocalypse: The Morgan Beatus Manuscript.* New York: George Braziller, 1991.

Williams, Steven J. "Roger Bacon and His Edition of the Pseudo-Aristotelian *Secretum secretorum.*" *Speculum* 69 (1994): 57–73.

Wilson, J. M. "On Some Twelfth-Century Paintings on the Vaulted Roof of the Chapter House of Worcester Ca-

thedral." *Reports and Papers of the Associated Architectural Societies* 32 (1913): 132–48.

Wittig, Susan. *Stylistic and Narrative Structures in the Middle English Romances.* Austin: University of Texas Press, 1978.

Woodward, David. "Medieval *Mappamundi*." In *The History of Cartography,* I, edited by J. B. Harvey and David Woodward, pp. 286–370. Chicago: University of Chicago Press, 1987.

Woolf, Rosemary. "The Theme of Christ the Lover-Knight in Medieval English Literature." *Review of English Studies* 13 (1962): 1–16.

Wormald, Francis. "An English Eleventh-Century Psalter with Pictures." *The Walpole Society* 38 (1960–62): 1–13.

"Some Illustrated Manuscripts of the Lives of the Saints." *Bulletin of the John Rylands Library* 35 (1952): 248–66.

"Some Pictures of the Mass in an English XIVth Century Manuscript." *The Walpole Society* 41 (1966–8): 39–45.

Wormald, Francis, and P. Giles. *A Descriptive Catalogue of the Additional Illuminated Manuscripts in the Fitzwilliam Museum Acquired between 1895 and 1979.* 2 vols. Cambridge: Cambridge University Press 1982.

Wright, Rosemary Muir. "Sound in Pictured Silence: The Significance of Writing in the Illustration of the Douce Apocalypse." *Word and Image* 7 (1991): 239–74.

Yates, Frances. *The Art of Memory.* Chicago: University of Chicago Press, 1966.

The Year 1200. 2 vols. New York: Metropolitan Museum of Art, 1970.

Young, Karl. *The Drama of the Medieval Church.* 2 vols. Oxford: Clarendon, 1933.

Zinn, Grover A. "Hugh of Saint Victor and the Art of Memory." *Viator* 5 (1974): 211–34.

Zumthor, Paul. *Essai de poétique médiévale.* Paris: Seuil, 1972.

"Intertextualité et mouvance." *Littérature* 412 (1981): 8–16.

Index of Manuscripts

Index of Persons and Places

Aaron, flowering rod of, 316, 318, 328, 332, 397 n. 253, fig. 240
Abaddon, 95, 97, 99, figs. 61–3
Abel, 138, 313, 318, figs. 238, 241
Abelard, Peter (ca. 1079–ca. 1142), 224, 306
Abingdon Abbey, illustrated Apocalypse of, 38, 210, 214, 240; anathema in, 210–12
Abraham: meeting with Melchizedek, 318, fig. 241; sacrificing Isaac, 323, 328, fig. 244; sword of, 323
Acre, 221, 276
Adam: adoring the Lord, 313, fig. 238; Christ as the new, 308; debt satisfied on cross, 323; dispute over fall of, 335; and Eve expelled from Paradise, 313–15, fig. 238
Adam of St. Victor (ca. 1110–ca. 1180), 158
Adam of Whitby, commentary on Aristotle, 380 n. 63
Adso of Moutier-en-Der (d. 992), *De ortu et tempore Antichristi*, 111, 228
Ælfric (ca. 955–1010/15): on legends of Theophilus and St. Mercurius, 388 n. 29; on life of St. John, 25, 31, 32; sermon on the Assumption of the Virgin, 279
Alain de Lille [Alanus de Insulis] (d.

1203): on the Cherub, 282–3, 293, 295; on Creation, 313; on *nummulatria*, 143; on smiling and light, 362 n. 150; on Song of Songs, 297
Alban, Saint (d. 287): dream of, 38, fig. 23; life of, 37–8; looking through window, 38; *see also* Subject Index: *Vie de Seint Auban*
Albertus Magnus, Saint (ca. 1200–80): on the authorship of the Apocalypse, 24, 28; on the bare thigh, 168; *De bono*, 244; on memory, 242, 244, 246
Alcher of Clairvaux (d. 1153), 62
Alcuin of York (ca. 730–804): Bible of, 359 n. 80, 366 n. 267; on Mary Magdalene, 284
Alexander III [Rolando Bandinelli], pope (1159–81), 214
Alexander III the Great, king of Macedonia (d. 323 B.C.), 232
Alexander the Minorite (d. 1291), commentary on the Apocalypse: on the Eucharist, 260–1, 263; on the Marriage of the Lamb, 368 nn. 298, 303, 307; on the Third Horseman, 374 n. 99; *see also* Index of Manuscripts: Cambridge University Library MS Mm.5.31
Alhazen, *see* Haytham, Hasan ibn al-
Althusser, Louis, 208

Amadeus VIII, duke of Savoy (1416–40), 240
Ambrose [Aurelius Ambrosius], Saint (ca. 340–97), 174
Aminadab: chariot of, 303, 332, 335, 400 n. 309, 466, figs. 250, 251; as type for Christ, 332
Amphibalus, Saint, 38, fig. 23
Anagni, commission of, 227
Angela of Foligno (d. 1309), 303, 307
Anselm of Canterbury (1033–1109): *Meditationes et Orationes*, 30, 49, 248; prayer to the Virgin, 379 n. 22
Anselm of Havelburg (d. 1158), 3
Anselm of Laon (ca. 1050–1117), 42; anti-Jewish sentiments of, 216; on Song of Songs, 297, 300
Aristotle (d. 322 B.C.): Arabic commentaries on, 6; *De memoria et reminiscentia*, 242; medieval commentaries on, 235, 380 n. 63; medieval rediscovery of, 235; on memory, 242; on narrative, 356 n. 1; perception theory of, 6, 8; *Posterior Analytics*, 215, 235; theory of causality, 24; translations of, 242
Asia, *see* Subject Index: Churches of Asia
Astell, Ann W., 297

431 ∎

Subject Index

Abyss: beast from, 95, 100, 114; dragon locked in, 182, 184; pit of, 97; unlocking of, 97

Adoration: of the angel by John, 22–3, 176–7, 196–8, 249, 270; of the Lamb, 91–2, 247, 256; of the sea beast, 41; by twenty-four Elders, 70–1, 116, 172–3, 260, 360 n. 96; *see also* Worship

Æthelstan Psalter, *see* Index of Manuscripts: London, British Library MS Cotton Galba A.XVIII

Albani Psalter, *see* Index of Manuscripts: Hildesheim, Library of St. Godehard

Allegory: in the Apocalypse, 13–14, 21, 42, 53, 266, 338; author's role in, 21, 22; in the Berengaudus commentary, 58–9, 95; and exegesis, 13, 208, 233; hexaemeral, 313; as ideological structure, 14, 208, 233; in interpreting Scripture, 11, 199, 207, 217, 236, 240; of Israel redeemed, 300, 301; John as the hero, 20; metanarrative enframing of, 63; narrative structure in, 97, 123, 129, 180, 266; parody of, 209; of Penitence and Faith, 244, 292–3, fig. 228; reader's role in, 14, 22, 208, 246,

266; reading, 42, 52, 84, 207, 208; repetition in, 97; signs in, 13; in Song of Songs, 296–307; of spiritual armor, 276, 293; syntactical isolation of imagery in, 13, 97; temporal difference in, 266; typological, 397 n. 248; unfinished, 128; vertical organization of, 12; of virtues and vices, 307–9; visual nature of, 13; of the world, 207

Altar: censing of, 72, 94–5, 248; as Church, 152; empty, 119, 318, 397 n. 257; four corners of, 100; image of beast on, 141–2; Lamb standing on, 76, 203; souls beneath, 85–7; in the temple, 107; voice of, 159; veil, 328

Amesbury Psalter, *see* Index of Manuscripts: Oxford, All Souls College MS 6

Amplification: medieval practice of, 55, 272; of picture cycles, 273

Anathema, 210–12, 372 n. 37

Ancrene Riwle: clerical and lay readership of, 240, 241, 272; on the Crucifixion, 287, 293, 325; on millstones, 172

Andachtsbild of Christ and St. John, 350 n. 61

Angel: Abraham's sword grasped by, 323; Adam and Eve expelled

from paradise by, 313; adored by John, 196–8, 249; altar censed by, 72, 94, 248; ascending from the rising sun, 90, 361 n. 126; birds summoned by, 179–80, 200; book given to John by, 101–7, 209, 256; Christ as figure of, 182, 248; Church defended by, 97; conflicted gesture of, 108, 196–7; contemplative capacities of, 250; descends from heaven, 182; distributing trumpets, 92; doom of beast worshipers announced by, 147–9; dragon enchained by, 182–4, 252; eagle replaced by, 361 n. 137; eternal gospel announced by, 147; fall of Babylon announced by, 147, 169; fourth (*angelum quartum*), 159; harlot of Babylon explained by, 166, 168; as intellectual being, 348 n. 21; as intermediary, 23, 24, 25, 196; as interpretive agency, 22; John carried by, 168, 190; John commanded to write by, 176–7; John shown the heavenly Jerusalem by, 192–4, 301; lion-headed, 158; millstone cast by, 170–2; as Old Testament prophet, 72–5; on Patmos, 61, 62–3, 253; question asked by, 72–5; robes conferred on martyrs

■ 440

Subjectivity: of authorial presence, 22; medieval cultivation of, 15–16, 233, 241, 336

Subversion: of meaning, 258; of narrative, 199–204

Sun: angel ascending from, 90, 361 n. 126; angel standing on, 179; Christ as, 122–3, 179, 221, 294; eagle gazing at, 158; face like, 358 n. 57; flames of, 161–2; harbinger of Christ's Advent, 163, 223; *sol iustitiae*, 90; symbol of Christ's virgin birth, 90; vial poured on, 161–2; *see also* Woman in the Sun

Super Hieremiam prophetam, 375 n. 127

Superbia, see Pride

Supplicationes variae, 285, 294, 346 n. 45, 387 n. 13

Suspense in narrative, 124, 128, 267

Sword: of Abraham, 323; angel with, 292, 313, 323; attribute of power, 114; double-edged, 258 n. 66; of the false prophet, 141; of the Fourth Horseman, 83, 360 n. 114; of justice, 185; in the mouth of the Lord, 68, 178, 358 n. 66; of the sea beast, 133; of the Second Horseman, 79

Symbols: in the Apocalypse, 49; of Christ, 256, 315, 359 nn. 76–7; of the Eucharist, 265, 365 n. 235; polyvalence of, 49; present in signs, 56; role in knowledge, 10; of the Trinity, 287, 292, 293; world as system of, 292; *see also* Allegory

Synagogue: blindfolded, 323; conversion of, 334; defeated by Church, 287; elect portion of, 332; identified with John, 35, 288; represented by the Shulamite, 300, 303; represented by the sponge bearer at the Curcifixion, 227; return of, 332; ritual vessel of, 332; scapegoat as attribute, 315, 399 n. 285; unveiling of, 315, 323, 328–31, 335, 399 n. 293, 400 n. 305; veiled, 328

Synods, anti-Jewish, 216

Tartars, *see* Mongols

Tau, 34–5, 274, 323

Temple: as the Church, 107, 157, 164; of God in heaven, 55, 108, 118, 256; measuring of, 54, 107–8; pagans forbidden to enter, 107–8; presentation in, 318, 331; smoke from, 157; veil, 331, 352 n. 103; voice from, 154, 220

Ten Commandments, 213–14, 272, 395 n. 225; in the Eton Apocalypse, 309, 310

Ten Lost Tribes of Israel, 231

Testaments: binary opposition of, 309; book of, 128; Church accepts two, 127, 200, 249; double-edged sword as two, 358 n. 66; eagle's wings representing two, 203, 249; *see also* Old Testament; New Testament; Typology

Text: Anglo-Norman, 198; authentication of, 23; author present in, 338; authority of, 338; division of, 12, 33, 41, 49, 58, 159, 247; eccentric breaks in, 132, 157; fragmentation of, 12, 49, 51; in frames, 301, 303, 309; ideology encoded in, 338; and image, 2, 12, 45–6, 47–8; inscribed interior appropriation of, 12; juxtaposition with gloss, 266; meaning of, 249; medieval transformations of, xxiii; medieval transmission of, 45; memorizing, 149, 246; mimed by illustration, 338; as object, 50; omission of, 65; open-ended, 338; paraphrases of, 247; performed, 338; role in revelation, 9; sequel, 54; summaries of, 247; as system of symbols, 338; threshold, 63; unfinished, 338; variants, 57, 338, 366 n. 267; visual appearance of, 3, 12, 246; written by a devil, 300; *see also* Commentary; Gloss; Exegesis; Textual image

Textual image: ambiguity of, 253; contradiction in, 306; in picture books, 12; potential redundancy of, 242, 290; problem in alignment of, 63, 242; relationship with reader-viewer, i, 10, 12, 14; *see also* Text, and image

Theophany: Adoration of the Lamb, 91–2; Majesty, 68–70

Theory related to art historical practice, 1

Third Horseman, 55, 79–81, 266, 374 n. 99

Third Seal, 217, 266–7; Berengaudus commentary on, 35

Third Vial, 159–61

Thousand-year reign, 184–5, 228, 268, 386 n. 223

Throne: of the beast, 162; in the First Vision, 66; in heaven, 68; of judges, 184, 187; of judgment, 189; of mercy, 34, 273

Time: in allegory, 266; discontinuity between author and reader in, 338; end of, 225–34, 240, 269, 313, 323; illusion of, 55; image positioned in, 56; interlude, 267; lapse in narrative, 112, 266; measured, 115, 184, 267, 313; medieval experience of, 266; metaphors of, 194, 269; narrative, 266; in numbered sequences, 269; outside John's vision, 115; outside narrative, 122; problematic of, 266; related to eternity, 225; in romance, 51; ruptures in, 266; sacred, 259, 266; spatializations of, 194, 265–71; totality of, 313; understanding of, 197, 269; warp, 266; wheels of, 336

Title board on the cross, 288

Tituli, see Inscriptions

Tonsure, 70, 212, 249

Tractatus de arte memorativa, see Index of Manuscripts: Vienna, Nationalbibliothek Clm. 539

Transformation: discourse of, 305; of existence, 313; of the reader, 22, 266; of the self, 338; spiritual metamorphosis, 305; through vision, 281

Translation: exegesis as, 43; vernacular, 243, 272, 379 n. 40

Tree: of Jesse, 399 n. 293; of Life and Death, 394 n. 206; representing the world, 292; of Vices, 248,